Timeless Beauty

Timeless Beauty

Traditional Japanese Art
from the Montgomery Collection

Essays by
Edmund de Waal, Rupert Faulkner, Gregory Irvine
Anna Jackson, Annie M. Van Assche

SKIRA

Art Director
Marcello Francone

Editorial Coordination
Marzia Branca

Editing
Claudio Nasso

Layout
Monica Temporiti

Photographers
Roberto Buzzini
Stefano Ember
Roberto Paltrinieri

Note to the reader

In the text by Annie M. van Assche,
there are the following abbreviations:
Skt Sanskrit
Ch Chinese
J Japanese

The dimensions of the work, unless
indicated otherwise, are expressed
in the form: 'height × maximum diameter',
or 'height × base × depth'. When necessary,
the following abbreviations are also used:
l. length
w. width
h. height
d. diameter

First published in Italy in 2002 by
Skira Editore S.p.A.
Palazzo Casati Stampa
via Torino 61
20123 Milano
Italy

Printed and bound in Italy. First edition

ISBN 88-8118-735-3

Distributed in North America and Latin
America by Abbeville Publishing Group,
22 Cortlandt Street, New York,
NY 10007, USA.
Distributed elsewhere in the world by
Rizzoli International Publications, Inc.
through St. Martin's Press, 175 Fifth
Avenue, New York, NY 10010.

Acknowledgments

This book presents a selection of works discovered over the past thirty years. For me, the collection is an expression of life, sometime toil, but, above all, of love. I may only hope that you, the reader, will experience interest and joy from its content.

To my partner, Mariangela, I thank you for support and devotion. A special thanks to Elio Bollag, Lugano, to Irene Martin, Los Angeles, to Michael Dunn, Tokyo, to Judith Dowling, Boston and Robert Moes, New York.

I am most thankful for the skills of Eric Ghysels, whose determination, sincerity and enthusiasm made this project possible.

A special acknowledgment to my friends and authors, Rupert Faulkner, Gregory Irvine, Anna Jackson to have given me their time from a most busy schedule at the Victoria & Albert Museum, London. To Edmund de Waal who stopped potting so that he could write. And to dear Annie Van Assche. What a civilised and charming group of experts.

For research and translations I thank the following collaborators:
– Tom Gregerson, Morikami Museum & Japanese Gardens, Delray Beach, Florida
– Motoki Sakamoto, Morikami Museum & Japanese Gardens, Delray Beach, Florida
– Eriko Ijima, Hamilton Graduate Research Library, University of Hawaii
– Takahashi Shunkin, New York
– Mr. T. Maruyama, Munakata Shiko Memorial Museum of Art, Aomori City, Japan

Contents

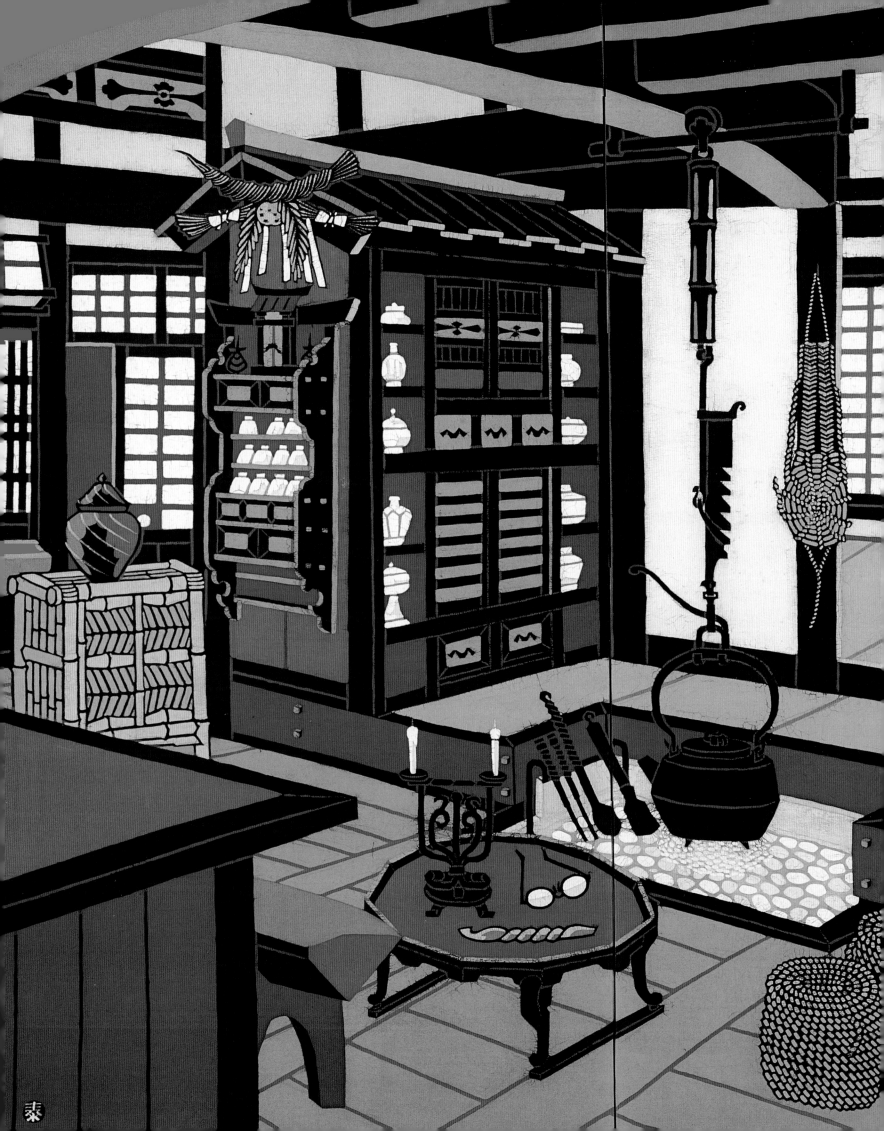

Edmund de Waal

'Art without finish': Japanese Arts in the West

It has become an anthropological truism that it is possible to write the 'biography of an object', to track its life from creation through the different stages of its ownership, its patterns of use and its progress into old age. It is a useful way of thinking about the 'status' of an object and how that manifests itself through time: how the meanings of an object change in its encounters with people[2]. The biography of one of the Japanese objects that are known variously in the West as *mingei*, or Japanese folk craft, or Japanese folk art or indeed Japanese art, would be spectacularly complex. Imagine the layerings of the narrative, the twists and turns and uncertainties of our putative object's life. Imagine its moment of birth in the deep cultural matrix of Japanese craft, the web of artistic, economic, social, religious aspirations that cause it to be made. Then its launch into the world of the commodity to be bought and sold and traded. Imagine all the ways in which it was handled, imagine the ways it was stored. And then think of what happens when it is collected, when its meanings as an object with a measure of utility get transposed into the world of critics, curators, collectors, art historians and cultural theorists. What does its life hold next?

For when we see one of these objects, whether it is a piece of Wajima lacquer or a quilt cover, in an exhibition or in a beautiful catalogue, when we are transfixed by its austerity, its sense of abbreviated gesture, its humour, we are looking at something whose life-history is as gripping as any airport novel. And at the start of this new millennium we should not only take time to be gripped, to think about how we come to be in this extraordinary situation of being able to see these things, but try and work out why there is such a complex trajectory

from workshop or kitchen hearth to cabinet. We can look back on a century or more in which certain Japanese objects, made in the main for use rather than contemplation, have become powerful and iconic representations of a panoply of rich concepts. For some they have come to represent 'timelessness', 'authenticity', 'the Kingdom of Beauty', 'direct simplicity and joy in making'. For others they have become examples of an art of abstraction, a balance of forms, visual weight and mass that are the equal of sculpture. And for an impressive list of artists, designers and architects in the West they have provided a profound source of influence. Any cursory list would include, *inter alia*, the designer Christopher Dresser, the architects Frank Lloyd Wright and Le Corbusier, the painters Mark Tobey, Franz Kline and Robert Motherwell, the sculptor Isamu Noguchi, the potters Bernard Leach, Paul Soldner, Peter Voulkos and Robert Turner, the fibre artists Annie Albers and Peter Collingwood and the basket makers John McQueen and Joanne Segal Brandford. It is also present in the work of contemporary artists who use wood, contemporary jewellers and metal workers and glass artists. Bridging all these heterodox cases there is an over arching debt to just these kinds of Japanese objects.

This debt lies in the upsetting of Western norms of thinking about how art gets made and how it is valued, just as much as what it looks like. The iconoclasm has been greater at particular moments than others but it is just this aspect of 'looking the opposite direction' that has proved so fruitful and influential. It is possible to detach four salient characteristics of this influence, out of many. The first is in the use of materials, the second an acceptance of the marks of age and wear, thirdly the use of

1. *Two-fold screen* (byobu) (detail)
Minagawa Taizō (b. 1917)
The home of the potter Kawai Kanjirō
Cotton, wax-resist (*rōketsu-zome*)
175 × 195 cm
1951

gesture and fourthly, and most critically, there is an abstraction not only in mark and pattern making, but of form.

The phrase 'truth to materials' has become so common that its radicalism has been lost, the shock there must have been when seeing unglazed pottery or an unadorned lacquer surface for the first time. This idea of the use of truthful materials meant revealing rather than effacing certain properties of clay, wood or metal. It also meant dramatizing a connection between 'the organic form of the sculpted material and the organic development of the material from which it was carved…'[3] as Rosalind Krauss wrote of Henry Moore. This shows itself as a kind of structural clarity – when you see something you apprehend the manner of its construction. Thus a sieve for beans (*mame-doshi*) is 'clear' in its use of split bamboo, you can work out how it was put together, even if you are not able to copy it. The repeated geometries of merchant chests, the echoing of the shape of drawers and balancing of its formalities is an aesthetic that reveals the architecture of the construction of objects. The nails holding the bamboo veneer to the wood of a *hibachi*, or the split bamboo running round a wash basin create an aesthetic out of necessity – they imply, dramatically, that there is no other way of keeping the structure together. There might be manifold alternatives, but the drama suggests this singularity.

Then there is what might be described as the valorizing of age, so that the chips and cracks and wear on the surface of a Muromachi period circular tray (*marubon*) or even in the lattice of gold lacquer mends in a Seto stone plate (*ishizara*), contribute to the pieces' aesthetic. They supply the temporal dimension, the 'hand patina' that tells of use. In the Western 'biography of an object' age usually implies a falling off from the moment of creation through use towards disuse and discardment. Acceptable marks might include the patinas of Renaissance bronzes, or the craquelure on a painting: but on the whole age was unaesthetic in the coterie of High arts. So there is an element of the iconoclastic in these Japanese objects here too – they challenge the Western concept that the very integrity of an object is contingent on its remaining unchanged.

The third key area of influence lies in the power of gestural markings, the sudden explosion of movement. This can be seen in the glaze splashes from the rim of a water jar (*mizugame*) or in the fierce slashing cuts in the toy falcon (*Sasano-bori ningyo*). The implication of a kind of inclusiveness of happenstance was again a profoundly unusual way of thinking about the experience of making art. The sense that objects could be made in this way connected to the growth of interest in Zen in the West, discussed later in this essay. But perhaps the most significant debt – and the most difficult to analyse – to these Japanese arts lies in abstraction. By abstraction I do not mean the lack of images. Many of these articles have complex iconographies, there are treasure-sacks on the *furoshiki* symbolising auspicious events, Daruma toys, pothook adjustors in the form of carp: each object spins webs of puns, allusions behind it. By abstraction I mean the sense that there is a simultaneous apprehension of form as the meeting place of utilitarian requirement and decorative impulse, and a sculptural compulsion.

In each case the language in which these Japanese objects have been described is weighty and to some extent codified. How this happened through the agency of particular charismatic artists, collectors and critics, most notably Christopher Dresser, Edward Morse, Yanagi Sōetsu and Bernard Leach, is a piece of fascinating cultural history. The language of description that has shaped the aesthetics of Western views of these Japanese things is their language. Their language of prescription has also made certain characteristics acceptable and certain beyond the pale: some objects fitted into their patterning of 'good' Japanese taste and some most certainly did not. They have provided a lens through which much has been refracted, their vocabularies – and hence their conceptual frameworks – have been used wholesale and with a casualness that has occluded the dense specificity of meanings that these objects have had in Japan. In short, whenever an Okinawan textile or a piece of Wajima lacquer is swooningly described as 'timeless' or 'authentically vigorous', what we are hearing are echoes of Morse, Yanagi and Leach – echoes that only serve to romanticise and aestheticise, to wrap the textile and the lacquer in a protective smog of Orientalist cliche.

As it is only in the last twenty years that there have been attempts to critique the assumptions of these writers, it will be an uphill struggle to change the ways in which these arts talked about. The romantic projection onto Japan as a place of happy, intuitive craftspeople still runs deep. The value of this book is that it allows for a balance between the necessary contextualisation of objects and their visual presentation. It reaches out to the balance that the theorist Stephen Greenblatt talked of as the pull between 'resonance' and 'wonder' that happens in our encounter with art in an exhibition: 'A resonant exhibition often pulls the viewer away

from the celebration of isolated objects and towards a series of implied, only half-visible relationships and questions: How did the objects come to be displayed? What is at stake in categorising them as "museum quality"? How were they originally used? What cultural and material conditions made possible their production…?'[4] In analysing the effects on the West of what I shall just call the Japanese arts (abjuring the use of 'folk' and 'traditional' as unnecessary) far too often there has been the swooning, the 'wonder' aspect, over the objects.

In the first encounters in the West with these new kinds of objects, there was just this mixture of beguilement and shock, best seen in the reactions to the new pots of Japan shown at the Paris Exposition in 1878. These were the tea wares, pots that had emerged from the vernacular and rural traditions, and had been chosen by tea masters as expressions of vigour and freedom. Often warped or slumped, and mainly monochromatic, the emphasis here was on gesture – either in the flow of glaze or in the marks of throwing. It was obvious that these new kinds of pots required a particular aesthetic; a late Victorian commentator acknowledging that 'a connoisseur must have been specially educated when he consents to pay ten or twenty guineas for a water holder that might be easily mistaken for a drainpipe, partially blackened by fire and ornamented by patches and streaks of brick colour'[5]. That there were such connoisseurs around, albeit few in number, can be seen in the critical reception accorded to these pots when exhibited at the grand international expositions; bafflement giving way to a grudging respect for what was described in 1901 as 'a world in which pottery was not ashamed of its earthy origin or the human fingers that fashioned it, but was content in the satisfactory fulfilment of its mission'[6]. The very idea of the fulfilling of a mission implies a radically different way of thinking about how clay is used, of clay as possessing an essential character that needed to be respected. This was a focus on the process of making and firing – in contradistinction to the ideal of Chinese porcelains where the processes of making were subsumed into the idealized object. Here the pot could be said to be a celebration of process rather than its transcendence. And this was a point that Christopher Dresser had made in his report on Japanese pottery in 1871: 'I have before me some specimens of Japanese earthen-ware, which are formed of a coarse dark-brown clay, and are to a great extent without the finish which most Europeans appear so much to value, yet these are artistic and beautiful. In the case of cheap goods we spend time in getting smoothness of surface, while the Japanese devote it to the production of art effect. We get finish without art, they prefer art without finish'[7].

The challenge that these objects offered was thus two-fold. One was aesthetic. Japanese pottery seemed to break away from any known canon: 'some modern specimens of Japanese pottery are curiously and intentionally deformed-crooked, twisted, or bulging like a sack of potatoes-and, nevertheless, in the most refined taste…'[8]. The second was conceptual, the very idea that 'refinement' or 'art effect' could be predicated on distortion or coarseness was new. And if one wants to try and track the ways in which these quotidian objects have become influential in the West it is critical to examine the language of the artists, critics and curators who have mapped these Japanese arts. Perhaps the most compelling description of projection comes in Bernard Leach's version of Yanagi Sōetsu's essay on the Kizaemon teabowl. The essay focuses on the Korean maker of the bowl, stressing that the primary marker for authenticity is that the maker of the object must not be self-aware, must be unconscious of the possibility of inauthenticity in making. Therefore the process of making must be consuming, even self-abnegating, allowing little of the destructive self-consciousness that has infected the West. It is a piece of what might be described as aesthetic ethnography, a way of making attractively comprehensible the conditions in which the bowl was made, a bowl that a poor man would use everyday: '…a typical thing for his use; costing next to nothing; made by a poor man; an article without the flavour of personality; used carelessly by its owner; bought without pride; something anyone could have bought anywhere and everywhere. That is the nature of this bowl. The clay has been dug from the hill at the back of the house; the glaze was made with the ash from the hearth; the potter's wheel had been irregular. The shape revealed no particular thought: it was one of many. The work had been fast; the turning was rough, done with dirty hands; the throwing slipshod; the glaze had run over the foot. The throwing room had been dark. The thrower could not read. The kiln was a wretched affair; the firing careless. Sand had stuck to the pot but no one had minded; no one invested the thing with any dreams. It is enough to make one give up working as a potter […] The plain and unagitated, the uncalculated, the harmless, the straightforward, the natural, the innocent, the humble, the modest: where does beauty lie if not in these qualities? […] Only a commonplace practicality can guarantee health in something made'[9].

That great list of descriptive words, 'The plain and unagitated, the uncalculated, the harmless…' stands sentinel over almost all post-war writings on these Japanese arts. For most post-war English and American commentators, Yanagi or Leach were the conduits to understanding the Japanese 'folk arts'. Thus Yanagi's Korean potter, healthily illiterate, naturally aesthetic, too busy to be self-conscious, became the iconic figure of the Oriental craftsman. He is a vivid example of 'homo orientalis […] by nature mystical and concerned with great ideas', the peasant craftsman who could be said to underpin the creation of Leach's 'authentic' Orient. By extension this kind of making can also be found in children, as Leach iterates when writing on the feeling of glazes to the touch: 'Unconsciously our fingers are invited to play over the contours, thereby experiencing pleasure through the most primitive and objective means. Children play with pebbles with a similar awakening of perception, and orientals have lost touch with the fresh wonder of childhood less than we have'[10]. Authenticity is indeed pre-lapsarian. And the Edenic fall into self-consciousness is particularly dangerous for the Korean bowl maker, or the young Japanese potters counselled by Leach on his travels who wanted to escape their traditional roles. In other words the imaging of Korean or Japanese craftsmen comes down to their stereotyping as people whose immersion in tradition safeguarded them from the perils of innovation.

But the shaping of Western understanding of Japanese crafts has also been the product of the actual encounters of Japanese craftsmen and artists. The most significant example of this was the tour of America in 1952 by Leach, Hamada and Yanagi. The trio travelled extensively, giving workshops and lectures at Black Mountain College in North Carolina, the Archie Bray Foundation in Montana and in Los Angeles. Leach lectured on his pottery workshop at St Ives and Yanagi on aesthetics, but it was the vigour with which Hamada threw and decorated that provided the most memorable outcomes from the visit. His relaxedness in brushing slip onto a pot, or in trimming a footring found an audience receptive to new and responsive approaches of handling clay. For a post-war generation of American potters and students watching Japanese potters use the wheel, not as an exercise in making perfect forms, but as a starting-point for other kinds of manipulation, seemed to show how academicised American thrown pottery had become. The tension between the expected and planned, the centrifugal force of the pot on the wheel, and the spontaneous gesture that disrupts

this, is central to many Japanese ceramic traditions. Iga and Shigaraki pots with their gaping rents from the firing, or Bizen pots with their dented sides from gestural handling were known through photographs. In the 1950s not only Hamada, but Toyo Kaneshige and Kitaoji Rosanjin all visited California and their pots, distorted, textured or inscribed whilst still wet from the wheel, were exciting manifestations of these traditions. It was exciting partly because the potters were so relaxed. Hamada at Black Mountain College in 1952 said he could 'make do' with the materials to hand, Paul Soldner remembered how Kaneshige 'trimmed the pots with a twig he had broken off an orange tree outside the studio'[11].

This was pottery, and crucially the making of vessels, as an exploratory, improvisational art. That it was an art – the conscious selection of a medium and its expression – was most apparent in the visit of Kitaoji Rosanjin. Rosanjin, the famously cussed potter, *gourmand* and *restauranteur* whose studio in Tokyo bore the sign 'Beautiful Useful Cultural: Rosanjin Greatest Artist in Japan', spectacularly failed to fit into Yanagi's normative view of the proper (humble) conduct of a Japanese artist, what might be described as the *mingei* narrative. The consolatory spiritualizing of the craftsman could not withstand the actual encounters: it all became much more complex when you met the people who did it. But these potters also made a bridge with the burgeoning excitement in Zen. For America in the 1950s Zen came mediated through the writings of D.T. Suzuki and Alan Watts: they showed a world where spontaneity and sudden violent expression were markers of real communication, where conventions were waiting to be broken asunder at revelatory moments. It meant iconoclasm – 'looking in the opposite direction' as Suzuki put it. Zen became a shorthand way of describing a particular expressionist approach to making art. Knowing about Zen was a marker of contemporary *savoire-faire*: Ad Reinhardt even caustically anatomised one part of the 50s art world as 'café-and-club-primitive and neo-Zen-bohemians'[12].

And perhaps it is just this 'looking in the opposite direction' that continues to underlie the multiplicity of interpretations of these Japanese arts in the West. Their capacity to move us to 'wonder' remains undiminished, the challenge of their 'resonance' is still with us.

[1] Quoted in Clark, G., *The Potter's Art*, London 1995, pp. 108-109.
[2] 'The Cultural Biography of Things: Commodisation as Process', by Koptyoff, I., in Appadurai A. (ed.), *The Social Life of Things*, Cambridge 1986, pp. 64-91.

[3] Krauss, R.E., *Passages in Modern Sculpture*, MIT Press, 1977. This ed. 1998, p. 143.

[4] Cf. 'Resonance and Wonder', by Greenblatt, S., in *Exhibiting Cultures*, Karp, I. and Lavine, S.D. (eds.), Smithsonian Institution Press, 1991, p. 45.

[5] Quoted in Jenyns, S., *Japanese Pottery*, London 1971, p. 104.

[6] *The Studio*, XXII, 1901, p. 289.

[7] Clark, *op. cit.*, pp. 108-109.

[8] Quoted in Gombrich, E.H., *Art and Illusion*, London 1979, p. 56.

[9] Sōetsu Yanagi and Bernard Leach, *The Unknown Craftsman*, Kodansha 1972, pp. 190-196.

[10] Cf. de Waal, E., 'Homo Orientalis: Bernard Leach and the Image of the Japanese Craftsman', in *Journal of Design History*, Vol. 10, No. 4, 1997, pp. 355-362.

[11] For descriptions of the encounter between Japanese and American potters in the 1950s cf. Levin, E., *The History of American Ceramics*, Harry N. Abrams, 1988, pp. 198-200, and Clark, G., *A Century of Ceramics in the United States 1878-1978*, pp. 129-133.

[12] Winther-Tamaki, B., *Art in the Encounter of Nations*, University of Hawaii Press, 2001, p. 40.

Rupert Faulkner

The Making of the Montgomery Collection

The collection of Jeffrey Montgomery is widely acknowledged as the finest assemblage of Japanese folk crafts outside Japan. It consists of nearly six hundred works, approximately half of which are featured in this book. Ceramics and textiles are the two largest categories, each comprising about a quarter of the collection. Figurative sculpture in various media makes up a further fifth of the total. The remaining third consists in roughly equal numbers of furniture, lacquerware, metalwork, paintings and masks. The objects come from many different parts of Japan and include Ainu and Okinawan material as well as a small number of works by twentieth-century makers associated with the Japanese Folk Craft (*mingei*) movement.

Although the collection has been in the making for nearly thirty years, it was only in 1990, when Jeffrey was encouraged by a friend to hold an exhibition in the Galleria Gottardo, in his adoptive home town of Lugano in southern Switzerland, that the public first became aware of its extraordinary scope and quality. The organization of *Mingei: Folk Arts of Japan, A Private Collection*[1] and the production of the accompanying catalogue proved to be something of an initiation by fire, for not only was the amount of work involved enormous, but Jeffrey found himself exposed to the scrutiny of the outside world to an extent he had not fully anticipated.

For an essentially private person like Jeffrey, the experience of this first exhibition was perhaps as painful as it was enjoyable, but it marked in two crucial ways a turning point in his approach to collecting. On the one hand he found himself forced to look at his collection more objectively than before and to clarify for himself how he wanted it to develop. An immediate outcome of this was a short but concerted bout of weeding of what he felt to be the more anomalous and less desirable pieces he had collected over the years. On the other hand he started to see himself less as the owner of his collection than as its guardian. Yes, the objects, intimate components of his everyday life, were and still are very much his, but they are there to be shared, not hoarded and hidden away from all but his immediate circle of family and friends.

The exhibition at the Galleria Gottardo was the first of a series of similar undertakings that have occupied Jeffrey ever since. One project has led to another, chance meetings and the striking up of new friendships resulting in what has been, despite its apparently regular progression, a programme less planned than determined by providence and fate. The exhibition *Mingei: Japanische Volkskunst, Sammlung Montgomery*[2] held in Germany in 1991 at the Ateliers des Museums Künstlerkolonie, Mathildehöhe, Darmstadt came about because its director happened to see the 1990 exhibition in Lugano. This was also the case with *Japanese Folk Art: A Triumph of Simplicity*[3], organized by the Japan Society, New York in 1992. This travelled to the Museum Bellerive in Zürich the following year, where it was shown as *Mingei: Volkkunst aus dem alten Japan*[4].

As on the occasion of his exhibition at the Galleria Gottardo, Jeffrey was happy to have his name associated with his collection when it was shown in Darmstadt and Zürich. In New York, however, he chose to remain anonymous, being referred to in the catalogue obliquely as 'an American living in Switzerland.' If modesty and wariness of possible criticism by his compatriots may have caused him to be reticent, his concerns proved wholly un-

2. *Seto ware 'stone' dish* (ishizara) (detail)
Glazed stoneware with painted design of bamboo
6.8 × 27 cm
Edo period, late 18th-early 19th century

founded. The Japan Society exhibition generated so much interest that he shortly found himself embarking on an even more ambitious project with Art Services International to tour his collection around the United States. *Mingei: Japanese Folk Art from the Montgomery Collection*[5] travelled to six American venues between 1995 and 1997, and was accompanied by the most substantial and handsomely produced catalogue of his collection up to that time. On its return to Europe it was shown in Belgium and Holland.

The United States also played host to his next exhibition, *Favorite Sons: Folk Images of Daikoku and Ebisu from the Jeffrey Montgomery Collection*[6], which was held at the Morikami Museum and Japanese Gardens at Delray Beach, Florida in 1998. This came about as a result of Jeffrey's visit to Palm Beach when his Art Services International exhibition was shown there the previous year. The foreword to the catalogue begins, rather touchingly, with a sentiment shared by many who have met Jeffrey: 'Once one gets past the incongruous image of an American expatriate who lives in Switzerland and collects Japanese folk art, the thing that strikes one about Jeffrey Montgomery is the passion he brings to sharing his enthusiasm with the world.' Jeffrey's next project, this time in France, came about as a result of a visit he made to the recently opened Musée des Arts Asiatiques in Nice, near to where he and Mariangela, his partner of many years, have a second home. Jeffrey was immediately taken by the serenity of Tange Kenzō's exquisitely realized building that sits, semi-submerged and surrounded by water, at the edge of a small lake. He was also impressed by the regional government's attempts to foster local understanding of Asian arts and cultures. Jeffrey, who had become used to being approached by others, decided that this time he would take the initiative and offer his collection for exhibition. This led to a wonderful association whose outcome, *Mingei de la Collection Montgomery: Beauté du Quotidien au Japon*[7], proved such a success that it was extended for several months beyond its scheduled showing of April to September 2000.

Most recently, a small selection of works from the Montgomery collection was included in the section entitled '*Soboku*: Artless Simplicity' in the exhibition, *Traditional Japanese Design: Five Tastes*[8], which opened at the Japan Society, New York in September 2001. Preparations are also well advanced for an Art Services International exhibition entitled *Quiet Beauty: Fifty Centuries of Japanese Folk Ceramics from the Montgomery Collection*. This is due to tour the United States after opening in Palm Beach in early 2003. Plans beyond this remain undecided, the present publication having been the main focus of his energies for the past two years. In the same way as with so many of Jeffrey's exhibitions, *Timeless Beauty: Traditional Japanese Art from the Montgomery Collection* has come about as the result of a chance meeting, in this instance between Eric Ghysels of Skira editore and the exhibition at the Musée des Arts Asiatiques. Eric stumbled upon *Mingei de la Collection Montgomery: Beauté du Quotidien au Japon* as he was passing through Nice and was so taken by the quality of what he saw that he set out to find Jeffrey and persuade him to publish his collection with Skira.

As the first book rather than exhibition catalogue devoted to the Montgomery collection, *Timeless Beauty* stands as a unique monument to Jeffrey's activities as a collector. The objects illustrated have been jointly selected by Jeffrey and the respective authors of the chapters that follow in order to demonstrate the richness of the collection and to offer insights into that which has moved and inspired him over the years. Photographs can only ever hint at the range of sensations to be enjoyed from real artefacts, but when they are of the quality they are here, they do succeed in allowing one to experience at least in part the pleasure and excitement that comes from seeing, handling and contemplating objects of distinction.

Jeffrey pinpoints the beginning of the Montgomery collection as we know it today to the purchase of some Japanese folk masks in the early 1970s. As is so often the case, though, the instincts that led him to become a collector go back much further, to when he was a child. Jeffrey's background is a privileged one. He spent his childhood and early youth in Norway, the United States and the United Kingdom among surroundings in which fine and beautiful objects were the norm. His maternal grandmother collected Chinese ceramics, especially Ding wares, while his mother had a substantial collection of Japanese Nabeshima porcelains. Both of these kinds of ceramics are characterized by precise forms and stylized decoration, often quite abstract in feeling, of plant and animal motifs.

Severity, austerity, simplicity, profundity, tranquillity, timelessness. These are some of the terms that Jeffrey and others use to describe the qualities embodied in the objects that appeal to his aesthetic. This is not where he began, however, whatever the latent propensities suggested by the fondness with which he remembers his mother's and grandmother's collections of ceramics. His first purchase, which he made as a teenager in the early 1960s, was a richly decorated Chinese porcelain vase. This was

3. *Vase in the form of a tea-kettle* (chagama) (detail)
Cast and patinated iron with applied lacquer decoration of a hawk, two squirrels, two birds and a bee amongst branches
18.5 × 31.5 cm
Chagama: Edo period, early 19th century; applied lacquer: Meiji period, late 19th century

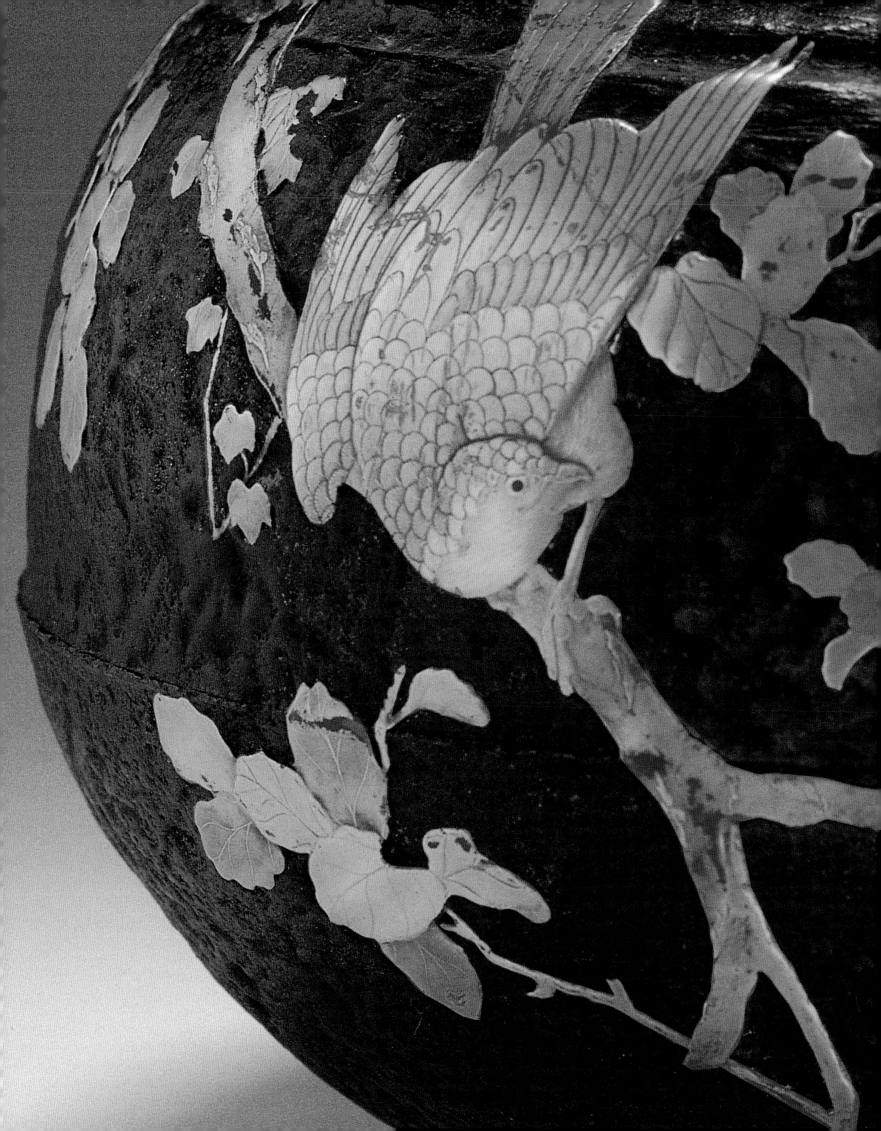

followed shortly afterwards by a similarly colourful Japanese Kutani ware bowl. Interestingly he has kept both of these, though admittedly well shut away in the back of a wardrobe. Taken out and compared with the types of ceramics that excite him today, one can see how far he has come in his journey away from the 'baroque', the term Jeffrey uses to describe his youthful propensity towards the ornate and highly wrought.

This journey began in 1973 when, in a moment of sudden resolve, he rolled up and symbolically cleansed himself of the busily designed Chinese carpets that had covered the floors of his Lugano apartment. During the next few years, and especially from 1976 onwards, the interest sparked off by the group of folk masks he had purchased led him to seek out more Japanese objects. His sources, then as now, were diverse, but extensive travelling, which is something he enjoys, was a *sine qua non*. He made his first trip to Japan in 1977. Visiting dealers and buying have always been important to him, but on this and the visits he has made to Japan every second or third year since, his real gain has been the deepening of his understanding of the culture that produced the artefacts that affect him so profoundly. In this respect he goes more to absorb and learn than to hunt down and take. This is also true of his attitude towards his extensive library, which he uses not as a means of researching what he might purchase next but as a way of finding out more about what he already has.

Between 1978 and 1990, when Jeffrey ran a crafts gallery in central Lugano, he travelled widely to secure Japanese items for his private collection and to buy contemporary crafts, mainly northern European and North American, to sell. Vestiges of his gallery-owning days survive in the form of decorative objects dispersed around his homes in Switzerland and France. A few, like a group of minimalist black earthenwares by a Scandinavian maker he has retained, resonate sympathetically with his Japanese collection. But the majority are rather more ornate and whimsical. Some belong to Mariangela, while others are his. Walking around their shared spaces, the juxtapositions are both unexpected and endearing, born as they are out of long and closely overlapping personal histories.

The closure of Jeffrey's gallery in 1990 coincided with the first public showing of his collection at the Galleria Gottardo. Since then he has consolidated his collection alongside seeing through the series of exhibition and publication projects outlined above. Just as in the early 1980s he had acquired some very fine works from the collection of Nat and Marion Hammer, late residents of Lugano, in 1992 he had the good fortune of being able to purchase a group of over forty pieces, more than half of them textiles, from Cornelius Ouwehand, a distinguished Dutch anthropologist who was teaching at the University of Zürich at the time. He had seen the exhibition at the Museum Bellerive and was so impressed by what Jeffrey was doing that he approached him with the offer of choosing what he wanted from his collection.

As suggested earlier, the greater objectivity with which Jeffrey has come to view his collection since the early 1990s has resulted in a generally more cautious and measured approach to further acquisitions. As the collection has expanded and matured, the urgency to acquire has diminished, and Jeffrey's growing discernment has made him increasingly selective about what he buys. There is also the fact that the last decade has seen a marked drop in the number of good quality works on the market accompanied by a sustained and, to Jeffrey's regret, increasingly unaffordable rise in prices. As he wryly observes, the success he has had in promoting enthusiasm for Japanese folk crafts among a wider public has made him his own worst enemy. The result is that he has bought relatively in the last few years and is gradually coming to the conclusion, though without any great misgivings, that his collection is about as complete as it can ever hope to be.

In addition to the dealers and collectors he already knew, Jeffrey's exhibition and publishing programme has brought him into contact with numerous European and North American curators and museum directors. Many of these have become his friends, whom he enjoys for the enthusiasms they share with him. He is indebted to them for the insights they provide into the works in his collection and is generous to a degree in expressing his appreciation towards them. His personal understanding of Japanese art and culture has grown immeasurably as a result; and his collection – researched, catalogued and contextualized in the way that it has been – is now much more than a group of beautiful artefacts that happens to have been assembled by a single impassioned individual. Jeffrey maintains, however, a respectful distance from the numerous opinions expressed to him. He listens, and indeed actively solicits comment, but he takes his time in digesting what has been put to him and acts, when he does, independently and with the conviction of his own views.

Nearly thirty years since he started collecting Japanese folk crafts, Jeffrey's approach is subject to and dependent upon the knowledge he has gained through personal study and collaboration with

scholars, curators and others. But what really guides him is his intuition, the directness of his response to the physical object in front of him. The introduction to the catalogue of the 1992 Japan Society exhibition contains one of the rare passages to have appeared in print articulating the nature of his affinity towards material artefacts. It observes how he acquired his first pieces of Japanese folk art not because they intrigued him in terms of what they might have been used for or where they came from, but simply because he was awed by their sculptural power. He was moved by what struck him as the timelessness of their beauty, a quality he felt they shared with modern works of art informed, as many of them have been, by an engagement with the primitive.

While Jeffrey's name is now synonymous with Japanese folk art, it is clear that he started collecting in this area instinctively and without any kind of foreknowledge. When he began he didn't know about Yanagi Sōetsu (1889-1961) or the Japanese Folk Craft movement, though of course he soon learned about them and discovered an approach to the appreciation of objects closely in tune with his. Yanagi's parameters have been useful as a framework both for his collecting and for the public dissemination of the fruits of his collecting. But Jeffrey is aware of the compromising anomalies in Yanagi's philosophy and is not an adherent in any substantial way to *mingei* thinking. He is certainly not interested in the total ethical system that *mingei* at its most extreme purports to be. His has been a profound journey, certainly, but an independent and highly individual one in which he has sought out objects that he would have discovered, one might hazard, even without the pre-existing legacy of Yanagi and his followers.

Jeffrey has come thus far. It is difficult to anticipate where he will go next, but it is likely to be somewhere new, given the line he is beginning to draw under his Japanese folk craft collection. There are two things one can rest assured of, however. The first is that he will continue to exercise his 'seeing eye' with characteristic acumen. The second is that those he meets on whatever venture he embarks upon will be the fortunate recipients of his unique and remarkable blend of thoughtfulness, ebullience and supreme kindness.

[1] Galleria Gottardo, Lugano, 1990.
[2] Darmstadt, 1991.
[3] Japan Society, New York, 1992.
[4] Museum Bellerive, Zürich, 1993.
[5] Art Services International, Alexandria, VA, 1995.
[6] Morikami Museum and Japanese Gardens, Delray Beach, FL, 1998.
[7] Musée des Arts Asiatiques, Nice, 2000.
[8] Japan Society, New York, 2001.

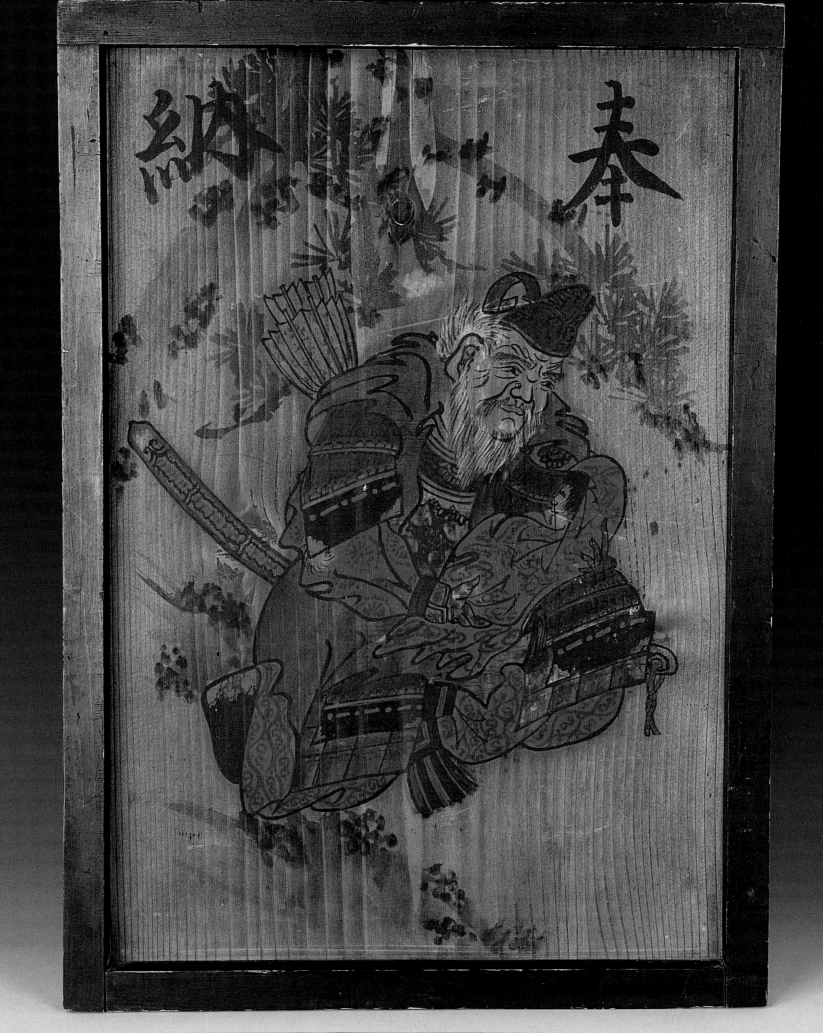

Annie M. Van Assche

Objects, Sculptures, Lacquerwares, Paintings, and Furniture

The objects, sculptures, lacquewares, paintings and furniture in the Montgomery Collection, and discussed here, collectively represent Japan's traditional lifestyle – a lifestyle which evolved out of an agrarian culture that mantained a complex, spiritual and intimate relationship with the natural world for many millenniums. This relationship was codified in Japan's indigenous Shintō religion, and manifested in its many benevolent deities, each with his or her individual attributes and characteristic. As well, Buddhism, which arrived in Japan from the continent in 552, had a profound affect on the Japanese culture. Many indigenous Shintō deities merged with Buddhist one's, and new quasi-religious folk characters were born. Some of the objects in this section are strictly utilitarian, used as tools for mundane, everyday activities related to this ancient, agrarian culture. Others are multidimensional, that is, besides being utilitarian, they may be religious in nature. While many of these objects represent a quintessential Japanese aesthetic sensibility, all emanate a beauty that is uniquely Japanese.

Bamboo Objects

The beauty and versatility of bamboo (*take*) have long been appreciated in Japan. With more than 400 varieties of this giant grass growing in Japan, the Japanese artisan has been utilizing bamboo to make a wide variety of everyday, utilitarian items for centuries. Examples of Japanese items made of bamboo include baskets, trays, water scoops, toys, chopsticks, umbrellas, screens, tea whisks, musical instruments, and fences. Bamboo is relatively easy to work with, allowing for a broad range of creative expression. Together with pine and plum, bamboo symbolizes one of the 'three friends of winter' (*shōchikubai*) and is a popular auspicious motif in

Japanese art. Stands of bright, green bamboo growing throughout the low-lying hillsides of Japan create a visual experience of unparalleled beauty. On windy days, a hollow, haunting sound emanates from the tall stalks, as they hit against each other.

One of the most popular uses of bamboo in Japan is as a material for baskets. The two baskets shown here are made of split and woven bamboo. The charcoal basket (*sumitori*) shown in figure 95 held chunks of coal for use in the Japanese tea ceremony (*chanoyu*). The basket is lined with lacquered paper to contain the coal dust within the basket. It began as a square-shaped basket, but ended with a large circular rim. This subtle transformation of shape created an object of delicate and graceful beauty. Tea ceremony objects such as this basket are often handed down from teacher to student, creating a long lineage of deep appreciation. They are prized by their owners, and are often personalized with names. The bamboo basket shown in figure 96 is a sieve used to clean beans (*mame-dōshi*). Built from the bottom up, it began as a six-sided form. But like the charcoal basket, it was finished with a large circular rim. Such quality in craftsmanship enhances the humble beauty of these simple, everyday utilitarian objects.

The stacked food container (*jū-bako*) shown in figure 97 is made of one large piece of bamboo. It has four compartments – three for food, and one for saké. Its maker preserved the original shape and natural beauty of the bamboo by utilizing its horizontal joints for the base of each compartment. After all of the sections were completed, the artisan faceted one side of the outer surface of the container, while keeping the natural form of the bamboo on the other side. The handle was made to both fit securely and to prevent excess movement. One end of the han-

4. *Ema with Takenouchi no Sukune Holding the Infant*, Ōjin
Wood, paint
Inscription (right to left): *hōno* (offering)
47 × 34.5 cm
Edo period, 19ᵗʰ century

dle has a small piece of wood that slots into the vertical bar, while the other end was designed with a simple locking device. The shape of this food container resembles that of 'horned' saké kegs (see figure 82).

The bark of cherry and birch trees was also used to make baskets in Japan. An example of a traditional Japanese basket made to carry a small load on one's back (*shoi kago*) is shown in figure 12. It is made of split and woven cherry bark, a specialty craft of Gifu Prefecture. Baskets such as this one could be used to collect wild mushrooms, herbs, or kindle in the woods. An example of a birch bark basket made in the former province of Hida (present-day Gifu Prefecture) is shown in figure 94. It was used as a lunch box, and includes a silk carrying cord, and a bead that functions as a cord-tightening device to keep the lid closed.

Wooden Household Objects

Apothecaries prescribing traditional Chinese herbal remedies in Japan's not-too-distant past would have used a medicine grinder (*yagen*) to pulverize seeds, leaves, roots, and berries (figure 79). Smaller grinders were also used in the Japanese home.

The tinder box (*hiuchi-bako*) was an invaluable tool in the traditional Japanese home, since it provided fire for heating, cooking, and lighting (see figure 81 a-b). By hitting the iron striker against a piece of flint, a spark was produced and tinder ignited. The tinder was then transferred to the kitchen stove to start the home's main fire.

The wooden candlestick (*rōsoku tate*) shown in figure 85 was made with a piece of zelkova wood (*keyaki*) that acquired its twisted shape through a process of gradual turning. Water was applied to the wood during the turning process to minimize the pressure on the wood and prevent it from breaking. The main challenge for its maker was to keep the piece of wood perfectly straight in the process.

Japanese lanterns were made of stone, metal, bamboo and wood. The wooden oil lamp shown in figure 86 has two parts: a paper shade, and a compartment for the oil dish. It was called an *ariake andon* (literally, 'dawn light'), because it often remained lit through the night until daybreak. A burning wick floating in oil in a small, porcelain dish emitted a soft, long-burning light. The lantern was made in two parts, allowing for two light settings. For brighter light, the paper shade was placed on top of the base (i.e., not used); for dimmer light, the shade was placed inside the base. The thin, decorative, wooden crosspieces on the shade both provided protection for the delicate paper and added strength to the shade's frame.

The kneading basin (*kone-bachi*) shown in figure 77 was used to knead dough for wheat and rice noodles, and sweet rice cakes, must be kneaded until smooth and pliable. It is made of one piece of paulownia wood (*kiri*), a soft, light-coloured wood that expands and contracts in response to changes in temperature and humidity. Bow-tie shaped, tongue-and-groove pegs have been skilfully inserted across two cracks on the outer bottom surface of the basin. Original chisel marks are still visible on its inner surface, except for the base, which has become smooth from years of use. It was coated with several layers of clear lacquer, making it impervious to heat and liquid.

The small box shown in figure 88 was used to store 'pictures of Edo' (*edo-e*), popular, inexpensive paintings and prints that depicted scenes in and around Edo (present-day Tokyo). It is made of cryptomeria (*sugi*), a Japanese cedar that emits a delicate scent. The top of the box was scoured with a stiff brush to accentuate the natural grain of the wood.

Traditional Japanese writing tools include an animal hair brush, an inkstone, and a dried cake of *sumi* ink. When not in use, the brush is typically hung vertically on a special stand, to keep the brush hairs straight. The inkstone and ink cake, along with a small water dropper, are often stored in a box (*suzuri-bako*) made specially for this purpose. The box shown in figure 87 was made to hold a large inkstone. The illustration on the lid of the box is likely that of a Japanese folk tale. It shows a fox making an offering of saké, as if performing a Shintō rite.

Farmers living in the remote, mountainous, northern regions of Japan traditionally passed the long winter months making handmade items they could sell for a second income. Japanese *asa*, a linen-like fabric made from one of various bast fibres, was one such item that fetched a good price. After being woven into yardage, the stiff *asa* fabric was beaten to make it soft and to add sheen. The fulling mallet and block (*kinuta*) shown in figure 80 a-b was used for this purpose.

Traditional Japanese saké containers came in a variety of sizes, shapes and materials. One of the most distinctive styles is the 'horned cask' (*tsuno-daru*; see figure 82). The shape of the *tsuno-daru* cask was borrowed from the design of a water bucket indigenous to the remote Shōnai region of Yamagata Prefecture. These casks were made of cryptomeria cedar wood using the coopering technique, in which staves are cut on an angle, assembled, and bound together (without adhesive) by several thick, plied bands of split bamboo. The staves had to fit together snugly to prevent leaking. This required the exacting skills of a master craftsman. After assembly, the wood was

sealed with an undercoat of cinnabar-dyed lacquer and a top coat of clear lacquer. The inscription on the cask shown here indicates the name and address of its original owner, the Matsuya shop located in Kichizaemon, Kōjimachi jū-san-chōme, (Tokyo). Traditional saké ewers called *chōshi* were made of either metal, ceramic, or wood and used for ceremonial occasions. The body of the *chōshi* ewer shown in figure 78 was made of one piece of turned zelkova wood. The handle, made of a piece of bent zelkova wood, was attached to the vessel body with wooden plugs. It likely once had a lid (now lost). The decorative, carved element on its side (below the handle) playfully mimics the metal rings of cast iron *chōshi* ewers.

Large calabash gourds (*hyōtan*) were specially grown in Japan for use as saké flasks (see figure 84). A carrying rope was tied around their natural, hourglass-shaped waist. They had a wooden stopper with a string that was attached to the larger rope, to keep it from being lost. They were coated with a layer of clear lacquer. Naturally, no two *hyōtan* gourds were ever identical, and the more whimsical (or perfect) the shape, the more appealing.

Irori Hearth

Traditional Japanese homes (*minka*) were built with an open hearth (*irori*) located in the home's main, centrally-located room (see figure 1). The wooden floor of this room was slightly elevated from ground level, and the hearth was recessed into the floor. The main function of the *irori* hearth was to heat the home, but it could also be used to boil water and for general cooking. Most cooking took place in the kitchen, which was built at ground level with an earthen floor, adjacent to the outside. The stove in the kitchen (*kamado* or *kudo*) was made of either stone, brick, or an earthen stucco material. Wood was fed into the stove through a door on its side. Large cauldrons with flanged bottoms (*kama*), made of either brass or iron, were placed into holes in the top of the stove. The typical kitchen stove could accommodate several cauldrons at one time. The red lacquered wooden lid shown in figure 83 was used for such a *kama* cauldron. It is larger and more elaborate than most, suggesting that it may have been used in the kitchen of a Buddhist temple.

Pots were hung over the home's *irori* hearth with an apparatus called *jizai kagi* (literally, 'free-moving hook') that included a device for adjusting the distance of the pot to the fire. The *jizai kagi* was hung by a thick rope from a ceiling rafter located directly above the hearth. There were several different styles of *jizai kagi*. The simplest was fashioned with metal hooks and chains. A slightly more sophisticated style

consisted of two vertical, iron rods – one stationary and one moveable – held together with metal rings. A pot was hung from a small metal hook attached to the end of the moveable rod. The placement of the pot was adjusted by sliding this rod up or down. A horizontal crosspiece (*yokogi*) secured the pot in place by transferring pressure from the weight of the pot to the rods.

Japanese homeowners took much pride in their *jizai kagi*. The open hearth, with its kettle of ever-brewing water for tea, was considered the heart of the home. When guests arrived, they were brought to the main room where everyone sat on cushions (on the floor) around the hearth. A merchant's expensive zelkova-made *jizai kagi*, decorated with auspicious symbols, was meant to impress clients and ensure good business.

The most elaborate style of *jizai kagi* included a large, wooden hanger (*jizai-gake*; see figures 66, 67, and 68). The main rope that suspended the hanger from the ceiling beam was wrapped several times around the hanger. Another rope, used to hang the pot from this hanger, was looped around the curved part of the hanger and threaded twice through the *yokogi* crosspiece. The pot hung from a smaller metal hook attached to one end of this rope.

There are two distinct types of *jizai-gake*, and each takes its name from one of the kitchen deities, Daikoku and Ebisu. Figure 66 shows an 'Ebisu type' *jizai-gake* which received its name from the straight, vertical section that was said to resemble Ebisu's hat. This 'Ebisu-type' hanger was made with a solid piece of wood that was selected for its natural 'J' shape. The maker roughly finished the wood, and then into a hexagonal shape. A deep groove was created by the rope from which the kettle hung. Figures 67 and 68 show two examples of 'Daikoku-type' *jizai-gake*, thus named because their shape was thought to resemble Daikoku's floppy hat.

The crosspiece used to secure the hanging pot, called a *yokogi*, was both utilitarian and talismanic. Most *yokogi* adjusters were carved in the shape of a fish, such as carp (*koi*), sea bream (*tai*), and sweet fish (*ayu*). Water (*mizu*) – either as a decorative motif or as a *kanji* character – was also a popular *yokogi* design. These designs were chosen primarily for their association with water, which was considered auspicious because of its ability to extinguish fire. A water-shaped *yokogi* thus provided the home with added protection against the destructive powers of fire.

While fish in general was the most popular *yokogi* design, certain fish had special appeal. The carp (*koi*), long admired in Japan for its ability to swim upstream against the currents of the river (see fig-

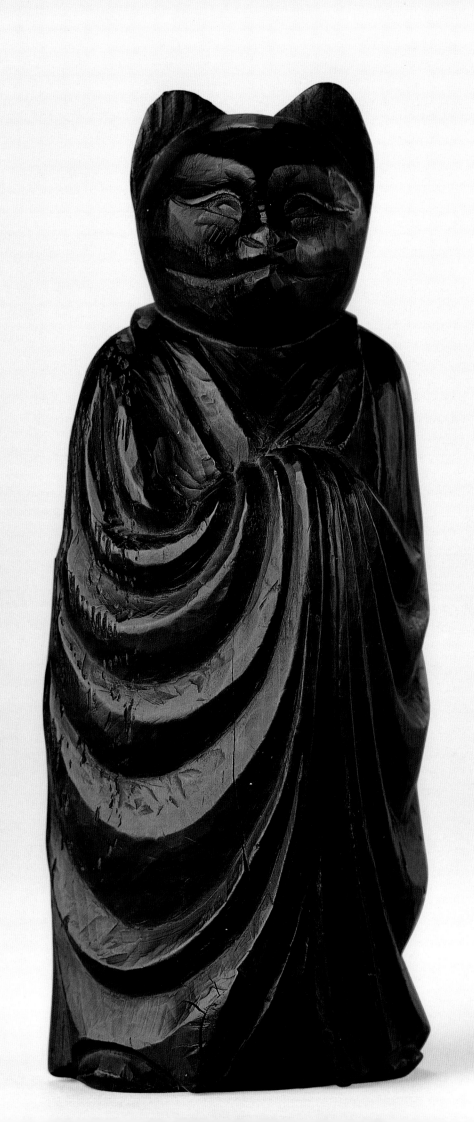

ure 75a), came to symbolize success. One of the carps *yokogi* shown in figure 75d holds a magic, wish-granting jewel (*nyoi*) in his mouth, which symbolizes the legendary Chinese 'dragon king of the sea'. Sea bream (*tai*) was also a propitious design for *yokogi* because the homonym, '*tai*', is included in the expression '*omedetai*' (congratulations). Sea bream is traditionally eaten on special occasions in Japan for this reason. Three different examples of sea bream *yokogi* are shown in figures 75c, 75e, and 76. Like the carp, sweet fish (*ayu*) swim upstream in late autumn to spawn (figure 75b). In spring they return to the sea and repeat the cycle. From early times, this fish has been considered a good omen in Japan. Both the Chinese *kanji* character for water (read '*mizu*' in Japanese) and the water motif were popular *yokogi* designs (see figures 70a, 70b and 71). Many of the formalities of gift-giving that originated in ancient times in Japan are still evident today. For example, the custom of presenting an offering of a bundle of dried abalone strips (*abare noshi*) to the gods is the source of today's custom of decorating gifts with a piece of red and white folded paper. The origin of this custom lies in a play on words. *Noshi* can mean both 'abalone' and 'prolong', depending on the *kanji* character used. The *noshi* abalone motif thus became a symbol of longevity, and an appropriate gift for the gods. The *yokogi* shown in figure 72 represents the conventionalized *abare-noshi* bundle motif. It is decorated with two additional symbols of prosperity – the wish-granting jewel (*nyoi*), and the gold coin-producing mallet (*uchide no kozuchi*).

The *kanji* character for the numeral one (*ichi*) was also a popular design for *yokogi* (see figures 69a and 69b), because '*ichi*' is an abbreviation of '*ichi ban*' (literally, 'number one') meaning 'the best'. The *ichi* character hanging over a successful merchant's hearth suggested that his product was the best.

The *yokogi* in the shape of a calabash squash shown in figure 73 was made to be used over a small hearth in a room reserved for tea ceremony (*chashitsu*), and is much smaller than those used for the *irori* hearth. This squash has a fresh, organic feel, as if it had just been picked and is resting on a bed of moist soil in the garden. Its delicate, serpentine lines add an element of high elegance.

The scroll (*e-maki mono*) is a very atypical design for *yokogi* (see figure 74). In Chinese folklore, the scroll is one of the myriad treasures and an auspicious symbol. It therefore would have been an appropriate design for a *yokogi*. This *yokogi* is in pristine condition, while typically they are coated with black soot from years of exposure to fire.

Transoms (*ramma*) were a common architectural element in traditional Japanese homes. They were commonly placed between two rooms, above the frame of a sliding door, and viewed from both sides. They were both decorative and utilitarian in nature, allowing air to circulate between the rooms when the sliding doors were closed for privacy. This elaborately carved transom, showing a mother dog and her puppy (see figure 89), carries the message "*hi no yo shin*" meaning 'take care with fire'. Like the mother teaching her pup the important lessons in life, the message reminds one that fire must be respected. This transom likely hung in the main room, of a home, where the hearth was located.

Kanban Shop Signs

Traditional Japanese shop signs (*kanban*) were essentially utilitarian in nature. They were meant to communicate the rudiments of the business, such as the company name, proprietor, product, and shop patronage. A well-designed sign also communicated the character of the merchant doing business within. Shop signs with pleasing designs played an important role in catching the attention of passers-by and attracting potential customers. Some shop signs vaguely hinted at what was being sold inside, adding an element of mystery. Many signs took on a humorous or witty quality, such as those using puns or figurative allusions. The earliest shop signs were made of fabric and hung outside the shop across the doorway. The hanging *noren* curtain meant that a shop was open; no curtain meant that it was closed. Eventually, wooden signs replaced cloth signs as the predominant type.

On the shop sign shown in figure 93, the Japanese *hiragana* syllabary on the upper section reads '*ame*' meaning 'sweet'. It was made in the shape of a candy jar, another indication that this was a candy shop sign. The lower inscription written in Chinese *kanji* characters reads '*kōkō tōya*', or 'Kōkō Candy Shop', the name of the shop.

Figure 92 shows a shop sign with caricatures of seven popular, Japanese folk characters, four of which are members of the 'Seven Gods of Good Fortune'. From left to right the seven characters are: Okame, Goddess of Mirth; Tengu, a long-nosed goblin; Oni, a demon; Hotei, God of Happiness; Daikoku, God of Wealth; Benten, Goddess of Art; and Fukuroku-ju, God of Longevity. The facial features of each are grossly exaggerated, which increases the graphic impact of the sign. Although it is not known for what shop this sign was made, the cut-out eyes suggest that it may have been intended for a mask-maker's shop.

The signboard shown in figure 13 was used by an inn. The three *kanji* characters carved on the sign,

5. *Fox Daruma* (kitsune *Daruma*)
Zelkova wood (*keyaki*)
23 × 25.5 cm
Edo period, late 18th-early 19th century

reads '*goyō yado*', meaning The Goyō Inn (literally, 'honorable business inn'). The proprietor's name, Tatebayashi, is carved to the right of this.

The fan-shaped shop sign (figure 90a, b) with two different *kanji* characters (one on each side) was used by a money lender. One side reads '*dai*' (large), while the other side reads '*shō*' (small). According to the lunar-solar calendar (*taiin taiyō reki*) used in Japan until 1873, the length of a year was determined by alternating cycles of six long months with 30 days each, and six short months with 29 days each. Based on this calendar, one year had 366 days, except for leap years, which had an extra 30-day month and occurred once every seven out of 19 years. The Japanese money lenders set their interest rates according to this calendar. In front of his shop, he would hang the sign with the *dai* side facing out to indicate a long year, and the *shō* side facing out for short years. The characters, *dai* and *shō*, were forged in metal and inset into the sign's wooden frame.

The iron pot-maker's shop sign shown in figure 91 reads (from left to right) '*okama shi*' (literally, 'master craftsman of honorable iron pots'). It is made in the shape of a hot water pot resting on a three-legged, portable brazier. This type of brazier, called a *furo*, is commonly used instead of the open hearth for formal tea ceremony during the hot summer months because it is cooler. This shop likely catered exclusively to practitioners of tea ceremony.

Auspicious Objects

Many traditional Japanese toys (*omocha*) were believed to posses special protective, talismanic powers. They were thought to keep away evil spirits and help ensure that a child grows up healthy. While children's *omocha* toys were meant to be played with, Japanese culture included another category of traditional auspicious objects, called *engi mono*, which were displayed in the home on special festival days.

Figurines of plump, beckoning cats (*maneki neko*) have long served shopkeepers as loyal, auspicious mascots in Japan. They received the name, *maneki neko* (literally, 'beckoning cat'), because their upraised paw gesture reminded the Japanese of the gesture made to beckon (or lure) someone. Some believe that this cat actually originated in classical Chinese literature, where it cleans its face with its upraised paw. Whichever belief one adheres to, the *maneki neko* cat has continued to play a vital role as an *engi mono* for many centuries in Japan, attesting to its enduring appeal. Throughout Japan today, the ubiquitous *maneki neko* cats sit unpretentiously on command in shop windows, often intermingling with plants, open-closed signs and other store paraphernalia. Although secular, *maneki neko* cats are sold at Shintō shrines and Buddhist temple stalls throughout the year.

Figure 26 shows an unusually large (60 cm high), humble-looking *maneki neko* – without the typical gold coin dangling from its collar. It is made of low-fired clay and painted white with a gesso-like material obtained from ground oyster shells (*gofun*). Details are painted over its polished white surface with paints made from ground mineral pigments. Showing generous wear from years of devoted service, this *maneki neko* cat radiates a timeless charm. Not all cat figurines in Japan belong to the *maneki neko* genre. One such example is the wooden crouching cat shown in figure 16. In Japan, it has long been believed that cats possess special powers, and legends tell of cats transforming themselves into beautiful, bewitching women and ghosts. The cat is the only domestic animal that was not included in the 12 zodiac animals (*jūnishi*). As explained in an old Japanese children's story, the cat ate the rat who was carrying medicine to the dying Buddha. The cat was thus blamed for the death of the Buddha, and was therefore considered unworthy of being in the zodiac. Omission from the zodiac was meant as a kind of karmic punishment.

Chinese Zodiac

The ancient lunar calendar, first developed in China, was based on the 12 years it takes Jupiter to circle the heavens. By mapping Jupiter's position in the sky, the Chinese astronomers were able to measure seasons, months, days and hours. As the system developed, each year was assigned an animal. The 12 animals, in order of how they appear in the calendar, are: rat (*ne*), oxen (*ushi*), tiger (*tara*), hare (*u*), dragon (*tatsu*), snake (*mi*), horse (*uma*), sheep (or ram, *hitsuji*), monkey (*saru*), rooster (*tori*), dog (*inu*), and boar (*i*). This system (*jūnishi*) continues to be recognized today in Japan. At the beginning of each new year, people proudly display figurines of the respective animal in their home beginning on the first day of January[1].

Besides being assigned a year, each animal has an hour, day, month, and point on the compass. It is believed that an individual acquires an animal, and its attributes, based on the year one is born. For example, the horse is a symbol of purity, nobility, and wisdom, and people born under this animal are thought to be well-liked, affable, intelligent, and self-reliant. Compatibility among people was also believed to be predetermined by the cosmos, and when making important life decisions, such as considering marriage prospects or opening a business, this system was consulted. Diviners and fortune tellers

6. *Daikoku, God of Wealth*
Yonezawa style; wood, lacquer
12.5 × 24 cm
Edo period, 19th century

as well used it as a tool to guide individuals seeking advice.

The recumbent ox (*ushi*) holds special meaning in Japan. It is one of the 12 zodiac animals and a symbol of Sugawara Michizane (845-903), a famous statesman and scholar posthumously deified as Temma Daijizai Tenjin, the Shintō God of Literature (see figure 27). Michizane was very talented and well loved by all. Yet, there were those who envied his quick rise to the top. In 901, Michizane was falsely accused of a conspiracy and exiled to far-off Dazaifu in Kyūshū. He died there two years later, and immediately following his death, many disasters occurred in his hometown of Kyoto. This led people to believe that Michizane's angry spirit had returned to avenge his enemies. When Michizane was exonerated in 910, these strange events surprisingly ended, and people again believed that Michizane was responsible. To appease his spirit, shrines were erected throughout Japan in his honour. The Kitano Tenmangu Shrine in Kyoto is one of the oldest and most noteworthy. On the 25th day of each month, people visit these shrines to pay their respects to this patron saint of learning.

According to local legend, the ox pulling the cart that carried Michizane's ashes to the cemetery suddenly stopped and refused to move. This was seen as an omen, and Michizane's retainers decided to bury his ashes on the spot. Dazaifu Tenmangu Shrine, in Daizaifu, Kyūshū, was later erected by the local officials on this site. The ox shown in figure 18 could have adorned a Japanese home during the new year of the ox, and on Tenjin Festival Day (the 25th of February).

Throughout Asia, the white hare (*unagi*) is considered auspicious because of its association with the moon (see figure 17). According to an ancient Chinese Taoist belief, a white hare (and frog) mixed the elixir of immortality on the moon. The Japanese version of this legend has the white hare pounding rice paste (*mochi*) for sweet cakes, rather than mixing an elixir. Depictions of the Japanese hare in the moon show a small, white hare standing on his hind legs in front of a huge mortar. He is further dwarfed by the large pestle he holds. The white hare is charmingly represented once more in the form of a small, ceramic handwarmer (*te aburi*) (see figure 24). To use, a few burning embers of coal would be placed inside the cavity of the rabbit. The handwarmer could be moved easily from room to room, as if loyally following its owner around the home on cold winter days.

The dog (*inu*) is revered in Japan as one of the 12 zodiac animals, as well as an auspicious animal for expecting mothers. Because dogs give birth to multiple puppies with relative ease, the mother-to-be would place a dog in her home in the hope that she too could have a safe and smooth delivery. The unwavering loyalty of the dog is wonderfully depicted in the face of the papier-mache puppy (*ko inu*; literally, 'small dog') shown in figure 28. Looking up with loving eyes, the puppy patiently waits for his cue.

Figure 19 shows a wooden mold used to make papier-mache boxes in the shape of a dog (*inu-bako*). These boxes were made by coating such a mold with oil and then covering it with many layers of glue-soaked paper. It was cut after drying, and the ears, mouth, and tail were colourfully painted. These dog boxes were both functional and auspicious, and often used as a new year's ornament for the home.

The monkey (*saru*), another of the 12 zodiac animals, is represented here in the form of a small, portable handwarmer (see figure 23). In Japan, the monkey took on Shintō associations. The monkey is believed to be a messenger of the gods (*kami*) and therefore auspicious. Children born in the year of the monkey were thought to be especially fortunate. The goat (*yagi*) and sheep (*hitsuji*) were interchangeable in the Chinese zodiac, and seem to have been associated exclusively with the zodiac (see figure 25).

Besides being a zodiac animal, the horse (*uma*) had special associations in Japan's *samurai* culture. Families with male children traditionally displayed the horse with a mounted, warrior doll in full regalia to celebrate Boy's Day (*tango no sekku*) on May 5. These displays were meant to inspire courage and determination in male children. The horse shown in figure 21 is much larger than those typically used for Boy's Day displays and was more likely made as a hobby horse. Its body is made of a solid piece of wood; its attached head was made to bob up and down.

Other Auspicious Animals

The three wooden hawk figurines shown in figure 20 a-c represent a regional folk toy made in the remote mountain village of Sasano, located in Yamagata Prefecture. The origin of the Sasano hawk figurine is said to trace back to a ninth-century military campaign between the Japanese and the indigenous Ainu people. According to legend, the leader of the campaign presented the local Buddhist deity, Seshu Kannon, with a carving of a hawk, a symbol of strength, in a plea for success[2]. The hawks were carved in the 'single-chisel carving' (*ittō bori*) out of a local, light-coloured, soft wood (*aburanko*). Eventually, the craftsmen of Sasano expanded their repertoire to include additional birds such as roosters and owls. Sasano *ittō bori* bird figurines are dis-

tinguished by a severe abstraction of form, and thin, curled shavings that imitate feathers.

The mythical lion-dog guardian, called *koma inu* (literally, 'Korean dog'), was introduced to Japan from China and Korea alongside the transmission of Buddhism. Many early Buddhist paintings show pairs of *koma inu* lion-dogs – one with an open mouth, and one with a closed mouth – flanking a Buddhist throne. From here, they protect the Buddhist law. The open mouth (Skt.: *a* or *aum*) is said to represent the beginning, or alpha, while the closed mouth gesture (Skt: *un* or *hum*) symbolizes the end, or omega. Together, they represent infinity. In China, stone lion-dogs (called *kara shishi*; literally, 'Chinese Tang lion') were placed outside the entrances of Imperial mausoleums as guardians of those interred inside. Because Japanese *koma inu* lion-dogs closely resemble these Chinese mausoleum *kara shishi* figures, many believe that they share the same origin. Paired *koma inu* lion-dogs also appear in Japan's indigenous Shintō religion as shrine guardians, and can be seen flanking the entryways of shrine compounds throughout Japan. In some rural areas of Japan, these lion-dogs were popularized as household guardians, and placed in the kitchen's *kami-dana* (literally, 'shelf for god'). The *koma inu* shown in figure 22 has an open mouth symbolizing the Buddhist syllable, *aum*. It was likely once one of a pair.

Although not one of the 12 zodiac animals, the fox (*kitsune*) maintains a special place in Japanese folklore. The *kitsune* is both magical and mischievous, and is believed to have supernatural powers, such as the ability to transform itself into a human or a Shintō deity. The benevolent *kitsune* serves Inari, the Shintō deity of rice, as a divine messenger. As such, he flanks the entryways of Shintō shrines, often replacing *koma inu* as a divine guardian of the sacred. The other *kitsune*, a cunning deceitful creature, is said to enjoy reeking havoc on small villages for his own amusement. Stories of these ill-intended foxes are numerous in Japan, and their exploits have sometimes even made it into the local newspapers.

The sly fox shown in figure 5 is hiding behind the cloak of the clergy. He is dressed as a monk in the guise of Daruma, the patriarch of Zen Buddhism. According to a well-known legend, Daruma crossed the Yangtze river riding on a bamboo reed. Depictions of this legend show a standing image of Daruma wearing a hooded robe in a similar manner as this fox. Daruma's stern face expresses years of hardships endured during strict meditation (spent while living in a cave for nine years). The smug look on this fox-as-Daruma rather suggests coy irreverence. It is carved minimally in the *ittō bori* technique.

Auspicious Folk Characters

Japanese dolls (*ningyō*; literally, 'human figure') were traditionally given to children and adults as talismans. The tradition of giving special 'palace dolls' (*gosho ningyō*) developed among members of the Imperial court during the Tokugawa period. They were made in the image of young male children, and given as a tribute to feudal lords to show appreciation for their support and to grant them good luck in their travels. Ladies of the court, as well, kept *gosho ningyō* dolls as fertility charms.

A superb early example of a 'big-headed palace doll' (*zudai gosho ningyō*) is shown in figure 29. Palace dolls were made to represent a variety of Japanese personages. Among these, the Sambasō dancer was especially popular. Like the doll shown here, Sambasō dolls wore only a court hat and a bib. This doll would have once held a fan in his right hand and bells in the other. The Sambasō dance originated in Japan as an ancient agrarian rite to foster prosperity. By stamping his feet and shaking the bells, it was believed that the dancer could invoke the gods. The dance continues to be performed today in Noh theatre as an *Okina* (prelude performance) during the new year's holiday. This doll was made of clay and covered with a thick layer of a crushed shell mixture (*gofun*). After the shell mixture dried, the white surface was polished to a high luster with a piece of the scouring rush plant (*tokusa*). Features and details were then painted with a fine cat's hair brush.

Bunraku is another indigenous Japanese performance art with ancient, agrarian origins. It was adapted from *ningyō joruri* (literally, 'storytelling dolls'), a 500-year-old puppet art form that originated on Awaji Island. *Bunraku* was a popular form of entertainment for the common people. Many of the stories told in *bunraku* emphasized Confucian concepts, such as the importance of loyalty over personal feelings, and the tragedy that begets those who stray from these principles.

Large *bunraku* puppets weigh an average of ten kilograms, and consist of a head and body, and costume (see figure 31 a-b). The protagonist's puppet is manipulated by three puppeteers. The master puppeteer (*omozukai*) works the head and right arm, while apprentice puppeteers simultaneously operate the two legs and left arm. The three puppeteers must synchronize their movements and breath as one, to enable the soul of the puppet to come to life on stage. The expression, 'three flavours blending into one' (*sanmi ittai*), refers to this concept that is unique to *bunraku*.

While it can take as long as seven years to master the movements of the arms and legs, it is said to take

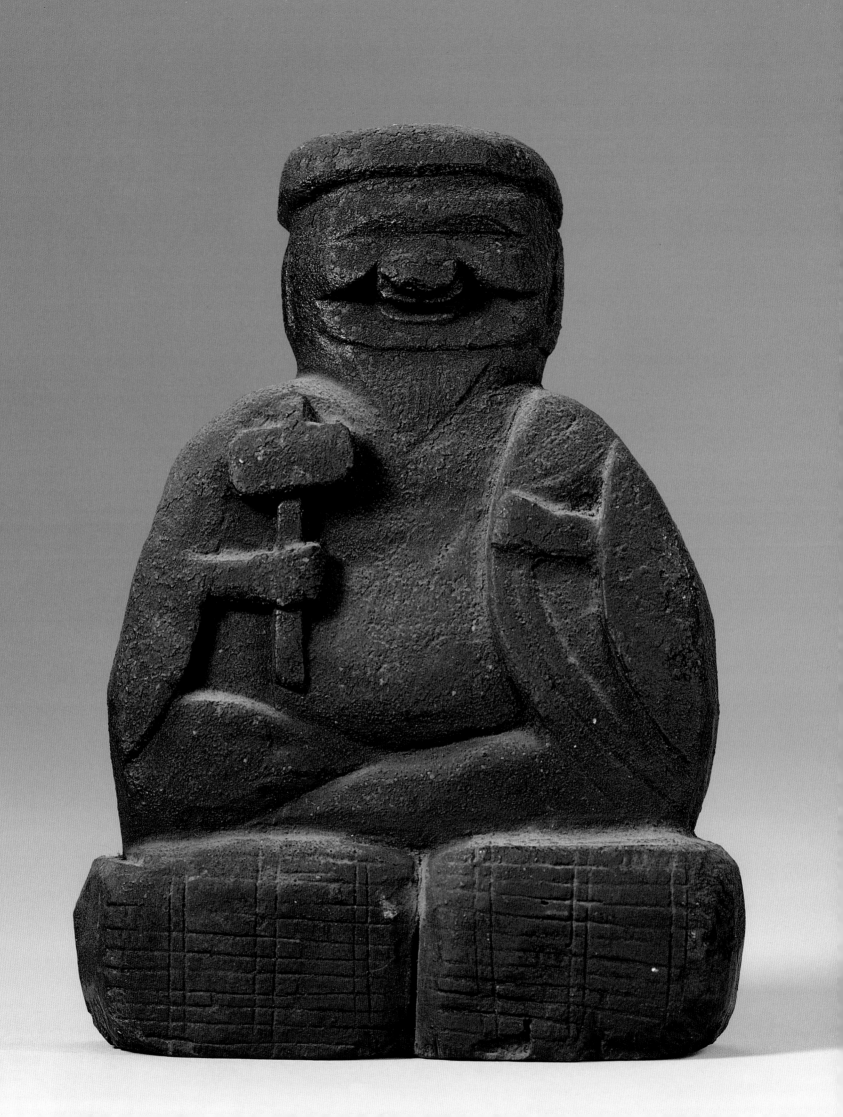

a lifetime to master the head and right-hand movements. The subtlest of human emotions can be expressed by the master puppeteer by pulling strings attached to the puppet's eyes, lids, lips, and eyebrows. The apprentices are covered from head to toe in black robes and hoods, while only the master puppeteer remains visible to the audience. The puppeteers stand on tall wooden platform shoes which, when prompted by the musician and narrator, they stomp loudly onto the stage floor to express the emotions of the puppets.

Like many Japanese folk characters, Okame, the Goddess of Mirth, can assume multiple identities and is believed to posses supernatural qualities. Also known as Ofuku, Otafuku, and Oto Gozen, Okame is commonly portrayed as a comical plump, middle-aged peasant woman, with a narrow forehead, pudgy cheeks (often with dimples), and a small, rose bud-shaped mouth. Images of Okame were traditionally placed in Japanese homes as talismans, and in shops to help bring prosperity. Masks of Okame as Otafuku (literally, 'big bosom') can be seen today in Japan attached to a symbolic rake (*kamade*) that is decorated with good luck charms. These rakes are distributed on Rooster Day (*tori no chi*) which is celebrated each year in November, and used symbolically to 'rake in' good fortune.

Okame's most lofty role is as the Shintō deity, Ama no Uzume no Mikoto. In the well-known legend, Ama no Uzume no Mikoto helped to restore light to the world by enticing Amaterasu no Mikami (the Supreme Shintō Sun Goddess) out of a cave with her lively dance. Illustrations of this legend show a beautiful, young Ama no Uzume no Mikoto dancing to a crowd of cheering onlookers.

As Oto Gozen, Okame is a well-to-do townswoman of the Edo period. The image of Oto Gozen in figure 33 shows her dressed elegantly in many layers of fine silk robes. Okame also appears in Japanese culture as an unsympathetic noble woman in a classic comic farce (*kyogen*) in which the male protagonist mistakenly believes that a woman, of whom he has only caught a fleeting glimpse, is beautiful. After pursuing the woman and enduring her numerous, cruel rejections, he painfully learns the truth.

Just as special dolls were displayed on Boy's Day, Japanese families with daughters traditionally displayed special dolls in their home during the Girl's Day Festival (*hina matsuri*), which is celebrated each year on March 3. The Empress doll shown in figure 32 would have sat alongside the Emperor (*dairibina*) at the apex of an elaborate doll display assembled to celebrate this festival. On a large stepped platform covered with bright red felt, dolls representing the various members of the Imperial court were placed at the top of the platform. Musicians, attendants, and the accoutrements of the court were arranged in descending order on the platform. The Empress doll wears a twelve-layered, formal, court robe (*jū ni hitoe*).

An oni (ogre, demon, or devil) is a popular Japanese monster-like creature who frequently appears in Japanese folktale, legends, and proverbs. Possessing a hideous countenance and having a violent and cruel temperament, *an oni* is portrayed with a red face, two horns, three eyes, three fingers, and three clawed toes. He wears only a loin cloth and often yields a big thorny iron club. Although with Herculean strength, they are generally thought to be dull-witted.

In the Shintō religion, an *oni* is thought to be a departed soul trapped in limbo who returns to the world of the living to rectifying injustices waged against him when alive. Each year during the first week of February, Japanese people celebrate *Setsubun*, a festival that marks the beginning of Spring according to the old lunar calendar. It is celebrated on the eve of the first day of Spring by people throwing roasted soy beans outside their homes while chanting '*oni wa soto, fuku wa uchi*' ('out goes the demon, in comes good luck'). This demon-chasing rite (*oni harai*) is believed to purify one's home from evil. Larger, more formal Setsubun celebrations take place at temples throughout Japan.

The skilful carver of the *oni* sculpture shown in figure 36, took full advantage of the natural grains of the wood to emphasize the fleshy, muscular attributes of the demon. He is carved out of one block of wood (*ichiboku zukuri*) except for his horns, which were carved and attached separately. He was likely specially made for Setsubun.

Seven Gods of Good Fortune

The Seven Gods of Good Fortune (*shichifuku jin*) are deities who personify the seven virtues of man, and symbolize wealth and fortune. They often appear together aboard the auspicious 'treasure ship', (*takara-bune*) which is believed to come into the harbor each New Year's Eve. The seven gods are: Bishamonten, the God of War; Fukurokuju (or Jurōjin), the God of Longevity; Hotei, the God of Happiness; Kichijōten, the Goddess of Happiness; Ebisu, the God of Merchants (and a patron saint of fishermen); Daikoku (or Daikokuten), the God of Wealth (and a patron saint of farmers); and Benzaiten (or Benten), the Goddess of Art, Literature, Music, and Eloquence. Several of these deities assume multiple roles as Buddhist, Shintō, Taoist, and Hindu deities.

7. Daikoku, God of Wealth
Wood, soot patina
17.5 × 12.5 × 4 cm
Edo period, 19th century

The Seven Gods of Good Fortune first became popular in Japan in the early seventeenth century. They were placed on the kitchen's *kamidana* shelf, where it was believed they could watch over the home and protect the family from harm. Family members placed daily offerings of saké, rice, persimmons, and mandarin oranges on the shelf to thank and appease the gods.

Fukurokuju, the God of Longevity, is portrayed as an old man wearing a Chinese robe (see figure 40). His especially tall head symbolizes wisdom attained from great age. In China, he is known as Shou Lao, who is thought to be the deified form of the legendary sage and founder of Taoism, Lao tzu. The Japanese exaggerated the height of his head, making it nearly as tall as his body.

Hotei, the God of Happiness, is portrayed as a short, pot-bellied Zen monk leaning on a bag twice his size with a big smile on his face (see figures 41 and 42). His head is shaven and he wears a tattered robe that is loosely tied, exposing his big belly. Hotei is believed to be the historical, sixth-century itinerant Chinese monk, Pu Tai Ho Shang. Pu Tai, roamed the countryside carrying a huge bag, and was thought to be an incarnation of the Buddha of the Future (Skt: *Maitreya*; J.: *Miroku*). In Japan, Hotei is revered as one of the patron saints of Zen Buddhism. Because he is jolly and compassionate in spite of having neither property, home, nor family, he exemplifies the Zen ideal of 'no-mind'.

By far, the two most popular gods among the Seven Gods of Good Fortune were Daikoku, the God of Wealth, and Ebisu, the God of Merchants. As objects of worship, small sculptures of these two deities appeared as a pair in Japanese homes where they were worshipped as 'kitchen deities' (*kamado kami*; literally, 'oven spirits'). Most extant Daikoku and Ebisu statues are often richly patinated with a thick layer of black soot accumulated from years of exposure to the wood smoke of the home's kitchen stoves.

Daikoku can be easily identified by his attributes. He holds a special mallet (*uchide no kozuchi*) in his right hand that produces a shower of gold coins when shook. Over his left shoulder he carries a bottomless 'bag of treasures' (*takara-bukuro*). Together, these two attributes symbolize fertility. Stubby and dwarf-like, Daikoku is dressed as a prosperous Chinese merchant. He stands on two bales of rice (*komedawara*) that symbolize prosperity. Each bale is marked with the auspicious Buddhist 'flaming jewel' (*nyoi*). He has a goatee and wears a puffed-up baret-like hat (*zukin*). He has a benevolent smile on his face.

Daikoku was first introduced to Japan as the Indian Tantric Buddhist deity, Mahākāla, by Japanese Buddhist monks of the Tendai sect in the ninth century.

Like the Indian word, Mahākāla, Daikoku translates into English as 'Great Black Deity'. From his association with Mahākāla, Daikoku became known as defender of the temple's supply of food and a fierce god of war. Early statues of Daikoku show him wearing the garb of a Japanese warrior. Daikoku was also popularly associated with the Japanese Shintō deity, Ōkuninushi no Mikoto, and is venerated as such at Izumo Shrine in Shimane Prefecture. In Kyūshū, stone sculptures of Daikoku were traditionally placed along the edges of rice paddies, and he was worshipped as 'God of the Rice Field' (Ta no Kami). In other parts of Japan, he is associated with Inari Daimyōjin, the Shintō God of Rice.

Daikoku and Ebisu sculptures were typically not signed by their makers. They can, however, sometimes be attributed to an individual artist based on stylistic characteristics. Such is the case with the unsigned Daikoku sculpture shown in figure 45, which has been attributed to Mokujiki Myōman (1718-1810). Mokujiki was born in the Kai province (present-day Yamanashi Prefecture) and became a Zen Buddhist monk when he was 22 years old. At the age of 45, he took a strict Buddhist oath from his teacher, Mokujiki Kankai, to abstain from rice and other grains and eat only the fruits, nuts and berries that grow on trees. He also assumed the name of his teacher, Mokujiki, which translates as 'tree-eater'. He travelled extensively throughout all of Japan during his long life, offering blessings and lecturing to the people, while living on alms. During his travels, he incessantly carved religious folk images. When he died at the age of 92, he left behind thousands of sculptures – footprints along the spiritual journey of this extraordinary individual.

Mokujiki's sculptures express both a charming simplicity and a high level of sophistication. The Japanese folk art (*mingei*) connoisseur and theorist, Yanagi Sōetsu (1875-1961) introduced Mokujiki's works to his contemporaries in 1923, after seeing his work at a private residence in Tokyo. Yanagi once said, 'True folk craft is made without obsessive consciousness of beauty … of what is meant by "no-mind."' For Mokujiki, carving was a form of meditation, his path toward enlightenment.

The exceptional Daikoku sculpture shown in figure 55 was made by a professional Buddhist monk-carver (*busshi*), and carved in the mature temple style[3]. Unlike the roughly-carved images of this deity done by anonymous sculptors, this sculpture was made with the skilled hands of a talented artist.

The extraordinary ceramic sculpture of Daikoku, shown in figure 48, shows a beaming Daikoku stroking a large forked radish (*daikon*) that sits on his lap. This gesture, with its erotic overtones, relates

Daikoku (symbol of human procreation) to agricultural production (radish). According to a local fertility rite, large, white radishes – especially those that are bifurcated, such as this one – is offered to the deity of the rice field in a symbolic betrothal. The ceremony goes by various names: *Daikoku Age* (Daikoku's ascent), *Daikoku no Yome Mukae* (Marriage of Daikoku), or *Daikoku Toshitori* (Daikoku's new year). It is thought that such a betrothal would ensure an abundant harvest in the coming year. This sculpture was made at the pottery village of Bizen. The Daikoku sculpture shown in figure 44 dates from the Momoyama period. It shows an animated Daikoku stomping energetically atop his treasure bag. He likely once held a symbolic gold coin-filled mallet in his hand, which could produce unlimited riches by shaking vigorously.

The origin of the Three-faced Daikoku (*Sanmen Daikoku*) (see figures 49 and 50) is associated with Enryakuji, the Tendai Buddhist monastery atop Mt. Hiei, located outside Kyoto. In this form, Daikoku represents a manifestation of the fiercesome Hindu deity, Mahākāla. The face in the middle represents Daikoku as Mahākāla; the faces on the right and left represent Benzaiten and Bishamon. Like Daikoku, Benzaiten and Bishamon originated in India. Three-faced Daikoku sculptures are especially auspicious, because they included three of the Seven Gods of Good Fortune. These two examples were executed in the mature temple style.

As a kitchen deity, Daikoku is often paired with Ebisu, the God of Merchants (see figures 46, 47, 52, 53, 56 and 57). Ebisu can also assume multiple identities, and he is the only indigenous deity (of these seven gods). He is mentioned in several ancient Japanese annals, including the *Kojiki* (completed 712), and the *Nihon Shoki* (or *Nihongi*, completed 720)[4]. According to these chronicles, the deity Hiruko was created by the two Shintō gods, Izanagi no Mikoto and Izanami no Mikoto. Hiruko was born disabled and unable to stand by the age of three. He was put in a raft and set afloat. According to a local legend preserved at the Nishinomiya Ebisu Shrine (Hyōgo Prefecture), in the late Kamakura period a local man named Ebisu Saburō found an infant in a raft that had washed ashore. Familiar with the ancient *Kojiki* story, the locals believed that the infant boy was Hiruko, and they deified him. He was given the name, Ebisu, after the man who found him.

In the Shintō religion, there is a special classification of divine spirits called 'drifted deities' (*hyōchaku jin*)[5]. In Japan's past, objects (both animate and inanimate) with special or unusual characteristics found along the ocean beaches were believed to be *hyōchaku jin*, and they were deified and enshrined by the villagers. The infant found in Nishinomiya by Ebisu Saburō was believed to be such a 'drifted deity'. Today, the Nishinomiya Ebisu Shrine holds Japan's largest annual festival which celebrates this deity. More than one million people visit here to honour 'Ebessan', as he is popularly called, each year on the tenth day of January.

Because he originated from the sea, Ebisu also became the patron saint of fishermen in some small villages. He holds a sea bream (*tai*) under one arm and a fishing pole in the other, while sitting on a rocky outcrop. When written with a different character, the homonym '*tai*' can also mean 'congratulations', as in the word '*omedetai*'. Sea bream is often served for special occasions in Japan for this reason. Ebisu is dressed in the Japanese court costume of the Heian period. He wears a stiff, black-lacquered *e-boshi* hat, a kimono tucked into baggy trousers, and a jacket. In some places in Japan, Ebisu is thought to represent the Shintō deity, Kotoshironushi no kami[6]. Besides being worshipped in the cities as the God of Merchants, he is also worshipped in countryside as Ta no Kami, alongside Daikoku[7].

The Ebisu sculpture shown in figure 54 is unusual because it is made of stoneware (with a natural ash glaze).

The pair of Daikoku and Ebisu shown in figure 46 and 47 were carved in low relief and made to be used as printing blocks. The blocks were covered with *sumi* ink and then a piece of paper was placed on top of the ink. By rubbing the backside of the paper gently with a baren, the image was transferred to the paper. These simple, black and white prints were placed around the home as talismans.

The unusual, sixteenth-century image of Ebisu shown in figure 51 is thought to be carved out of a meteorite. It likely represents Ta no Kami, since it is reportedly from Kyūshū where Ta no Kami was especially popular. It would have been placed outside, near a rice field.

The image of Ebisu shown in figure 60 was made as an architectural ornament for the fascia of a building that was likely religious in nature.

Fukusuke was a popular shop talisman among merchants in nineteenth-century Japan. He is typically depicted as a big-headed dwarf dressed in a formal *kamishimo* vest-like jacket, with big shoulders worn over a kimono. His hair is fashioned into a top-knot, and he has unusually large ear lobes, a sign of wealth. He sits on his legs and makes a bowing gesture with his hands together in front of him. This polite gesture was meant to welcome clients into the shop. The Fukusuke shown in figure 30 is quite dif-

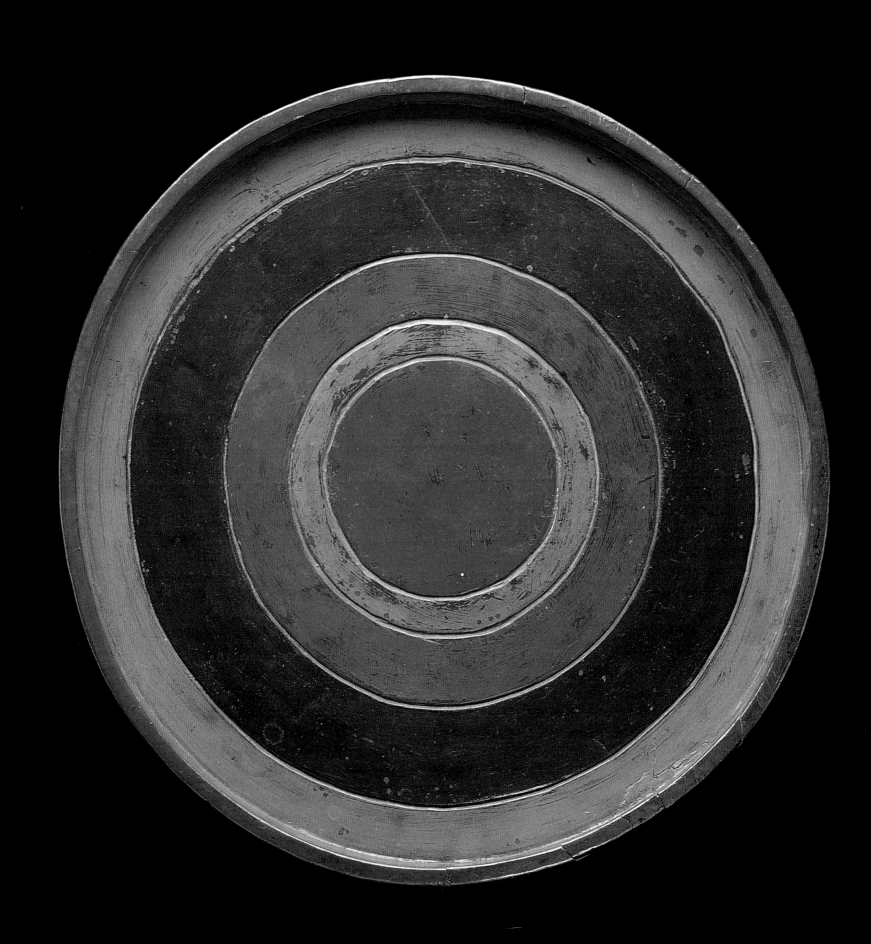

ferent from the standard depiction of this character as described above. This Fukusuke mimics the beckoning gesture of *maneki neko*, and wears the more common striped kimono and haori jacket ensemble of a merchant.

The sculpture shown in figure 43 is a rare example of a Japanese Buddhist itinerant monk represented in sculptural form. He has a shaved head and wears the usual vestments of an ordained monk. The straw hat and knapsack he carries indicate that he is travelling. In his left hand (now missing), he may have once carried an alms bowl. The custom of travelling on long, arduous religious pilgrimages was common among the Buddhist community in Japan from early times. It seems likely that the artist of this figure intended to depict one of Japan's well-respected monk-pilgrims, such as Kūkai (b. 774) or Saigyō (1118-1190).

Buddhist Sculptures

The Buddhist religion is based on the belief in reincarnation, or the constant transmigration of one's soul through the cycles of birth and death. Accordingly, sentient beings wander endlessly through six realms of existence, and it is only through enlightenment that can one liberate oneself from this cycle of suffering. According to the Buddhist sutra written in China in the tenth century, *Jū-ō kyō* (Sutra of the Ten Kings of The World of the Dead), all souls of the deceased meet their time of judgement in the World of the Dead. Once there, an individual's sins are compiled and analysed by Emma-ō (Skt: *Yama*), the supreme arbiter of the underworld. Depictions of The World of the Dead show a world filled with grotesque half-human, half-animal demons and hungry ghosts conducting torturous acts. These paintings, called 'scrolls of hungry ghosts' (*gaki zōshi*), portray the ceaseless torments of these creatures in shocking detail.

Sculptures of the Ten Kings of The World of the Dead (*jū-ō*) are very rare in Japan. An exceptional example of one of these ten kings, Datsueba, is shown in figure 34. While sculptures of Datsueba are rare, this deity often appears in 'hungry ghost' paintings. Datsueba, whose name means 'clothes-depriving old woman', is Emma-ō's main assistant, and she sits alongside him at his place of judgement. She is responsible for determining the weight of a person's guilt (i.e., sins). She does this by calculating the weight of an individual's clothing, which is believed to be equivalent to the weight of one's sins[8]. Based on this, Emma-ō assigns the individual to one of the eight 'great hells'. Datsueba is dressed in the hooded robe of a Buddhist nun, and her emaciated condition represents prolonged years of depravity and self-sacrifice. This Datsueba sculpture likely once sat alongside Emma-ō on a dais in a Buddhist temple's worship hall. Individuals would have prayed to her for mercy while making an offering of food, incense, and lit candles.

The wooden sculpture shown in figure 37 represents Kishingyo-ten, one of four heavenly Buddhist *deva* guardians (*ten*) with supernatural powers. His special power is his ability to provide divine help to sentient beings in this life[9]. Kishingyo-ten is shown here striking the classic militant pose of a Buddhist guardian. Standing at attention and scowling fiercely, he flexes his exposed muscles to their limit. He wears an Indian-style skirt made of animal skin (*dhoti*) and he has clawed feet (two toes each) indicating that he is a member of the underworld. His dwarfed size and grotesqueness further confirm his underworld status.

Daruma (Skt: Bodhidharma) was a historical Indian ascetic who, in the early sixth century, introduced the discipline of meditation to China. Daruma was the third son of the Indian king of Kōshi (a country in South India). He travelled to China to study Buddhism at the age of sixty, and after years of travelling from place to place, he settled at the Shao lin ssū temple. There he underwent rigorous meditation. Of the many legends surrounding this eccentric monk, perhaps the best known is the one that tells of how he sat facing a wall for nine years, and as a result lost the use of his legs. It is also said that Daruma drank green tea in excess, and cut off his eyelids to keep from falling asleep.

Figure 38 shows a standing sculpture of Daruma, which represents one of Zen Buddhism's most popular legends. According to the legend, Daruma crossed China's Yangtze River atop a bamboo reed. The Japanese version of this Chinese legend tells how Daruma came to Japan by crossing the Sea of Japan on a bamboo reed. Images of this legend symbolically express the greatness of Daruma, and show how the patriarch overcame physical limitations in order to achieve enlightenment. This sculpture is roughly executed in the 'single-chisel carving' (*ittō bori*) technique. Its maker has captured the subtle nuances of Daruma's facial expression – grimacing with wide-open eyes and a hardcore scowl, with a minimum of details.

The seated image of Daruma shown in figure 39 represents the Zen monk in meditation, and shows him with his trademark scowl and fixed stare. This sculpture reveals the detailed modelling of a skilled, professional Buddhist sculptor.

Jizō Bosatsu (Skt: Ksitigarbha-bodhisattva), whose name means 'Matrix of the Earth', is a Buddhist being renowned for infinite compassion and mercy,

8. *Round Tray (maru-bon),*
Concentric Circle Motif
Takamatsu ware; wood, lacquer
2 × 35 cm
Edo period, mid-19th century

who has postponed his own enlightenment to assist in the salvation of sentient beings (see figures 35 and 61). As quoted in the sutra, *Jizō bosatsu hongankyō*, Jizō vowed: 'Throughout immeasurable eons until the very boundaries of the future, I will establish many expedient devices for the sake of suffering and criminal beings in the Six Paths. When they have all been liberated, I myself will perfect the Buddha Way'[10]. Jizō sometimes serves as an attendant to Amida Butsu (Skt: Amitābha-buddha), the buddha of infinite light who resides in the Pure Land of the Western Paradise. The ten merits of Jizō include abundant crops, longevity in this life, no disasters of fire or water, and no bad dreams. By worshipping Jizō, an individual hopes to gain one of these merits, while strengthening one's chances of entry into the Western Paradise in the afterlife. By the Nara period, the worship of Jizō was well established in Japan. He continues to be one of Japan's most revered Buddhist deities.

Jizō is portrayed as a Buddhist monk wearing a monastic robe, with a shaven head. One of his attributes is the sacred, wish-granting jewel (*nyoi*), which he holds in his right hand. He uses this to light the darkness of the underworld. In his left hand, he holds a monk's staff (*shakujō*). He is encircled by an elaborate mandorla (*kōhai*) and stands with each foot on an open lotus flower base (*renge za*).

By the Edo period, Jizō had become a popular guardian deity of the departed souls of children. He is also said to protect travellers from harm and rescue the damned from Hell. Multiple stone statues of standing Jizō images with bright red bibs can be seen today along roadsides and in neighbourhood shrines throughout Japan. Many families also keep a small statue of Jizō on their home altar.

Stone steles of Jizō Bosatsu, such as the one shown in figure 61, were commissioned by Buddhist worshippers and placed along roadsides or at unattended temples as acts of piety. This stele is inscribed (left side) with the dedication date, Kyōhō (1716-1735), 16th year, 1st month, 14th day, which corresponds to January 14, 1732. The inscription on the right side reads, 'Tōsui-myō Ryu Shinnyoi' (literally, 'female lay believer of Tōsui-myō'), indicating the name of the person who dedicated it[11]. This female layperson hoped to enter the Western Paradise, after her death.

The tall, wooden statue of Jizō Bosatsu shown in figure 35 was reportedly made between the years 1480 and 1500, and was housed at the Kannon Temple in Ueda. It is a superb example of a Jizō image made for worship at a temple. Although minimally carved from one piece of wood, it reflects the characteristics of formal Japanese Buddhist iconography of this

period – a strong sense of symmetry, a head proportionately large for its body, and a pensive face with downcast eyes and large, arched brow lines.

The image carved into the large granite stele shown in figure 62 represents the Buddhist deity, Nyoirin Kannon (Skt: Cintāmani-cakra Avalokitesvara-bodhisattva). Nyoirin gets his name from one of his attributes, the flaming jewel (*nyoi*; Skt; *cintāmani*), which empowers him to grant wishes. The '*rin*' in Nyoirin refers to *hōrin*, the Buddhist Wheel of Law, a symbol of the teachings of the Buddha. Nyoirin is often depicted with six arms, and in each of his hands he holds a different attribute. Like Jizō, Nyoirin Kannon is a *bosatsu*, a compassionate being who has postponed his own enlightenment for the salvation of others. Nyoirin is one of 33 manifestations of Kannon, each of which is capable of endowing sentient beings with a particular expression of compassion[12]. Nyoirin wears the crown and robe of an Indian prince, referring to his royal lineage that he shares with Prince Siddhartha, the historical Buddha (Skt: Sakyamuni). Nyoirin is usually depicted sitting on a lotus base in the 'pensive attitude' pose, as he is shown here.

This stele of Nyoirin is a type of dedication stele. Dedication steles of Kannon Bosatsu were often made in a series of 33, one for each of his manifestations, and distributed among temples in a particular precinct. It was customary in the Edo period for pious Buddhist followers to travel to each of the 33 temples and worship the particular Kannon deity within each. A pilgrimage to all 33 Kannon deities required great sacrifice, and it was believed that completing this act granted one entry into the Western Paradise. This stele is inscribed with the name of the donor, Gesso Myōshun (the female follower's name) and the date of dedication, Kambun (1661-1672) 11th year, 7th month, 11th day, which corresponds to July 11, 1671. The single, archaic Indian *siddham* character, '*sa*', appears at the top of the deity's body mandorla. This refers to Kannon's ability to manifest himself into 33 forms.

When Sakyamuni, the historical Buddha, died around 486 BCE, he was cremated according to Indian custom. Afterwards, his remains were divided and interred inside large reliquary mounds constructed of earth and stone, located at several sacred sites in India. These large sacred mounds (Skt: *stūpa*) became holy places of worship, and eventually, temples were erected on these sites. As Buddhism spread to China, Korea, and Japan, the *stūpa* took on different forms and functions. The architectural temple pagodas of China and Japan, for example, are an evolved form of the ancient *stūpa* of India.

The five-tiered, geometric stone sculpture, called

9. *Saké Pourer* (shuchū)
Wood, lacquer, metal hardware
32 × 54.5 cm
Late Meiji-early Taisho period, c.1910

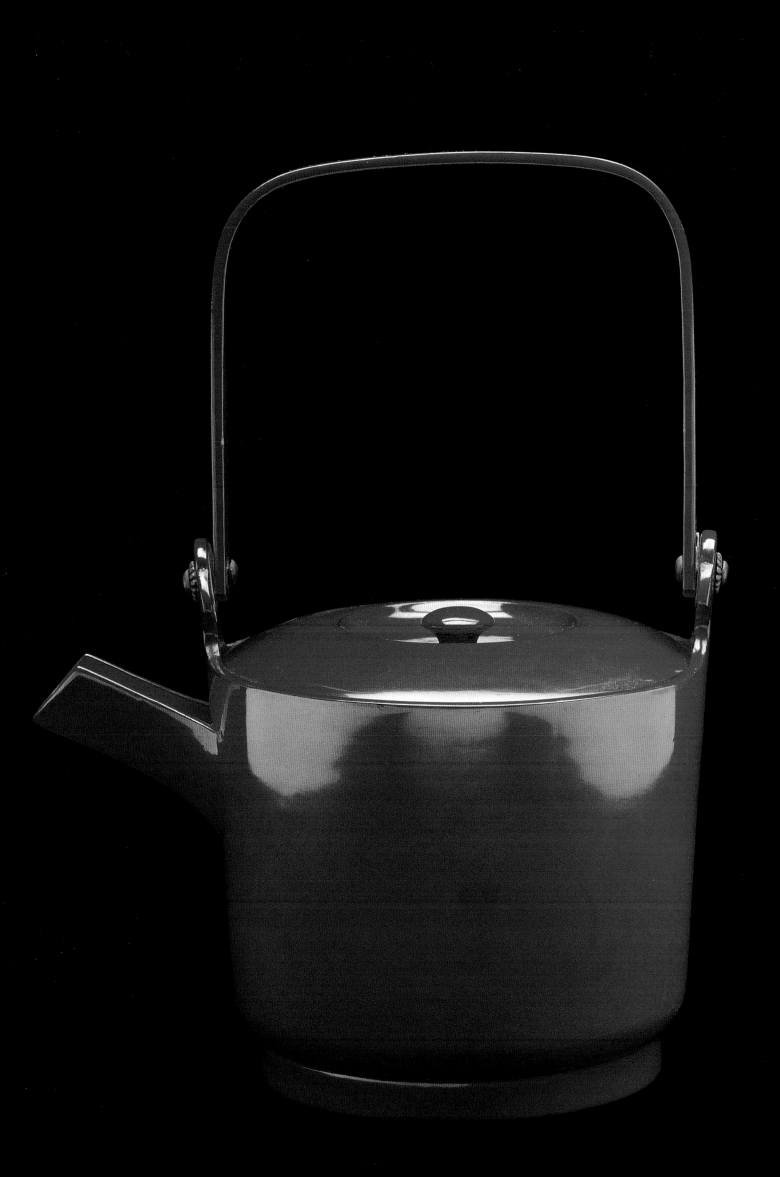

gorintō (or *gorin sotoba*; see figure 64), is a Japanese funerary monument made in the shape of the aniconic form of a *stūpa*. Starting at the bottom, the *gorintō* is made up of a square (*hō*), globe (*en*), triangle (*sankaku*), half-globe (*hanen*), and gem (*hōju*). Each of these geometric parts (or bodies) symbolizes one of the five elements of the universe – earth, water, fire, wind, and void (or ether). Together they symbolize the universe. Now illegible, each stone once had an inscribed *siddham* character that identified its element.

The stone reliquary (*zushi-game*) shown in figure 63 was made (in three parts) to resemble a Japanese Shintō shrine, in miniature form.

The large, wooden, spherical, Buddhist temple drum (*mokugyo*) shown in figure 65 received its name from Chinese prototypes made in the shape of a long fish. The sound of these fish-shaped drums was meant to inspire disciples to stay awake during meditation, just as fish never close their eyes while sleeping.

Mokugyo drums are used in a daily ritual conducted inside the main worship hall. It sits on a red, silk pillow atop a wooden stand that is placed in front of the temple's main deity. The repeated striking of the drum with a large, padded drumstick helps keep chanting monks in unison. It creates a distinctive, rhythmic, hollow acoustic sound. This sound, accompanied by the muffled, low chants of the monks, can still be heard early each morning throughout Japan today.

Lacquerware

Lacquering is an ancient art form in Asia, where it has been used to preserve and decorate wooden objects for many millenniums.

The earliest Japanese lacquered objects date back to the Jōmon period and are believed to be the oldest in the world[13]. Throughout its long history, Japanese lacquer art has reached an unrivalled apogee in technical and artistic excellence. Many contemporary Japanese artists continue to create lacquer objects of unsurpassed beauty.

Japanese lacquer (*urushi*) is derived from the sap of the lacquer tree, *Rhus verniciflua* (Anacardiacaea family), which is related to poison sumac and poison ivy. When harvested, it is a clear substance. Mineral pigments, such as cinnabar (*shu*), are added to the lacquer for colour; in some instances, these pigments also increase the natural preservative qualities of the lacquer. While varieties of the lacquer tree can be found throughout the Asian continent, it is believed by many that the Japanese lacquer tree produces the highest quality *urushi*.

Urushi is a highly toxic material that can cause a strong allergic reaction when contact is topical; when inhaled, it can cause internal damage. For this reason, only persons with a natural immune response to the raw lacquer sap can take up this craft as a profession. Even these individuals, however, must build up the high level of tolerance needed to safely work with lacquer on a daily basis. This requires years of painful exposure.

Lacquer is a complex organic substance that is applied in layers; each layer must 'harden' or cure (rather than dry) gradually, before the next layer is applied. This hardening happens through a process of polymerization. Each layer is burnished and smoothed before the next coat is applied. Once hardened, lacquer is extremely strong and impregnable to even the harshest solvents. Exposure to high humidity and temperature enhance the drying process. Although the process is time-consuming and tedious, the end result is an object of exquisite beauty with a highly protective coating.

Lacquer varies greatly by grade. The highest grade, 'A-quality lacquer', is used primarily for *maki-e* (literally, 'sprinkled picture'), a distinctive lacquering art form. The lacquered objects discussed here mainly involve the B-quality (plain lacquer) and C-quality (mainly black) grades, which were commonly used for everyday objects and furniture. A wide variety of decorative effects could be created by adding oil, colouring, and other agents.

Over the centuries, several distinctive styles of lacquerware have become famous products (*meibutsu*) of a respective region or village. The Negoro Temple located atop Mt. Negoro in Wakayama Prefecture (former Ki Province) is the home of one such style, called *negoro nuri*. Beginning with the temple's founding in 1288 and until its demise in 1585, industrious monks of Negoro Temple produced a large number of objects for ritual and everyday use. However, most extant objects that are said to be '*negoro* lacquerware' were actually made using the *negoro nuri* techniques that were transmitted to various regions of Japan by Negoro temple monks.

The distinctive characteristics of Negoro lacquerware include an outer layer of thick, opaque, cinnabar red lacquer that covers an underlayer of black lacquer. Through normal use, the red layer wears off and in the process exposes the black underlayer. This aging process happens slowly and randomly, in small areas at a time. It is this accidental transformation – from new and perfect, to old and imperfect – that has so appealed to the Japanese aesthete throughout history. The most prized *negoro* lacquerware objects show ample distress from wear, and are favoured by the tea ceremony aficionado.

Wajima nuri is a distinctive, opaque red lacquerware named after the town of Wajima, located in

Ishikawa Prefecture (formerly, Noto Province). Wajima lacquerware dates back to the Ōei era (1394-1428), when a Buddhist monk from Negoro Temple moved to Wajima and began making lacquered furniture and everyday Buddhist implements for the temple[14]. As the craft developed over the years, local villagers organized into guilds and began producing lacquered goods for everyday use for the general populace. These guilds formed a network whereby members specialized in one of the various stages of production – preparing the wooden core, preparing the lacquer, preparing shell for inlay, preparing paint mixtures, applying the lacquer, and curing the objects. This increased production and allowed individual artists to develop a high level of specialization.

The quality and beauty of Wajima lacquerware is due to the unique lacquering method used. This involves a special undercoating made from a mixture of burnt earth (*jinoko*), rice paste, and lacquer. For each additional coating, a higher percentage of lacquer is added to the mixture. The red lacquerware products of Wajima became an economic mainstay for the village throughout the Edo period. A small number of individuals continue to make Wajima lacquerware today, but these contemporary examples tend to be colourful and elaborately decorated with gold, a style which developed in the early nineteenth century.

The large, red, eighteenth-century Wajima *katakuchi* (literally, 'mouth-shaped') spouted bowl shown in figure 98 was used as a saké server for large gatherings on special occasion. Each of the three parts, the spout, bowl, and base, were made separately with turned wood. The parts were joined together with strips of lacquer-coated fabric, and the final coats of lacquer were applied over this. The colour red was preferred for these spouted bowls because of its felicitous connotations.

The *katakuchi* shown in figure 101 represents another distinctive style of saké server used for special occasions. This nineteenth-century black and red *katakuchi* displays two variants of the Kashiwa family crest (*mon*). The two crests and the inscription on its underside, '*kaiyō*', indicate that it was made for a member of the military elite, since the display of family crests was restricted to this class during this period.

Kagawa lacquerware (*kagawa shikki*) is a specialty product of the city of Takamatsu, in Kagawa Prefecture, located on the island of Shikoku. This style of lacquerware is also known as 'Sanuki lacquerware', referring to the old name for this province. While the art of lacquering in this area has a long history, the origin of the polychrome style that came to be known as *kagawa shikki* actually dates back to the year 1830, when a local lacquer artisan went to Thailand and China to study the different lacquering methods used there[15]. Upon his return, he developed a unique decorative style in which layers of paper and polychrome lacquer were built up over a wood core. By carving through the layers, the coloured lacquer was exposed. The circular tray (*maru-bon*) shown in figure 8 is a classic example of Kagawa lacquerware. The concentric circle motif is said to have been inspired by children's wooden tops.

Artisans of the village of Yoshino (former Kaga and Noto Provinces), located outside Kyoto, began to produce lacquerware during the Nambokuchō period. Many of these early examples were replicas of highly-prized Chinese imported lacquerware objects. That which has since come to be known as 'Yoshino lacquerware' (*yoshino nuri*), however, is a product of the late sixteenth century. According to historical sources, Sen no Rikyū, the tea master serving Toyotomi Hideyoshi (1536-1598), commissioned several lacquer artists in Yoshino in 1587 to make items for use at the shogun's cherry blossom viewing party. The popular designs on these utensils became the predominant style for several hundreds years. Figure 99 shows a Meiji-period lacquered food container (*futamono*; literally, 'lidded object') in typical Yoshino lacquerware style. This red and black lacquered container is decorated with the 'cotton rose' motif (*fuyō*), a design that was used on items for the above-mentioned party[16]. The slightly raised rose motif is painted on a highly polished black lacquer ground.

The ancient painting technique called *mitsuda-e*, done with a lead-oxide (litharge) oil paint made with mineral pigments and perilla oil (*mitsudasō*), was introduced to Japan via China. The earliest known Japanese example of this technique dates to the early seventh century[17]. Around the Azuchi Momoyama period (1568-1600), this technique began to be used to decorate inexpensive, everyday serving trays. The conventionalized pine (*matsu*) motif, as seen on the red lacquer tray shown in figure 105, was a popular design on *mitsuda-e* trays. Pine is considered a sacred tree in Japan. It is also a symbol of longevity because some species can grow to be several hundred years old. Trays, such as this one, were widely used during the Edo period.

The red lacquered saké server (*shuchū*) shown in figure 9 was made of thinly-carved, lathe-turned wood. Containers such as this one were popular in the Meiji period and used exclusively for special occasions. It has a highly polished cinnabar-red lacquer surface, and is decorated with chrysanthemum rosette-shaped handle nails.

The long-handled container (*yuto*) shown in figure 102 was used to serve hot water with noodle dishes. It is decorated with red over black lacquer. The large circular crest (*mon*) appearing on its lid and side represents the mandarin orange flower (*tachibana*). This crest was used exclusively by members of the ruling Tokugawa shogunate during the Edo period. It is further decorated with pine, bamboo, and plum, which symbolize 'the three friends of winter' (*shōchikubai*). An additional auspicious symbol, the long-tailed tortoise (*minogame*) symbolizing longevity, appears on its side.

Large, shallow, footed basins such as the one shown in figure 104 were used at Buddhist temples during the *futatsu kai* purification ceremony, which is conducted every 15 days. In this ceremony, monks recite sacred texts to confirm their vows, and confess their sins. These basins were filled with water that was used by the priests to wash their hands. This example is made of zelkova wood (*keyaki*), and lacquered red over black in the *negoro nuri* technique. Its outside surface was treated with a light coat of clear lacquer that was tinted red (*shunkei nuri*), revealing the natural grain of the wood.

Ryūkyūan Lacquer

The history of the Kingdom of Ryūkyū began in the twelfth century, when petty local chiefs (known as *aji*) organized as a means to legitimize royal successors. Eventually, the dominant ruling forces established three kingdoms: Sanhoku, in the north; Chūzan, in the middle region; and Nanman, in the south. The Kingdom of Ryūkyū was officially established in 1429, when Shō Hashi (1372-1439) unified these three separate kingdoms into one and founded the Shō dynasty. Until its annexation to Japan in 1872, the Kingdom of Ryūkyū remained an independent state and ruled over an archipelago of 55 islands stretching from the southern tip of Japan's Kyūshū island to Taiwan.

In 1609, the Japanese feudal lord (*daimyō*) of the Shimazu clan of Satsuma (Kyūshū) attacked Ryūkyū, reportedly in retribution for poor treatment of Japanese shipwrecked fishermen. This resulted in the subjugation of several of Ryūkyū's northernmost islands to the Shimazu clan, and for the next 250 years, the kingdom of Ryūkyū was required to pay tribute to Satsuma. Irrespective, Ryūkyū remained independent until 1879, when King Shō Tai was forced to abdicate after the Meiji government took over the kingdom and renamed it Okinawa.

Due to a lack of comprehensive research on Ryūkyūan lacquer until the present day, a number of false theories have been fostered for many years. Only recently, through the careful reexamination of historical records, have these theories been analysed, and a revised history been written[18]. Yet little is known of the origins of Ryūkyūan lacquer production. Some believe, however, that because the oldest Japanese lacquer pieces date back some 5,500 years, lacquer production in Ryūkyū may have begun by this time, since the lacquer tree is native to these islands.

By 1372, King Satto (d. 1372) of the Chūzan clan had established official relations with China. From this time onward, the two nations maintained healthy trade relations for many centuries. Chinese lacquer production techniques were being introduced to Ryūkyū, while raw lacquer, shells for mother-of-pearl inlay, and finished lacquerware products from Ryūkyū were being exported to China. As Chinese lacquer artists developed new techniques and styles, the Chinese government was quick to transmit these to Ryūkyū, so that the lacquer artists there could update their motifs and techniques on goods made for export to China. Ryūkyū lacquerwares reflecting Chinese tastes were also exported to mainland Japan, but these were considered luxury items and obtainable only by the ruling elite. The exotic flavour of many of these rare objects especially appealed to tea practitioners who enjoyed showing them off to fellow connoisseurs.

For the first 300 years, Ryūkyūan lacquerware mainly reflected Chinese taste, since the large majority of goods were destined for China. Most in demand was carved, cinnabar-red lacquerware (*tsuishu*), followed by red lacquered items decorated with mother-of-pearl inlay (*raden*). However, after the Shimazu annexation of the islands in 1620, a shift in taste and design toward mainland Japan became evident in Ryūkyūan wares. At the helm of this shift was the Tokugawa shogun who had a great hunger for Ryūkyūan lacquerwares that reflected both Chinese and Japanese tastes. These two divergent tastes were often combined on the same object, enhancing their exotic appeal. Demand for goods decorated with mother-of-pearl inlay on a black lacquer ground, in particular, increased during this time.

In the eighteenth century, production of Ryūkyūan goods decorated with mother-of-pearl grew dramatically. This period also witnessed a revival in demand for red *tsuishu* carved-lacquer goods. By the late eighteenth century, decorations resembling Chinese landscape paintings done in mother-of-pearl and gold paint became a standard style. Up until this time, production of Ryūkyūan lacquerware was restricted to workshops controlled by an agency of the government, the Office for Shell Polishing (*kaizuri bugyōsho*).

The greatest change in Ryūkyūan production

10. *Chest on Wheels (*kuruma-dansu*)
Zelkova wood (*keyaki*), lacquer, iron hardware
86.5 × 85.5 × 40.5 cm
Meiji period, 19th century

occurring during this time was a shift in exclusive production of lacquer goods by the Office of Shell Polishing, to production by the common people. This meant both an increase in production, as well as a drop in quality. While this government office continued to make high quality objects for the ruling elite throughout the eighteenth century, this new class of lacquer artisan provided the public with inexpensive objects of lesser quality, but which reflected the popular tastes of the common people.

The best Ryūkyūan lacquerwares dating from the nineteenth century onward, including those decorated with mother-of-pearl, were made exclusively for the royal family by the Office for Shell Polishing. When comparing these pieces made under the supervision of the office with those made for the general populace, the contrast is remarkable, in terms of refinement and quality of decoration. The majority of lacquer objects discussed here were made in the eighteenth century, and many of these reflect a quality and style similar to those produced under the supervision of the Office of Shell Polishing.

Mother-of-pearl Inlay

The technique of decorating with thin pieces of mother-of-pearl shell, called *raden*, was used by Ryūkyūan lacquer artists from the mid-seventeenth century. These early lacquered pieces were most often red in colour, and made in great numbers for export to China. The motifs decorating these export items were Chinese-inspired, and many were taken from fourteenth-century, Chinese silk brocades. The most valued pieces were done with extremely thin layers of shell, requiring great skill.

The saké flask shown in figure 107 was made in Ryūkyū for export to mainland Japan, probably in the late eighteenth or early nineteenth century. It is elaborately decorated with Chinese diaper motifs done in mother-of-pearl inlay. These motifs include the linen flower design (*asa no ha*; top), the coin pattern (*shippō*; sides), and the opposing lines design (*tatewaku*; base). The design of the wooden stopper, in the shape of a geodesic prism, was borrowed from Shōnai-style flasks from the mainland. This flask represents a mainland style of saké container called *sode-daru* (literally, 'sleeve-flask') that gets its name from the shape of a kimono sleeve[19]. *Sode-daru* flasks were used in pairs for weddings, as a symbol of the union of two people. Ryūkyūan *sode-daru* flasks were much smaller than their prototypes.

Sword stands were also made in Ryūkyū for export to Japan in the Edo period. The sword stand shown in figure 108 was made in the eighteenth century and reflects a continued demand for goods decorated with Chinese-inspired designs during this period.

Like the above-mentioned *sode-daru* saké flask, it is elaborately decorated with geometric designs done in mother-of-pearl inlay on a black lacquer ground. It is also decorated with various Chinese motifs and symbols, including the *karakusa* arabesque design (literally, 'Chinese grass'). The mythological birds painted in red lacquer also reflect Chinese rather than Japanese taste. This stand was made to hold five swords.

The late eighteenth-century Ryūkyūan sword stand shown in figure 109 reflects both Japanese and Chinese tastes. It was made for two swords and is portable; it folds into a rectangular box that can be easily transported. The two hinged side panels fold over its body. A top section (separate) fits over the folded box and completes the assemblage. Plum blossoms on a branch, done in mother-of-pearl inlay, decorate the side panels. Single plum flowers are lightly scattered over its remaining black lacquered ground area. The top is decorated with a Chinese landscape done in mother-of-pearl inlay. This creates an interesting juxtaposition with the scattered-plum design that is quintessentially Japanese.

Large black lacquer trays decorated with dragons rendered in mother-of-pearl inlay were produced in large numbers from the seventeenth to the nineteenth century under the careful supervision of the government at one of the court-run *kaizuri bogyō-sho* workshops. Trays such as the one shown in figure 110 were made as presentation (or tribute) gifts for high ranking members of the Chinese court, including the emperor, and represent the best of Ryūkyūan lacquer craftsmanship. Using the *urazaishiki* technique, gold foil and gold paint were applied randomly onto the back surface of exceptionally thin pieces of mother-of-pearl shell to create a unique colouring effect.

One is generally able to differentiate dragon trays made in the seventeenth century from later examples by the quality of the craftsmanship. Based on its superb quality, and comparing it to similar examples in Japanese collections, this tray seems to be a relatively early eighteenth century example. On this tray, two, five-clawed, heavenly dragons (symbolizing the Chinese emperor) hold a flaming jewel and fly among celestial clouds. The rim is decorated with treasure motifs framed by an intricately inlayed tortoise shell diaper pattern.

The lacquering technique used on the red, peach-shaped, food container shown in figure 100 was called *tsuikin*, and is unique to Ryūkyū. In this technique, lumps of coloured lacquer are mixed with raw lacquer and then cut into designs. These designs are next applied onto the surface of the container. The design of peonies and butterflies, native to neither Ryūkyū nor Japan, gives this piece a foreign

11. *Merchant's Sea Chest, Ledger Box type* (chō-bako)
Zelkova wood (*keyaki*), lacquer, iron hardware
Crest (*mon*): *han* (prosperity)
44.9 × 39 × 47.5 cm
Edo period, 19th century

flavour. It was likely made by an independent, local craftsman, rather than at one of the government-sponsored workshops.

The six plates shown in figure 106 a-f are delicately painted with depictions of flowers, birds, and Chinese architecture and landscapes. They were done with the lead-based *mitsuda-e* lacquering technique. Silver and gold were applied sparingly to the painted decorations for accent. The asymmetric composition, with plenty of void space, reflects Japanese, rather than Chinese or Ryūkyūan, taste. Elegant without being ostentatious, these plates would have been appropriate for use in Japanese tea ceremony during their time.

The black lacquered stationary box (*bunko*) shown in figure 103 is a good example of nineteenth-century Ryūkyūan lacquerware done by a local craftsman. The box is decorated with various Chinese mythological creatures. The top of the lid is decorated with a three-clawed dragon, two bats, and a long-tailed bird that fly among celestial clouds. The inside surface of the lid is decorated with three birds, a pheasant, plover, and vulture, and a flowering plum tree and orchid growing among rocks. Three bats are painted on the inside of the box, again Chinese in design. In contrast to the food container discussed above (see figure 100), this piece has a strong folkish quality. It was painted with coloured lacquer directly onto a black lacquer ground.

Ōtsu-e Paintings

Ōtsu-e (literally, 'pictures of Ōtsu'), also known as *Oiwake-e* (literally, 'pictures of Oiwake'), was a popular, regional, painting genre of the Edo period. *Ōtsu-e* began as devotional images sold along the roadside at Oiwake (Shiga Prefecture), located on the shore of Lake Biwa near the town of Ōtsu (outside Kyoto). Oiwake was situated on a major Buddhist pilgrimage route and was one of the scheduled stops along the Tōkaidō highway that connected Edo to Kyoto (and beyond). Sometime during the seventeenth century, local town artists (*machi eshi*) began to create pictures with popular Buddhist themes as mementos for the pilgrims passing through. These artists did not sign their pictures. Early *Ōtsu-e* pictures were reproductions of Buddhist woodblock prints, another inexpensive art form done for the travelling pilgrims' market. Like their religious prototypes, *Ōtsu-e* paintings carried didactic messages that reminded followers of their Buddhist duties.

By the eighteenth century, *Ōtsu-e* artists had shifted from religious to secular subjects, and their works began to reflect technical and stylistic influences from *ukiyo-e* (literally, 'images of the floating world'). Subjects were numerous, and included popular legendary heroes, folk characters, beauties, and animals. Humorous images of animals and beasts shown in human situations ridiculed people of rank and power. Others were meant as parodies on the foibles and frailty of humanity. In the late eighteenth century, themes current in the new religious movement, Shingaku (literally, 'teachings of the heart') began to appear in *Ōtsu-e*. The teachings of this 'folk' religion, which borrowed elements from Confucianism, Buddhism, Taoism, and Shintō, were simplified by *Ōtsu-e* artists into trite admonitions with a Confucian bent (ex. know one's place, hold one's tongue, avoid excesses of all kinds, be obedient to one's parents).

Techniques employed by *Ōtsu-e* artists included painting with pigments and ink, woodblock printing, painting with stencils, and the use of rulers, compasses and templets. By applying these techniques in ingenious ways, artists were able to mass-produce affordable paintings with subjects that were easily understandable and appealed to the common people. To minimize costs, they used inexpensive materials such as metal filings, in place of gold, for metallic accents. In spite of these limitations, *Ōtsu-e* paintings appear fresh and capture a wide range of expressions. The calligraphy on *Ōtsu-e* paintings often appears fluid, but in fact was typically executed by a poorly educated town artist and included irregular characters written in an idiosyncratic manner.

The *Ōtsu-e* painting in figure 115 shows a drunk, slouching, red-faced monkey riding on a large saké gourd. This monkey represents the small, indigenous, Japanese macaque with a short tail and a red face. In the painting, both the saké gourd and the saké cup are proportionately large for the monkey, adding an element of humour. The bright red of his face is echoed in the red lacquer on the inside of the saké cup, adding emphasis to this freakish feature. This work is meant as an admonition against drinking alcohol in excess, a common theme in *Ōtsu-e* paintings. The poem on the painting is written with several irregular characters, suggesting that it was copied off of a master text by a poorly educated individual. The black outlines on the monkey, saké cup, and saké gourd were likely done with either a stencil or a woodblock. A crude, unbleached, handmade paper was used, reflecting a cost-saving concern by its maker.

The poem on the painting reads:

hyōtan ni norite, sake nomu sarujie wa [to?], shiri mo suwarazu ashi mo suwarazu

The cunning, saké-drinking monkey, riding on a saké gourd, is unstable.

hyakuyaku no chō taru ue ni kaerite wa, mata hyakubyō no moto to naru sake

Although with many medicinal qualities,
even saké will result in numerous ailments,
if imbibed in excess[20].

The Japanese demon (*oni*) was an especially popular subject in *Ōtsu-e* paintings throughout the eighteenth and nineteenth centuries. Most of these paintings of demons were meant as a satire on the clergy. The demons in these paintings posed as raucous musicians, itinerant monks, and the God of Thunder, among other characters. Paintings of demons as itinerant Buddhist monks, such as the one shown in figure 15, were called 'the devil's invocation' (*oni no nembutsu*). This late nineteenth-century example incorporates all of the standard conventions of these paintings. The demon wears the robe of a monk on a pilgrimage. He carries a small gong and striker that he would use while praying for alms. In his right hand, he holds a tablet for recording offerings that he might receive.

As hard as he attempts to appear pious, this demon cannot hide his 'real' character. Instead of the proper clean-shaven head of a Buddhist monk, he has two horns – one flopped over – growing out of an unkept head of hair. He attempts a benevolent grin, but his two fangs – one up, and one down – protrude unevenly out of his mouth. In place of pants he wears spotted animal fur leggings. Without the usual woven-grass sandals of the travelling monk, his bare feet with two toes sprout ugly claws.

This painting is inscribed with '*Ōtsu eshi*' (Ōtsu artist) and '*oni nembutsu*' (the devil's invocation). The red seal also reads '*oni nembutsu*'. While *Ōtsu-e* artists generally did not sign their paintings, several well-known professional artists began to create *oni no nembutsu* paintings in the late eighteenth century[21]. The artists of these paintings often signed their works, and by the late Edo period, *Ōtsu-e* artists were signing their works as well. While the *Ōtsu-e* painting shown here is not signed with the artist's name, these inscriptions represent a break from tradition. Images of beautiful women (*bijinga*) first emerged as a distinct painting category in Japan in the Momoyama period with a rise in popularity of the pleasure quarters. The Japanese plebian woodblock print genre, called *ukiyo-e* (literally, 'images of the floating world'), followed these early paintings of beauties. *Ukiyo-e* prints initially included both women of the pleasure quarters and *kabuki* actors, but eventually, the images of women became the predominant subject. The demand for *ukiyo-e* prints remained strong throughout the Edo period. *Ōtsu-e* paintings of beautiful women first appeared

in the late seventeenth century, and show women dressed in the latest fashion of their time. *Ōtsu-e* artists chose two types of women – the dancing geisha and the high-ranking courtesan (*tayū*) – as their stereotypical beauties. The *tayū* in *Ōtsu-e* paintings wore a luxurious silk robe with a silk sash (*obi*) tied elaborately in front, and tall wooden clogs (*geta*). The women's faces were painted white in traditional courtesan fashion, and they wear their hair in the style worn by women of their rank and file.

The early eighteenth-century painting shown in figure 114 is a superb early example of an *Ōtsu-e* painting of a *tayū* courtesan, and includes all of the trademark conventions of this particular subject. In this painting, a courtesan glances over her shoulder and away from the viewer, while striking the suggestive 's-curve' pose in a typical flirtatious gesture of women of her profession (called *mikaeri*). She holds her kimono in a manner that exposes her expensive *benibana* red under-kimono, and she balances on tall, wooden *geta* clogs.

Of interest here is the way in which the courtesan in this painting stands with her feet sprawled and pointing in different directions. This unconventional stance was likely meant to heighten the erotic appeal of the painting, while also providing an element of humour. The artist seems to be ridiculing this 'sacred' symbol of beauty and femininity.

The Japanese have an old saying '*kasa me, tō me, yo me*', which roughly translated, means 'when one sees a woman under an umbrella (or at night, or from a distance), she is invariably beautiful'. This saying could also apply here. Although she appears beautiful at first glance, her clumsy mannerisms reveal her true, low-class status.

The major traffic along the Tōkaidō highway in the Edo period came from the large *daimyō* processions that travelled between Kyoto and Edo, and beyond. The men in these processions held ranks from high-level *samurai* lords to lowly porters, but they shared a common taste in their choice of secular art – images associated with the military elite.

Highly stylized *Ōtsu-e* paintings of tethered hawks (*kumataka*), such as the one shown in figure 14 were good sellers to this group, and a large number of these paintings was made throughout the Edo period. The hawk, a bird of prey, symbolized the ideal of military prowess.

The Japanese tradition of paintings of hawks (and falcons) date back to the Muromachi period when Chinese prototypes were avidly being collected by the nobility. These early examples were painted by professional artists on screens, sliding door panels, and mounted as a hanging scroll. Extant *Ōtsu-e* hawk paintings from this period often have the same

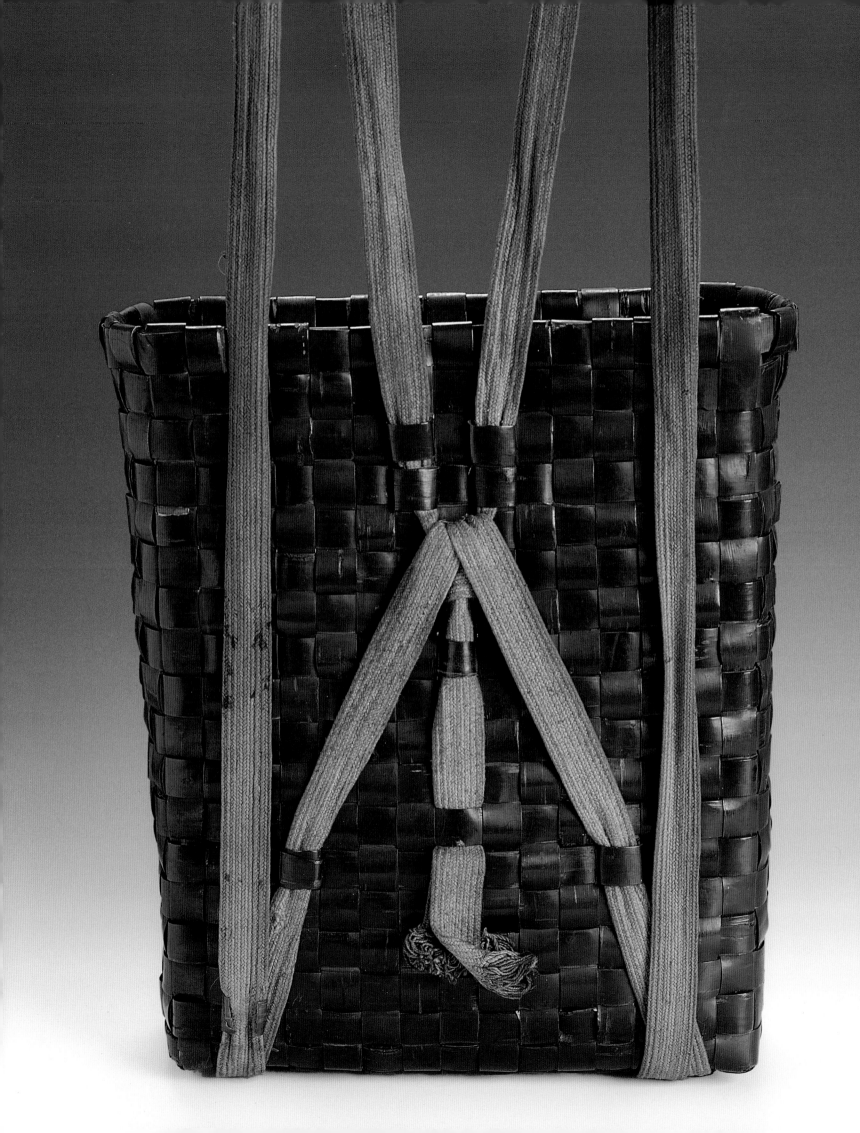

inscription as the one shown here; only the writing irregularities differ among them. The inscription on these paintings warned men against greed, and reminded them of the importance of maintaining a sound moral constitution. Long life was promised to the good at heart. The inscription here reads:

takaki nimo mata hikuki nimo ōi no wa yoku ni kumataka kore washizukami

The tethered hawk, whether perched high
or low, greedily grabs like the eagle at everything.

yoku wa teki taru wa mikata to omoitsutsu fudan mamoraba jumyō nagaku

If led with the perspective that greed is the enemy and satisfaction is the ally, one's life will be long[22].

Doro-e Painting

Doro-e (literally, 'mud picture') is another indigenous Japanese genre of painting which first emerged in the late eighteenth-century when self-taught town painters began producing inexpensive paintings of a secular nature for the popular market. They were executed on thick paper with water-based, pigment paints (*doro-e no gu*), to which ground shell (*gofun*) was added as a thickener. This paint medium gave the paintings an opaque surface quality that at the time was considered exotic.

Many *doro-e* artists experimented with the techniques they saw in prints brought to Japan by traders from Europe, such as the one-point perspective and shading. The earliest *doro-e* paintings were made as stage sets and shop signs. Eventually, artists began to create images of 'famous places' (and foreigners), such as the foreign quarters of Nagasaki.

There are two distinct styles of *doro-e* paintings, the Kamigata style of the Kansai area (present-day Osaka), and the southern, Nagasaki style (Kyūshū). The painting of Mount Fuji shown in figure 116 represents a nineteenth-century Kamigata style *doro-e* painting from Kyoto.

Ema Paintings

The practice of donating plaques with auspicious images to a Shintō shrine has a long history in Japan. Early records from the Kitano Shrine of Kyoto show the donation of a plaque with an image of a horse (*ema*) as early as 1012. These plaques came to be called '*ema*' (literally, 'horse picture') from the earlier practice of donating actual horses to shrines by members of the nobility. Eventually, small, wooden horse figurines were given in place of actual horses; the custom further evolved into the donation of small wooden plaques with paintings of horses. This practice originated from the belief that horses

were the favourite mounts of the Shintō gods and therefore sacred. The colour of the horse being donated corresponded to a particular wish by the donor. Black horses were given when one wished for rain, whereas a white horse was given for protection from a flood. These donated horses were kept in the shrine grounds as sacred horses (*shin me*) and on Shintō festival days, they were dressed with lavish brocade sashes and led in a procession alongside the shrine float. Two important Shintō shrines, Nikko and Ise, continue to keep sacred *shin me* horses today. The name of the donor and the date of donation was customarily inscribed on *ema* plaques, and they were displayed on the shrine grounds for all to see. In time, other images besides horses, such as Japanese folk heroes, began to appear on the plaques, as the practice spread to the common people. In the late sixteenth century, sailors began to donate *ema* plaques with images of ships sailing on a calm sea to express their wish for a safe voyage. Eventually *ema* plaques came to be associated exclusively with the new year. Today's *ema* are usually printed (rather than painted) with the zodiac animal of the new year. Because the horse is one of the 12 zodiac animals, it appears on *ema* once every 12 years.

Three exceptional examples of horse *ema* are shown here. The small *ema* (*ko ema*) of four dancing horses (three brown and one black), shown in figure 113, dates from the nineteenth century. *Ema*, such as this one, were made in large quantities and sold at shrines. They were either inscribed by the donor and left at the shrine (displayed on a wall with other *ema*) or used as an amulet for the home. The horses are dressed with the special mounting (*umakake*) worn by shrine horses on festival days.

The horse on the *ema* shown in figure 112 bows his head low while looking out at the viewer. His fancy mount is the focal point of the painting. Damage to *ema* was common, since many remained outside for long periods of time.

The inscription on the *ema* shown in figure 111 tells us when and by whom it was donated. It reads 'Temmei Heigo (1786), 5th month [day illegible]'. It is also inscribed with '*hōno*', which means 'offering'. National heroes, both legendary and historical, were a popular subject for *ema*. The hero on the *ema* shown in figure 4 is Takenouchi no Sukune, a historical figure whose greatness took on legendary proportions through the years. Takenouchi no Sukune was a famous general who served under Empress Jingū Kōgū (ca. late fourth century). According to the two ancient chronicles of Japan, the *Kojiki* and *Nihon Shiki*, Takenouchi no Sukune, was the great grandson of Emperor Kōgen. He played a vital role in Empress Jingū's expedition to Korea, as well as

12. *Pannier (*shoi kago*)*
Split and woven cherry bark, cotton (*straps*)
34.5 × 28 × 9.5 cm
Meiji period, late 19ᵗʰ–early 20ᵗʰ century

in the subjugation of Kyūshū, two military campaigns that greatly expanding the Yamato court's rule. He is often depicted as seen here, holding the Empress Jingū's infant, Ōjin. Legend tells of how Empress Jingū, while several months pregnant with Ōjin, led a successful invasion against the state of Silla (present-day Korea). After returning, she gave birth to a healthy baby boy who succeeded his mother to become the fifteenth ruler of Japan. Takenouchi no Sukune also served under his rule. The inscription on this *ema* also reads '*hōno*'. It has a small ring that would have been used as a handle on a drop-fit door, suggesting that this *ema* was once used as such for a cabinet.

Okame Painting

Okame, the Goddess of Mirth, sometimes assumed identities contrary to her true nature, as a means to act out subtle parodies. In the painting shown in figure 117 she appears as Otafuku, whose name means 'many fortunes'. The subject of this painting is 'gathering of one hundred Otafuku's (*hyakufuku kai*; literally, 'gathering of one hundred fortunes'). *Hyakufuku kai* paintings, which are unique to Japan, are meant to illustrate the many talents of the Goddess of Mirth in the form of Otafuku. In this painting, Otafuku dances as a *maiko* (geisha in training) to a large gathering of identical-looking Otafuku's. She practices tea ceremony (*chanoyu*) with her Otafuku friend. She dresses another Otafuku friend in a kimono, and plays the *koto* (a Japanese harp). The Otafuku merchant receives a bundle of money from an Otafuku client. The literatus Otafuku engages in lively conversation over saké and tobacco with two Otafuku friends. The rare, solitary Otafuku practices *ikebana* (flower arrangement). Otafuku also cooks, sews, and applies make-up to a *geisha*. Indeed, there seems to be nothing that this goddess of mirth and fortune cannot, or does not, do in this painting.

The seal on the painting, reads, '*sanman rokusen nichi*', referring to the Chinese expression, 'call to thirty-six-thousand days which equals one hundred years'[23]. In a poem written by the famous Chinese poet, Li Po (701-762), this concept is mentioned as follows: 'Even if we live to be one hundred years old, this would only be thirty-six-thousand days. We should drink at least three hundred cups of saké wine [to live a long life]'[24]. Li Po is expressing his hope for longevity, in typical Chinese fashion – through exaggeration.

This Otafuku painting is an example of a Japanese 'parody picture' (*mitate-e*). It praises the unlimited talents of Otafuku and expresses the ideal of longevity. Interestingly, it is executed in conventional Chi-

nese literati landscape style. The artist here has cleverly transposed Otafuku figures – layering them one on top of the other – in the same way that Chinese landscape artists use the elements of nature, such as mountains, mist, and sky, in their paintings to establish illusion. Firstly, the use of the long, narrow, vertical, hanging scroll format is the same as that preferred by Chinese landscape painters. It is meant to be read from top to bottom, with the three picture planes – foreground, middle ground and background – depicted in a vertical orientation. Starting at the top of the painting, the figures are small and blurred, as if farther away from the viewer. This represents the background and recalls the manner in which Chinese painters often depict mountains – in the distance, hidden in mist. Moving down the painting, the Otafuku figures grow larger and are more in focus. In Chinese painting terms, the viewer is gradually moving closer to the mountains and the mist begins to clear. The saturation of ink becomes heavier as the viewer travels lower in the painting. This enhances the illusion of distance and depth. In this painting, as with Chinese landscape paintings in general, the artist has provided a path on which the viewer is invited to travel.

Most *hyakufuku kai* paintings were executed by common town painters who made multiple copies and typically did not sign their works. This painting, however, is both inscribed with the title, '*hyakufuku kai*' (upper right) and signed with the artist's name (*gō*; lower left), 'Hyakunen gu'[25]. The red seal reads 'thirty-six thousand days', another reference to the subject of the painting. It was painted by the accomplished Kyoto artist, Suzuki Seiju (1825-1891), who went by the name, Shikō, and used 'Hyakunen' as his artist name. Hyakunen is best known for his Japanese style (*nihonga*) landscape paintings[26].

Munakata Shikō

Munakata Shikō (1903-1975) was born in the northern Tsugaru region of Japan (Aomori Prefecture), a poor, remote, mountainous area that borders the Sea of Japan. He was the third child (of 15) of a blacksmith who made cutlery and farming implements. With only an elementary education, Munakata showed a passion for art from an early age. At the age of 21, (1924), he decided to dedicate his life to becoming an oil painter, and he moved to Tokyo. Four years later, he was invited to show in the prestigious, government-sponsored 'Teiten' exhibition. That same year, he decided to shift his attention to woodblock prints, and began to study with Hiratsuka Un'ichi (b. 1895). In the 1930's, after seeing the works of the French Impressionist artists, Munakata was quoted as saying that he wanted to

become 'the Van Gogh of Japan' (he was especially impressed with Van Gogh's *Sunflowers*). He was an extraordinarily prolific artist whose works span three historical periods – Meiji, Taishō, and Shōwa. He became one of the forefathers of the 'creative print' movement in Japan, and inspired a whole generation of woodblock artists. Munakata won numerous awards, both national and international, during his lifetime. The works of this great artist express a quiet but powerful dynamism.

Munakata was born with a severe, nearsighted disability, causing him to have a very limited field of vision. This often resulted in oversized figures and compositions that ended abruptly at the outside edges of the picture frame. Ironically, his visual limitation became the genius behind his works. Munakata was known for his gentle spirit and big heart, and his photographs invariably show a gentle man with a big smile. Themes represented in Munakata's paintings, prints, and calligraphy include Buddhist imagery, and heroes from Japanese mythology and folk legends. He often included text in his works, and even created several woodblock print series that incorporated complete folk tales. Later in his career, he produced several books done entirely in the woodblock printing method.

In the late 1930's, Munakata's works caught the attention of members of Japan's Mingei Movement, and he was invited to join their group. This association, while positive on the whole, caused Munakata to be labelled as a 'folk artist'. As a result, he is often omitted from published biographies on Japanese artists. Yet, Munakata did not technically fit the 'folk art' (*mingei*) label either. He was not self-taught and he signed his works. As well, his strongly independent, eccentric nature did not fit the conventional folk artist's image. Many of Munakata's works do however share a simple, innocent beauty with Japanese folk art.

During the air raids on Tokyo in 1945, most of Munakata's home and the works he kept therein were destroyed. Irrespective, Munakata continued to work, in watercolour, oil, and calligraphy. His works are included in museums worldwide, with three museums in Japan named after him. Throughout his life, Munakata never forgot his humble beginnings nor did he try to conceal them. He was, in his own words, always 'the son of a blacksmith'.

The calligraphy by Munakata Shikō shown in figure 119 reads, '*hana fukaki tokoro*' (place where flowers grow deep)[27]. These three characters are part of the expression, '*hana fukaki tokoro, gyōseki nashi*' (no footprints show where flowers grow deep). This expression, either complete or partial, was a favourite of Munakata's[28]. This work (mounted as a hanging scroll) is accompanied by a long, wooden tablet that resembles a *mokkan* used for writing in ancient Japan[29]. The calligraphy on the tablet reads, '*suichū no sekizō, ame ni nureru o osorezu*' (a stone statue, wet from the rain, does not get angry)[30]. The inside of the scroll box lid is inscribed with '*Munakata Shikō no sanji "hana fukaki tokoro" kaku*' (three letters written by Munakata Shikō, 'place where flowers grow deep')[31].

The work by Munakata shown in figure 118 includes both calligraphy and painting. In the middle ground, a tea bowl and tea caddy are expressively painted in watercolour. The calligraphy on the upper half of the painting reads, from right to left, '*temmei*' (literally, 'heavenly brightness'). In the lower left ground, Munakata has signed his work, from right to left, 'Munakata'. With two *kanji* characters played off two *objects d'art* of equal proportions, Munakata has created a dynamic composition.

Furniture

Japan has been blessed with a great variety of broadleaf and evergreen trees. These include: zelkova (*keyaki*; *Zelkova seratta* Makino), cryptomeria (*sugi*; *Cryptomeria japonica* D. Don.), pine, (*matsu*; *Picea jezoensis* Sieb. et Zucc.), paulownia (*kiri*; *Paulownia tomentosa* Steu.), chestnut (*kuri*; *Castanea creenata* Sieb. et Zucc.), cypress (*hinoki*; *Chamaecyparis obtusa* Sieb. et Zucc.), persimmon (*khaki*; *Diospyros khaki* Thunb.), and magnolia (*hō*; *Magnolia obovata* Thunb.). Among these, zelkova wood is the most dense, and is the preferred wood for fine furniture and daily household items and tools.

Japanese cabinetry is constructed using the same principles applied to traditional Japanese architecture. Structures are made without rigid joints to allow for a minimum of stress and a maximum of flexibility. Because the Japanese archipelago experiences radical changes in humidity throughout the year – especially from summer to winter – and because it is prone to frequent earthquakes, flexibility in furniture makes good sense. Techniques such as placing the flooring boards of cabinets perpendicular to the drawer face were done to counteract swelling and allow for adjustments to climatic changes. Moreover, rarely is the joinery of Japanese cabinets pinned with iron; instead wooden pegs are used to secure panels and lock tenons.

Most traditional Japanese furniture was made so that it could be easily moved. One reason for this feature is that traditional Japanese houses were made of wood and often built in rows. Inhabitants usually shared common walls with their neighbours on either side. This close proximity meant that once a house fire broke out, it spread rapidly from house

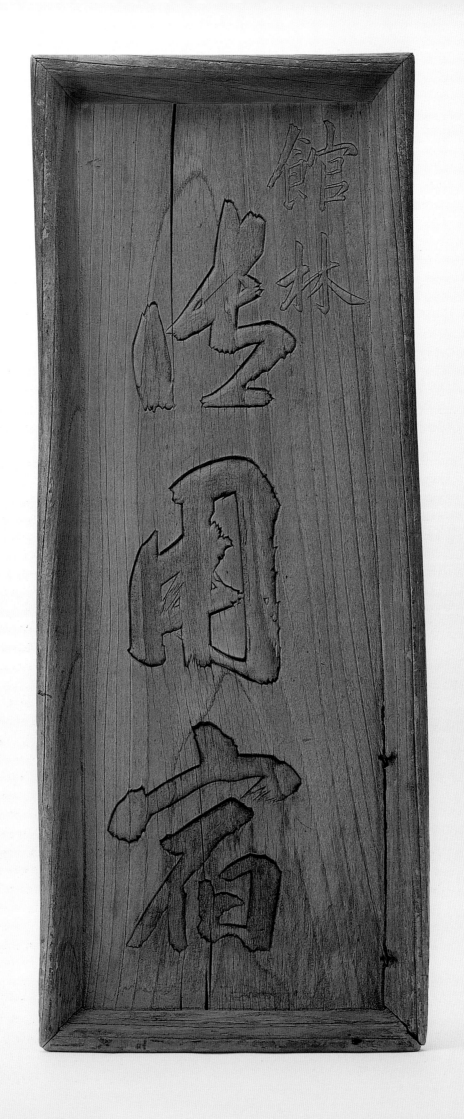

to house. The firefighting method used up until the late nineteenth century was to tear down houses in the path of the fire[32]. Cabinets were built on wheels or with handles for carrying because they provided families some insurance against the loss of their goods in the event of a fire. Japanese furniture was made portable for another reason. Rooms in traditional Japanese houses had multiple functions – a room used as a bedroom at night may also be used as a family gathering place or as a room for meals during the daytime. Japanese furniture therefore had to be light enough, and small enough, to move when additional space was needed.

The cabinet (*kaidan-dansu*) shown in figure 121 is a good example of traditional Japanese furniture that was made to serve a dual function – as both a storage chest and a staircase. Unlike Western staircases, this Japanese example is freestanding, allowing it to be moved from place to place. Such a staircase would have led up to a loft or storage space above the main floor of a traditional Japanese home[33].

While most *kaidan-dansu* chests were made to allow access from both sides (i.e., drawers could be pulled out from either side), the drawers of this chest only pull out in one direction. This indicates that it was made to be used in a corner, placed against two perpendicular walls.

Three different lacquering techniques are used on this chest. The expensive zelkova burl wood on the sliding doors is treated with clear lacquer, while the frames of these doors are coated with an opaque, black lacquer, creating a strong contrast. Red lacquer is used to cover the remaining drawers.

The merchant's chest (*chō-dansu*) shown in figure 128 has a variety of drawers, for storing paper, ledger books, contracts and letters, stamps and ink pads, writing brushes and ink stones, and money (lower right drawer with locking device). The iron hardware that covers its rich zelkova burl face was treated with the *benigara* lacquering technique. In this technique, the iron is coated with lacquer while red hot. The lacquer fuses with the iron in the process, and a durable black protective surface is created on the hardware.

The castle town of Tsuruoka (Yamagata Prefecture) became a flourishing manufacturing centre for furniture in the late Edo period. The *benigara* technique was done exclusively by Tsuruoka carpenters until the Meiji period, when it began to spread to other furniture centres. Another distinguishing feature of Tsuruoka furniture is the clear coat of lacquer painted on the burl face of the chest, which over time has turned a reddish honey colour. This feature was created with the *kijiro* lacquering technique. A *kara uchiwa* (Chinese fan) crest decorates

its vertical locking bar (on face). This chest would have sat an arm's reach from a merchant in the entryway of the home where he conducted his work. This 'place of business' (*chōba*) was slightly elevated (from street level) and the floor was covered with *tatami* (straw mat). Judging by its good design and quality craftsmanship, this chest was likely owned by a well-off merchant. Visible to his clients, the chest was meant to make a good impression.

The town of Mikuni, located along the Japan Sea coast in Fukui Prefecture (former Echizen province) became one of the three principal furniture production centres in the late Edo and early Meiji periods, when family altar-makers converted to making chests for merchants. The severe climate and the concentration of land ownership prevented the establishment of a furniture trade until this time. Mikuni merchant chests, such as the one shown in figure 127, are very distinctive and represent an indigenous style. It has four outer drawers, three of which have locking devices. One of the two inner drawers also has a locking device.

The hardware is elegant without visually dominating the natural grain patterning of the zelkova wood used on the face of the drawers. It is painted with a honey-red lacquer coating. The subtle patina, resulting from years of polishing with rice bran, enhances the beauty of the wood.

The nineteenth-century chest shown in figure 11 was used by a merchant at sea to store his ledger books. These ledger chests were called *chō-bako* (literally, 'ledger box'). The example shown here is representative of the *kakesuzuri* type; it has a heavily fortified door, with five heavy iron hinges, and five inner drawers. Two of these drawers have locking devices. Because these chests were used by men operating from ships, they were also referred to as *funa-dansu* (literally, 'ship chest'). Its iron face and handle on top are typical characteristics of merchant chests made for travel. The crest on the face of this chest reads '*han*' (prosperity).

Another example of a merchant's sea chest is shown in figure 125. This chest has two upper drawers each of which has a locking device. The two hinged doors, called '*kannon*' doors, open to expose five inner drawers, and one of these inner drawers also has a locking device[34]. The other four inner drawers are of the pull-open type. It was carried by rope that was looped through the iron rings fastened to the sides of the chest.

This chest has three different styles of drawer pulls. Because chests were generally made with matching pulls, it seems likely that not all of these pulls are original to the chest. The oldest type of pull, the Edo-period *kakute* type, is used on the top drawers. These

13. *Sign for Inn (*kanban*)*
Cryptomeria wood (*sugi*), ink, metal hardware
Inscription: '*goyō yado*' (honorable business) and Tatebayashi (name of innkeeper)
116 × 46 × 11 cm
Edo period, 17th century

appear to be original, suggesting that this chest was made in the late Edo period. The frame is made of zelkova wood (*keyaki*), with a zelkova burl used for the front. Because zelkova wood, especially burl wood, was expensive, this chest was likely owned by a well-to-do merchant.

Large cabinets used to store dishes and other food-related utensils were placed either in the kitchen or in the room with an open hearth in traditional Japanese homes. These chests were called *mizuya* (literally, 'water room') because of their association with the room in which water was stored (in large ceramic pots). *Mizuya* cabinets were generally made in two parts and stacked one on top of the other. Rather than having hinged doors that swing out, they were typically made with sliding and drop-fit doors. The *mizuya* shown in figure 124 has four small and four large sliding doors, and a small drop-fit door (called 'kendon-buta')[35]. Zelkova wood was used for the face of these doors. An exceptionally wide piece of zelkova lumber with rich burl grain patterns was used for the four large sliding doors (upper and lower sections), making this chest very expensive. The use of rare persimmon wood (*khaki*) for the two small drawers (upper section), and the four larger drawers (lower section) would have dramatically added to its value. The natural, irregular contrasting colours of the persimmon wood on the four drawers in a row (lower section) create the illusion of a landscape, when looked at as a whole. The cypress wood (*hinoki*) used for the chest's frame is treated with *tamenuri* red lacquer, creating a lovely contrast with the honey-coloured zelkova wood.

The two garment chests shown in figures 126 a-b represent a distinctive, regional style of furniture made in the town of Yahata, located on Sado Island. These chests, called *ishō kasane-dansu* (literally, 'stacked garment chest') were made in pairs, and were composed of a top and bottom of equal size. Each chest had two full-width drawers. *Ishō kasane-dansu* chests were made to order by wealthy rural families for their betrothed daughters (as trousseau chests). The craftsmen of Yahata began producing these chests in the Meiji period. They are distinguished by their abundance of hardware decorated with elaborate designs. Most Yahata chests have a maroon surface created with oil and lacquer applied over a persimmon-tannin stain.

The two chests shown here are technically not a pair, but they are of equal size and represent the conventional size and style of Yahata chests. The hardware with Shintō-inspired motifs are said to have been popular on Yahata chests in the Taishō period. The motifs on these two chests include the elderly Takasago couple, Ebisu and Daikoku, the *abare-*

noshi bundle and Mt. Fuji, suggesting that they were made in the Taishō period. The larger *warabite* drawer pulls on each also suggest this later date.

Many traditional Japanese chests were made with wheels, enabling them to be moved easily on such occasions as the seasonal airing out of goods, and in the event of fires. These wheeled chests were collectively called *kuruma-dansu*. The merchant's chest with wheels shown in figure 10 has zelkova wood drawer panels that were treated with a reddish *kijiro* lacquer finish. The two sliding doors (lower section) were made with lighter-coloured chestnut wood and coated with clear lacquer. Like the chest shown in figure 128, the black opaque iron metalwork on this chest suggests that it was also made in Tsuruoka. An auspicious pine motif decorates the locking device on its largest (upper) drawer. In addition to having wheels, the chest also has handles on each side.

Large general storage trunks on wooden wheels, with a hinged, removable lid (called *nagamochi kuruma-dansu*), were typically made of expensive zelkova wood, and kept in the family's annexed storehouse (*kura*), rather in the home itself (see figures 122 and 123). *Kura* were essentially large, fire-proof walk-in safes made with exceptionally thick earthen walls. They were used by the wealthy to store the family's valuables, and the *nagamochi* trunk was a standard fixture in them. The extremely humid climate of Japan required that homes and storehouses be aired out several times a year, to prevent mildew and wood rot. Because of this, wheels were a necessary component for these trunks.

The nineteenth-century *nagamochi* trunk shown in figure 123 was made with a very wide piece of expensive zelkova lumber (the top is 145.5 cm wide). This chest would have been very expensive when new, representing a major expense for its owner. Two very large hinges attach the top to the body of the chest. A simple, decorative, locking device closes the chest securely. The Meiji-period *nagamochi* storage chest on wheels shown in figure 122 was reportedly made in Yonezawa, one of three major furniture centres located in Yamagata Prefecture.

A *butsudan* is a family altar used in the home to worship one's ancestors. The eighteenth-century Ryūkyūan *butsudan* altar shown in figure 120 is a rare example of Ryūkyūan lacquer art at its best. It is decorated with gold and coloured litharge paint, with mother-of-pearl inlay decoration.

The illustration on the two front doors of this altar is that of a classic Chinese story, 'The Three Laughers at Tiger Creek' (Ch: Hu-ch'i San-hsiao; J: Kokei Sanshō). In the story, the priest, Hui Yuan, who taught at Tung Lin Temple on Mount Lu during the fourth century, vowed to never leave the mountain.

14. *Ōtsu-e Painting, Tethered hawk* (*kumataka*)
Anonymous
Hanging scroll; ink and colour on paper, silk mounting
42.8 × 28.5 cm (painting only)
Edo period, late 18th century

Poem (right to left, top to bottom):

takaki nimo mata hikuki nimo ōi no wa yoku ni kumataka kore washizukami.

The tethered hawk, whether perched high or low, greedily grabs like the eagle at everything.

yoku wa teki taru wa mikata to omoitsutsu fudan mamoraba jumyō nagaku.

If led with the perspective that greed is the enemy and satisfaction is the ally, one's life will be long.

(translated by Shunkin Takahashi, 2001)

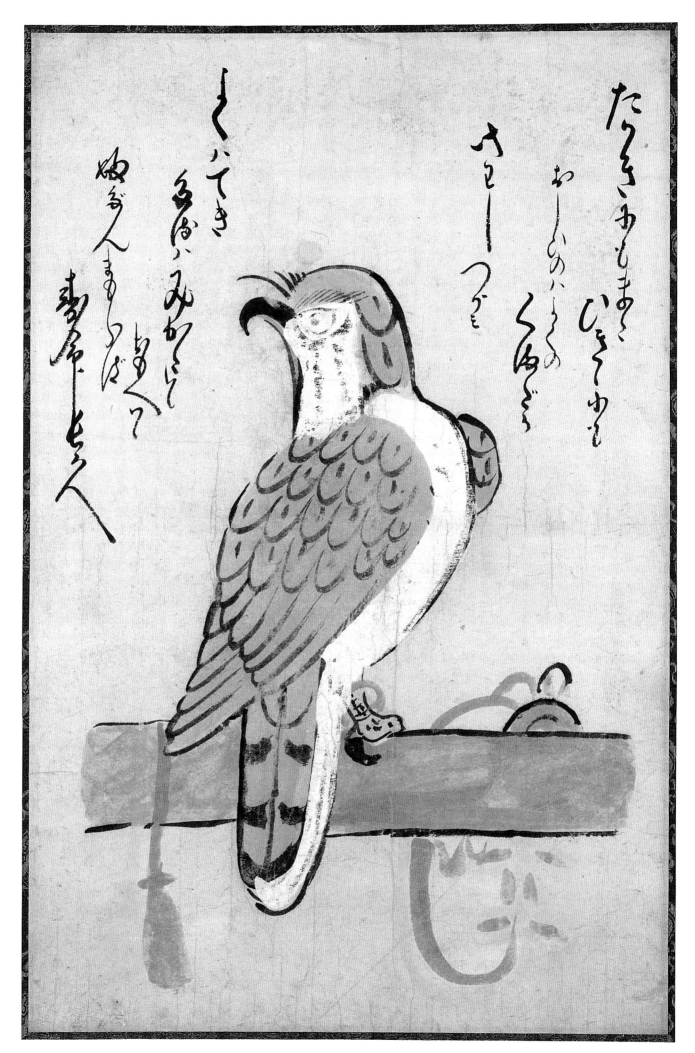

15. *Ōtsu-e Painting, Oni no Nembutsu (Devil's Invocation)*
Anonymous
Hanging scroll; ink and colour on paper, silk mounting
Inscription: *Ōtsu-e shi* (Ōtsu-e artist); *oni nembutsu* (devil's invocation)
Seal: *oni nembutsu (devil's invocation)*
51 × 28 cm (painting only)
Meiji period, late 19th century

He customarily escorted his departing guests only as far as the bridge over Tiger Creek, but never crossing the bridge himself. One day, he was visited by two poet friends, Tao Yuan-ming and Liu Hsiu-ching, who often came to see him. As they were leaving, Hui Yuan was so absorbed in conversation that he walked across the bridge with his visitors. When they realized what had happened, they had a good laugh. The moral of the story, a common theme among Chinese folktales, is that one should never take oneself too seriously.

Hui Yuan is shown standing on a bridge on the altar's left door panel. The waving poets are shown on the right panel. The scene is painted in polychrome lacquer, with gold accents, on a red lacquer ground. The figures' garments are exquisitely outlined in gold, creating the illusion of volume. The inside is decorated with Chinese mythological, long-tailed birds and pomegranates rendered in gold lacquer on a red lacquer ground. The smaller sliding doors are decorated with floral designs painted with polychrome lacquer on a red ground. The edges of the altar are decorated with a delicate star diaper motif. This altar was likely once owned by a member of the ruling elite.

[1] The Western calendar was adopted in Japan in the Meiji period, and the new year began to be celebrated as it is in the West, from January first.

[2] Amaury Saint-Gilles, *Mingei, Japan's Enduring Folk Arts*. Charles E. Tuttle Company, Rutland, Vermont and Tokyo, Japan, 1989, p. 19.

[3] This sculpture is signed, but the signature is illegible.

[4] Dowling, J., *Favorite Sons, Folk Images of Daikoku and Ebisu from the Jeffrey Montgomery Collection*. The Morikami Museum and Japanese Gardens, Delray Beach, Florida, 1998, p. 14.

[5] *Ibid.*, p. 15.

[6] *Ibid.*, p. 18.

[7] *Ibid.*, p. 18.

[8] Tanaka, Y. and Hoshiyama, S., *Me de Miru Butsuzō*. Tokyo Bijitsu Co. Ltd., Tokyo, 1987, pp. 115-119.

[9] *Ibid.*, p. 19.

[10] Little, S., *Visions of the Dharma*. Honolulu Academy of Arts, Honolulu, Hawaii, 1991, pp. 41-42.

[11] Inscription translated by Motoki Sakamoto, 2001.

[12] Sanjūsan Kannon (thirty-three Kannon) is based on the Hokekyō Sutra (S: *Saddharma pundarika sutra*). Shuppansha, D., *Japanese-English Buddhist Dictionary*, Daitō Shuppansha, Tokyo, 1991, p. 282.

[13] Japan Craft Forum, *Japan Crafts Sourcebook*, Kodansha International, New York, Tokyo, London, 1996, p. 84.

[14] Tokyo Bijutsu Company, *A Dictionary of Japanese Art Terms*, Tokyo Bijitsu Co. Ltd., Tokyo, 1990, pp. 669.

[15] Japan Craft Forum, *Japan Crafts Sourcebook. op. cit.*, 1996, p. 100.

[16] Tokyo Bijutsu Company, *A Dictionary of Japanese Art Terms. op. cit.*, 1990, pp. 642.

[17] The seventh-century Tamamushi shrine in Hōruyji, Nara is decorated with *mitsuda-e*. Kodansha, Ltd., *Japan An Illustrated Encyclopaedia*. Kodansha International, New York, Tokyo, London, 1993, p. 982, 'mitsuda-e'.

[18] Much of what is reported here is based on the revised history of Ryūkyūan lacquer presented by Tokugawa, Y. and Arakawa, H. *Ryūkyūan Shikkōgei*. Nihon Keizai Shinbunsha, Tokyo, 1977.

[19] These flasks were also sometimes called *sashi-daru*, after the popular style of flasks from the Shōnai region (former Dewa Province).

[20] Translation by Takahashi Shunkin, 2001.

[21] Three such artists included the Maruyama Shijō painter, Watanabe Nangaku (1767-1813), Yokio Kinkaku (1761-1832), and Shibata Zeshin (1807-1891).

[22] Translation by Takahashi Shunkin, 2001. There is a play on words with *takaki* (perched high) and *taka* (hawk).

[23] 'Sanman rokusen nichî literally translates as 'thirty-six thousand days'.

[24] Takebe, T., *Ri haku shōden*. Shinshōsha, Tokyo, 1955, pp. 160-171. Many of Li Po's poems were associated with drinking alcohol.

[25] The meaning of the last character, 'gu' (written after 'Hyakunen'), which means 'Shintō shrine', is a mystery.

[26] 'Nihonga' which translates as 'Japanese-style painting' is a term that first came into use in the 1880's to differentiate between indigenous, water-based pigment paintings (*nihonga*) and Western-style oil-based paintings (*yoga*). These two terms came to mean 'traditional' and 'modern', and 'Eastern' and 'Western', respectively. Technically, Hyakunen's career spanned both the pre-*nihonga* and the early *nihonga* eras, since he worked from the 1840's to the 1890's.

[27] Translation by Motoki Sakamoto/Eriko Iijima, 2001.

[28] The author wishes to thank Mr. T. Maruyama of the Munakata Shikō Memorial Museum of Art, in Aomori City, for his assistance with this work. This museum's collection includes a work by Munakata with the full expression (dated 1965). Another work, in the Philadelphia Museum of Art, also includes the full expression (date unknown).

[29] *Mokkan* tablets (approx. 7 × 2.5 cm) were used as a record-keeping device, to issue directives, for general note-taking, as talismans, and as scroll title tags in the seventh and eighth centuries. A large cache of *mokkan* were excavated in Japan in 1961.

[30] Translated by Eriko Iijima, 2001. 'Sekizō' translates as 'stone statue' and implies Buddhist stone statue. Munakata's works often include Buddhist references, either in imagery, or in words.

[31] Documentation evinces that this work was created by Munakata for the Japanese scholar, Cornelius Ouwehand, between the years 1958 and 1962 during a visit to the artist's home.

[32] Water pumps were not used in Japan to fight fires until the late nineteenth century.

[33] Traditional Japanese homes did not have a second floor.

[34] The term, 'kannon doors', refers to a type of paired, hinged doors that open from left to right, and typically used on family altars.

[35] The term, 'kendon-buta', refers to a noodle vender's carrying box. *Kendon* is an abbreviation for *kenyaku udon* (thrifty noodles) and *buta* means lid.

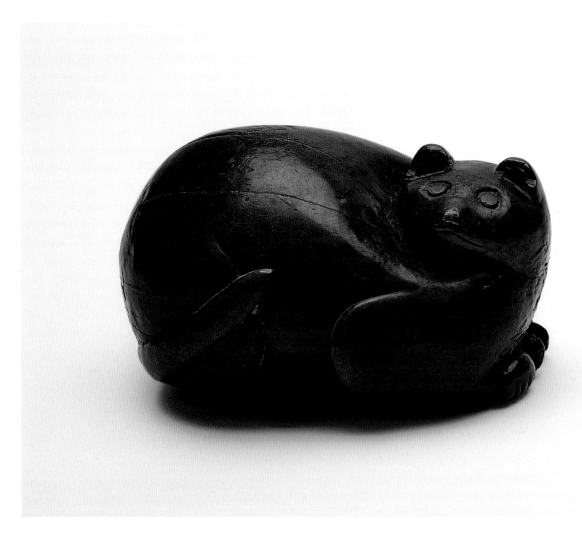

16. *Crouching cat (*neko*)*
Zelkova wood (*keyaki*), lacquer
13 × 21 × 13 cm
Edo period, 17th-18th century

17. *Rabbit (*unagi*)*
Wood, paint
18 × 30 cm
Edo period, 19th century

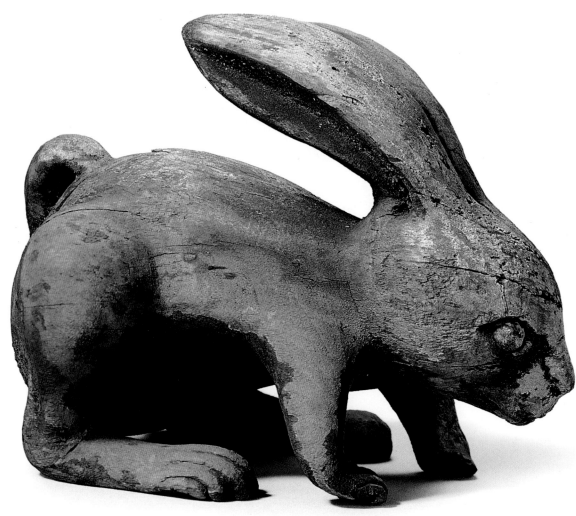

18. *Recumbent Ox (*ushi*)*
Japanese cypress wood (*hinoki*)
14 × 32 × 17 cm
Edo period, 17th-18th century

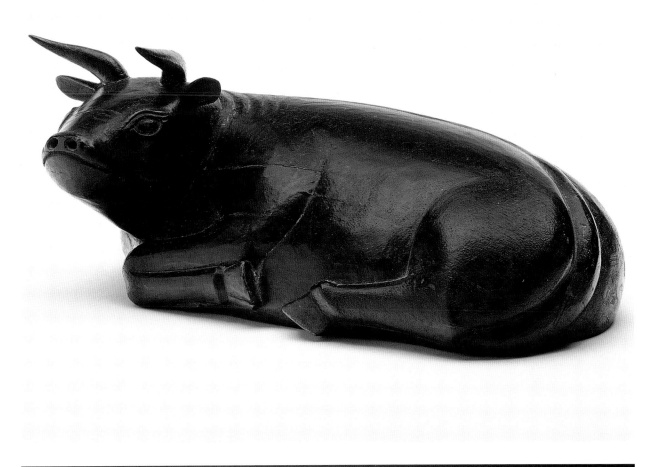

19. *Mold for Dog Box (*inu-bako*)*
Wood
Inscription (bottom): '*toshaku*' (mold),
'*men-mata*' (made by Mata,
the mask-maker?)
19 × 30 cm
Edo period, late 18th-early 19th century

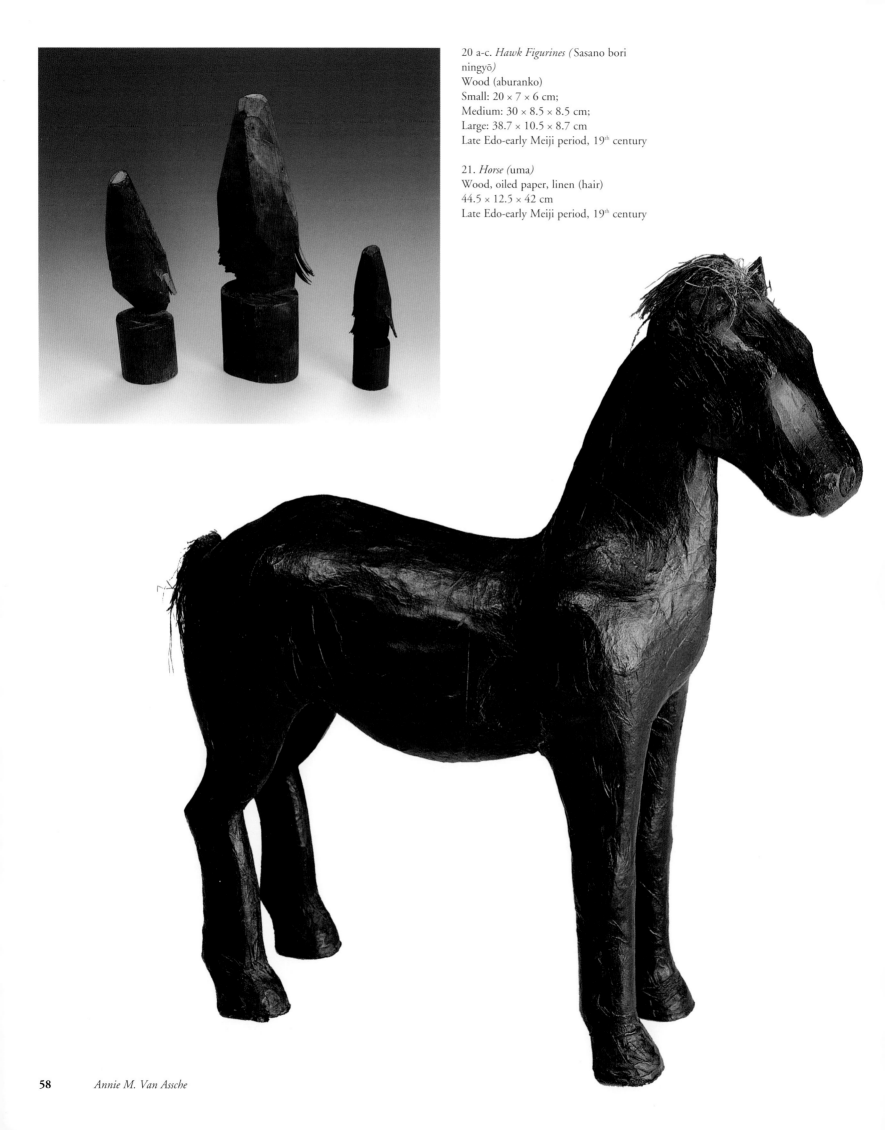

20 a-c. *Hawk Figurines (*Sasano bori ningyō*)*
Wood (aburanko)
Small: 20 × 7 × 6 cm;
Medium: 30 × 8.5 × 8.5 cm;
Large: 38.7 × 10.5 × 8.7 cm
Late Edo-early Meiji period, 19th century

21. *Horse (*uma*)*
Wood, oiled paper, linen (hair)
44.5 × 12.5 × 42 cm
Late Edo-early Meiji period, 19th century

22. *Mythical Lion-dog (*koma inu*)*
Wood, lacquer
17 × 8 × 16 cm
Edo period, 18th century

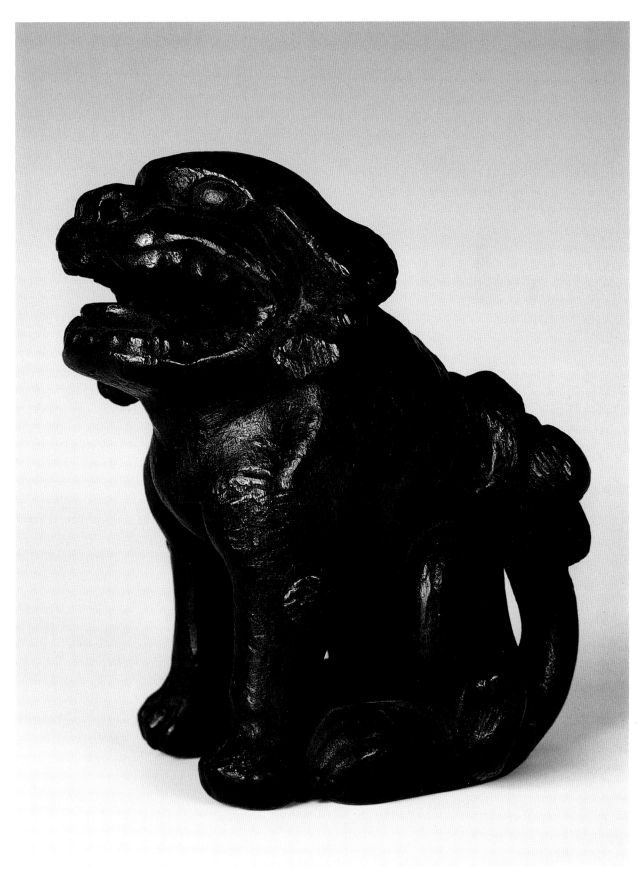

23. *Handwarmer, Monkey (*saru*)*
Seto ware; glazed stoneware
24 × 18 × 19 cm
Edo period, 19ᵗʰ century

24. *Handwarmer, Rabbit (*unagi*)*
Mino ware; glazed stoneware
18 × 22 × 25 cm
Edo period, 19ᵗʰ century

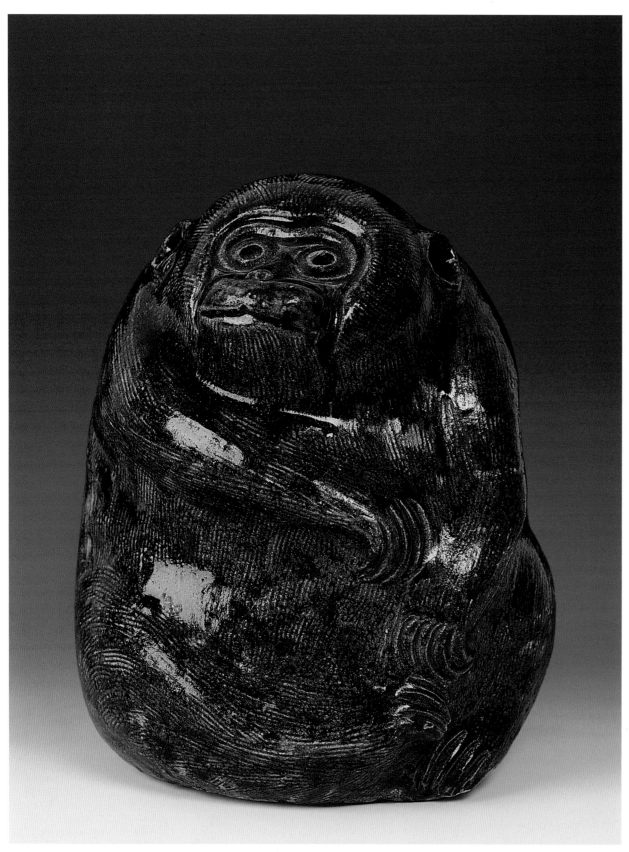

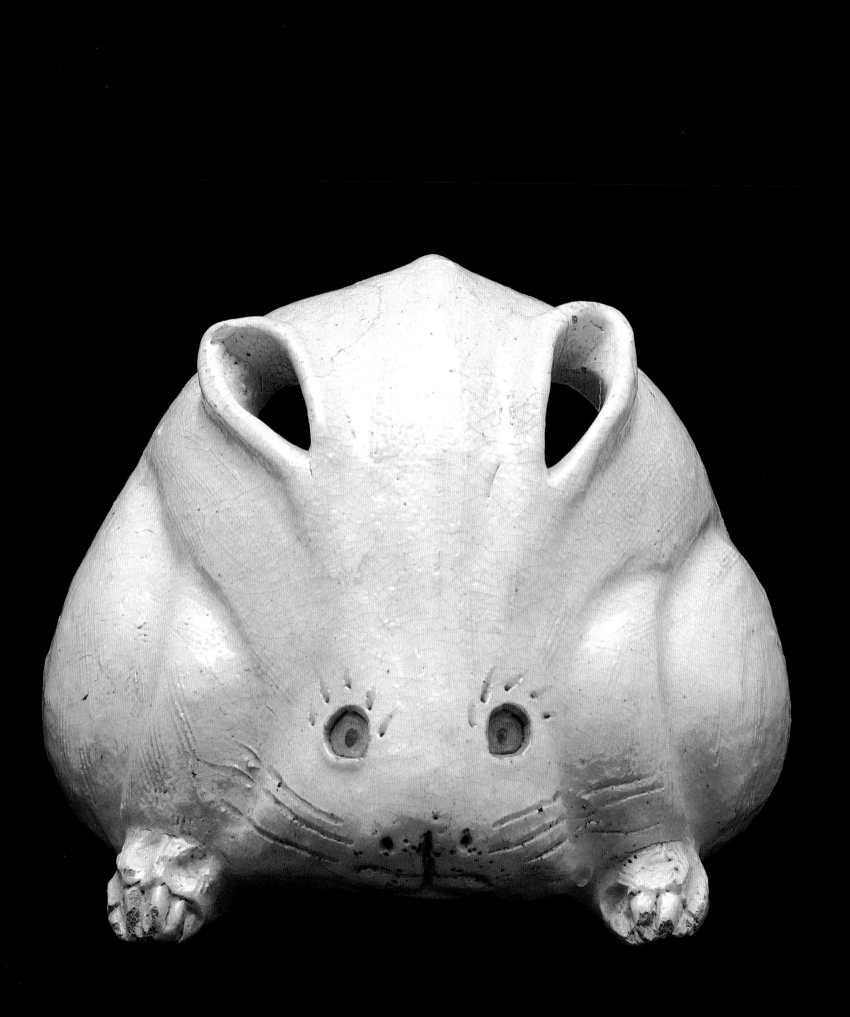

25. *Goat (*yagi)
Painted clay
22 × 30 × 15 cm
Meiji or Taishō period, early 20th century

26. *Beckoning Cat (*maneki neko)
Painted clay
60 × 1.3 cm
Meiji period, late 19th century

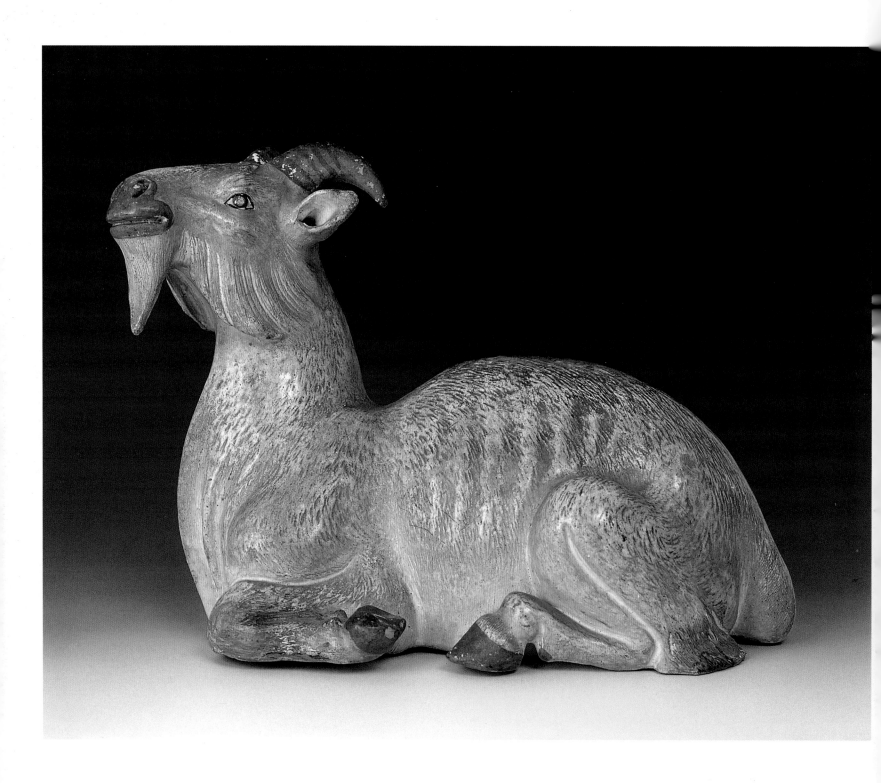

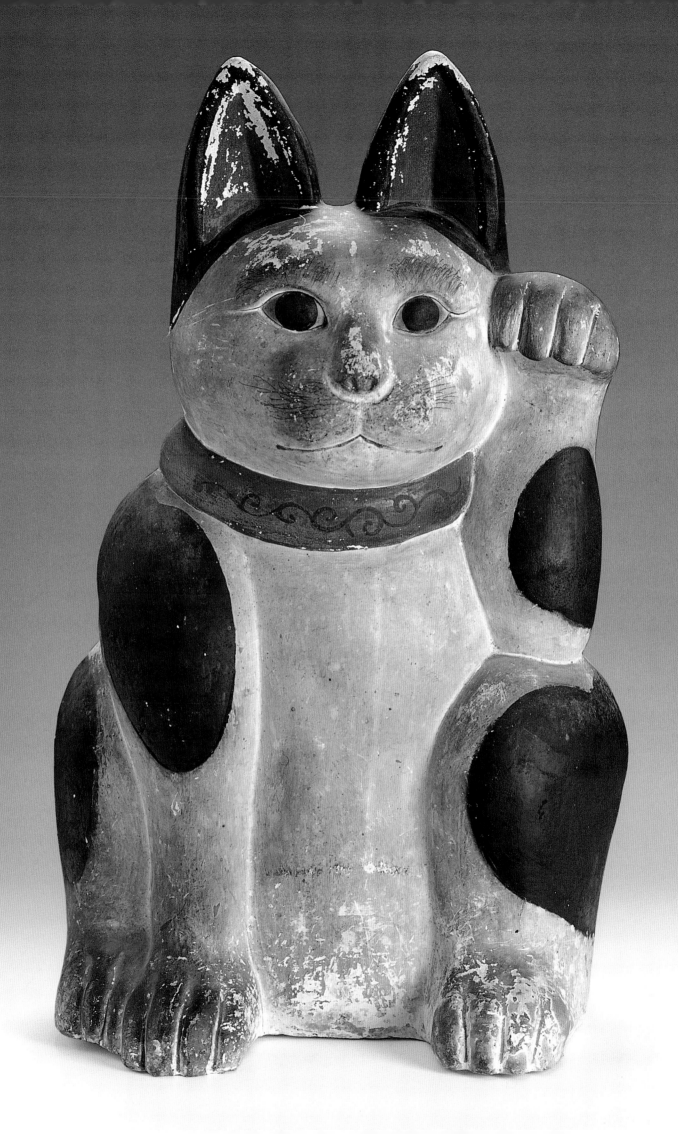

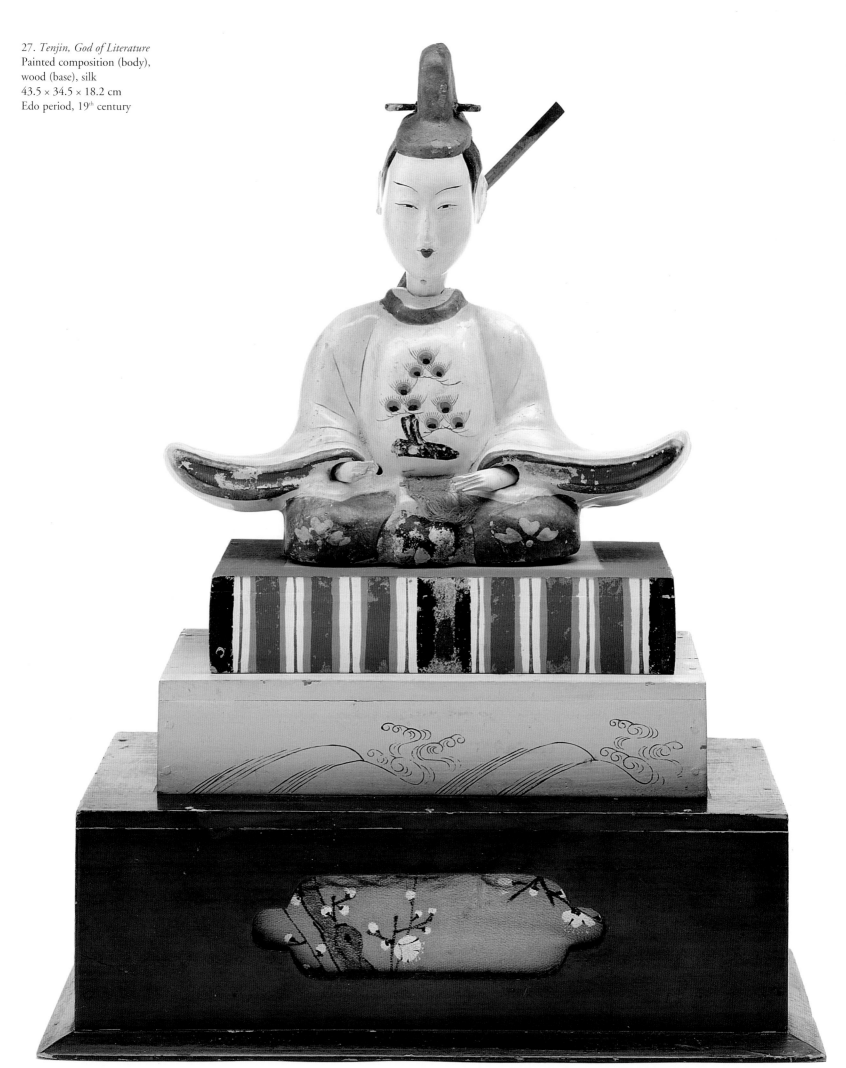

27. *Tenjin, God of Literature*
Painted composition (body),
wood (base), silk
43.5 × 34.5 × 18.2 cm
Edo period, 19th century

28. *Puppy (*ko-inu*)*
Painted clay
16 × 38.2 cm
Meiji period, 19th century

29. *Palace Doll (*gosho ningyō*),*
Sambasō Dancer
Painted clay, silk, paper
26 × 25 × 22.5 cm
Edo period, 19th century

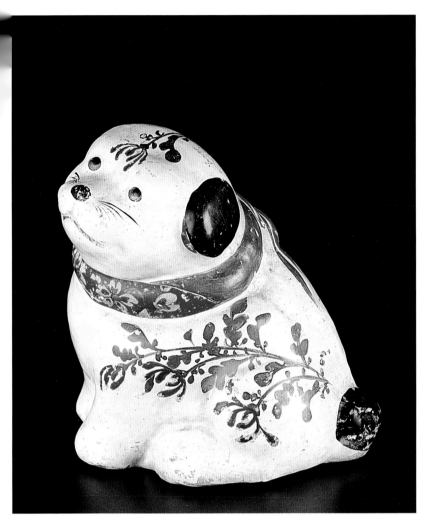

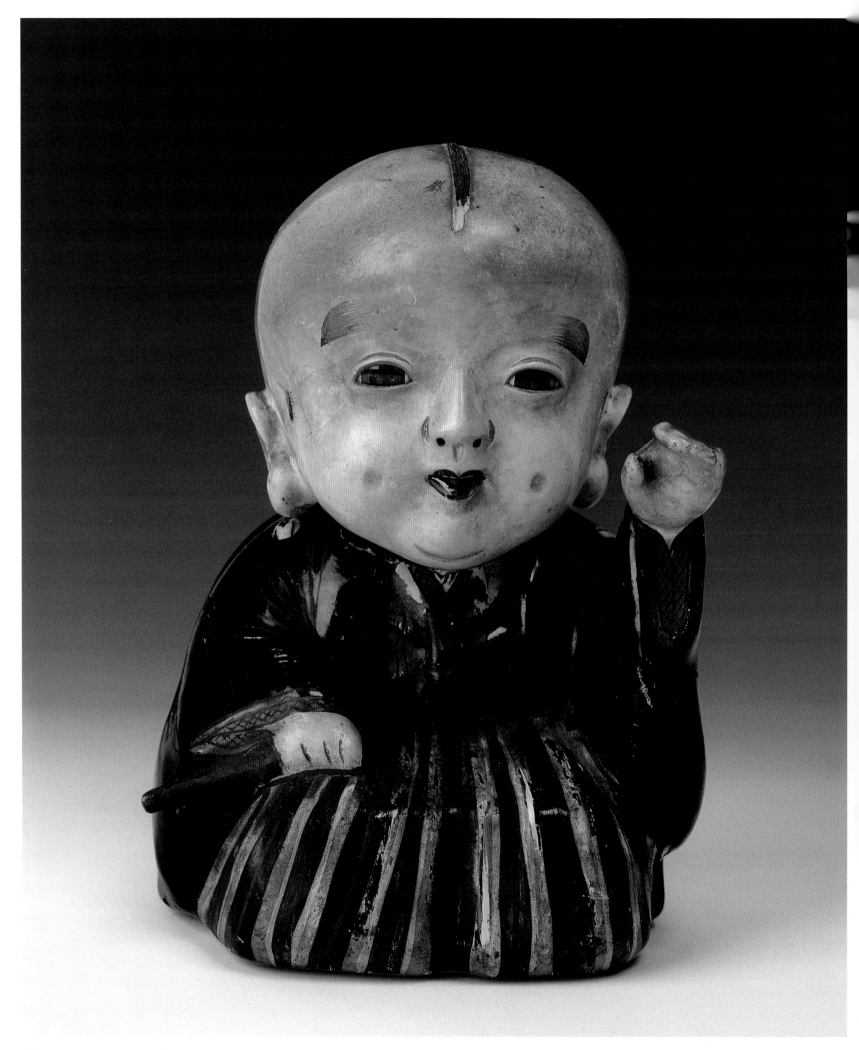

30. *Fukusuke*
Composition (sawdust and glue), paint, papier maché (*hariko*)
18.5 × 13 × 12 cm
Meiji period, 19ᵗʰ century

31 a-b. *Two Bunraku Theater Puppet Heads, Warrior (*bunshichi*), and Young Woman (*musume*)*
Wood, hair, paint, ground shell (gofun)
Man: 15 × 10 cm; Woman: 14 × 13 cm
Edo period, 19ᵗʰ century

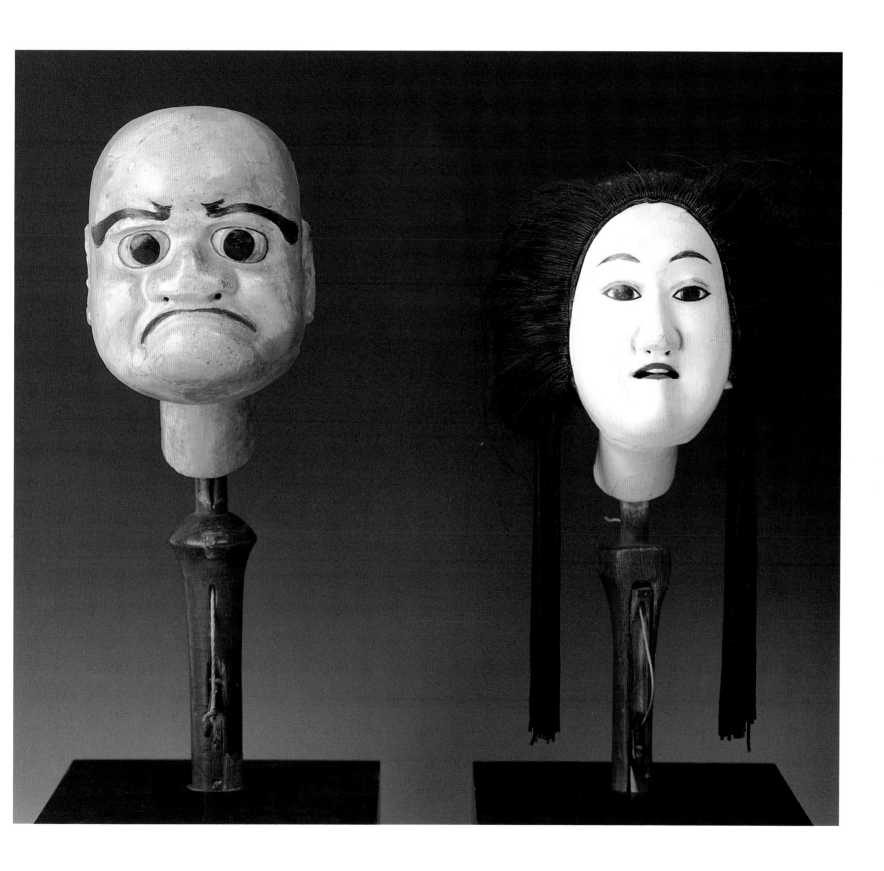

32. *Empress Doll* (hina ningyō)
Painted wood
20.5 × 24 × 16 cm
Edo period, 19th century

33. *Oto Gozen Doll*
Fushina; painted clay
39 × 17 cm
Edo period, 19th century

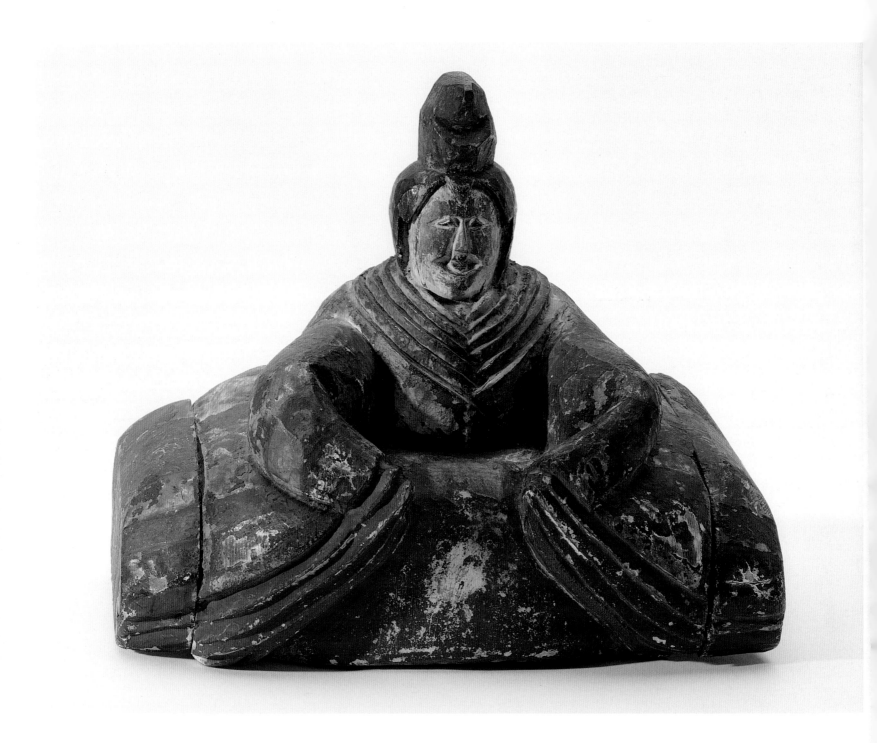

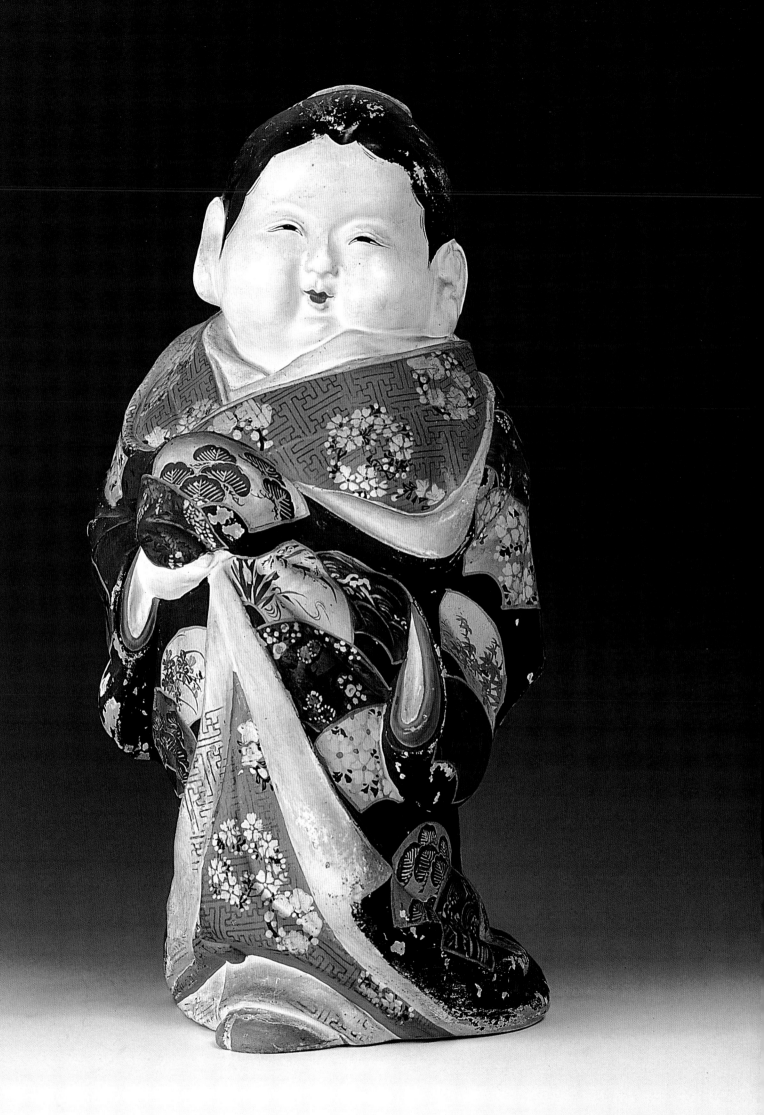

34. *Datsueba*
Painted wood
31.5 × 22.5 × 13 cm
Edo period, early 17th century

35. *Reportedly from Kannon Temple, Ueda*
Jizō Bosatsu Statue
Japanese cypress (*hinoki*)
75·× 16.5 × 16.5 cm
Muromachi period, c.1480-1500

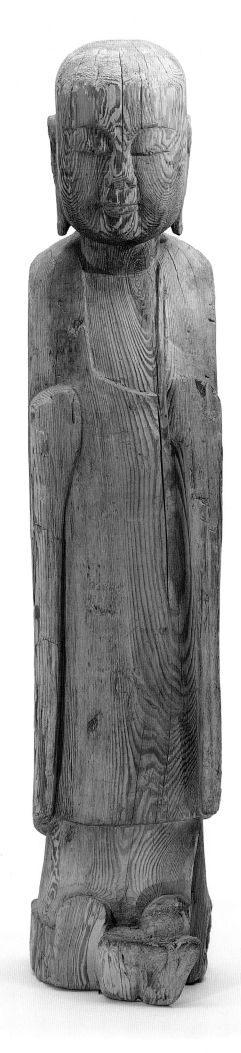

36. *Demon* (oni)
Painted wood
48.5 × 20.2 × 14.5 cm
Edo period, 17th century

37. *Guardian Figure* (Kishingyo-ten)
Wood, paint
47 × 22.5 × 12 cm
Edo period, 17th century

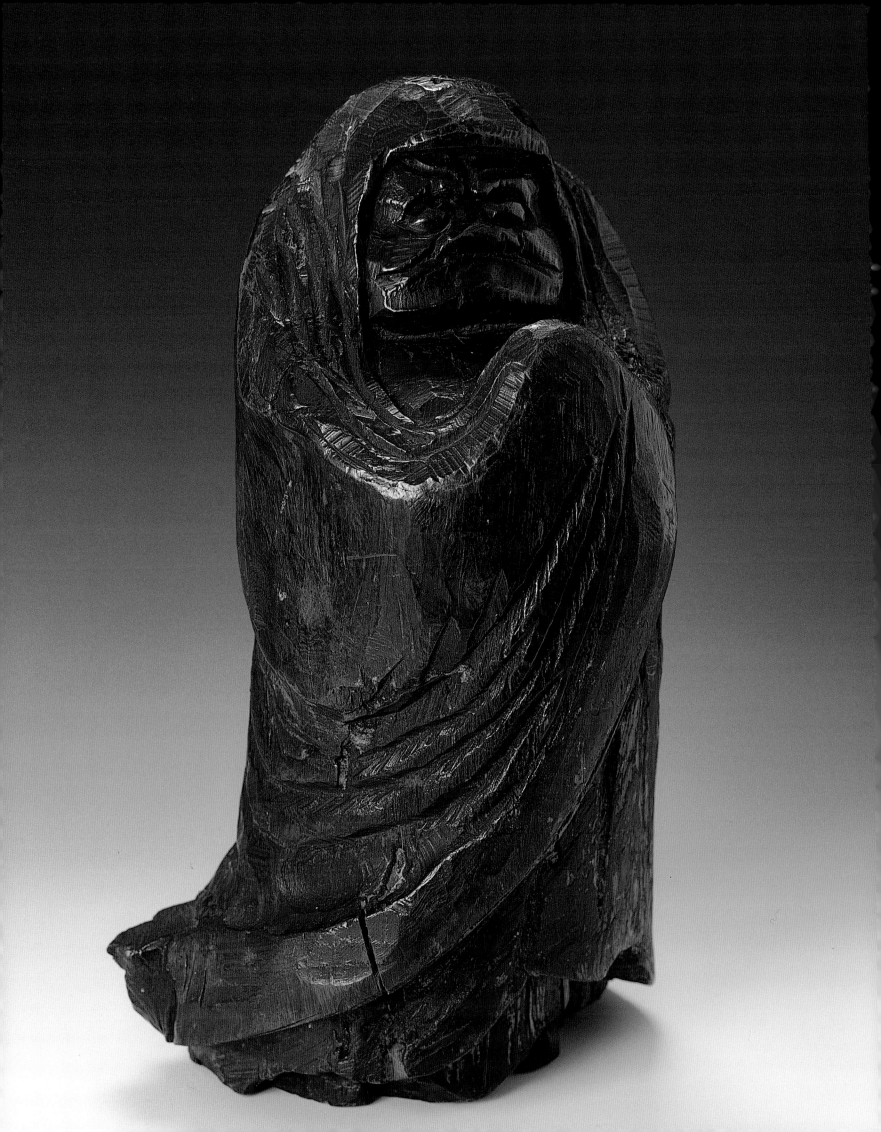

38. *Daruma*
Zelkova wood (*keyaki*)
43.4 × 61.5 cm
Late Edo period, 19th century

39. *Daruma*
Cryptomeria wood (*sugi*), lacquer,
rock crystal (eyes)
33 × 37 cm
Momoyama period, 16th century

40. *Fukurokuju, God of Longevity*
Wood
22 × 7 × 8.2 cm
Edo period, 19th century

41. *Hotei, God of Happiness*
Wood
8 × 7.5 × 4.5 cm
Edo period, 19th century

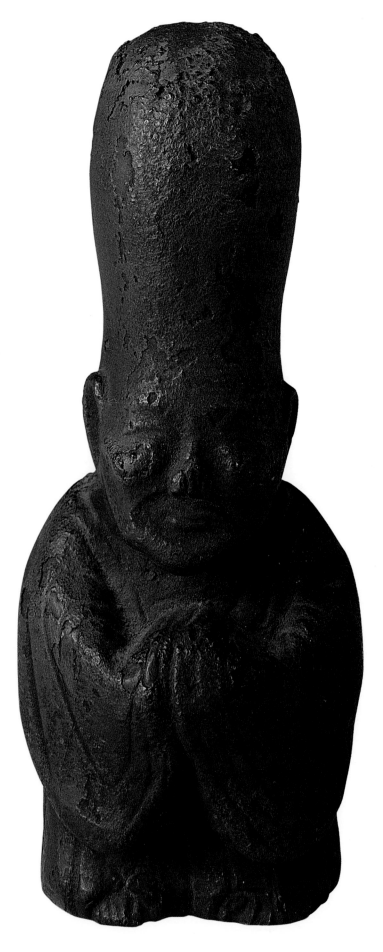

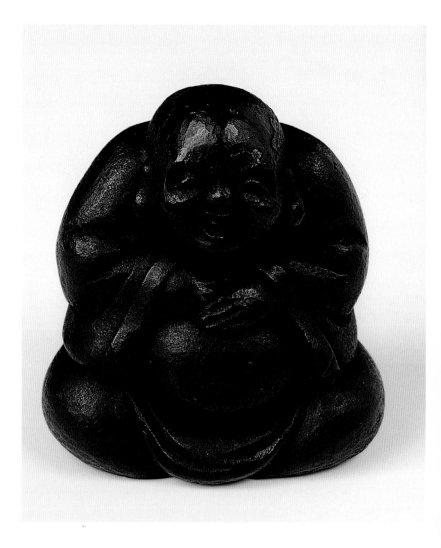

42. *Hotei, God of Happiness*
Bizen ware; stoneware with natural
ash glaze
15 × 19 × 15 cm
Edo period, 18th century

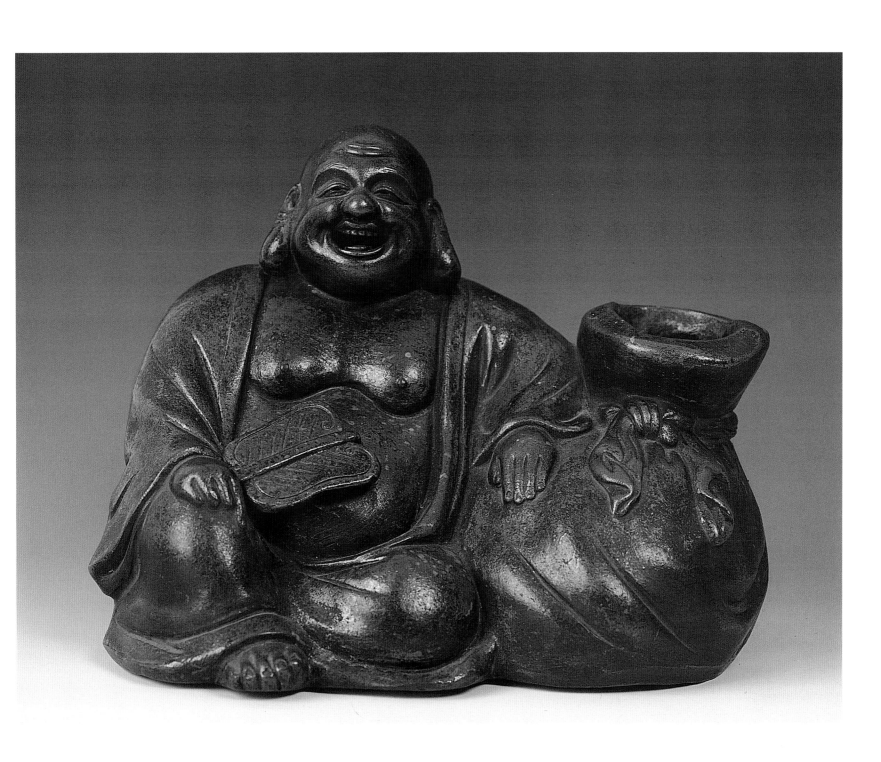

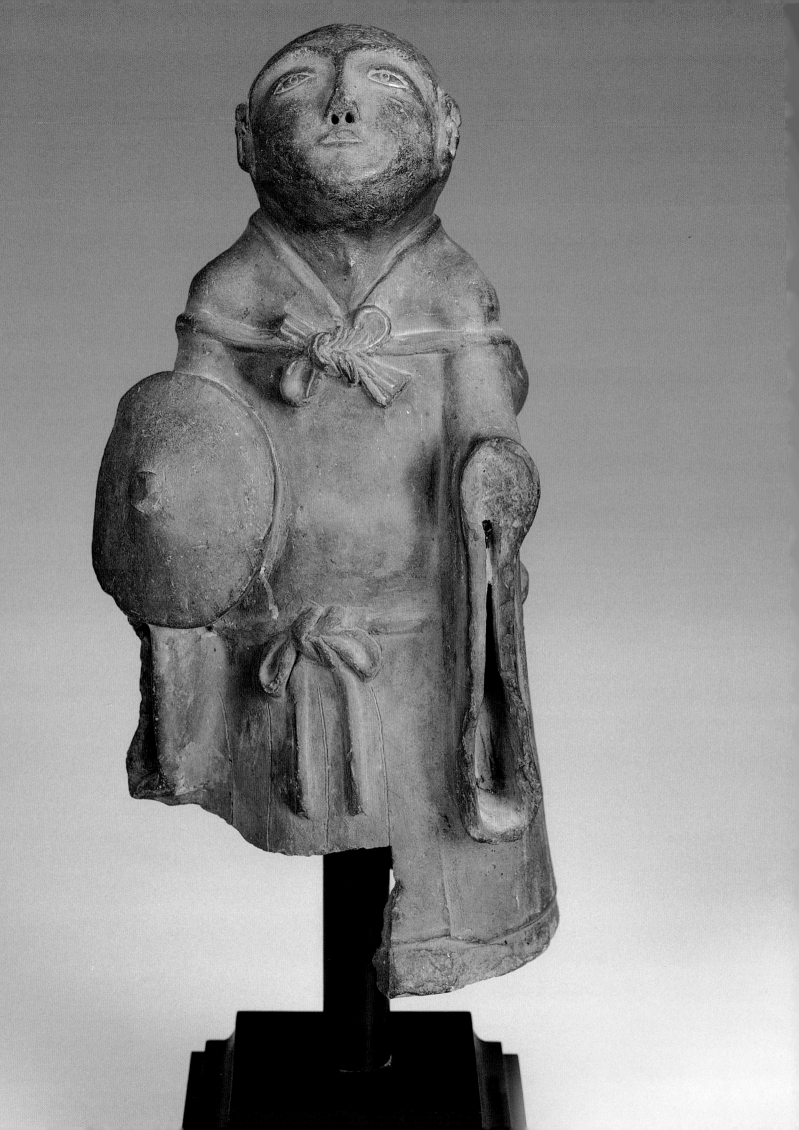

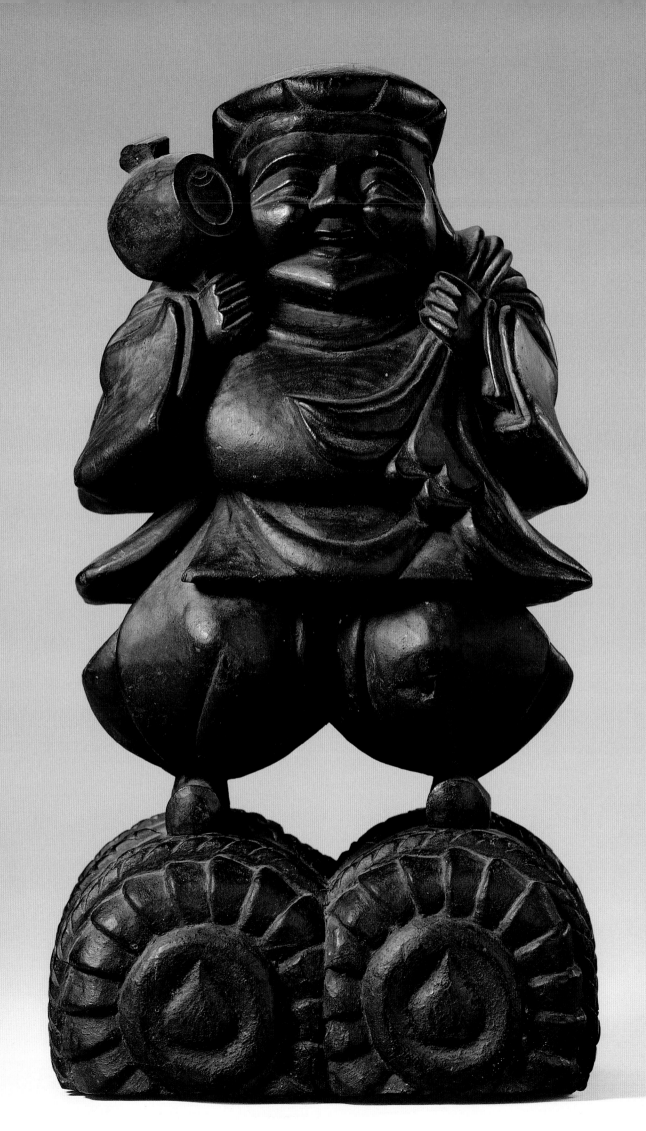

46-47. *Printing Blocks, Daikoku, God of
Wealth, with Ebisu, God of Merchants*
Wood, ink
Daikoku: 24 × 20 × 7.5 cm;
Ebisu: 24.7 × 20.5 × 6.5 cm
Edo period, early 19ᵗʰ century

 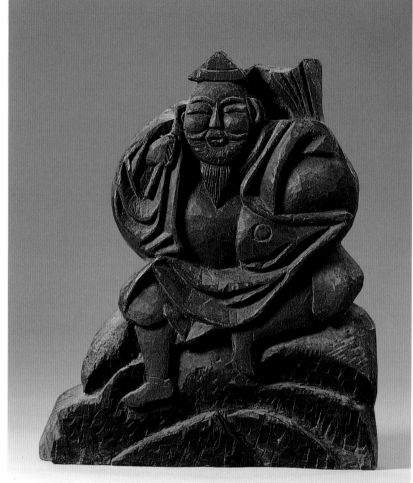

48. *Daikoku, God of Wealth,*
with Forked Radish
Bizen ware; stoneware
with natural ash glaze
20 × 32 × 18 cm
Meiji period, late 19th century

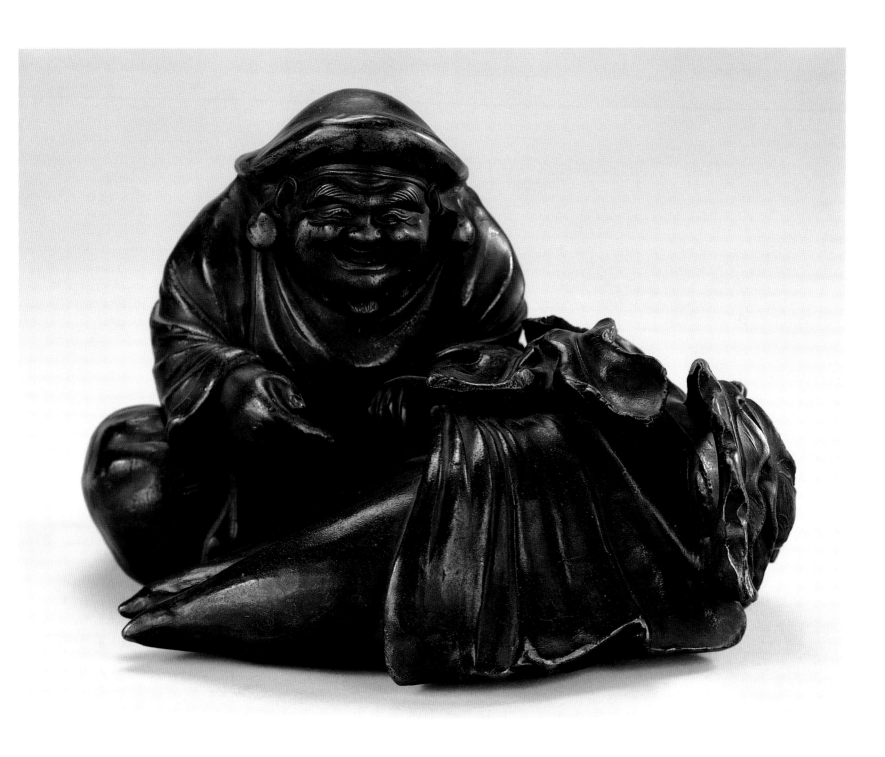

49. *Three-faced Daikoku (Sanmen Daikoku), God of Wealth*
Wood, soot patina
18 × 11.5 × 9.5 cm
Edo period, late 18th-early 19th century

50. *Three-faced Daikoku (Sanmen Daikoku), God of Wealth*
Wood, soot patina
15.5 × 10.5 × 8 cm
Edo period, 18th century

51. *Ebisu, God of Merchants*
Stone (meteorite?), paint, traces of gold
14.5 × 6.5 × 5.5 cm
Momoyama period, late 16ᵗʰ century

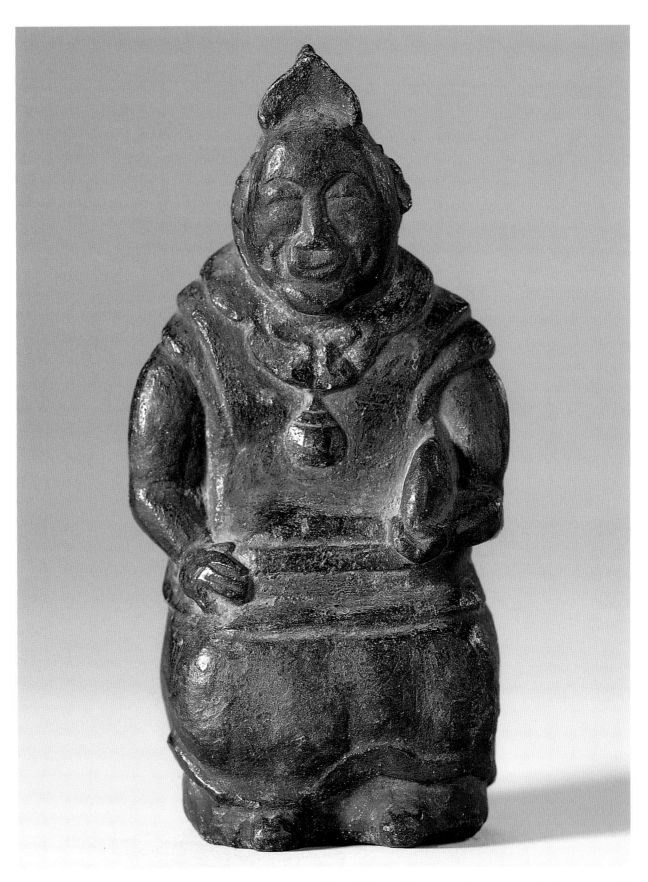

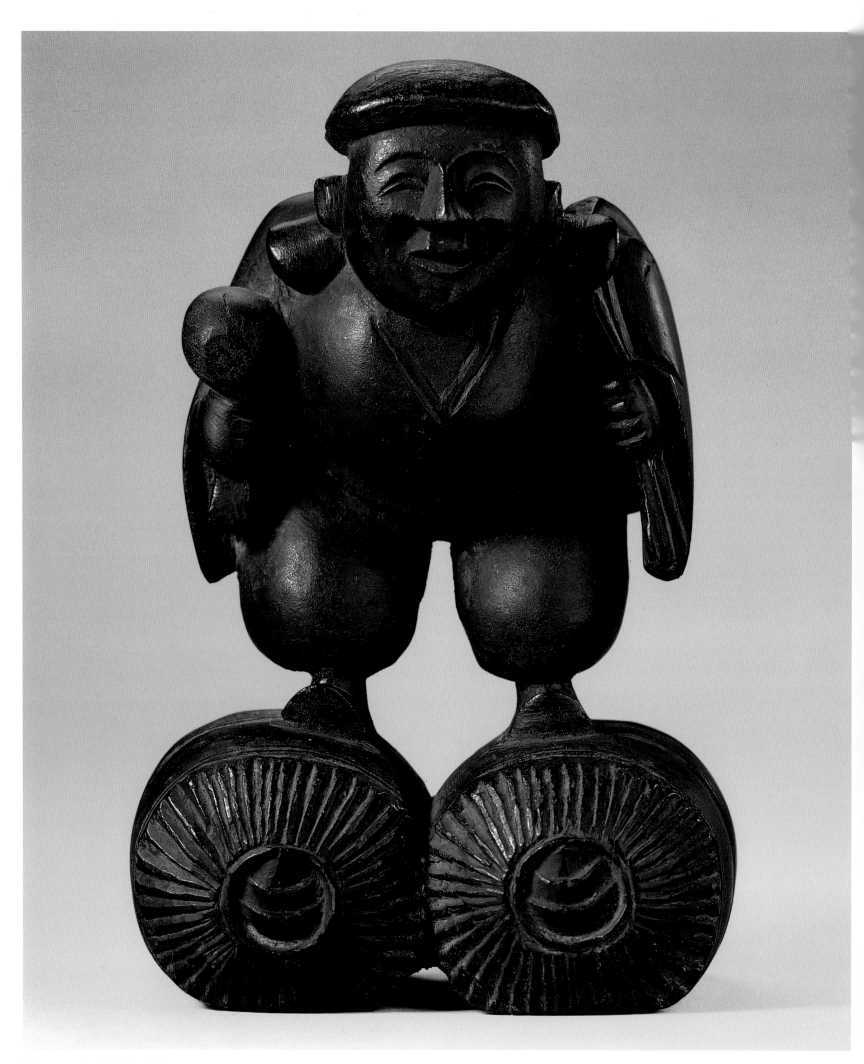

52-53. *Daikoku, God of Wealth,
with Ebisu, God of Merchants*
Wood, soot patina
Daikoku: 24.2 × 15 × 11.5 cm;
Ebisu: 24 × 15 × 11.5 cm
Edo period, 18th century

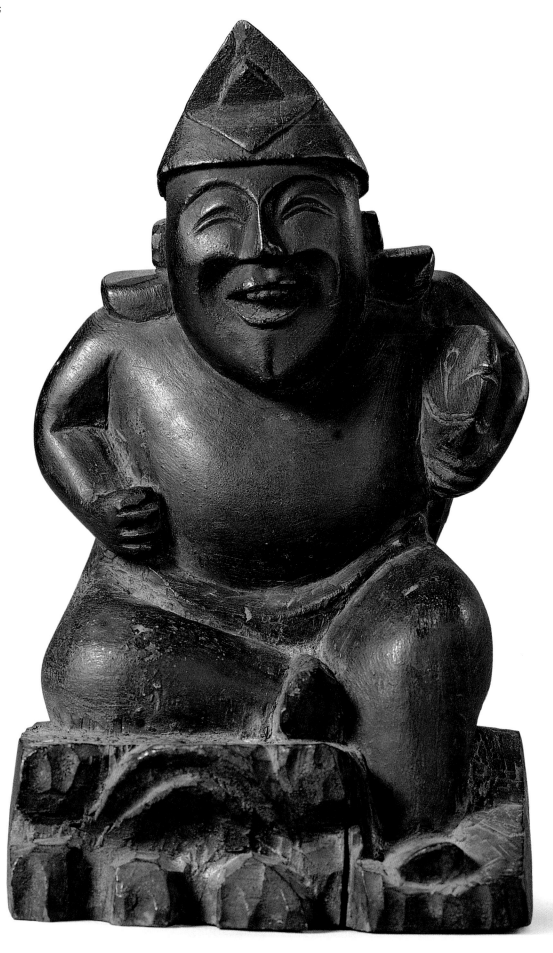

54. *Ebisu, God of Merchants*
Tokoname ware; stoneware
with natural ash glaze
19 × 18 × 12.5 cm
Edo period, 19th century

55. *Daikoku, God of Wealth*
Wood, soot patina, traces of gold
Inscription (on underside): '*shamon*'
(Skt: *sramana*; Buddhist monk; temple
name and name of monk illegible).
14.7 × 12.5 × 9 cm
Edo period, inscribed date: Genroku,
13th year (1700)

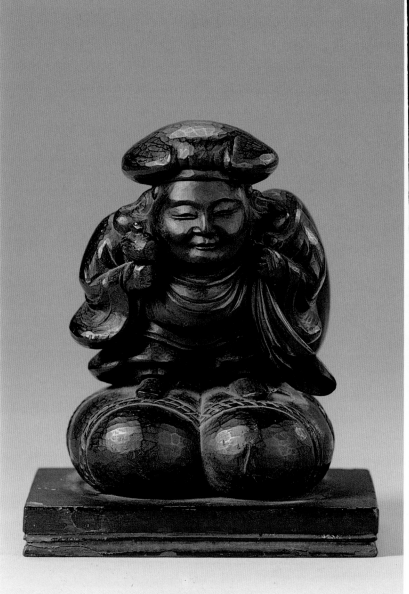

56-57. *Daikoku, God of Wealth,*
with Ebisu, God of Merchants
Wood, lacquer, soot patina
Daikoku: 23.5 × 13.5 × 7.8 cm;
Ebisu: 22.3 × 13 × 8.5 cm
Edo period, late 18th–early 19th century

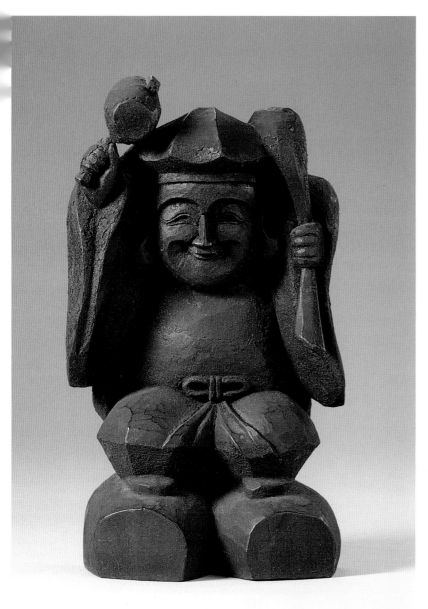
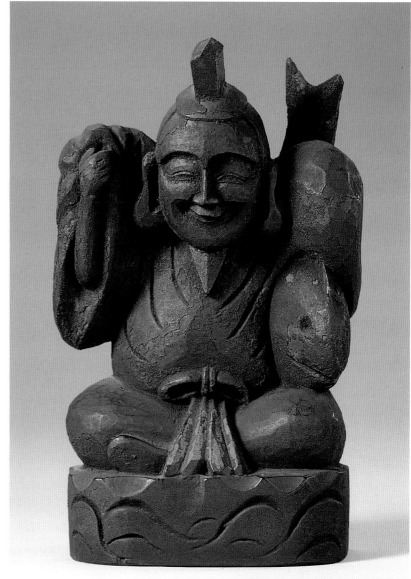

58. *Daikoku, God of Wealth*
Wood, soot patina
12 × 10 × 8.5 cm
Edo period, 19th century

59. *Daikoku, God of Wealth*
Wood, soot patina
21.6 × 18 × 21 cm
Edo period, 17th century

60. *Architectural Ornament, Ebisu, God of Merchants*
Fukuoka Prefecture; zelkova wood (*keyaki*), traces of paint
33 × 27 × 9.5 cm
Edo period, late 18th-early 19th century

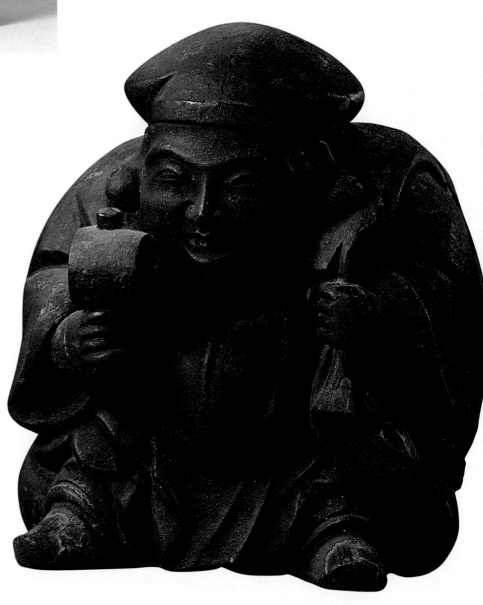

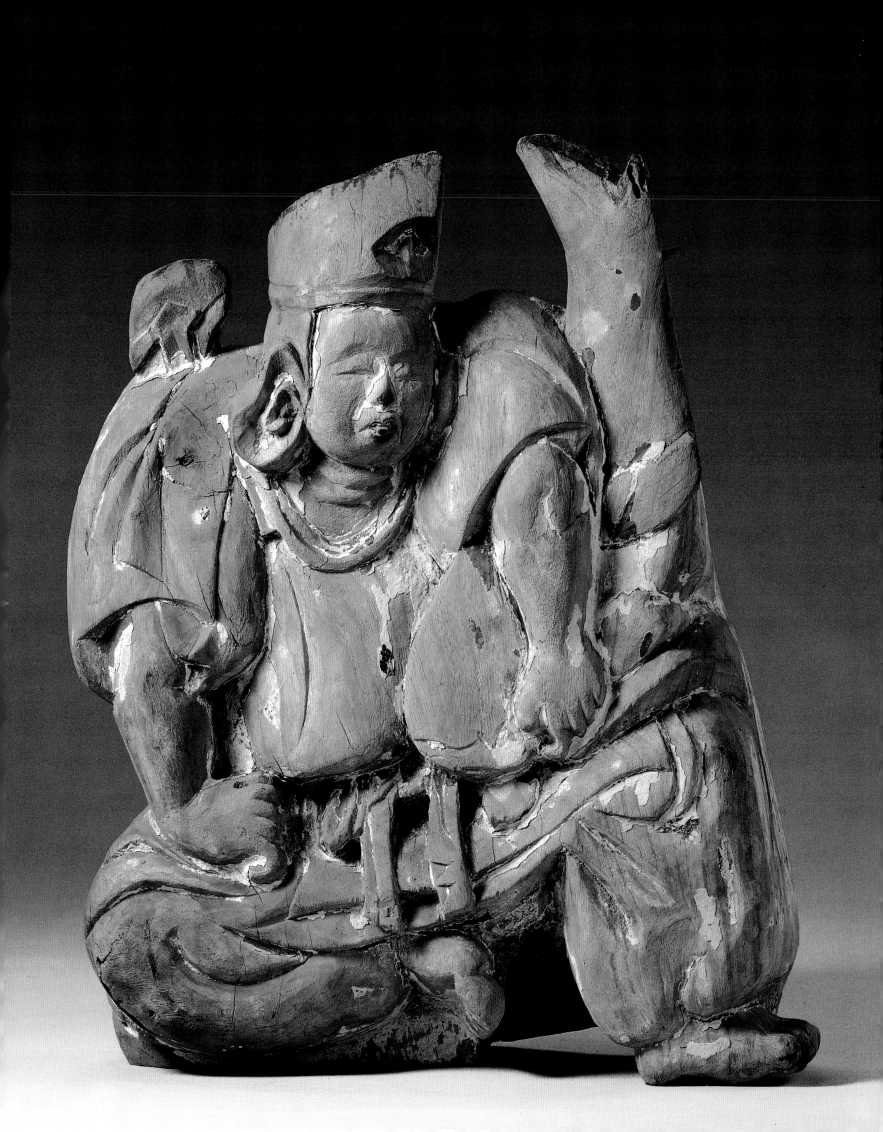

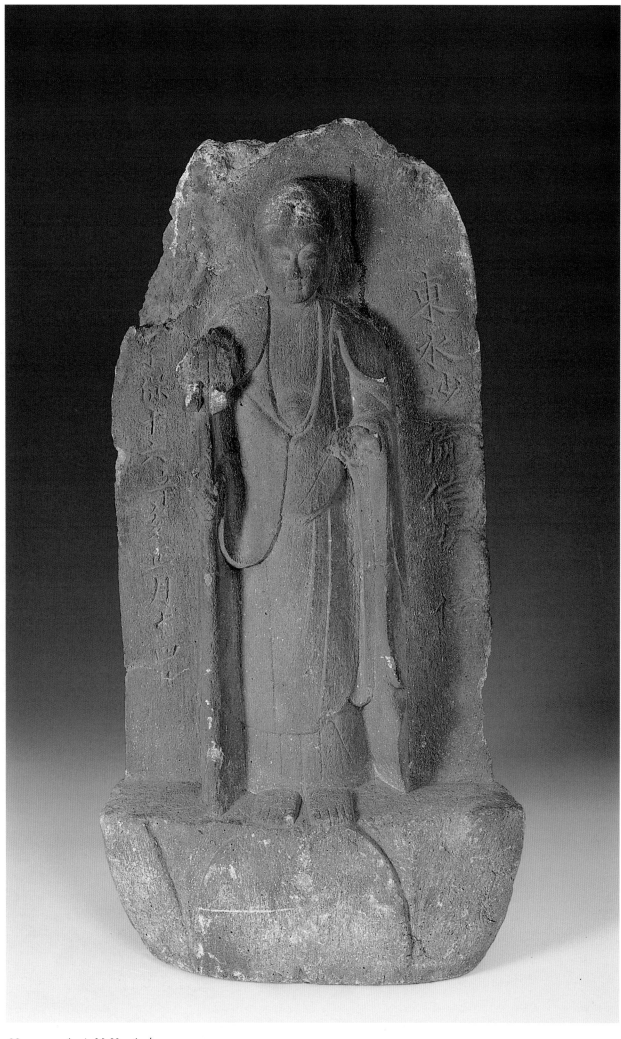

61. *Jizō Bosatsu Stele*
Granite (*mikage ishi*)
Inscription (right side): *Tōsui-myō
Ryu Shinnyo-i* (female lay follower
of *Tōsui-myō*; second to last character
illegible)
75 × 36 × 21 cm
Edo period, inscribed date (left side):
Kyōhō, 16th year (1731), 1st month,
14th day

62. *Nyoirin Kannon Bosatsu Stele*
Granite (*mikage ishi*)
Inscription: '*sa*' (top centre): Gesso
Myōshun (name of female donor;
left side)
87 × 42 × 23 cm
Edo period, inscribed date (right side):
Kambun, 11th year (1671), 7th month,
11th day

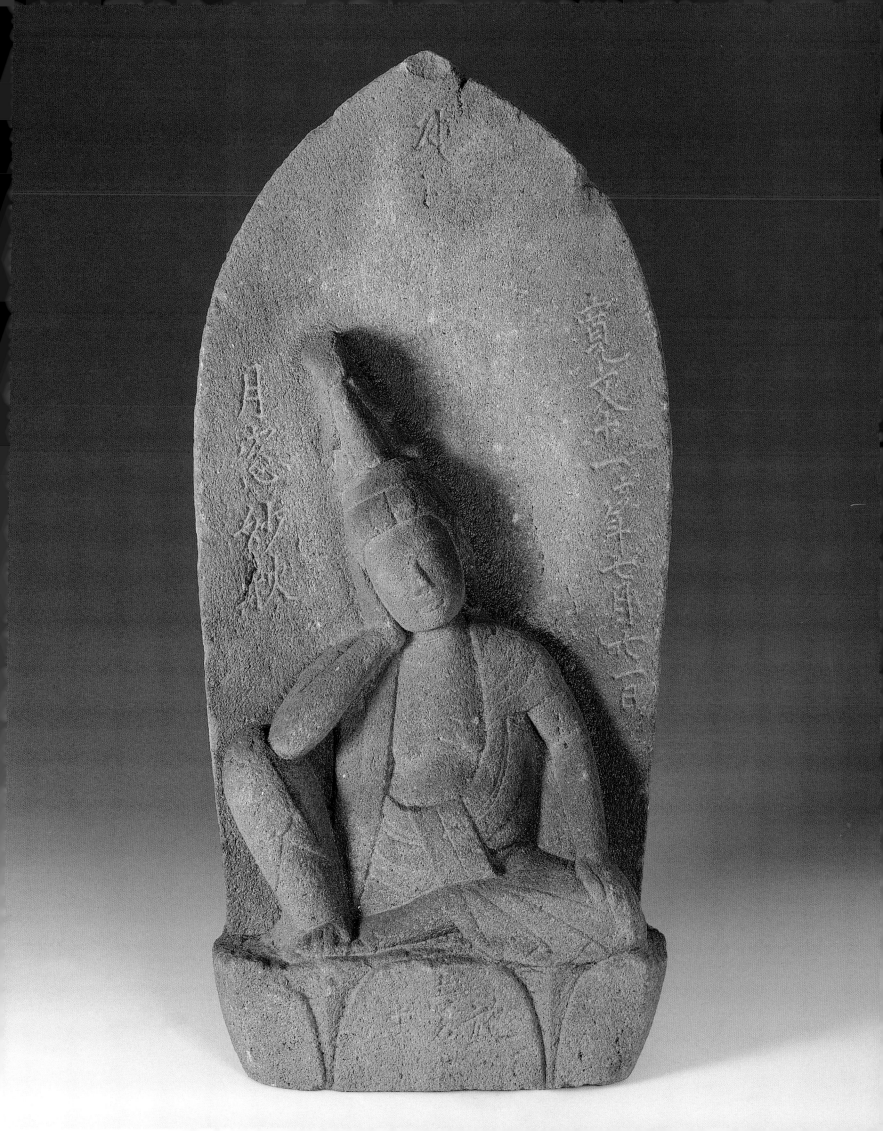

63. *Funerary Urn (*zushi-gama*)*
Granite (*mikage ishi*)
59.6 × 33.7 × 27.7
Edo period (1600-1868)

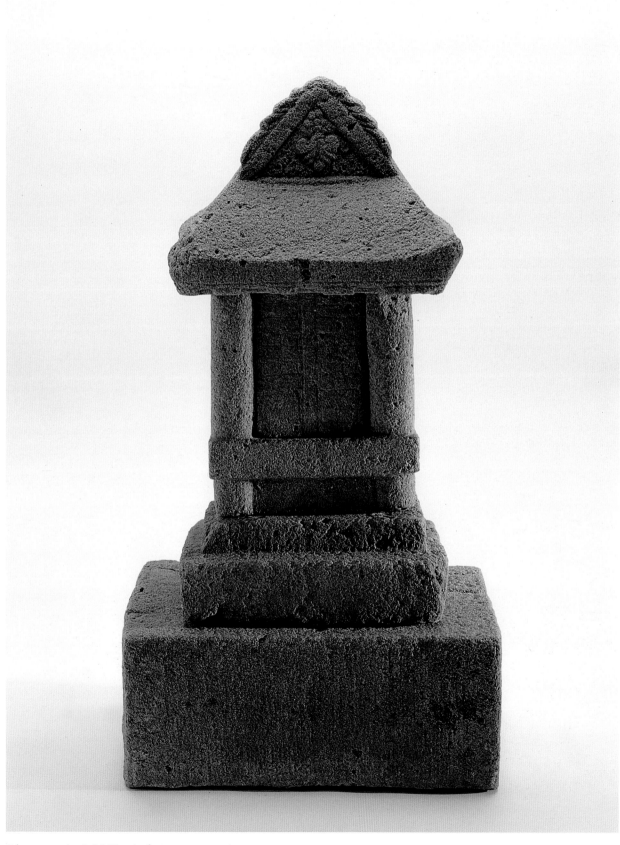

64. *Cemetery Marker, Stupa Type*
(gorintō)
Granite (*mikage ishi*)
Inscription (second stone from bottom):
illegible
77 × 25.8 × 25.8 cm
Edo period (1600-1868)

65. *Wooden Temple Drum (*mokugyo*)
Zelkova wood (*keyaki*)
40 × 32 × 30 cm
Edo period, 19th century

66. *Kettle Hook Hanger (*jizai-gake*),
Ebisu Type*
Zelkova wood (*keyaki*)
47 × 40 × 20.5 cm
Late Edo-early Meiji period, 19th century

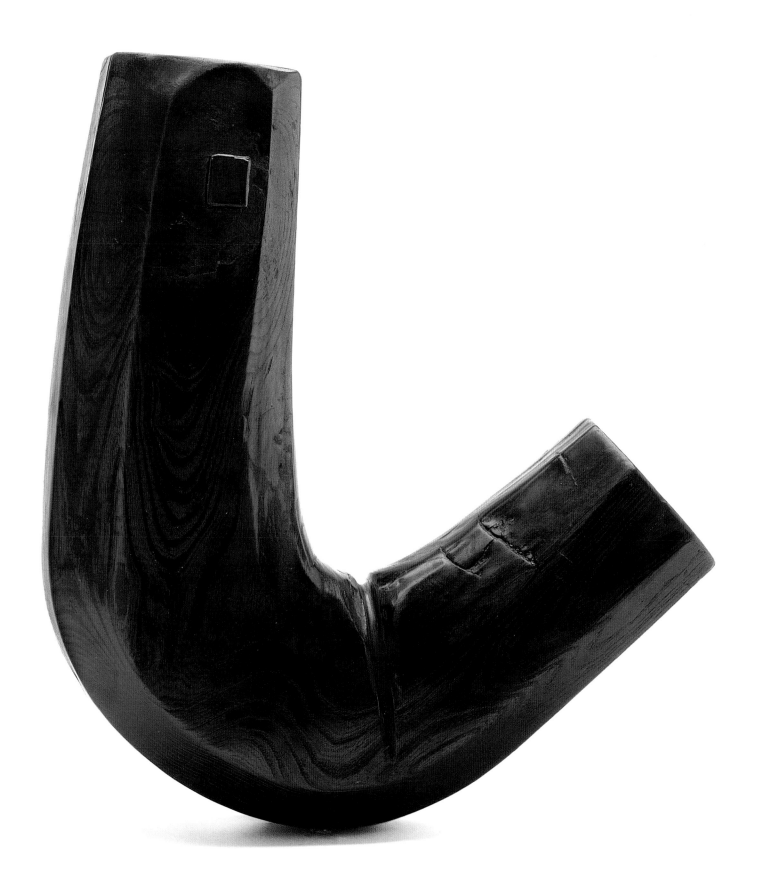

67. *Kettle Hook Hanger (*jizai-gake*),
Daikoku Type*
Zelkova wood (*keyaki*)
42 × 23 × 38.5 cm
Late Edo-early Meiji period, 19th century

68. *Kettle Hook Hanger (*jizai-gake*),
Daikoku Type*
Zelkova wood (*keyaki*)
70 × 47 × 36.5 cm
Late Edo-early Meiji period, 19th century

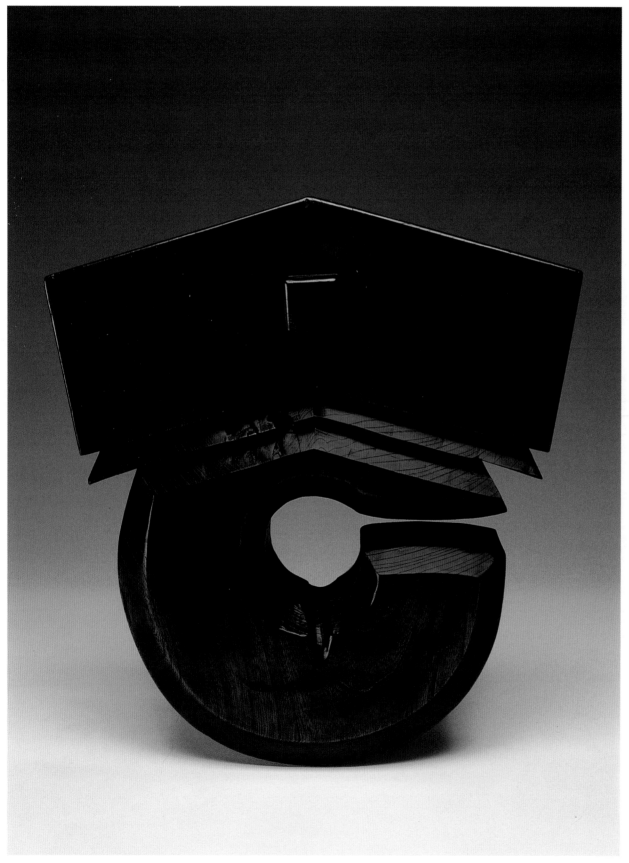

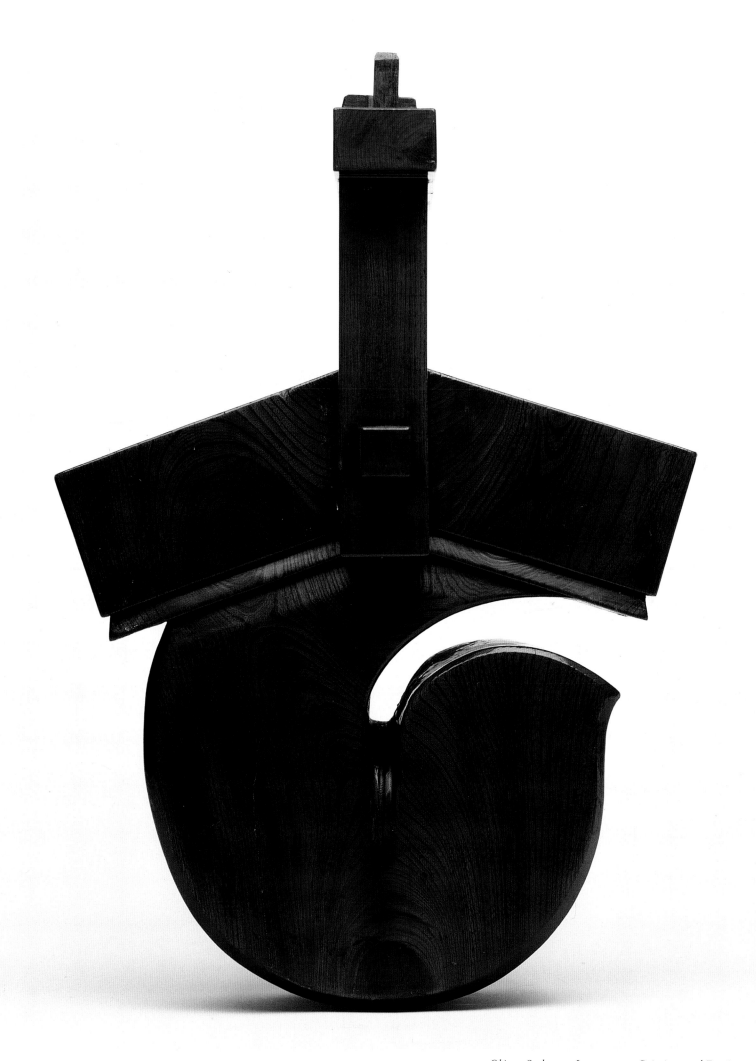

69a. *Kettle Hanger Adjuster* (yokogi), *in the Shape of Numeral One* (ichi)
Zelkova wood (*keyaki*)
12.5 × 37.5 × 6 cm
Late Edo-early Meiji period, 19th century

69b. *Kettle Hanger Adjuster* (yokogi), *in the Shape of Numeral One* (ichi)
Zelkova wood (*keyaki*)
9.5 × 30.3 × 6 cm
Late Edo-early Meiji period, 19th century

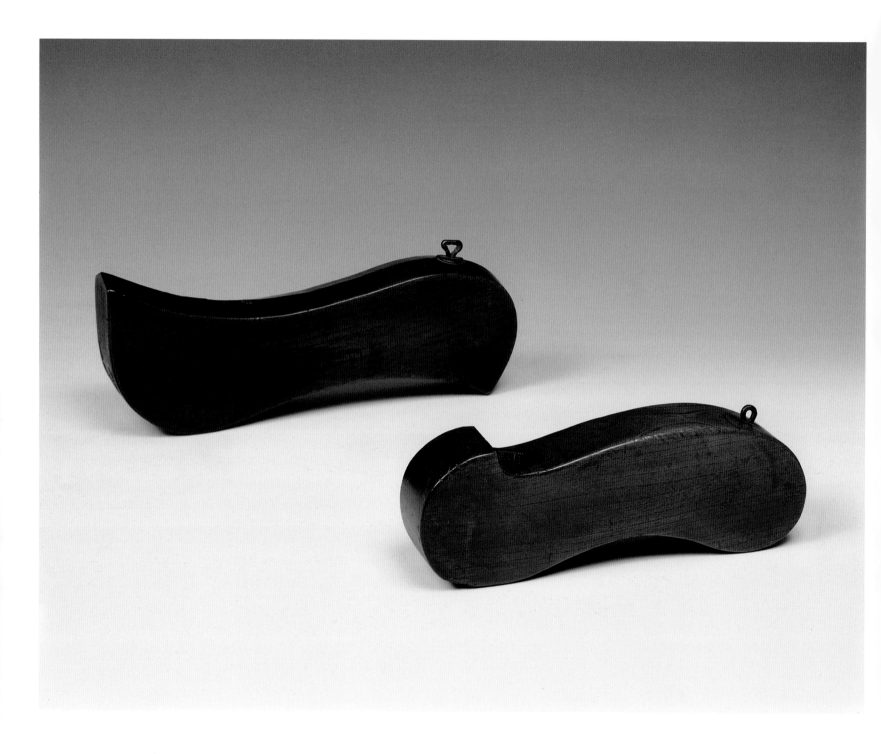

On the right:
70a. *Pot Hanger Adjuster (*yokogi*),
Chinese Character for Water (*mizu*)
and Chrysanthemum*
Zelkova wood (*keyaki*), soot patina, metal
hardware
12 × 33 × 4
Edo period, 19th century

On the left:
70b. *Pot Hanger Adjuster (*yokogi*),
Chinese Character for Water (*mizu*)*
Oak wood (*nara*), soot patina, metal
hardware
11.7 × 30 × 5 cm
Edo period, 19th century

Lower:
71. *Pot Hanger Adjuster (*yokogi*),
Chrysanthemum on Water*
Zelkova wood (*keyaki*), soot patina, metal
hardware
9.2 × 27 × 5 cm
Edo period, 19th century

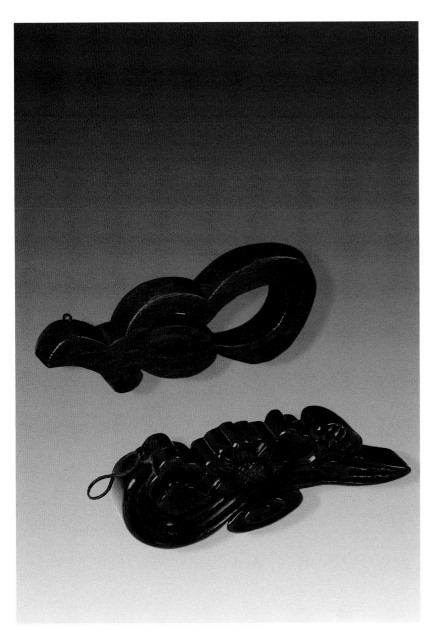

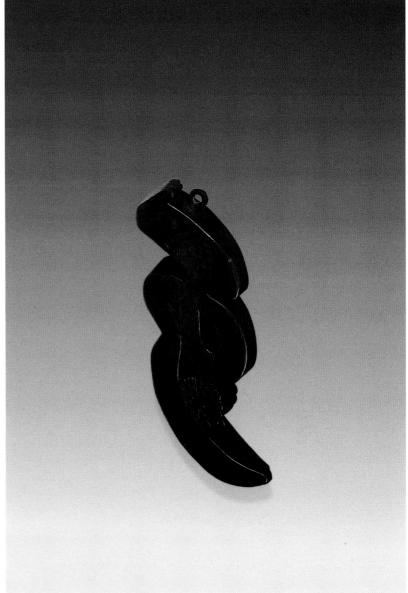

72. *Pot Hanger Adjuster (*yokogi*),
Dried Abalone (*noshi*) with Mallet
(*uchide no kozuchi*) and Jewel (*nyoi*)
Zelkova wood (*keyaki*), soot patina, metal
hardware
5.2 × 42.4 × 8 cm
Edo period, 19th century

73. *Pot Hanger Adjuster (*yokogi*),
Calabash Gourd (*hyōtan*)
Zelkova wood (*keyaki*), soot patina
5 × 21 × 4.5 cm
Edo period, 19th century

74. *Pot Hanger Adjuster (*yokogi*),*
*Rolled Scroll (*e-maki mono*)*
Zelkova wood (*keyaki*)
h. 30 cm
Edo period, 18th-19th century

75a. *Pot Hanger Adjuster (*yokogi*)*,
*Carp (*koi*)*
Wood, soot patina
9 × 37 × 5.5 cm
Edo period, 18th-19th century

75b. *Pot Hanger Adjuster (*yokogi*)*,
*Sweetfish (*ayu*)*
Wood, soot patina
11.5 × 35 × 11 cm
Edo period, 18th-19th century

75c. *Pot Hanger Adjuster (*yokogi*)*,
*Sea Bream (*tai*)*
Wood, soot patina
17 × 36.5 × 7 cm
Edo period, 18th-19th century

75d. *Pot Hanger Adjuster (*yokogi*)*,
*Carp (*koi*) with Jewel (*nyoi*)*
Wood, soot patina
12.5 × 32.5 × 7.5 cm
Edo period, 18th-19th century

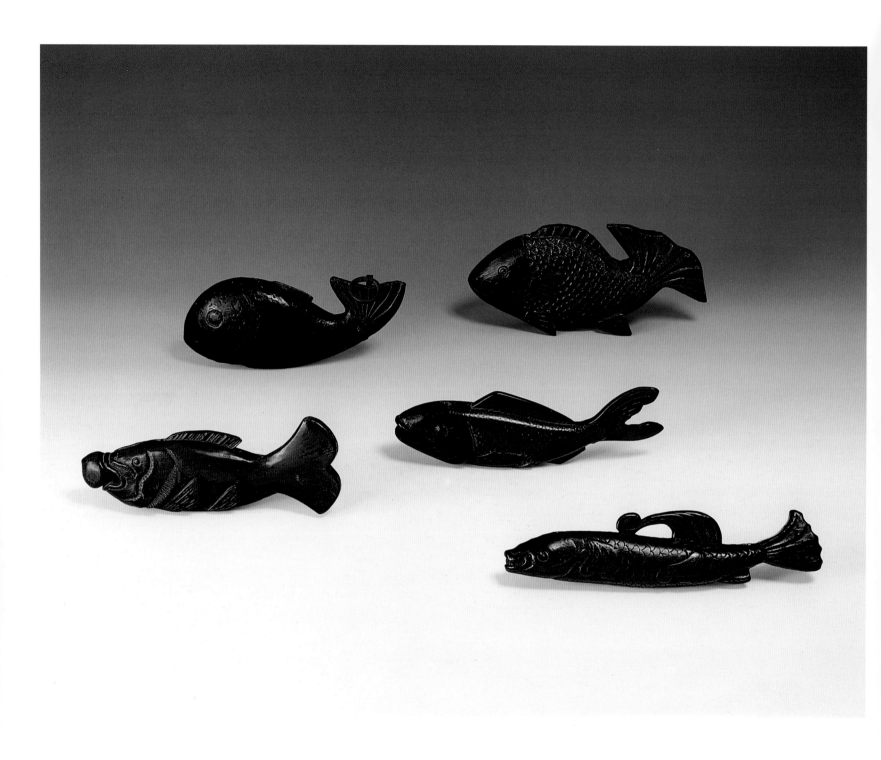

75e. *Pot Hanger Adjuster (yokogi),*
Sea Bream (tai)
Wood, traces of paint, soot patina,
metal hardware
15 × 34 × 6 cm
Edo period, 18th-19th century

76. *Pot Hanger Adjuster (yokogi),*
Sea Bream (tai)
Wood, soot patina, brass eye,
metal hardware
33.8 × 42 × 18 cm
Edo period, 19th century

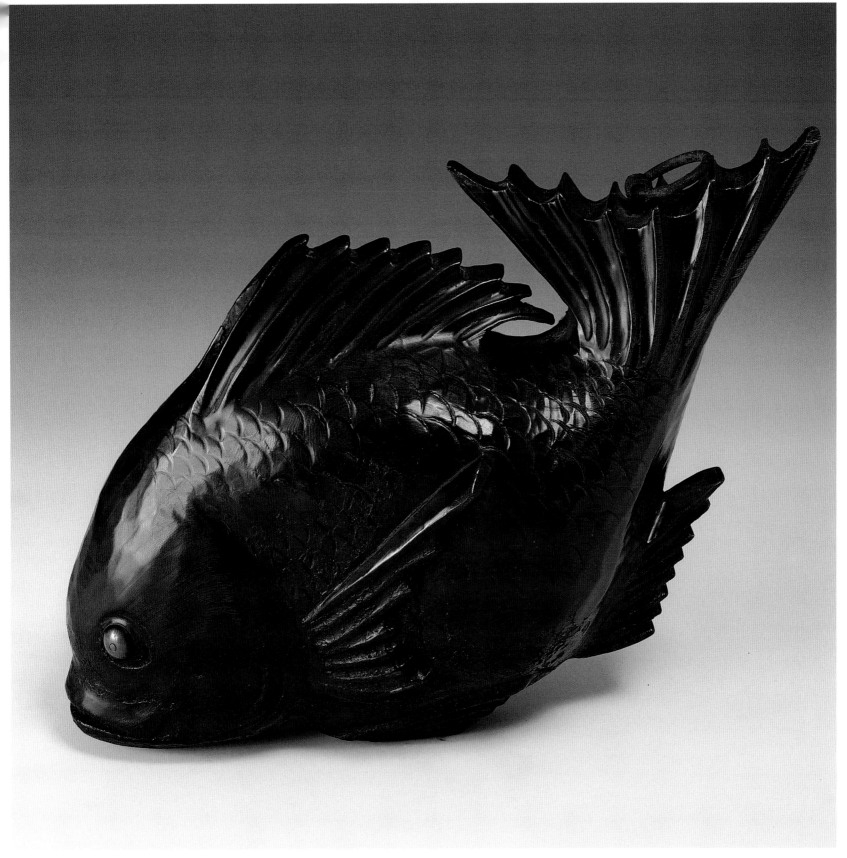

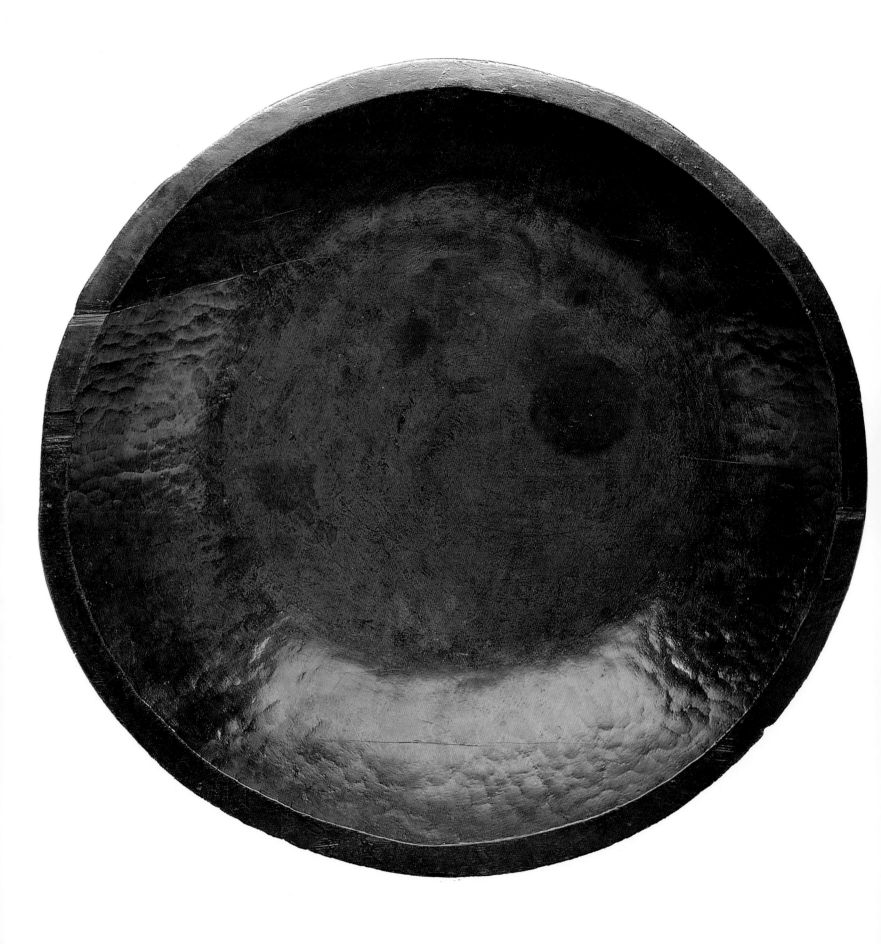

77. *Kneading Basin (*kone-bachi*)*
Paulownia wood (*kiri*)
13 × 80 cm
Edo period, 19ᵗʰ century

78. *Saké Ewer (*chōshi*)*
Zelkova wood (*keyaki*), lacquer
32 × 22.5 × 32 cm
Edo period, 18ᵗʰ century

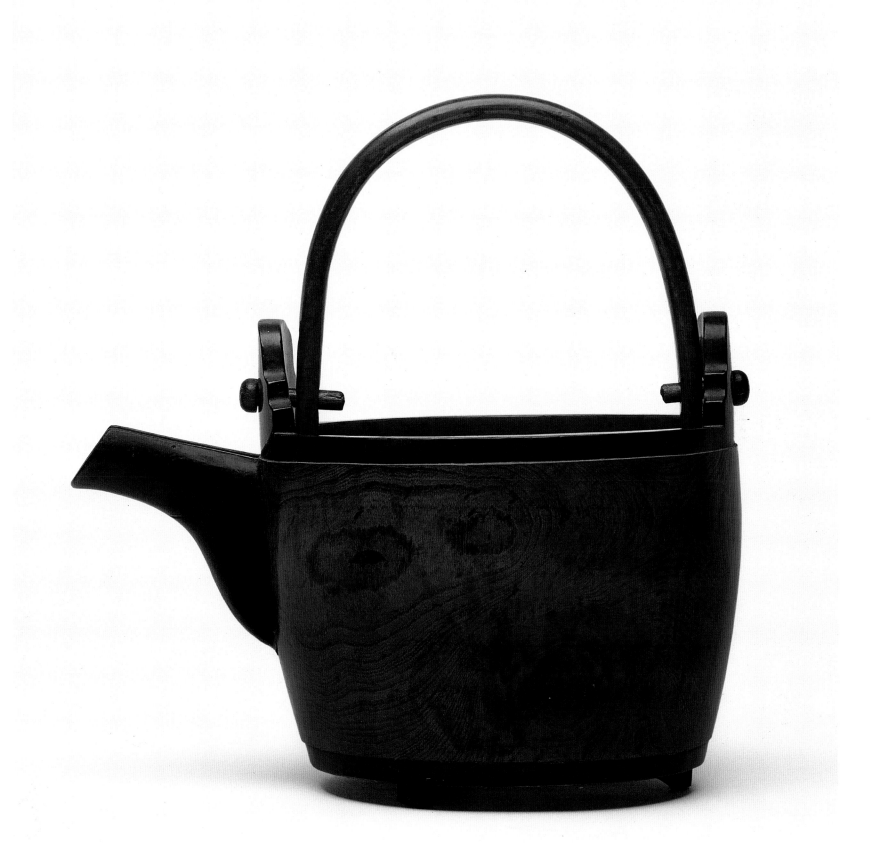

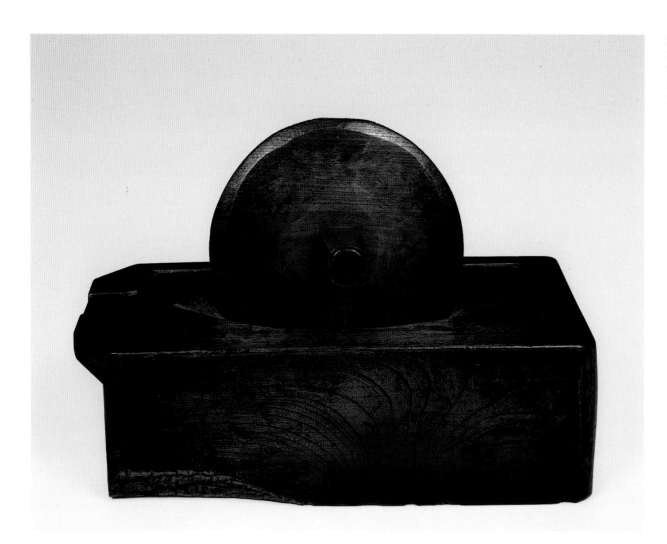

79. *Medicine Grinder (*yagen*)*
Zelkova wood (*keyaki*)
Wheel: diameter 22 cm;
bowl: 12 × 41 × 17.5 cm
Edo period, 19th century

80 a-b. *Fulling Mallet and Block (*kinuta*)*
Zelkova wood (*keyaki*)
Mallet: 23 × 11 cm; block: 14.5 × 24 cm
Edo period, 19th century

81 a-b. *Tinder Box (*hiuchi-bako*)*
Zelkova wood, iron
11 × 14.3 × 25 cm
Late Edo-early Meiji period, 19th century

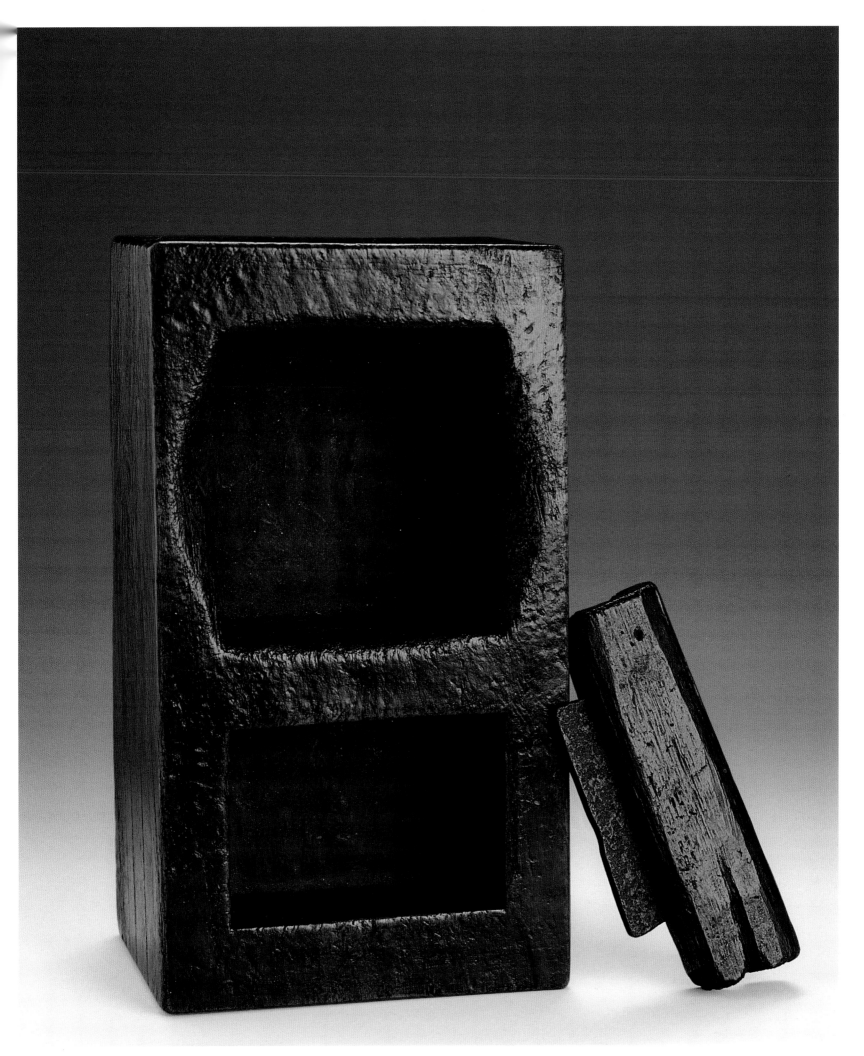

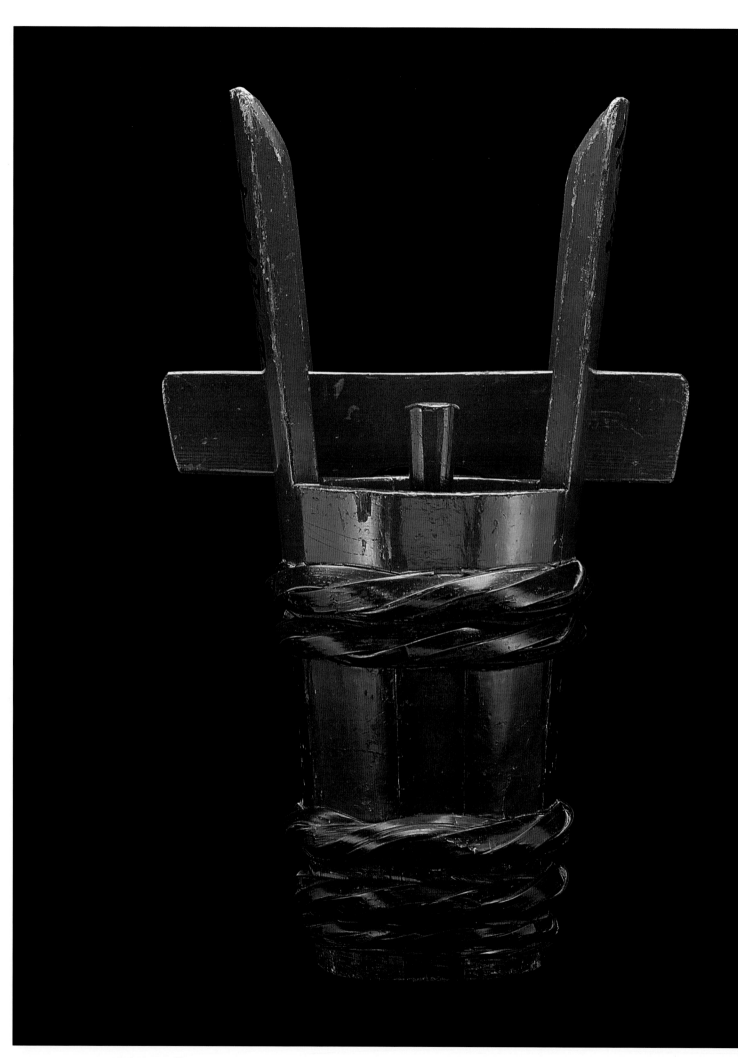

82. *Horned Saké Kegs* (tsuno-daru)
Shōnai; wood, lacquer
Inscription: *Matsuya* (shop name),
Kichizaemon, Kōjimachi jū-san-chōme
(address, in Tokyo)
57 × 34 × 23 cm
Meiji period, late 19th century

83. *Cauldron* (kama) *Lid*
Zelkova wood (*keyaki*), lacquer
25 × 68 cm
Edo period, 19th century

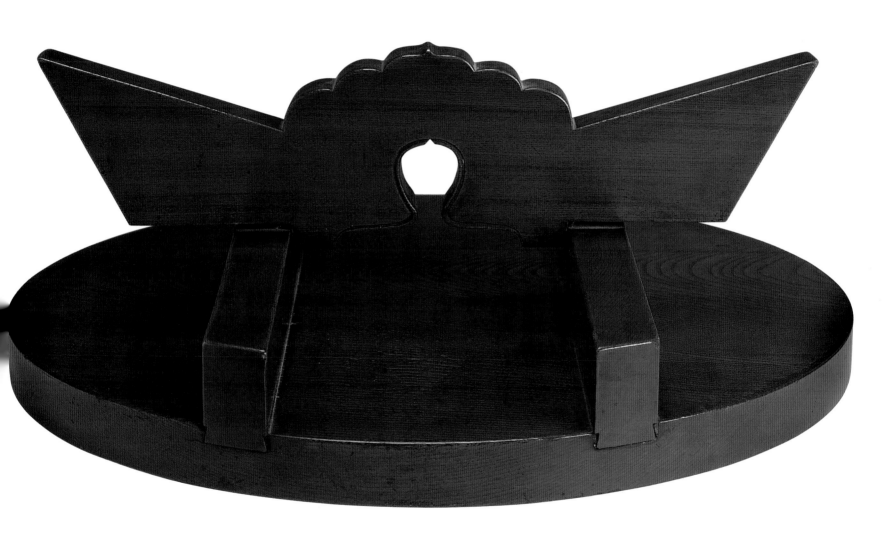

84. *Gourd-shaped Saké Flask*
Calabash gourd (*hyōtan*), lacquer, wood
plug with silk cord, linen (rope)
55.5 × 93 cm
Late Meiji-early Taishō period,
c.1900-1920

85. *Candlestick (*rosōku tate*)*
Zelkova wood (*keyaki*)
43 × 17 cm
Meiji period, late 19th century

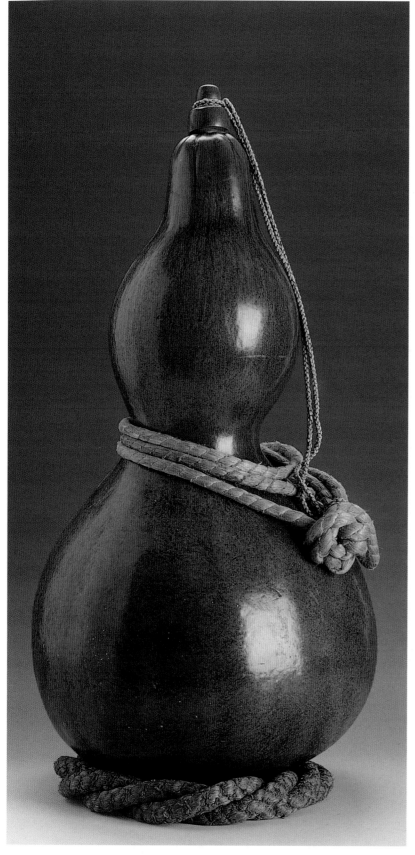

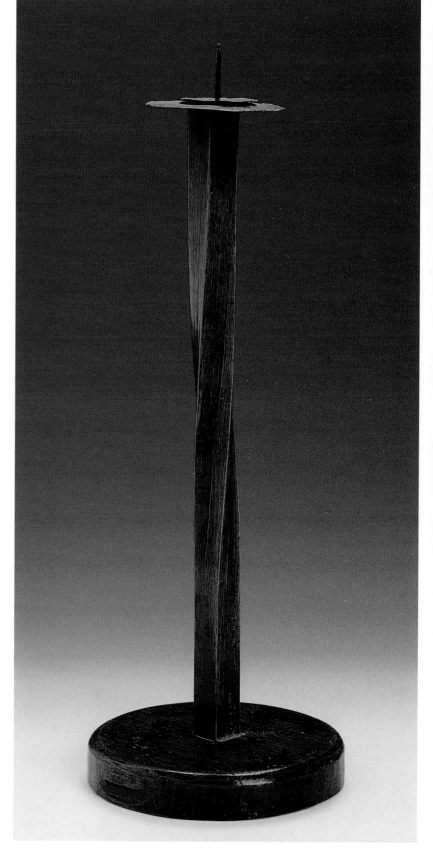

86. *Oil lamp (*ariake andon*)*
Wood, lacquer, paper
53 × 21 × 21 cm
Edo period, early 19th century

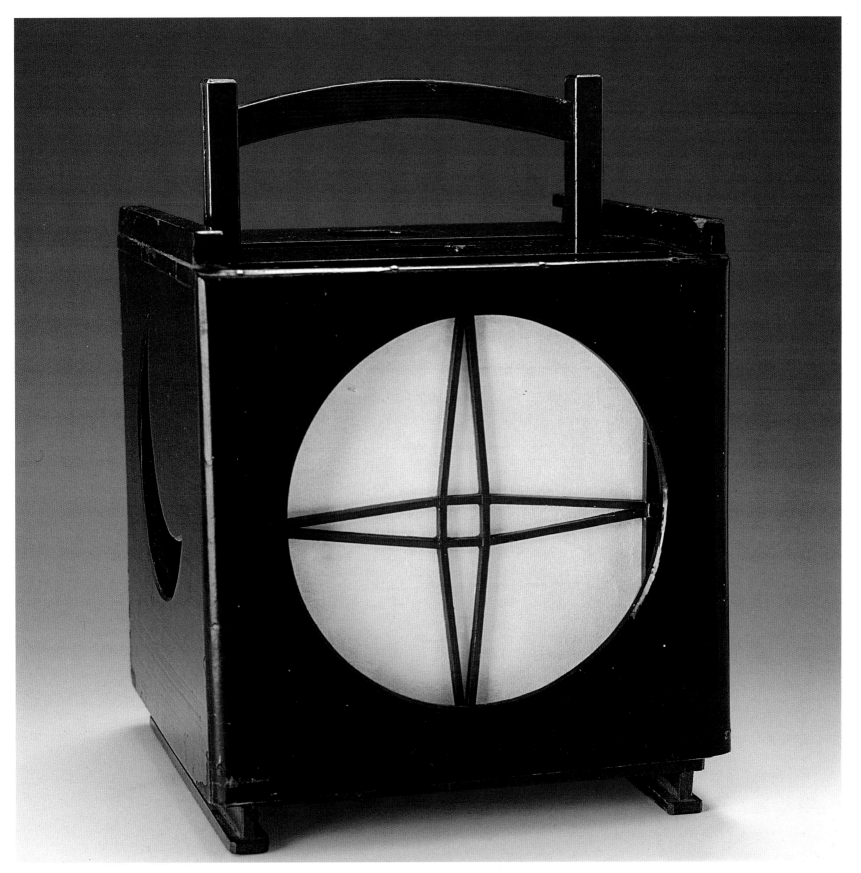

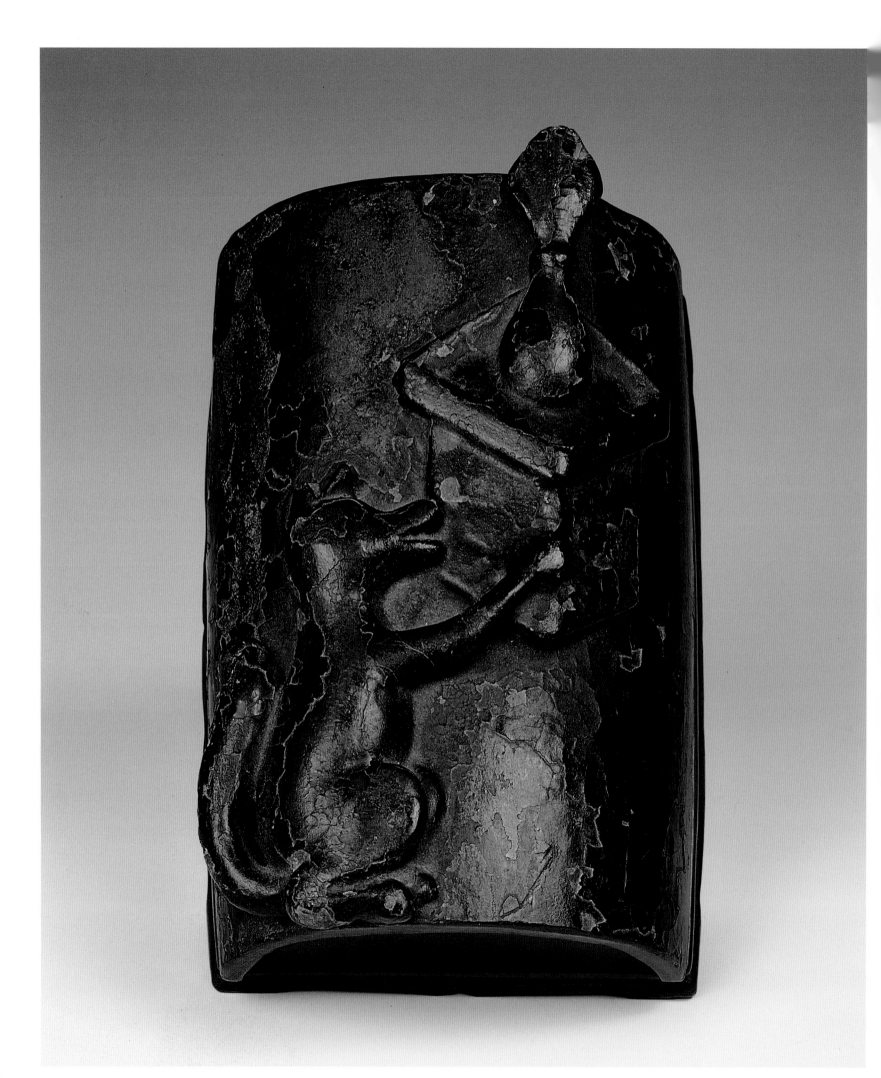

Annie M. Van Assche

87. *Ink Stone Box* (suzuri-bako)
Wood, lacquer
8 × 18.5 × 13 cm
Edo period, 18ᵗʰ century

88. *Album Box*
Cryptomeria wood (*sugi*)
6 × 34 × 45 cm
Edo period, late 18ᵗʰ-early 19ᵗʰ century

Pages 116–117:
89. *Carved Transom* (ramma)
with Mother and Puppy
Wood
Inscription: 'hi no yō shin'
(take care with fire)
34.5 × 100 × 10.5 cm
Late Edo period, 19ᵗʰ century

Objects, Sculptures, Lacquerwares, Paintings, and Furniture

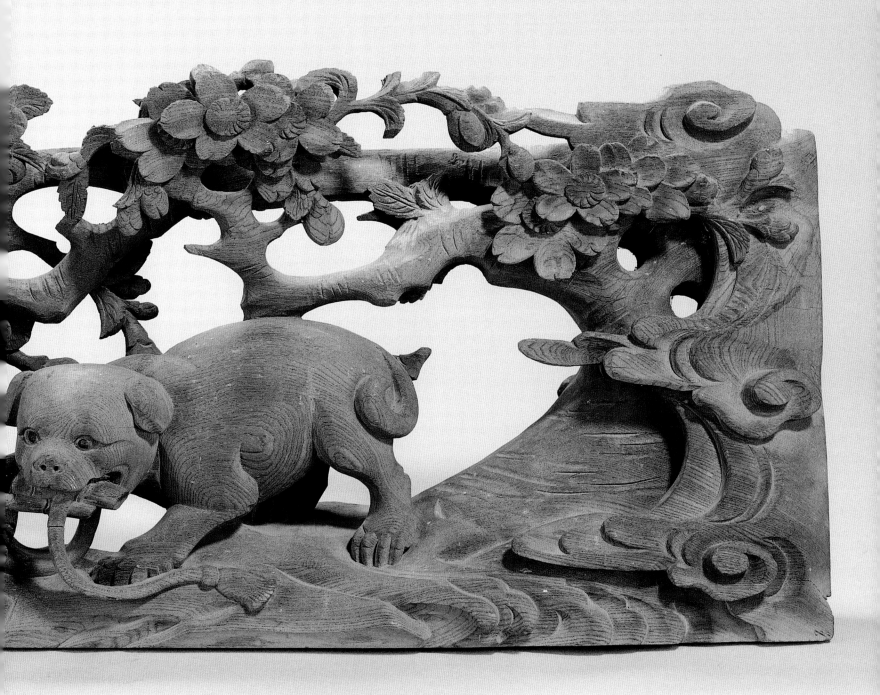

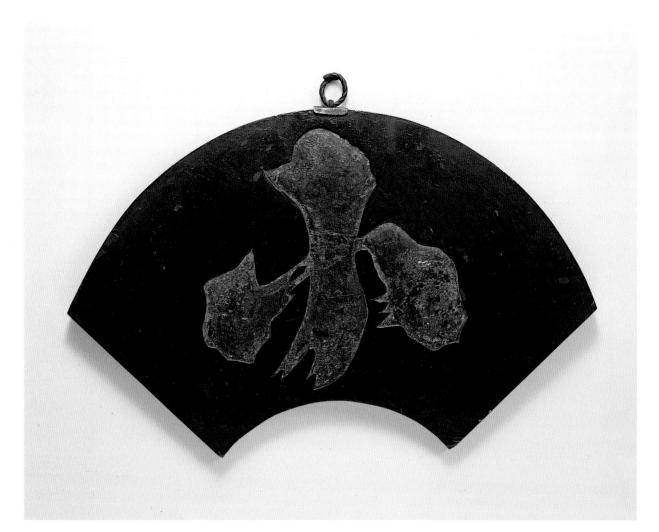

90 a-b. *Money Lender's Shop Sign*
(kanban)
Wood, paint, metal hardware
Inscription: '*shō*' (small) and '*dai*' (big)
32 × 50 × 1.8 cm
Late Edo-early Meiji period, 19th century

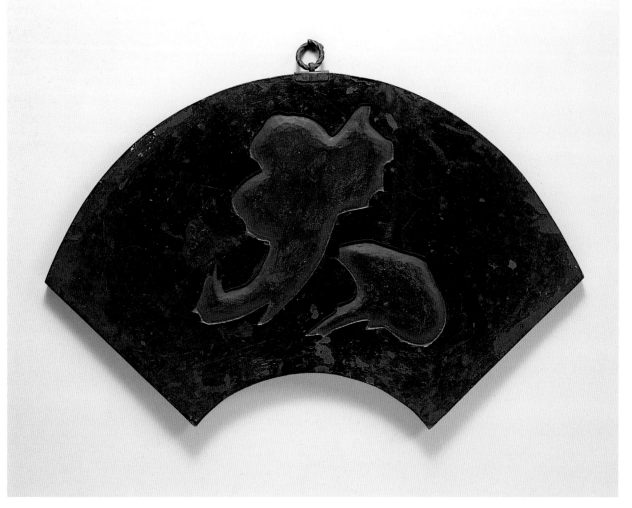

91. *Iron Pot Maker's Shop Sign* (kanban)
Wood, paint, cotton, metal hardware
Inscription: '*okama-shi*'
(maker of iron pots)
38 × 47 × 4 cm
Meiji period, late 19th-early 20th century

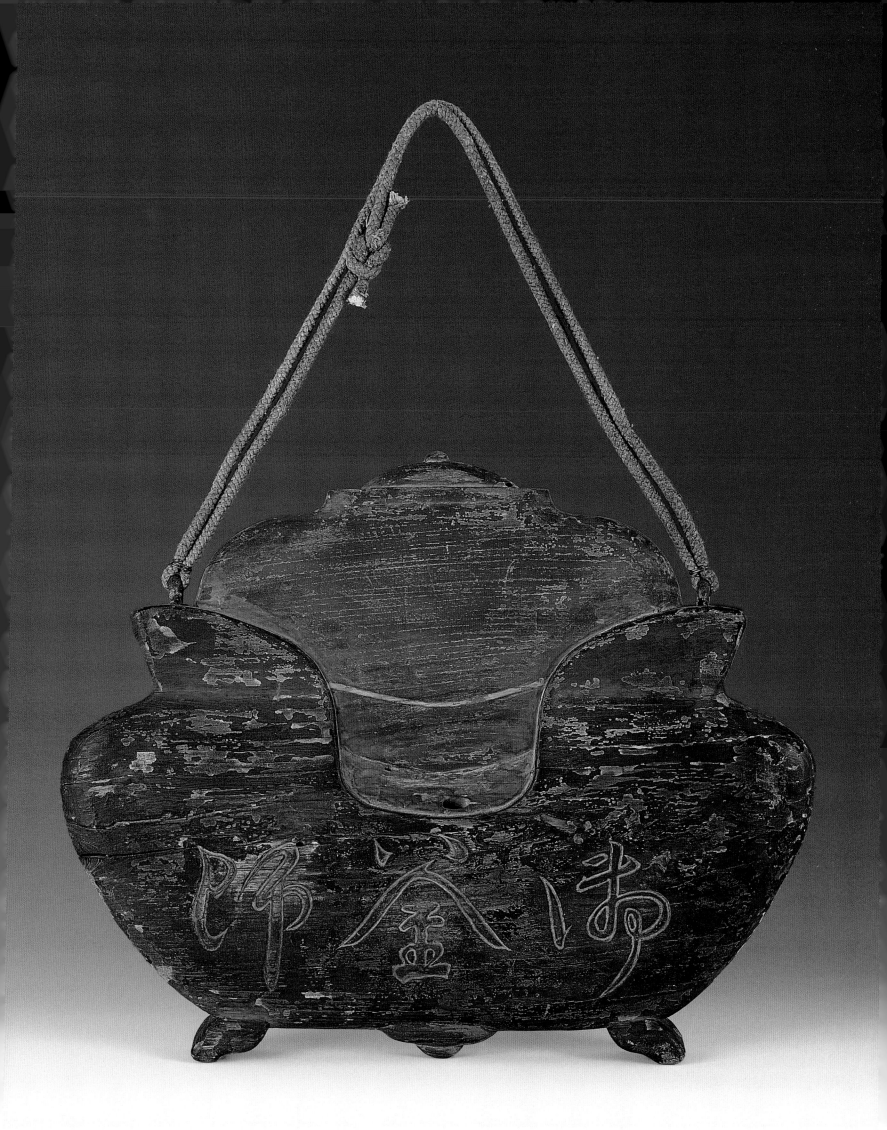

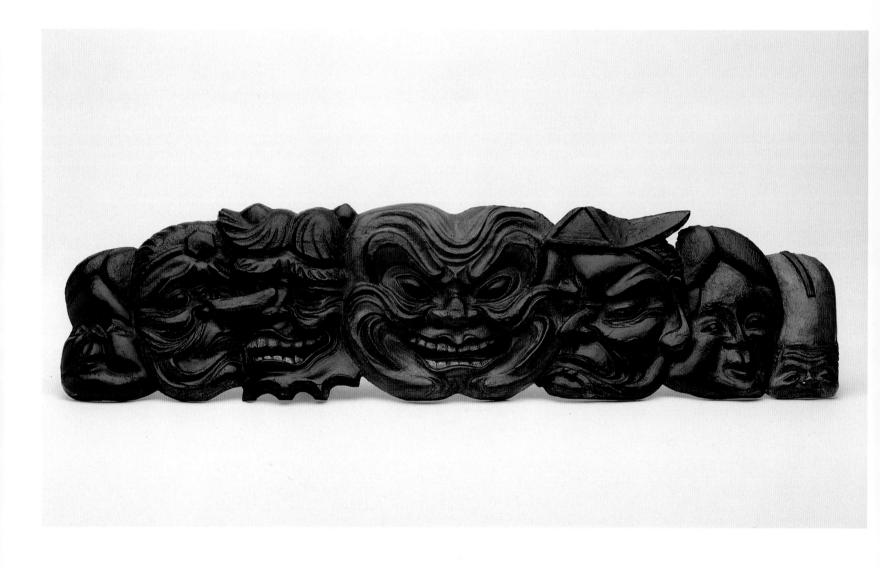

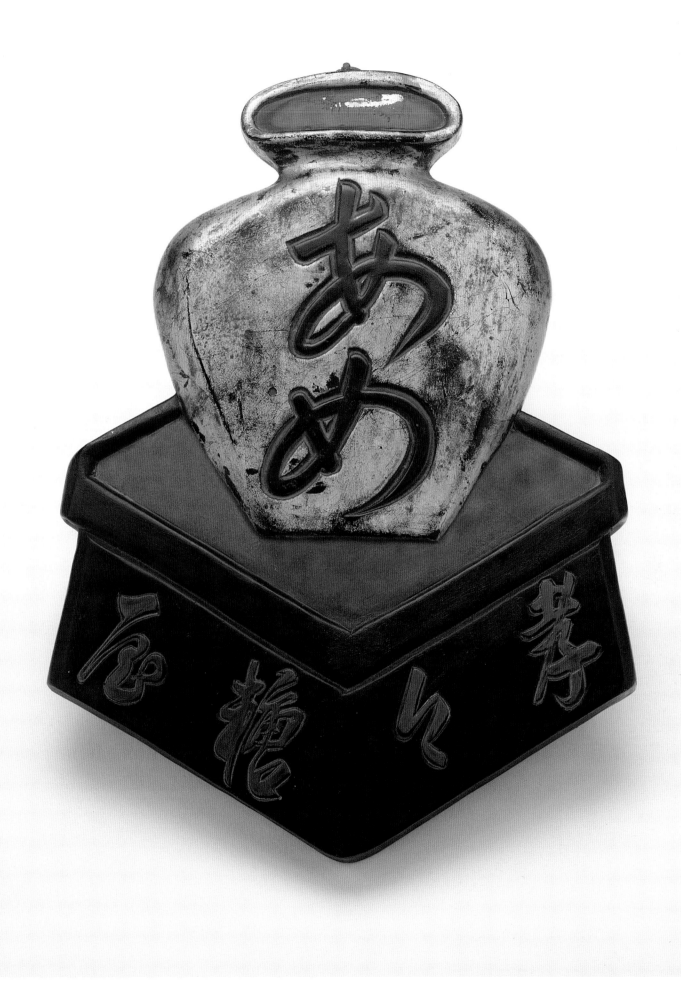

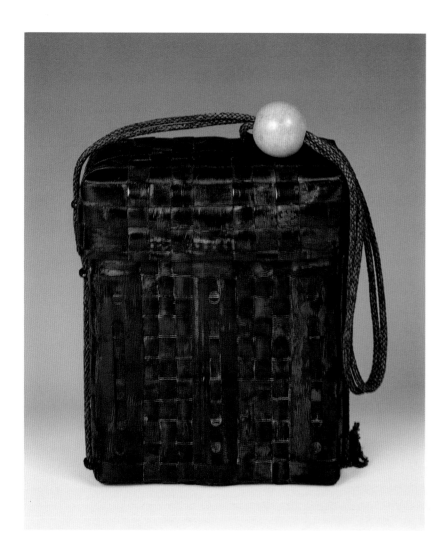

94. *Lunch Basket*
Hida; split and woven birch bark, silk
(cord), stone (bead)
19.3 × 17.5 × 10.5 cm
Late Edo-early Meiji period, 19th century

95. *Charcoal Basket* (sumitori)
Woven bamboo, paper lining
13 × 81 cm
Meiji period, late 19th-early 20th century

Opposite page:
96. *Sieve for beans* (mame-dōshi)
Woven bamboo
16 × 56 cm
Meiji period, 19th century

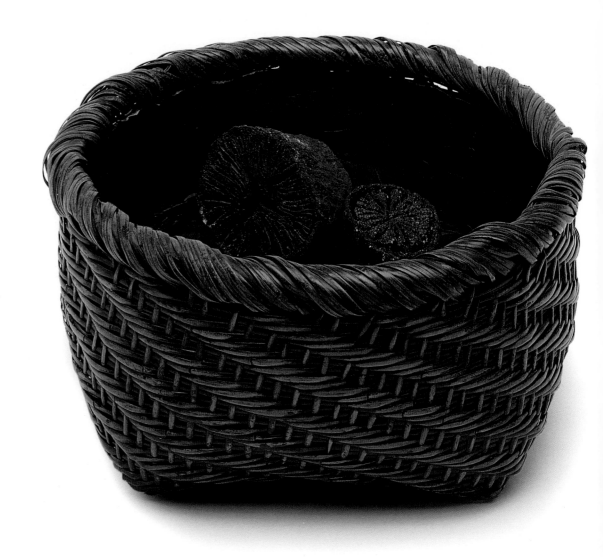

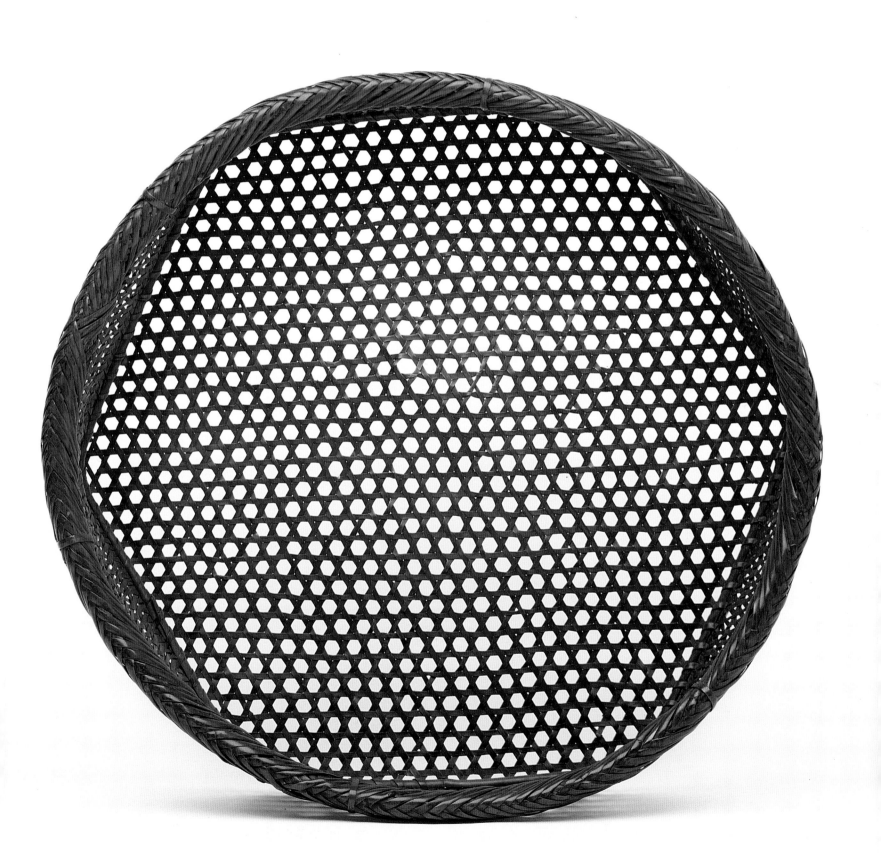

Left and opposite page:
97. *Stacked Food Container (*jū-bako*)*
Lacquered bamboo
27 × 15 cm
Edo period, 19th century

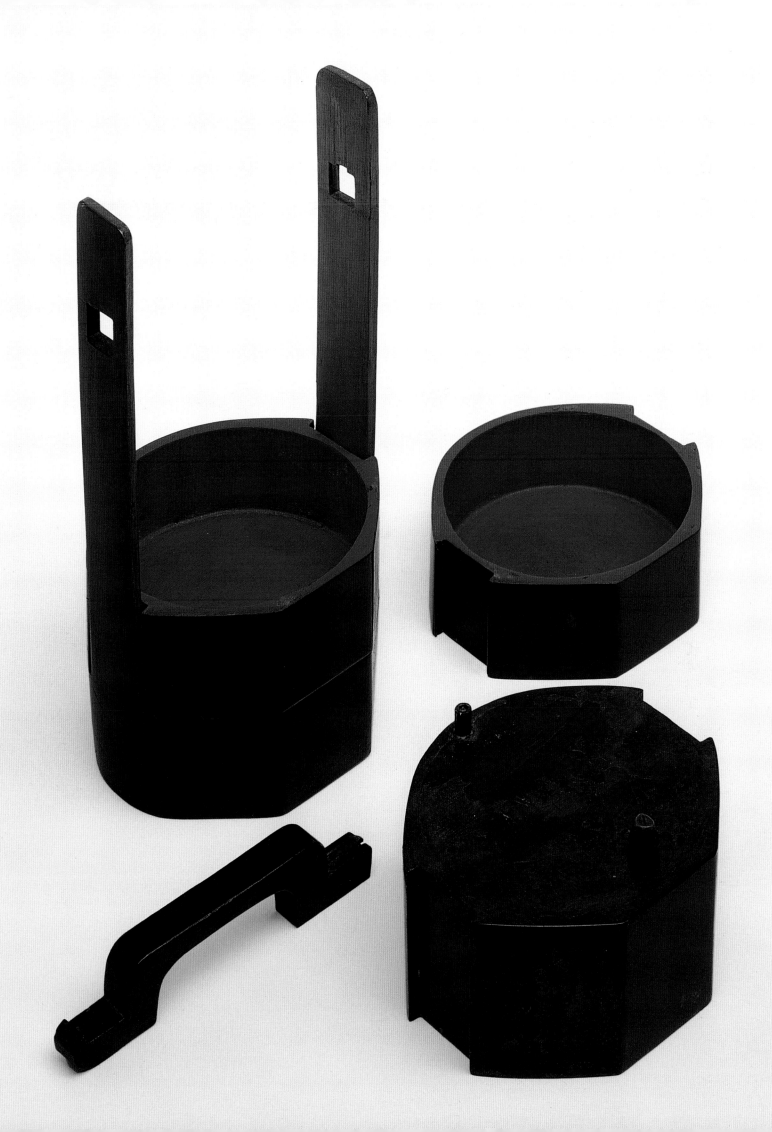

Below and opposite page:
98. *Large Spouted Bowl (*katakuchi*)*
Wajima ware; wood, lacquer
21 × 36 × 26 cm
Edo period, 18th century

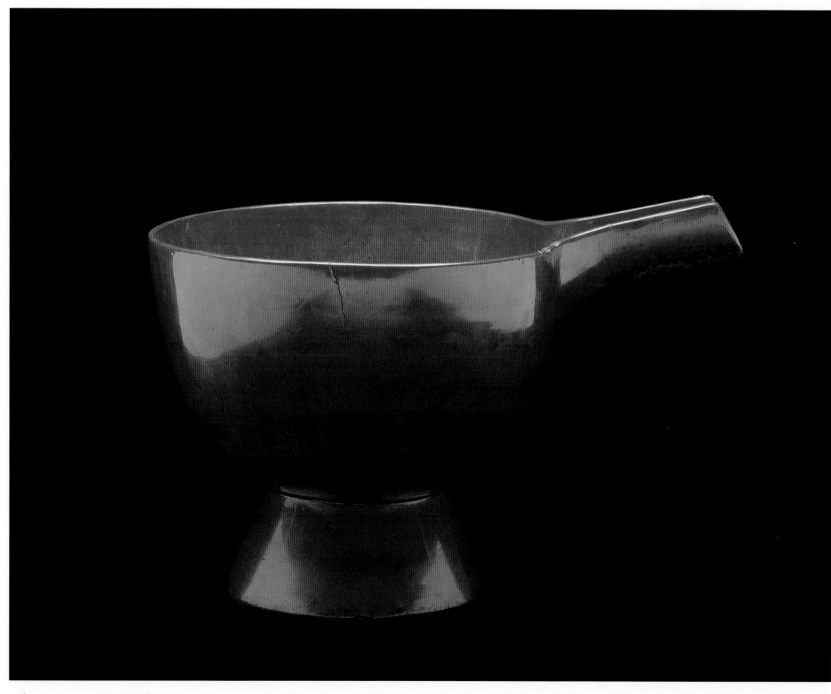

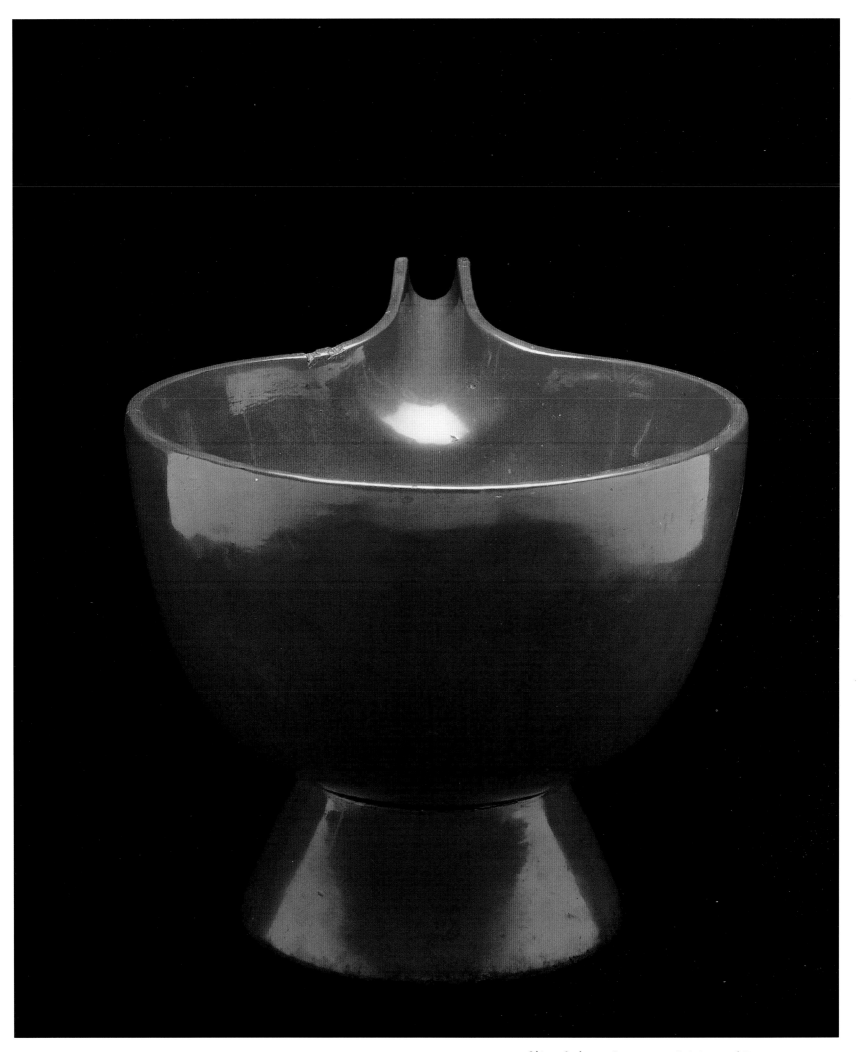

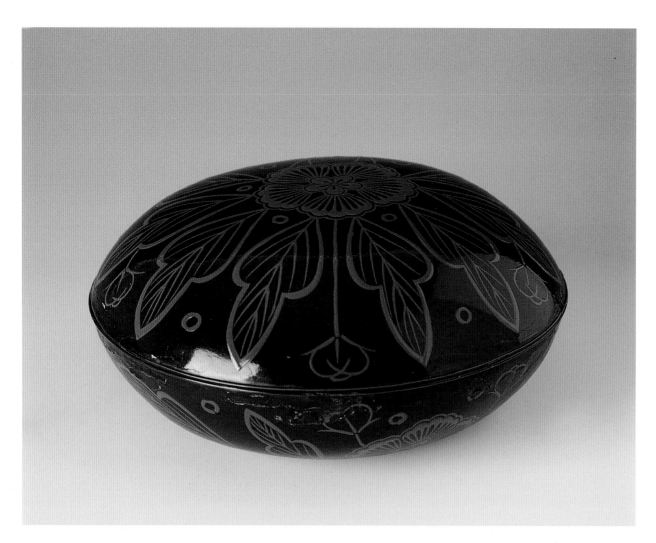

99. *Covered Box (*futamono*)*
Yoshino ware; wood, lacquer
10.5 × 21 cm
Meiji period, late 19th-early 20th century

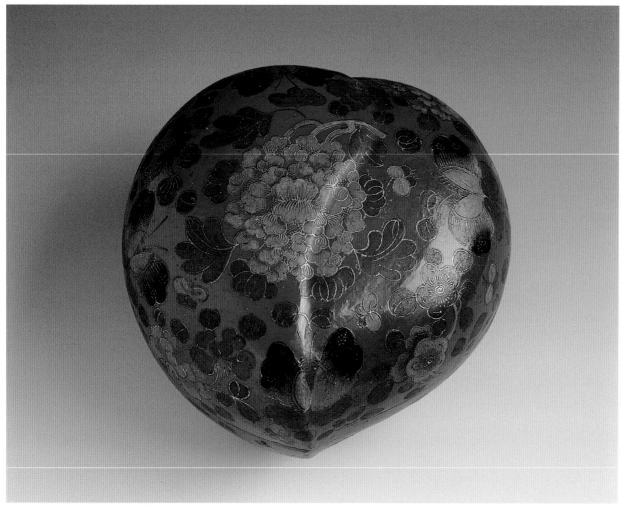

100. *Peach-shaped Food Container*
Ryūkyū (Okinawa); wood, lacquer,
coloured litharge paint, gold
11.5 × 67.4 cm
Edo period, late 18th century

101. *Spouted Bowl (*katakuchi*)*
Wood, lacquer
Crest (*mon*): two variants of Kashiwa
family insignia (on side); *kaiyō* (for use
with large groups; on underside)
13.3 × 27.5 × 21.2 cm
Edo period, 19th century

102. *Hot Water Ewer (*yuto*)*
Wood, lacquer
Crest (*mon*; on lid): *tachibana*
(mandarin orange flower)
12 × 32 × 36.8 cm
Edo period, 19th century

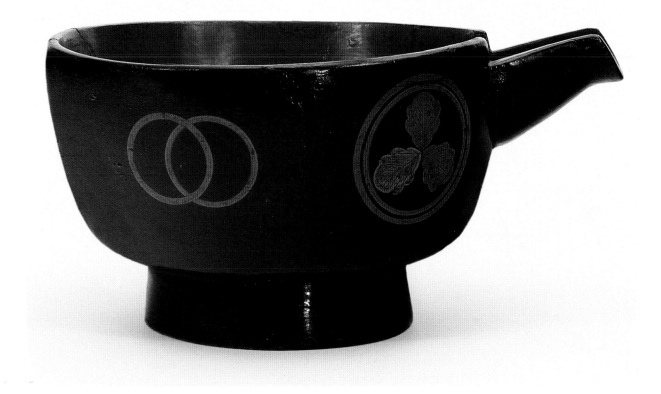

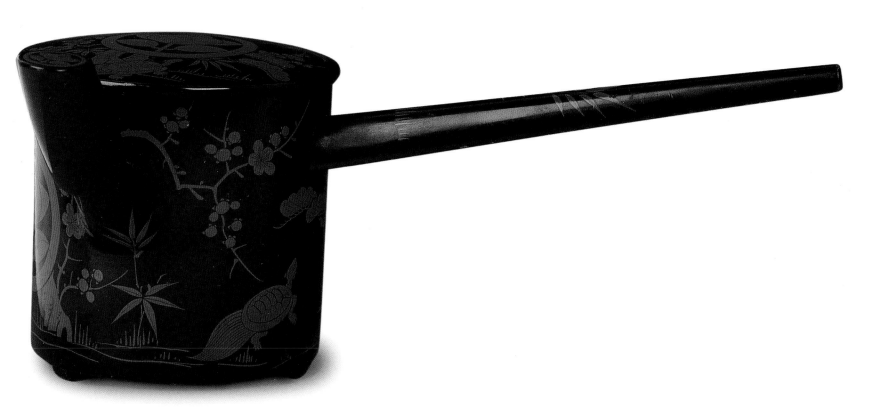

Below and opposite page:
103. *Stationary Box (*bunko*)*
Ryūkyū (Okinawa); wood, lacquer
8.5 × 33 × 18 cm
Edo period, 19ᵗʰ century

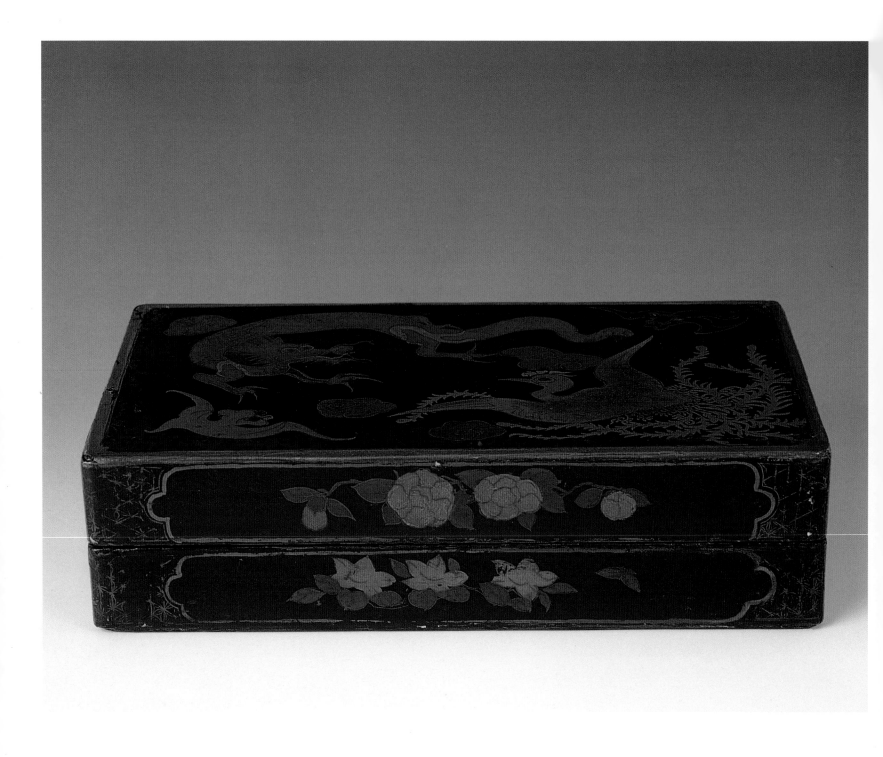

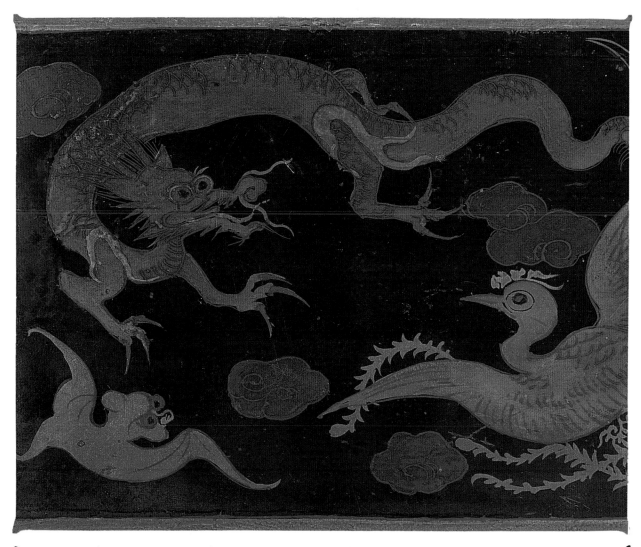

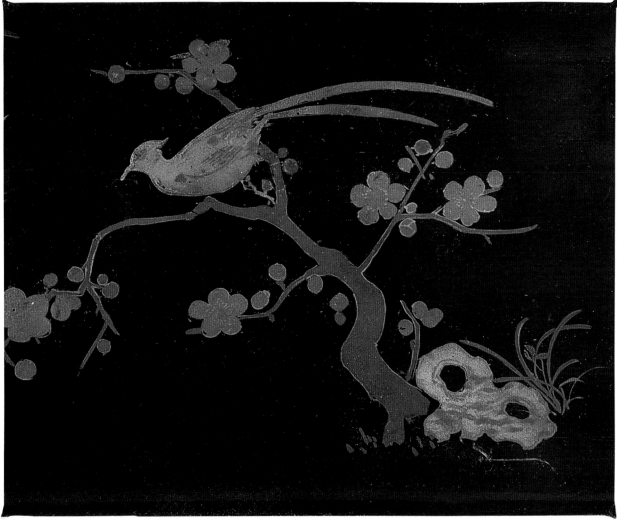

104. *Footed Wash Basin (*ashitsuki tarai*)*
Negoro ware; zelkova wood (*keyaki*),
lacquer
10.5 × 30 cm
Muromachi period, 15th century

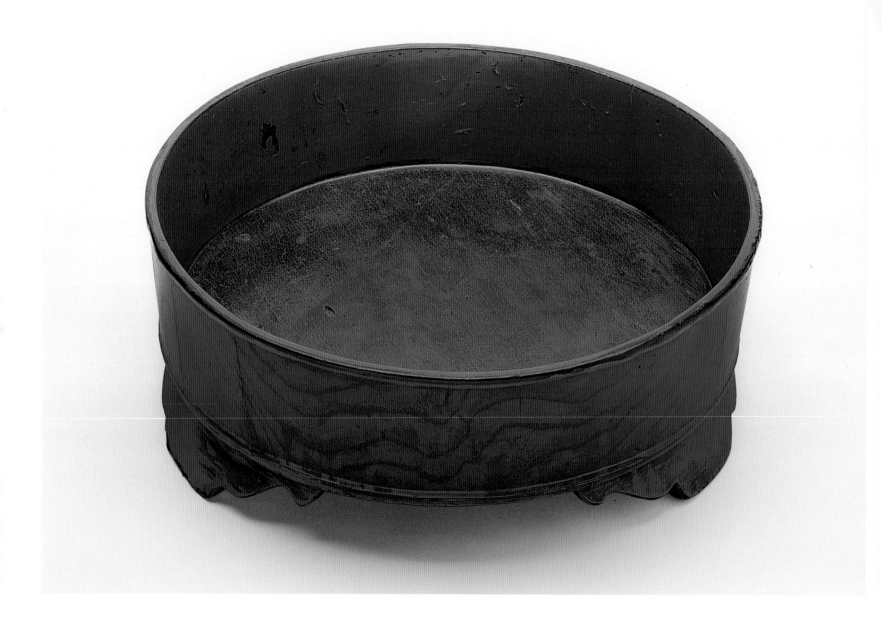

105. *Round Tray (*maru-bon*), Pine Motif*
Wood, lacquer, oil paint decoration
(*mitsuda-e*)
3.5 × 38 cm
Edo period, 19th century

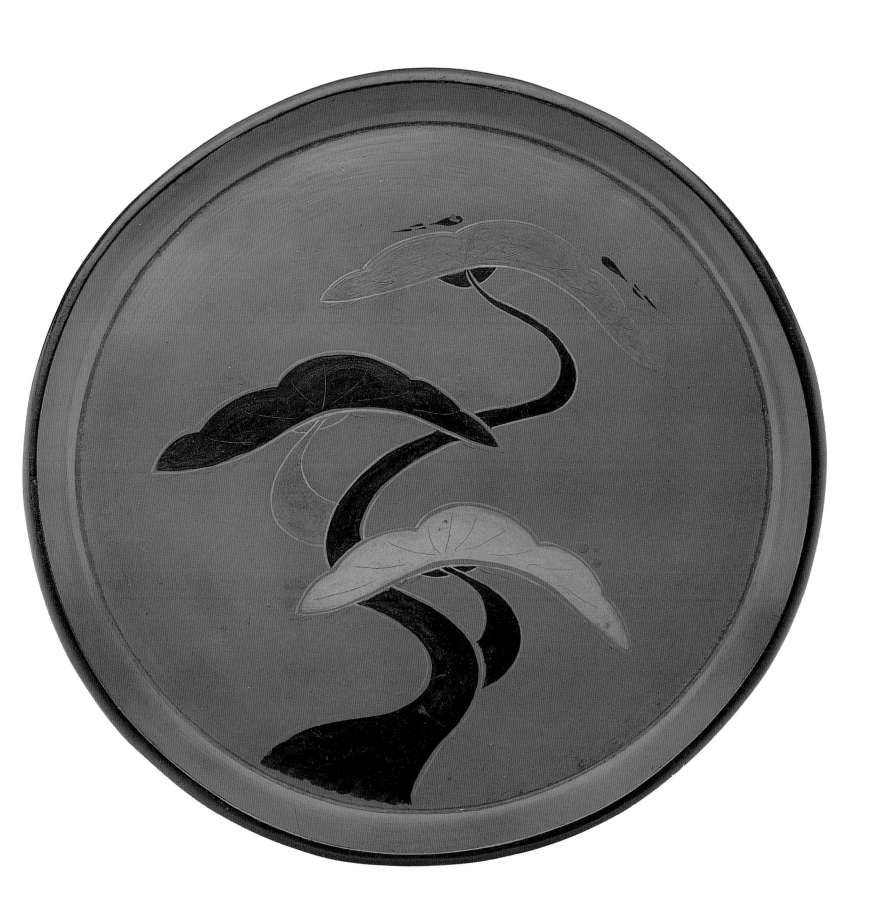

Left and opposite page:
106 a-f. *Set of Ten Plates* (six shown)
Ryūkyū (Okinawa); wood, lacquer,
colour litharge paint, gold, silver
3.2 × 21 cm
Edo period, 18th century

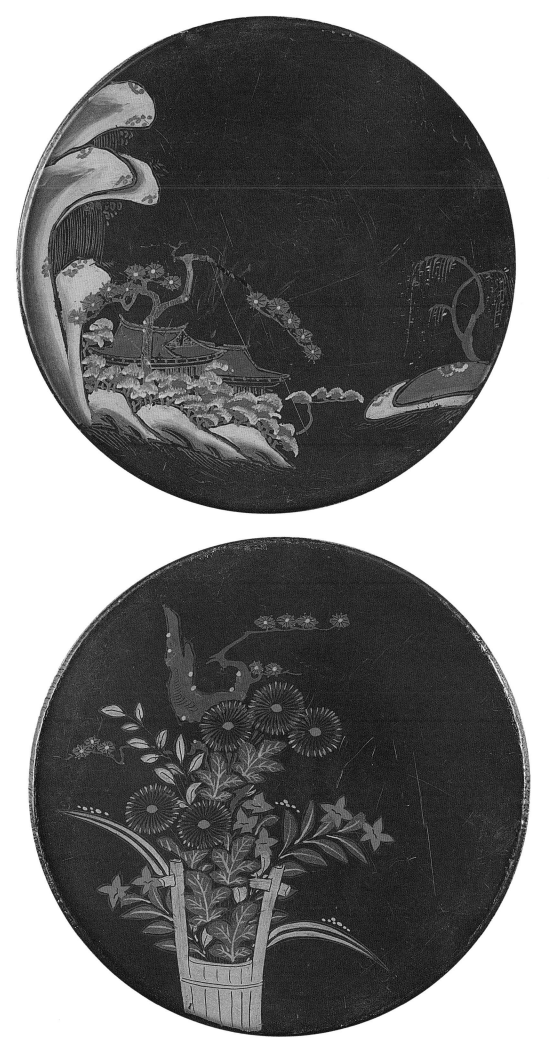

107. *Saké Flask* (sashi-daru)
Ryūkyū (Okinawa); wood, lacquer,
mother-of-pearl inlay, leather cord
15 × 14.8 × 5.3 cm
Edo period, 18ᵗʰ-19ᵗʰ century

Opposite page:
108. *Sword Stand*
Ryūkyū (Okinawa); wood, lacquer,
mother-of-pearl inlay
54 × 46 × 23 cm
Edo period, 18ᵗʰ century

Left and below:
109. *Sword Stand*
Ryūkyū (Okinawa); wood, lacquer,
mother-of-pearl inlay, metal hardware
25.4 × 54 × 16.6
Edo period, 18th century

Opposite page:
110. *Tray (bon)*
Ryūkyū (Okinawa); wood, lacquer,
mother-of-pearl inlay
35 × 4.5 cm
Edo period, 18th century

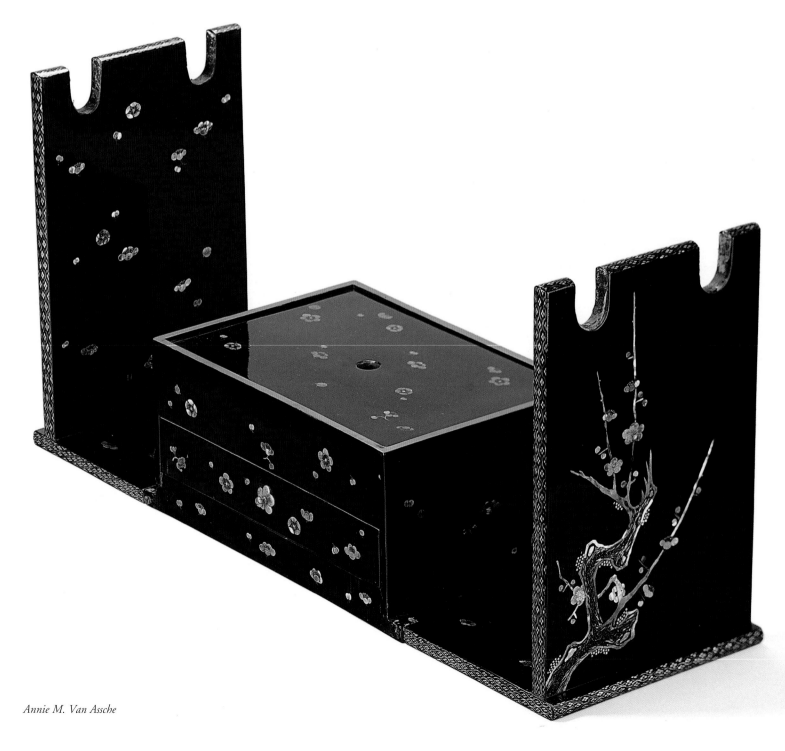

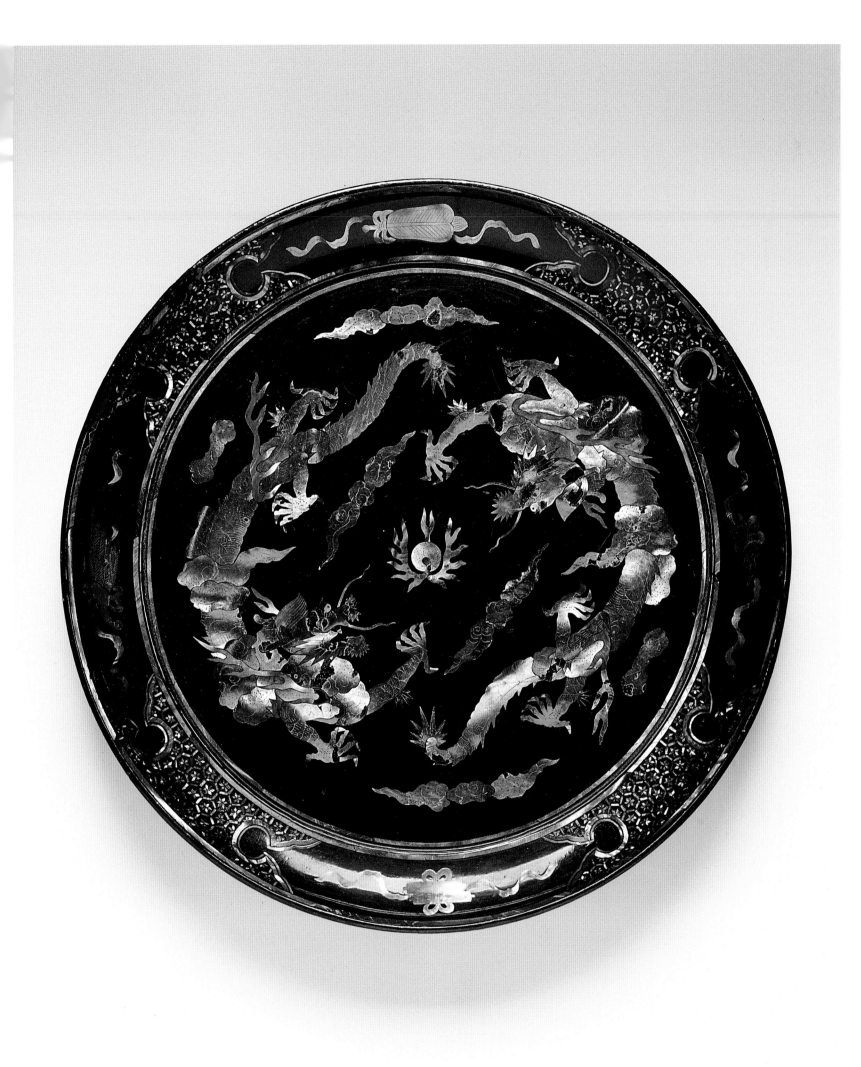

111. *Votive Horse Plaque (*ema*)*
Cryptomeria wood (*sugi*), paint
Inscription: *hōno* (offering)
60.7 × 76 × 1.75 cm
Edo period, inscribed date: Temmei
Heigo (1786), 5th month, (day illegible)

112. *Votive Horse Plaque (*ema*)*
Wood, ink, paint
14 × 18.5 × 0.7 cm
Edo period, 19th century

113. *Votive Horse Plaque (*ema*)*
Painted wood
17.7 × 38.5 cm
Edo period, 19th century

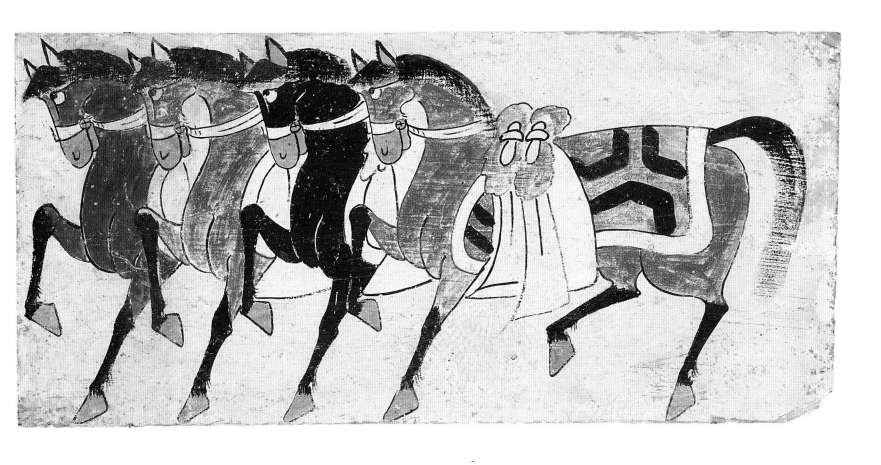

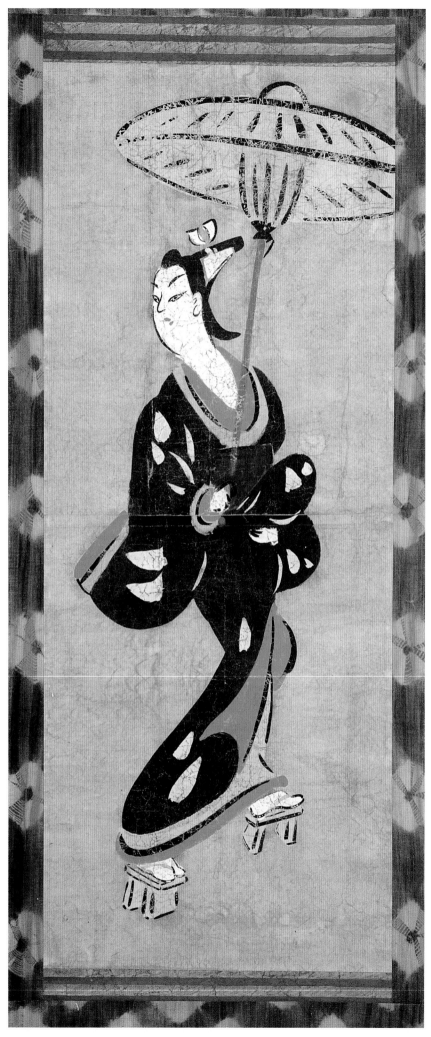

114. *Ōtsu-e Painting, Courtesan with Umbrella*
Hanging scroll; ink and colour on paper, silk mounting
58.8 × 22.5 cm (painting only)
Edo period, late 17th-early 18th century

115. *Ōtsu-e Painting, Red-faced Monkey Drinking Saké*
Anonymous
Hanging scroll; ink and colour on paper, silk mounting
33.3 × 23.3 cm (painting only)
Edo period, 18th century

Poem (right to left):
Hyōtan ni norite, sake nomu sarujie wa [to?] shiri mo suwarazu, ashi mo suwarazu (upper).

The cunning, saké-drinking monkey, riding on a saké gourd, is unstable.

hyakuyaku no chō taru ue ni kaerite wa, mata hyakubyō no moto to naru sake (lower).

Although with many medicinal qualities, even saké will result in numerous ailments, if imbibed in excess.

(translated by Shunkin Takahashi, 2001)

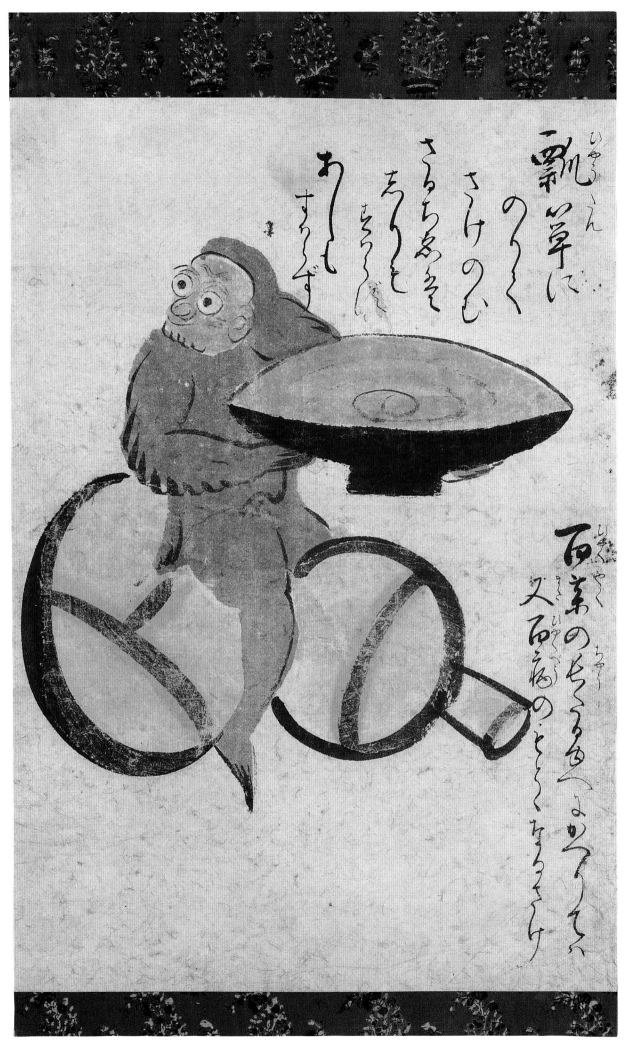

116. *Doro-e Painting, View of Mount Fuji from the Tōkaidō*
Anonymous
Hanging scroll; ink and colour on paper, silk mounting
13.5 × 47.5 cm (painting only)
Edo period, 19th century

117. *Painting, Hyakufuku-kai*
(Gathering of One Hundred Otafuku's)
Suzuki Seiju (1825-1891)
Hanging scroll; ink and colour on paper,
silk mounting
Signature (*gō*): *Hyukunen-gu*
Inscription (top to bottom, right to left):
'*hyakufuku-kai*' (gathering of one
hundred Otafuku's).
Seal: *sanman rokusen nichi* (thirty-six
thousand days).
112 × 43.8 cm (painting only)
Edo period, 1st half of 19th century

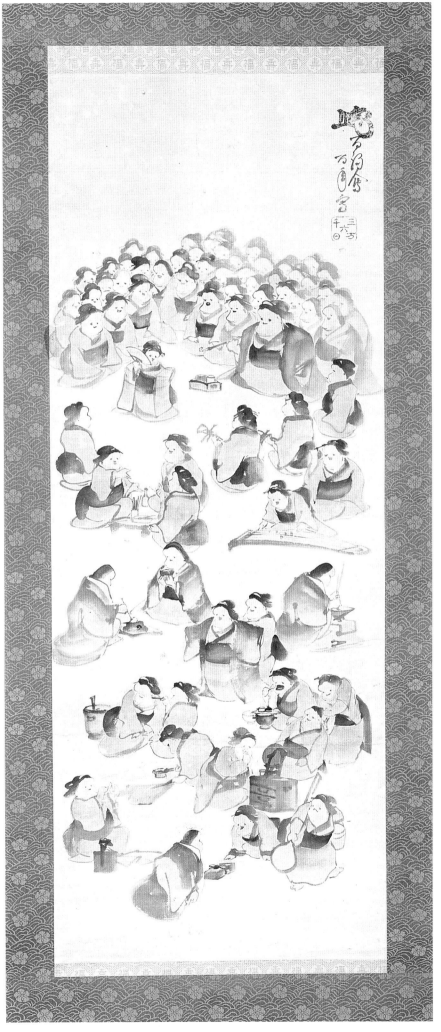

118. *Painting, Tea Bowl and Tea Caddy,*
with Calligraphy
Munakata Shikō (1903-1975)
Hanging scroll; ink and colour on paper,
silk mounting
Signature (with seal): *Shikō* (Muna)
Calligraphy (right to left): *temmei*
(heavenly brightness)
29 × 32 cm (painting only)
Early-mid Shōwa period, 1926-1975

119. *Calligraphy*
Munakata Shikō (1903-1975)
Hanging scroll; ink on paper, silk
mounting
Signature (seal): Muna
Calligraphy (scroll): *hana fukaki tokoro*
(Place Where Flowers Grow Deep).
Inscription (lid): *Munakata Shikō no san
ji, hana fukaki tokoro, kaku*
Three letters written by Munakata Shikō,
'Place Where Flowers Grow Deep'
Inscription (tablet): *suichū no sekizō ame
ni nureru o osorezu* (a stone statue,
wet from the rain, does not get angry).
Munakata Shikō jidai (Munkata's
own title). *Muna* (seal).
135.6 × 68.5 cm (painting only)
Mid-Shōwa period, c.1962

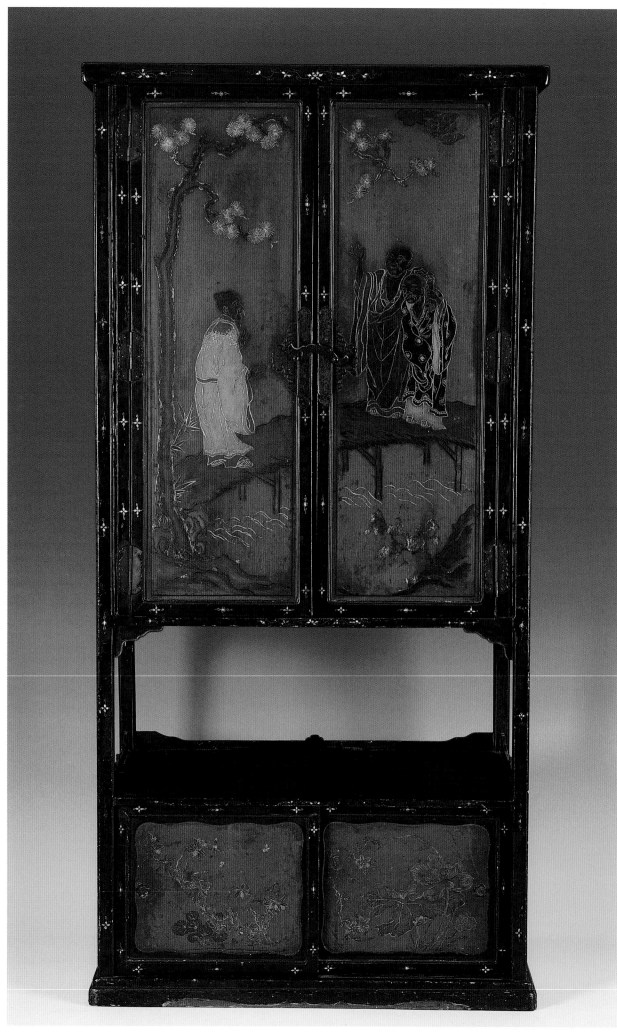

Left and opposite page:
120. *Altar (*butsudan*)*
Ryūkyū (Okinawa); wood, lacquer,
coloured litharge paint, mother-of-pearl
inlay, gold, iron hardware
163 × 81.3 × 49 cm
Edo period, 18th century

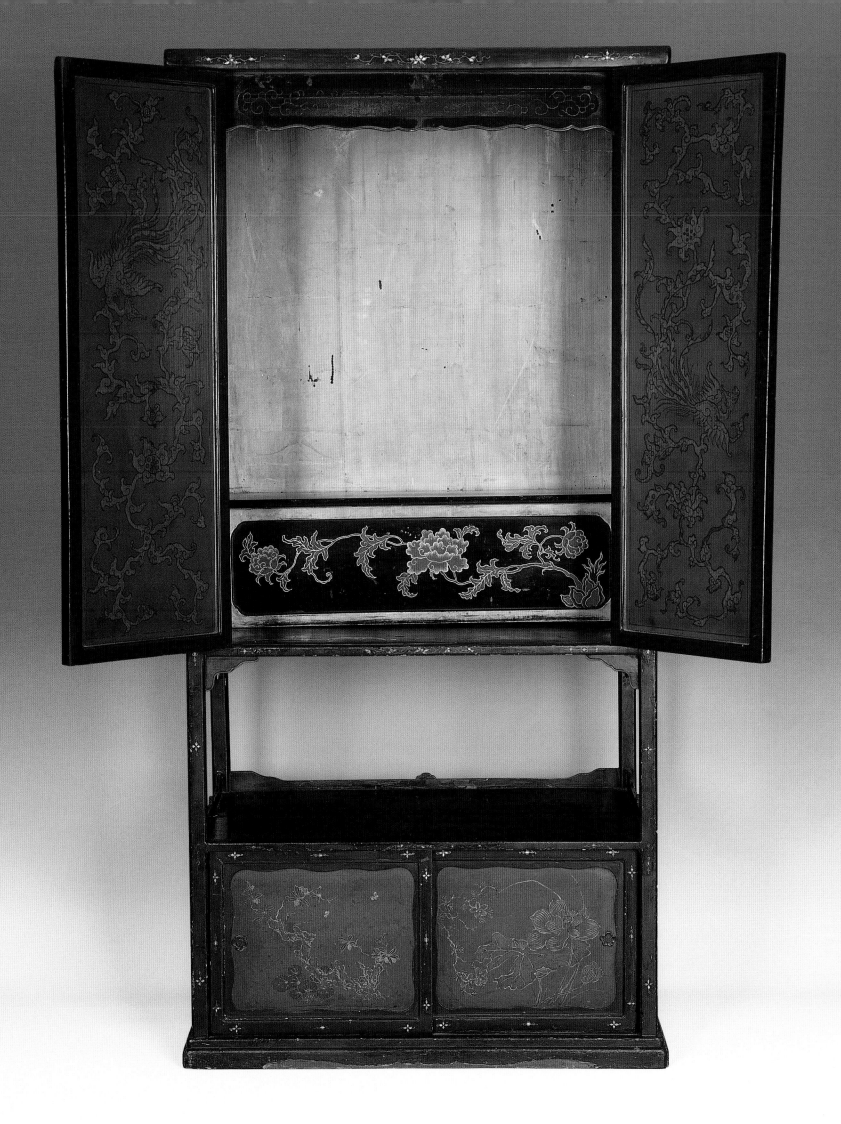

121. *Staircase Chest (*kaidan-dansu*)*
Zelkova wood (*keyaki*) wood, lacquer,
iron hardware
178.9 × 81.3 × 168.4 cm
Edo period, 19th century

122. *Storage Chest on Wheels*
(nagamochi kuruma-dansu)
Yonezawa; zelkova (*keyaki*)
and cryptomeria (*sugi*) wood, lacquer,
iron hardware
90 × 99 × 51 cm
Meiji period, 19th century

123. *Farmer's Chest on Wheels*
(nagamochi kuruma-dansu)
Zelkova wood (*keyaki*), lacquer, iron
hardware
37 × 145.5 × 73 cm
Edo period, 19th century

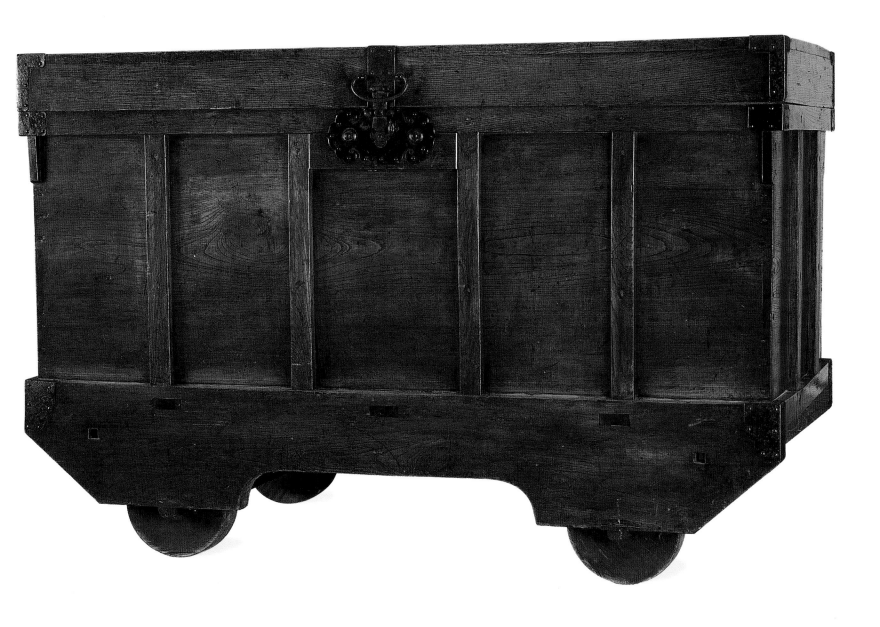

124. *Kitchen Cabinet (*mizuya*)*
Zelkova (*keyaki*) and persimmon (*khaki*)
wood, lacquer, iron hardware
71.5 × 158.5 × 48.5 cm
Late Edo-early Meiji period, 19th century

125. *Merchant's Sea Chest, Ledger Box type (chō-bako)*
Zelkova wood (*keyaki*), lacquer, iron hardware
48 × 51 × 44 cm
Edo period, late 19th century

126 a-b. *Two Garment Chests (ishō kasane-dansu)*
Yahata (Sado Island); paulownia wood (*kiri*), lacquer, iron hardware
60 × 118 × 43 cm
Taishō period, 1920's

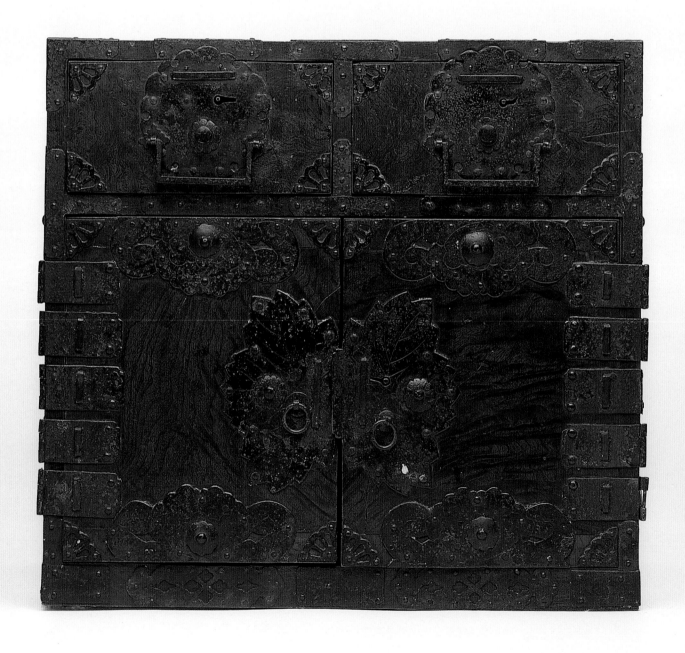

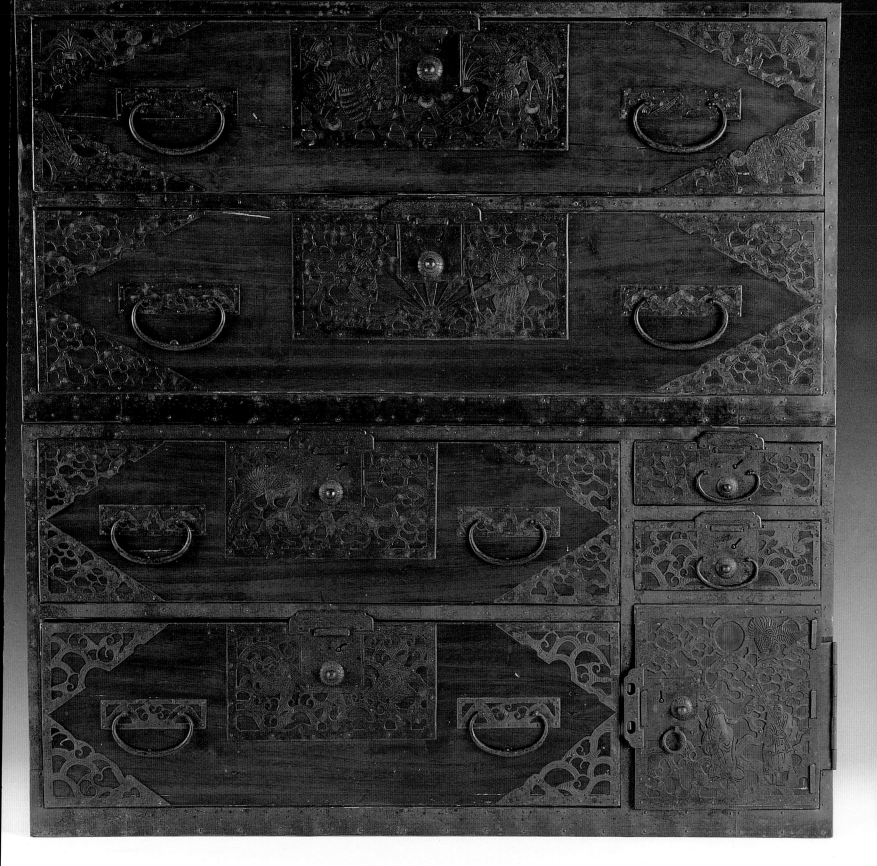

127. *Merchant's Shop Chest (*chō-dansu)
Mikuni (*Echizen*); zelkova wood (*keyaki*),
lacquer, iron hardware
87 × 93 × 40 cm
Meiji period, 19th century

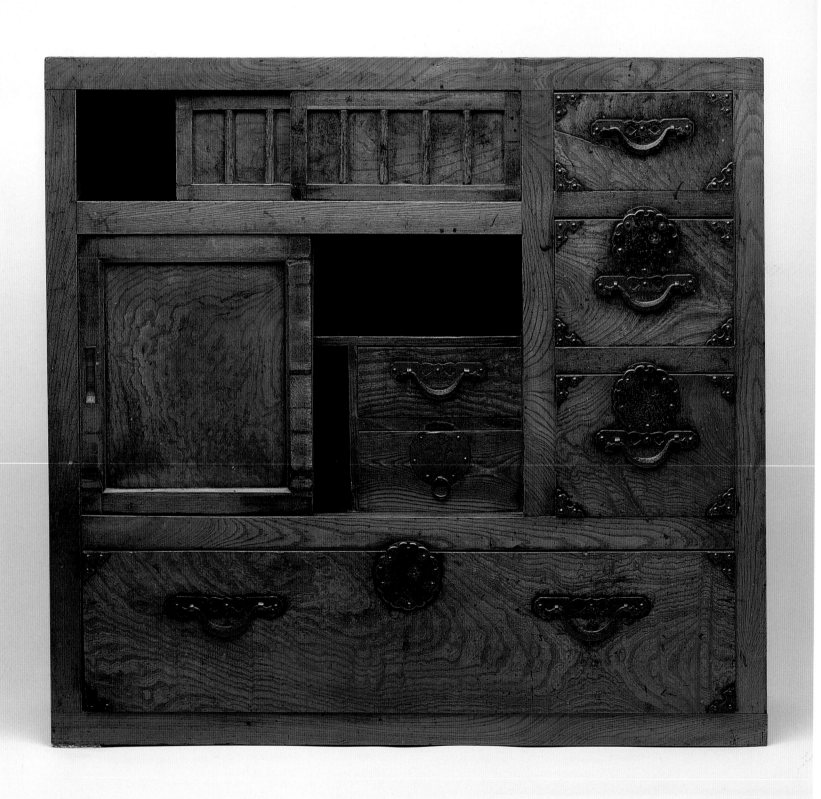

128. *Merchant's Shop Chest (*chō-dansu*)*
Tsuruoka (*Shōnai*); zelkova wood
(*keyaki*), lacquer, iron hardware
Crest (locking bar): *kara uchiwa*
(Chinese fan)
61.5 × 80.5 × 37.5 cm
Late Edo-early Meiji period, 19ᵗʰ century

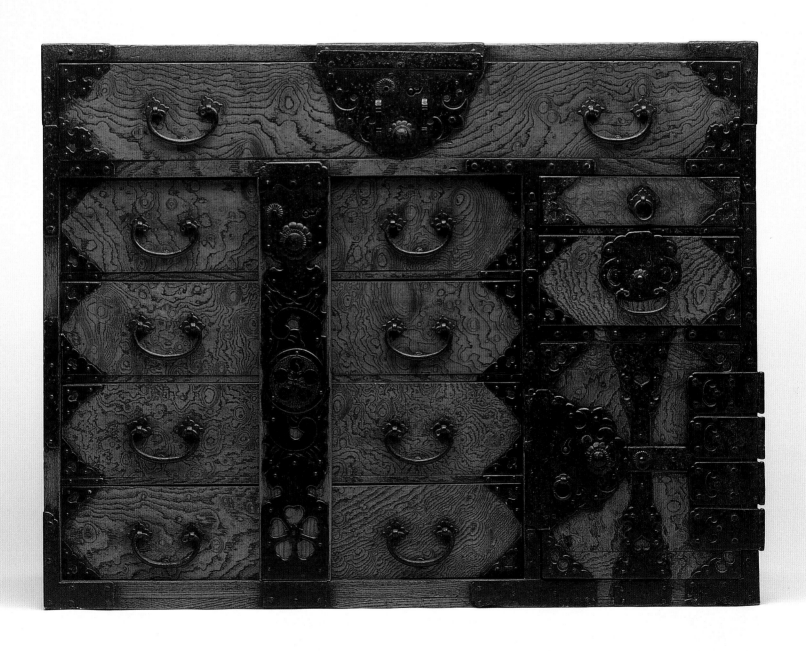

Rupert Faulkner

Ceramics

The Montgomery collection contains some one hundred and fifty ceramics, a little under half of which are illustrated in this book. They range in date from the third millennium BC to the late twentieth century, the majority being from the Edo (1615-1868) and Meiji (1868-1912) periods. From the Tōhoku region in the north-east to Okinawa in the extreme south, they come from pottery-making centres all over Japan. The prominence accorded to ceramics in the collection is a measure of the universality with which they feature in Japan, both historically and today, and of the strength of their appeal to Jeffrey's taste. Ceramics were not the first Japanese folk craft items he collected, but, prompted by memories of his mother's and grandmother's collections of Japanese and Chinese ceramics as well as by his exposure to European and North American studio pottery during the 1970s and 1980s, they soon became a major focus of concern.

The nature of Jeffrey's fascination with ceramics can be understood in terms of the characteristics shared by the works so beautifully illustrated on the following pages. Their forms, particularly those of the vats, jars and bottles, are robust, often quite rugged, and compellingly abstract in a way that only ceramic vessels can be. They are rich in the textures and muted colours that derive from the use of relatively simple glazes, often splashed or trailed for decorative effect, on stoneware clay. The painted decoration found on many of the dishes and some of the other stoneware forms is fluent, immediate and direct. This is also true of the painting on the two porcelain bottles in figures 145 and 185. The only pieces imbued with a clearly metropolitan sense of sophistication are the two enamel-decorated bottles from Kyoto in figures

148 and 144. But even these, particularly the square bottle, have an expansiveness about them that is in keeping with the other ceramics in the collection.

As suggested earlier, Jeffrey's approach to collecting is a fundamentally intuitive one. It is also ahistorical in so far as Jeffrey has never been interested, beyond concentrating in the broadest terms on Japan, in charting the development of the ceramics of a particular region or period. The varieties of ceramics favoured by Yanagi Sōetsu (1889-1961) and other members of the Japanese Folk Craft (*mingei*) movement have served as a framework for his collecting activities, but only loosely and never proscriptively. The small number of modern studio ceramics in the collection are all by makers who have been associated with the Japanese Folk Craft movement in one way or another. He has never, however, sought out the types of Chinese and, more importantly, Korean ceramics that lay so close to Yanagi's heart. At the same time he feels quite uninhibited about admiring and acquiring works for which there are no precedents in the *mingei* canon.

While the visceral excitement of coming face to face with a fine pot has always been Jeffrey's prime motivator, it is not that he is disinterested in the historical background to the pieces in his collection. On the contrary, his numerous trips to Japan have been in order to find out about the culture that produced the objects he loves; his reference library is a source of pride and joy; and he engages knowledgeably and enthusiastically with the curators and other specialists who work on his collection. With this in mind, the discussion that follows is organized along essentially historical lines. After an overview of prehistoric and early Japanese ceram-

129. *Seto ware oil dish* (aburazara) (detail)
Glazed stoneware with stencil resist design of Mt. Fuji, an eggplant and two hawk's feathers
2 × 21.5 cm
Edo period, late 18th-early 19th century

161

ics, it begins by looking at the products of Bizen, Echizen, Shigaraki, Tamba and Tokoname, kiln groups that became well-known for the manufacture of unglazed storage jars during the Kamakura (1185-1336) and Muromachi (1336-1573) periods and have seen continuous production ever since. The discussion moves on to the major ceramic-producing centres of Seto and Mino, Seto in particular being represented in the Montgomery collection by many fine pieces from the Edo period, and then to Kyoto. The products of various kiln groups established in western Japan from the late sixteenth century onwards, Karatsu and Arita being the most important of these, are considered next. This is followed by an examination of a small but choice group of wares from the Tōhoku region and Okinawa. The chapter ends with a discussion of some of the works from Jeffrey's collection of twentieth-century studio ceramics.

Japan's claim to fame as one of the great ceramic cultures of the world rests on the richness of its ceramic traditions and on the fact that its earliest ceramics are among the oldest in the world. The Jōmon period (10,500-300 BC) takes its name from the cord-impressed patterning that appeared on its powerfully sculpted earthenwares some ten thousand years ago. The succeeding Yayoi period (300 BC-AD 300) saw the emergence of new styles of earthenware that were similarly made by coil-building but had thinner walls, smoother surfaces and sharper, more regular contours. The extreme evenness of form of some Yayoi wares indicates the use of turntables for finishing.

Earthenwares of the succeeding Tumulus period (AD 258-646) are known as Haji wares. These were produced in large numbers and were fired in shallow pits. The potters who made Haji wares also produced the large *haniwa* figures that feature so dramatically in Japanese tombs of the fifth to seventh centuries. Jōmon, Yayoi and Haji wares were all unglazed, though secondary decoration by means of painting was not uncommon, particularly on Yayoi wares.

Unglazed earthenwares were ubiquitous until the twelfth century, remained important in many parts of the country throughout the Kamakura and Muromachi periods, and continued to be made in considerable numbers well into the Edo period. They are still produced today, if only in small quantities, for ritual usage.

Stoneware production started in Japan with the manufacture of Sue wares in the late fourth to early fifth century. The necessary technologies, which included the use of refractory clays, the potter's wheel and tunnel kilns with sloping floors (*anagama*) capable of reaching stoneware temperatures, were introduced from Korea. Although examples with natural ash-glazing are not uncommon, Sue wares were in principle unglazed. They were fired in reducing conditions, which resulted in their typically greyish black colouration. They were initially produced for the rich and powerful, but during the Heian period (794-1185), when they were made all over the country, they were used, like unglazed earthenwares, by the populace at large.

An important development of the late ninth century was the appearance in Sanage, a kiln group to the east of modern Nagoya, of white-bodied ash-glazed ceramics modelled after imported Chinese Yue wares. These were fired in neutral to oxidising rather than reducing conditions. From the tenth century onwards the tunnel kilns used in Sanage were fitted with a pillar between the firebox and main chamber. This so-called flame-dividing pillar improved the distribution of heat through the kiln and, by breaking up the flow of the flames from the firebox, lessened the risk of damage to the wares stacked in the lower part of the main chamber. The ash glaze, a simple suspension of wood ash in water, was applied by dipping or by brush. The resulting ceramics were nothing like as sophisticated as their Chinese prototypes, but they were, nonetheless, high quality products intended for elite consumption.

When ash-glazed wares appeared in the late ninth century, they were the first ceramics with an artificially applied high-fired glaze ever to have been made in Japan. Low-firing lead glazes, on the other hand, had already been in use for some time. Japanese lead-glazed wares were twice-fired: the body was fired blank and then coated with glaze, which was fused on by means of a secondary firing. Monochrome green-glazed wares were first produced in the seventh century. During the Nara period (710-794) two-coloured and three-coloured wares were also made, the latter being extremely close to Chinese Tang dynasty (618-906) models imported into Japan. Seventh- and eight-century products usually have a buff to reddish earthenware body. During the ninth to eleventh centuries, after which lead-glazed wares were no longer made, production was largely limited to monochrome green-glazed wares. Some had earthenware bodies as before, but there were also varieties with high-fired bodies either of a dark reduction-fired Sue ware type or of a light oxidation-fired Sanage ware type.

The demise of lead-glazed and also of ash-glazed wares during the eleventh century signalled the be-

ginning of the transition to what archaeologists refer to as Japan's medieval pattern of ceramic production. This prevailed from the twelfth to the mid-sixteenth century. In the Nagoya region there were three distinct types of manufacture. Most important in terms of output volume were numerous kilns specializing in high-fired, unglazed bowls and dishes, often rather rough-bodied, that met local demand for everyday tablewares in the same way as earthenwares did elsewhere in the country. Then there were kiln groups like Tokoname and Atsumi, both near the coast, that made large unglazed wares such as vats, jars and mixing mortars for national as well as regional distribution. Finally there was the manufacture of high quality ash- and iron-glazed ceramics known as Koseto wares. These were made in Seto, not far from Sanage to the north-east of Nagoya, in a large variety of shapes based on imported Chinese ceramics, and from the fifteenth century in neighbouring Mino as well. Koseto wares were marketed all over the country and were particularly in demand in areas where Chinese originals were either unavailable or too expensive to buy.

Elsewhere in Japan, where over twenty medieval stoneware-producing kiln groups have been identified, the main products were unglazed storage vessels similar in kind to those made at Tokoname and Atsumi. Some continued using locally inherited Sue ware traditions to produce dark reduction-fired wares. The Suzu kilns on the Japan Sea coast in the north of modern Ishikawa Prefecture are the best known of these. Other kiln groups such as Echizen were newly established using oxidation firing technology introduced from the Nagoya region. A third category, to which Bizen, Shigaraki and Tamba all belong, combined the technologies of both traditions but developed in favour of oxidation firing. Kiln groups that used oxidation firing produced wares in various shades of orange to brown, the intensity of colour being dependent on the amount of iron in the clay, as opposed to the greyish black of reduction-fired wares from Suzu and its equivalents.

The Montgomery collection includes some very fine medieval stonewares, the earliest example being the fifteenth-century Bizen jar in figure 130, which has a more than usually liberal splashing of natural ash glaze running down its front. The jar with combed patterning in figure 132 and the bottle in figure 133, both of which date from the Momoyama period (1573-1615), also have the characteristically deep purplish brown colouration for which Bizen wares are so admired. It can be seen how the neck of the bottle was deliberately covered during firing with a small jar or other vessel. This protected it from the fly ash that deposited itself over the rest of the bottle to such dramatic effect. The circular mark visible between the combed decoration and the neck of the storage jar is a potter's or workshop mark. By the late sixteenth century Bizen wares were being fired in three large communal kilns near the centre of the town of Imbe rather than in the smaller kilns in the surrounding hills that had been used previously. Because pots from different workshops were fired together, they had to be distinguished in some way, hence the use of stamped or incised marks.

The sixteenth-century jars in figures 135 and 134 come from Shigaraki and Tamba respectively. They both have an angularity of profile, particularly powerful in the case of the Shigaraki jar, that results from their having been coil-built in stages. This was done to prevent them from collapsing under their own weight, the clay having been allowed to partially dry out and harden between each stage of the forming process. Their necks and mouths are relatively smooth and regular due to the final coils from which they were made having been thrown into shape. Their bodies have a considerably lower iron content than their Bizen counterparts. With the Tamba jar, the light orange of the fired clay contrasts especially beautifully with the pale green of the natural ash glaze deposited on its shoulder. The overall effect is further heightened by the distinctive combed patterning beneath the glaze. While the Shigaraki jar is rather darker and more muted in tone, its surface is wonderfully enriched by a myriad of small white beads of fused or semi-fused particles of feldspar.

The jars and bottles from Tamba and Tokoname in figures 137, 142 and 153 are more sombrely coloured, but they all benefit from the ash deposits that have settled on their surfaces. This is particularly effective on the Momoyama period Tamba bottle with its strikingly tapered wheel-thrown form. The Tokoname jar and bottle, which date from the seventeenth and eighteenth century respectively, demonstrate the fact that unglazed stoneware storage vessels continued to be made throughout the Edo period even though glaze technology was widely available.

The use of glazes at kiln groups that had previously made only unglazed stonewares started in the second half of the sixteenth century and became firmly established during the early Edo period. The seventeenth-century tea jar in figure 143 is decorated with the classic scheme pioneered in

Tamba whereby glaze was trailed from a narrow bamboo tube over a previously applied covering of iron slip (*akadobe*). The line visible around its waist is the result of it having been assembled from two wheel-thrown components of roughly equal size. The three lugs around its shoulder were for securing the lid that would have been used to keep its contents fresh. A similar combination of iron slip and trailed glaze, in this case green ash glaze, was used on the elegantly potted nineteenth-century candle-shaped Tamba bottle in figure 183. The jars and bottles in figures 180, 178, 186 and 188 are fine examples of glazed ceramics from nineteenth-century Shigaraki. The tea jar in figure 180 bears on its shoulder the seals of its maker, Okuda Shinsai (1821-1902), a one-time *sumo* wrestler who was active as a potter during the 1860s. The interior is fully glazed, whereas the exterior has ladle-trailed copper-green splashes over an otherwise unglazed surface. This has fired a typically orange-brown colour and is flecked with white feldspar beads in the same way as the sixteenth-century jar in figure 135. The same ladle-trailed copper-green glaze was used on the bottle in figure 186, where it is combined with a cobalt-blue glaze in a delightfully rhythmic play of colours, and also on the large jar in figure 188. The trailed glazes on these two pieces were applied not directly over the clay body as in the tea jar, but, more typically, over a white-glazed ground. The 'Hagi' of the term 'Hagi-*nagashi*' used to describe the green-over-white striped patterning on the large jar comes from the name of a pottery centre in western Japan famous for its white-glazed tea bowls and other wares; *nagashi* simply means 'poured' or 'trailed'. Ladle-trailed decoration, this time of ash glaze over a brown-glazed ground, is also the distinguishing feature of the large and emphatically potted bottle in figure 178. Iron-brown and Hagi-white were standard glaze types not just in nineteenth-century Shigaraki but in many other parts of Japan as well. Popular demand for similar sorts of ceramics all over the country resulted in different local potteries adopting identical technologies and styles. This led to a uniformity, especially among larger products, that can make it difficult to distinguish between wares from different kilns.

The jar and vats in figures 155, 189 and 191 were all made in Echizen during the eighteenth and nineteenth centuries. The wheel-thrown tooth-blackening jar in figure 155 is small but heavy, and is covered in an olive-coloured ash glaze. It has two lugs and a slight spout, which would have facilitated the pouring of the tooth-blackening solution into the bowl or other receptacle that a woman would have used when applying it to her teeth. The rugged profiles of the two vats in figures 189 and 191 indicate that they were coil-built in stages like the medieval storage jars discussed earlier. The former has a total exterior covering of very thin glaze complemented by a thicker application of white rice-straw-ash glaze to its mouth and upper shoulder. The latter stands well over a metre tall and would have been kept outside the house as a container for water. The ash glaze that covers the interior as well as the exterior has fired a rich yellowish brown colour. The distinctive surface patterning, which looks as if it was created in a moment of abstract-expressionist abandon, comes from the glaze having been ladled on and then smeared about. The thick, belted rims on both jars give them an added sturdiness.

The late sixteenth to early seventeenth century was a period of major transformation not only at kilns that had produced unglazed stonewares during the medieval period. It also saw the beginning of stoneware manufacture in the former capital of Kyoto and the founding of an extensive network of kiln groups in western Japan using technology introduced from Korea. Major changes also took place in Seto and Mino, which had been the only areas to produce glazed ceramics during the Kamakura and Muromachi periods. The development of an improved version of the tunnel kiln known as the *ōgama* in the early 1500s paved the way for the flourishing in Mino of a plethora of new ceramic types such as Yellow Seto, Black Seto and Shino wares during the last decades of the sixteenth century. These were followed by Oribe wares, which appeared in early-seventeenth-century Mino after the replacement of the *ōgama* by the even more efficient and more easily controlled multi-chambered climbing kiln (*noborigama*). Developments like these were stimulated by the expansion of the domestic economy, in turn the outcome of the growing political stability of the time. The rise of the tea ceremony was also a significant factor. The growing demand for tea wares and tablewares in native as opposed to Chinese styles prompted a remarkable spate of experimentation not just in Mino but at potteries all around the country. The Bizen bottle in figure 133 is a classic example of the expressionistic approach to pottery-making that took root during the Momoyama period and has been a defining characteristic of Japanese ceramics ever since.

The examples of Seto and Mino ceramics in the Montgomery collection belong to a later period when the making of tea wares, sophisticated products for the relatively few, had been largely su-

130. *Bizen ware storage jar* (tsubo)
Stoneware with natural ash glaze
33 × 32 cm
Muromachi period, 15th century

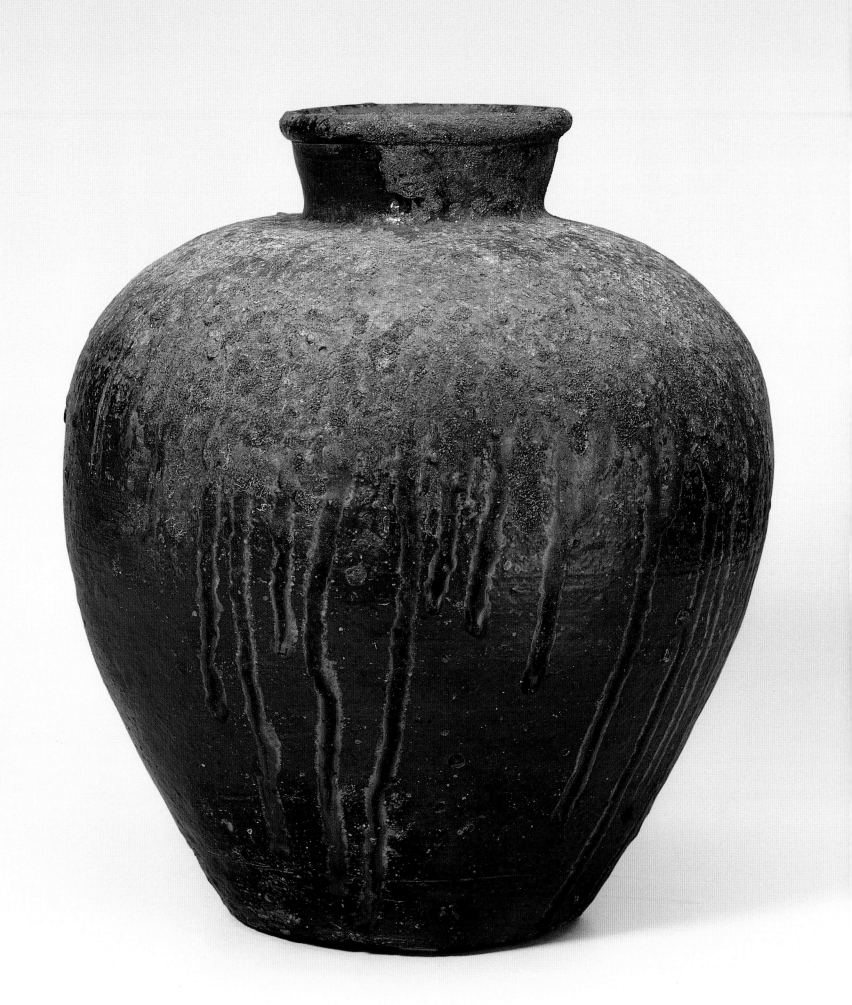

perseded by the manufacture of utilitarian ceramics for the masses. They are of three main types: vessels (figures 150, 154 and 156); oil dishes (*aburazara*) (figures 164, 168-175); and serving dishes of the 'stone' dish (*ishizara*) (figures 159-164, 166, 167, 169, 176) and 'horse-eye' dish (*umanomezara*) type (figures 165a and 165b).

The three vessels, two of them saké bottles and the third a spouted bowl, are all wheel-thrown and glazed in iron-brown. On the Mino bottle in figure 150 this was applied to only the uppermost part of the exterior, a thin transparent glaze having been used over the rouletted decoration that covers the main part of the body. This is termed 'armour scale' due to its resemblance to the patterning of the laced panels from which Japanese suits of armour are made. The drum-shaped bottle in figure 156 with its lovely caramel-coloured glaze is a *tour-de-force* of small-ware potting. Two flat-based shallow forms were thrown separately and joined mouth-to-mouth to create the body of the bottle. A hole was cut through the centre and filled with a short cylindrical tube. The neck, thrown separately like the cylindrical tube, was attached to a hole cut into the top of the bottle. Flower-shaped buttons were applied around the base of the neck and four small pieces of clay were used to form the feet on which the bottle sits. The spouted bowl with its mottled brown glaze in figure 154 is much more roughly finished than either of the saké bottles. This reflects the fact that it was made for use in the kitchen rather than at table.

Oil dishes were used to catch the drips that fell from the oil lamps and candles that were the main forms of lighting in Japan until the advent of gas and electricity. Spun brass dishes were the norm until the potters in Seto started making ceramic equivalents in the late eighteenth century. They have flat bases for maximum stability and small upright rims. The majority are decorated in the style of early-seventeenth-century Oribe wares from Mino with iron-brown painting under a clear glaze combined with patches of copper-green glaze. The copper-green has been omitted on the example in figure 129, the latter also being interesting for the way in which the decoration has been achieved not by painting but by the spattering on of the colourant over paper cut-outs laid on to the surface of the dish. A resist technique was also used on the three dishes in figures 172a, 172b and 172c. In this case the chrysanthemum motifs were painted on in the normal way and clear glaze applied over them. Wax or some other material was then used to protect the painted areas before the copper-green glaze was applied.

During the firing the resist material would have burned off, leaving the painted motifs reserved against a green background.

'Stone' dishes and 'horse-eye' dishes are generally much larger than oil dishes. They have solidly turned footrings, rounded sides and, in the case of 'stone' dishes, flat everted rims. 'Horse-eye' dishes take their name from the abstract spiral motifs with which they are decorated. These are always painted, as in the examples in figures 165a and 165b, in underglaze iron-brown. The painting on 'stone' dishes is usually in a combination of iron-brown and cobalt-blue, though there are examples like those in figures 176 and 167 that are decorated in Oribe style.

The motifs on oil dishes and 'stone' dishes are popular ones with seasonal or symbolic connotations of one kind or another. The saké flask and inscription on the dish in figure 161 allude directly to its function as a container of delicacies to be consumed with alcohol. The shrimps on the oil dish in figure 168 are somewhat enigmatic, but there is no doubt about the symbolism of the design on the oil dish in figure 169. This refers to the belief that good fortune will ensue if one sees Mt. Fuji, hawks or aubergines in one's first dreams of the New Year. The motifs on the oil dish in figure 175 represent the idea of the straw broom of Zen sweeping away human desires and the three magic jewels of Buddhism – Buddha, the Law and the Priesthood – which, to one who has achieved enlightenment, are no longer of relevance. The oil dish in figure 171 shows Mt. Fuji viewed from above the famous grove of pine trees on the promontory that juts out into Miho Bay. The view from this celebrated location on Japan's eastern seaboard was frequently depicted in Edo period gazetteers and woodblock prints.

The rabbit on the dish in figure 162 is one of the twelve zodiac animals. There is also the belief that if one looks at the full moon one can see a rabbit pounding rice. The crane on the dishes in figures 163 and 166 is primarily a symbol of longevity, cranes being popularly thought to live for a thousand years. When associated with willow fronds as in the second of these dishes, there are also connotations of spring and sexual passion. The crane is well known for its elaborate mating dance while the willow, which features on its own on the dish in figure 164, is associated with feminine elegance and the suppleness of a slender-hipped young woman.

Suppleness is also a characteristic of bamboo, the subject matter of the dish in figure 158. The ubiquity of bamboo, both as part of the natural land-

scape and as the material from which many household items have traditionally been fashioned, has led to its frequent depiction in Japanese art. The early-flowering plum, which appears in the form of scattered blossoms on the dish in figure 170, is prized as the first herald of spring. In a country where the four seasons are as clearly marked as they are in Japan, the association of particular plants with different times of the year is very strong. The peonies on the dish in figure 167 and the grapevine on the dish in figure 174 are both indicators of summer. The chrysanthemums that figure naturalistically on the dish in figure 159, and as stylized motifs on the dishes in figures 172a, 172b and 172c, are associated with autumn. Autumn is similarly suggested by the maple leaves on the dish in figure 160. The Mt. Mimura referred to in the accompanying inscription is a location near the former capital of Nara celebrated for its autumn colours. Pampas grass is another plant closely associated with autumn and the sense of melancholy that anticipation of winter brings with it. It appears on its own on the dish in figure 173 and combined with the moon and a flight of plovers on the dish in figure 176.

The painting on these various dishes is very different in feeling from the more controlled and elaborate decoration on the seventeenth- and eighteenth-century Kyoto bottles in figures 144 and 148. These were both made at the kilns that operated on the slopes of the hill on the eastern side on Kyoto below the famous Kiyomizu temple. As Japan's cultural and imperial capital from the end of the eighth century until the Meiji Restoration of 1868, when the Emperor moved to Edo (modern Tokyo), Kyoto was a major consumer of ceramics and an important centre of patronage. While unglazed earthenwares and architectural ceramics such as roof-tiles had always been produced in Kyoto, tea wares and high quality tablewares were not made locally until the end of the sixteenth century. The Kiyomizu kilns were established by potters from Seto, who initially made brown-glazed and iron-brown-painted ceramics in austere tea ceremony taste. With the advent of overglaze enamelling in the middle of the seventeenth century, however, the emphasis shifted towards the making of more colourful ceramics of the sort seen here. The square bottle is slab-built and quite heavy. The round bottle is thin-walled and very much lighter. It was thrown on the wheel and its sides were pinched into shape while the clay was still wet. The clear crackled glaze of both bottles is typical of Kiyomizu wares. The pine, bamboo and plum on the square bottle form an auspicious combination known in English as the 'Three Friends of Winter'.

From the late sixteenth until the end of the eighteenth century, when the emergence of new potteries and increasing output at other existing kiln groups began to challenge their pre-eminence, Japan's main ceramic-producing centres were Seto, Mino, Kyoto and the Karatsu-Arita complex in the north-west corner of Kyūshū, the westernmost of Japan's four main islands. Western Japan was similar to Kyoto in having been only a relatively minor producer of ceramics until the end of the medieval period. Its proximity to the Asian mainland meant that for much of its history its requirements for high quality ceramics were met by imports from China. This changed at the end of the sixteenth century when large numbers of Korean potters abducted during Japan's invasions of Korea in 1592 and 1597 were forced to settle in various parts of Kyūshū and western Honshū. The regional warlords responsible for this were keen to have access to local supplies of tea wares and other high quality ceramics. They were also eager to improve the economy of their fiefs by encouraging new forms of industry. The success of the various kiln groups established at this time depended both on local patronage and, perhaps even more critically, on the efficiency of the multi-chambered climbing kilns (*noborigama*) they used. Karatsu, for example, grew from being a small cluster of kilns in the late sixteenth century into a massive stoneware-producing centre that overtook Seto and Mino as the main supplier of tablewares to Kyoto and Osaka in the early 1600s. Seto and Mino survived because they turned their attention eastwards to the burgeoning market of Edo, but this was only after having adopted climbing kiln technology from western Japan.

The jar in figure 136 is a fine example of *madaragaratsu* or mottled Karatsu ware produced at the Kishidake subgroup of kilns in the northern part of Karatsu. It is heavily potted from grainy, reddish-firing clay and is covered with an unctuous off-white glaze. The Kishidake kilns were established by Korean potters some time after the middle of the sixteenth century and predate the expansion of the industry that followed the Korean invasions of the 1590s. The dishes in figures 138 and 139 belong to the main, seventeenth-century phase of Karatsu production. The former is simply decorated with heavy streaks of white slip applied by brush to its interior and underside. The decoration on the latter is more complicated. Stamped motifs of different shapes and sizes were

applied to the leather-hard form and brushed over with white slip. When this was dry, it was scraped away to leave the stamped patterning set in white against the dark body. The use of white slip seen on Karatsu wares and other western Japanese ceramics had its origins in Korean *punch'ong* wares, one of a number of kinds of Korean ceramics for which Japanese tea masters of the sixteenth century had developed a liking.

The decorative use of white slip is also a defining characteristic of the mid- to late Edo period bottle and water vat in figures 151 and 147. These were both made in the Takeo subgroup of kilns in the southern part of Karatsu. The spiral pattern on the bottle was made by moving a finger slowly upwards as the wet, slip-covered form was rotated on a wheel. In the case of the water vat white slip was thickly brushed on to its central and upper parts. Finger-wiping was used to create the wave pattern below the wonderfully bold depiction of a pine tree that was then executed in underglaze iron-brown and overglaze copper-green. Vats like this were a speciality of a group of kilns in the extreme south of the Takeo area and are known more specifically as Yumino wares.

While the Karatsu stoneware tradition survived to the end of the Edo period in the form of Yumino wares and their like, production of the types of ceramics that flooded the Kyoto and Osaka markets in the early 1600s did not last long. The reason for this was the discovery of porcelain stone in the neighbouring area of Arita and the development there of Japan's first native porcelain industry. This catered to growing domestic demand for porcelain such as had previously been met to a limited degree by imports from southern China. From the mid-seventeenth century onwards the Arita kilns also supplied a variety of blue-and-white and enamel-decorated porcelains to Europe and elsewhere via Chinese and Dutch merchants operating out of Nagasaki. Increasing consumer preference for porcelain resulted in the majority of Karatsu potters either abandoning their kilns or changing, if this was an option, to porcelain manufacture. The seventeenth-century and nineteenth-century bottles in figures 145 and 186 are good examples of Arita porcelain produced for the domestic market. They are both decorated in underglaze cobalt-blue, the greyish hue of the blossoming plum bough on the earlier bottle being due to the presence of impurities in the unrefined cobalt ore that was used. The horses on the later bottle are, like the rabbit on the Seto 'stone' dish in figure 162, one of the twelve zodiac animals. The examples of Edo period stoneware in figures

140, 141, 146, 149, 152 and 179 were made at Yatsushiro, Shōdai and Satsuma, some of the kiln groups other than Karatsu and Arita that were established in Kyūshū by immigrant Korean potters and their successors in the late sixteenth to early seventeenth century. The Yatsushiro and Shōdai kilns, both in modern Kumamoto Prefecture, were founded under the patronage of the locally powerful Hosokawa family. The Satsuma kilns, located in modern Kagoshima Prefecture in southern Kyūshū, prospered under the rule of the Shimazu family. The large dish in figure 140 with its combed decoration and trailed white glaze is an early and rather unusual example of Yatsushiro ware, the majority of which are decorated with complex slip-inlaid patterning in a more obviously Korean style. The three-lugged tea jar and the two bottles from Shōdai all have white rice-straw-ash glaze splashed or trailed over a darker primary glaze. The application was quite controlled in the case of the bottle in figure 179, but less so on the other two pieces, especially the tea jar in figure 149, whereby the glazes have spontaneously combined to create what one might call a natural landscape. The applied decoration around the middle of the bottle in figure 152 refers to the use of dried gourds with carrying ropes as portable drinking vessels. Applied decoration is also a feature of the splendidly robust eighteenth-century Satsuma vat in figure 146. Vats like this, which were used to store the sweet, fermented rice drink known as *amazake*, were a speciality of the Naeshirogawa subgroup of kilns. The elegantly potted bottle in figure 141 is an archetypal example of early Satsuma ware. Its mottled glaze has a hard lustrous sheen and its iron-bearing body has fired a deep reddish brown. The overall gracefulness of form and colour is enhanced by the thin metal band fitted as a repair to the rim.

The nineteenth-century bottles in figures 181 and 184 were both made at western Japanese kilns established towards the end rather than the beginning of the Edo period. The former was made at the Maruyama kilns in the northern part of modern Miyazaki Prefecture. Founded in the 1830s by a potter brought from Kyoto by the locally powerful Naitō family, the Maruyama kilns were operative for only a short period and went out of production in the late 1880s. The delightful combination of a two-coloured ground, achieved in this case by dipping the upper part of the bottle in brown slip, with underglaze iron-brown painting is typical of Maruyama wares. The Fujina kilns, at which the magnificent aubergine-shaped bottle with its contrasting white and dark brown

glazes in figure 184 was made, are located near the Japan Sea coast in modern Shimane Prefecture. They were established in the mid-eighteenth century and were patronized by the ruling Matsudaira family, for whom they made high quality tea wares at the same time as producing utilitarian ceramics for wider local consumption.

The use of contrasting glazes is also a feature of the sturdy nineteenth-century bottle in figure 177. This was made at the Matsushiro kilns in the northern part of modern Nagano Prefecture in central Honshū. The Matsushiro kilns were founded in 1816 and were active until the early twentieth century. Like the Fujina kilns, they started out by making solid utilitarian ceramics for general consumption alongside higher quality wares for use by the local rulers, in this case the Sanada family.

Moving north-eastwards to the Tōhoku region, one finds the same robustness of form and simple but effective use of dual glazes on the nineteenth-century stonewares in figures 187a, 187b, and 190. The two water vats in figures 187a and 187b were made at the Tatenoshita kilns in modern Fukushima Prefecture. Their angular profiles indicate that they were coil-built in stages. The sense of rugged spontaneity is enhanced by the liberal application of a secondary bluish white rice-husk-ash glaze over their mouths and shoulders. A similar formula was used on the vat in figure 190, which was made at the Narushima kilns in modern Yamagata Prefecture. This was also made in stages, but it has a more regular profile and a taller neck. The Tatenoshita and Narushima kilns were both founded in the eighteenth century, but their principal period of activity was during the nineteenth century.

The large dish in figure 163 with its wonderfully rhythmic trailed glaze decoration was made at the Aizu Hongō kilns in modern Fukushima Prefecture. These are recorded as having been established by a potter from Seto in 1645, which makes them one of the oldest post-medieval ceramic-producing centres in the Tōhoku region.

The *sansui dobin* or landscape teapot in figure 197 was made at the Mashiko kilns in Tochigi Prefecture, which were founded in the 1850s by potters from Kasama in neighbouring Ibaragi Prefecture. Landscape teapots were a speciality of Shigaraki introduced to Mashiko by an itinerant potter in the early 1900s. They were a popular product made in large numbers until the spread of cheap aluminium kettles in the 1930s rendered them obsolete. This particular example was painted by Minagawa Masu (1872-after 1953), a

remarkable woman who spent her life travelling around the country decorating teapots.

A film made in the 1920s shows how she worked at lightning speed, painting the formulaic landscape design in a rapid sequence of deft and lively brushstrokes.

The bottles in figures 182 and 157 hail from Okinawa at the opposite end of Japan. Okinawa is the largest of the Ryūkyū Islands, which stretch in a long arc between Japan and Taiwan. It was the centre of the Ryūkyūan Kingdom, which, although nominally subject to China, flourished as a largely independent state until the beginning of the seventeenth century. For the duration of the Edo period it was controlled by the Shimazu family, rulers of the Satsuma domain (modern Kagoshima Prefecture) in southern Kyūshū, who invaded the islands and took the king hostage in 1609. In 1879 the Ryūkyūan Kingdom was abolished by the Meiji government and incorporated into Japan as Okinawa Prefecture.

The Ryūkyū Islands are well known for the distinctive varieties of ceramics that have been produced at kilns on the island of Okinawa, the Tsuboya kilns being among the most important, and elsewhere. The eighteenth-century bottle in figure 157 is a classic example of a kind of unglazed stoneware made in large numbers for day-to-day storage purposes. These are generically known as *arayaki* or rough wares, a term used to distinguish them from so-called *uwayaki* or 'quality' glazed wares such as the nineteenth-century guitar-shaped bottle in figure 182.

The *dachibin* or hip flask in figure 196 is, like the guitar-shaped bottle, a form that is unique to Okinawa. It has lugs for the attachment of a carrying rope and a curved profile that sits comfortably against the body. This is a modern example made in the 1950s by Arakaki Eizaburō (born in 1921), a close friend of Hamada Shōji (1894-1977). Hamada is represented in the Montgomery collection by the group of dishes in figures 195a, 195b and 195c. Although he lived and worked in Mashiko after settling there in 1924, he was a regular visitor to Okinawa, where he maintained a workshop and kiln that he used during the winter months. Hamada was much influenced by what he found in Okinawa in the same way as Okinawan potters learnt much from him. The design on the wax resist decorated dish was inspired by the sugar cane plantations he saw in Okinawa. Conversely, the splashed iron-brown and copper-green decoration on Arakaki's hip flask is not traditionally Okinawan, but something he would have learnt from Hamada or his fellow potter

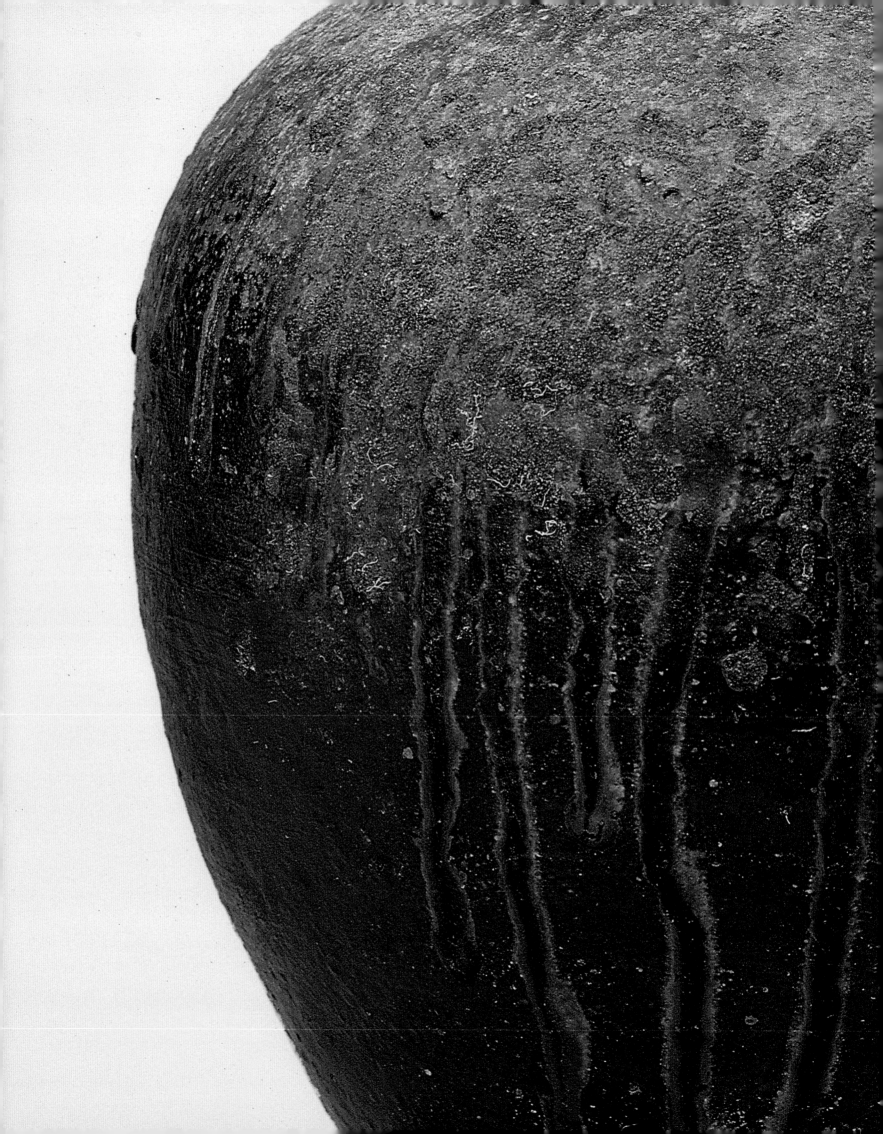

Kawai Kanjirō (1890-1966), the maker of the rectangular vase with its mottled cobalt-blue glaze in figure 194.

Hamada and Kawai are famous not only for their great artistic abilities but also for the role they played, along with Yanagi and Tomimoto Kenkichi (1886-1963), as the founders of the Japanese Folk Craft movement. A major legacy of the *mingei* project is the exceptional collection of folk crafts preserved in the Japan Folk Crafts Museum in Tokyo. This was established in 1936 and has several branches in the regions. Another legacy has been the dissemination of the belief that selflessness, anonymity and detachment from commercial concerns idealized by Yanagi as the source of the 'true' beauty to be found in historical folk crafts should be the starting point for the activities of contemporary makers. Through the writings of Bernard Leach (1887-1979), the English maker of the bottle vase in figure 193 and a close friend of Yanagi and his circle, this and other *mingei* concepts have been transmitted to Europe and North America. The notion that ideals of innocence should underlie or inform the quest for artistic originality is not unproblematic, however. It has been applied with varying degrees of success over the years, but nowadays, in a world which prizes individualism above all else, it no longer has the compulsion it had when first expounded by Yanagi. For potters working today *mingei* is more a style than a way of life. The work of Shimaoka Tatsuzō (born in 1919), Hamada's leading disciple and the maker of the faceted vase in figure 192, is very much about looking to the past as a way of negotiating the present. In no way, however, does he aspire to the state of self-negation that the logic of Yanagi's philosophy would have him do. The strength of modern *mingei* lies in its potential as a vehicle for particular forms of expression and in its celebration of continuities with the past. These are what will guarantee its survival, not the recycling of an unworkable code of ethics.

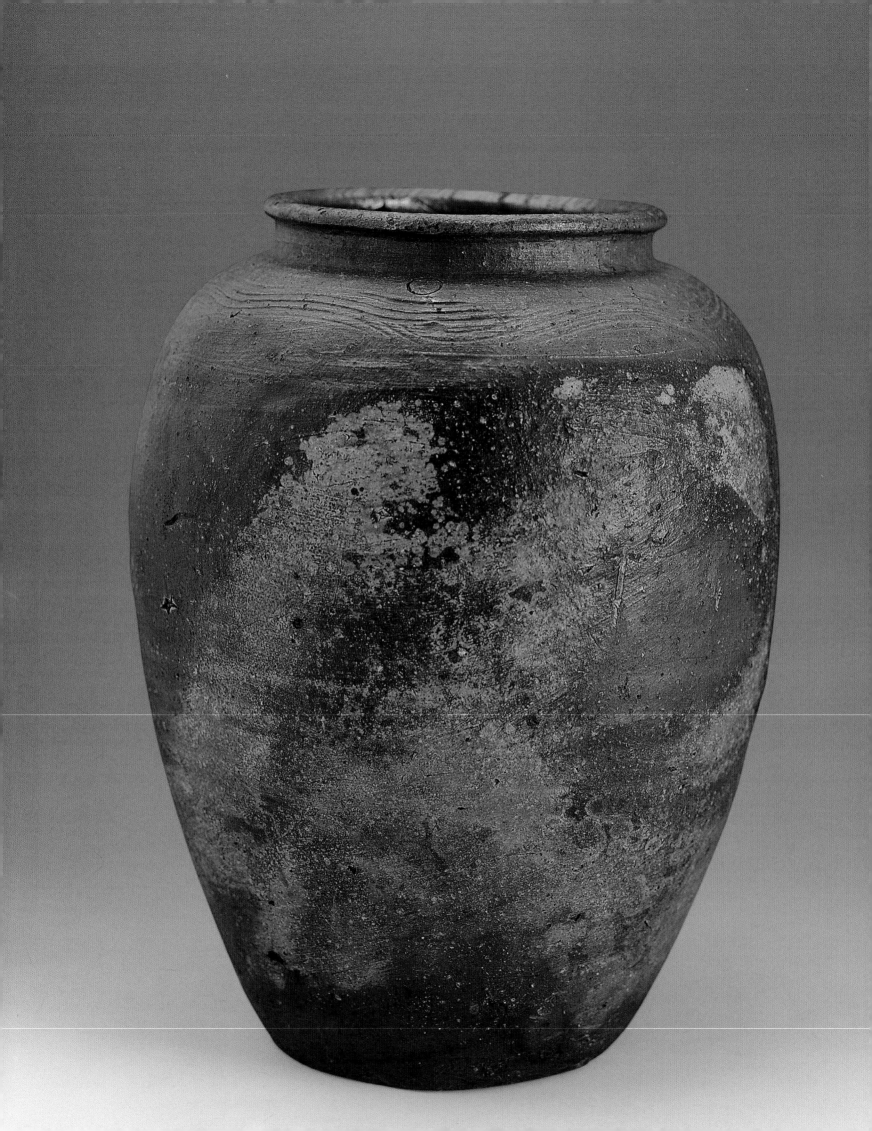

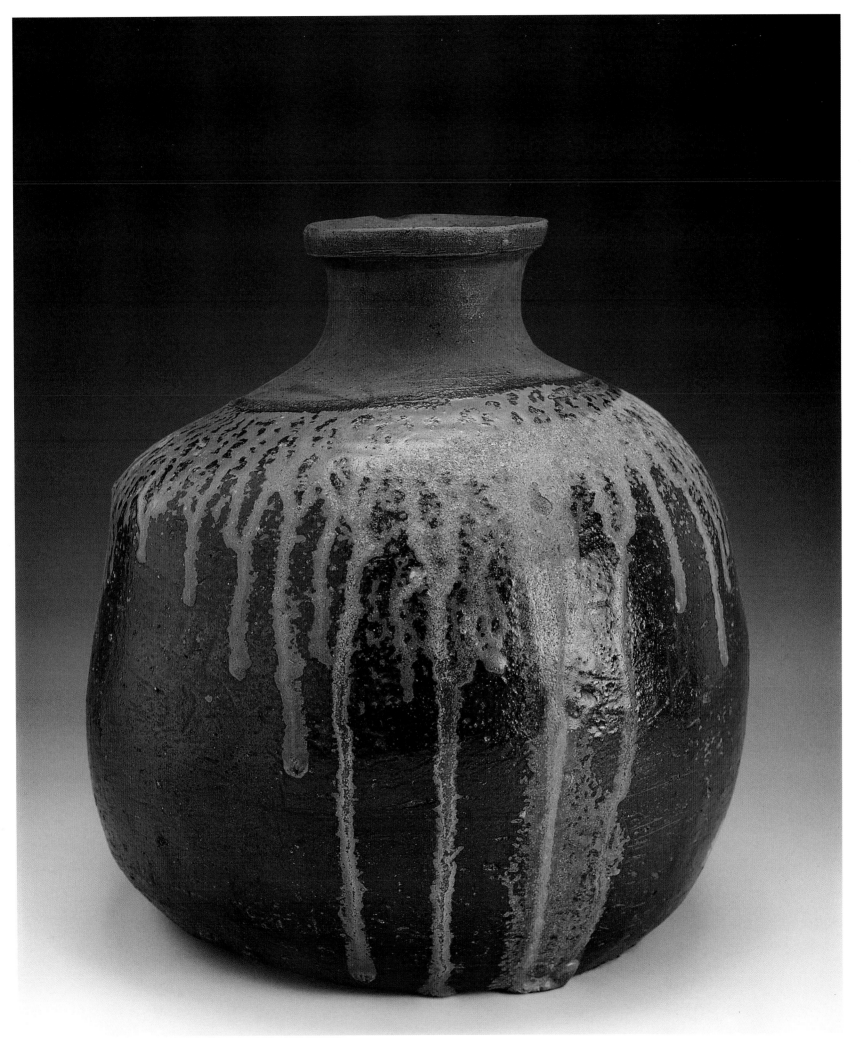

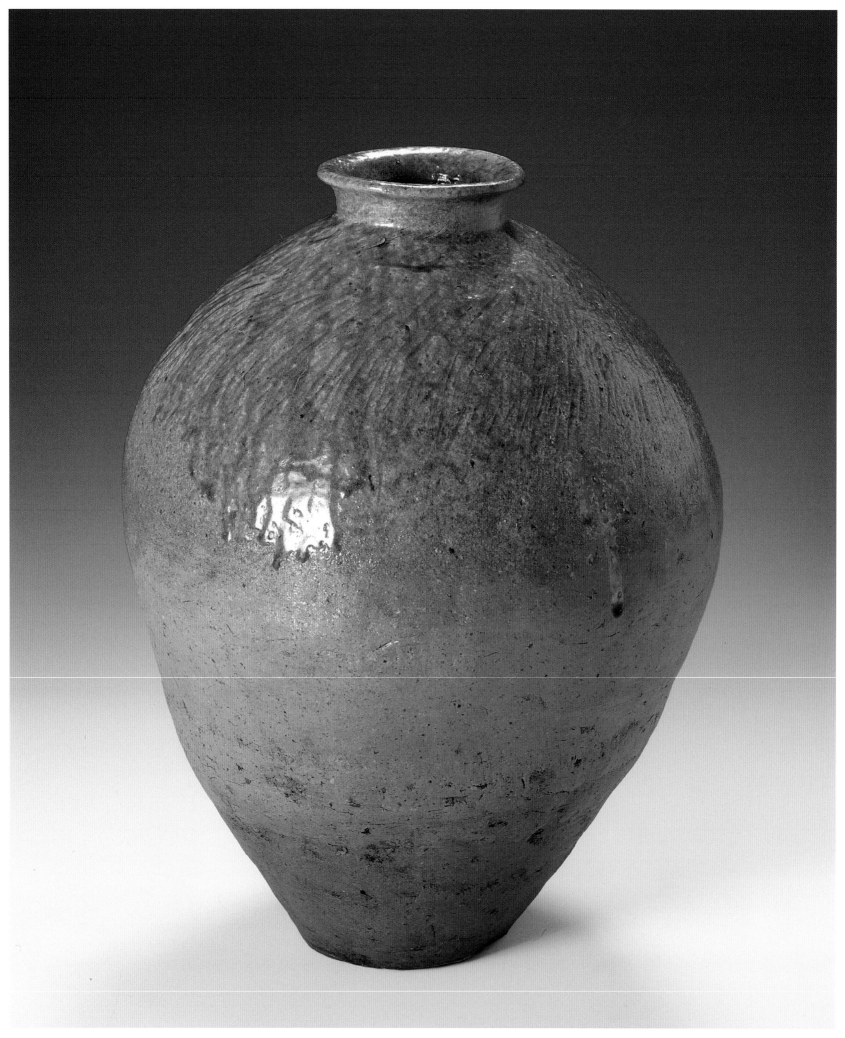

134. *Tamba ware storage jar (*tsubo*)*
Stoneware with natural ash glaze
49 × 40 cm
Muromachi period, 16th century

135. *Shigaraki ware storage jar (*tsubo*)*
Stoneware with natural ash glaze
47.5 × 39 cm
Muromachi period, 16th century

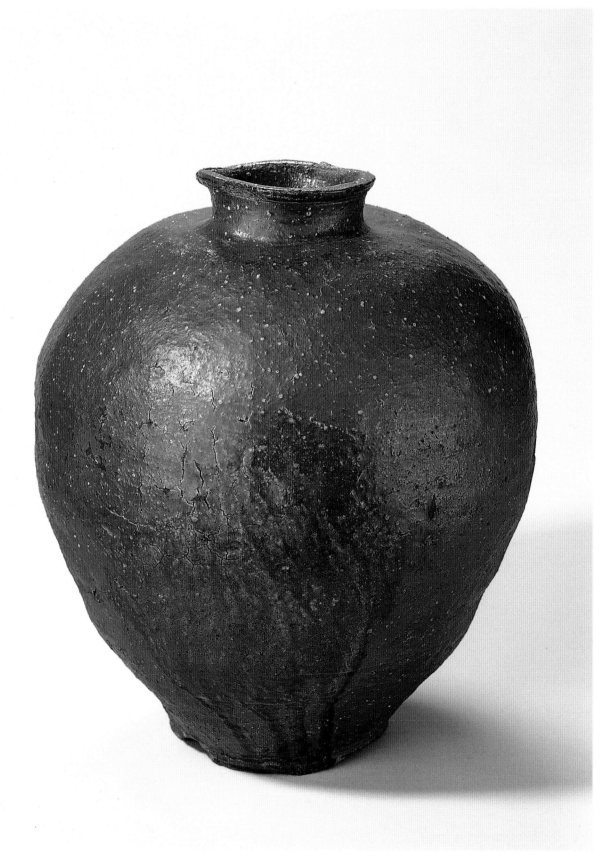

136. *Karatsu ware jar (*tsubo*)*
Glazed stoneware
13.5 × 16.5 cm
Momoyama period, late 16th century

137. *Tamba ware saké bottle (*tokkuri*)*
Stoneware with natural ash glaze
28.6 × 15.4 cm
Momoyama period,
late 16th-early 17th century

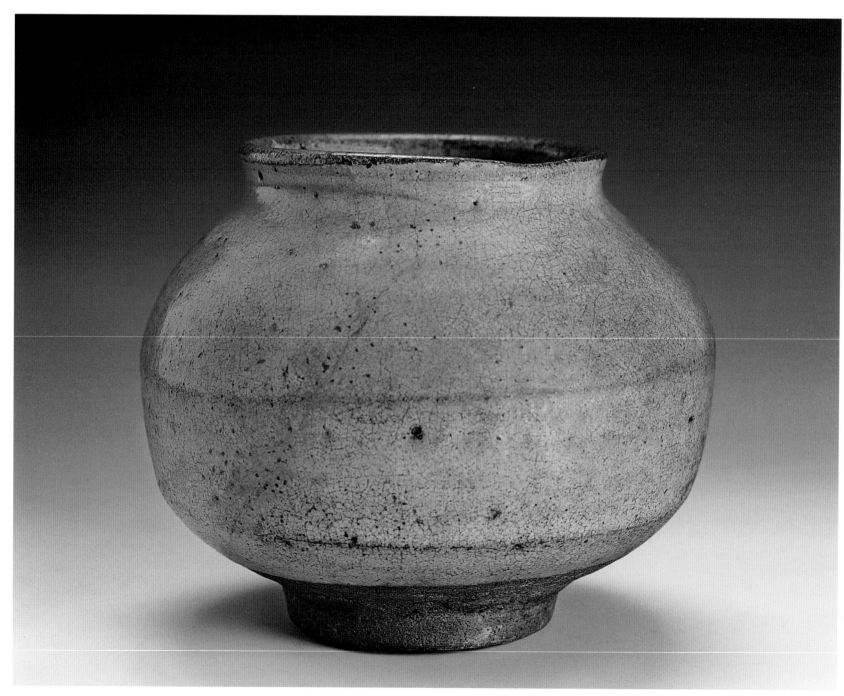

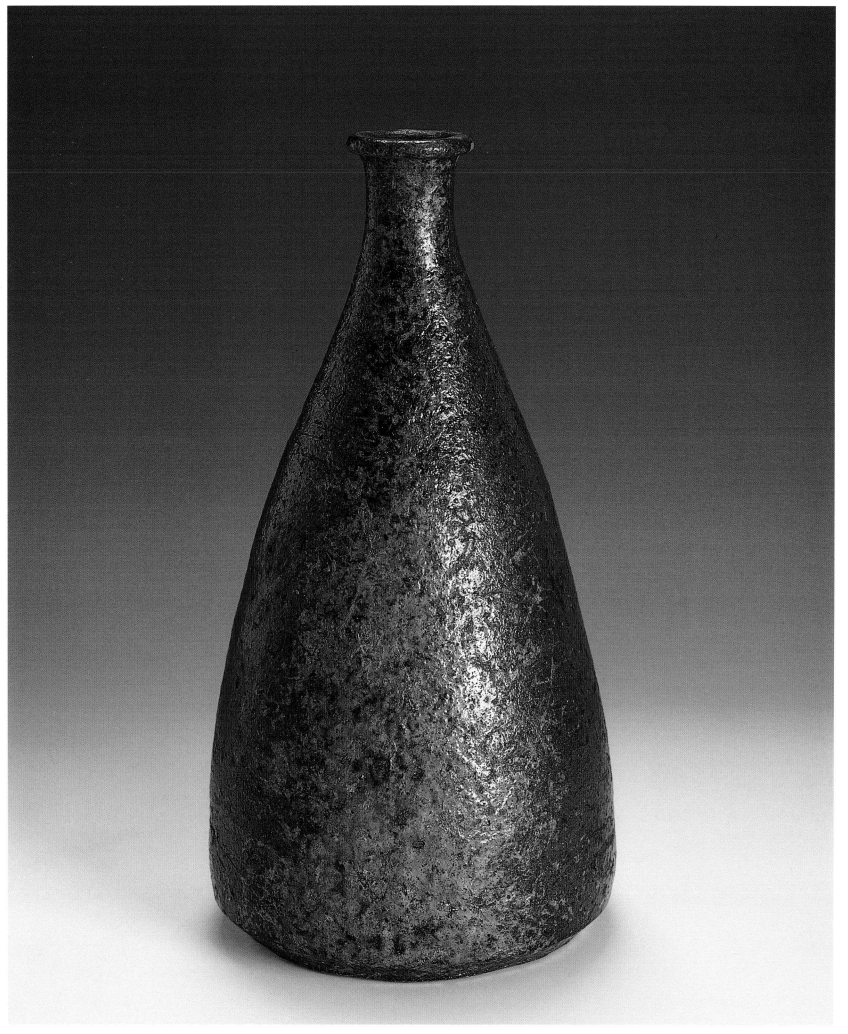

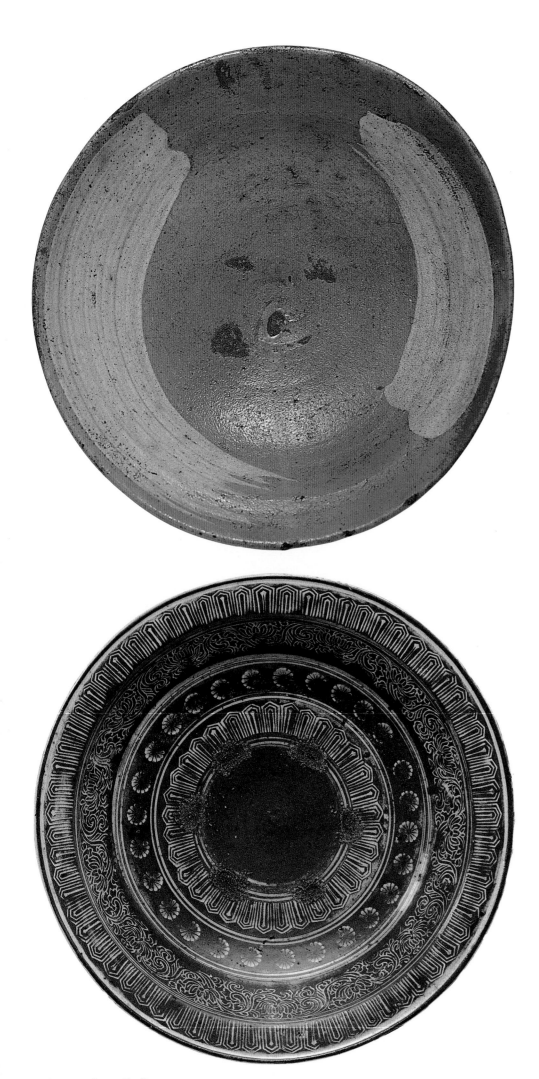

138. *Karatsu ware dish (ōzara)*
Glazed stoneware with brushed slip
decoration
7.5 × 25.3 cm
Edo period, 17th century

139. *Karatsu ware dish (ōzara)*
Glazed stoneware with stamped and
slip-filled decoration
7.5 × 30 cm
Edo period, 17th century

140. *Yatsushiro ware large dish (ōbachi)*
Glazed stoneware with combed
patterning and trailed glaze decoration
11.5 × 42 cm
Edo period, 17th century

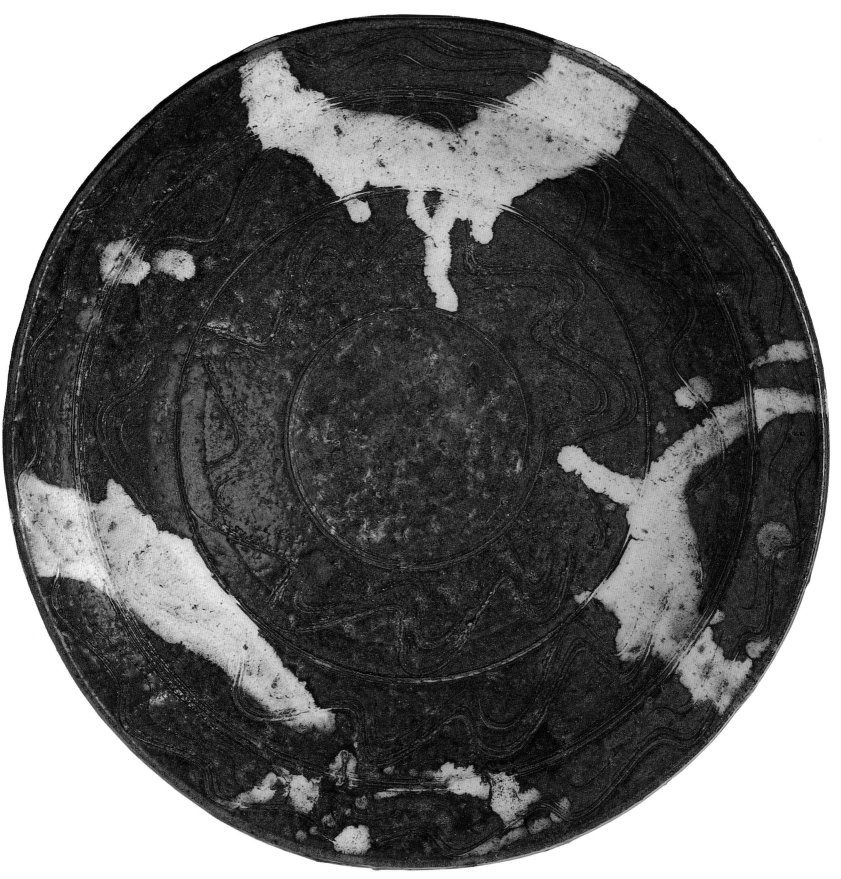

141. *Satsuma ware saké bottle (*tokkuri*)*
Glazed stoneware
23.5 × 13.5 cm
Edo period, 17th century

142. *Tokoname ware storage jar (*tsubo*)*
Stoneware with natural ash glaze
31.5 × 27 cm
Edo period, 17th century

143. *Tamba ware tea jar (*chatsubo*)*
Stoneware with slip and trailed glaze
decoration
33 × 32 cm
Edo period, 17th century

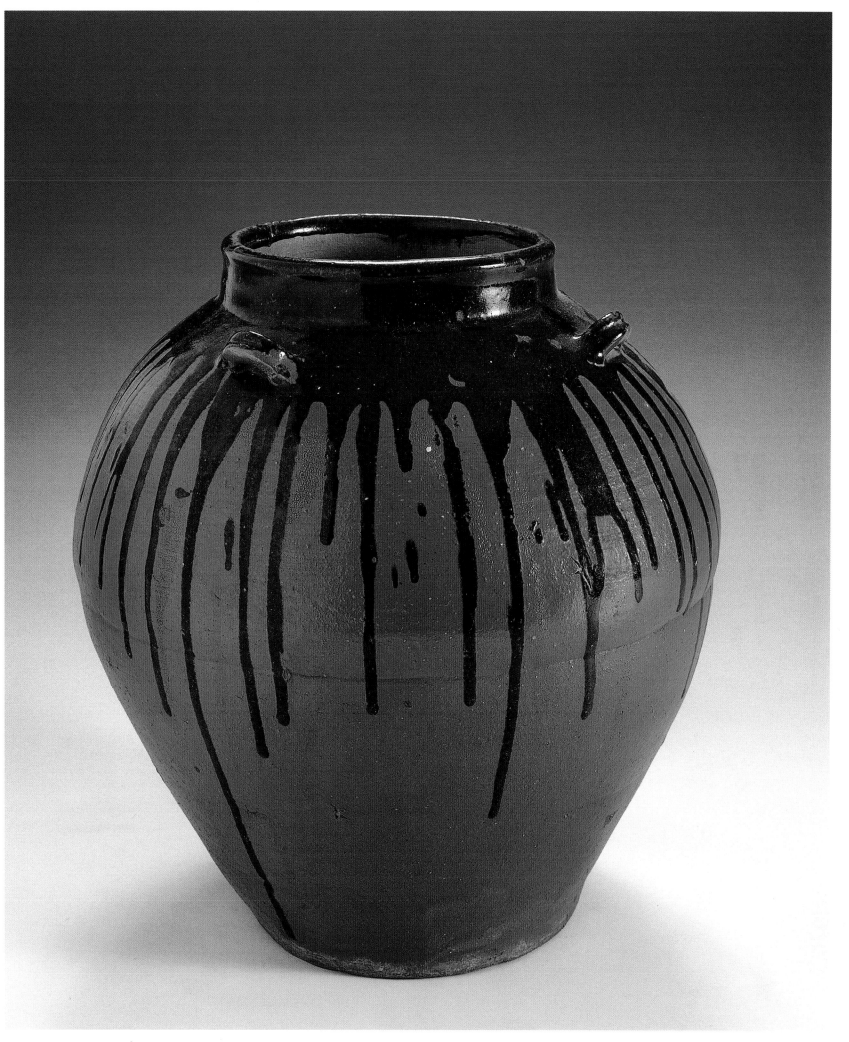

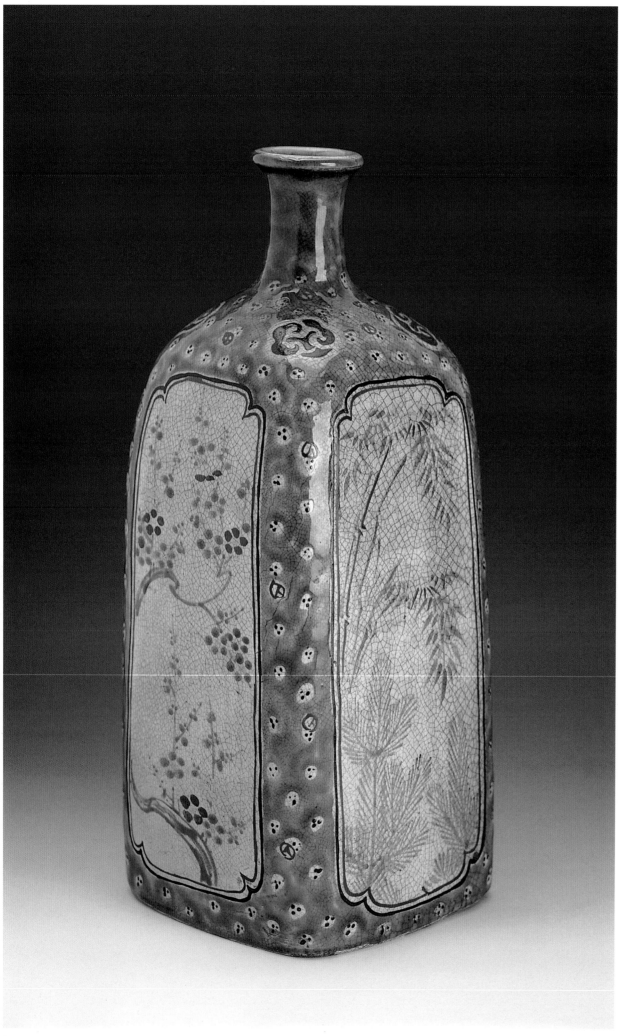

144. *Kiyomizu ware square saké bottle (*tokkuri*)*
Glazed earthenware with decoration of pine, bamboo and plum in coloured enamels and gold
16.5 × 11.9 cm
Edo period, late 17th century

145. *Arita ware saké bottle (*tokkuri*)*
Glazed porcelain with painted design of a blossoming plum bough
31 × 15 cm
Edo period, 17th century

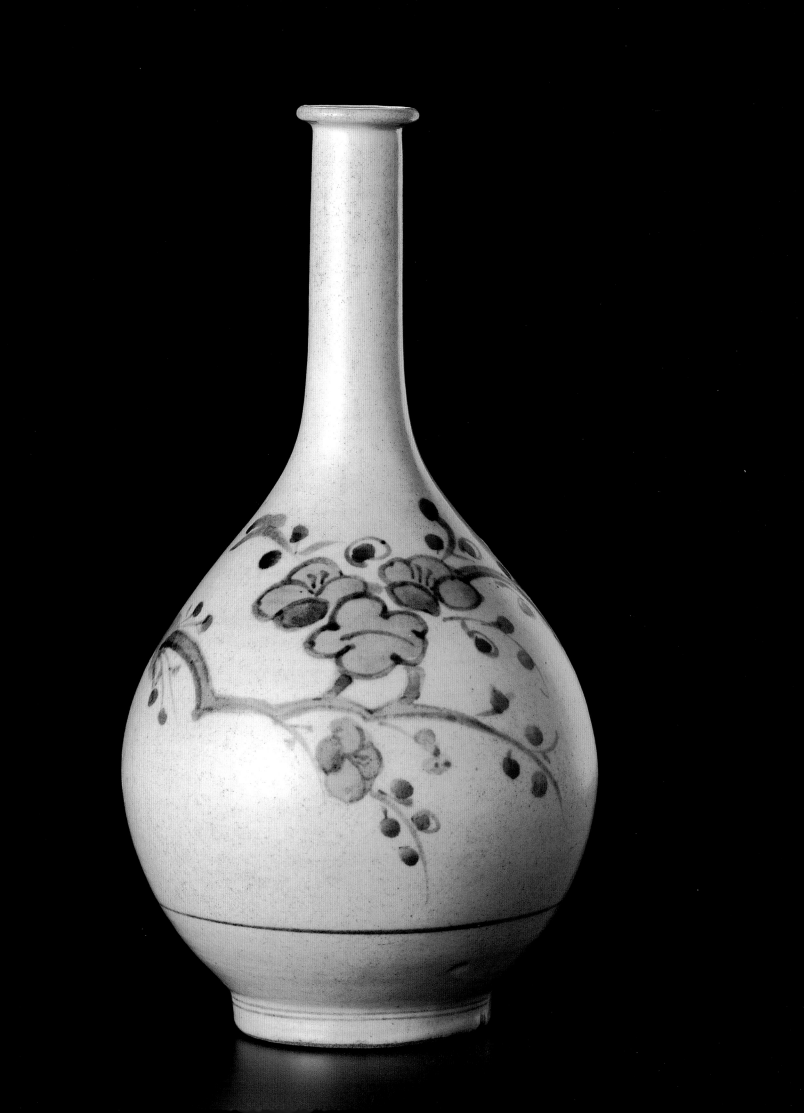

146. *Satsuma ware sweet saké* (amazake)
storage vat (kame)
Glazed stoneware with applied floral
decoration
32 × 35 cm
Edo period, 18th century

147. *Yumino ware water vat* (mizugame)
Glazed stoneware with painted design
of a pine tree
35 × 36 cm
Edo period, 18th-19th century

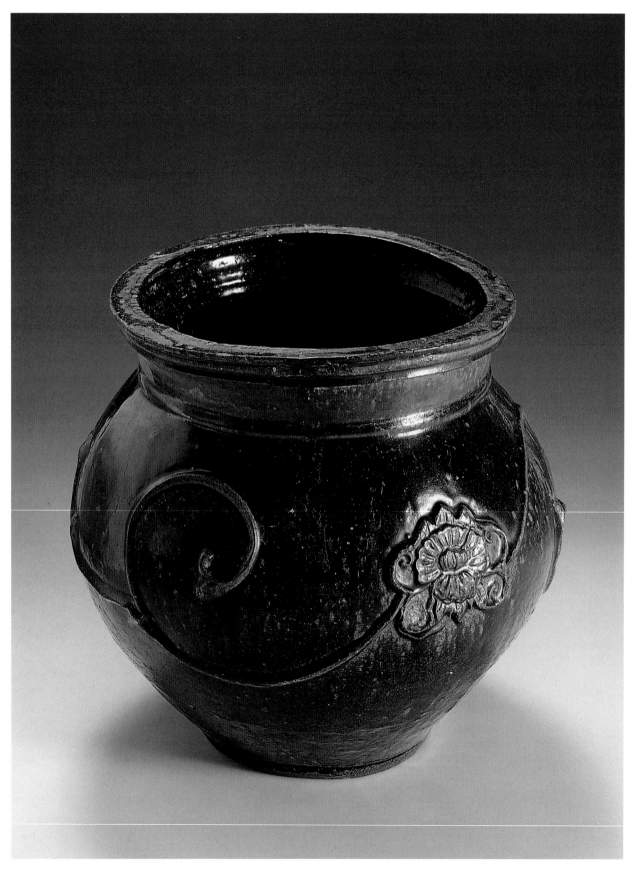

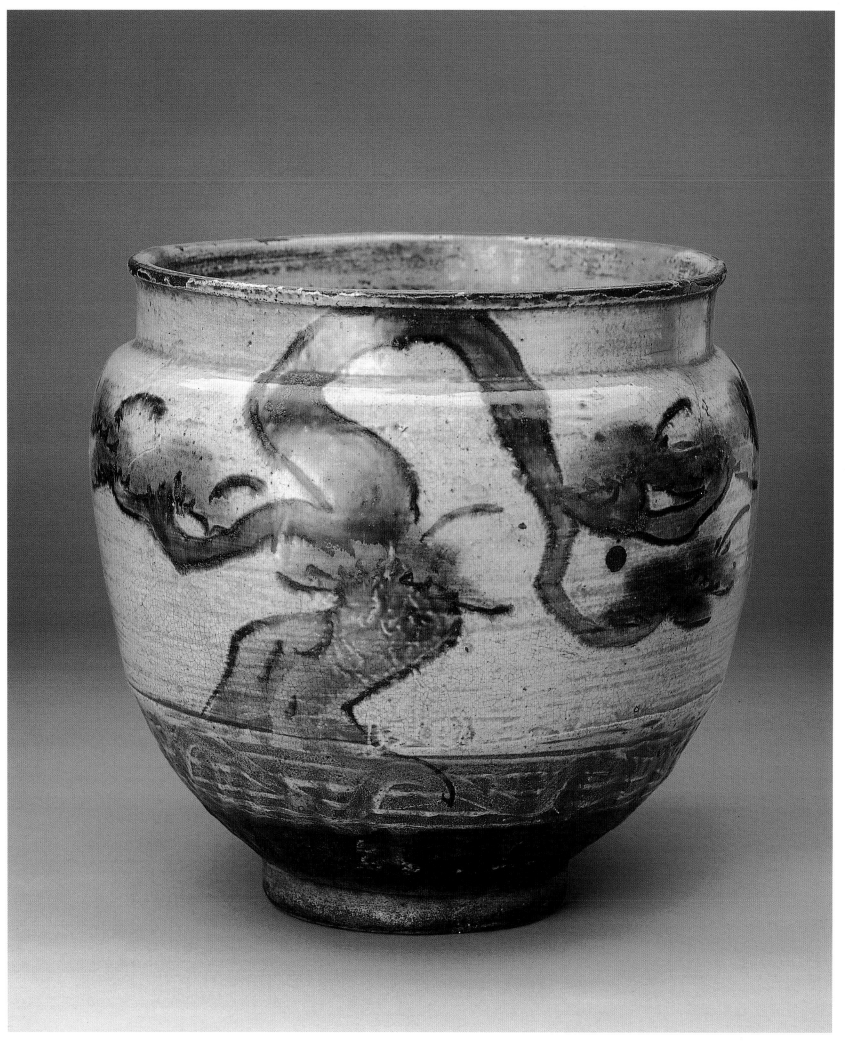

148. *Kiyomizu ware saké bottle (*tokkuri*)*
Glazed earthenware with decoration
of chrysanthemum, ivy and vine-scrolls
in coloured enamels
16.5 × 11.9 cm
Edo period, 18th century

149. *Shōdai ware tea jar (*chatsubo*)*
Glazed stoneware with trailed glaze
decoration
31 × 22.7 cm
Edo period, 18th-19th century

150. *Mino ware 'armour scale' saké bottle*
(yoroidokkuri)
Partially glazed stoneware
with rouletted decoration
27.5 × 16 cm
Edo period, 18th century

151. *Karatsu ware saké bottle* (tokkuri)
Glazed stoneware with finger-wiped
slip decoration
19.8 × 12.5 cm
Edo period, 18th century

152. *Shōdai ware gourd-shaped*
saké bottle (tokkuri)
Glazed stoneware with applied
rope decoration
28.5 × 19.5 cm
Edo period, 18th century

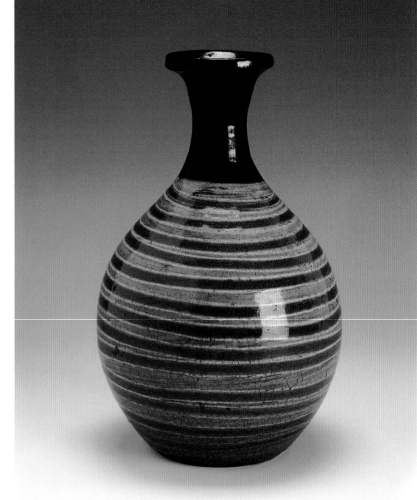

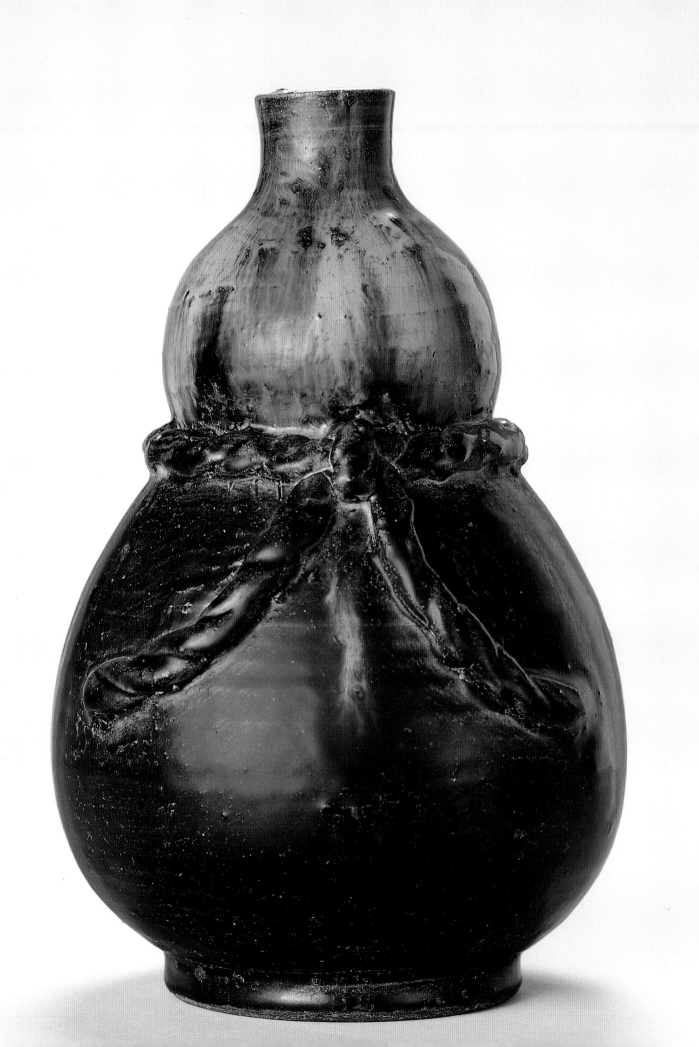

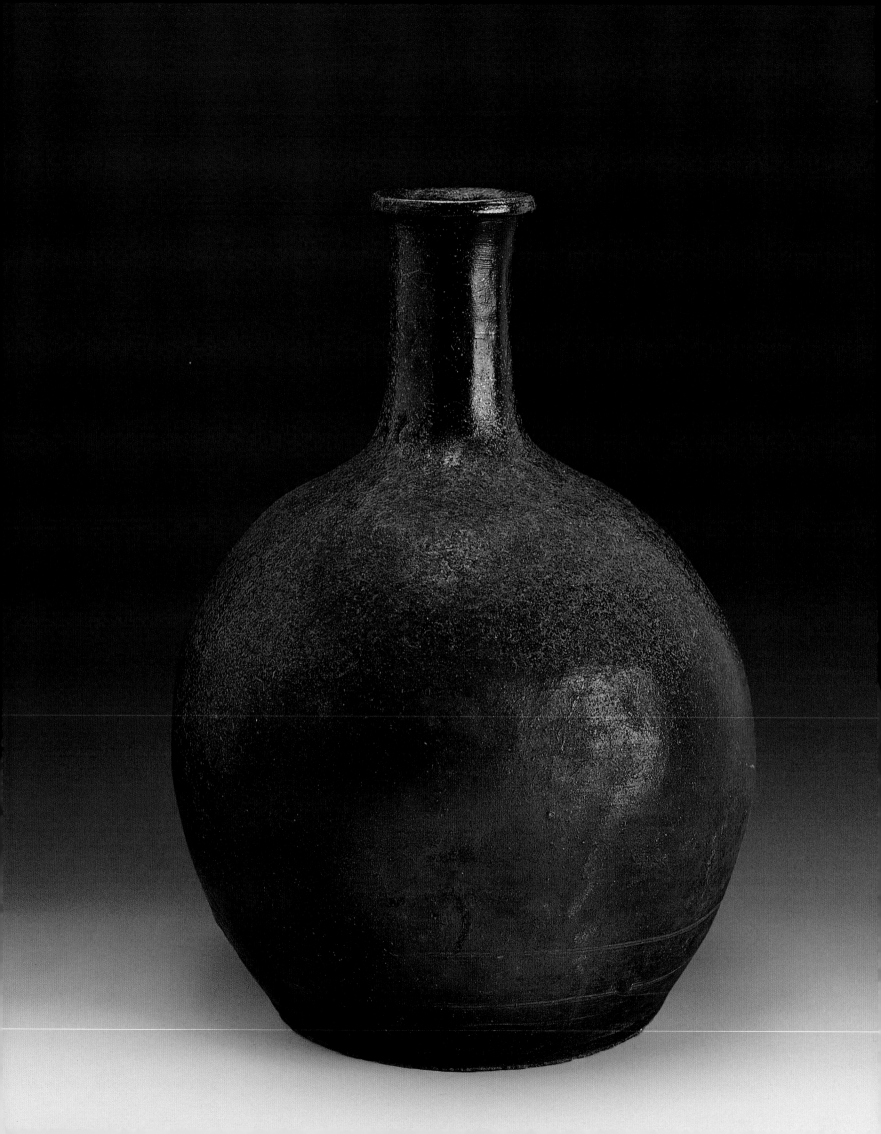

153. *Tokoname ware ship's*
*saké bottle (*funadokkuri*)*
Stoneware with natural
ash glaze
30 × 23 cm
Edo period, 18th century

154. *Seto ware spouted bowl*
(katakuchi*)*
Glazed stoneware
11 × 23 × 18.5 cm
Edo period, 18th century

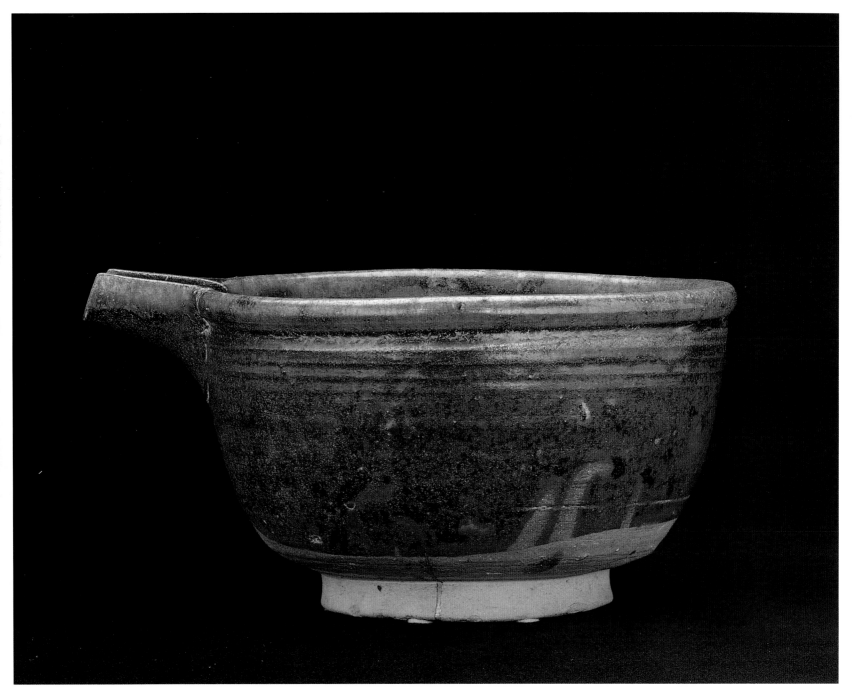

155. *Echizen ware tooth-blackening jar (ohagurotsubo)*
Glazed stoneware
16.0 × 15.5 cm
Edo period, 18th century

156. *Seto ware drum-shaped saké bottle (tokkuri)*
Glazed stoneware
20 × 15 × 7.2 cm
Edo period, 18th century

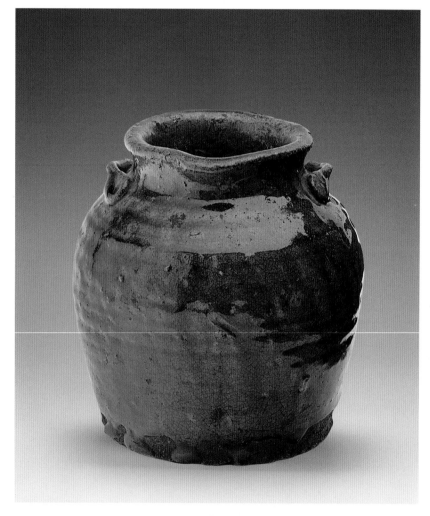

157. *Okinawan saké bottle (*tokkuri*)*
Unglazed stoneware
24.2 × 8.5 cm
Edo period, 18th century

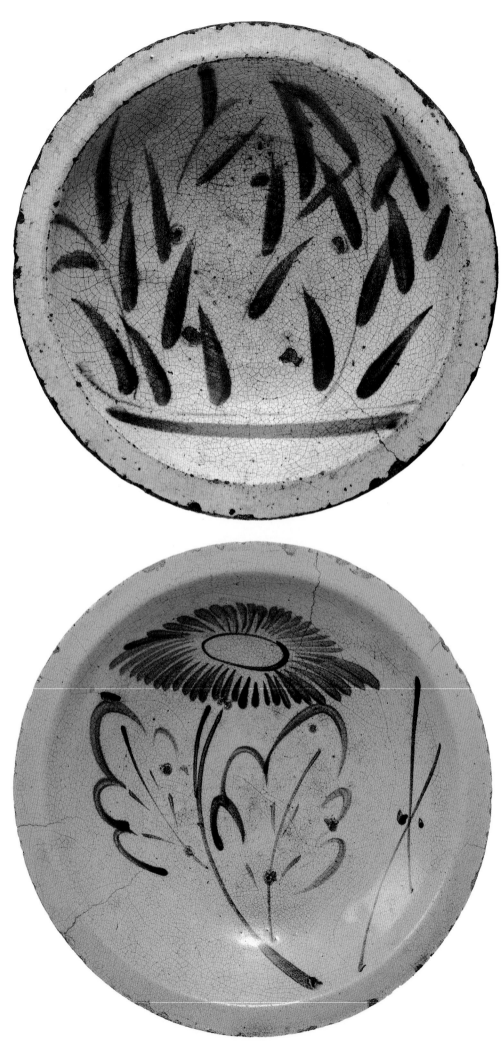

158. *Seto ware 'stone' dish (*ishizara*)*
Glazed stoneware with painted design
of bamboo
6.8 × 27 cm
Edo period, late 18th-early 19th century

159. *Seto ware 'stone' dish (*ishizara*)*
Glazed stoneware with painted design
of a chrysanthemum
7.5 × 35.8 cm
Edo period, late 18th-early 19th century

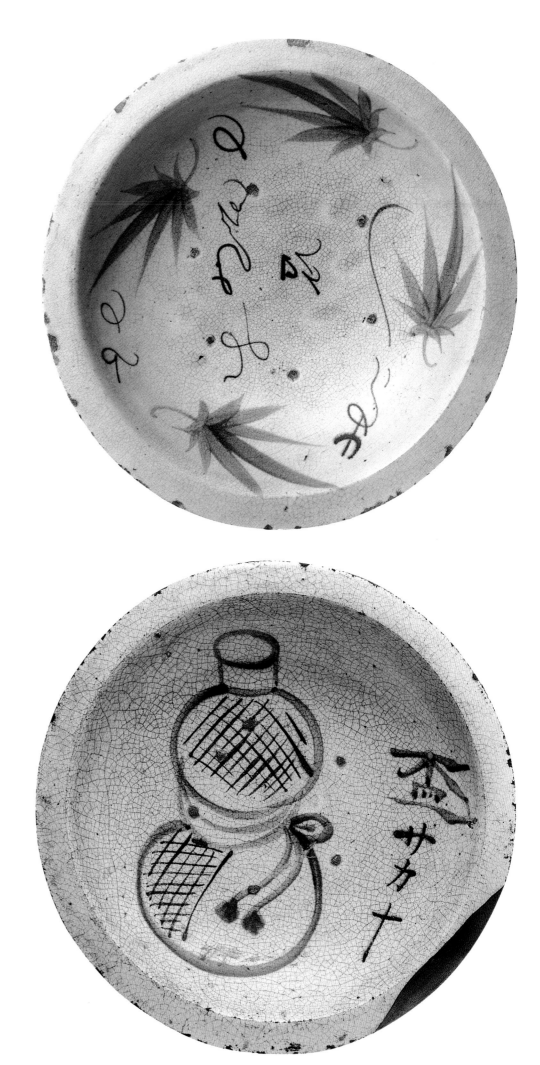

160. *Seto ware 'stone' dish (*ishizara*)*
Glazed stoneware with painted design
of scattered maple leaves and the
inscription '*Arashi fuku / Mimura
no yama ni*' ('At Mt. Mimura a storm
is blowing')
6 × 33 cm
Edo period, late 18th-early 19th century

161. *Seto ware 'stone' dish (*ishizara*)*
Glazed stoneware with painted design
of a gourd-shaped saké bottle and the
inscription '*Sakazuki sakana*'
('Saké cup and tidbits')
6 × 27.5 cm
Edo period, late 18th-early 19th century

162. *Seto ware 'stone' dish (*ishizara*)*
Glazed stoneware with painted design
of a rabbit
5 × 27.5 cm
Edo period, late 18th-early 19th century

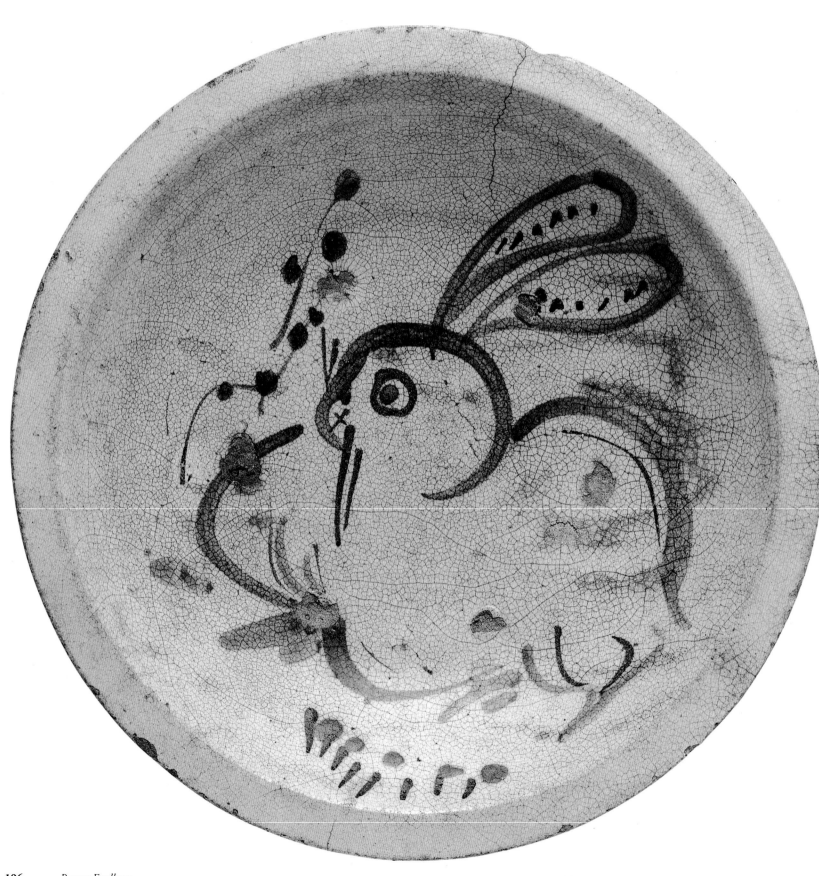

163. *Seto ware 'stone' dish (*ishizara)
Glazed stoneware with painted design
of a crane
6 × 29 cm
Edo period, late 18th-early 19th century

164. *Seto ware 'stone' dish (*ishizara*)*
Glazed stoneware with painted design
of a willow tree
5.7 × 27 cm
Edo period, late 18th-early 19th century

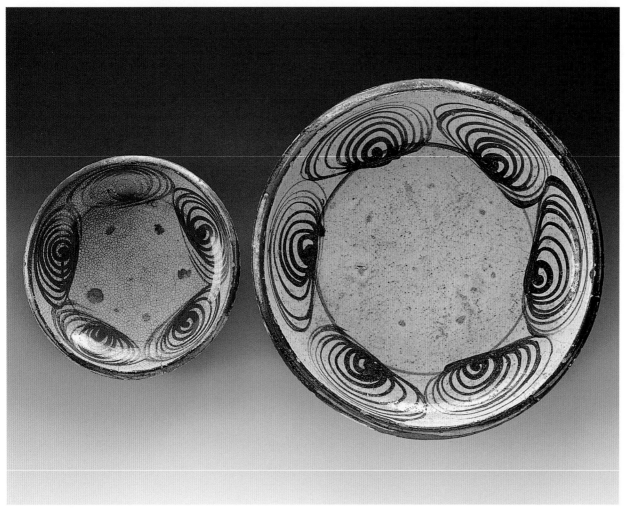

165a. *Seto ware 'horse-eye' dish*
(*umanomezara*)
Glazed stoneware with painted decoration
4.6 × 21.5 cm
Edo period, late 18th-early 19th century

165b. *Seto ware 'horse-eye' dish*
(*umanomezara*)
Glazed stoneware with painted decoration
6 × 34.5 cm
Edo period, late 18th-early 19th century

166. *Seto ware 'stone' dish (*ishizara*)*
Glazed stoneware with painted design
of a crane and willow fronds
4.7 × 22.5 cm
Edo period, late 18th-early 19th century

167. *Seto ware 'stone' dish (*ishizara*)*
Oribe style glazed stoneware with painted
design of butterflies and a peony
6.4 × 34 cm
Edo period, late 18th-early 19th century

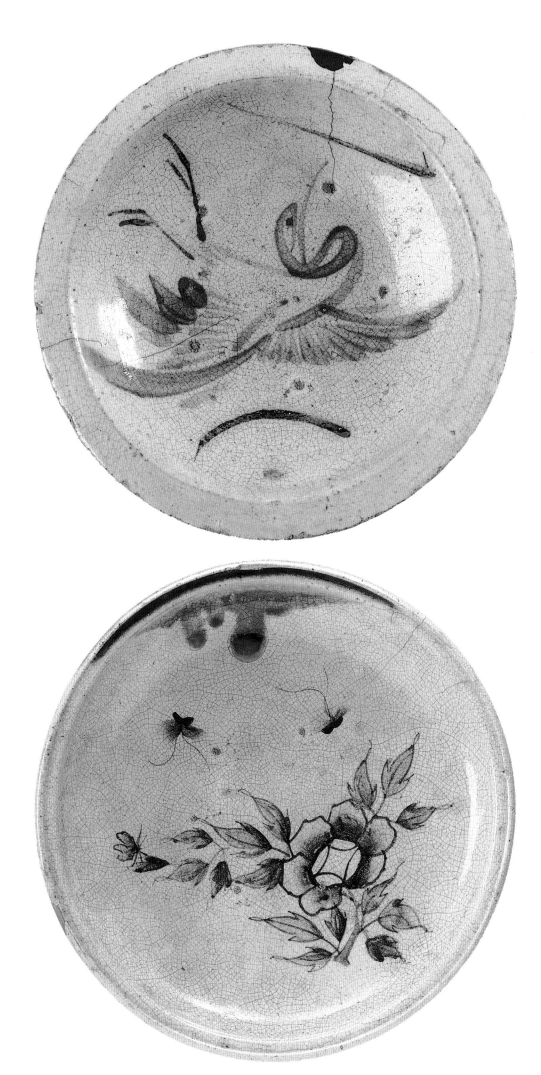

168. *Seto ware oil dish (*aburazara*)*
Oribe style glazed stoneware with painted
design of shrimps
1.8 × 23 cm
Edo period, late 18th-early 19th century

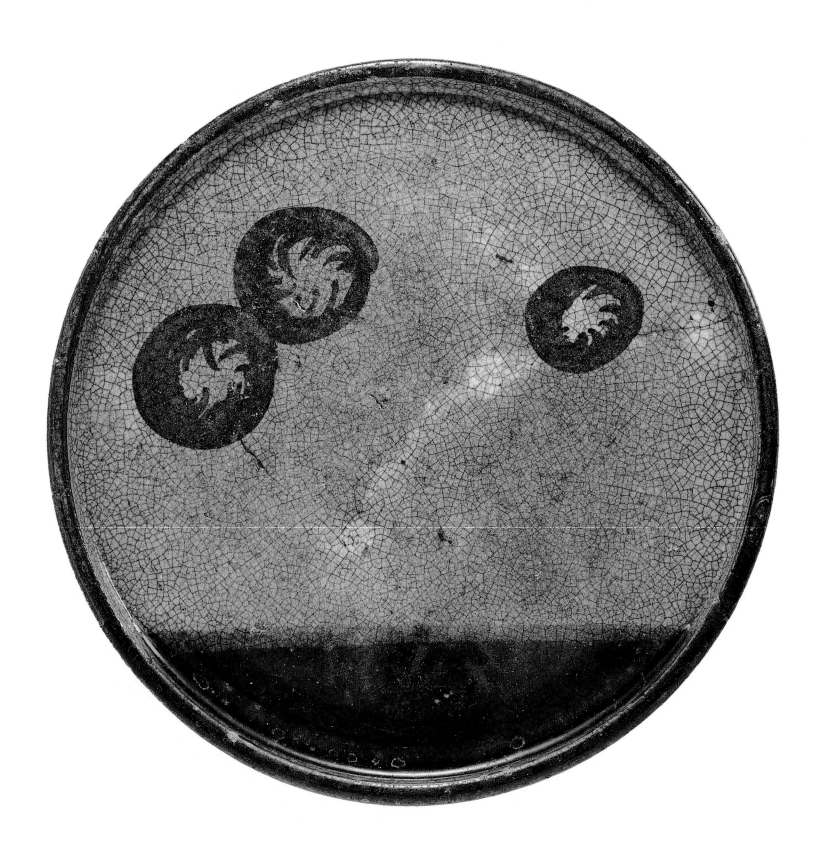

169. *Seto ware oil dish (*aburazara*)*
Glazed stoneware with stencil resist
design of Mt. Fuji, an eggplant and two
hawk's feathers
2 × 21.5 cm
Edo period, late 18th-early 19th century

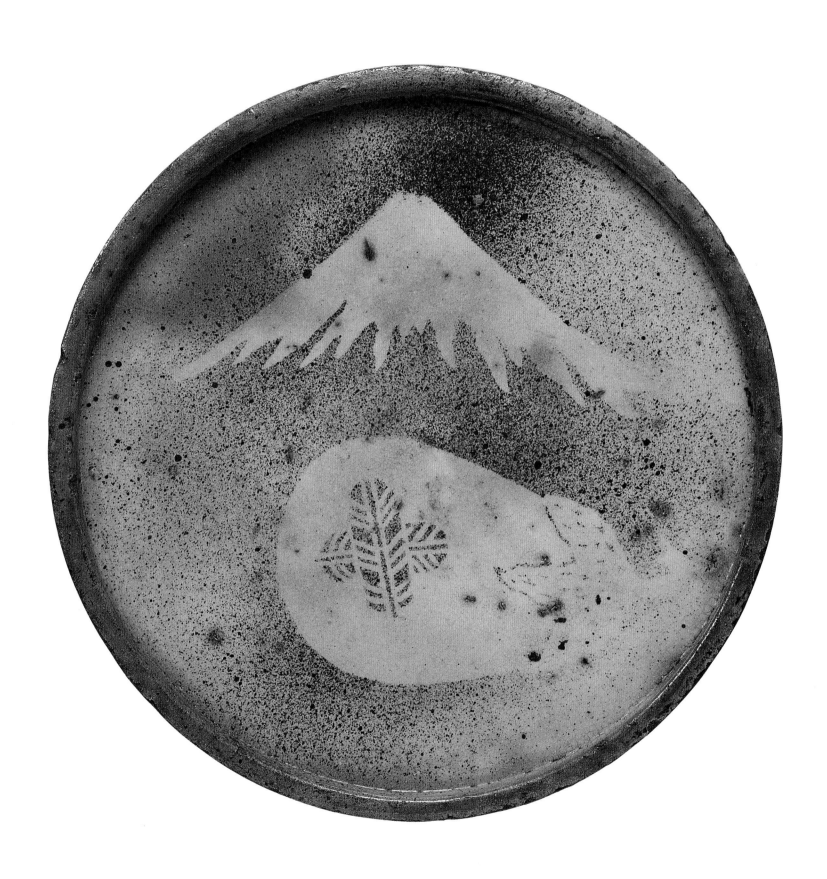

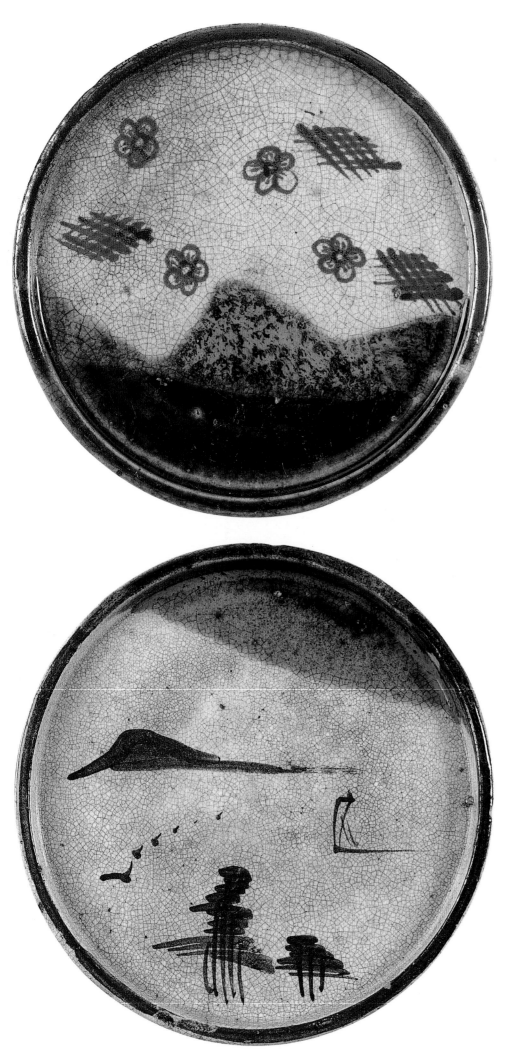

170. *Seto ware oil dish* (*aburazara*)
Oribe style glazed stoneware with painted
design of plum blossoms and trellises
2 × 18.5 cm
Edo period, late 18th-early 19th century

171. *Seto ware oil dish* (*aburazara*)
Oribe style glazed stoneware with painted
design of Mt. Fuji seen across Miho Bay
2.5 × 19 cm
Edo period, late 18th-early 19th century

172a. *Seto ware oil dish* (*aburazara*)
Oribe style glazed stoneware with painted
design of chrysanthemums
1.7 × 22.5 cm
Edo period, late 18th-early 19th century

172b. *Seto ware oil dish* (*aburazara*)
Oribe style glazed stoneware with painted
design of a chrysanthemum
1.7 × 22.5 cm
Edo period, late 18th-early 19th century

172c. *Seto ware oil dish* (*aburazara*)
Oribe style glazed stoneware with painted
design of chrysanthemums
2.3 × 21.5 cm
Edo period, late 18th-early 19th century

173. *Seto ware oil dish (*aburazara*)*
Oribe style glazed stoneware with painted
design of pampas grass
2 × 19.5 cm
Edo period, late 18th-early 19th century

174. *Seto ware oil dish (*aburazara*)*
Oribe style glazed stoneware with painted
design of a grapevine and trellis
2 × 22.6 cm
Edo period, late 18th-early 19th century

175. *Seto ware oil dish (*aburazara*)*
Oribe style glazed stoneware
with painted design of a broom
and the three magic jewels
2 × 28.3 cm
Edo period, late 18th-early 19th century

176. *Seto ware 'stone' dish (*ishizara*)*
Oribe style glazed stoneware with painted
design of plovers, moon and pampas grass
3.5 × 27 cm
Edo period, late 18th-early 19th century

177. *Matsushiro ware large saké bottle*
(tokkuri)
Glazed stoneware
45.5 × 30 cm
Edo-Meiji period, 19th century

178. *Shigaraki ware large saké bottle*
(tokkuri)
Glazed stoneware with trailed glaze
decoration
45.5 × 30 cm
Meiji period, 19th century

179. *Shōdai ware saké bottle (*tokkuri*)*
Glazed stoneware with trailed glaze
decoration
17.5 × 19.5 cm
Edo period, 19th century

180. *Maker's marks* Kyō *('Grant a prayer')*
and Shin *('Faith') impressed on shoulder*
*Shigaraki ware tea jar (*chatsubo*)*
By Okuda Shinsai (1821-1902)
Stoneware with trailed glaze decoration
31 × 28.2 cm
Edo-Meiji period, 1860s

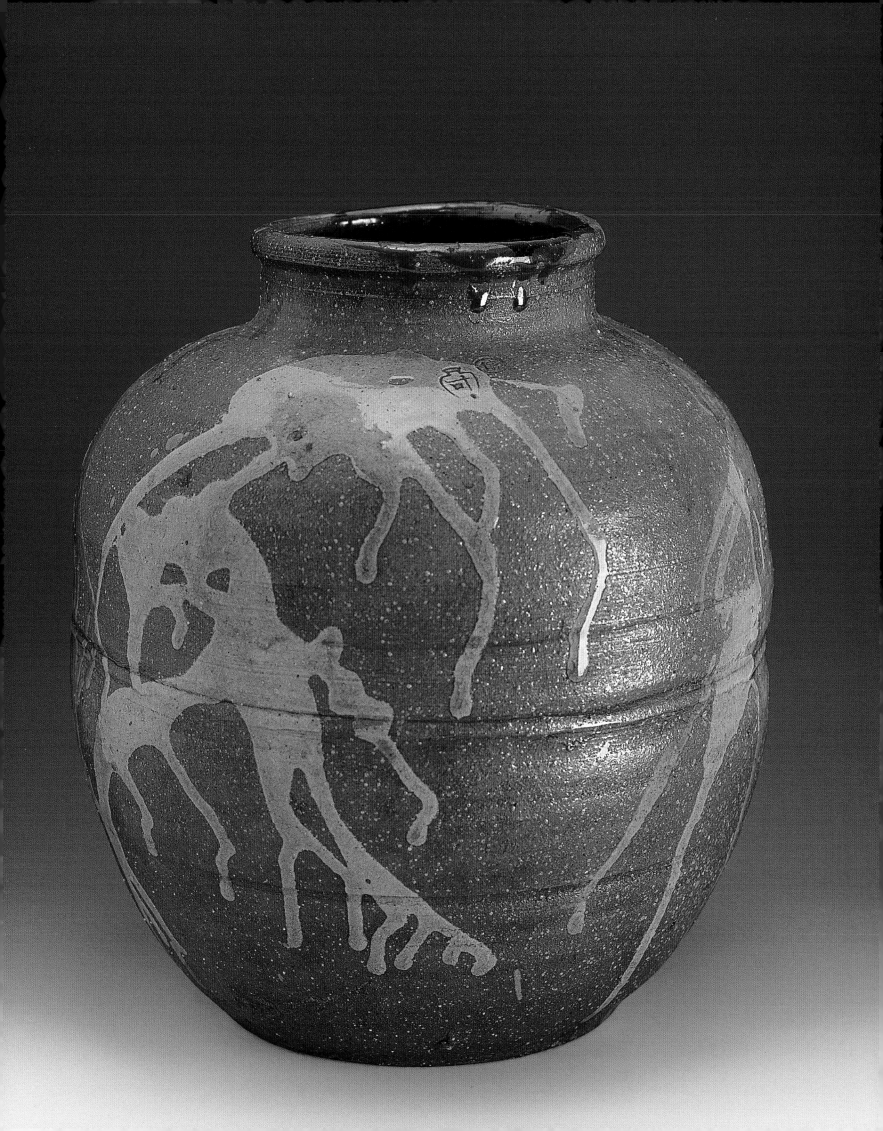

181 a-b. *Maruyama ware saké bottle*
(tokkuri*)*
Glazed stoneware with painted design
of flowering plants and insects (butterfly?)
21 × 9.8 cm
Edo-Meiji period, 19ᵗʰ century

182. *Okinawan gourd-shaped saké bottle (*tokkuri*)
Glazed stoneware
28.3 × 13 cm
Edo period, 19th century

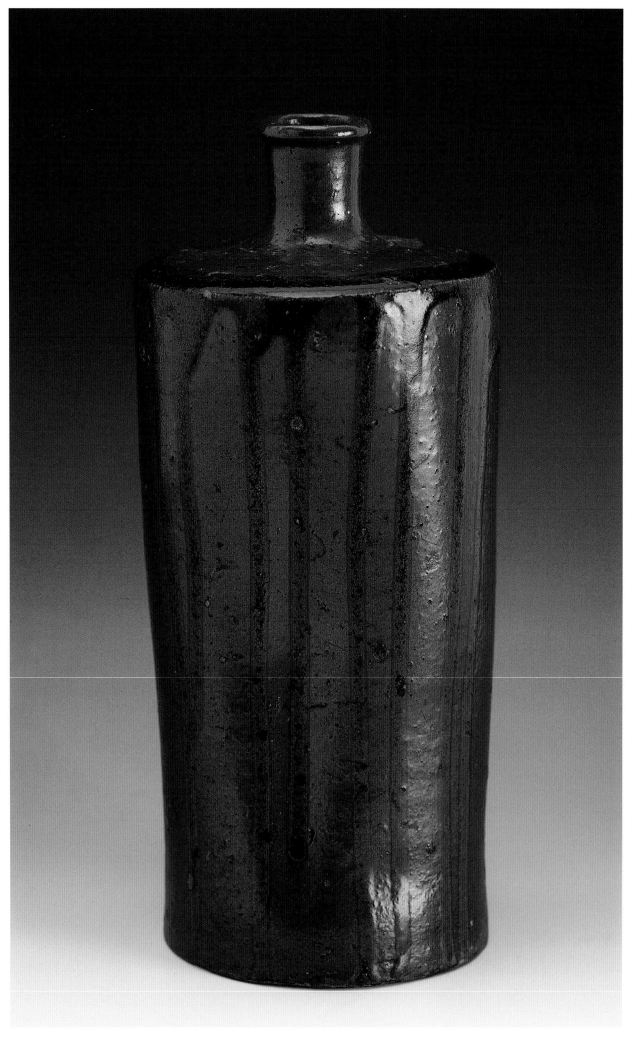

183. *Tamba ware candle-shaped saké bottle (*tokkuri*)*
Stoneware with slip and trailed glaze decoration
23 × 10 cm
Edo period, 19th century

184. *Fujina ware saké bottle (*tokkuri*)*
Glazed stoneware
25 × 14.5 cm
Edo-Meiji period, 19th century

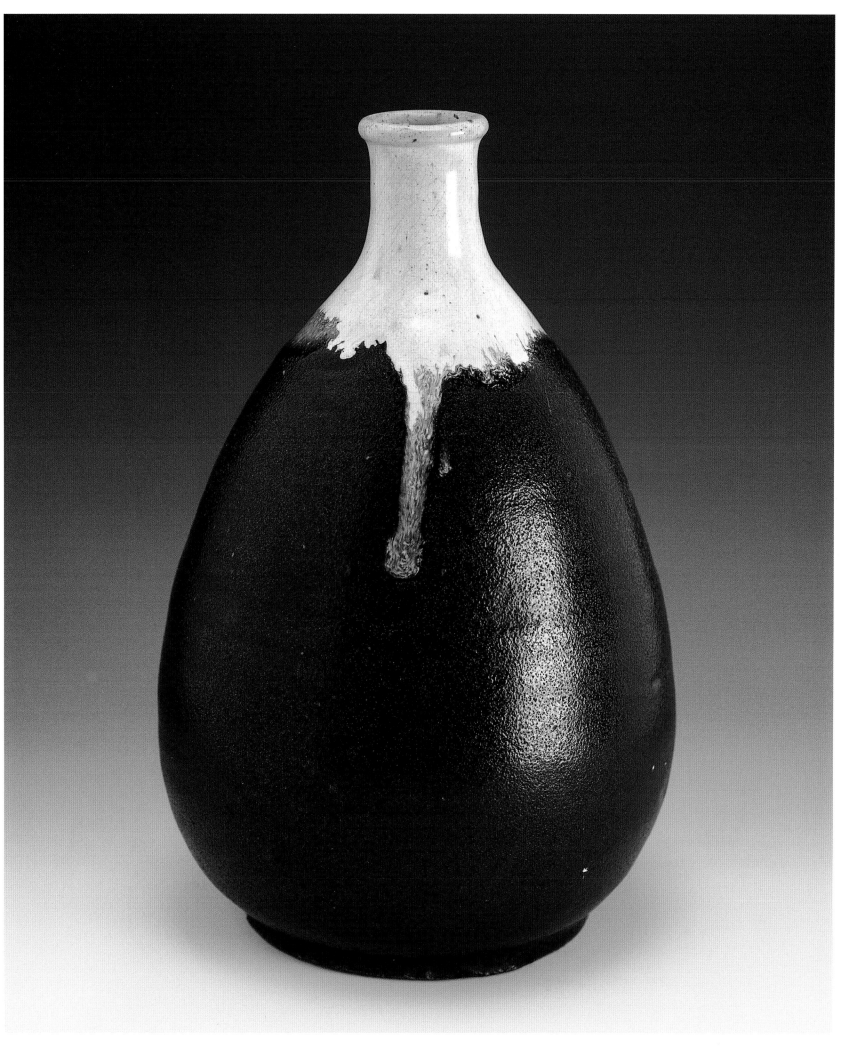

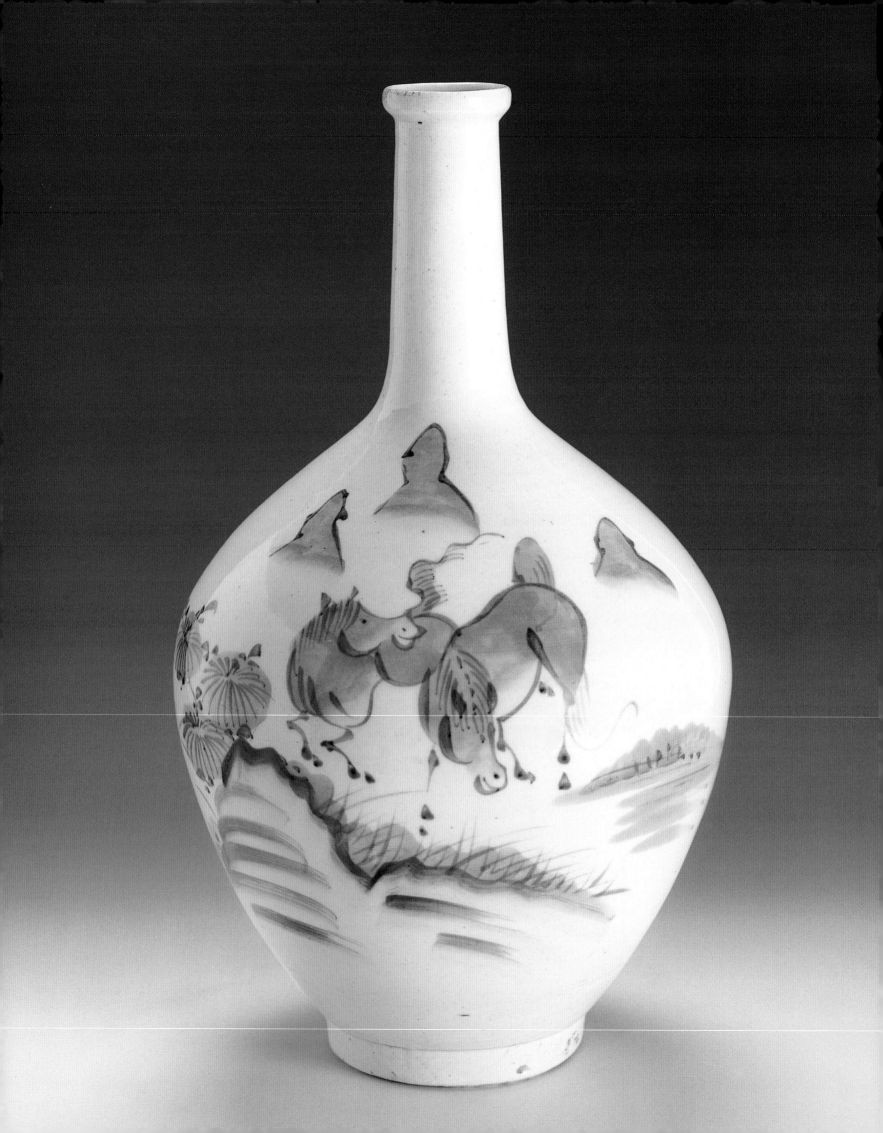

185. *Arita ware large saké bottle (*tokkuri*)*
Glazed porcelain with painted design
of horses in a landscape
38.5 × 21 cm
Edo period, 19ᵗʰ century

186. *Shigaraki ware saké bottle (*tokkuri*)*
Glazed stoneware with trailed glaze
decoration
28.5 × 17.5 cm
Edo-Meiji period, 19ᵗʰ century

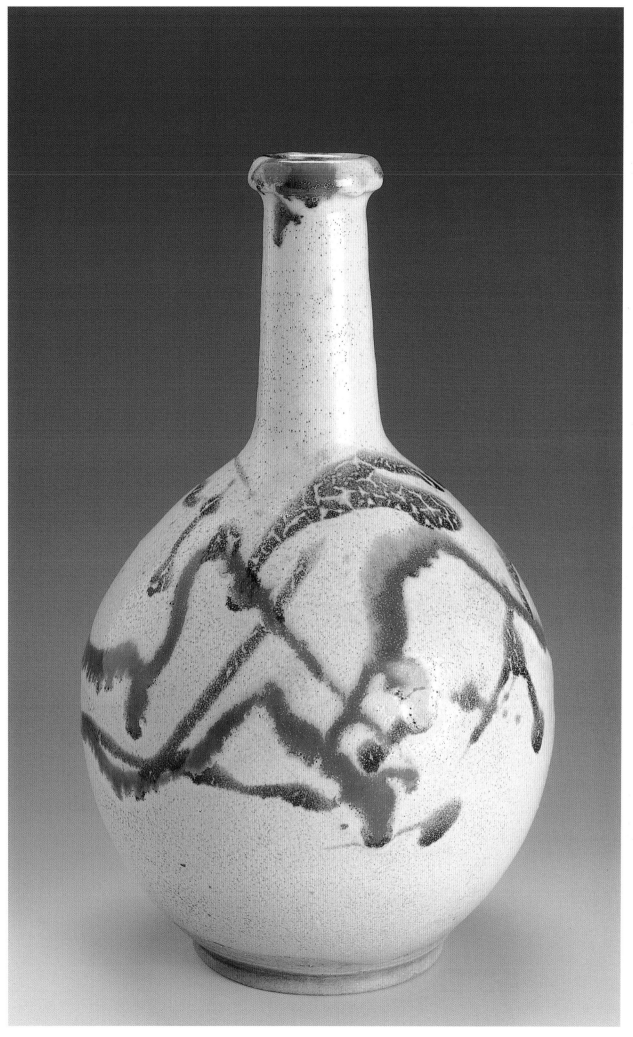

187a. *Tatenoshita ware water vat* (mizugame)
Glazed stoneware with trailed glaze decoration
64 × 54 cm
Edo period, 19th century

187b. *Tatenoshita ware water vat* (mizugame)
Glazed stoneware with trailed glaze decoration
50 × 46 cm
Edo period, 19th century

188. *Shigaraki ware storage jar* (tsubo)
Glazed stoneware with *Hagi-nagashi* type trailed glaze decoration
54.2 × 39 cm
Edo-Meiji period, 19th century

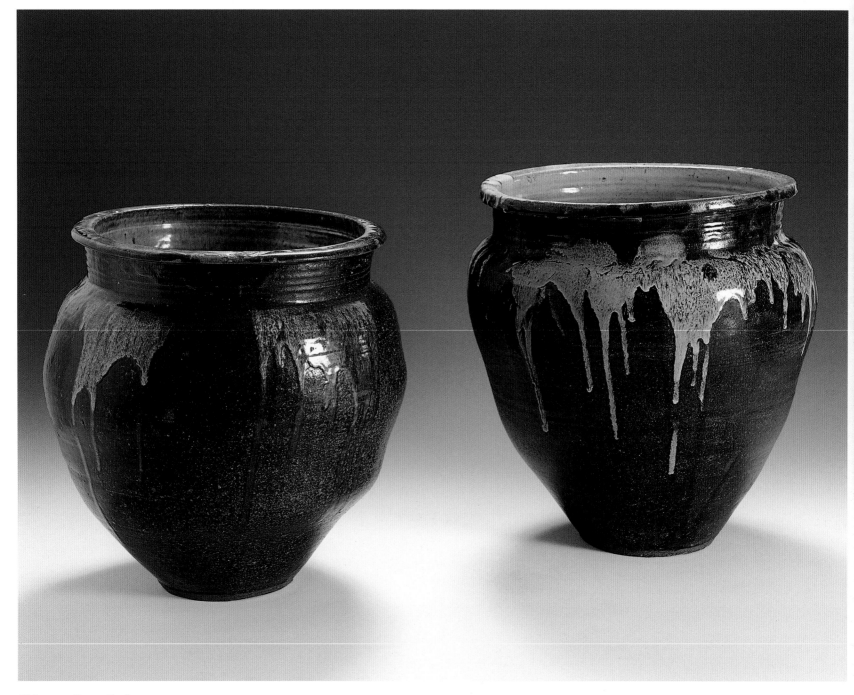

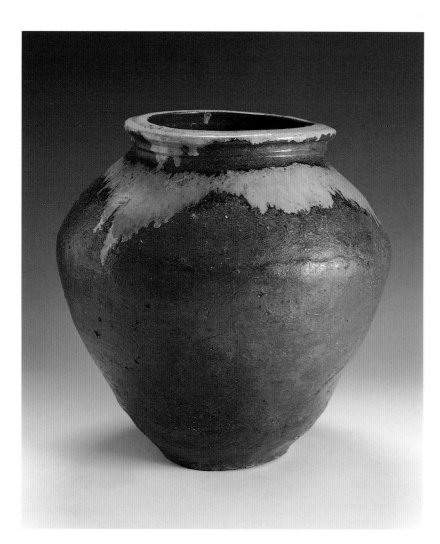

189. *Echizen ware storage vat (*kame*)*
Glazed stoneware
48 × 48 cm
Edo period, 19th century

190. *Narushima ware storage vat (*kame*)*
Glazed stoneware with trailed glaze
decoration
56 × 47 cm
Meiji period, 19th century

Opposite page:
191. *Echizen ware water vat (*mizugame*)*
Glazed stoneware
125 × 84 cm
Edo period, 19th century

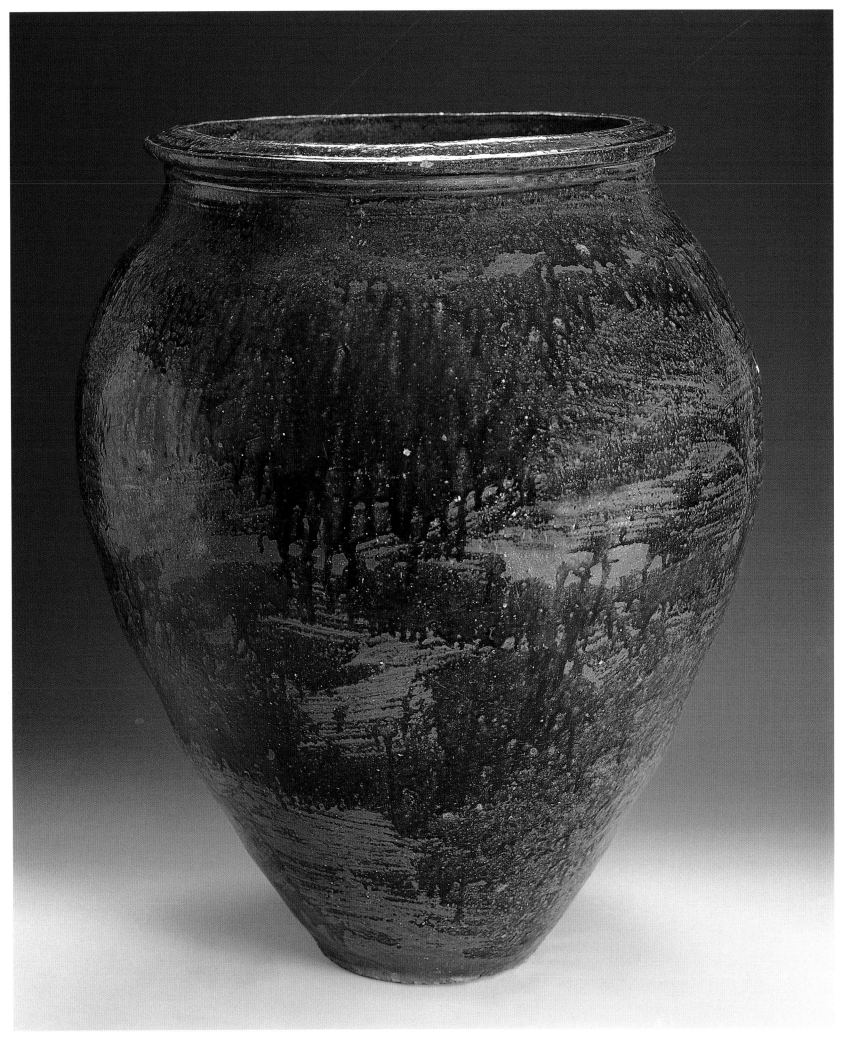

192. *Maker's mark* Ta *(Tatsuzō)*
impressed on base
*Faceted vase (*kabin*)*
By Shimaoka Tatsuzō (1919-)
Glazed stoneware with rope-impressed
and slip-filled decoration
22.6 × 15.3 × 14.7 cm
Heisei period, about 1990

193. *Maker's marks* BL *(Bernard Leach)*
and SI *(St. Ives) impressed on lower side*
*Square bottle vase (*kakubin*)*
By Bernard Leach (1887-1979)
Glazed stoneware
37.5 × 17.2 × 17 cm
Shōwa period, 1950s

194. *Rectangular four-footed vase (*henko*)*
By Kawai Kanjirō (1890-1966)
Glazed stoneware with slip-trailed
relief decoration
16.5 × 11.6 × 9.8 cm
Shōwa period, 1950s

195a. *Dish (*ōzara*)*
By Hamada Shōji (1894-1977)
Stoneware with trailed glaze decoration
4.8 × 27 cm
Shōwa period, 1950s

195b. *Dish (*ōzara*)*
By Hamada Shōji (1894-1977)
Stoneware with wax resist design of sugar
cane stalks
5.3 × 27.2 cm
Showa period, 1950s

195c. *Dish (*ōzara*)*
By Hamada Shōji (1894-1977)
Stoneware with trailed glaze decoration
4.2 × 24 cm
Shōwa period, about 1970

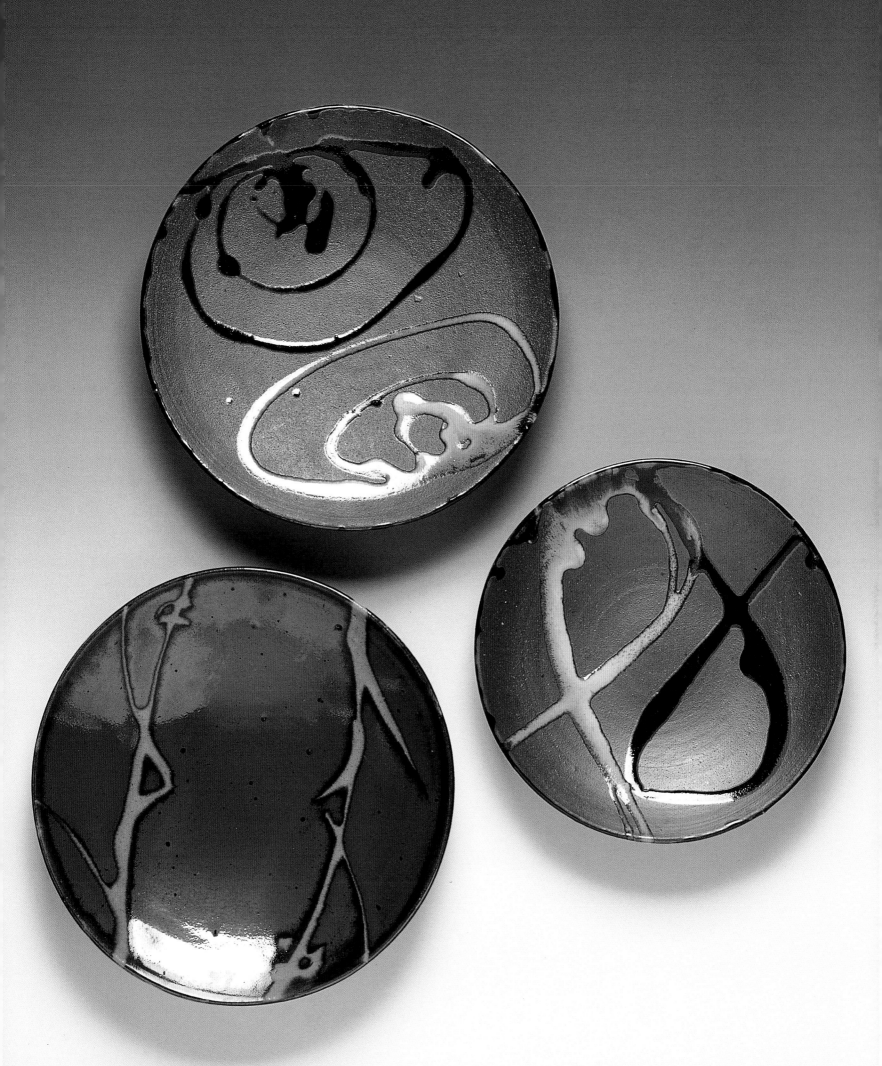

196. *Hip flask (*dachibin*)*
By Arakaki Eizaburō (1921-)
Glazed stoneware with splashed
decoration
18.8 × 23.7 × 15 cm
Shōwa period, 1950s

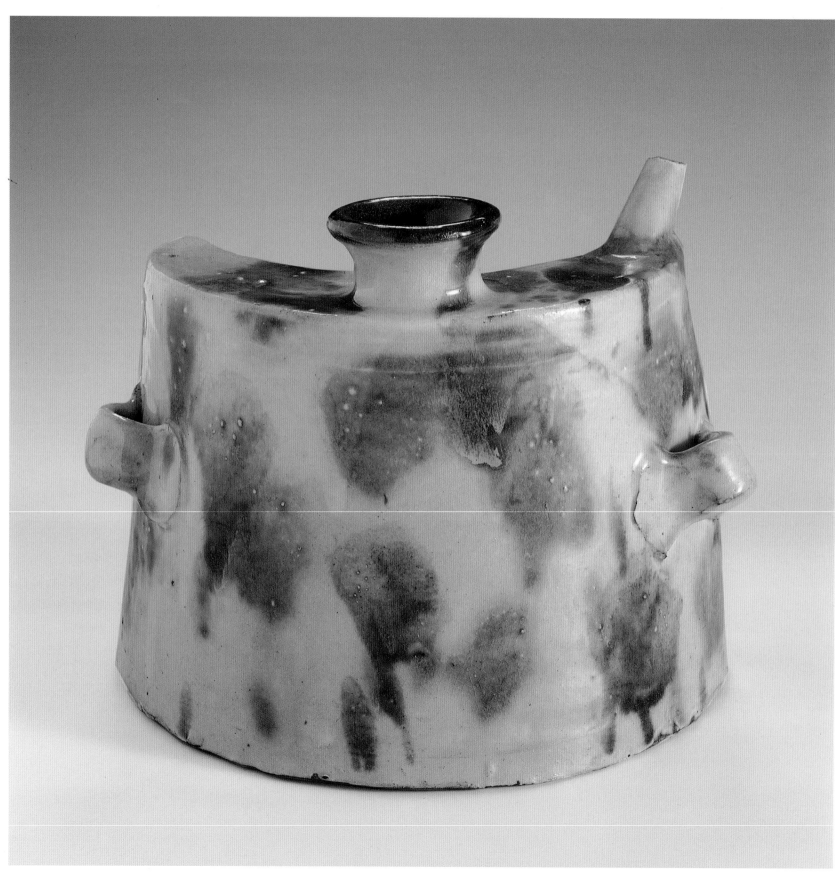

197. *Mashiko ware teapot (*dobin*)
Decorated by Minagawa Masu
(1872-after 1953)
Glazed stoneware with painted
landscape design
15 × 20.5 × 15.5 cm
Taishō-Shōwa period, 1915-1935

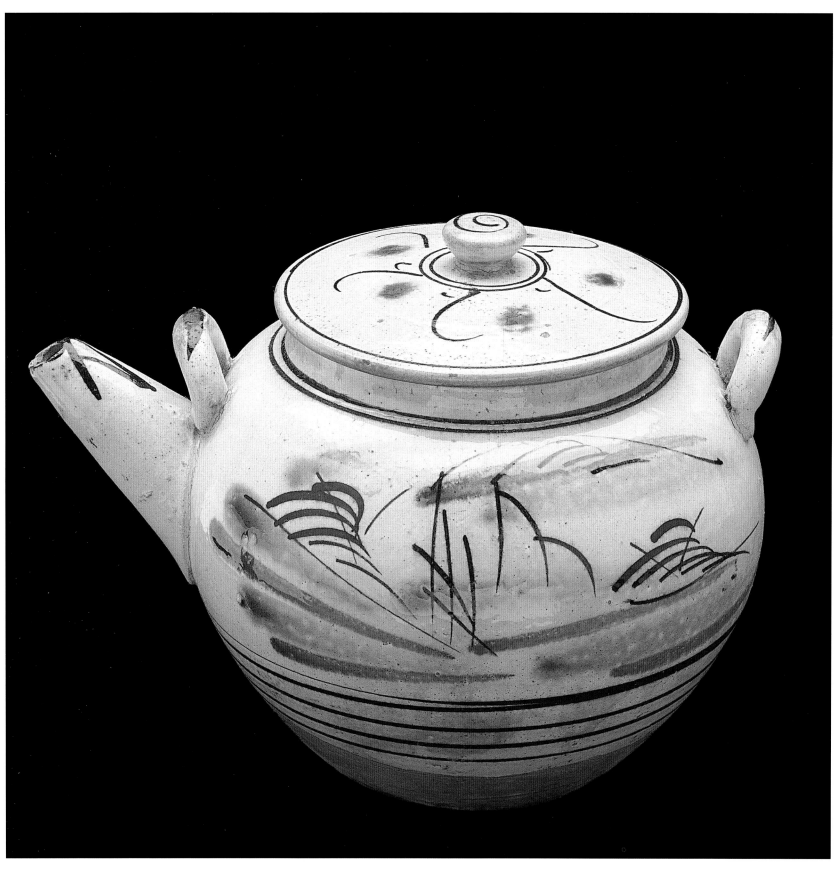

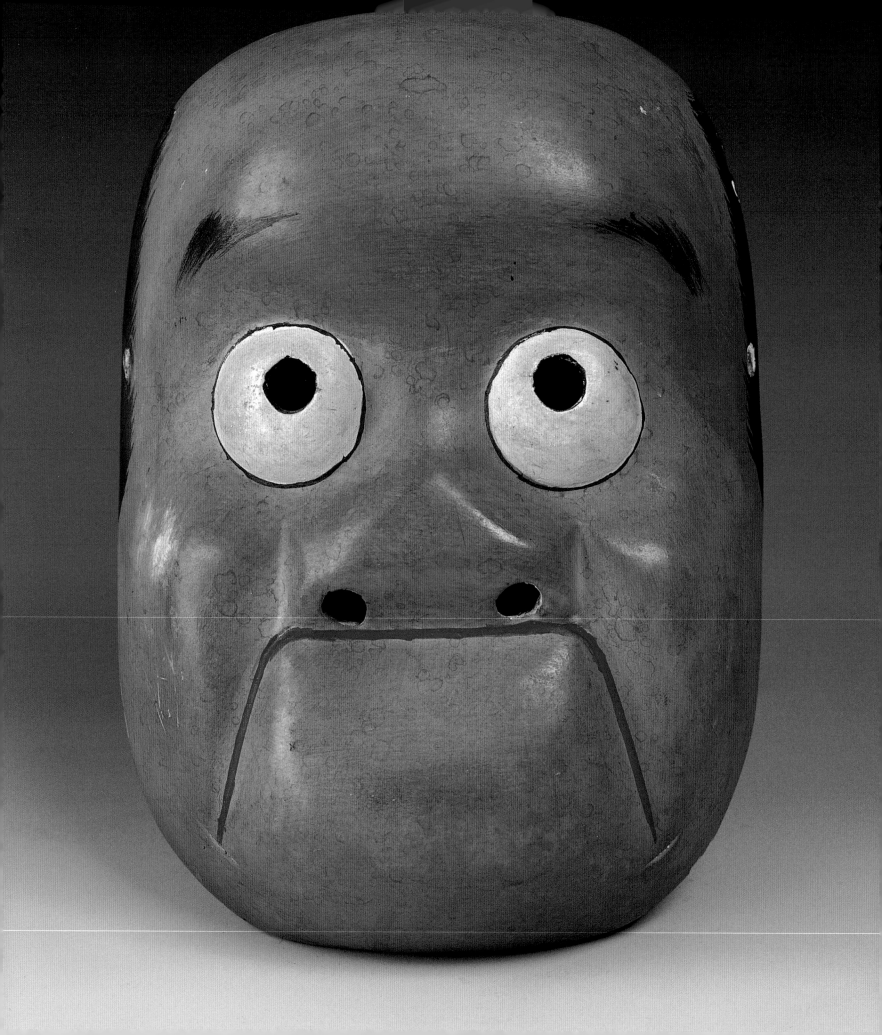

Gregory Irvine

Masks

Masks have long served as an integral part of Japan's religious observances and its rituals and festivals in what are generally referred to as the 'folk performing arts' (*minzoku geinō*), a term which covers a diverse range of activities. The performances include a whole range of observances related to Shintō, defined as *Kagura* in Honda Yasuji's classification of folk performing arts[1], the associated observances of the yearly agricultural cycle of rice farming (*Dengaku*), the symbolic exorcisms or rites to avert natural disasters (*Furyū*) and the rites pertaining to Buddhist practises (*Gyōdō*). They are also used in the celebration of local historical events and in regional folk versions of the more refined performing arts of Bugaku and Nō, traditionally more popular among, and at times reserved exclusively for, the ruling classes of Japan.

Kagura rituals have their roots in the relationship between the land and the people dependent upon it. Most forms of *Kagura* are connected with fertility rites and offer performances to the gods to ensure a plentiful harvest. The tradition of *Kagura* thrives in modern day Japan with masked performances featuring many of the popular deities of Shintō enacted at shrines on important occasions such as harvest time or at New Year festivals. *Kagura* has its roots in the erotic (for this read shamanistic) dance performed by Ame no Uzume to lure the Sun-Goddess Amaterasu no Mikami out of her cave. The folk deity of Okame (or Otafuku) is linked with Ame no Uzume and has her own origins in this legend.

Okame is also known as the goddess of mirth and is associated with fertility. This popular plump country beauty is frequently to be found at Japanese festivals, where she is paired with a male character called Hyottoko. Her chubby figure makes her attractive to Hyottoko, who dances around her making amorous advances. Figure 206 portrays her simple beauty and, although unpainted (the mask is frequently painted in colours which are a variant of the more elegant female Nō mask), reveals the attractiveness of this down-to-earth character.

Japanese masks depict real people, animals, indigenous deities (including the sacred beings referred to as *kami*, who have their origins in the mythology and folk beliefs of Japan), as well as abstract concepts relating to natural phenomenon. Specific types of masks can be used in many different categories of performance and this, especially once the mask has been physically removed from the actual context of a performance, can make identification and classification at times rather difficult. The ancestors of today's modern Japanese created masks for the roles of gods and demons when enacting rituals or to represent the gods when they were being entertained at festivals. It is therefore perhaps not surprising that so many Japanese masks seem to be otherworldly or have features based on wild animals. The mask serves a medium between man and the gods and enables those involved with the rituals to express and physically manifest their innermost primitive thoughts and fears about the forces of nature and concepts of a spiritual world. These ideas are almost primeval and the doubts and feelings over those aspects of our life over which we have no control cannot have changed substantially from those of our ancestors.

Japanese masks are not always worn: they can be carried, held in the hand during a performance, hidden in clothing or simply placed. An example of the latter category is the *Kamado-men* (figure 220). This large, powerful mask represents the *Kamado-gami* (literally 'oven deity') although in western

198. *Mask of* Ko-Beshimi, *possibly for Sato-Kagura (village* kagura*)*
Carved wood with applied gesso and paint
19.5 × 14.2 cm
Edo period, 19th century

Japan it is known as *Kojin-sama*. In the north of Japan, especially the north-east, where perhaps the widest range of Japanese folk masks and associated rituals may be found, a new (traditional) house was not considered complete until the guardian deity had been installed in the kitchen. Figure 217 is another example of a mask not intended for use. This demon (*kishin*) mask without holes for eyes is of the type made as an offering to a shrine or temple to enable the fulfilment of a wish on the part of the donor. Additionally the gift was intended to ensure protection and prosperity for the receiving shrine or temple.

The very act of putting on a mask implies a transformation from the real to the unreal, often adopting the persona associated with the type of mask worn. The mask is a symbol of 'possession' and not only can the wearer symbolise the *kami*, but the mask can also represent the incarnation of the *kami* when appearing in human form. The efficacy of the mask relies heavily on the full acceptance of the illusion it creates and the sense of mystery and wonderment it produces in us, the other-worldliness of the character and what it represents. The performer is then accepted as the temporary embodiment of that character portrayed. When the mask itself is to be regarded as the physical manifestation of the *kami*, it is treated with great respect and reverence, in the way a figurative or representational religious sculpture can also be an object of devotion.

Although there is sometimes perhaps a tendency to think of the 'traditional' and 'modern' as mutually exclusive, yet in contemporary Japan there is still much observance of the traditional, albeit modified by the demands of a radically different form of society to that which was found prior to industrialisation in the late nineteenth century. With today's society no longer based on the smaller village units largely dependant on the seasonal patterns of agriculture, and with increased mobility, social restructuring and changing work patterns, these observances have become increasingly more difficult to stage in the 'traditional' manner. Numerous long-established festivals (*matsuri*) have, for example, now become mainly commercial enterprises and perhaps in the process neglected their original function as a means of active communion between man and the *kami*, and are now performed purely for their festive and social aspects.

So why do these historically based activities continue to take place? The origins of most masked festivals or celebrations usually have at least some relationship with the passing of the seasons, the agricultural cycle and the traditional folk beliefs

(*minkan shinkō*), which had been an integral part of the life of the people of Japan. Frank Hoff points out that 'it is difficult to measure accurately the degree to which they [beliefs] remain alive as a prerequisite for the continuation of folk performances into the future. It is possible that folk beliefs are being replaced by new incentives like the recognition of festivals as part of the national cultural heritage, their usefulness for tourist or commercial benefit, or simply the pride a village takes in the arts of its ancestors'[2].

In an increasingly secular and displaced modern Japanese society with the break-up of both the social units of family and village, together with the pressures of working patterns in both the cities and to at least some degree in the countryside, the festival presents an opportunity, consciously or otherwise, to renew spiritual ties and to throw off those inhibitions which would otherwise perhaps be disapproved of in the normal daily routine of hard work and socialising. The element of the absolute enjoyment of these occasions should also not be forgotten.

Japan's early masking traditions

The establishment of the various masked traditions in Japanese religion and the performing arts did not really develop until the sixth century AD, when new religious and secular concepts were introduced to Japan from China and Korea. The indigenous Japanese beliefs and the imported mainland Asian philosophical and religious systems of Buddhism, Taoism and Confucianism combined to create a rich and intricate system of interrelated concepts whose influence extended into the arts, both physical and dramatic.

Gigaku was the first of these imported dance dramas which used masks to great effect and these masks and performances were to influence all later forms of Japanese masked drama. *Gigaku* performances were lively affairs and utilised large masks with facial characteristics showing influences from China, India and as far away as Persia. Most of the themes of *Gigaku* were in some way moralistic presenting, for example, precepts against lust and drunkenness which were regarded as obstacles to spiritual enlightenment, or illustrated examples of filial piety.

The art flourished at court and at Buddhist temples of the period and some early *Gigaku* masks used at the consecration of the Great Buddha of Tōdaiji which bear the date of the ceremony in AD 752 are preserved today at the Shōsōin, the imperial repository. Others can be found in the collection of the Hōryūji and many spectacular examples of the lat-

ter are displayed in the special building in the grounds of the Tokyo National Museum where the treasures from Hōryūji are exhibited.

Gigaku declined in popularity at court, but in the *Kyōkunshō*, a treatise written in AD 1233, we have a record of an actual performance. Masks were carried in procession in a temple courtyard, the procession being led by Chidō, a character wearing mask with a long nose. He was accompanied by a *shishi*, a mythical lion-like creature here represented by a large mask attached to a length of cloth and manipulated in its actions by two men, one for the mask and one for the body; two young masked attendants known as *shishiko* attended the beast.

During the Heian period *Gigaku* at the imperial court was gradually replaced by the austere, and at times complex, dance form known as *Bugaku*. *Bugaku* flourished and was adopted as part of the ritual of the court, being performed by nobles as well as by the hereditary guilds of professional musicians. *Bugaku* itself declined under the military government which controlled Japan from the twelfth century onwards, but was kept alive both at court and at the temples and shrines of Nara, Kyoto and Osaka. It was revitalised by the Tokugawa shōgunate during the Edo period, and is even today performed at Nikko in the shrine dedicated to Ieyasu Tokugawa, founder of that dynasty.

The masks of *Bugaku* are smaller and lighter than those of *Gigaku* and generally cover the face and top of the head only. A unique feature of many of the masks is that they have moveable parts such as noses, eyes or chins, which serve to accentuate the performances. *Bugaku* was traditionally performed on occasions such as consecration ceremonies (for example that of the Great Buddha at Todai-ji in Nara where a variety of different masks were known to have been used), for purification rites, at festivals and at times as an invocation for rain.

The civil wars which ravaged Japan during the Muromachi period served to disperse the performing arts and many actors were forced to find new patrons. A result of these disturbances was that forms of dance and masking previously only found at court and at temples and shrines were now being performed in remote regions of Japan. The *Bugaku* mask of Batō (figure 212) is an example of such a type of mask. Although not as austere as some examples of this character, nevertheless the mask has an imposing presence. Nishikawa writes '…the dances and masks that spread to the countryside were liberated from traditional forms. Not all types of Bugaku masks were adopted in the provinces, only those that could be easily adapted for use in such folk-religious as exorcism or in

prayers for securing harmony […] Masks of the more lively and amusing pieces, particularly those with mysterious or mystical powers such as […] Batō are distributed widely throughout the main islands'[3].

Dengaku and Nō

Perhaps the best-known Japanese masks are those for the uniquely Japanese drama of Nō. Nō grew out of the earlier folk performances of *Dengaku* and *Sarugaku*, both of which utilized masks. The flowering of Nō as a dramatic art form came during the fourteenth and fifteenth centuries under the two great actors Kan'ami (1333-1384) and his son Zeami (1363-1443). *Dengaku* was (and indeed still is) a type of religious performance, or series of performing arts, derived from rice planting and harvesting rituals, *Sarugaku* was a lively art form brought over from China which included juggling and acrobatics in its repertoire. *Dengaku* was popular with the ruling military class of the Kamakura period but was gradually replaced by *Sarugaku* which by the late 13th century had started to standardize the words, music and gestures of the performances. It was from a combination of these art forms that Kan'ami and Zeami created the Nō drama as we know it today.

The oldest performance included in the Nō repertoire is that of Ōkina, the felicitous holy old man who has featured in performances from as early as the tenth century. The performance comprises three auspicious dances offering prayers for peace, fertility and longevity. It is sometimes called the first play, and is performed only on special occasions. Masks are used in numerous forms in the traditional folk performing arts, some of which are particular to only one specific geographical area, but may often share some similar attributes. For example, a variant mask of Ōkina is used in performances of *Dengaku* which are still to be found throughout rural Japan today as part of regional festivals.

Figure 210 is a *Jō* (old man) mask which has its roots in the archetypal Ōkina mask. However, unlike Ōkina the group of *Jō* masks generally present a more severe type of character and are often used to portray either an historical character or indeed a minor deity.

Kagura and Festivals

Perhaps one of the reasons for the acceptance, and indeed continuing popularity of the traditional myths and legends in Japan is the strong belief in nature spirits. Shintō, the indigenous Japanese system of beliefs refers to the 'eight million gods', the *kami*. *Kami* is a term applied to the forces which

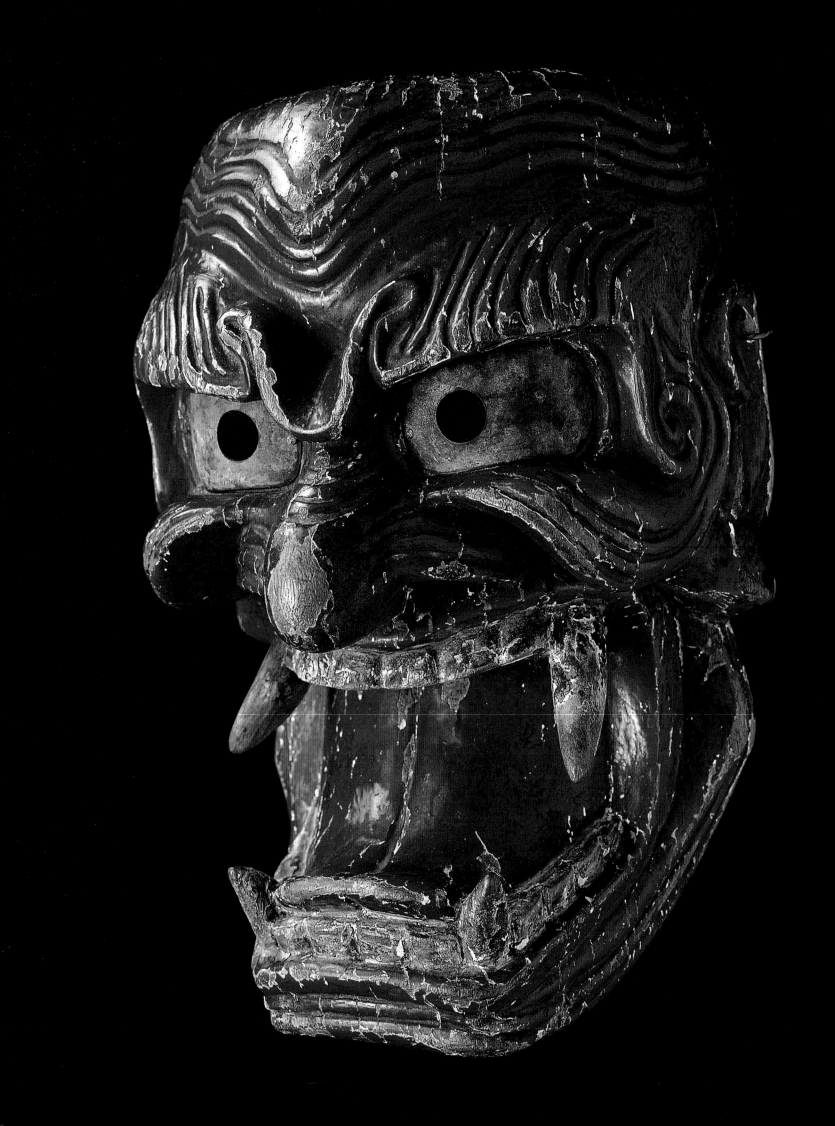

resides in the natural world, in the elements such as wind, thunder or rain, in trees, mountains and rocks, in saucepans, rice pots and in kitchens, or even in animals or people.

Kagura, literally 'music of the Gods', is used today to refer to any type of performance (which generally includes masked dancing) relating to the annual cycle of festivals held at a Shintō shrine. In the classification adopted by Honda Yasuji, it is defined as an invocation of the *kami* followed by an entertainment for them in song, dance or indeed both. The whole serves as a prayer for the revitalisation of the human life force. The masks utilised during these performances represent the gods themselves or indeed, as mentioned before, are a physical manifestation of the deity.

With the evolution of Shintō, so the definition of *kami* became more marked, with a distinction being made between heavenly divinities, such as Amaterasu no Mikami, and the earthly divinities such as the deity of the mountains, Oyamatsumi no Kami. With the introduction of Buddhism in the sixth century and the adoption of Confucianism and Taoist ideals, so the pantheon of deities increased, and with typical resourcefulness, they were adapted to meet more specific Japanese requirements. Indeed, some deities from the Buddhist pantheon have even crossed over into Shintō. The Seven Gods of Good Fortune (*Shichifuku jin*) are one excellent example of the popularisation of deities from Shintō and Buddhism whose original attributes may have long since been forgotten.

One of the Shichifuku jin, Ebisu, normally seen with a fishing rod and sometimes also with a sea bream signifying the good fortune of the sea, traces his origins to the first child of Izanagi and Izanami. In Japan's creation myths (*Kojiki* and *Nihon Shoki*) the deities Izanagi and Izanami (who were brother and sister) descended from the High Celestial Plain (*Takamagahara*) to create solid land from the formless mass which previously existed. *Daikoku*, with whom Ebisu is often paired, derives from the Hindu god Mahakala (although his name is also a homophone for the Shintō deity Okuninushi), and carries a magic mallet which can grant wishes. He is often depicted standing on bales of rice and carries a bag which symbolizes inexhaustible wealth. The mask of the jovial Daikoku (figure 214) has holes along the top of the mask where a hood or Daikoku's traditional headgear would have been attached.

Together, the seven deities were said to bring long life and wealth. They became extremely popular during the sixteenth and seventeenth centuries, particularly among the rising merchant class. The association with this group is of particular note as merchants were despised by the ruling samurai who regarded trade as a contemptible occupation. Despite their apparent lack of social standing, the merchants continued to increase in power and influence during the Edo period and one could perhaps speculate that this was due in part to their devotion to the Shichifukujin.

Demons, spirits and mythical beasts

The *Oni* are the archetypal Japanese demon, usually representing the more negative side of universal forces, but with an ambivalent character, as they can be both benevolent as well as demonic and can be regarded as a manifestation of the wilder aspects of nature or as an aspect of man's inherent character. They are frequently represented as squat, horned beings, with fangs and clawed hands and feet and inhabit not only the supernatural world but also cross over to ours to interact with, and influence the lives of humans. *Oni* are mentioned in an early written record of the eighth century, the *Kojiki* (Records of Ancient matters) as being inhabitants of Yomi, the land of the dead, where they are portrayed as a type of spirit. In a Buddhist context, they are depicted as the servants of Emma-o, the king of hell, and they can be seen torturing the souls of those poor unfortunates condemned to suffer.

In another role, *oni* are conspicuous at the head of festival processions today, where they can be seen sweeping away all evil influences. However, they themselves are driven out in the New Year household ritual known as *setsubun*, (or *oni yarai*). This is when all the misfortunes of the past year attributable to bad luck are cast out before the New Year arrives. With shouts of '*Oni wa soto, fuku wa uchi!*' (Out with the *oni*, in with good fortune!) specially prepared beans are scattered about in order to drive out the evil spirits. The demon mask (in its traditional red and green colours) is also used in the *tsuina* ceremony (a form of exorcism with similarities to the rites of *setsubun*) at temples and shrines on the first day of the New Year (now traditionally 3 or 4 February).

The Montgomery collection of masks contains many interesting variants on the theme of the *oni*. Figure 216 is an unusual form of *oni* and the deeply carved features give the mask a powerful animal feel. The gold eyes and teeth are symbolic of the demonic nature of the mask (masks of gods also share these attributes with demonic characters). Holes on the upper lip and lower chin contain traces of the moustache and beard which this demon would have sported. A curious feature of this mask is what appears to be a Buddhist-style lotus flower carved between

199. *Mask of a demonic deity* (*Kishin men*), Ko-Jishi *type*
Carved wood with applied gesso and paint; applied gilt copper disks on eyes
Inscribed in ink on right interior 'Tenshō jusan nen' (13th year of Tenshō = 1585); on central interior '*Nariyoshi no Miya*' (possibly a shrine name); two further lines of indecipherable ink inscriptions
26 × 17.5 cm
Momoyama period, late 16th century

the eyes which may indicate that the mask was used in some form of Buddhist exorcism. Figure 218 is a classic formidable demon of the Beshimi ('compressed lip') type which features prominently in the Nō theatre and is also found in provincial versions of this aristocratic drama.

The powerful demon mask (figure 199) fulfils all the requirements of a mask for an exorcism. It has all the typical characteristics for a demon, notably the gilt copper plates for the eyes (demons usually have golden eyes) as well as the fangs and gaping jaws. The early date inside this mask and the partially readable inscription referring to a shrine make it almost certainly a mask for exorcism and quite possibly the oldest mask in the collection. The *oni* can also represent the violent powers of nature, most commonly representing the forces of wind and thunder. These are portrayed by their respective demons (or *kami*, the distinction is not clear). *Fuden* (God of wind) is shown carrying his bag containing winds, and *Raiden* (God of thunder) carries his drums of thunder, both creatures usually being carried along on clouds as they fight together.

Another type of ambiguous demon is the *tengu*. The *tengu* is a mythical creature which has its roots in the woods and mountains of Japan. Like so many other mythical Japanese creatures, the *tengu* can trace its origins in part to Chinese folklore. There are Chinese tales of a creature called a *t'ien kou* (celestial dog). The characters used to write these words can be read as 'tengu' in Japanese. The Chinese tales are of mountain demons with a bird's beak and wings, and the ability to transform themselves into human form. They are also reputed to steal children and eat them: these are all characteristics associated with the Japanese *tengu*.

With the arrival of Buddhism in Japan, the *tengu* acquired some of the attributes of the guardian deity *Garuda*, a creature with a human body, but also with the wings and beak of a bird, and like the *t'ien kou*, the ability to change into human form. The *tengu* were soon divided into malicious and benevolent types, the good becoming the masters of the bad. Some *tengu* became guardians of Buddhist monasteries and helped the priests with their studies. Others took on the form of priests, nuns and even Buddhas in order to deceive both the ordinary followers of Buddhism and particularly other members of the clergy. There are many tales of *tengu* spiriting away priests and leaving them tied up at the tops of trees.

The *tengu* have two distinct forms, the *Karasu tengu* (crow *tengu*) which has the head, beak and wings of a bird but with a human body, and the *Konoha*

(long-nosed) *tengu* which has a human body and head with an enormous nose and sometimes the wings of a bird. Being creatures of the woods and mountains, they are, not surprisingly, often found in the form of a *Yamabushi*, the mountain priests who are connected with the ascetic Buddhist practises of *Shugendō*. The association between the aspirations of the *Yamabushi* to attain supernatural powers, and the magical abilities of the *tengu* was an inevitable connection. During the later Edo period there was a growing number of itinerant *Yamabushi*, who were not serious practitioners of Shugendō but little more than exploiters of superstitious villagers and they were regarded with as much suspicion as the mythical *tengu*.

The collection contains two fine examples of the different forms of *tengu*: figure 201, the Karasu *tengu* and figure 202, the Konoha *tengu*. The Karasu *tengu* with its demonic golden eyes and applied horsehair whiskers is a truly malevolent looking creature and one certainly to be concerned about if wandering alone in the woods or on a Japanese mountain. The Konoha *tengu* tries hard to be fierce; he has all the correct demonic attributes but fails to impress and looks rather ridiculous in his feeble attempts to intimidate. Interestingly, without the long nose he would look very similar to the Beshimi type of demon mask (figure 218).

The Konoha *tengu* was identified with the long-nosed Shintō deity Saruta-hiko no Mikoto, who is regarded as the god of roads (under the name Koshin). He was responsible for leading Amaterasu no Mikami out of the cave in which she had hidden and is often shown with the goddess Uzume, from whom the more popular figure of Okame derives. There are numerous depictions in Japanese art of pilgrims carrying long-nosed masks on their way to Shintō festivals, such as that held today at Kumakuboto Shrine in Nakajima, Ishikawa Prefecture, where the masks are used in processions. In the countryside the people took no risks debating the existence or not of the *tengu*, and would set offerings of delicacies such as rice balls covered in bean-paste away from their homes so that they would remain undisturbed. Hunters and woodsman whose livelihoods depended on the goodwill of all deities of the mountains and forests were especially diligent in their offerings. Even the government as late as 1860 were so worried about the possible malicious tricks of the *tengu* that they posted a notice at the shrine at Nikko which instructed the *tengu* to remove themselves from the area while the reigning Shōgun visited the shrine of his ancestor. It is not unusual at all today to find offerings being made before a particularly old tree is cut down,

200. *Mask of a demonic deity (Kishin men)*, Hachimaki *type. The headband (*hachimaki*) can be used to represent a powerful being* Carved wood with applied gesso and paint; the lower jaw of a separate piece of wood. Loss of gilded copper disks for the eyes
24.4 × 16.8 cm
Edo period, 18th century

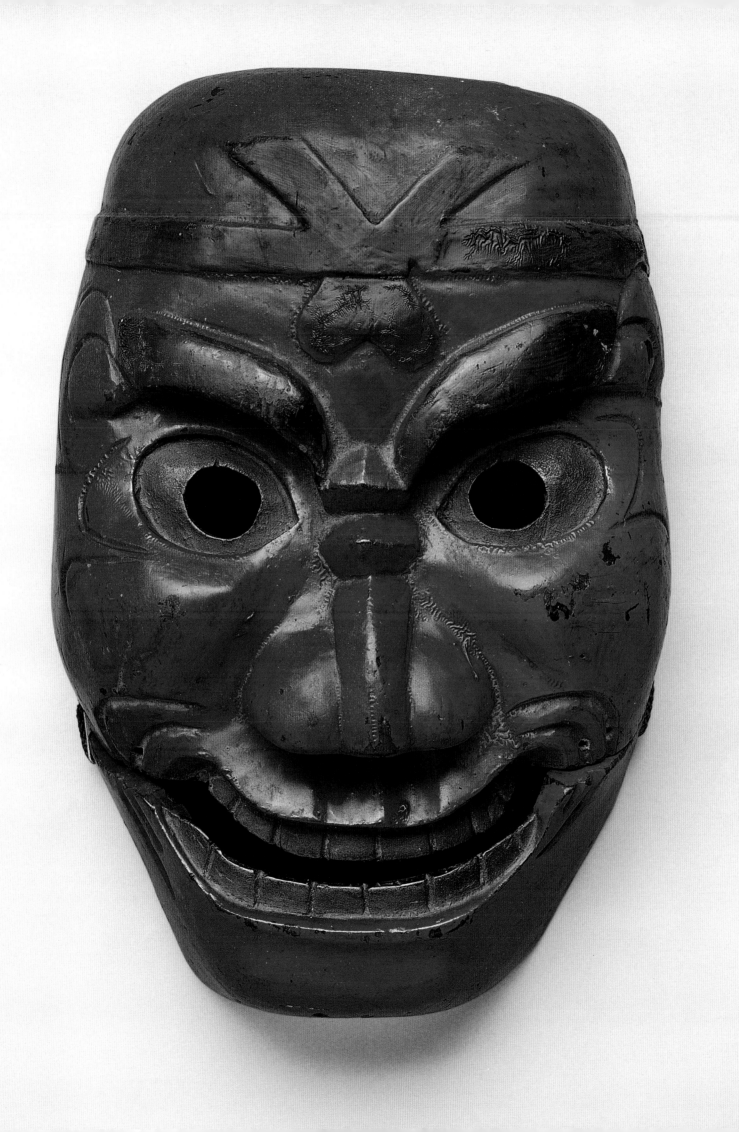

and *tengu* still have festivals and mountain shrines dedicated to them.

Of all the real animals accorded magical attributes, the fox (*kitsune*), and the *tanuki* (often referred to as raccoon-dog, or more mistakenly as a badger), have received most treatment in legend and depiction in Japanese art. Whereas the *tanuki* is regarded as generally mischievous, the fox is usually seen as a more wicked and sly creature, although the more malicious sides of their natures are rarely displayed. The two perform similar magical tricks, and both have the ability to transform themselves into human form in order to deceive or annoy people. The linking of their mischievous antics is demonstrated in the Japanese saying '*Kitsune to Tanuki no bakashi ai*' – a fox and a *tanuki* outfoxing each other – when referring to the dealings between crafty and devious people.

The fox has long been associated with the Shintō deity *Inari Daimyojin*, the deity of cereals, and was believed to be his messenger. Because of Japan's dependence on rice-based agriculture, the god Inari became the most widely worshipped of all the deities. In later years, however, the deity also became the guardian of blacksmiths, swordsmiths and a household guardian deity. Foxes who appear with nine tails were regarded as evil creatures, and are said to have the ability to see, hear and know all the secrets of men. The fox was believed to turn white when over 500 years old and then acquires the ability to transform itself into any form it chooses. In folklore there seems to be a predilection for the fox to transform itself into a woman in order to frighten or seduce a man.

There are two versions of fox masks in the Montgomery collection: figure 215 is a ferocious mask which would have been worn during a Kyōgen performance – possibly one such as *Tsuri-gitsune* (Fox-trapping). Kyōgen has similar roots to the Nō performance but is an altogether more humorous and light-hearted affair. Figure 219 is a former (or mould) for creating a papier-mâché mask of the fox which would have been regarded as a disposable item to be used at a local festival.

The Shishi

One mask which has appeared in almost all categories of Japanese masked performances – *Gigaku*, *Bugaku*, in Buddhist processions, in a variant form in the Nō drama and in most forms of folk performance is that of the *shishi*[4]. The *shishi* is frequently described as a lion, or lion dog, but it is a creature which has many and various characteristics. In archaic Japanese and in some local dialects the word meant 'game-meat' in general or 'wild an-

imal'. The word previously meant deer (now *shika*) and still today the word for a wild boar is *inoshishi*[5]. The mask can have the attributes of real beasts (such as horns or the antlers of a deer) as well as those of imaginary beasts such as the dragon or the mythical creature known as a *Kirin*.

The basic form of the dance which incorporates this mask is the *shishi-mai* in which a performer wears (or carries) the head/mask of the *shishi* while another forms the rear of the body under a length of cloth. A regional variation has just a single costumed performer wearing a mask and beating a drum. The *shishi* masks used since the latter part of the Edo period tend to depict a humorous creature with a moveable jaw and tongue, often with rotating ears, a creature far removed from the original fierce prototype.

The *shishi* mask can be found today in many *Kagura* performances with their origins lying in the *Gigaku* tradition. It is also to be seen in the *shishi-odori*, a deer dance found in Iwate Prefecture the Tohoku region of eastern Japan (an area which comprises parts of Akita, Aomori, Fukushima, Iwate, Miyagi and Yamagata prefectures). It is used at New Year festivals and on occasions at Buddhist temples (in a purification ritual during a Gyōdō ceremony) where it leads a procession of Bodhisattvas. An example of this can be seen in the Shoryoe ceremony held each April at Shitennoji in Osaka as a memorial service for Shotoku Taishi, the seventh century patron saint of Buddhism in Japan.

Although the *shishi*-mask (in its ferocious lion form) was certainly imported from mainland Asia along with *Gigaku*, the native Japanese form pre-dates this and has its roots in the shamanistic practises which depict animal dances which were performed by hunters in the mountains. The *kami* of the mountains is believed to take the outward appearance of an animal, so the dance would have originally been dedicated to him. The two varieties of *shishi* combined at an early stage in their history and it is now somewhat difficult to differentiate the two forms. Figure 224 represents the type of *shishi*-men which could be used either at the Buddhist Gyōdō ceremony or equally at a New-Year festival. In the latter instance the *shishi* may well be accompanied by a *tengu*. For example, in the ceremony of Ō-gashira Jinji performed at Tanahashi in Mie Prefecture, the *shishi* adopts a subservient role to the *tengu* which acts an intermediary between the local population and the powerful *shishi*[6].

Figure 223 is a splendid example of the type of mask used in the *Shishi-odori* deer dance performed by the Hayakawa school in Iwate Prefecture. The mask is worn on top of the head and the performers (tra-

ditionally eight in number) wear floor-length decorated cloth robes and have a long bamboo pole which is decorated with paper strips attached to their backs; the poles pass through the hole in the bottom plate of the mask. The performers also carry and beat a drum and the overall effect of the music together with the swishing of the bamboo poles in the performance, which is an invocation to the deities of a local shrine, is deeply atmospheric.

In some styles of *Kagura* the *shishi* mask (*shishi*-men, or *shishi-gashira*) is seen as the temporary residence of the *kami*. In other forms of *Kagura* (particularly *Yamabushi kagura*)[7] the *shishi* mask is regarded as the physical presence of the *kami* and the mask (or head) is referred to in honorific terms as *Ō-gashira*, or *Gongen-sama*, the latter term having Buddhist connotations[8]. The use of the *shishi* mask as a talismanic protector is well established and in many regions of Japan (such as Ishikawa prefecture) even today a *shishi-gashira* is sometimes placed beside a newborn baby boy to protect the child from evil spirits and misfortune. The *Ō-gashira* is also used in many areas of Japan to 'bite' the head of children in order to prevent sickness. The paper used as a substitute for hair on the top of the *Ō-gashira* is often collected and either carried as a protective talisman or placed on the *kamidana* ('god-shelf') in the kitchen to act in a protective role[9].

Figures 222 and 225 are both examples of an *Ō-gashira* which clearly show the powerfully spiritual nature of the *shishi*. In the case of an *Ō-gashira* the *shishi* 'head' is never regarded as an art object but is seen as the physical manifestation of the *kami* to which the performances will be directed. Those who use the *shishi* must ritually purify themselves in mind and body before even touching the head. The head will be kept enshrined at a temple (or shrine as the *kami* can be of Buddhist or Shintō origin) prior to the performance which will generally take place only once a year. Considering the sacred nature of such an object it is unusual to find such fine examples of the *Ō-gashira* in a private collection.

Although much of the original meaning of Japan's old folk-rituals may have now gone, there remains in people today an unquestioning wish to maintain and continue the roles to be performed at these festivals. This, together with the preservation of the craft of mask-making helps perpetuates the long-established Japanese tradition of learning by direct transmission of the teachings from one's master. The mask today still plays a fundamental role in the furtherance of the traditional performances of Japan. It can be used to become one with the nature spirits or can manifest a natural phenomena. It can represent an intangible yearning for spirituality in a modern world which perhaps no longer places such an importance upon such values. It can help continue centuries-old regional traditions and with it increase pride in Japan's heritage, or it can simply be an aid to enjoyment as with the donning of a mask people today can shed those inhibitions which would otherwise restrain them in their daily life.

[1] Honda, Y., *Zuroku Nihon no minzoku geinō*. Tokyo; Asahi Shinbunsha, 1960.
[2] Hoff, F., *Kodansha Encyclopaedia of Japan*, 'Folk Performing Arts', pp. 296-298.
[3] Nishikawa, *Bugaku masks*, p. 126.
[4] For an extensive study of the different forms of *Shishi* performances in *Kagura*, see Averbuch, I., *The Gods come dancing: a study of the Japanese ritual dance of Yamabushi Kagura*. Chapter 6.
[5] Sakurai, H., "The Symbolism of the *Shishi* Performance as a Community Ritual, The Okashira Shinji in Ise", in *Japanese Journal of Religious Studies*, 1988, 15/2-3,
[6] *Ibid.* Sakurai.
[7] Averbuch, *op. cit.*
[8] Sakurai, *op. cit.*
[9] Sakurai, *op. cit.*

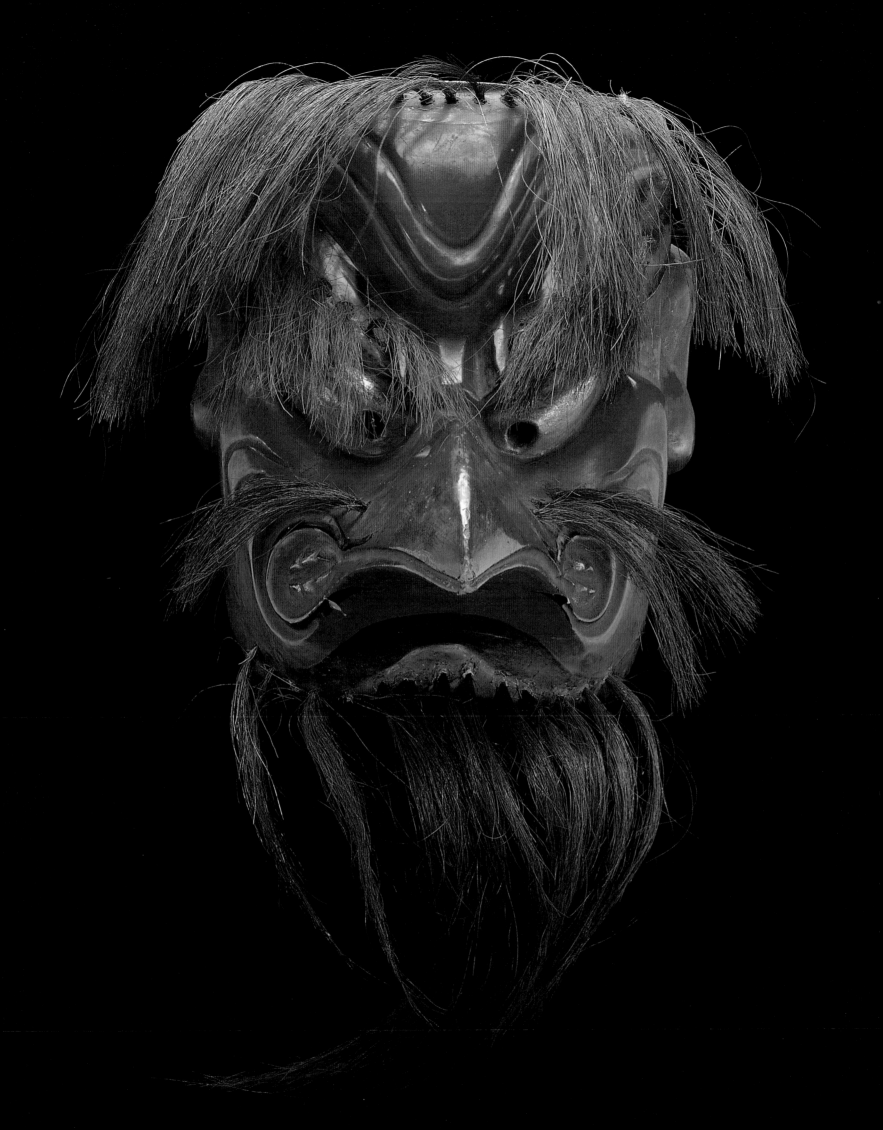

201. *Mask of a crow-like mountain demon* (Karasu Tengu)
Carved wood with applied gesso and paint, applied natural horsehair
21.6 × 19.2 cm
Edo period, 19th century

202. *Mask of a long-nosed mountain demon* (Konoha Tengu)
Carved wood with applied gesso and paint
21.1 × 17.1 cm
Edo period, late 18th century

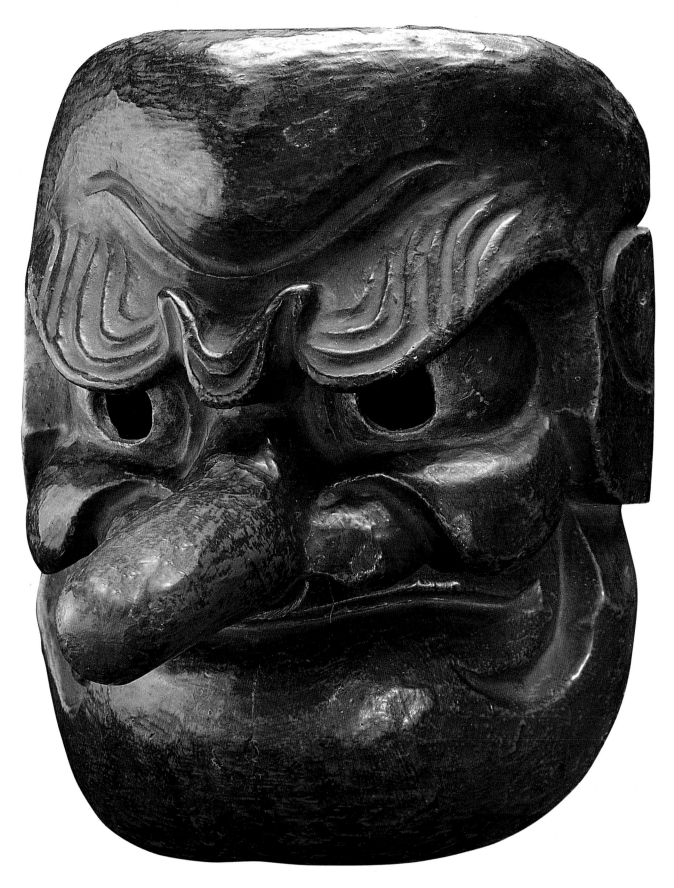

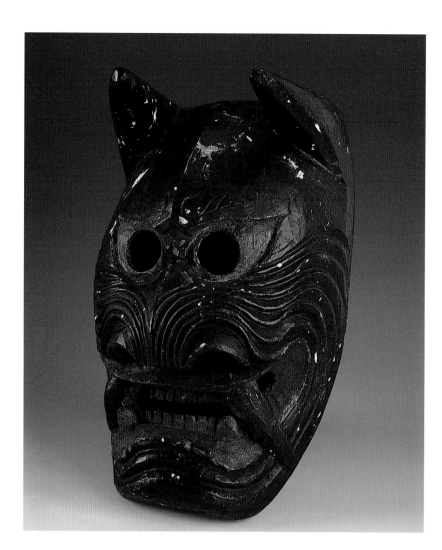

203. *Mask of a demonic deity (Kishin men) in the form of a cat*
Carved wood with applied gesso and paint
23.2 × 14.3 cm
Edo period, late 18th century

204. *Mask of a demonic deity (Kishin men), Hachimaki type. The headband (hachimaki) can be used to represent a powerful being*
Dark wood, carved and stained
Maker's mark incised under chin
20.5 × 12 cm
Edo period, late 18th century

Opposite page:
205. *Mask of a demonic deity (Kishin men), Ko-Jishi or Shikami type*
Carved wood with applied gesso and paint; applied gilt copper disks on eyes
28 × 17.5 cm
Edo period, 17th century

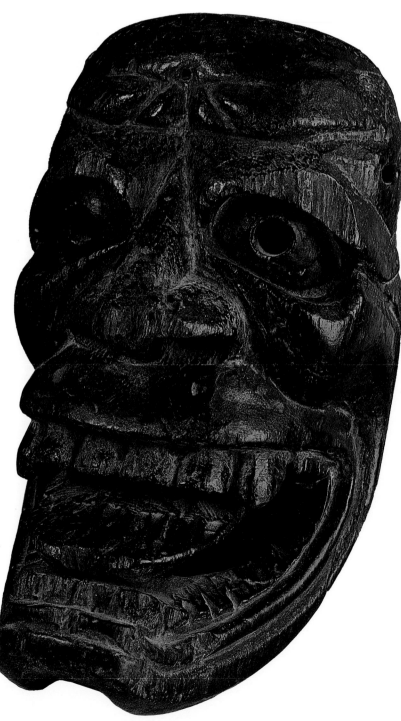

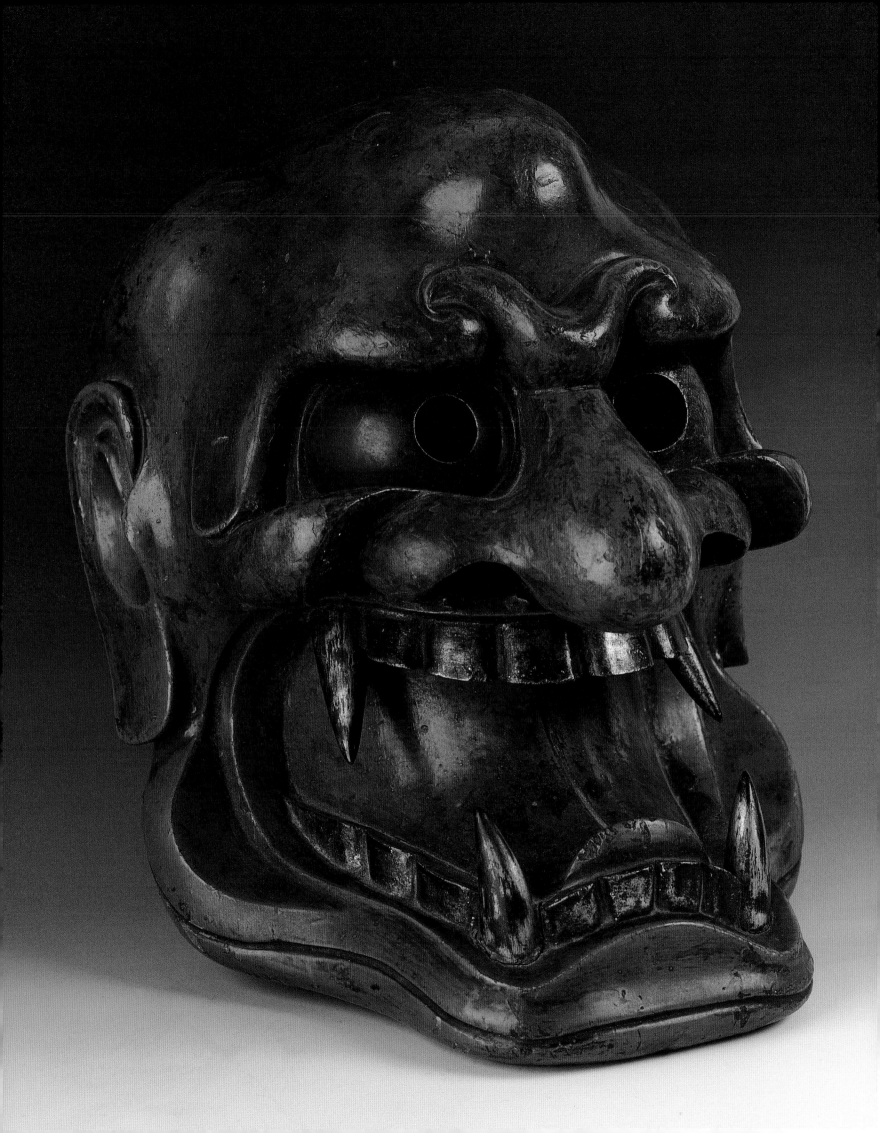

206. *Mask of* Okame
Carved and stained wood
16.4 × 12.6 cm
Edo period, late 18th century

207. *Mask for the* Haru Koma *festival;*
Hyottoko *type*
Carved and stained wood
19.5 × 14.7 cm
Edo period, late 18th century

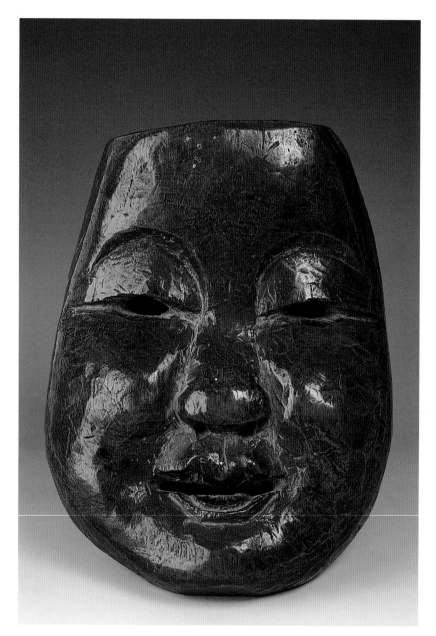

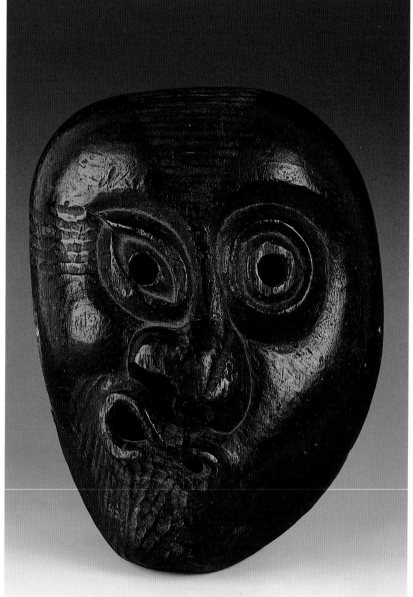

208. *Mask of* Okame
Carved and stained wood with details
painted in black ink (*sumi*)
22.1 × 15 cm
Edo period, late 18th century

209. *Mask of a demonic deity*
(Kishin men), Tobide *type*
Carved and stained wood
Inscribed '*Myō*' (bright) on underside
of chin
20.5 × 13.5 cm
Edo period, 19th century

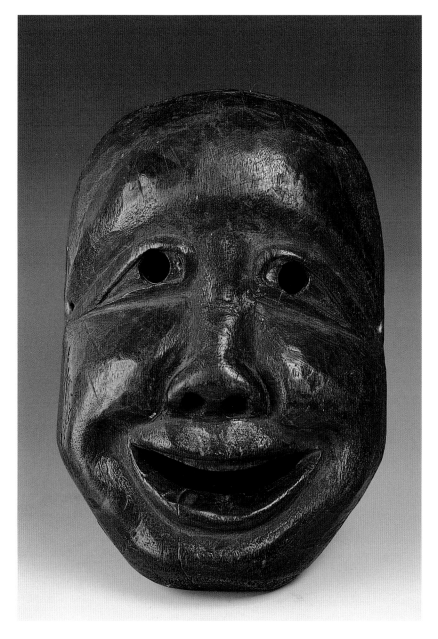

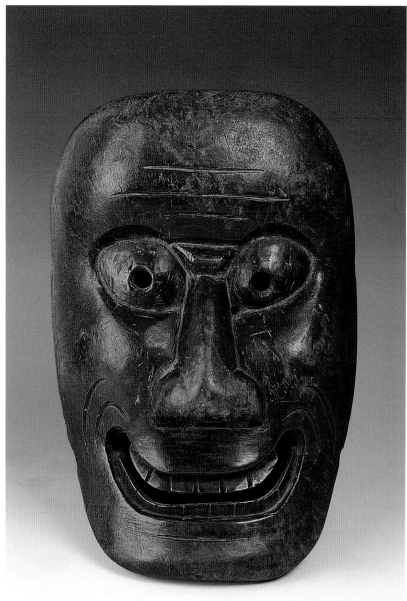

210. *Mask of an old man* (Jō-men)
Carved and stained wood, possibly
pauwlonia
21.2 × 16 cm
Edo period, 18ᵗʰ century

211. *Mask of a demonic deity*
(Kishin men)
Carved wood with applied gesso and
paint, residue of hair in holes on the chin
Three lines of illegible inscriptions
in black ink (*sumi*) in the interior
of the mask
27.8 × 20.5 cm
Edo period, early 17ᵗʰ century

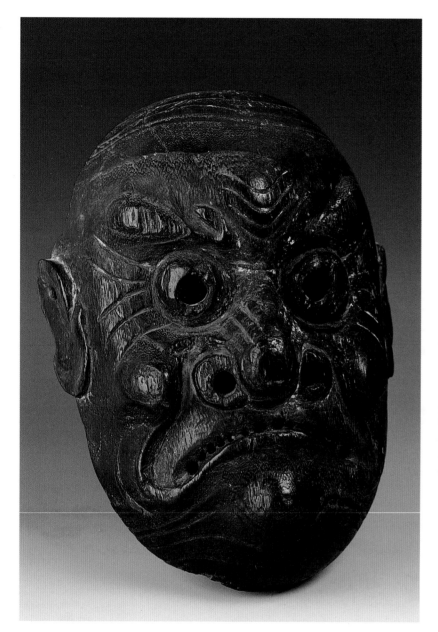

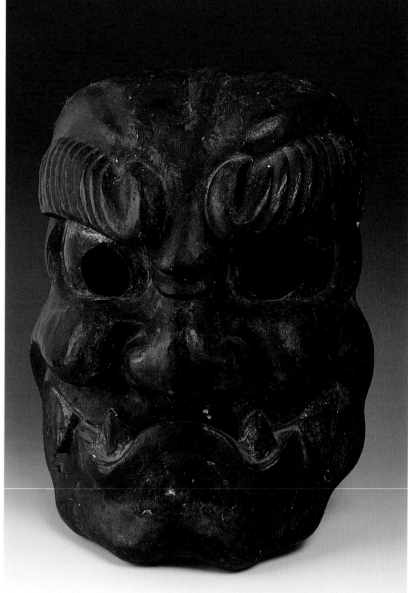

212. *Mask of* Batō *for a provincial type of* Bugaku
Carved wood with applied gesso and paint
22.7 × 17.1 cm
Edo period, 18th century

213. *Mask of a humorous demonic deity (*Kishin men*);* Buaku *type associated with* Kyōgen *performances*
Carved wood with applied gesso and paint
18.9 × 16.7 cm
Edo period, 18th century

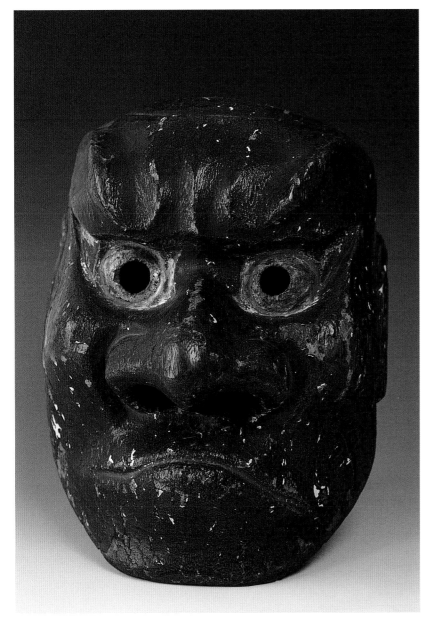

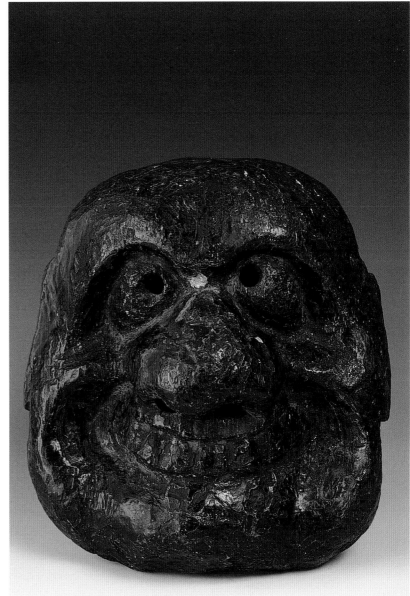

214. *Mask of* Daikoku, *Deity of Wealth*
(one of the Seven Deities of Good Fortune)
Carved wood with applied gesso
and paint
22.9 × 17.9 cm
Edo period, 19th century

215. *Fox* (Kitsune) *mask for a* Kyōgen
performance
Carved wood with applied gesso
and paint; leather and copper hinges
for the lower jaw
21 × 16.5 × 17.5 cm
Edo/Meiji period, 19th century

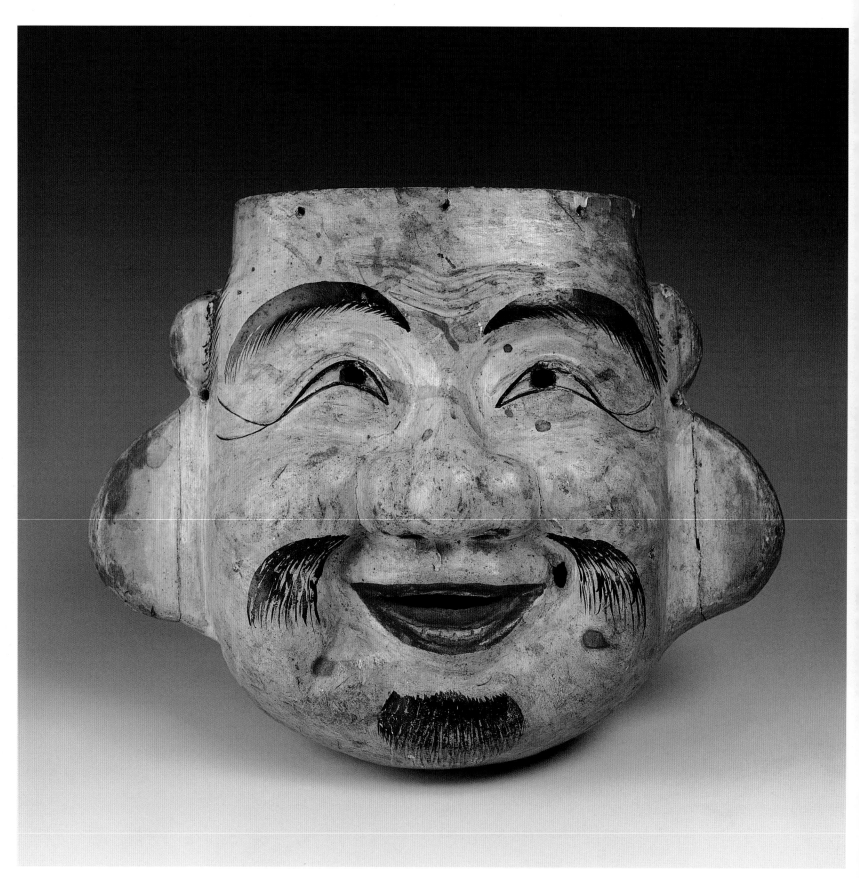

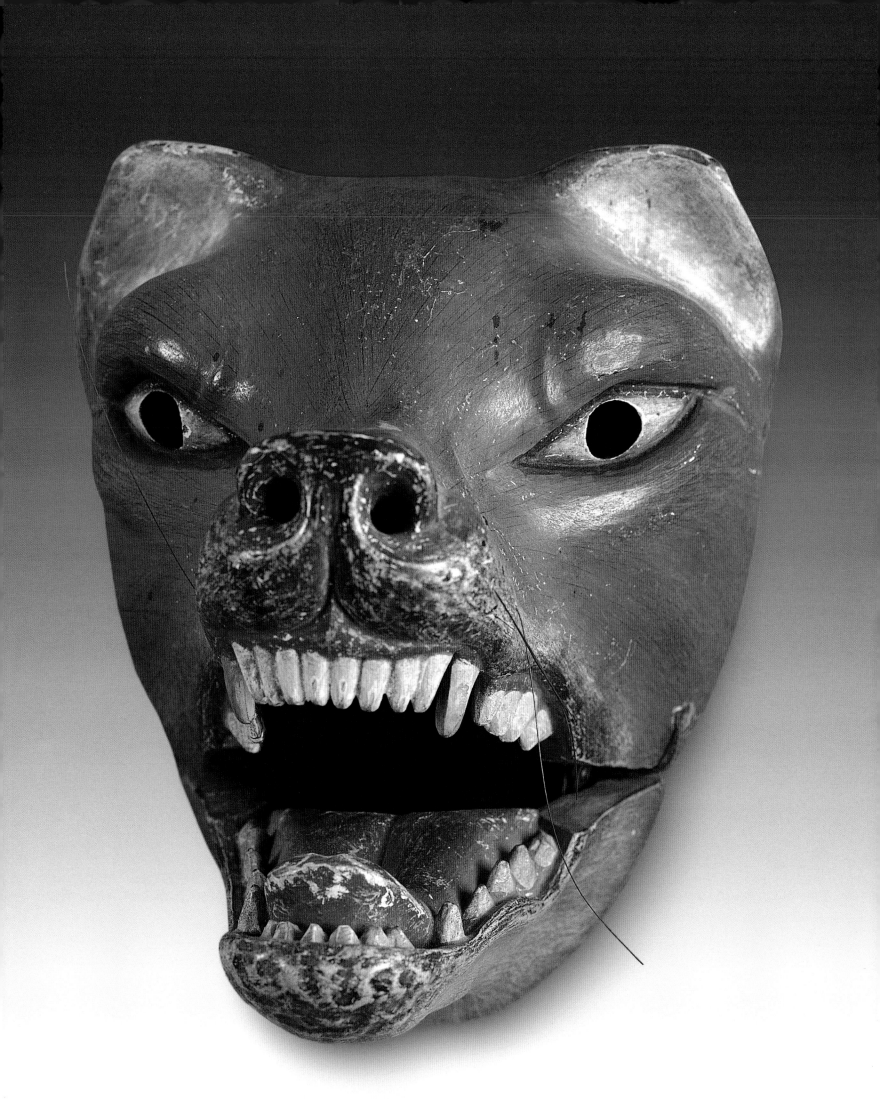

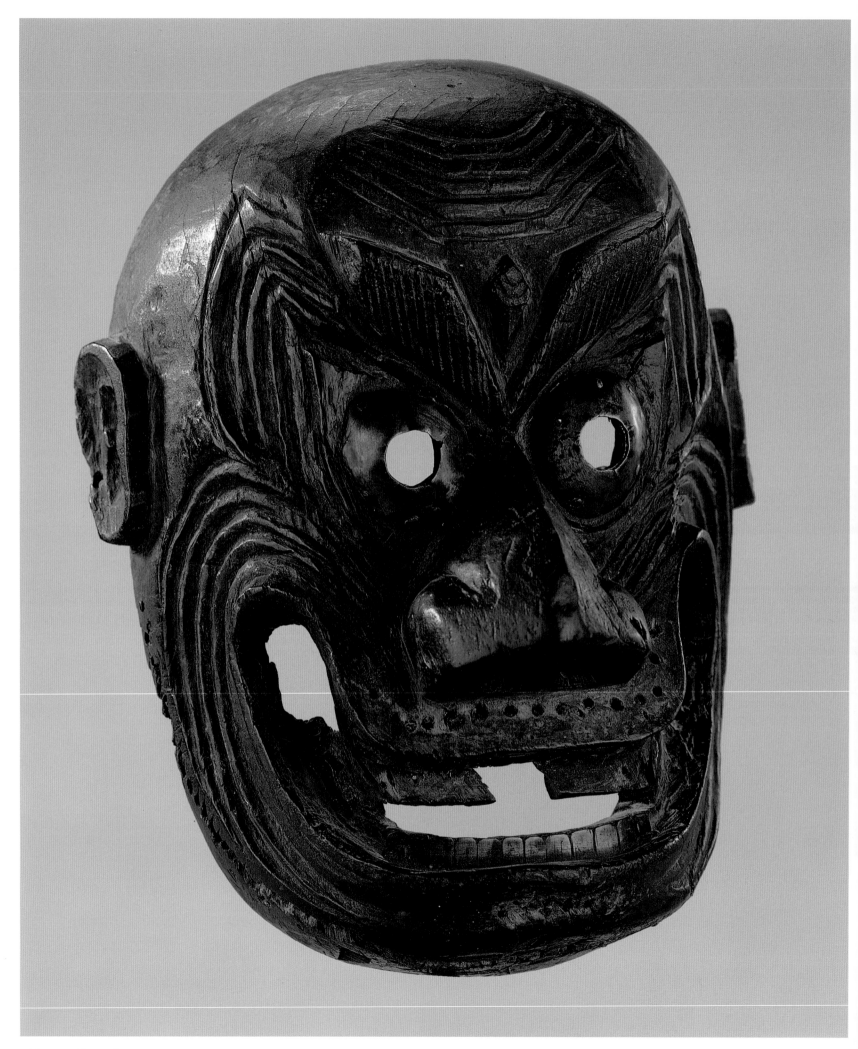

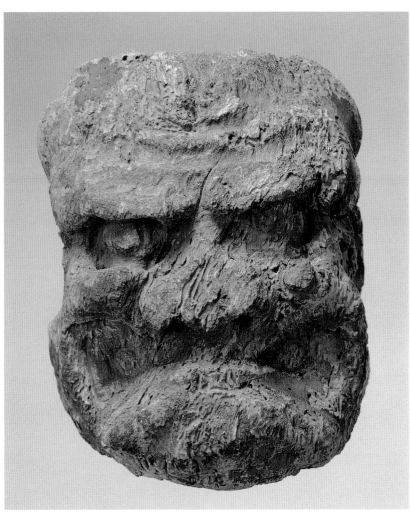

217. *Mask of a demonic deity (Kishin men); Beshimi type made as an offering to a shrine or temple*
Carved wood, possibly pauwlonia
26 × 11.2 cm
Edo period, 17ᵗʰ century

218. Nō *mask of* Beshimi
Carved wood, almost total loss of gesso and paint
Inscribed in black ink '[]-tarō' (first character illegible)
23.5 × 19.5 cm
Edo period, early 18ᵗʰ century

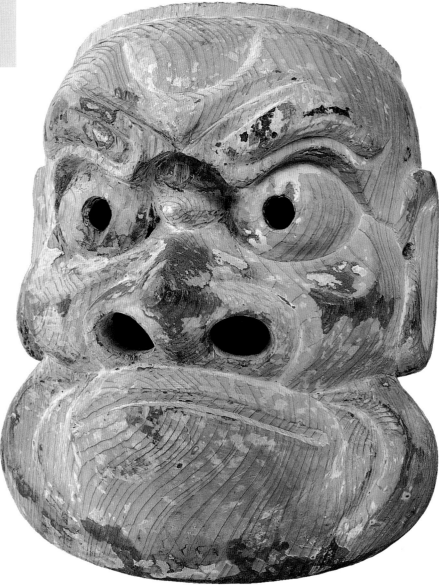

Opposite page:
216. *Demon mask (*Oni-men*)*
Carved wood with applied gesso and paint; gilt copper sheet for the eyes and teeth, residue of hair in holes around lips
31.2 × 24.5 cm
Edo period, early 17ᵗʰ century

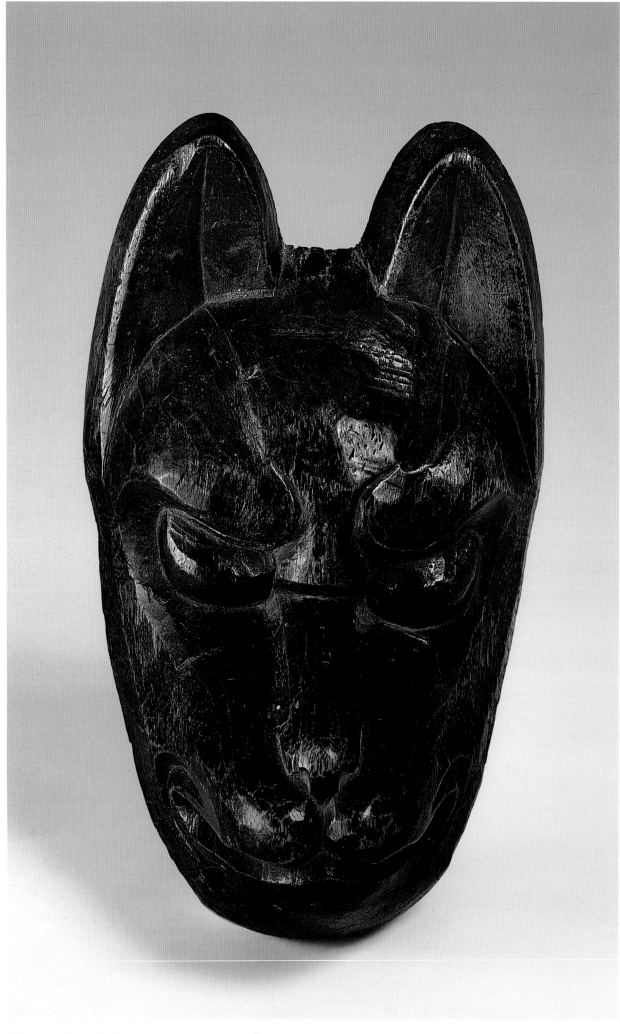

219. *Former for a papier-mâché
fox (*Kitsune*) mask*
Carved wood
Ink inscription on the back of the mask:
'*X hachi gatsu, kichi jitsu*' (X year, eighth
month, a lucky day); '*Menshi Oda saku*'
(made by Oda the mask-maker);
'*Miyamoto Tadayoshi kiyomeru kore o*'
(Miyamoto Tadayoshi ritually purified
this)
22.1 × 13.6 cm
Edo period, 19ᵗʰ century

220. *Mask of a Kitchen Spirit*
(*Kamado-men*)
Carved and stained wood
46.3 × 40.1 cm; h. 23 cm
Edo period, 19ᵗʰ century

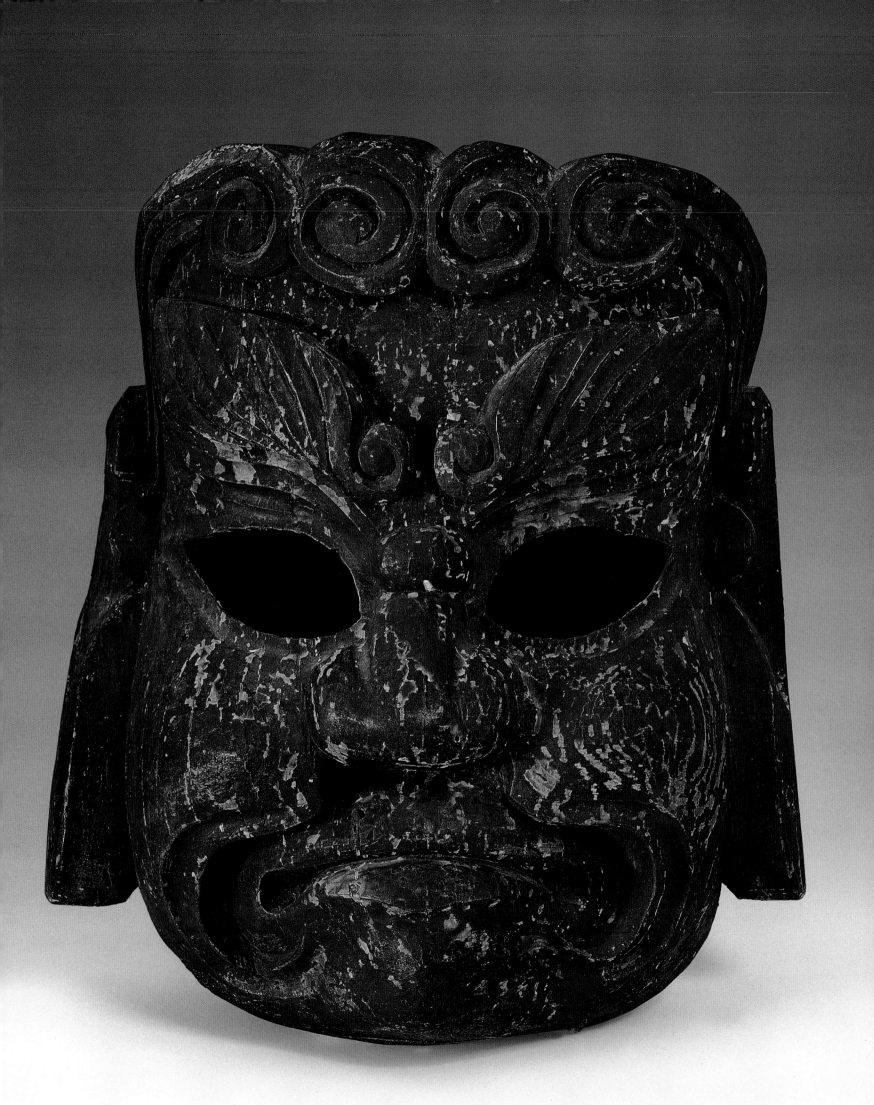

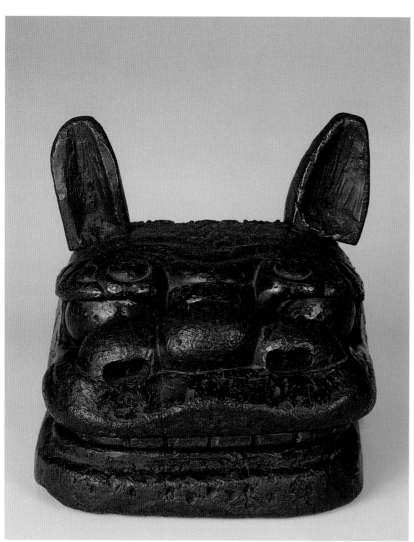

221. *Mask of a mythical lion*
(Shishi-gashira)
Carved and stained wood; ears and
lower jaw of separate pieces of wood.
Residue of gold paint on the teeth
14.7 × 20.3 × 19.5 cm (excluding ears)
Edo period, 18th century

222. *Mask of a mythical lion*
(Shishi-gashira)
Carved and stained wood, paper spacers
on jaw hinge
9.4 × 18.8 × 17.9 cm
Edo period, 18th century

Opposite page:
223. *Stylised deer mask*
(Shishi-men *for* Shika-odori)
Constructed of several pieces of wood
with applied gesso and paint; applied gilt
copper plates for teeth and eyes, hemp
rope bindings
Overall length 35.2 cm; 24.3 × 19.3 cm
Edo period, late 18th century

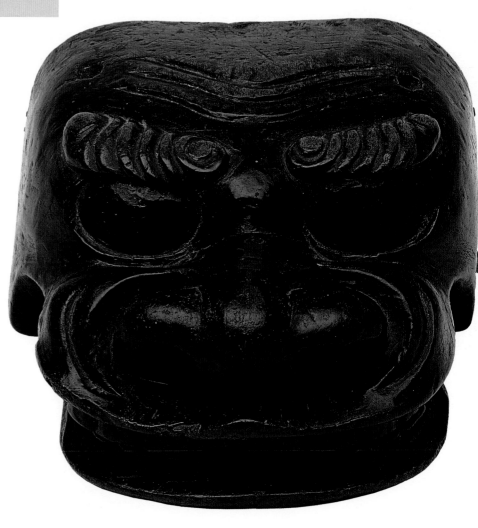

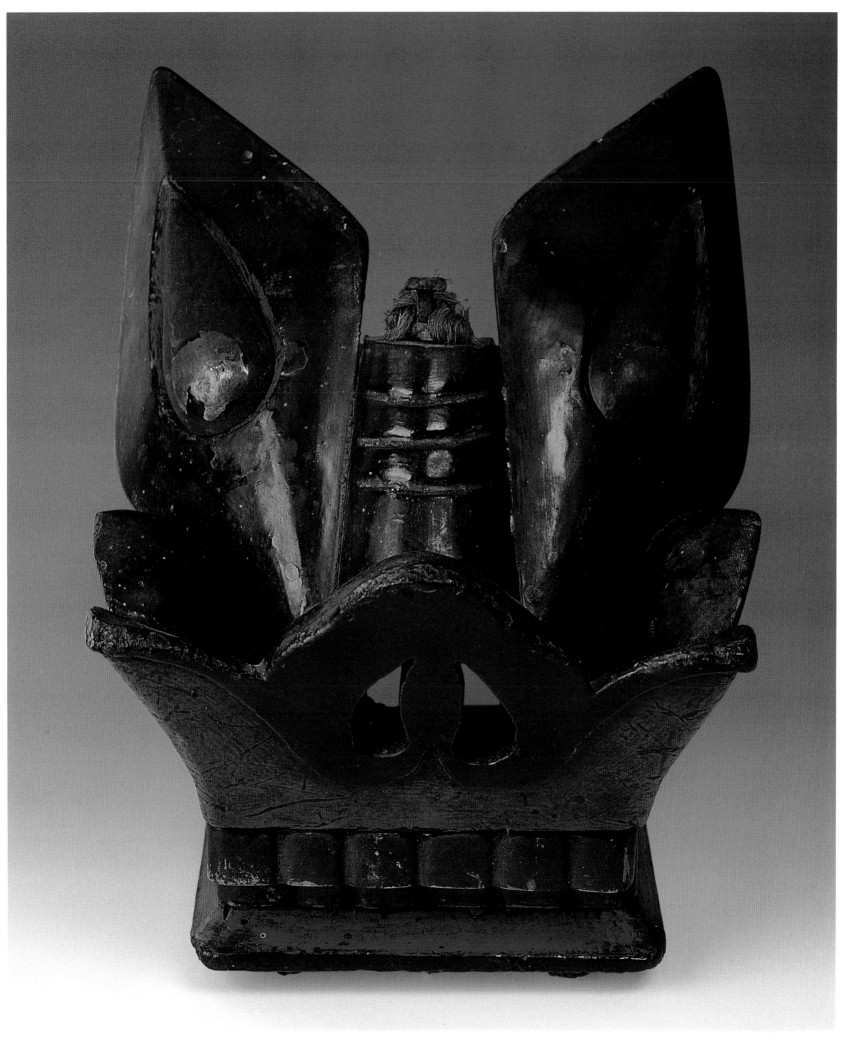

224. *Mask of a mythical lion (*Shishi men*)*
Carved and painted wood; paper disks
between the ears and the head
23.5 × 33.5 × 25.5 cm
Edo period, late 18th century

225. *Mask of a mythical lion*
*(*Shishi Gashira*)*
Carved wood with applied gesso,
painted, detailed metal fittings
and applied horse-hair
19.2 × 34.5 × 30.6 cm
Edo period, late 18th century

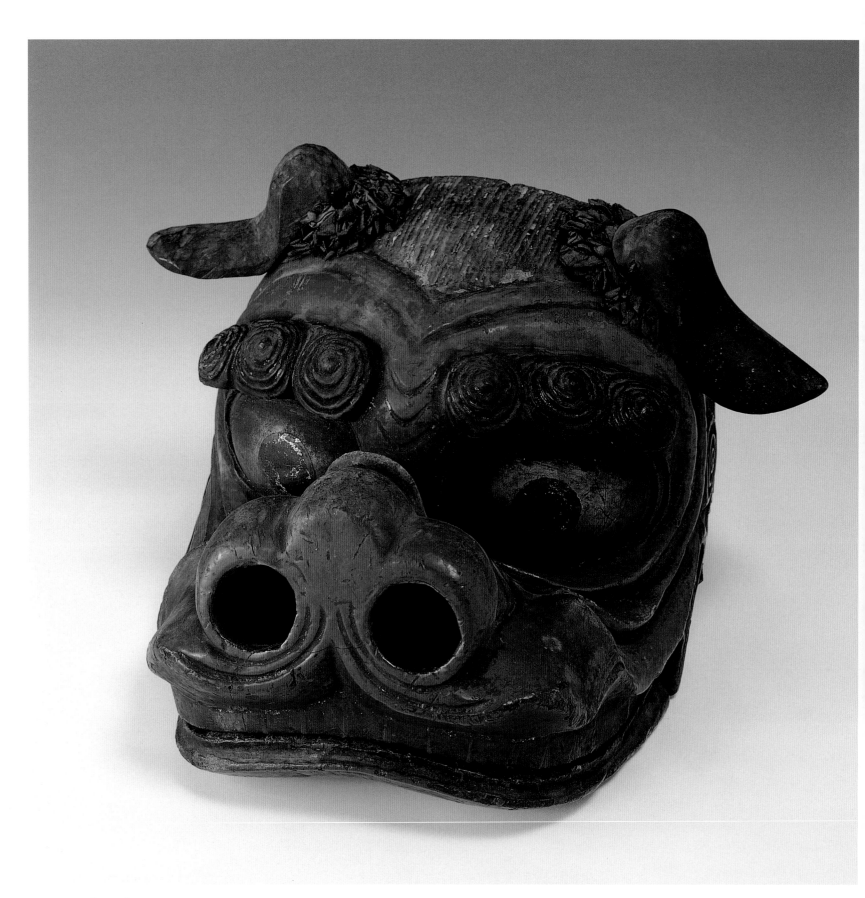

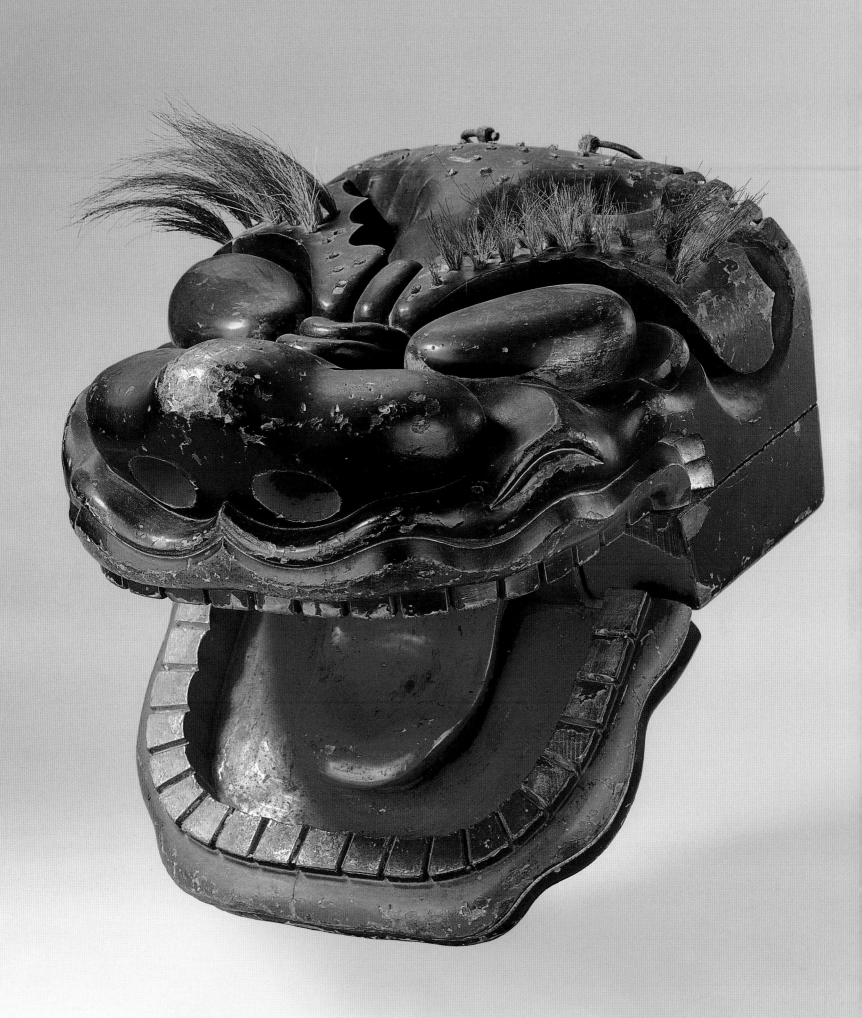

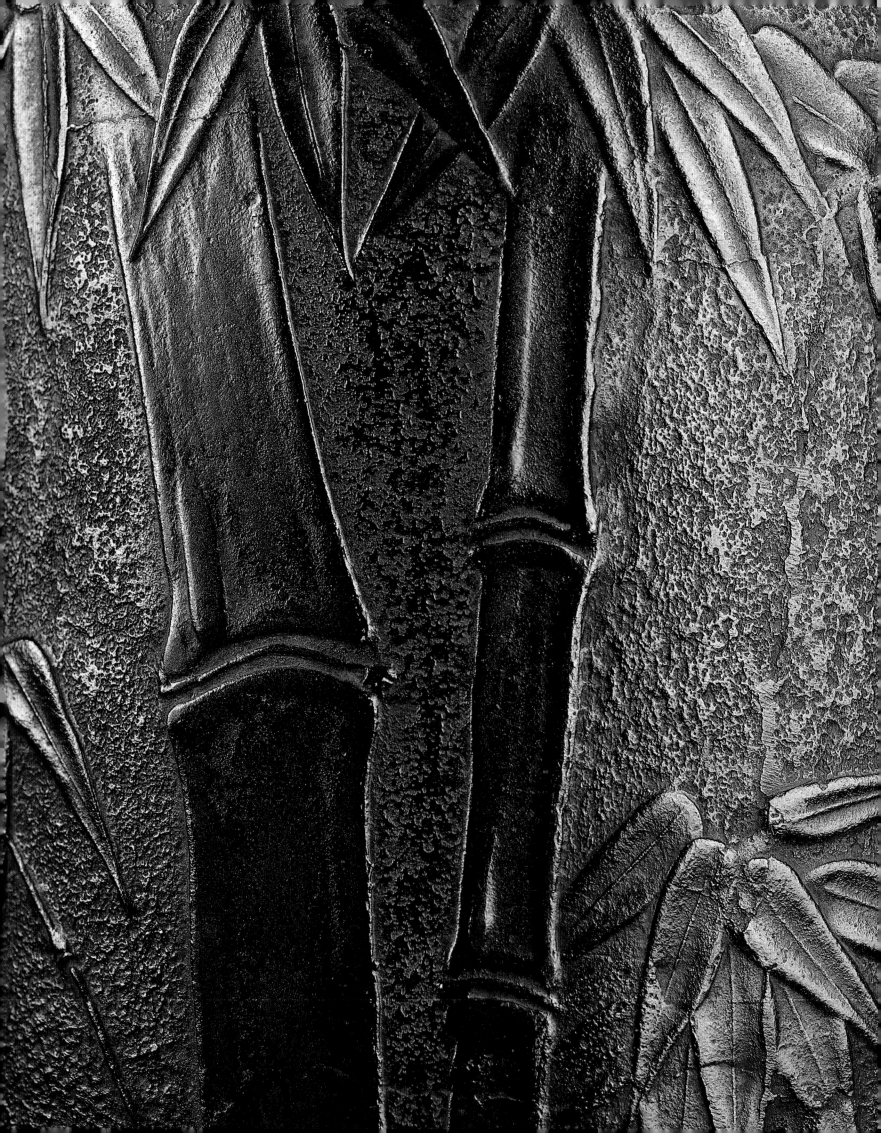

Metalwork

The objects in this chapter are all linked by being principally the creation of the metalworker and are, for the most part, utilitarian objects with their principal end-users being the occupants of the traditional Japanese house whose primary concern with such objects was on functionality, rather than their decorative form. Many of these objects later became valued and appreciated as art works for their simplicity of form as well as for their obvious functionality.

Metalworking in Japan began around 100 AD following the introduction of bronze and iron technology and other metalworking techniques from mainland Asia during the Yayoi period. Early Japanese metalworkers produced mirrors, swords, arrowheads, armour and many forms of ritual and ceremonial objects relating to Buddhism and Japan's own belief system. The most common process in Japanese metalworking was casting, but forging, hammering, engraving, embossing and gilding techniques were also employed. Iron and copper are the two most frequently used metals although lead, silver and gold and many alloys of copper were used for decorative purposes. Early examples of metalwork do survive, but a major problem with all forms of metalwork is that the finished object is inherently unstable and its constituent material constantly tries to revert to its elemental form, reacting with oxygen to form an oxide of its original mineral.

Metalworkers were often regarded as shaman for the control they exerted over the five traditional elements – fire, water, wood, earth and metal. Some metalworkers adopted religious rites in the production of their objects and would call upon the deities to assist them in their efforts.

Swordsmiths, for example, would ritually purify

themselves, their forges would be hung with sacred ropes, and an altar would be erected.

From the Muromachi period onwards the traditional style of rural Japanese house for those not part of either the aristocracy or the ruling samurai class (although there were exceptions for the latter) was the *minka*. There were two basic distinctions in the types of traditional domestic building. Village farmhouses are called *nōka* to distinguish them from the townhouses called *machiya* and the two types are very different in their layout and method of construction. Much of Japan experiences substantial rainfall and northern Japan has heavy snows so the roofs of rural *minka* were steeply pitched and usually thatched. Inside, the layout comprised an area known as the *doma*, which consisted of a compacted earth floor taking up about 30% of the interior floor space. Within the *doma* was the cooking space where a furnace-like oven (*kamado*) was located along with all the cooking equipment.

Alongside the *doma* was a raised area covered with either *tatami* mats or thin straw *mushiro* matting and this area could be subdivided by sliding doors or fixed panels. Within the floored area was an open hearth (*irori*) which provided a basic form of heating and, by default, lighting. There was no chimney and the rooms were dark and gloomy with family life centred around the *kamado* and *irori*. This form of farmhouse remained in use from the Muromachi period right up until the Meiji period. Even today, the *minka* style can be found, particularly in northern Japan.

As in many cultures, the hearth was the centre both tangible and symbolic for many family activities. It provided warmth and light (albeit a little smoky) and the family would gather there for communal meals. The seating arrangement was strictly organised with

226. *Tea-kettle (*tetsubin*) with lid* (detail)
Cast and patinated iron; wrought iron handle; cast-in low-relief decoration of bamboo and plum trees on a hammered (*ishime*) ground; the lid's knob in the form of two pine cones completes the imagery of the Three Friends of Winter (shōchikubai)
h. 41.3 cm (including handle),
w. 22.1 cm (including spout)
Late Edo/early Meiji period. 19ᵗʰ century

the head of the family seated furthest away from the *doma*. The seat closest to the entrance would be given to an honoured guest. The *kamado* would have a fire constantly burning and over openings in the top of the oven one would find the various iron cooking utensils. Pots and kettles (*kama*) and the casserole (*nabe*) were the two most frequently used cooking utensils. The *irori* was also used for simpler cooking and a *kama* would be suspended over the fire by means of an adjustable hook known as a *jizaikagi*. An altar dedicated to the oven deity (*kamado-gami*) would be found alongside the *kamado*. A mask such as that in figure 220 would have been installed nearby to protect both the kitchen and the family by driving away evil influences. When a new family house was constructed, for example following a marriage, fire was taken from the *kamado* of the main family house to light the new *kamado*. The *irori* too was kept constantly burning and provided constant hot water and with surrounding shelving was an area where food produce could be dried.

We can find detailed descriptions of the interiors of Japanese houses from the journals, diaries and books written by the many western travellers who flocked to the newly opened-up country of Japan in the latter part of the nineteenth century. Francis Hall, an American journalist and businessman lived in Japan from 1859-1866 and kept a diary of his travels around the country. In an entry for 1860 he writes of the traditional Japanese farmhouse: 'The insides of the houses are dingy with smoke discoloured paper windows. The kitchen is a confused collection of pots, kettles [...] and the simple domestic utensils. Over a fire hole left in the floor edged with stone swings from an iron crane the teakettle or perhaps a large kettle. Then there is the cooking range which is a small furnace with two or three places to set a pot or kindle a fire underneath, the smoke making such as vent as it may...'[1]

Figures 227 and 228 are exactly the type of 'crane', the *jizaikagi*, which Hall would have seen. They are simple yet elegant functional objects in which the deity of the *irori* was traditionally believed to lodge. The height of the hook (to which a pot can be attached) is adjusted by relieving the tension on the rod which passes through the horizontal counterweight adjuster (*yokogi*). Figure 227 has a *yokogi* in the form of a detailed study of a carp which even has moveable fins. Figure 228 is a plain, flat representation of a carp but the vertical rod has here been worked into a graceful spiral. In Japan the carp symbolises strength, success and perseverance. These *jizaikagi* are unpretentious objects and yet are particularly satisfying examples of metal craftsmanship. Meals in the traditional rural farmhouse centred

around what was cooked in the *nabe*, or casserole. This large cooking pot would either be placed on the *kamado* (figure 249), or could hang from the *jizaikagi* over the *irori* (figure 248). The latter also has three peg-like feet so would work equally well on the *kamado* and has a spout which would be useful for pouring broth into bowls. Both *nabe* have been cast with elegant curves and the aged patina of the iron contrasts agreeably with the colour and texture of the plain wooden and lacquered lids. Whichever form the *nabe* took, the method of cooking was no different. The communal one-pot dish into which almost any ingredient could be added was a popular and common meal in Japan's countryside. To be seated around the bubbling *nabe* in winter with a supply of warm saké must have been a most pleasurable experience. *Nabemono* – 'things for the *nabe*' is a popular form of cooking in Japanese homes (and restaurants) today, although now the *nabe* is more likely to be electrically powered.

Oil and candles were expensive so the light of the burning wood fires was the principal means of interior illumination. There were, however, various styles of lanterns to be found within the house. Most common was the *andon*, a standing lantern usually made with an iron (or sometimes wooden) frame covered with a paper shade. The shade was removable (for repairs) and the interior of the *andon* would have a fitting for either an oil-dish for burning rapeseed oil or a pricket candlestick, sometimes both can be found in one *andon*. Under the oil-dish or candle there was a plate (*abura-zara*) to collect any drips. The Japanese candle (*rōsoku*) was made from vegetable wax, generally from berries of the sumac or lacquer tree, and this was a time-consuming and therefore expensive process. Candlesticks and candle stands (*shokudai*) were also to be found in many shapes and sizes and these would usually have a simple form of drip tray.

The Montgomery collection has a wide and varied assortment of the various types of lanterns. The traditional *andon* is here represented by figures 256, 257 and 258. Figure 258 is a standing form of the *andon* which has holes in the feet as though it was once nailed down. Fire was a constant fear in a traditional Japanese house which was constructed of, and contained much combustible material. This combined with the ever-present threat of earthquakes would have required many such measures in order to prevent a conflagration. Figure 257 is able to both stand or hang in the manner of the *chōchin* – the folding paper and bamboo lantern traditionally found outside restaurants. Figure 256 is an extremely versatile lantern which can be hung, stood or carried and has fittings for both an oil-

dish with wick and a candle. What all these types of lantern reveal is an elegant combination of curves and square shapes in paper and metal which derives directly from their functionality. It is these types of lantern which inspired the twentieth-century designer Noguchi Isamu to create his famous 'Akari' lamps of mulberry paper and bamboo.

Figures 254a, 254b and 254c are hanging lanterns, *tsuri-dōro*, of cast iron lined with mulberry paper and are intended for outdoor use. Traditionally they hung in the eaves of the veranda outside the house. On a summer's evening light would shine through their pierced designs and cast interesting patterns of light into the house whose sliding doors, *shōji*, would have been removed, and at the same time send light into the garden.

Candlesticks (*shokudai*) were rarer items, as candles were even more expensive than oil. Figures 251 and 253 are tall adjustable candlesticks, although quite why the height would need to be adjusted is unclear. Their shapes are rather rudimentary and unsophisticated and they are simple, functional objects. Figure 252 is an unusual small adjustable candlestick which may perhaps have been used in an area of the house given over to writing – conceivably the farmer would have sorted his accounts by its light. The helical column, which broadens towards the top, sits on an elegant round base with a chrysanthemum design. This object demonstrates qualities of deliberate 'design' which may suggest that it may have been made for a customer of discerning taste.

We have from another nineteenth-century western traveller a description of the interior of a traditional Japanese house, this time describing the effect of lighting with an *andon*. The author, Isabella Lucy Bird, was an intrepid Victorian lady; born in 1831 she became the first woman member of the Royal Geographical Society. She travelled the world widely, visiting Japan in 1878 and publishing her experiences in 1880. With typical Victorian directness she writes: 'I don't wonder that the Japanese rise early, for their evenings are cheerless, owing to the dismal illumination. In this and other houses the lamp consists of a square or circular lacquer stand, with four uprights, 2.5 feet high, and panes of white paper. A flatted iron dish is suspended in this full of oil, with the pith of a rush with a weight in the centre laid across it, and one of the projecting ends is lighted. This wretched apparatus is called an *andon*, and round its wretched "darkness visible" the family huddles – the children to play games and learn lessons, and the women to sew; for the Japanese daylight is short and the houses are dark. Almost more deplorable is a candlestick of the same height as the *andon*, with a spike at the top which

fits into a hole at the bottom of a "farthing candle" of vegetable wax, with a thick wick made of rolled paper, which requires constant snuffing, and, after giving for a short time a dim and jerky light, expires with a bad smell. Lamps, burning mineral oils, native and imported, are being manufactured on a large scale, but, apart from the peril connected with them, the carriage of oil into country districts is very expensive. No Japanese would think of sleeping without having an *andon* burning all night in his room'[2]. There are several examples of other methods of lighting within the collection. Figure 259 is a type of candlestick used by travellers which could be folded flat when not in use and kept inside the front of one's clothing. Figure 259 is a folding *chōchin* with oiled paper for weatherproofing and with its fine lines and family crest is not an item which would have been used by a rural farmer. Believed to have originated in the town of Odawara, these *chōchin* were used mostly by travellers and in towns. Figure 255 is an elegant form of *tsuri-dōro* with similarities in its design to the famous bronze lanterns found at the Shintō Kasuga Shrine in Nara. Light can be used as a ritual form of purification and figure 250 is a *tōmyōdai*, a stand used for making votive offerings at a Buddhist temple in a ritual not unlike the traditional offering of candles in a Christian church. The central spike can hold a candle or an oil-burner while the side rings would hold dishes with oil and a burning wick. The shape of the elegantly curved sidepieces to the central column are reminiscent of the fittings (*magarikane*) on the hilts of Shintō votive swords of the Nara period.

The perhaps unintentional aesthetic to be found in the simple, yet functional, objects produced in Japan's provinces found a place in the tea ceremony (*Chanoyu*) a custom which had become formalised by the late Muromachi period. Despite this being an era riven with civil war, many of Japan's arts flourished and by the time of Sen no Rikyō (1522-91) the tea ceremony had developed into an aesthetic practise patronised by the ruling samurai class and also later by rich merchants. The practise revolved around the concept of *wabi*, itself an earlier tradition with its roots in the idealised world of the eremitic life. *Wabi* emphasised simplicity with a special regard for austere forms of beauty and became a concept which made loneliness and poverty synonymous with liberation from material worries. It also created its own aesthetic by making an apparent artlessness and lack of beauty in objects a new form of perfection in its own right.

Rikyō followed the *wabi* aesthetic and used utilitarian utensils in his form of the tea ceremony as well as the expensive and rare Chinese objects used in for-

mer periods. Everyday objects such as tea-kettles (based on the traditional *kama*) and simple ceramics which would today be regarded as 'folk-crafts' were utilised and the demand for these type objects resulted in an escalation in their production. The gentle noise of water boiling in the *chagama* as it sat on the hearth or charcoal brazier was believed to help to induce a relaxed atmosphere into the ritual.

The specially prepared area for the tea ceremony gave the impression of a mountain retreat with a simple house (*chashitsu*) which emphasised the 'rustic' ideal of frugality and austerity. Although perhaps the image of Marie Antoinette and her courtiers playing at peasants in Versailles may come to mind yet those who followed the austerities of tea were serious in their commitment to finding new forms of beauty. They would endeavour to appreciate the simpler qualities of life and through tea aspire to find and develop a personal inner quietness and restraint. The kettle used to prepare hot water for whipped tea was the *chagama*. This heavy iron vessel was sand-cast using an inner and outer mould in two halves, top and bottom. The horizontal casting line is usually left evident and a distinctive feature is frequently made of this line. The acquired patina found in old *chagama* was much admired and newly produced items were given an artificial subdued patination by physically treating the surface or through a corrosive process involving plum vinegar or iron oxide. Two areas of Japan became famous for the production of *chagama*; Ashiya in Chikuzen province (Fukuoka Prefecture) and Sano Temmyō (in what is now Tochigi Prefecture). There were many other areas producing *chagama*, some of which adopted the names of the Ashiya style. For example Echizen-Ashiya and Hizen-Ashiya; these may be appellations indicative of quality or could imply that Ashiya craftsmen had moved to these areas and set up new workshops. Figure 238 is a fine example of an Ashiya-style *chagama* which appears to have been made, or adapted, for more general use. It has the distinctive central casting flange but also has small tripod feet, a feature not found on a true *chagama* which would sit on the hearth or on a metal trivet on a brazier. Figure 245 is a true *chagama* which displays all the characteristics of an elegant quiet beauty with restrained evocative decorative qualities. Custom dictated the amount of water a *chagama* should contain and therefore predetermined its size; so too did the seasons. Figure 243 is the type of *chagama* which would have been used during the summer months. Its unusual shape, purposefully designed, has well-balanced proportions, exquisite patination and a restrained yet energetic quality.

In the eighteenth century the fashion developed (particularly in Kyoto and Osaka) for drinking *sencha*, thin, infused tea and the *tetsubin* form of teakettle came into prominence. The sizes of *tetsubin* as well as their decoration varied considerably and *tetsubin*, especially towards the end of the Edo period and well into the Meiji period, could be elaborately decorated with metal inlay and high relief cast-in decoration. Figure 234 is a large family-sized *tetsubin* which would have served many people and may have been used for large parties or perhaps in a restaurant. The 'face' has a low relief decoration of a horse which would be visible to the guest when the tea was poured; the opposite side is quite plain. It is an example of the '*Nambu*' teakettle which is still being made today. Nambu is a district of Iwate Prefecture in north-eastern Japan and has been producing fine ironware since the seventeenth century.

Figure 266 is another extremely large *tetsubin* with a decoration of the Three Friends of Winter (*shōchikubai*). The decoration extends over all the surface of the piece and therefore it has no particular 'face', which is uncommon in objects such as this. Figures 229 and 233 are typically restrained forms of *tetsubin*: the former decorated overall with a pattern of raised knobs which recall hailstones (*arare*), the latter with a profile said to suggest the conical shape of Mount Fuji. Both have a fine russet patination. Large kettles would hang over the *irori* to provide a constant supply of hot water[3].

Figure 230 is a refined and elegant *tetsubin* whose patinated and hammered-effect body contrasts with the raised and polished camellia leaf decoration. Figures 232 and 241 are small, intimate examples of the *tetsubin* and both show the Japanese love of natural forms. The natural gourd shape and aubergine forms have been patinated with the aubergine having a partially polished surface (perhaps with the addition of some lacquer) which gives the impression of age and much use. The gourd-shaped *tetsubin* has been cast vertically with the lines still prominent but any casting lines have been removed from the aubergine form.

The *kaiseki* meal which preceded the tea ceremony proper involved the drinking of saké. The pair of iron saké ewers (figure 239) known as *chōshi* may have been used for the tea ceremony, but more a more likely use would be for a picnic. While they have a 'rustic' patination their surface decoration is far removed from any romantic image of a simple country life but alludes to another idealised way of life. The Chinese literati had been figures of admiration for centuries and the idea of following a life free from daily worries whilst being able to appreciate the finer things in life was a dream for

many Japanese in all social strata. The lacquered lids and handle inlaid with silver are both in Momoyama period taste with the whole piece harking back to a period of luxurious taste and of leisurely pursuits.

Incense was burned at tea-ceremonies by placing the incense into the charcoal fire. Figure 244 is a rather cleverly designed incense burner (kōro) which would be used for burning incense on other occasions. Such is its design that for a while it was believed to be a chōshi. It is a consummate piece of the metalworker's skill as it is actually made of bronze patinated to make it appear to be of iron. Figure 240 is another elegantly decorated chōshi with a mixture of both rustic and refined decoration. It too would have been used at a picnic and the decoration of cherry-blossom suggests that it would be taken to hanami, cherry-blossom viewing, an activity still popular throughout Japan today at which industrial quantities of alcohol are consumed.

Objects which do not directly fit into any particular category include padlocks (jōmae). Purely functional objects, the three in the Montgomery collection have an inherent beauty in their line and form which belies their function – to keep out unwanted hands. Stout padlocks of this type could have been used to secure a large cabinet or more likely a kura, a storehouse which would be found in both town and countryside. Figures 246 and 247 are enigmatic objects which nonetheless have a curious charm about them, although their actual function is unclear. They are made in the form of chagama but their lacquer decoration renders them unfit for use as a kettle. All chagama have lugs to enable them to be lifted and there is no evidence of lugs on the sides of these pieces and no evidence of the lugs having been removed. It is possible that they were made as purely decorative pieces for export or for domestic use as vessels for flower arrangements. The combination of a traditional iron form with fashionable lacquering takes these objects outside the scope of wabi and into a completely different aesthetic.

In 1926 the art historian Yanagi Muneyoshi (Sōetsu) coined the term 'Mingei' as a description for Japan's folk crafts. Yanagi preferred the term 'crafts' to 'arts' and Mingei came to define both a genre of objects created for everyday use and the movement itself. The aesthetic which Yanagi expounded was that there was an unpretentious beauty to be found in an object which although produced in large numbers was created by skilled, but unknown, craftsmen who had honed their talents over years of repetitive work. This beauty was not cre-ated by any conscious intent on the part of the artisan, rather that the combination of personal skill and a respect for his materials would result in the artisan's creation of an object of intrinsic beauty. Yanagi was deeply interested in Buddhist philosophy and believed that the concept of mushin, selflessness, was part of the fundamental nature of these objects which had been made without thought of self-expression by anonymous artisans. Robert Moes has written that 'Mingei is the antithesis of the tea ceremony. Japanese folk art served the common people and was genuinely utilitarian. Its naivety, directness and lack of pretension contrast sharply with the self-conscious, sophisticated refinement of the tea ceremony. Nevertheless, for numerous rich merchant families, patronage of the tea ceremony and folk art actually overlapped'[4]. The anonymous artisan produces work without thought of artistic praise. A privileged class with leisure time has the opportunity to appreciate that which is created by those without the time to indulge in the appreciation of the finer aspects of arts and crafts. Nevertheless, anyone with a respect, appreciation and understanding of nature can surely appreciate a beautifully crafted object both for its form and functionality. The metalwork in the Montgomery collection exemplifies the aesthetic both of the original creator of the objects and of the collector himself. In the words of Yanagi: 'I must say that folk-crafts play an especially important part among applied arts in helping the realization of the kingdom of beauty. In folk-crafts we can find healthy and normal beauty most richly than in any other kind of art […] So I have come to the following conclusion. Spontaneity, humbleness, modesty and simplicity are the fundamental elements which nurture beauty, just as is the case of human virtue'[5].

[1] Notehelfer, F.G. (ed.), Japan through American eyes: The Journal of Francis Hall, Kanagawa and Yokohama, 1859-1866, Princeton University Press, 1992, pp. 170-171. Taken from William B. Hauser in Mingei and Japanese Society, an essay in Mingei: Japanese Folk Art from the Montgomery Collection. Art Services International, 1995, pp. 14-15.
[2] Letter X, June 23 1878; from Unbeaten tracks in Japan: An Account of Travels in the Interior, including Visits to the Aborigines of Yezo and the Shrines of Nikko and Ise, 1885.
[3] For an illustration of a large tetsubin in use over an irori see p. 194 in Morse, Japanese Homes and their surroundings. London; Sampson Low, Marcton, Searleand Rivington 1886.
[4] Moes, R., Mingei Categories and Characteristics, in Mingei: Japanese Folk Art from the Montgomery Collection. Art Services International, 1995, p. 29.
[5] Sōetsu, Y., "Kingdom of Beauty and Folk-Crafts", in Bulletin of Eastern Art, June 1940, no. 6, by The Society of Friends of Eastern Art, Tokyo.

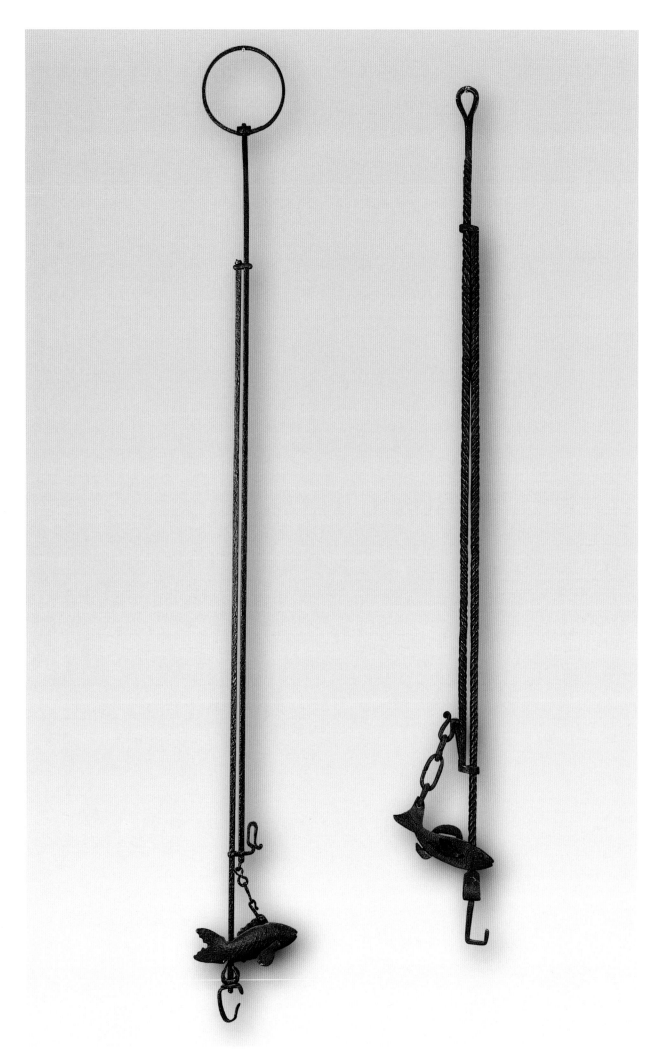

227. *Adjustable kettle-hook (jizaikagi)*
Cast and patinated iron
l. 139.3 cm (closed), 222.6 cm
(fully extended)
Edo/Meiji period, 19ᵗʰ century

228. *Adjustable kettle-hook (jizaikagi)*
Cast and patinated iron
l. 162.4 cm (closed), 257.4 cm
(fully extended)
Edo/Meiji period, 19ᵗʰ century

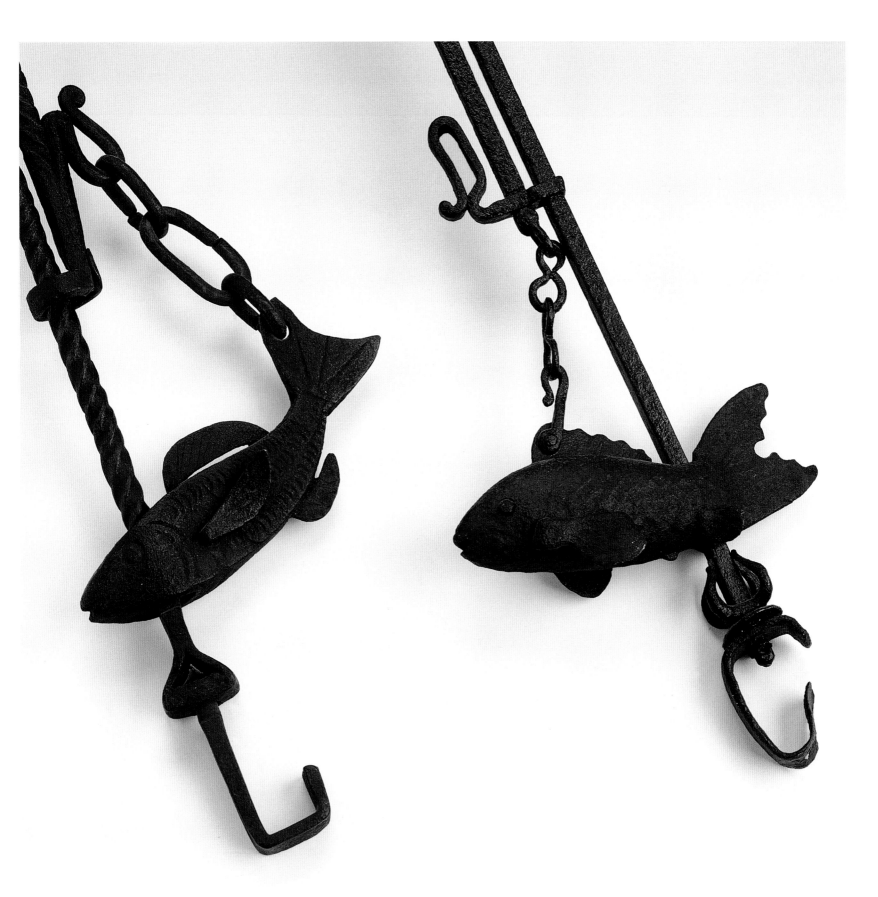

229. *Tea-kettle* (tetsubin)
Cast and patinated iron: wrought iron
handle; decorated overall in a raised
pattern known as 'hailstones' (arare)
h. 24.6 cm (including handle);
w. 19.9 cm (including spout)
Edo period, 19th century

230. *Tea-kettle* (tetsubin)
Cast and patinated iron; wrought iron
handle. Hammered surface with polished
cast-in decoration of camellia leaves
h. 27.2 cm (including handle),
w. 22.4 cm (including spout)
Meiji period, 19th century

231. *Tea-kettle* (tetsubin) *with lid*
Cast and patinated iron; wrought iron
handle; cast-in low-relief decoration of
bamboo and plum trees on a hammered
(ishime) ground; the lid's knob in the
form of two pine cones completes the
imagery of the Three Friends of Winter
(shōchikubai)
h. 41.3 cm (including handle),
w. 22.1 cm (including spout)
Late Edo/early Meiji period. 19th century

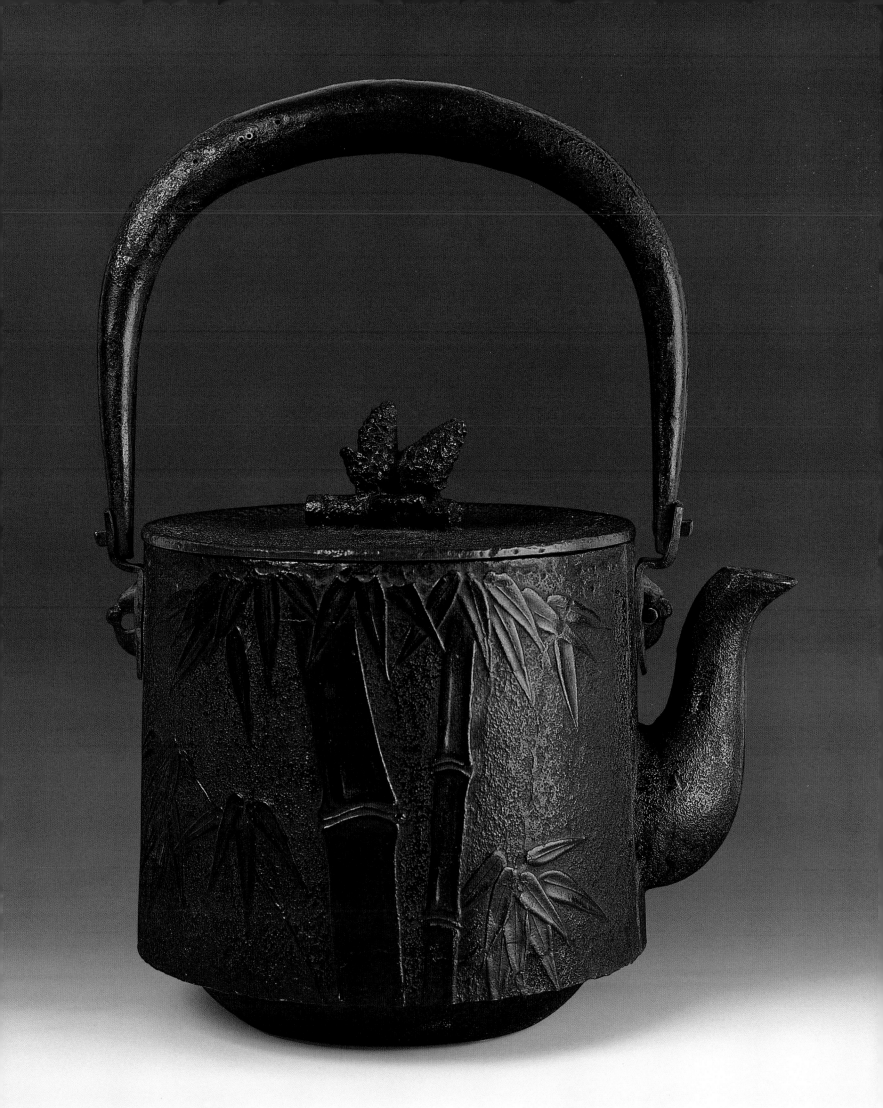

232. *Tea-kettle (*tetsubin*)*
Cast and patinated iron; wrought iron
handle; lid of patinated copper with
cloisonné knob
24.2 × 14.2 cm
Edo period, late 18th century

233. *Tea-kettle (*tetsubin*)*
Cast and patinated iron in the conical
shape of Mt. Fuji; wrought iron handle
h. 17.5 cm (including handle);
14 × 12.5 cm
Edo period, 19th century

Opposite page:
234. *Large tea-kettle (*tetsubin*)*
Cast and patinated iron; wrought iron
handle; cast-in low relief decoration
of a horse
h. 43.3 cm (including handle);
d. 33.2 cm
Meiji period, late 19th century

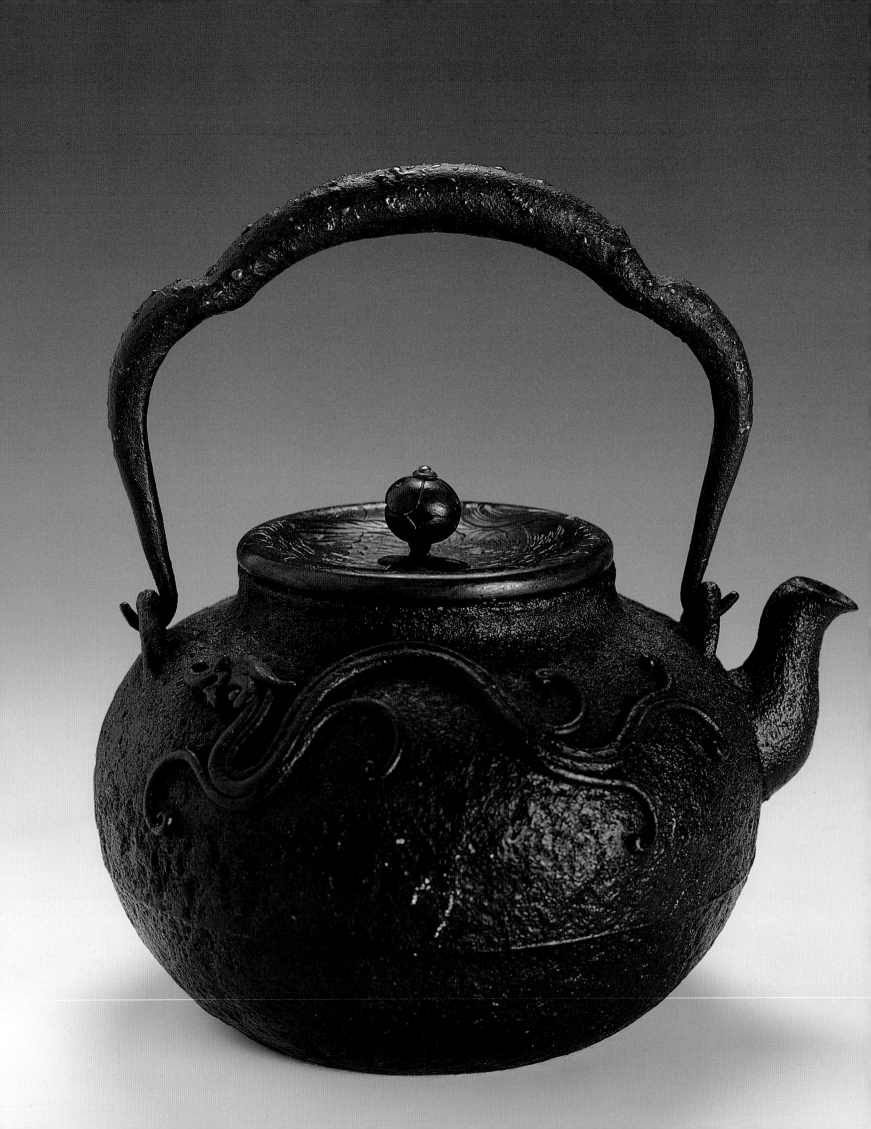

235. *Tea-kettle (*tetsubin*)*
Cast and patinated iron with applied splashed decoration of *sahari* to the wrought iron handle; patinated copper lid: sides decorated with a sinuous stylised dragon; lid engraved with a winged dragon in clouds
h. 20.8 cm (including handle);
w. 19.1 cm (including spout)
Edo/Meiji period, 19th century

236. *Tea-kettle (*tetsubin*)*
Cast and patinated iron; wrought iron handle; gilt-bronze lid ring. The round shape of the body symbolises the circle of heaven while the square lid represents the material world. Indentations of the shoulder of the tetsubin perhaps to relate to the constellation of Ursa Major.
h. 20.3 cm (excluding handle);
w. 18.2 cm (excluding spout)
Late Edo period, 19th century

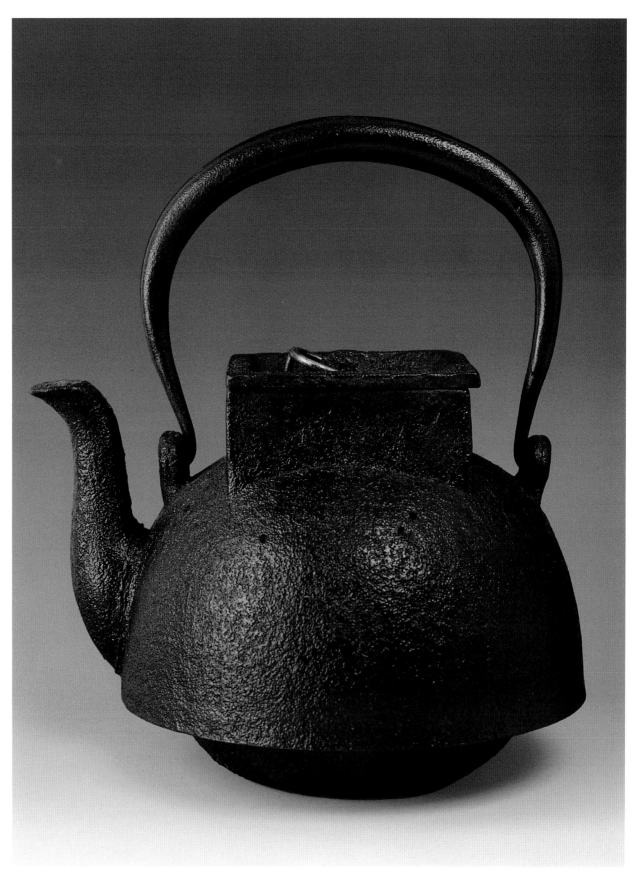

237. *Tea-kettle (tetsubin) with lid*
Cast and patinated iron; wrought iron
handle; cast-in low-relief decoration
of drying fishing nets and pine leaves
in the water together with a coastal scene
of a temple by a pine-covered mountain
h. 20.3 cm (including handle);
w. 15.1 cm (including spout)
Edo period, early 19th century

238. *Ashiya style 'Shin' type tea-kettle
(chagama)*
Cast and patinated iron: cast low-relief
decoration of the Seven Precious Things
(*Takaramono*) – a treasure bag, key,
hat, straw cape, flaming jewel (also
on the lid), a coin and a kite
h. 48.3 cm (including handle);
d. 35.2 cm
Edo period. 19th century

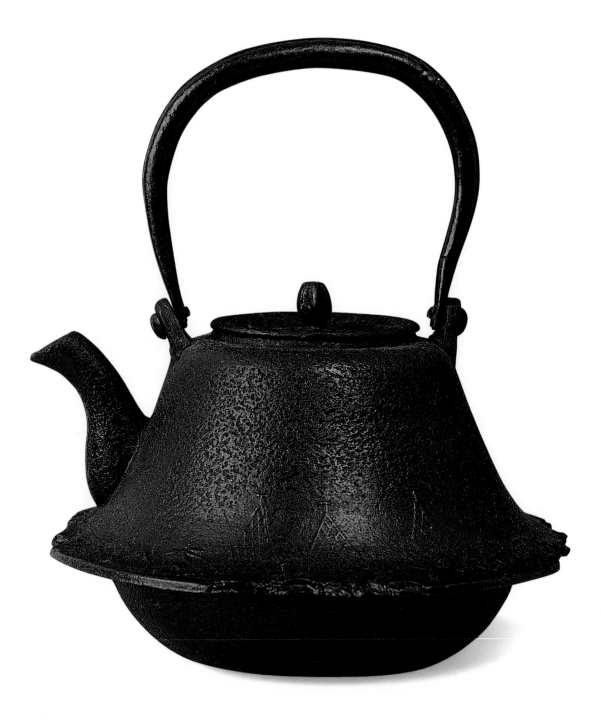

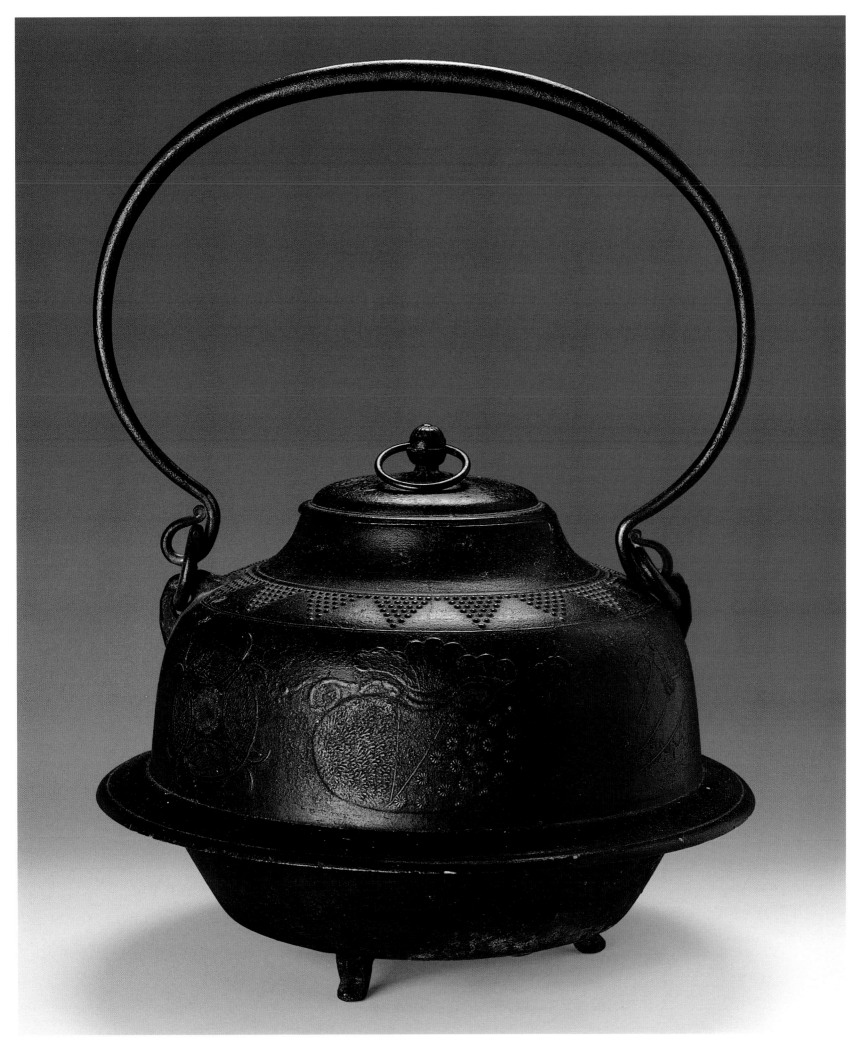

239 a-b. *Pair of saké pourers (*chōshi*)*
Cast and patinated iron; wrought iron
handle inlaid with silver; lacquered
wooden lids with patinated copper knob.
Decorated in low relief with a deer and
mythical turtle (*minogame*); four Chinese
scholars picnic under plum blossom while
a small boy makes tea for them
h. 16 cm (including handle);
w. 15.1 cm (including spout)
Edo period, late 18th century;
lids also late 18th century

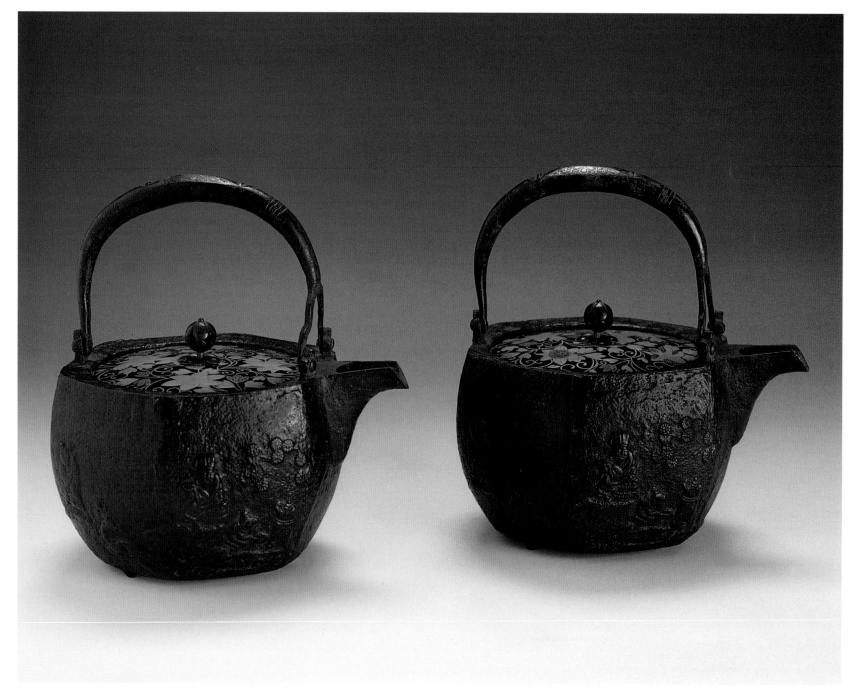

240. *Saké pourer (*chōshi*)*
Cast and patinated iron with lacquered wooden lid and brass (shinch) knob: low-relief cast-in decoration of cherry blossom (*sakura*). Handle inlaid with silver *nunome zōgan*. Spout and interior lacquered red
Signed on the base in red lacquer with the name '*Matsuda*' and a maker's mark
h. 17.3 cm (including handle);
d. 22.2 cm (including spout)
Edo/Meiji period, 19th century

241. *Tea kettle (*tetsubin*) in the form of an aubergine*
Cast and patinated iron; wrought iron handle
Illegible cast-in seal inside a gourd-shaped cartouche
h. 14.3 cm (including handle);
w. 10.7 cm (including spout)
Meiji period, late 19th century

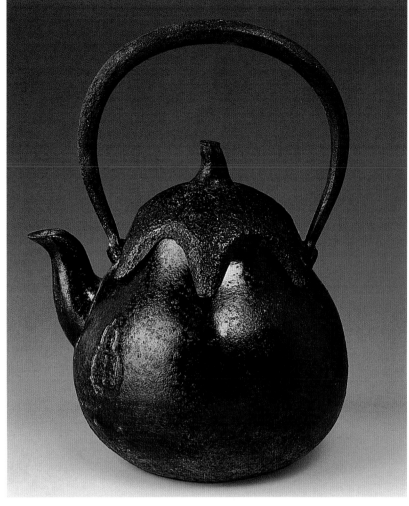

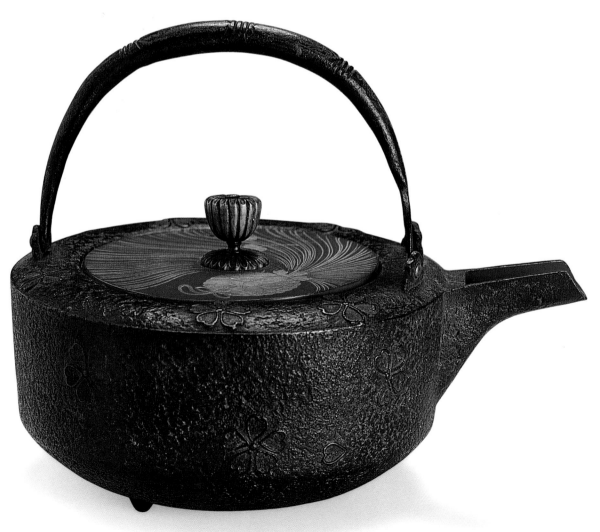

242. *Saké pourer (*chōshi*)*
Cast and patinated iron with a patinated
copper handle
h. 15.5 cm (excluding handle);
w. 14.5 cm (excluding spout)
Late Edo/early Meiji period, 19ᵗʰ century

243. *Polyhedral Tea-kettle (*chagama*)*
Cast and patinated iron with patinated
copper lid
h. 19 cm (including lid),
16.4 cm (without lid);
w. 16.9 cm (21.9 cm at widest point)
Edo/Meiji period, 19ᵗʰ century

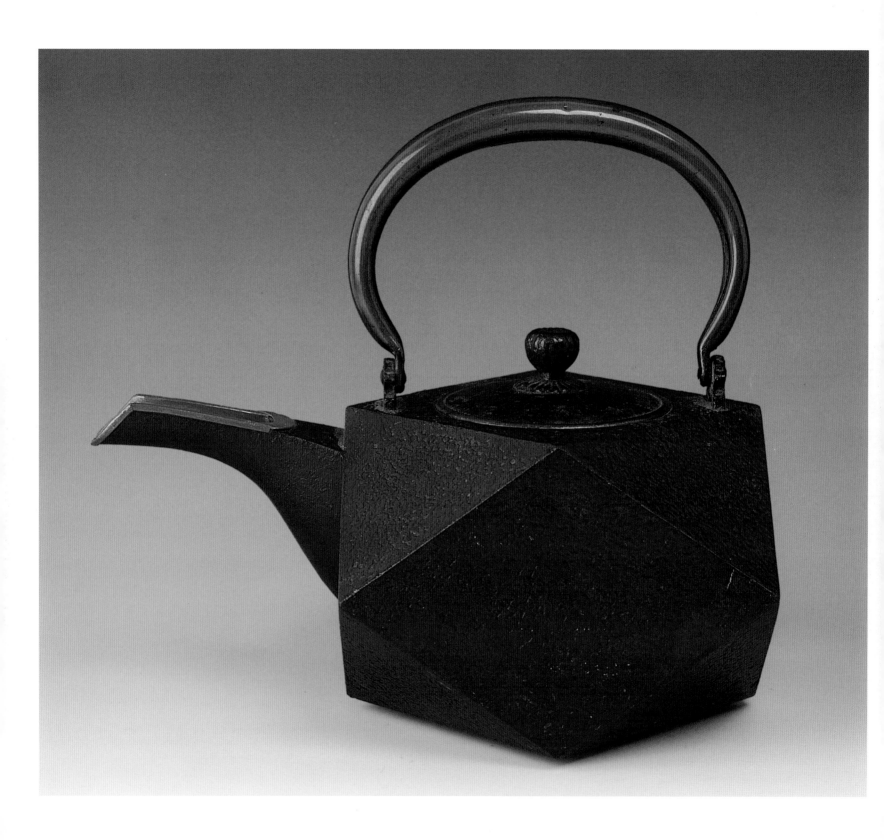

242. *Saké pourer (*chōshi*)*
Cast and patinated iron with a patinated
copper handle
h. 15.5 cm (excluding handle);
w. 14.5 cm (excluding spout)
Late Edo/early Meiji period, 19ᵗʰ century

243. *Polyhedral Tea-kettle (*chagama*)*
Cast and patinated iron with patinated
copper lid
h. 19 cm (including lid),
16.4 cm (without lid);
w. 16.9 cm (21.9 cm at widest point)
Edo/Meiji period, 19ᵗʰ century

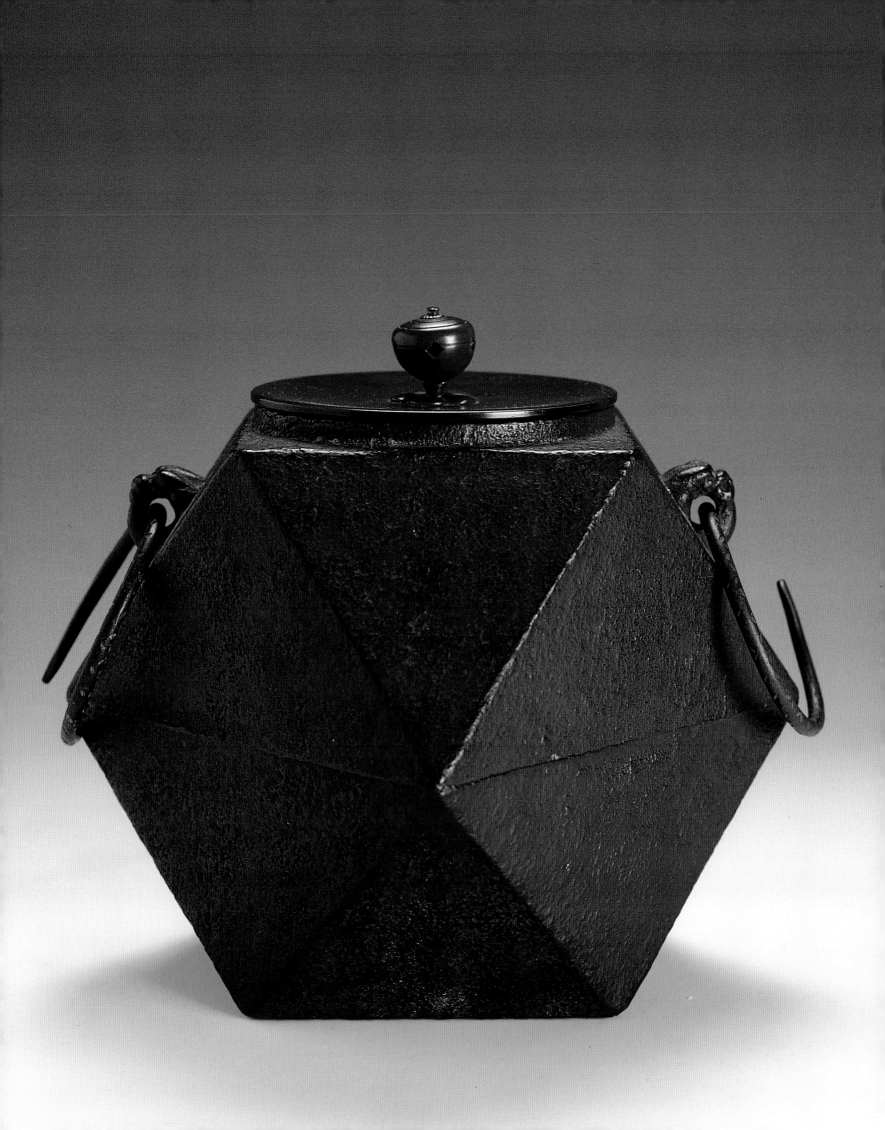

244. *Incense burner (kōro) in the form of a mythical long-tailed turtle (minogame)*
Cast and patinated bronze
Cast-in signature '*Yamashiro*'
h. 14.3 cm (including tail);
w. 11.2 cm (max.)
Edo period, late 18th century

245. *Tea-kettle (*chagama*)*
in 'Otafuku' style
Cast and patinated iron with patinated
copper lid and gilt bronze knob: cast-in
design of the *shōchikubai*, the 'Three
Friends of Winter' – plum blossom,
bamboo and pine
h. 17.9 cm (including knob), 15 cm
(without lid); d. 26.9 cm
Edo period, late 18th century

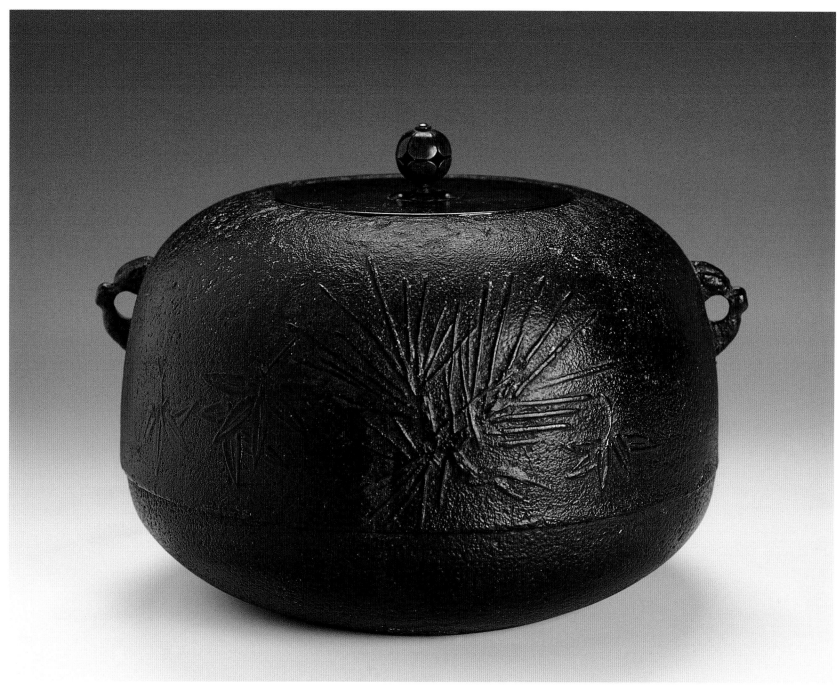

246. *Vase in the form of a tea-kettle*
(chagama)
Cast and patinated iron with applied
lacquer decoration of a hawk, two
squirrels, two birds and a bee amongst
branches
18.5 × 31.5 cm
Chagama: Edo period, early 19th century;
applied lacquer: Meiji period,
late 19th century

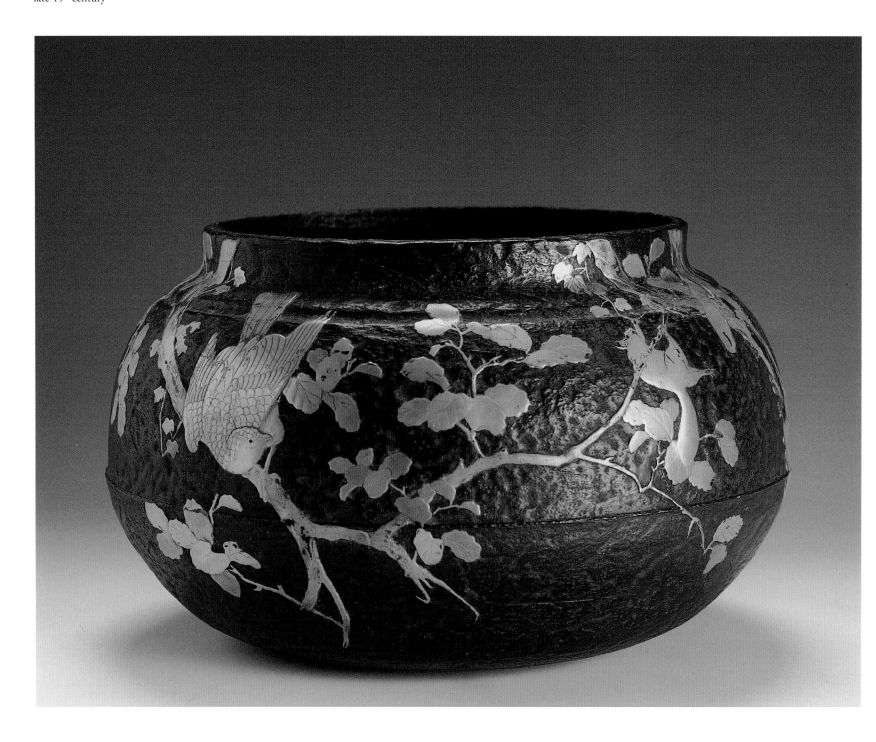

247. *Vase in the form of a tea-kettle*
(chagama)
Cast and patinated iron: cast-in
decoration imitating glaze dripping from
the shoulders. Applied lacquer decoration
of two fish, a crayfish, a crab and a spray
of magnolia
18.7 × 31.3 cm
Chagama: Edo period, early 19th century;
applied lacquer: Meiji period, late 19th
century

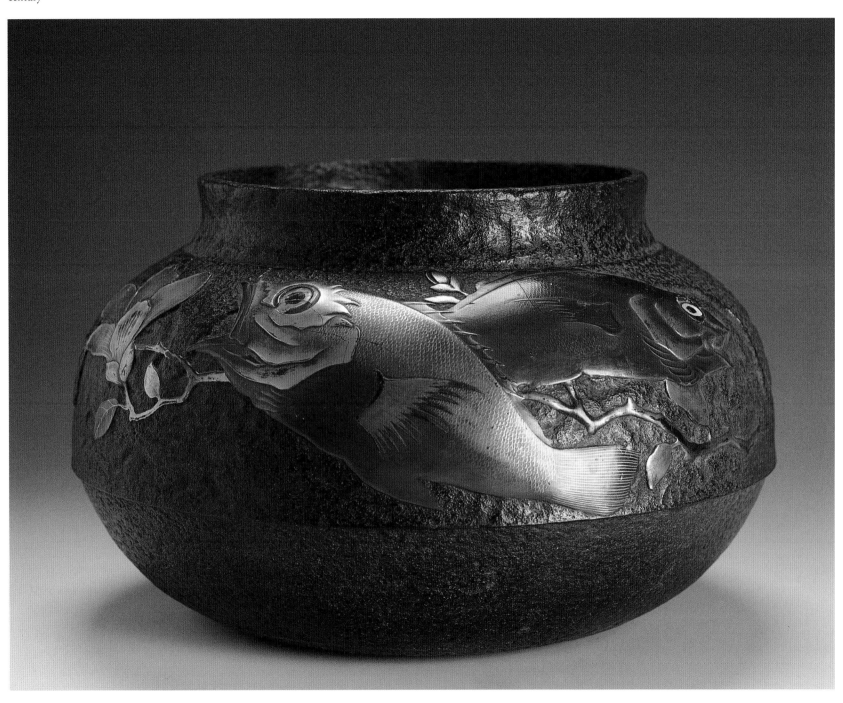

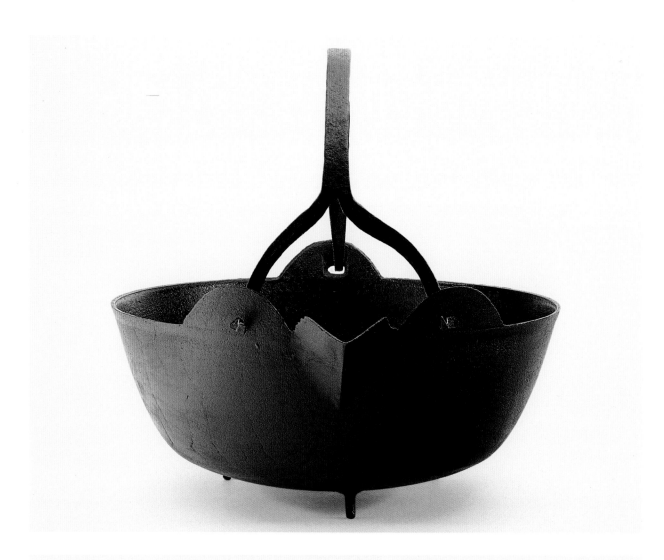

248. *Casserole* (nabe)
Cast and patinated iron, wrought iron
handle; wooden lid
h. 34.5 cm (including handle);
d. 35.9 cm (including spout)
Edo/Meiji period, late 19th century

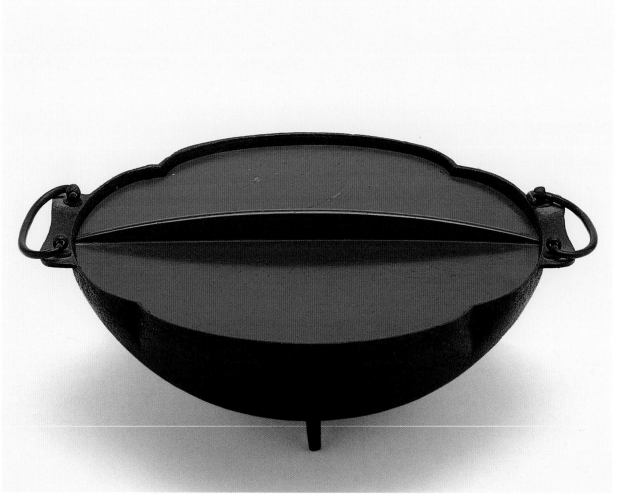

249. *Casserole* (nabe)
Cast and patinated iron; wrought iron
handles; lacquered wooden lid
9.2 × 26.3 cm
Edo period, 19th century

250. *Light offering stand* (tōmyōdai)
Wrought and patinated iron with
a patinated copper base
72.5 × 45.3 cm (max.)
Edo period, 19th century

251. *Adjustable pricket candlestick*
(shokudai)
Wrought and patinated iron. Tweezers
for adjusting and pinching out the candle
wick, or scissors for trimming the wick
would have hung from the small lower
hook
39.5 × 12 cm
Edo period, 19ᵗʰ century

252. *Adjustable pricket candlestick*
(shokudai)
Wrought, cast and patinated iron
h. 20.4 cm (max.), 17.3 cm (min.);
d. 11.9 cm
Edo period, 19ᵗʰ century

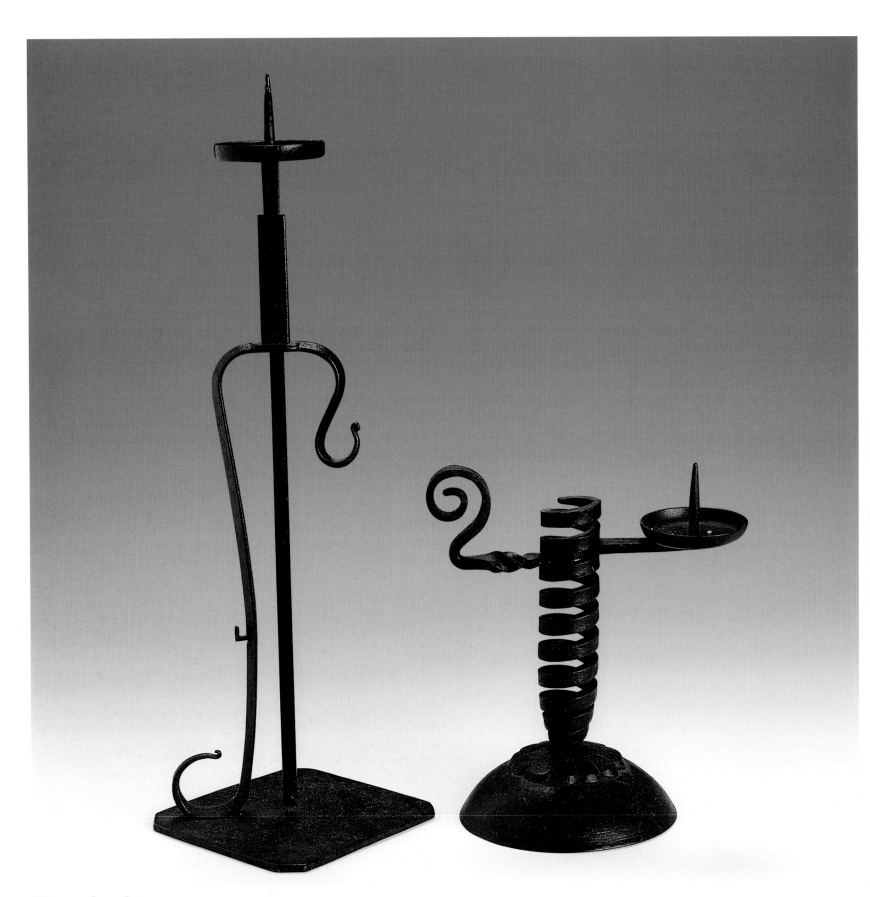

253. *Extendable pricket candle (*shokudai*)*
Wrought and patinated iron
h. 83.9 cm (min.), 108.7 cm
(fully extended); w. 26.6 cm
Meiji period, late 19th century

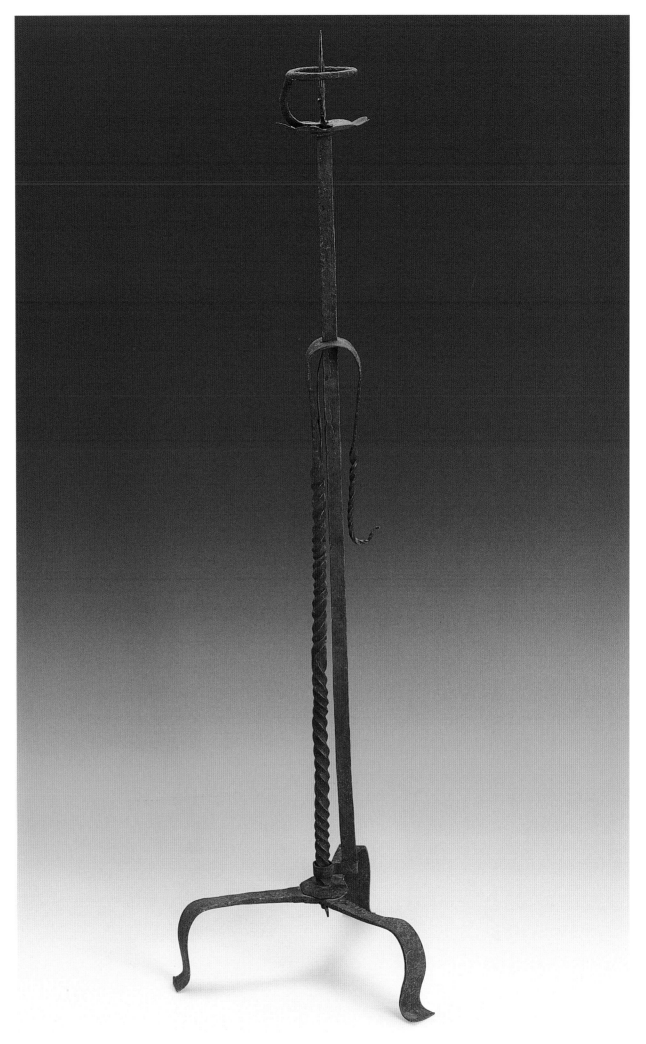

254a. *Hanging lantern (*tsuri-dōrō*)*
Cast and patinated iron: in the form
of a gourd with pierced decoration
of gourds, leaves, and stylised birds
33.2 × 25.1 cm
Edo period, 19th century

254b. *Hanging lantern (*tsuri-dōrō*)*
Cast and patinated iron: pierced design
of interlocking geometric shapes;
lid pierced with two holes in the form
of the sun and a crescent moon
28.3 × 18.2 cm
Edo period, 19th century

254c. *Hanging lantern (*tsuri-dōrō*)*
Cast and patinated iron with mulberry
paper liner: pierced decoration of stylised
flowers and the heart-shaped 'boar's eye'
(*inome*)
32.4 × 22.2 cm
Edo period, early 19th century

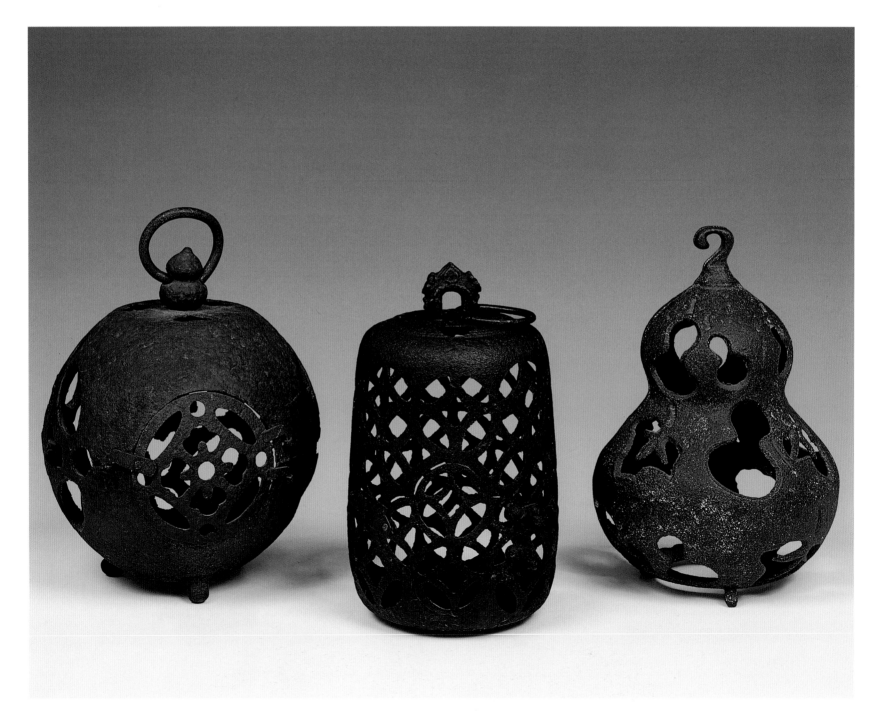

255. *Hanging lantern (*tsuri-dōrō*)*
Wrought and patinated iron plates and
fittings with mulberry paper liner. Foliate
edged lid pierced with leaf and the heart-
shaped 'boar's-eye' (*inome*) decoration
52.5 × 39.4 cm
Edo period; late 18ᵗʰ century

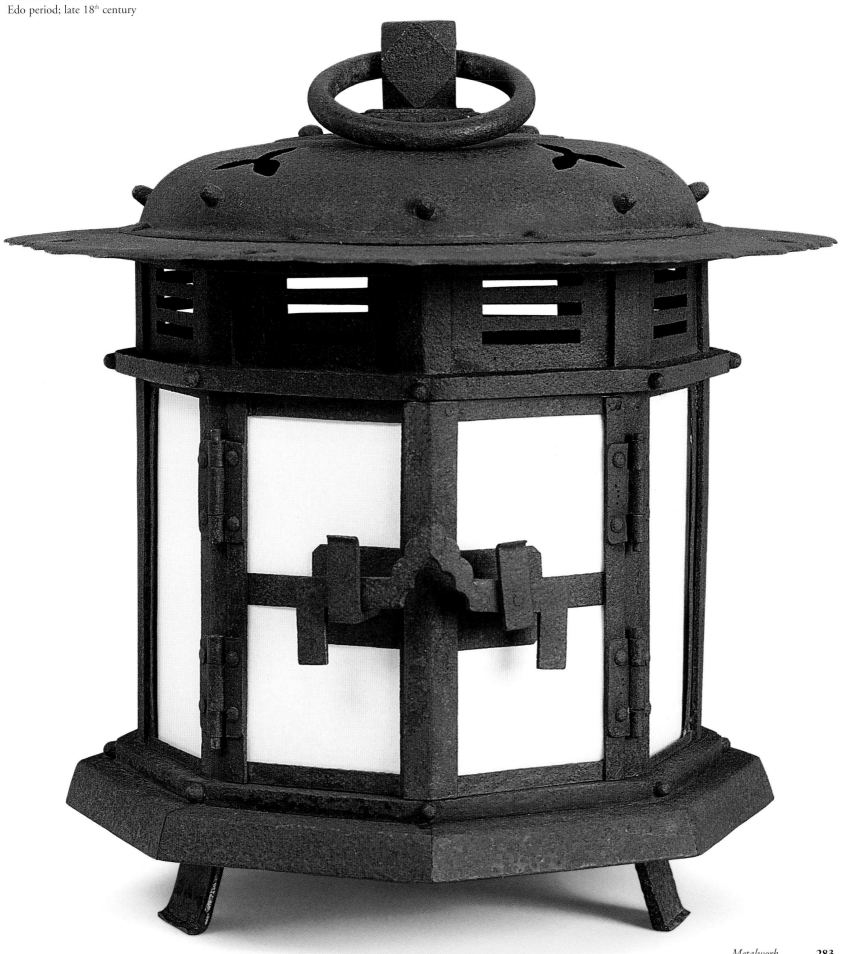

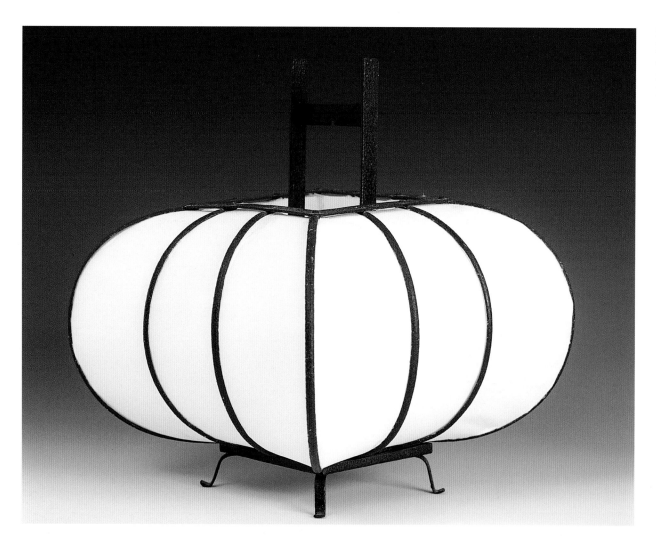

256. *Lantern* (andon)
Patinated wrought iron ribs and fittings;
mulberry paper liner
37.3 × 31.5 cm
Late Edo-early Meiji period, 19th century

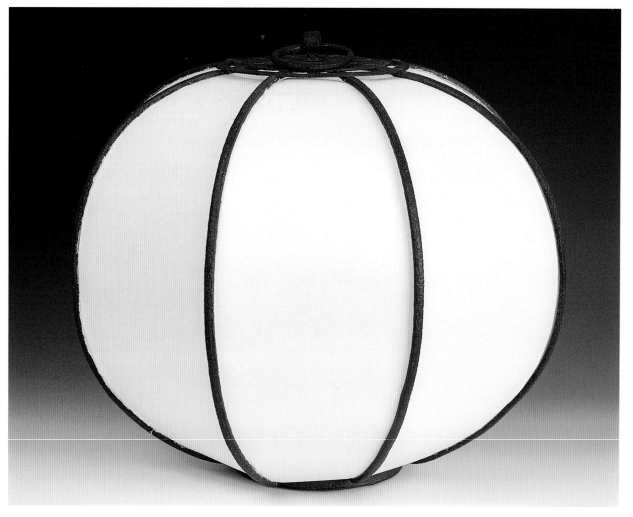

257. *Lantern* (andon)
Patinated wrought iron ribs and fittings;
mulberry paper liner
55.5 × 45.2 cm
Late Edo-early Meiji period, 19th century

258. *Standing lantern* (kaku andon)
Wrought and patinated iron
with mulberry paper liner
65.2 × 32.1 × 32.3 cm
Edo period, 19th century

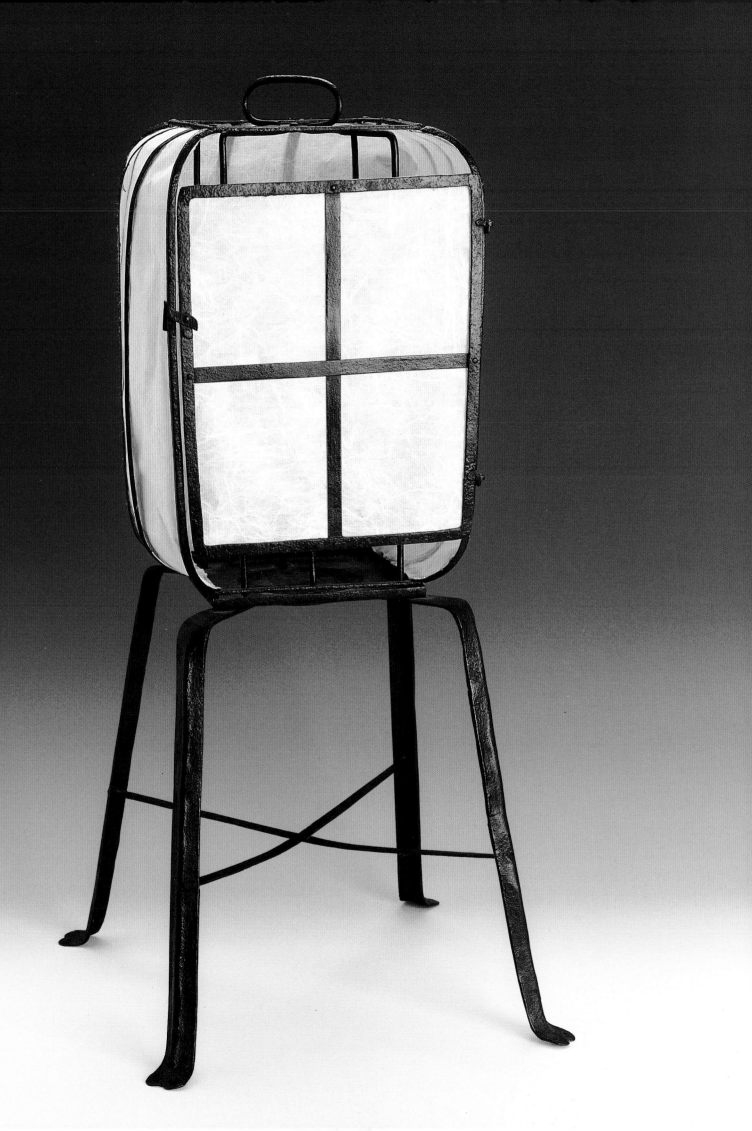

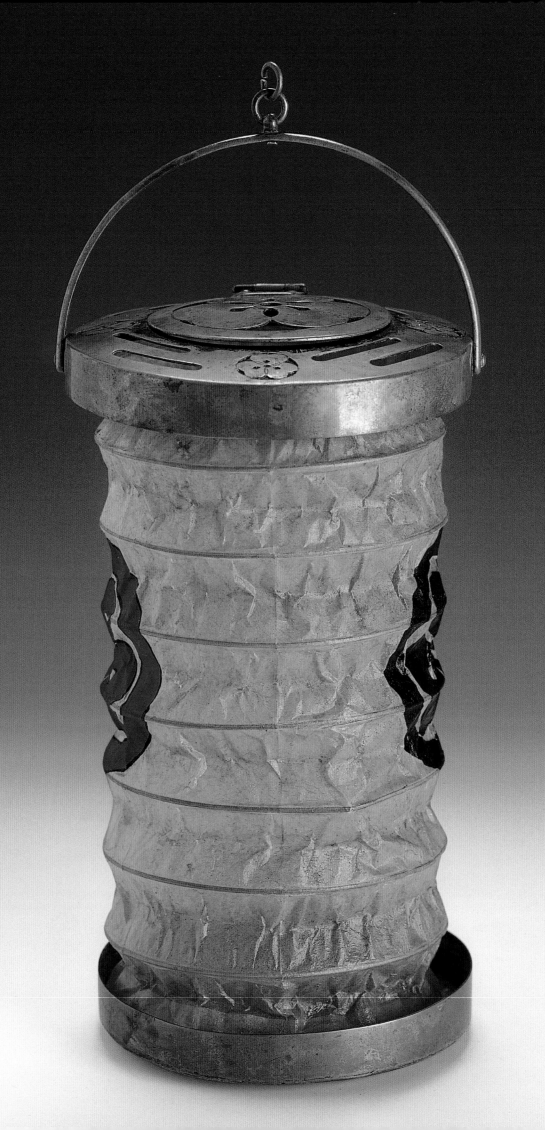

260 a-b *Padlock (*jōmae*) and key (*kagi*)*
Wrought and patinated iron plates
Signed '*Norimoto Yoshihisa saku*'
(made by Norimoto Yoshihisa)
17 × 8.8 cm
Meiji period, late 19th century

261a. *Padlock (*jōmae*) and key (*kagi*)*
Wrought and patinated iron plates
14.1 × 8.7 cm
Edo period, 19th century

261b. *Lock (*jōmae*) and key (*kagi*)*
Wrought, cast and patinated iron plates
decorated with floral motifs and cast-in
relief depictions of bamboo, plum
blossom and a pine cone, the 'Three
Friends of Winter' (*shōchikubai*),
one plate engraved with a formal flower
arrangement
Signed '*Kashu ju Yamane Masayoshi*'
(Yamane Masayoshi of Kashu [Kawachi
Province, now part of Osaka prefecture])
20.3 × 13.8 cm (overall)
Edo period, late 18th century

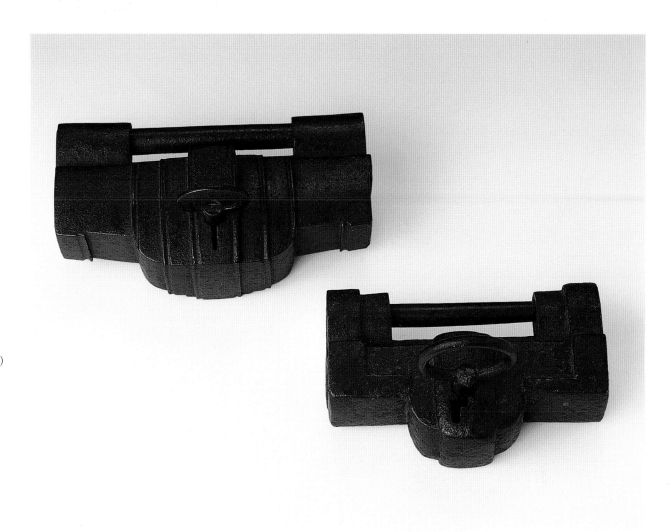

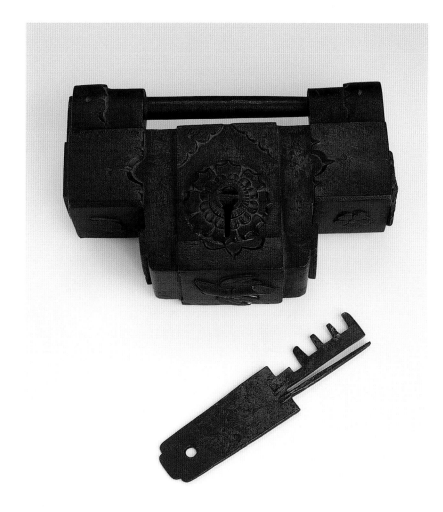

Opposite page:
259. *Portable pricket lantern*
(*odawara chōchin*)
Brass (*shinchō*) and oiled paper: pierced
and painted decoration of a family crest
(*mon*) of the triple hollyhock
Flat 4.3 cm; extended 28.2 cm
(inc. handle), d. 13.1 cm
Meiji period 19th century

Textiles

Anna Jackson

The wonderful textiles in the Montgomery collection reveal the extraordinary richness of Japan's weaving and dyeing traditions. Beautiful in the bold simplicity of their construction and often striking in the exuberance of their design, these domestic textiles and garments were central to the social, economic and cultural world of those who produced and used them. Through their fibres, colours, patterns and forms they express the skills and artistry of the weavers, dyes and stitchers who created them and convey something of the life, status, values and beliefs of those who used them.

These clothes and textiles, whether used for work, leisure or celebration, were part of the everyday life of the farmers, fishermen, merchants and military elite of nineteenth and early twentieth century Japan. Yet they are far from ordinary. Their importance to those who owned them is revealed in the careful way in which many of them have been patched and mended. Latterly, they have been treasured more especially for their artistic qualities, as demonstrated in the transformation of a four-panel textile into a two-fold screen (figure 276). This depiction of a tiger in a bamboo grove is perhaps the most powerful of the many dramatic images that adorn the textiles in the Montgomery collection. The physicality of the creature is almost palpable; one can imagine the feel of the fur and sense the twitching of the tail.

Like a great many of the textiles in the collection, the design on the screen has been created using a technique called *tsutsugaki*, or 'tube drawing'. In this method woven fabric is stretched on a frame of bamboo and a design drawn on the cloth with paste squeezed from a tube (*tsutsu*). The tube is made from paper treated with persimmon juice to make it wa-

ter resistant and has a nozzle of bamboo or metal through which the paste is extruded. The paste, made of rice flour, lime and water, forms a protective coating which prevents the colour penetrating when the cloth is dyed. Before the dye is applied the surface of the fabric is brushed with soya-bean liquid to seal the paste and help fix the dye. Once the dyed cloth is dry the rice paste is washed off. On the tiger screen this technique has been used with enormous skill. The vigorous outline of the animal and the soft strokes of the fur have been drawn with the paste and the shades of yellow, washes of ink and touches of red then brushed on. The whole image of the tiger, bamboo and rocks would then have been covered with paste before the fabric was dipped in the indigo-dye bath numerous times to create the deep blue background.

As *tsutsugaki* is a free-hand method of drawing on fabric, the range and style of designs that can be produced is limited only by the talents of the dyer. The images that decorate the textiles in the Montgomery collection are very compelling in themselves, but they also carry important symbolic meanings. The tiger, for example, is one of the twelve animals of the zodiac and is associated with military prowess and courage[1]. The animal is also believed to act as a talisman to ward off evil and invite good fortune. A tiger among bamboo also has a more specific meaning, being emblematic of the hospitality of the weak, the tree, for the strong.

While the tiger's attributes are male, those of the mythical *hōō* bird are female (figures 277 and 283). Usually referred to as phoenix, the *hōō* bears little relation to its western equivalent. In East Asia the bird represents peace and prosperity and is said to appear at the time of a truly virtuous leader. The phoenix is the female counterpart of the dragon and

262. *Bedding cover (*futon-ji*) or chest cover (*yutan*)*
Cotton with a stencilled paste-resist (*katazome*) design of fan papers and a crest
188.2 × 164.2 cm
Late Meiji period - Taishō period, 1ˢᵗ quarter 20ᵗʰ century

its many feathers represent the virtues of truthfulness, propriety, righteousness, benevolence and sincerity. It is generally depicted with a paulownia tree which, according to legend, is the only plant on which the bird with alight. The phoenix is an extremely popular motif in Japan, these two examples demonstrating the rich variety of ways in which it is depicted on textiles. The graceful elegance of one (figure 277) contrasting with the bold composition and dramatic, sweeping, lines of the other (figure 283).

The first example (figure 277) has been woven with cotton warps and wefts of thick, nubbly silk which gives the piece an interesting texture and the blue ground an attractive variation of tone. This use of silk, probably obtained from wild cocoons or the spoilt leftovers of cultivated silk production, is quite unusual in domestic textiles and everyday garments. The most common fibre is cotton, the introduction of which in the sixteenth century brought radical social and economic changes to Japan. Prior to this the commoner classes wove cloth from fibres gathered from wild plants. Cotton proved to be much warmer, softer, stronger and more durable than these bast fibres (*asa*). Raw cotton could also be used as wadding in winter garments and bedding. For those accustomed to sleeping on straw covered only by the clothes they had worn during the day this must have brought hitherto unimaginable luxury into their lives. The increased demand for cotton encouraged more and more farmers to cultivate the profitable plant, while the expanded trade networks of the Edo period meant that even in areas where cotton could not be grown, raw cotton, cotton thread or finished cloth could be purchased. In the early Edo period the cotton grown in Japan was sold to city merchants for processing and finishing, but by the nineteenth-century rural producers were successfully competing with urban artisans and merchants in the supply of finished goods. The ability to weave cotton became a marketable commodity and in some rural areas men took up the activity. In most parts of the countryside, however, weaving and sewing were female occupations. Indeed a woman's ability with the loom and needle were very important and skills were passed from mother to daughter and taught in special needle shops called *ohariya*. Ensuring a good marriage was vital both economically and socially and the production of textiles provided evidence of a young women's skills. All the textiles in the Montgomery collection have a weave structure which is known as tabby or plainweave, which is the simplest way of interlacing the weft (horizontal) with the warp (vertical) threads. Widths of cloth are sewn together

to create bedding covers, doorway curtains or hangings. This simple construction allows the surface of the cloth to be exploited to the full and decorated with rich and varied patterns.

Many of the textiles in the collection were made for special occasions such as festivals or celebrations that marked important stages of life. As such they tend to have vivid designs that would have brought colour and vitality to the event and drawn attention to its importance. Many of the textiles are associated with weddings. In nineteenth and early twentieth century Japan weddings provided a very public opportunity for the bride's family to establish their status within their community. The bride would be accompanied to her new home with a trousseau of gifts which would include many textiles, the production of which would begin as soon as the marriage was agreed. The bride and other female members of the family would spin the yarn and weave the cloth. Although some dyeing would have been done in the home, the importance of the wedding textiles would have required the skills of a specialist. Dyeing was a male profession and commercial dye shops were a feature of every town and village in Edo and Meiji period Japan. The choice of design would depend, not only on the dyers skills, but on the taste and wealth of the bride's family. One of the most important items in the trousseau was the bedding cover, or *futon-ji* (figures 264, 269, 272, 277, 280-283 and 285). The *futon* is the traditional form of Japanese bedding and consists of a mattress and cover both stuffed with raw cotton. The celebratory cover would be used by the couple of their wedding night after which it would be carefully stored and used only on special occasions or for important guests. The survival of so many *futon-ji*, such as the stunning *tsutsugaki* examples in the Montgomery collection, is due to their being treasured in this way. The auspicious images that decorate the *futon-ji* were designed to bring good fortune to the couple in their new life together.

One of the most spectacular *futon-ji* in the Montgomery collection depicts a hawk swooping down from the trees (figure 282). Suitably for a bedding cover this design has auspicious dreams as its theme. To dream of Mount Fuji, Japan's most famous mountain which rises up behind the bird, on the first full night of the New Year was considered extremely lucky. Second in the ranks of good fortune was a dream of a hawk, third a dream of aubergines which are seen in the bottom right of this cover. This sequence is known as '*ichi Fuji ni taka san nasu*'. The cover is brightly coloured with blues, yellows, red and browns. Various tones have been used for the shading, while the hawk's delicate under-

feathers have been carefully delineated in ink which lends them a remarkable three-dimensional appearance.

The colour used most prominently on the textiles in the collection is indigo-blue. The dye derives from *ai*, a group of plants that contain indican, a water soluble colourless substance that turns blue when exposed to oxygen. Repeated dipping in the dye bath builds up the layers of indigo, and allows for the creation of deeper and deeper shades. Other vegetable dyes used on the textiles include browns and greys, derived from the bark of oak, chestnut and walnut trees, and yellows produced from *phellodendron* and *miscanthus* plants. The brighter colours are usually mineral pigments rather than vegetable dyes. *Shu* (mercuric sulphide) produces bright red, *bengara* (iron-oxide) red-brown, *ōda* (iron hydroxide) dull yellow and *kiō* or *sekiō* (arsenic trisulphide) bright yellow. *Sumi* (black calligraphy ink) was derived from pine soot.

Bright colours have been used to brilliant effect on the bedding cover with the design of ducks and a snow-covered plum tree (figure 280). Paired mandarin ducks symbolise conjugal fidelity as, according to popular belief, these birds mated for life and would die if separated. The motif is thus a very appropriate one for a wedding *futon-ji*. While the colours on this textile remain very bright, fading of dyes and abrasion to pigments means that other examples, such as that of the two hawks, have lost their original intensity (figure 285). This textile is very large, so may not have been intended for bedding, but to cover and protect an important wedding gift such as a clothing chest. These *yutan*, as they are called, were made specifically to size. As they are constructed in the same way as *futon-ji* it is difficult to distinguish them, although often a lack of top/bottom orientation to a design or the use of a single motif can suggest that certain textiles were intended as *yutan* (figures 267, 270 and 268).

A limited range of colours, very effectively shaded, have been used as a delicate counterpoint to the playful image of sparrows and bamboo on another bedding cover in the collection (figure 264). Sparrows are symbolic of gentleness and their cry sounds like *chū chū*, 'loyalty! loyalty!' making them a fitting motif for a newly married couple. However, their appearance on textiles is quite unusual. Much more common are the pair of Chinese lions, or *karashishi*, that decorate another large, and very striking, wedding textile in the collection (figure 281). *Karashishi* are usually shown gambolling among peonies and here the flowers have been very skilfully shaded in tones of bright pink, red, yellow

and orange. Like many motifs, the lion and peony is derived from Chinese legend. It also relates to a play for the Japanese classical Nō theatre entitled *Shakkyō* (The Stone Bridge) in which a lion appears and dances among the peonies to celebrate long life and happiness. The lion symbolises male energy and valour, while the flower represents female beauty and sexuality. This combination of qualities makes such a design very suitable for celebrating the union of husband and wife.

Aquatic creatures are also a popular theme in the island country of Japan. The image of two lobsters is quite sparse and abstract compared to some of the other designs in the collection, but it is just as effective (figure 272). The curving bodies and antennae of lobsters were seen to echo the curved backs and long whiskers of old age, so this cover conveys wishes for a long life. It could also carry other blessings for two lobsters can also represent Izanagi-no-mikoto and Izanami-no-mikoto, the two gods enshrined at Ise, Japan's most important Shintō shrine. Another deceptively simple, yet dramatic, image is that of a carp rising from the waves (figure 269). The fine shading of the fish's body lends volume to the design and contrasts with the strong blue of the waves. The image of a carp leaping a waterfall derives from a Chinese legend in which any fish able to climb the falls was transformed into a dragon. This story is a metaphor for achievement and advancement, accomplishments seen as appropriate for boys rather than girls. This textile may have been part of a bride's trousseau, expressing the desire for male children, or may have been made for use during the Boy's Festival which takes place every year on the fifth day of the fifth lunar month. Like other celebratory textiles, such as the cover with the mandarin ducks (figure 280), this example features a large crest. The use of these family crests, called *mon*, was supposedly restricted to the *samurai*, but as their use had spread to the commoner classes by the nineteenth century it is not always possible to determine who owned or used these textiles. *Mon* served to distinguish one family from another and to affirm family status, kinship and loyalty and on celebratory textiles are often depicted on a large scale as if to stress the importance of such familial virtues. The mandarin ducks (figure 280) and carp (figure 269) *futon-ji* have another feature in common; a narrow middle panel which suggests they were constructed from another form of bedding called a *yogi* (figure 306). A *yogi* is shaped like an oversize *kimono* and, as with *futon*, is thickly padded with cotton. It wraps around the sleeper, protecting them from cold drafts. The pattern on the *yogi* in the Montgomery collection is of peonies and vine

scrolls, a design which features on another textile in the collection (figure 267). As with one of the earlier examples (figure 277) this *futon-ji*, or possibly *yutan*, combines silk wefts with cotton warps. Here though, the ground colour is not the customary blue but a beautiful green, probably produced by combining indigo with a yellow dye.

The most popular plant motifs used on celebratory textiles are pine, bamboo and plum which are symbols of longevity, perseverance and renewal (figures 270, 275 and 278). They often feature in combination with other motifs. The pine tree lives for many years, remaining green throughout the winter. It is extremely resilient, as is the bamboo which bends in the wind but never breaks. The plum is the first tree to blossom each year, its white or red flowers growing more beautiful as the tree ages. These plants are called the 'Three Friends of Winter', or *shōchikubai*, and as auspicious symbols together reinforce the wishes for long life and happiness. The motif is commonly used on *futon-ji*, *yutan* and on another type of textile known as a *furoshiki* (figures 273 and 278). These are square, or almost square, pieces of cloth of varying size used for wrapping and carrying objects. They are lightweight, fold up when not in use and can be wrapped around almost anything, the tied ends serving as handles. A bride would carry her possessions to her new home in a *furoshiki* and the guests at the wedding might also receive small gifts, perhaps of food, wrapped in one.

In addition to flora and fauna, inanimate objects also serve as auspicious symbols. *Noshi* are slices cut from the meat of abalone and dried. A homophone – a word with the same sound as another – of *noshi* means 'extend', so strips of dried abalone were traditionally tied to gifts to increase the wishes for a good and long life. *Noshi* often appear on celebratory textiles (figure 268). On this example each of the graceful strips is decorated with patterns and with depictions of the auspicious collection of treasures, the *takara-zukushi*. These treasures are also alluded to by the groups of shells that decorate one of the *furoshiki* in the Montgomery collection (figure 273). This image also refers to the shell matching game which is played with a set of clam shells on which identical designs have been painted on the concave surface of each pair. The aim of the game, to pair matching shells, makes it a suitable motif on a wedding textile. The double imagery on this textile makes it especially auspicious, the good fortune being bestowed on the new couple further enhanced by the three cranes that decorate the shell box. Cranes are one of the most popular motifs in Japanese art. Believed to

live for a thousand years, they are a symbol of longevity and are also said to inhabit *Hōrai*, the land of the immortals. Cranes mate for life and the female is extremely protective of its young, so both the real and legendary qualities make the bird an ideal motif for wedding textiles.

The crane is often paired with the tortoise, another symbol of longevity (figure 292). The tortoise is believed to carry good fortune on its back and to be the messenger of the gods. On celebratory textiles the design known as *minogame*, or caped tortoise, is very common, its long 'tail' of trailing seaweed being especially auspicious. In this celebratory textile it also alludes to the cape of invisibility, *kakure-mino*, one of the *takara-zushi*, thus reinforcing the main motif of a treasure sack. Reflecting the high regard in which *tsutsugaki* wedding textiles came to be regarded in the twentieth century, this piece has been mounted as a hanging scroll. So too has another textile in the Montgomery collection, this example bearing a very beautiful design of two open fans, symbols of a prosperous and happy future (figure 271). The tails that spread out under the fans may represent those of a tortoise, as in the *futon-ji* of auspicious dreams where a tortoise's tail rises above Mount Fuji (figure 282).

The rice-paste used to create free-hand patterns on textiles is also used with stencils, a technique called *katazome* (figures 288 and 262). Stencils are made from two or three sheets of *kōzo* (mulberry) paper laminated together with persimmon juice. Apart from its adhesive qualities the juice strengthens the paper and makes it water resistant. Various tools and methods are used to cut designs in the stencil. To pattern the cloth the stencil is placed on the fabric and the paste applied through it with a wooden or bamboo spatula. The stencil is then removed and repositioned on the next section of fabric and the process repeated along the length of the cloth. As with *tsutsugaki* the colour does not penetrate the pasted areas when the cloth is dyed. Stencil-dyed fabrics are distinguished by their repeat designs which, as with the *futon-ji* with the carp and waves, often creates a sense of movement across the textile surface. *Tsutsugaki* designs are unique, but *katazome* allows for mass production and is cheaper. Skill is still needed, however, to ensure a perfect match of the pattern. Even greater precision, and time, has been taken with this example as the pattern has been stencilled on both sides of the cloth to achieve a crisper design. Carp, symbols of success and achievement, are usually shown leaping over waves but in another *katazome futon-ji* in the collection the fish motif has been combined with peonies, symbolising wealth, happiness and nobility, and bam-

263. *Bedding cover (*futon-ji*) or chest cover (*yutan*)*
Probably Sakai (Osaka Prefecture)
Silk with a stencilled (*sarasa*) design of flowers and a crest
186 × 176.7 cm
Late Edo period - early Meiji period, 19th century

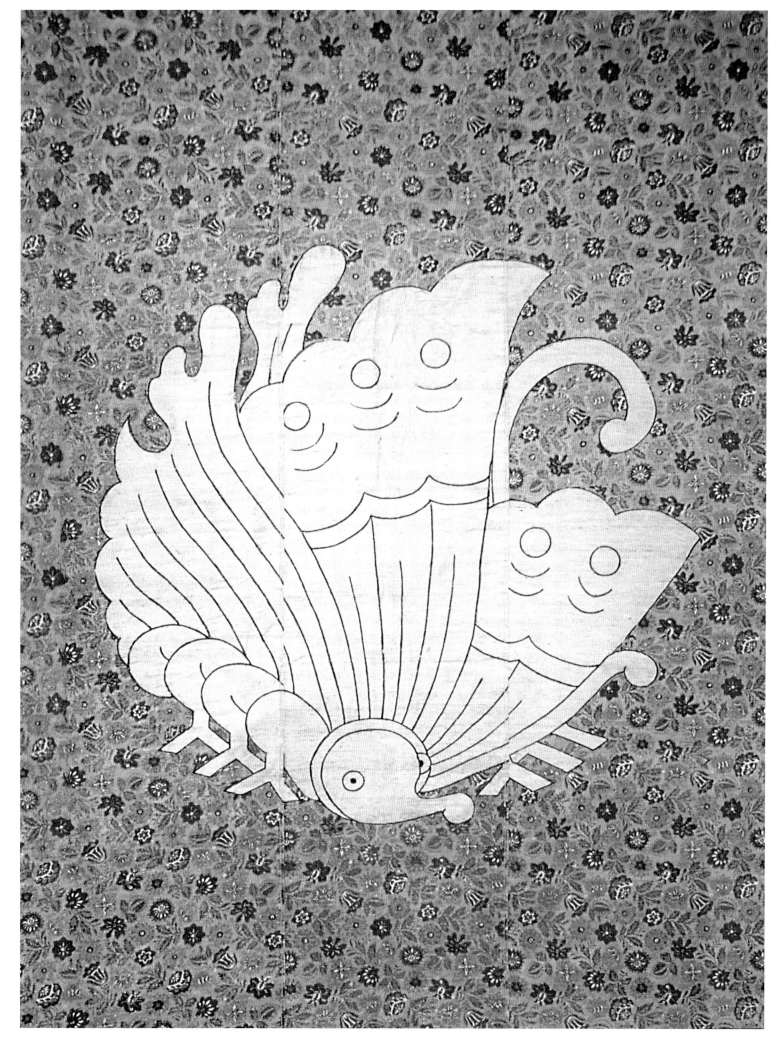

boo, symbolising resilience (figure 288). Both these *futon-ji* may have been used by sons of a family or by a couple hoping for the birth of male offspring. A completely different visual effect has been created on another *katazome* textile in the Montgomery collection (figure 262). A mass of scattered fan papers, decorated with plants, flowers and other motifs, over a geometrically patterned ground create an extremely detailed and dense backdrop for a large paulownia crest. The two previous examples were dyed only one shade of blue, but here repeated dipping in the indigo bath, with different sections of the design being reserved with paste, have created various shades. Black ink has also been brushed on to selected areas. The use of a large crest, this time of a butterfly, on a busy ground is a feature of another stencilled-dyed textile in the collection (figure 263). Unusually this *futon-ji* or *yutan* is of silk and has a yellow ground rather than blue. The crest and white areas of the flowers were stencil-resisted with paste before the background was dyed, but the blues and browns were applied directly through a stencil. This cover is an example of *sarasa*, a fabric inspired by the block-printed and wax-resist textiles of India and South-East Asia imported into Japan by Dutch traders. High quality *sarasa* was made to order in Saga, on the southern island of Kyūshū, for the local *daimyō*, but in Nagasaki, Kyoto and Sakai, where this example was probably made, the fabric was mass produced for domestic use. The use of silk and a family *mon* suggests that this example was made as a unique piece for a fairly wealthy family. The Montgomery collection contains another striking *sarasa* textile, a child's mattress (figure 286). The red-brown outline and small dots of the flowers are typical of Japanese *sarasa* and very reminiscent of the Indian chintzes that inspired it.

Both the *tsutsugaki* and *katazome* techniques involve the patterning of cloth after it has been woven which is known in Japan as *atozome*. The term *sakizome* refers to textiles produced by the weaving of pre-dyed yarns such as those created using the *kasuri* technique. In *kasuri* sections of yarn are bound or tightly compressed prior to being dyed. The dye does not penetrate these areas when the skein is dipped in the dye bath. The binding is then removed leaving a yarn which is partly white and partly coloured. This is then used as the warp and/or the weft and a pattern emerges as the cloth is woven, great skill being required on the part of weaver and dyer to ensure that the design appears as planned. The slight misaligning of the resist-dyed threads generally gives the patterns a soft, blurred outline, but on the two *kasuri futon-ji* in the Mont-

gomery collection incredibly precise alignment of the pre-dyed warps and wefts has given the designs crisp horizontal and vertical edges (figures 290 and 291). This type of pattern is characteristic of Kurume, in Kyūshū, and is known as *tōfu kasuri* because the squares resemble cubes of *tōfu* (white bean-curd). Castles are a common motif on *tōfu kasuri* textiles, the structure lending itself to rendition in squares, but the Montgomery example is unusual in that small areas are in green (figure 290). This gives the pattern a greater sense of depth. The other example features a battleship, which at first might seem a strange motif for a bedding cover (figure 291). The design reflects the nationalism and growing imperialism of the Meiji period. Characters above the ship identify it as the *Fuji*, a first-class battleship completed in 1896, shortly after Japan defeated China. The other characters read *sekai musō*, meaning 'without peers in the world'. The *Fuji* saw service in the Russo-Japanese war of 1904-1905[2].

In addition to bedding covers, chest covers and wrapping cloths, the Montgomery collection contains a number of *noren* (figures 284 and 289). These were hung in the entrances to houses or, more commonly, shops and restaurants to indicate that the establishment was open for business. Their bold design, usually executed using the *tsutsugaki* technique, acted as an advertisement. *Noren* are made from separate panels of cloth sewn together at the top. They give protection against rain and dust and shade from the sun. They also dissuade prying eyes yet can easily be brushed aside to allow people to enter. Most *noren* are made of cotton, but the collection contains one magnificent example, with a design of a hawk plummeting over crashing waves, which is made of hemp (figure 284). The use of hemp gives the *noren* a beautiful transparency, while the golden brown of the natural cloth revealed in the undyed areas contrasts with the usual cream-white of undyed cotton. Hemp is grown in northern Japan where the cold climate makes it an unsuitable area for cotton cultivation. It is mountainous region with a rugged coastline where hawks are common. The design is thus an appropriately regional one, the motif, indicative of courage, loyalty and the sport of falconry, also suggesting that the *noren* may of hung in the doorway belonging to someone of the *samurai* class.

The elegant textile with a design of lotus flowers probably once graced a Buddhist temple (figure 266). The lotus is a symbol of the benevolence of Buddha and represents enlightenment, truth and purity. Decorative textiles are an important feature of the interior *décor* of temples and often act as a focus of worship. In contrast to the exuberance of

many *tsutsugaki* textiles, this refined design with its limited, but radiant, colours has a beauty and sensitivity appropriate to its subject and purpose.

Another hanging in the collection, in which the panels of cloth are sewn horizontally rather than vertically, may have been used in the Girl's Festival which takes place on the third day of the third lunar month (figure 274). On this day dolls representing an imperial prince and princess, often with attendants, are displayed along with miniature sets of lacquer accoutrements. The textile, which shows two attendants in court dress sitting under a cherry tree, may have been used as a backdrop to such a display.

For Boy's Day, on the fifth day of the fifth month, it is traditional to fly banners, called *nobori*, to announce a male child in the family and declare the wish that he grow up with suitably manly virtues. *Nobori* were usually decorate with warrior themes or other masculine motifs such as carp or dragons. The set of four banners in the Montgomery collection are decorated with a more playful image of plovers swooping over waves (figure 307). The maritime theme may suggest that these banners were used in fishing festivals rather than for Boy's Day. Another spectacular, and extremely long, banner in the collection depicts the Seven Gods of Good Luck (*shichifuku jin*), Japan's most ubiquitous popular deities (figure 309). Usually considered Buddhist, the origin of the seven can also be linked to Hinduism, Taoism and Shintōism. Beneath a rising sun and a family crest, sitting under a pine tree, are depicted Bishamon, god of prosperity; Ebisu, god of daily food lifting aloft a fish; Jurōjin, god of learning carrying a scroll on his staff; Benten, the only women of the group, the goddess of love and music; Daikoku, the god of wealth, wearing the imaginary costume of a rich Chinese merchant; Fukurokuji, god of longevity and Hotei, the pot-bellied god of happiness.

Festivals played an important part of life in nineteenth- and early twentieth-century Japan and, indeed, still do so today. The use of boldly patterned textiles, often executed using the *tsutsugaki* technique, were a vital aspect of the events. In northern Japan horses ridden or led in festival processions wore trappings made of hemp and decorated with crests (figure 293). This textile would have been placed on the horse's back, the two bands hanging down each side. It is patterned with a crest of a mandarin orange surrounded by dots and edged with stripes and triangular motifs. Each corner has a character, reading, clockwise from the upper right, *kichi* ('good luck'), *shū* ('bush clover'), *nan* ('south') and *jō* ('top'), which probably relate to the family or business that led the horse.

The Montgomery collection also includes a fabulous and varied group of garments, some of which are also designed for celebration. The construction of traditional Japanese clothing is quite straightforward, with two lengths of cloth providing the body, a further two the sleeves and half or quarter lengths any overlaps or collars. On dress, as on the flat textiles, it is thus the surface that is the focus of the design. Although the cut and patterning of garments emphasizes the two-dimensional aspects of their styling, it is important to remember that these are three-dimensional objects. The presence and movement of the wearer would have served to transform their appearance and enhance their beauty.

Brightly coloured, auspicious motifs are a feature of *maiwai*, the robes worn by fishermen on the coast of the Bōsō peninsula near Edo (Tokyo) (figure 308). *Maiwai*, which means 'a thousand congratulations', were not work clothes but were instead donned at New Year and on other special occasions. Originally they were worn only by the ship's captain and patterned using the *tsutsugaki* technique, but by the beginning of the twentieth century it had become the custom to give *maiwai* to the entire crew to celebrate a big catch. As the result of such increased production robes began to be patterned with stencils rather than by free-hand paste-resist. In contrast to the familiar *katazome* repeat-patterning seen on *futon-ji* and *kimono*, *maiwai* have pictorial designs which spread around the bottom part of the garment. These were created with a number of large, carefully aligned, stencils. This example features a crane and tortoise amid pine, bamboo and plum on a rocky outcrop which rises out of the sea. A open fan on the lower left front bears the characters *dai kagyō*, 'great shrimp catch', while above the scene flies a crane, superimposed with a triangular crest. The bird carries in its beak a banner with the characters *Sansha-maru*, the name of the ship. The powerful outline of the design and the bold application of the pigments creates an exuberance highly appropriate to the celebratory nature of the garment. Vigorous design and intense colours are a feature of another festival robe in the Montgomery collection (figure 310). Here free-hand paste-resist (*tsutsugaki*) has been used to create a fiery dragon, which wraps itself around the lower body of the robe, and a phoenix, which flies above, its tail feathers gracefully fanning out over the shoulders and on to the front. Unlike other examples in the collection this robe has an undyed ground. Very unusually for a textile it bears the seal, in red pigment, of the dyer. Despite the brilliance of the pattern, however, this robe was worn as an undergarment.

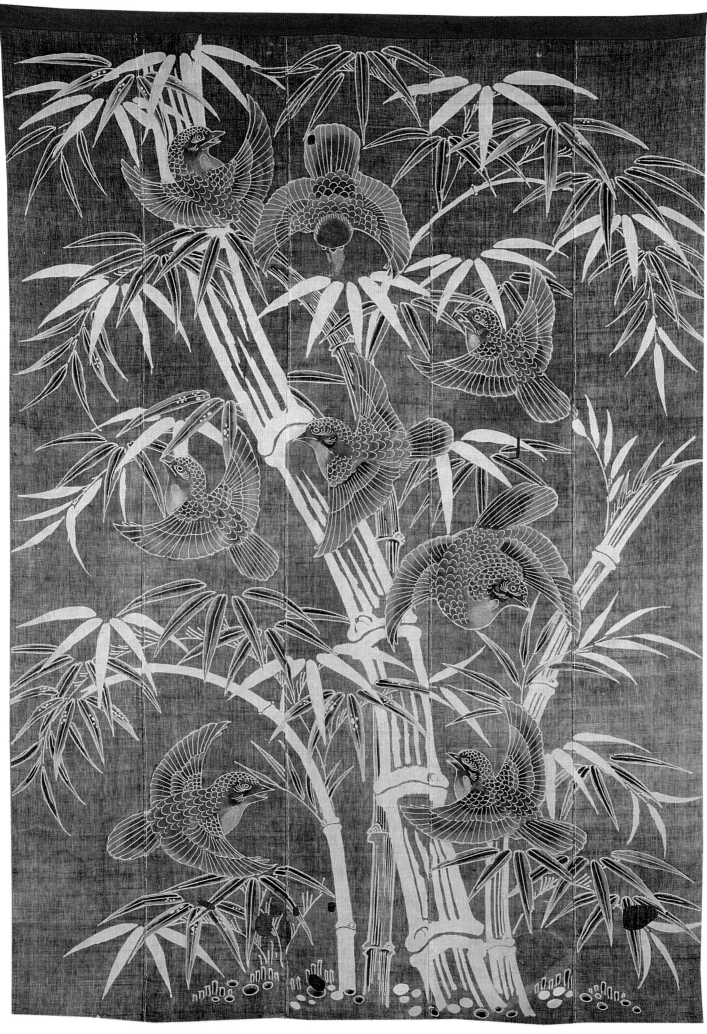

264. *Bedding cover (futon-ji)*
Cotton with a free-hand paste-resist
(*tsutsugaki*) design of sparrows
and bamboo
206 × 149 cm
Meiji period, late 19th - early 20th century

Jackets known as *hanten* or *happi* were everyday work wear for artisans and farmers in Edo and Meiji period Japan[3]. More decorated versions were worn during local festivals and are still often worn today on such occasions. Sweeping wisteria blossoms and a sawtooth pattern decorate such a jacket in the Montgomery collection (figure 294). The jacket is quite small so may have been worn by a woman, perhaps someone called Matsukuma Kane as this name appears on the front left neckband. On the right of the neckband are the characters *giyūdan-gumi*, the name given to volunteer groups of civilians who supported the military, and on the centre back *mori* (woods) which is probably the name of the business which employed the wearer[4]. The delicate and intricate wisteria design on this garment contrasts with the much simpler pattern on another jacket in the collection (figure 295). The rolling waves around the hem, the wave motif across the wide sleeves and the striped collar, still demonstrate the verve of the dyer, however, and reflect the spirit inherent in Japan's festival culture.

The free-hand, vitality of the *tsutsugaki* technique suited the types of clothing worn for festivals, but different methods were used to pattern other types of traditional Japanese garments. The *kasuri* technique – of selectively resist-dyeing yarns prior to weaving – was commonly used on travel capes (figure 319). The style of these garments was adapted from capes worn by Portuguese missionaries in Japan in the sixteenth century. They are called *bōzukappa* from the Japanese word for priest (*bōzu*) and the transliteration of the Portuguese for cape (*kappa*) and their use was initially restricted to members of the military class. By the eighteenth century, however, other sections of society were wearing them for travel along the expanding network of roads that linked Japan's towns and cities. Between the outer and inner fabrics of this cape is a layer of paper, probably treated with persimmon juice. This extra layer not only afforded some degree of waterproofing but also gave extra protection against the wind.

The popularity of the *kasuri* led to various technical innovations in the nineteenth century. The *ita-jime* technique not only speeded up the process but allowed for considerable artistic freedom. In this method yarn is tightly pressed between two boards carved with the desired image. The boards are then immersed in the dye which penetrates the carved areas through pierced holes. *Ita-jime kasuri* can be distinguished by the bands of white that appear at the selvedge ends and by the tighter outline of the design. This can be seen in the aubergine, wisteria and hawk motifs on another jacket in the Mont-

gomery collection (figure 299). These patterns are created in the weft, while the warp pattern of undulating lines has been executed by hand tying the yarns which gives a much more blurred effect. The theme of the motifs is of auspicious dreams, the same as one of the *futon-ji* in the collection (figure 282), with wisteria, *fuji* in Japanese, being substituted as a visual pun for Mount Fuji.

The jacket is of ramie or hemp and would have been worn by a man as an informal summer robe. The cool, transparent, fibre was perfect for Japan's hot and humid summers. An extremely elegant woman's garment in the collection is also made of bast fibre, probably ramie, and would have been worn as an under-*kimono* (*nagajuban*) during the summer (figure 305). The graceful design of fluttering banana leaves is also suggestive of warm, lazy days. This pattern has been executed using stencils, the outline and veins of the leaves having been reserved in lines or large dots. The under-*kimono*, like the majority of garments in the Montgomery collection, probably belonged to a member of the commoner classes. However, to have been able to afford what would have been a quite expensive garment the woman who wore this *nagajuban* was likely to be from a wealthy merchant family, probably living in a large town or city and enjoying a leisurely day out. By contrast this vest (*sodenashi*) would have been worn by a peasant working in the far north of Japan, although the stencilled-dyed fabric of the body was made in the city (figure 297). In the Edo period there was a major growth of transport and communication networks both on land and sea. The western shipping route that linked Osaka with the northern island of Hokkaidō via the Inland sea and the Sea of Japan was called the *kitamaesen*. The ships that plied the course traded in all kinds of commodities including new and used cotton cloth. Cotton could not be grown in Tohoku, the northern region of the main island of Japan, but these important trade routes meant that those living in the area could use the cloth in the garments they made. This vest makes very creative use of indigo-dyed *katazome* and *kasuri* fabrics. The attractive, blurred, effect on the body of the garment is created with white stitches using a quilting method known as *sashiko*. This technique is used in various parts of Japan, but is particularly prevalent in the cold climate of northern Honshū. *Sashiko*, originally used to make fabric last longer or to recycle old pieces, is a technique by which one or more layers of cloth are sewn together with running stitch. Garments stitched in this way are strong and warm and extremely suitable for working apparel.

The skilful way in which imported patterned cloth

was revitalised and reconstituted by the *sashiko* stitchers of northern Japan is demonstrated by three wonderful work coats in the Montgomery collection which use *kasuri* fabric (figures 296, 298 and 302). These were probably worn by farmers, their tapered sleeves allowing for ease of movement. The first uses two types of *kasuri* fabrics, one for the body and one for the sleeve, with the body being quilted in pale blue thread with a lining of plain, pale blue cotton (figure 296). The second also has a body in *kasuri* fabric and a plain lining quilted in white thread. The sleeves are of a dark, plain fabric and are of one layer only and are stitched in a blue lattice pattern. The upper part of the collar is of finely checked cotton (figure 298). The third coat uses small pieces of *kasuri* in the sleeve and a piece of checked fabric on the lower right front, but relies for its decorative effect on its bold *sashiko* stitches (figure 302).

Kōgin, a stitching technique related to *sashiko*, is employed in Tsugaru, the northernmost district of Honshū, to embellish *kimono* made from locally known ramie and hemp (figure 300). A garment such as this was made, not for work, but for wear at formal occasions. In *kōgin* white stitches are embroidered over and under an odd number of warps to produce a diamond pattern. The pattern on this example is characteristic of the eastern part of Tsugaru. The *kōgin* yoke is stitched separately and inserted into the garment, the visual density and physical weight of this section contrasting with the delicate body of the garment. If the sleeves and lower section of the *kimono* wore out, they could be replaced, but the carefully stitched *kōgin* section was repeated used.

This sleeveless jacket is also made out of bast fibre (*asa*), probably hemp, but would have been worn by a *samurai*, revealing how various types of fabric and technique were used by various sections of Japanese society (figure 311). This type of garment is called a *jimbaori* and would have been worn by a *samurai* over his armour. This example, the oldest textile in the Montgomery collection, bears the crest, in red, of the warrior's clan which was probably executed using a stencil. The main design, which is a dynamic image of crashing waves, was painted directly onto the cloth which lends the garment a great visual spontaneity.

The Montgomery collection has another jacket that may have been worn by a *samurai*, this time engaged in a very specific task (figure 314). Fires were a common occurrence in the wooden town and cities of Edo period Japan. In 1629 the Shōgun, Japan's military ruler, created the first fire brigade to protect his castle. Eventually three separate groups of fire-

fighters were established. The *jōbikeshi*, who worked in the area of the castle, and the *daimyōbikeshi*, who protected *daimyō* dwellings, public institutions and rice warehouses, were made up of members of the *samurai*. The third group were the *machibikeshi*, the townsmen firefighters, who were responsible for fires in the commoner's areas. Leather garments were usually associated with the *samurai* and this example was probably worn by a member of a *daimyōbikeshi*, although the leaders of the *machibikeshi* also wore leather jackets. It is made of deerskin imported from China or South-East Asia. The design was created by first paste-resisting the patterned area with a stencil and then exposing the leather to the smoke of a fire. The upper back bears the character *tai* ('big and fat') and the lowers back stylised versions of *jō* (matting). Around the front collar are the stylised characters for *jō* (matting), *oku* (house) and *yaku* (medicine). These characters could be seen from a distance and helped to identify squads and individuals through the smoke and confusion of a fire. While fighting a fire a *samurai* would also wear a leather hood, the top padded to give extra protection from falling debris (figure 313). The flap of this hood bears the crest, *mon*, of a *samurai* family and the front is decorated with the character '*I*', which is probably a squad number.

Members of the *machibikeshi* wore jackets made from several layers of thick cotton quilted together using the *sashiko* technique (figure 312a). Before tackling a blaze a firefighter would be drenched in water to protect him from the flames, the quilting of the jacket allowing for maximum absorption. Wearing this heavy garment the firefighter would attack the blaze, using a long pole to pull down buildings to prevent the fire from spreading. The design of the jackets provided more than just physical protection however. The auspicious pictorial motifs, created using the *tsutsugaki* technique, served to wrap the firefighter in divine protection. This example is decorated with a *karashishi*, a Chinese lion, on a rocky outcrop above rolling waves. The *karashishi* is symbolic of male energy and here the vigorous depiction of the animal's mane and tail is echoed by the movement of the water below. Shown among peonies, the *karashishi* also symbolises long life and happiness. Jackets such as this were reversible and during the actual fire the plain side would be revealed. When the fire had been defeated and on festival days the dynamic image would be revealed. Jackets such as this, whose creation required a number of dyeing and stitching skills, were expensive items. This, and the fact that this example lacks any crest or characters that would allow for identification during the blaze, suggests that the jacket may

not have been worn for a fire at all. Sometimes a neighbourhood would collectively pay for jackets such as this, which would be worn by a chosen representative when paying the customary condolences to victims of the fire and at other formal occasions. Like their *samurai* counterparts, townsmen firefighters would also wear padded hoods. Like their jackets these bore *tsutsugaki* designs and were quilted in *sashiko* stitching. The hood in the Montgomery collection features the design of a dragon, a suitably powerful beast who brought storms when it descended from the heavens (figure 312b). Another firefighting jacket in the collection bears a rare unusual design which may be a stylised character, but is also reminiscent of designs on Ainu costume (figure 303).

The Ainu are an aboriginal people who live primarily by hunting and gathering. They once occupied much of the Japanese archipelago, but they were gradually pushed further and further north by the Japanese and by the twelfth century they inhabited only Hokkaidō. Even there, the Ainu fishing and hunting territories were gradually eroded by the Japanese Matsumae clan who occupied part of the island from the sixteenth century and after the Meiji restoration of 1868 the Ainu lands were officially annexed by the government. Subjected to domination and discrimination for centuries, the Ainu were perceived as barbarians and outcasts by the Japanese. It seems strange, therefore, that a firefighter should chose Ainu motifs to decorate his jacket. The motifs on Ainu textiles do serve a very important symbolic function, however, and perhaps this informed the firefighter's choice.

The Ainu are a deeply religious people and their belief in the presence of spirits, both good and bad, in every part of the natural world effects all aspects of their lives. The spiral and thorn-like patterns that adorn their clothes served to protect the wearer from malevolent forces (figures 315-318). The decoration is laid out symmetrically to protect all parts of the body evenly and is concentrated at the hem, neck, cuffs and front openings to prevent evil spirits from entering at the most vulnerable points. Traditional Ainu robes are known as *attush* are woven from fibres taken from the inner bark of the elm tree. The most elaborate *attush* are worn by men conducting the religious ceremonies that play such an important role in Ainu society (figures 317 and 318). The robes are embellished with pieces of indigo-dyed cotton stitched down using an appliqué method known as *kirifuse* (meaning 'cut and lay down') and then embroidered with a technique called *oki-nuki* (placing and sewing). The main body of *attush* are often plain (figure 318), but one very

fine example in the Montgomery collection is striped with cotton yarn (figure 317). The collar on this robe has been formed with a piece of cotton quilted in the *sashiko* technique. This fabric, together with the indigo-dyed yarn and cloth, was imported from the mainland, highlighting the importance and extend of trade between the Ainu and the Japanese in the nineteenth century. As cotton cloth became more readily available it was used to make everyday garment known as *yayan'amip*, or 'ordinary clothes'. The densely striped garment in the collection has been embellished with the traditional pieces of cloth which have then been embroidered (figure 315), but the simpler plain blue robe relies purely on embroidery for its decoration (figure 316). Unlike the broad sleeves of the ceremonial *attush*, these two garments have tapered sleeves to allow for ease of movement.

Far removed socially, politically, religiously and geographically from the Ainu culture of Hokkaidō, is the Ryūkyū archipelago which lies to the south of Japan. The textiles produced here are very distinctive, the most striking being the *bingata* fabrics of Okinawa, the largest of the islands. *Bingata* is distinguished by its brilliance of colour which derives from the use of mineral pigments held in a medium of soyabean liquid. The pigments are applied with a stubby brush in a number of layers to achieve the intensity required. A stencil method is used to dye *bingata* garments, but a freehand pate-resist method is used to pattern ceremonial wrapping cloths (figure 279). These cloths, known as *uchukui*, differ from the *furoshiki* of the mainland in that they generally have circular designs and are made of ramie rather than cotton.

Until its annexation by Japan in 1879, Ryūkyū was an independent kingdom and *bingata* fabric was reserved exclusively for the use of the royal court. All sections of Ryūkyūan society were able to wear garments made out of banana fibre (*bashō*) which was obtained from the leaf of the thread banana plant (figure 304). However, the quality of the cloth and the designs that decorated it varied according to social status. Only the aristocracy were permitted to wear garments patterned with selectively resist-dyed yarns (*kasuri*). The rich brown colour of the stripes and *kasuri* warps of this robe were produced using a dye made from the woody part of the *shirinbai* tree, a member of the rose family. Restrictions on the use of *bingata* and *kasuri* dyed banana fibre cloth were lifted after 1879, but such fabrics still tended to be used only by the upper echelons of Ryūkyūan society.

Much earlier in its history, in 1609, Ryūkyū was invaded by the *daimyō* (military leader) of Satsuma

in Kyūshū. The islands were forced to pay tribute to Satsuma, the monarchy raising the funds in the form of a poll tax on its subjects. Some of this tax was paid in cloth, particularly the fine quality ramie (*jōfu*) made in the outer islands of Miyako and Yaeyama. Some of the cloth remained in Okinawa for use by the court, but much of the best *kasuri* patterned ramie went to Satsuma, from where it was often sold to other parts of Japan. The poll tax was abolished in 1903, but demand for the cloth on the mainland remained high. The cool, lustrous fabric was ideal for summer *kimono*. The beautiful example in the Montgomery collection is made from *jōfu* woven in Miyako with a subtle geometric *kasuri* pattern in dark and pale blue (figure 301).

The woman who wore this *kimono* would have delighted in its elegant pattern and in the luxurious texture of its fabric. The Japanese emphasis on the surface decoration of textiles and dress gives objects such as those in the Montgomery collection an enormous visual attraction. But they also appeal to our sense of touch. As items of personal apparel and private life these textiles not only have an arresting beauty, but a particular intimacy which enables us to respond to them today in a very immediate way. The individual history of those who originally made and owned them may be forever lost. Yet these textiles and garments give us a valuable insight into the lives of the craftsmen and women who created them and the farmers, fishermen, artisans, merchants and *samurai* who used and cherished them.

[1] The twelve animals of the zodiac are the rat, ox, tiger, rabbit, dragon, snake, horse, goat, monkey, rooster, dog and pig.
[2] See Moes, R. and Mayer Stinchecum, A., *Mingei: Japanese Folk Art from the Montgomery Collection*, Alexandria, VA; Art Services International, 1995, p. 253.
[3] These two terms, *hanten* and *happi* are used fairly interchangeably, although the latter is usually seen more as a kind of uniform intended to identify the wearer as belonging to a specific group. It is worn with a belt. The term *happi* is more commonly used to describe the type of garments still worn today.
[4] See Moes, R. and Mayer Stinchecum, A., *Mingei: Japanese Folk Art from the Montgomery Collection*, Alexandria, VA; Art Services International, 1995, p. 227.

265. *Two-fold screen (*byōbu*) mounted with four-panel cloth* (detail)
Cotton with a free-hand paste-resist (*tsutsugaki*) design of a tiger and bamboo
134 × 159 cm
Meiji period, late 19th-early 20th century

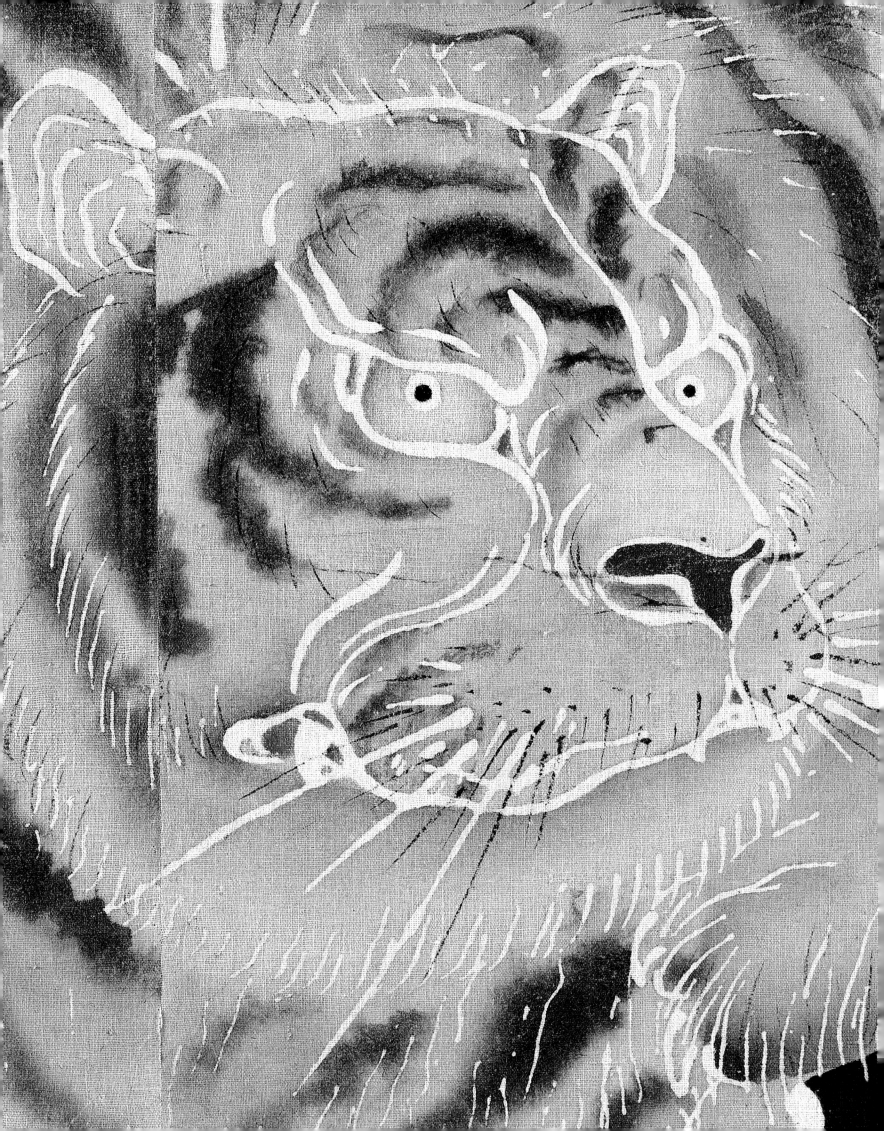

266. *Hanging, probably from a Buddhist temple*
Cotton with a free-hand paste-resist (*tsutsugaki*) design of lotuses in water
186.5 × 193 cm
Late Edo period - early Meiji period, 19th century

267. *Bedding cover (*futon-ji*) or chest cover (*yutan*)*
Cotton and silk with a free-hand paste-resist (*tsutsugaki*) design of peonies and vine scrolls
178 × 147 cm
Meiji period, late 19th-early 20th century

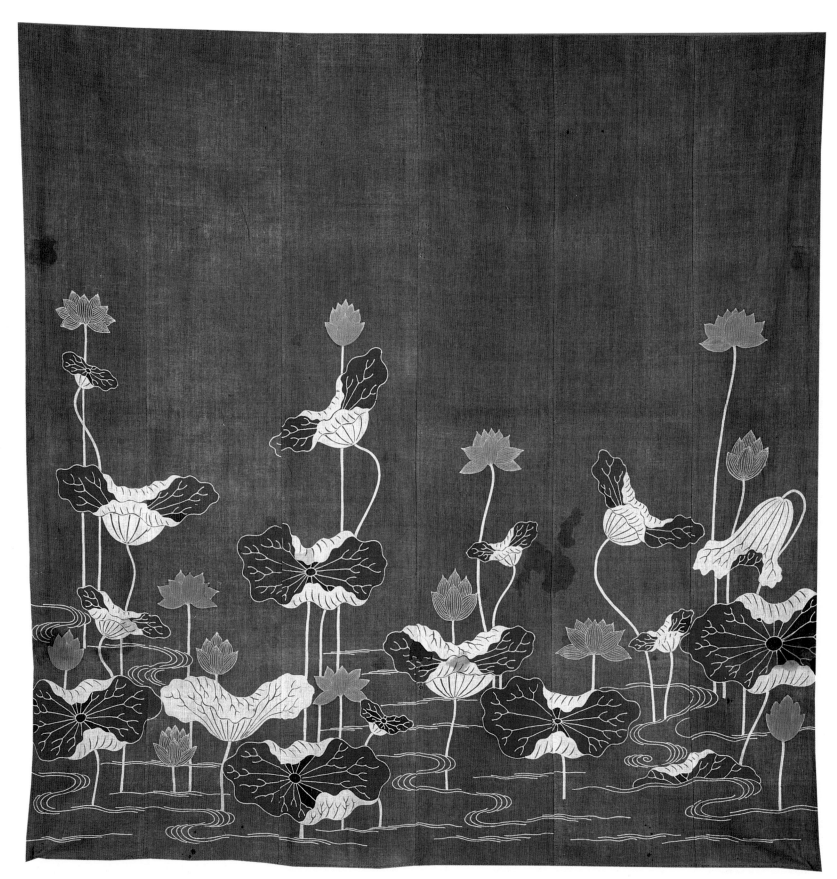

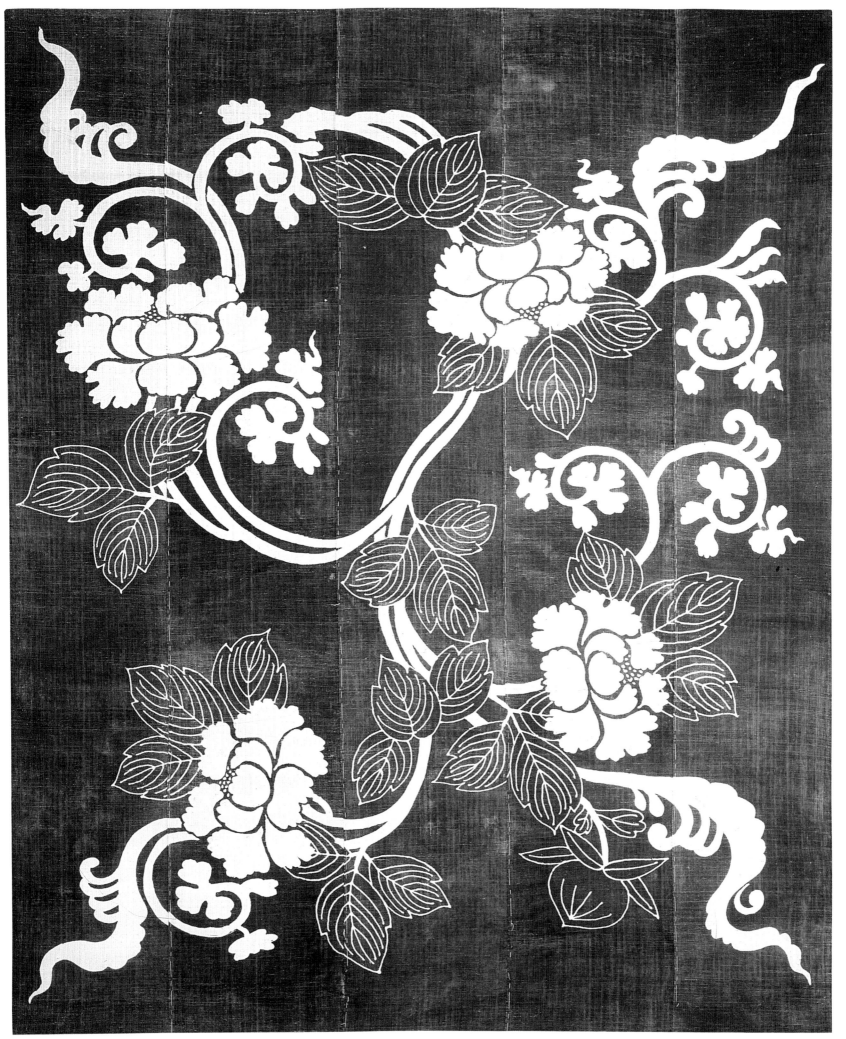

268. *Bedding cover (*futon-ji*) or chest
cover (*yutan*)*
Cotton with a free-hand paste-resist
(*tsutsugaki*) design of ceremonial dried
abalone (*noshi*)
147.3 × 125.2 cm
Meiji period, late 19th-early 20th century

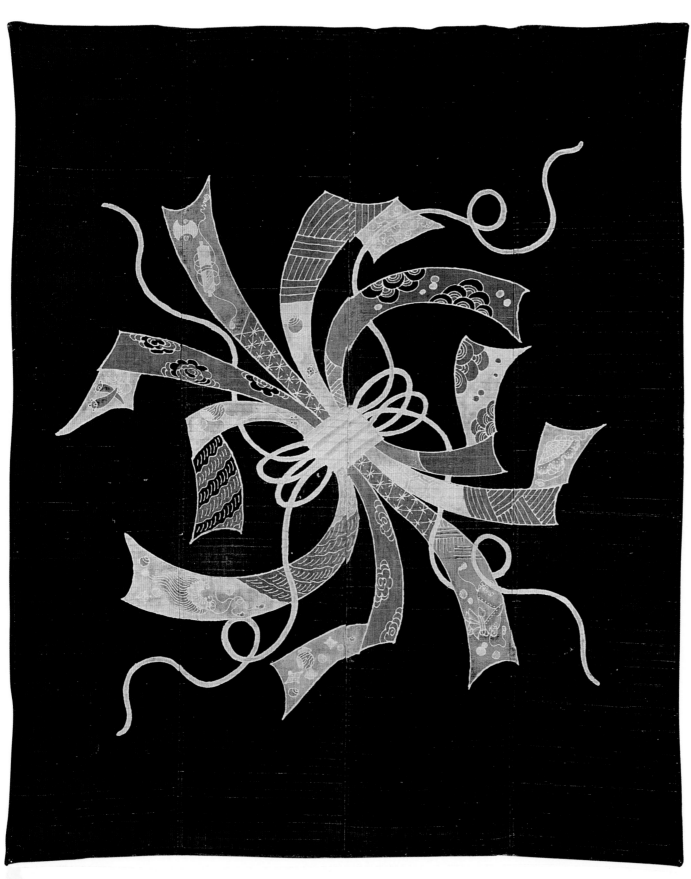

269. *Bedding cover (*futon-ji*) made
from a quilt in* kimono *shape (*yogi*)*
Cotton with a free-hand paste-resist
(*tsutsugaki*) design of a carp rising
from the waves and a crest
176 × 140 cm
Meiji period, late 19th-early 20th century

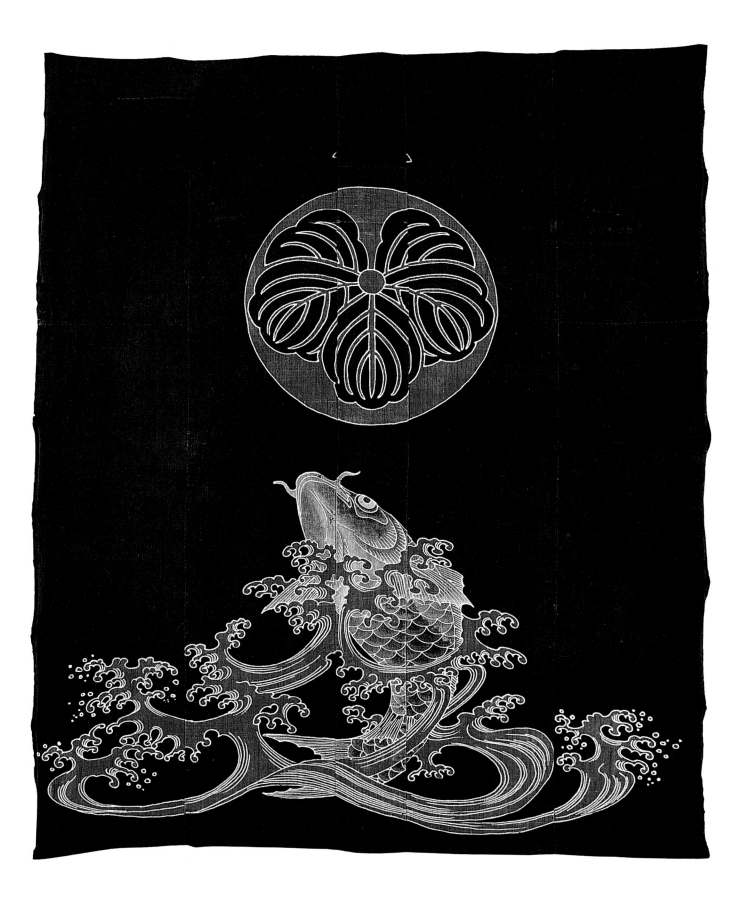

270. *Bedding cover (*futon-ji*) or chest cover (*yutan*)*
Cotton with a free-hand paste-resist (*tsutsugaki*) design of pine, bamboo, plum and crests
137.5 × 143.5 cm
Meiji period, late 19th-early 20th century

271. *Hanging scroll (*kakejiku*) made from a bedding cover (*futon-ji*) or chest cover (*yutan*)*
Cotton with a free-hand paste-resist (*tsutsugaki*) design of fans, cherry blossom and tortoise tails
176 × 160 cm
Meiji period, late 19th-early 20th century

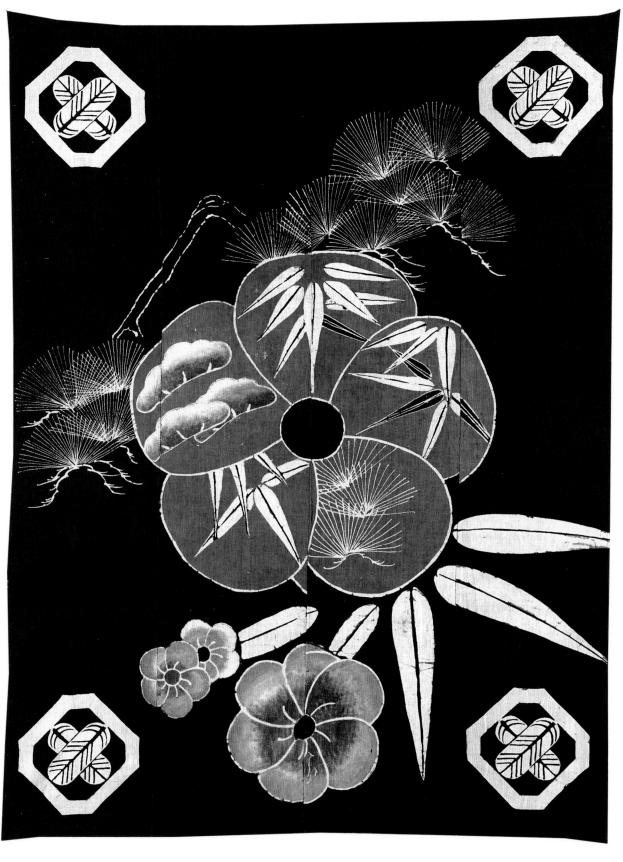

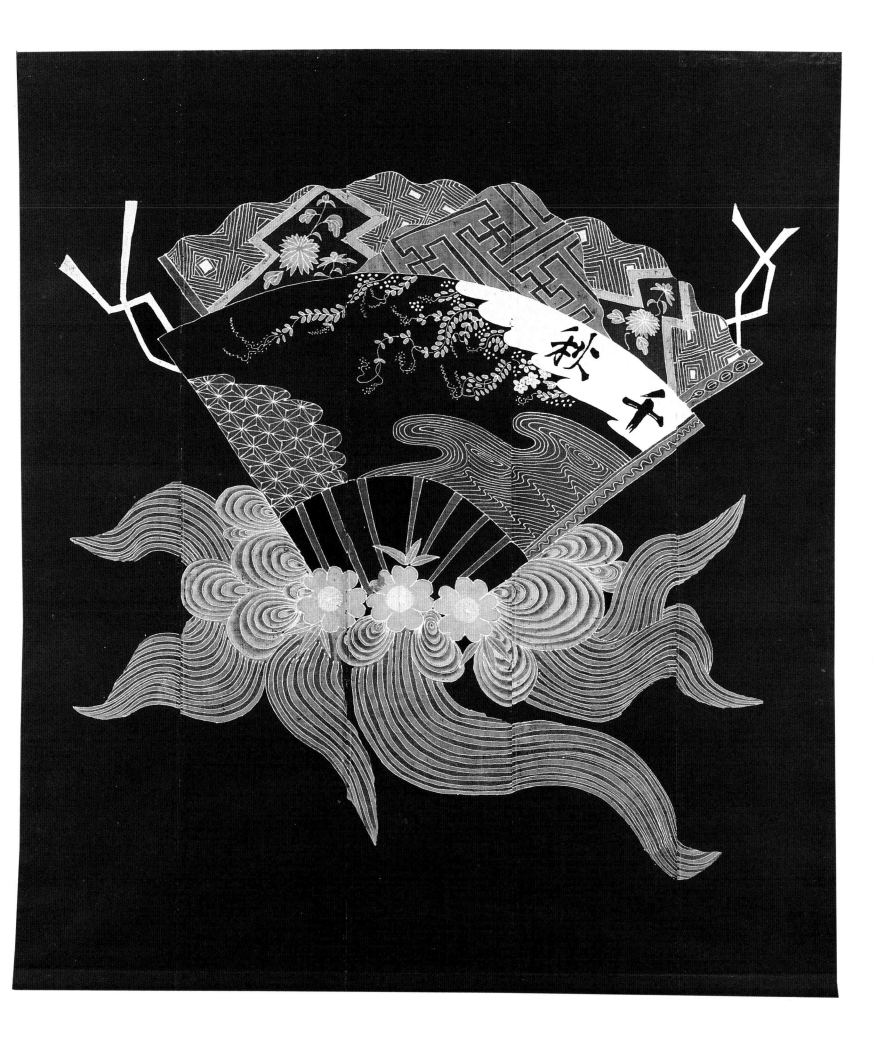

272. *Bedding cover (*futon-ji*)*
Cotton with a free-hand paste-resist
(*tsutsugaki*) design of two lobsters
172.3 × 133.4 cm
Late Meiji period - early Shōwa period,
1900-1939

273. *Wrapping cloth (*furoshiki*)*
Cotton with a free-hand paste-resist
(*tsutsugaki*) design of a shell box and crest
124 × 100 cm
Late Edo period - early Meiji period,
2nd half 19th century

274. *Decorative curtain (*maku*)*
Cotton with a free-hand paste-resist
(*tsutsugaki*) design of two figures
under a cherry tree
192 × 130.5 cm
Late Edo period - early Meiji period,
second half 19th century

275. *Bedding cover (*futon-ji*)*
Cotton with a free-hand paste-resist
(*tsutsugaki*) design of pine, bamboo
and plum
142.5 × 124.5 cm
Meiji period, early 20th century

276. *Two-fold screen (*byōbu*)*
mounted with four-panel cloth
Cotton with a free-hand paste-resist
(*tsutsugaki*) design of a tiger and bamboo
134 × 159 cm
Meiji period, late 19th-early 20th century

277. *Bedding cover (*futon-ji*)*
Cotton and silk with a free-hand paste-
resist (*tsutsugaki*) design of a phoenix
and paulownia above rocks and waves
146 × 128.2 cm
Late Edo - early Meiji period,
19th century

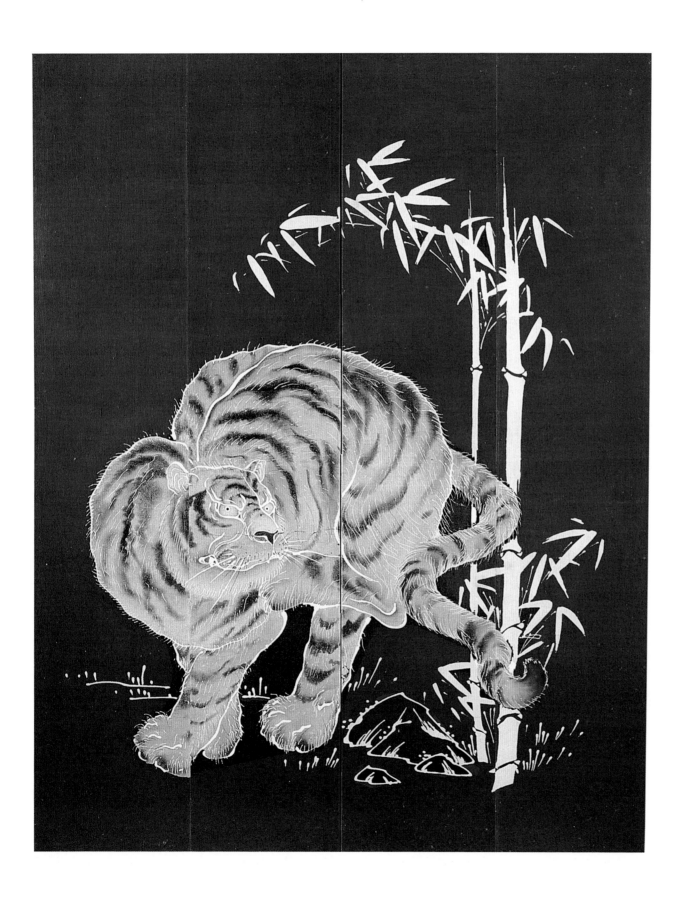

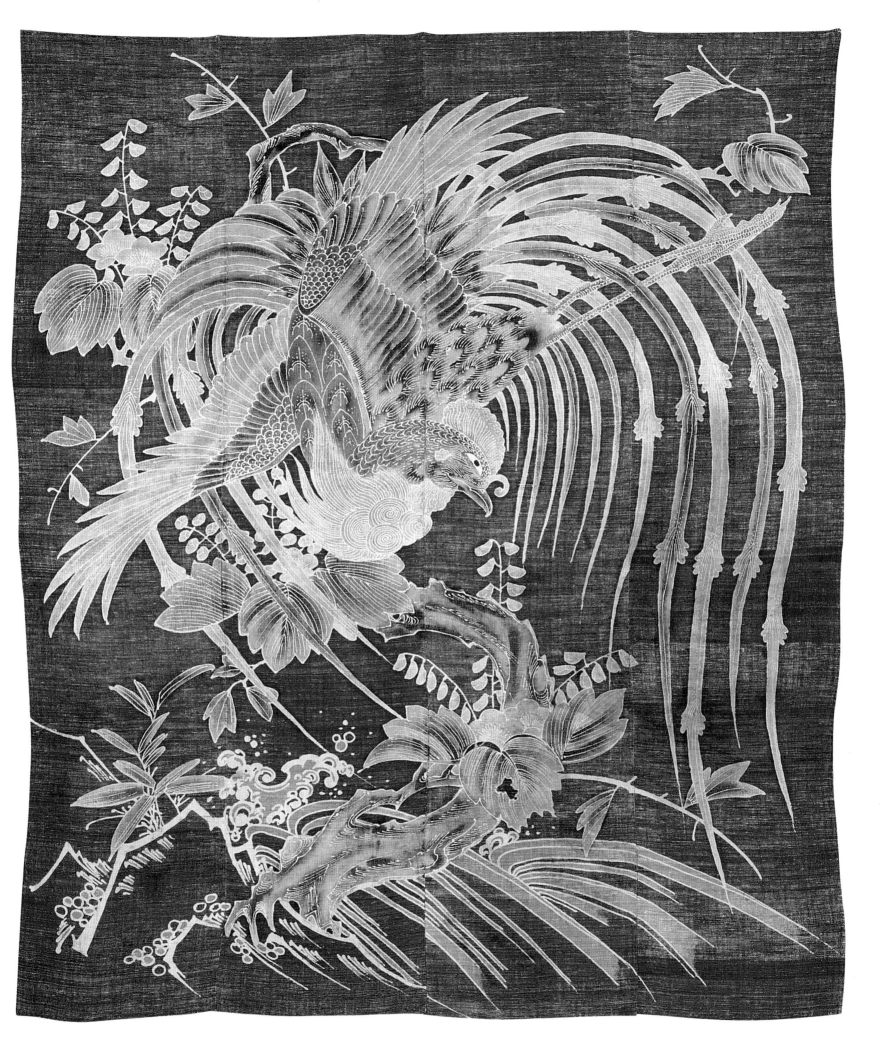

278. *Wrapping cloth (*furoshiki)
Cotton with a free-hand paste-resist
(*tsutsugaki*) design of pine, bamboo,
plum and a crest
100.5 × 101 cm
Meiji period, early 20ᵗʰ century

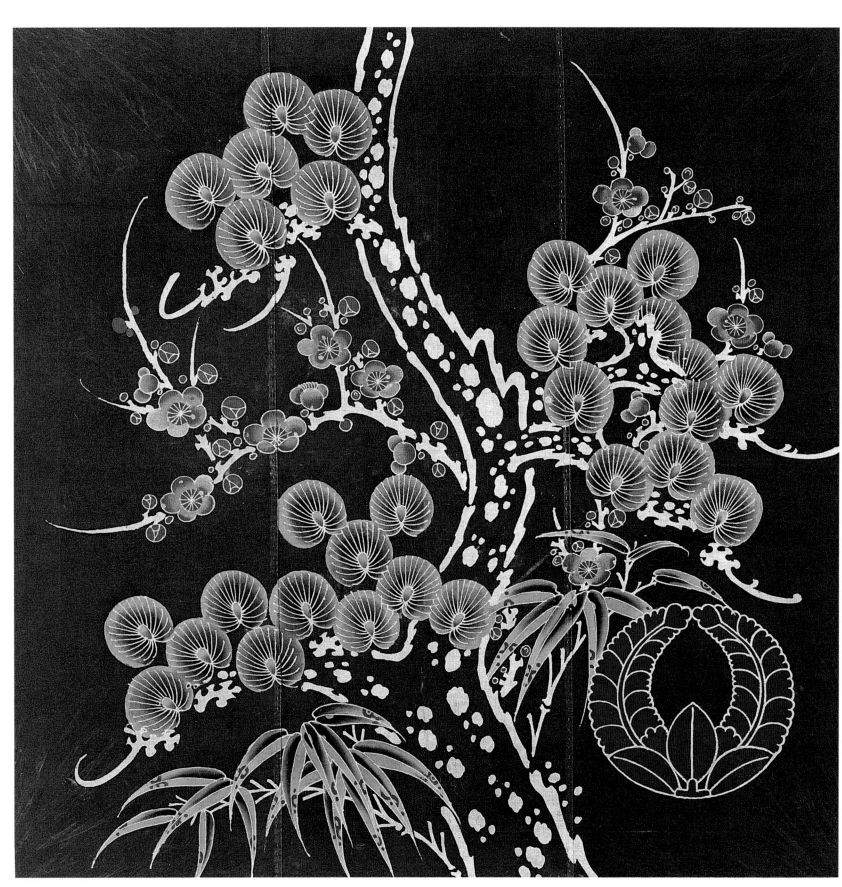

279. *Wrapping cloth (*uchukui*)*
Okinawa Island (*Ryūkyū*)
Bast fibre (*asa*), ramie, with freehand
bingata design of pine, bamboo, plum,
crane and tortoise
106 × 96 cm
Meiji period, late 19th-early 20th century

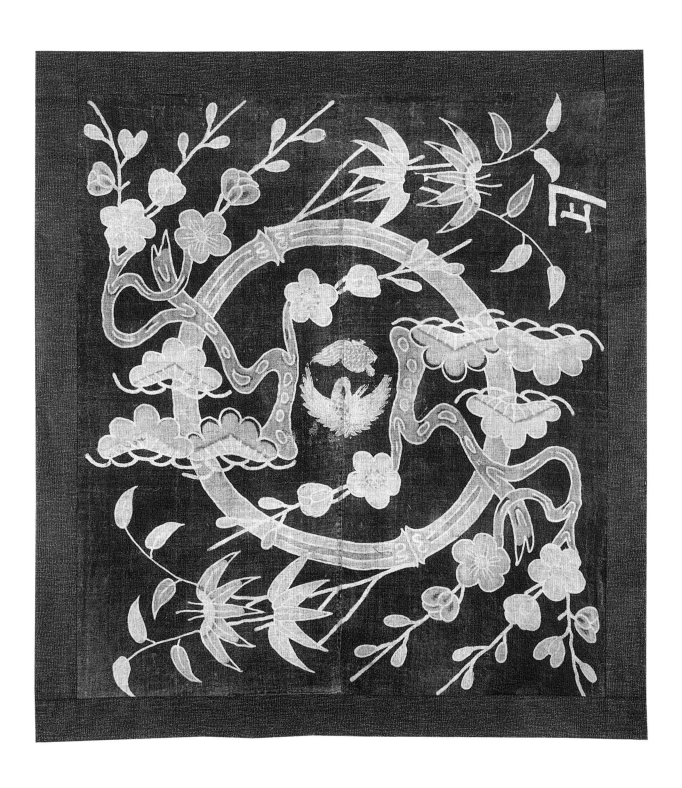

280. *Bedding cover (*futon-ji*) made from
a quilt in* kimono *shape (*yogi*)*
Cotton with a free-hand paste-resist
(*tsutsugaki*) design of two mandarin
ducks, a snow-covered plum tree
and a crest
156 × 146 cm
Meiji period, late 19th-early 20th century

281. *Bedding cover (*futon-ji*) or chest
cover (*yutan*)*
Cotton with a free-hand paste-resist
(*tsutsugaki*) design of two Chinese
lions among peonies
225 × 163 cm
Meiji period, late 19th-early 20th century

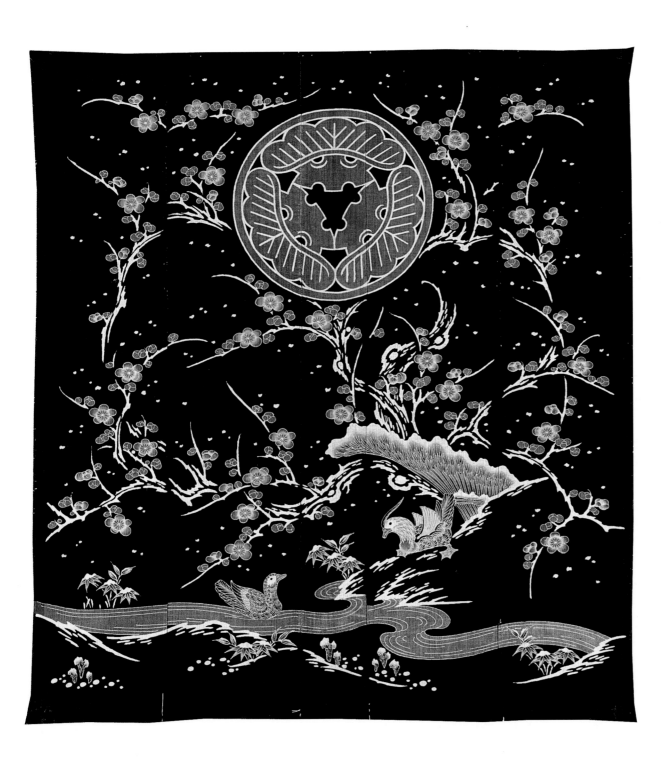

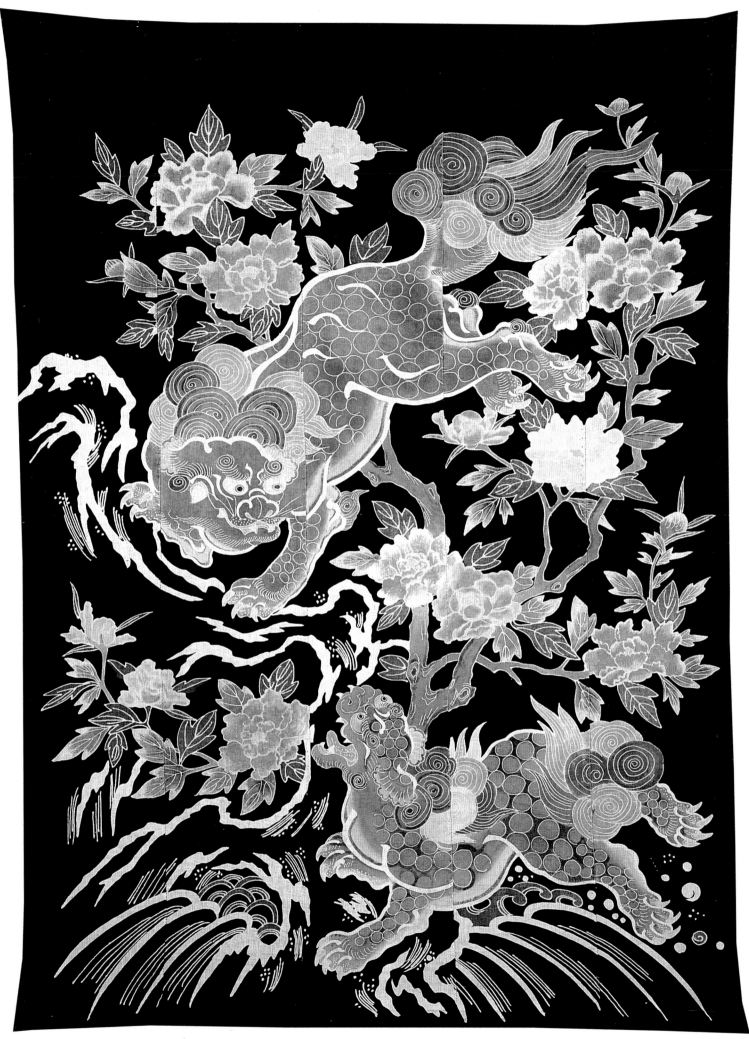

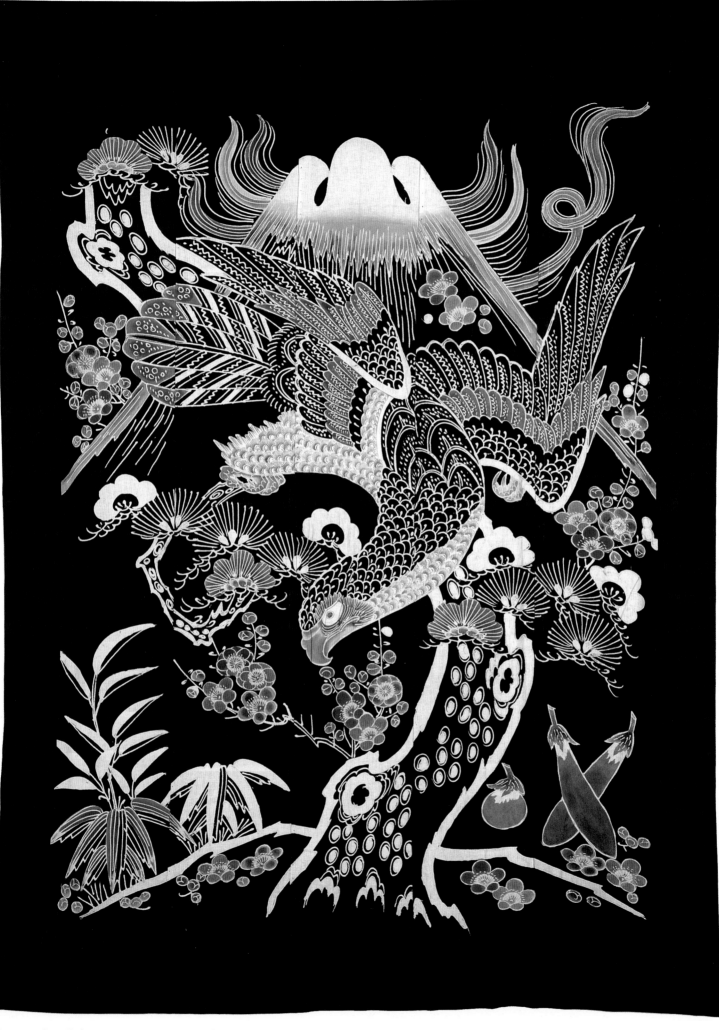

282. *Bedding cover (*futon-ji*)*
Cotton with a free-hand paste-resist
(*tsutsugaki*) design of Mount Fuji, a hawk
and aubergines
250 × 189 cm
Meiji period, late 19th-early 20th century

283. *Bedding cover (*futon-ji*)*
Cotton with a free-hand paste-resist
(*tsutsugaki*) design of a phoenix
and paulownia
215 × 163 cm
Late Meiji - early Shōwa, c.1900-1939

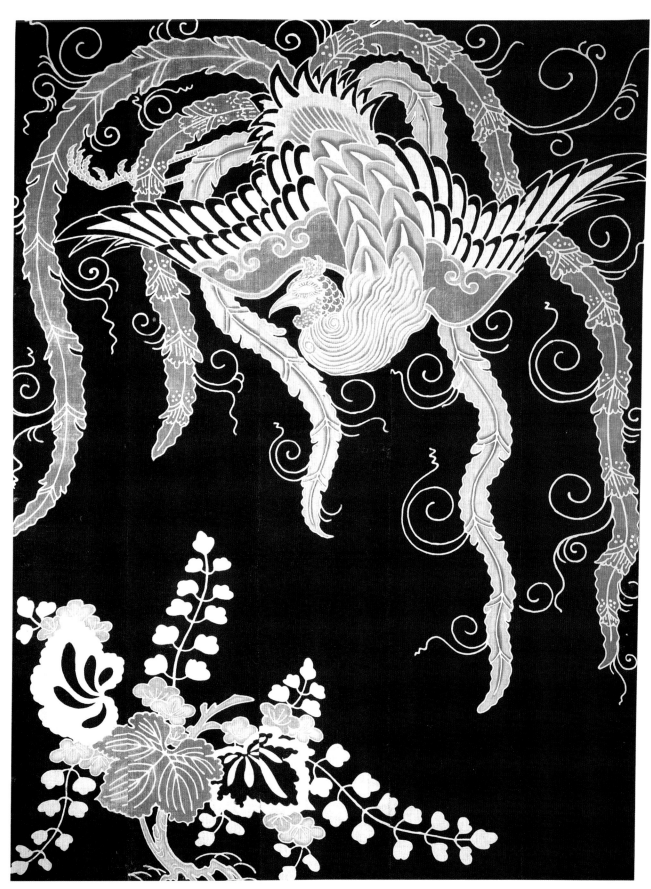

284. *Doorway curtain (*noren*)*
Northern Japan (Tōhoku region)
Bast fibre (*asa*), probably hemp, with
a free-hand paste-resist (*tsutsugaki*) design
of a hawk diving among rocks, waves
and pines with a crest
160 × 175 cm
Meiji period, late 19ᵗʰ-early 20ᵗʰ century

285. *Bedding cover (*futon-ji*) or chest
cover (*yutan*)*
Cotton with a free-hand paste-resist
(*tsutsugaki*) design of two hawks
and a pine tree
217.5 × 165.5 cm
Meiji period, late 19ᵗʰ-early 20ᵗʰ century

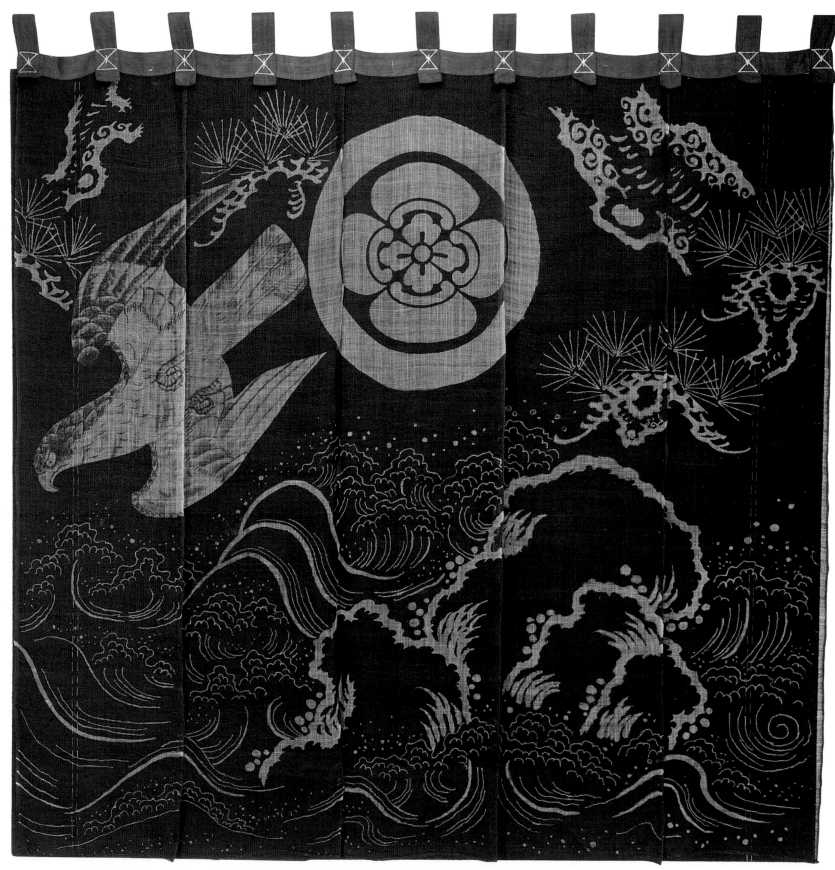

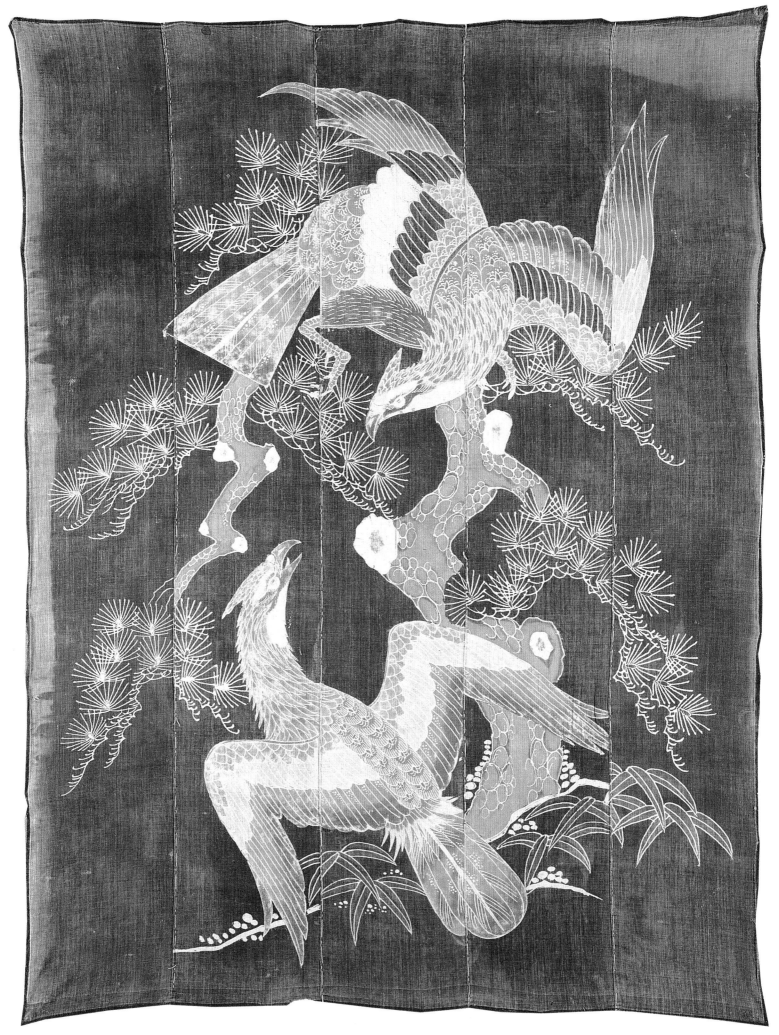

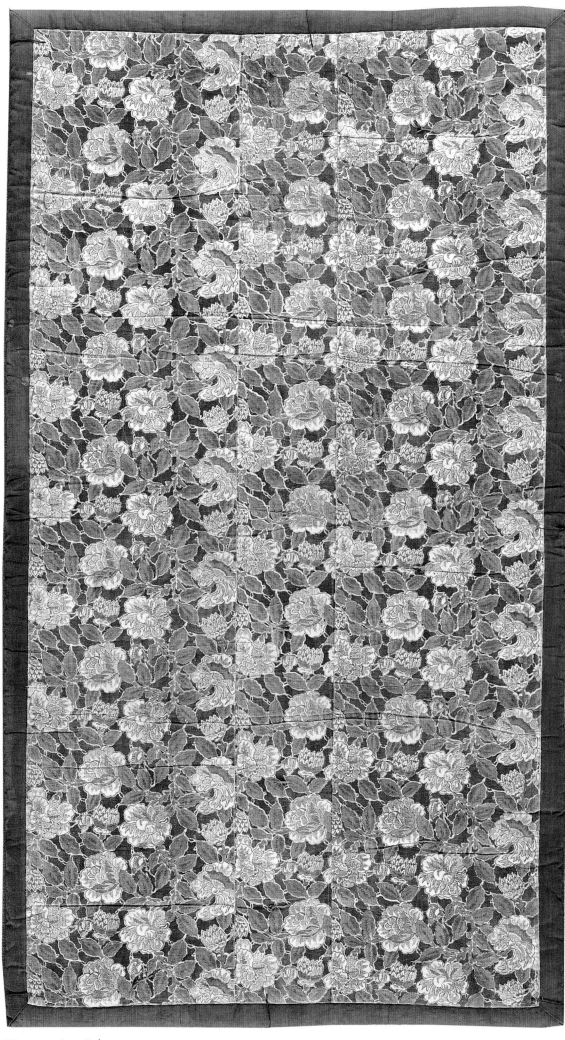

286. *Mattress (*shiki-buton*)*
Probably Sakai (Osaka Prefecture)
Cotton with a stencilled (*sarasa*) design
of peonies
150 × 87 cm
Late Edo period, 19th century

287. *Bedding cover (*futon-ji*) or chest cover (*yutan*)*
Cotton with a stencilled paste-resist
(*katazome*) design of fan papers
and a crest
188.2 × 164.2 cm
Late Meiji period - Taishō period,
1ˢᵗ quarter 20ᵗʰ century

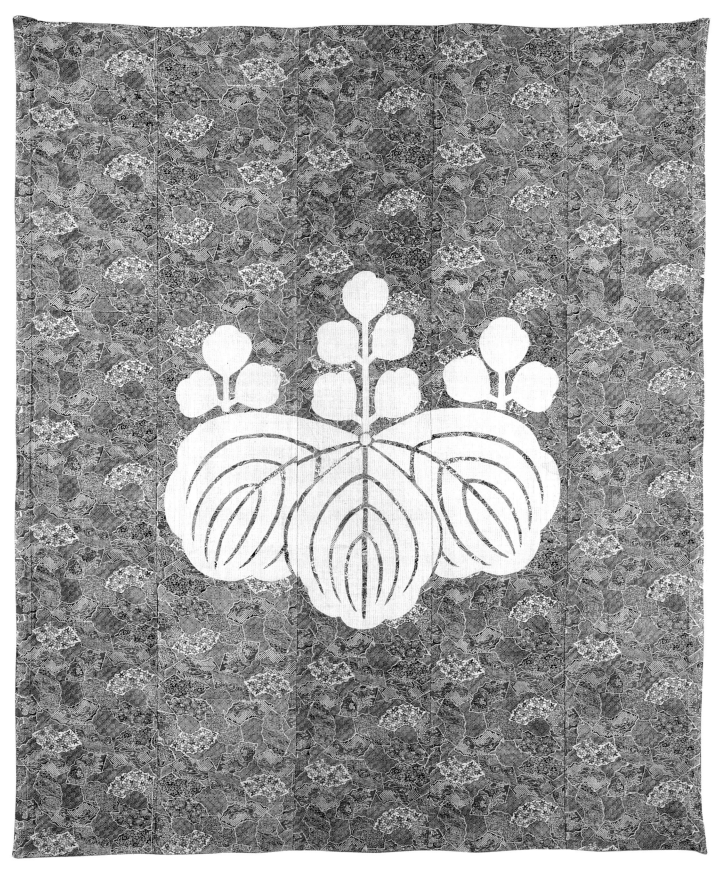

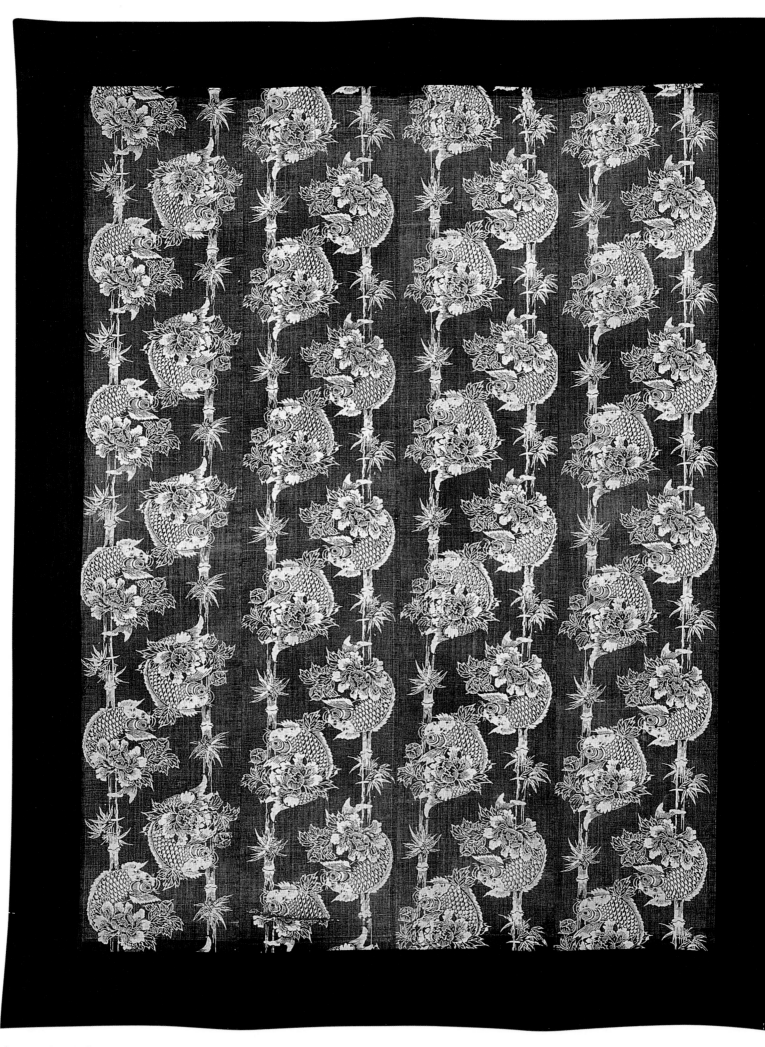

288. *Bedding cover (*futon-ji*)*
Cotton with a stencilled paste-resist
(*katazome*) design of carp, peonies
and bamboo
191 × 152 cm
Meiji period, late 19ᵗʰ-early 20ᵗʰ century

289. *Doorway curtain (*noren*)*
Cotton with a free-hand paste-resist
(*tsutsugaki*) design of drumheads,
pines and a crest
148.5 × 80 cm
Meiji period, late 19ᵗʰ-early 20ᵗʰ century

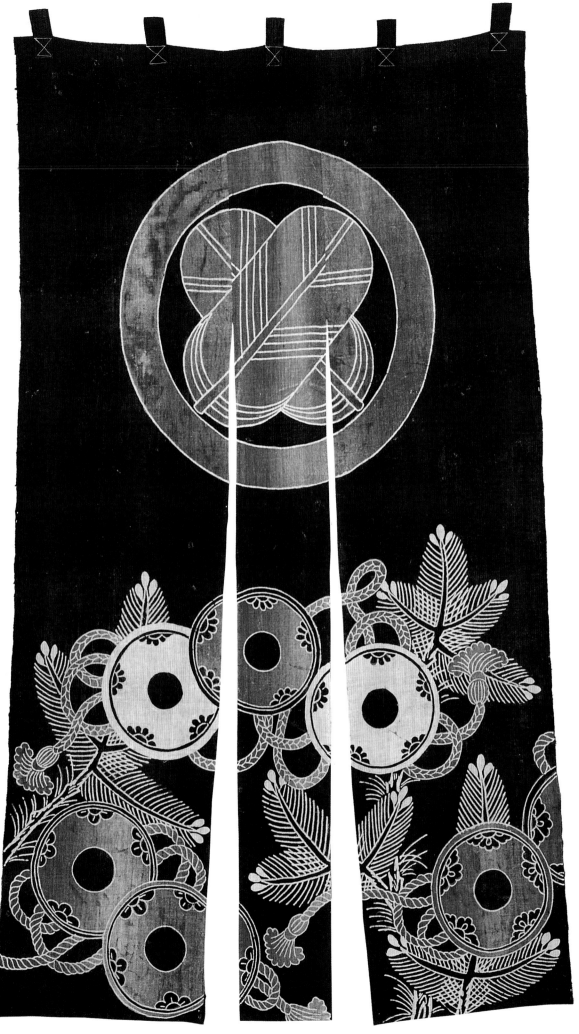

290. *Bedding cover (*futon-ji*)*
Kurume (Fukuoka Prefecture)
Cotton woven with a design of a castle
in selectively resist-dyed yarns (*kasuri*)
125 × 162 cm
Meiji period, late 19th century

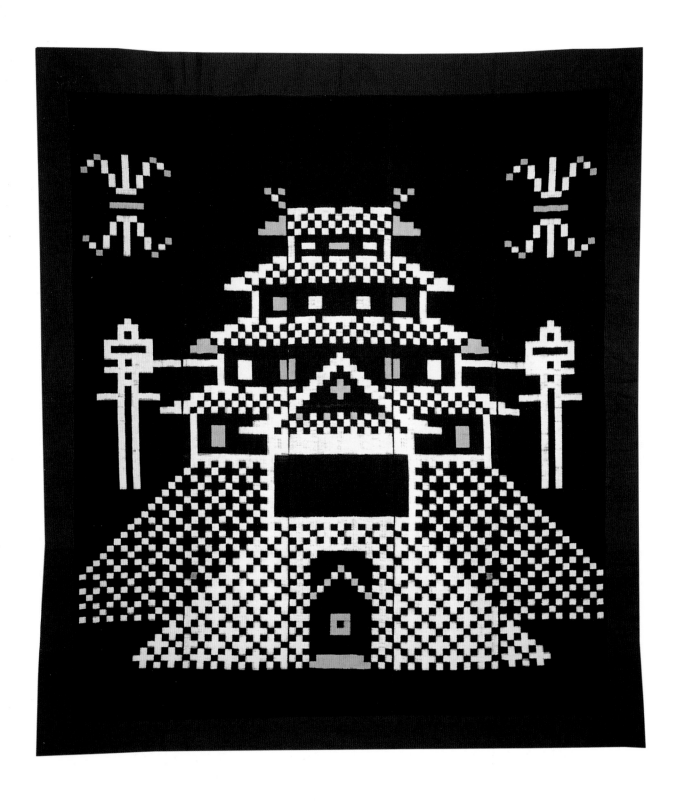

291. *Bedding cover (*futon-ji*)*
Kurume (Fukuoka Prefecture)
Cotton woven with a design of
a battleship in selectively resist-dyed
yarns (*kasuri*)
125 × 162 cm
Meiji period, c.1896-1900

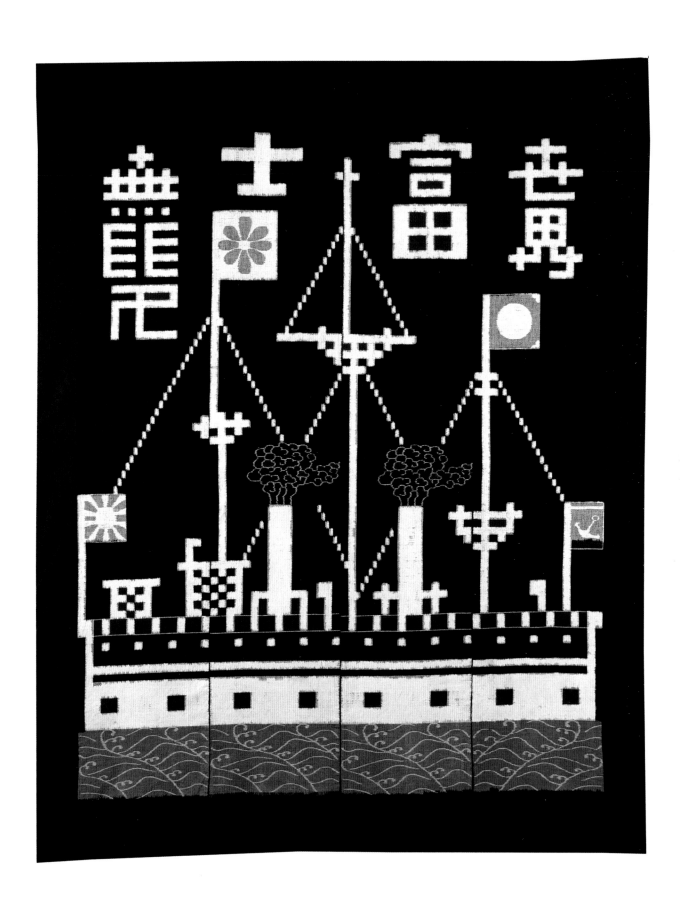

291. *Bedding cover (*futon-ji*)*

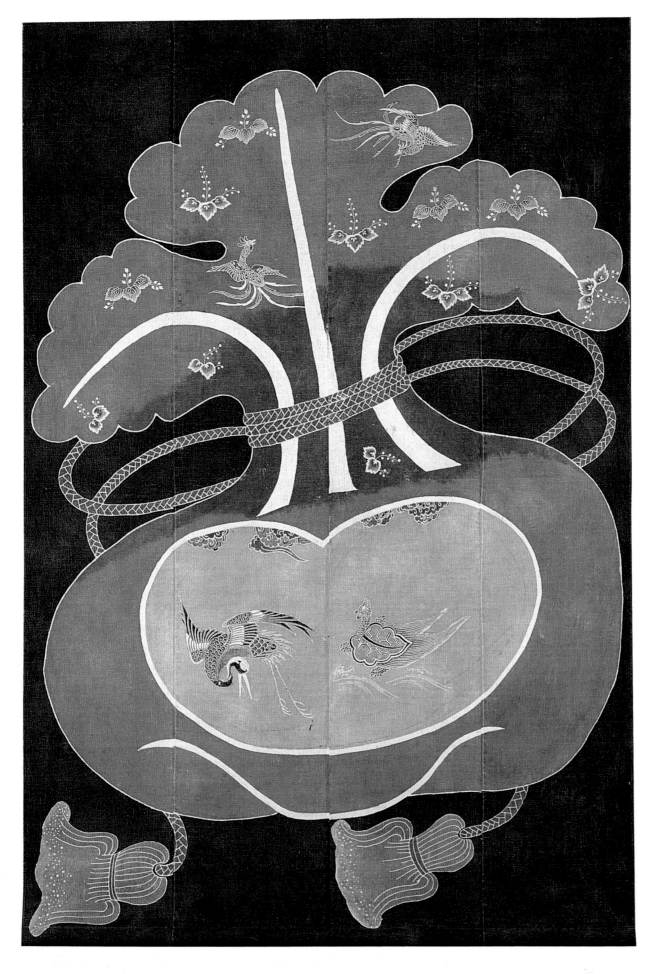

292. *Hanging scroll* (kakejiku) *made from a bedding cover* (futon-ji) *or chest cover* (yutan)
Cotton with a free-hand paste-resist (*tsutsugaki*) design of a treasure sack
176 × 120 cm
Late Edo period - early Meiji period, 2nd half of the 19th century

293. *Horse trappings (*uma kake*)*
Bast fibre (*asa*), probably hemp, with
a free-hand paste-resist (*tsutsugaki*)
design of crests and dots
82 × 273.5 cm
Meiji period, late 19ᵗʰ-early 20ᵗʰ century

294. *Jacket (*hanten*)*
Cotton with a free-hand paste-resist
(*tsutsugaki*) design of wisteria, triangular
motifs and characters
78 × 116.8 cm
Late Meiji period - Taishō period,
early 20ᵗʰ century

295. *Jacket (*hanten*)*
Cotton with a free-hand paste-resist
(*tsutsugaki*) design of waves
87 × 128 cm
Late Meiji period - early Shōwa period,
1st half 20th century

296. *Work Coat*
Northern Japan (Tōhoku region)
Cotton woven with selectively resist-dyed
yarns (*kasuri*), body quilted in cotton
thread (*sashiko*)
102 × 122 cm
Early Meiji period, late 19ᵗʰ century

297. *Vest* (sodenashi*)*
Possibly Tsugaru district
(Aomori Prefecture)
Cotton with a stencilled paste-resist
(*katazome*) design of chrysanthemums
quilted in cotton thread (*sashiko*),
yoke and collar woven with selectively
resist-dyed yarns (*kasuri*)
102 × 122 cm
Meiji period, late 19ᵗʰ-early 20ᵗʰ century

298. *Work Coat*
Northern Japan (Tōhoku region)
Cotton, body woven with selectively
resist-dyed yarns (*kasuri*), quilted
in cotton thread (*sashiko*)
110 × 122 cm
Early Meiji period, late 19ᵗʰ century

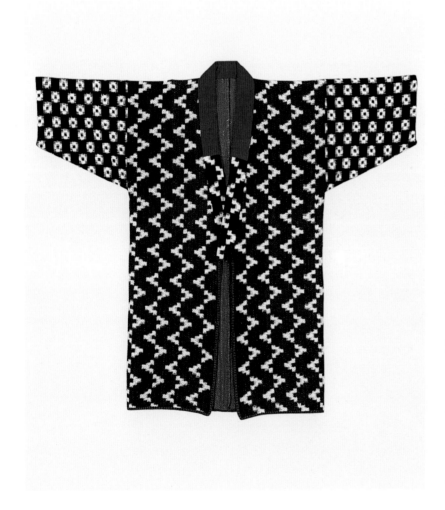

299. *Short robe (*jinbei*)*
Bast fibre (*asa*), hemp or ramie, woven
with a design of wisteria, hawks and
aubergines in selectively resist-dyed
yarns (*kasuri*)
105 × 128 cm
Meiji period, late 19ᵗʰ-early 20ᵗʰ century

300. Kimono
Tsugaru district (Aomori Prefecture)
Bast fibre (*asa*), probably ramie, with
cotton stitch embroidery (*kōgin*)
121 × 106.5 cm
Meiji period, late 19ᵗʰ-early 20ᵗʰ century

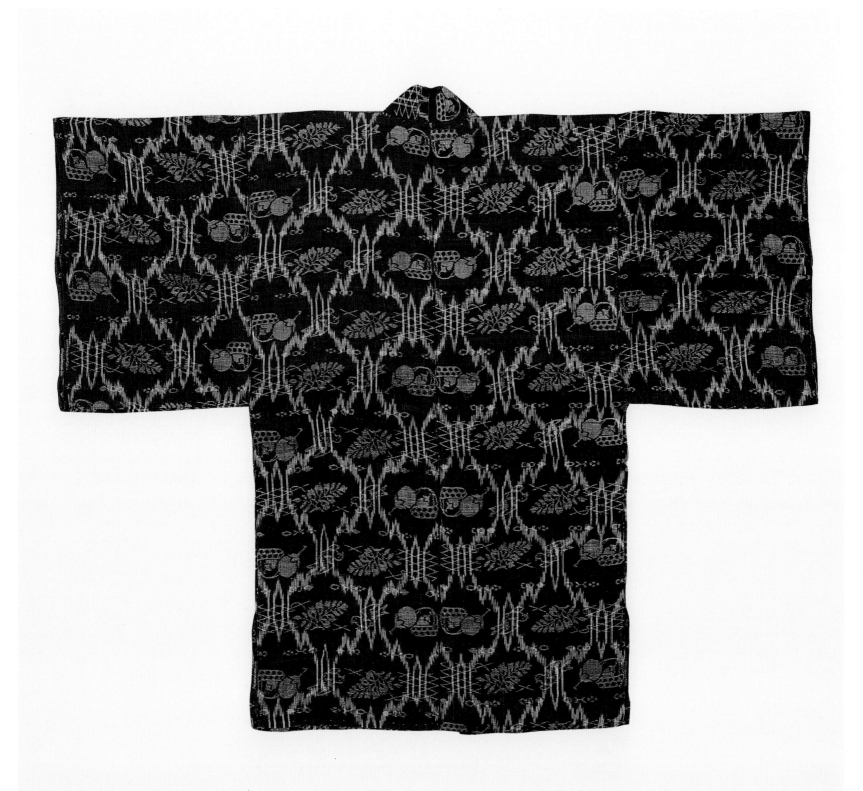

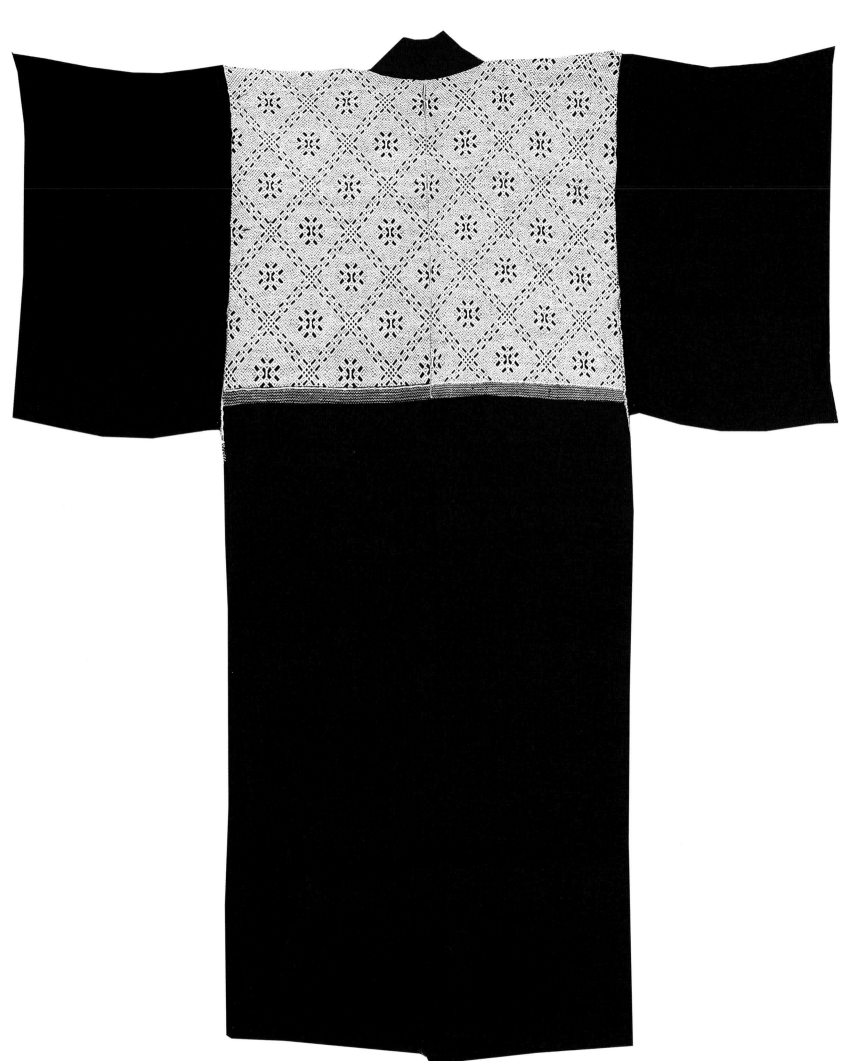

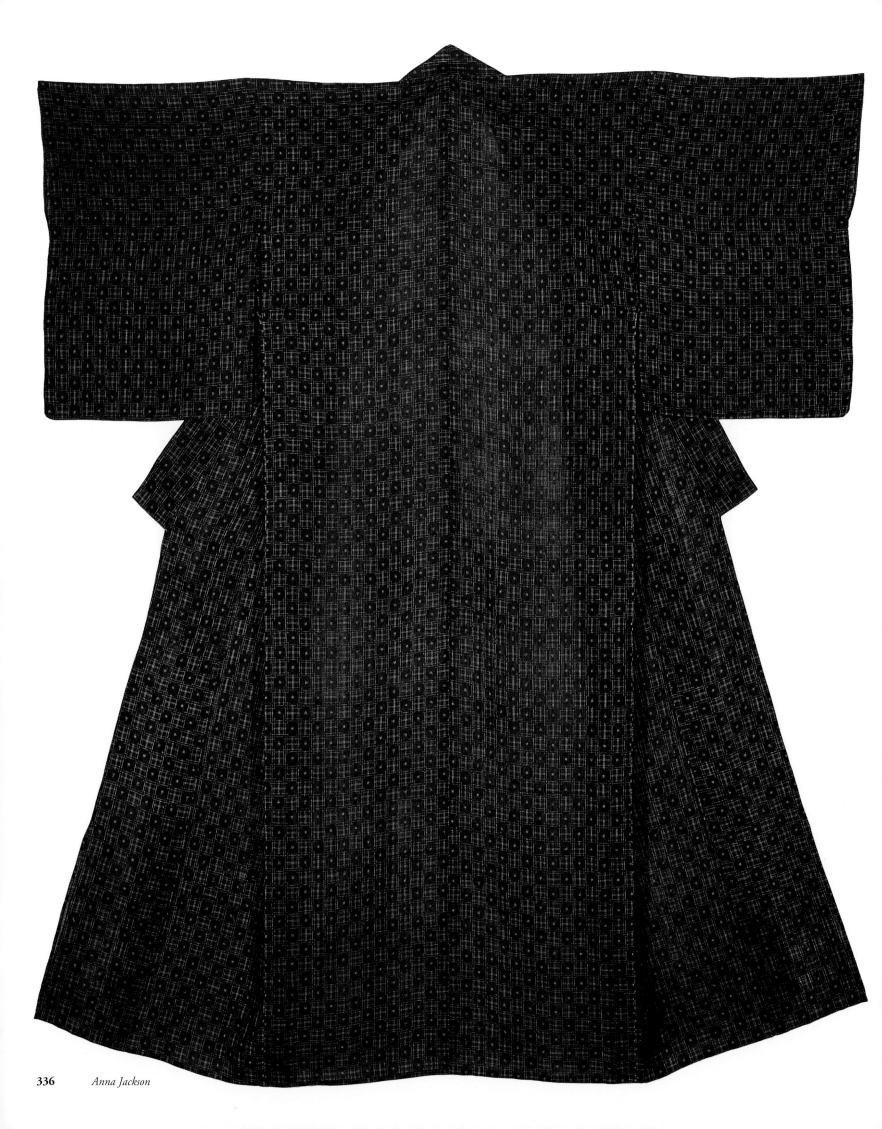

Anna Jackson

301. *Summer* kimono *(*katabira*)*
Miyako (Okinawa), garment made
in Honshū
Bast fibre (*asa*), ramie, woven with
selectively resist-dyed yarns (*kasuri*)
148.6 × 125.6 cm
Late Meiji period - Taishō period,
1ˢᵗ quarter 20ᵗʰ century

302. *Work coat*
Northern Japan (Tōhoku region)
Cotton quilted in cotton thread (*sashiko*),
with a section of each sleeve in fabric
woven with selectively resist-dyed yarns
(*kasuri*) and the lower front right
of checked fabric
107 × 113.5 cm
Early Meiji period, late 19ᵗʰ century

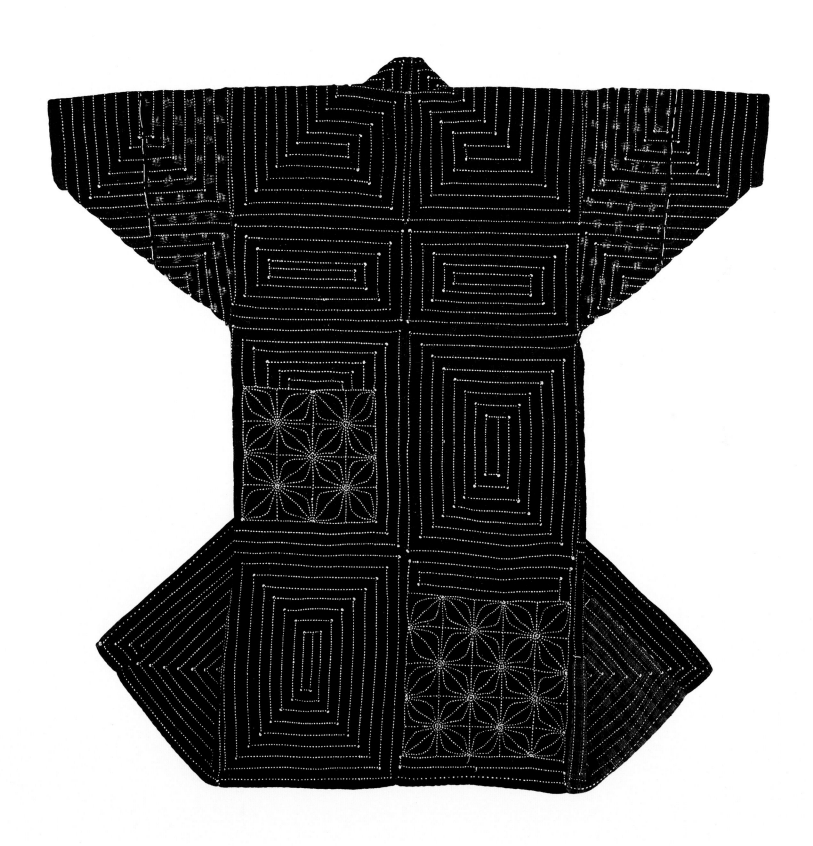

303. *Fireman's jacket (*hikeshi banten*)*
Cotton with a free-hand paste-resist
(*tsutsugaki*) design quilted in cotton
thread (*sashiko*)
82.5 x126.5 cm
Early Meiji period, late 19th century

304. *Robe (*basa-gin*)*
Okinawa Island (Ryūkyū)
Banana fibre (*bashō*), woven with
selectively resist-dyed yarns (*kasuri*)
116.2 × 111 cm
Meiji period - early Shōwa period,
late 19th-mid 20th century

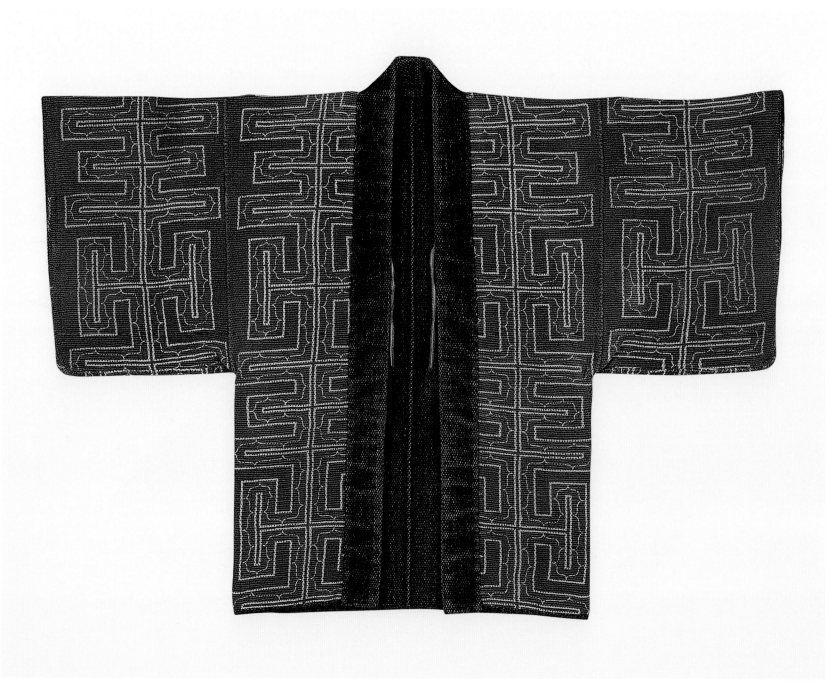

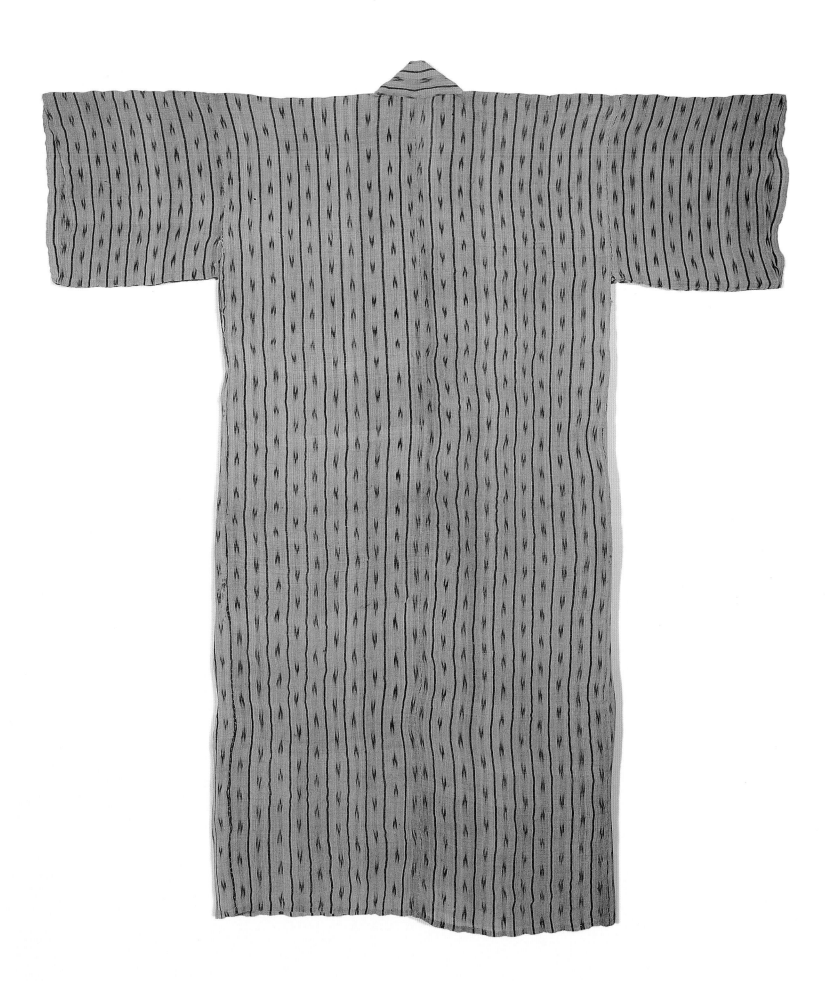

305. *Summer under*-kimono *(*nagajuban*)*
Bast fibre (*asa*), probably ramie,
with a stencilled paste-resist (*katazome*)
design of banana leaves
140 × 130.5 cm
Late Meiji period - early Shōwa period,
1st half of 20th century

306. *Quilt in* kimono *shape (*yogi*)*
Cotton with a free-hand paste-resist
(*tsutsugaki*) design of peonies, vine scrolls
and a crest
182 × 160.8 cm
Late Edo period - early Meiji period,
2nd half 19th century

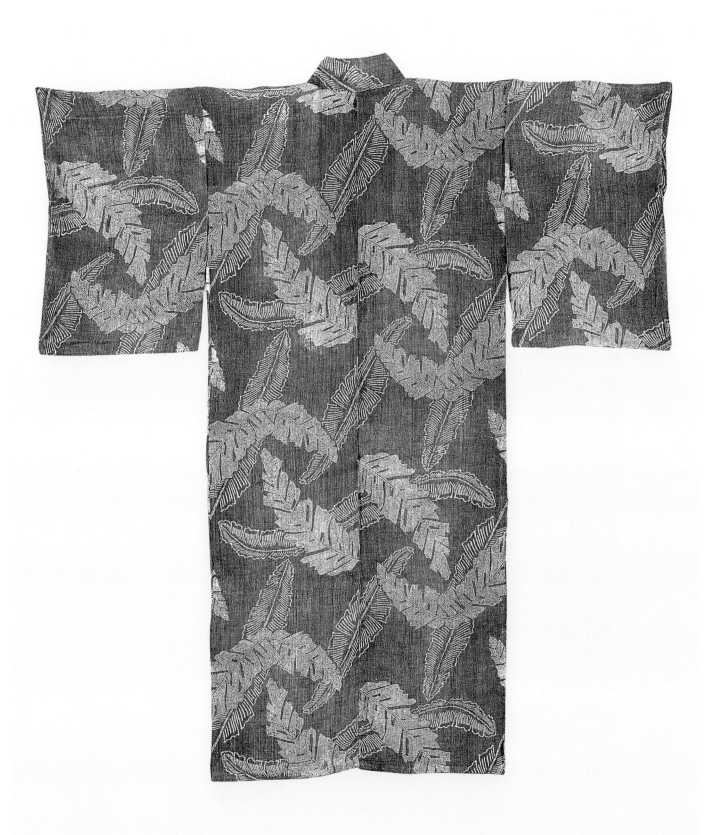

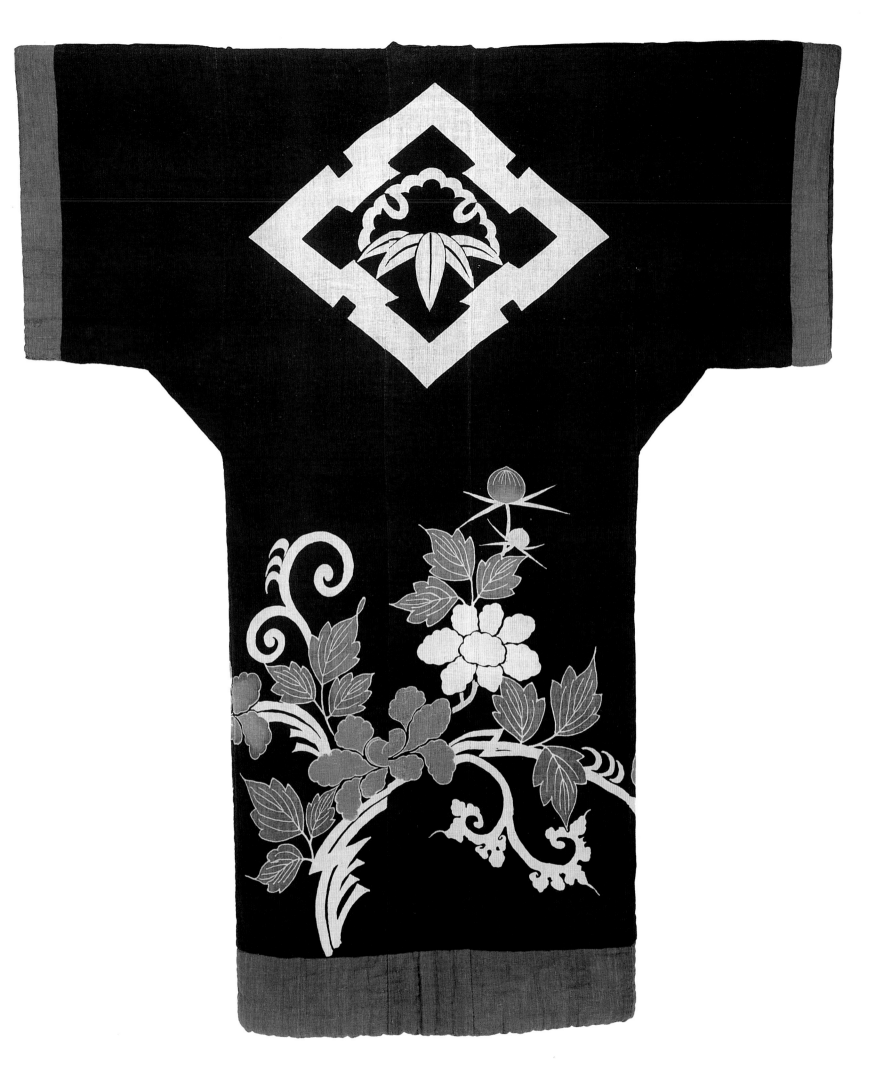

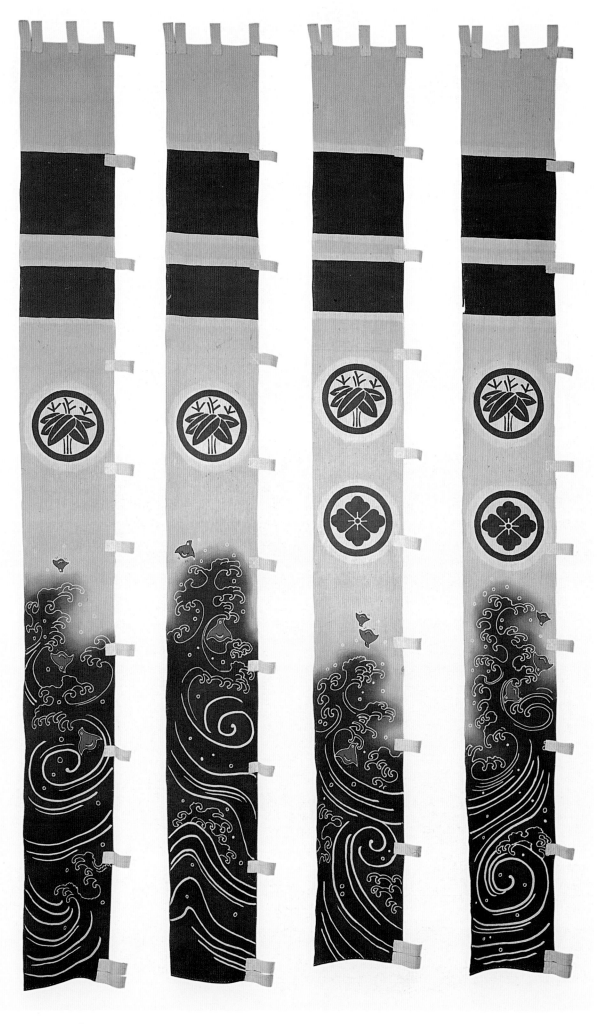

307. *Four banners (*nobori*)*
Cotton with a free-hand paste-resist
(*tsutsugaki*) and stencilled paste-resist
(*katazome*) design of plovers and waves
with crests
Each banner 339.5 × 35.6 cm
Meiji period, late 19th-early 20th century

308. *Fisherman's celebratory robe (*maiwai*)*
Bōsō Peninsula (Chiba Prefecture)
Cotton with a stencilled paste-resist
(*katezome*) design of a crane, tortoise,
pine, bamboo and plum with crane
and crest above
141 × 128.4 cm
Late Meiji - early Shōwa period,
1st half 20th century

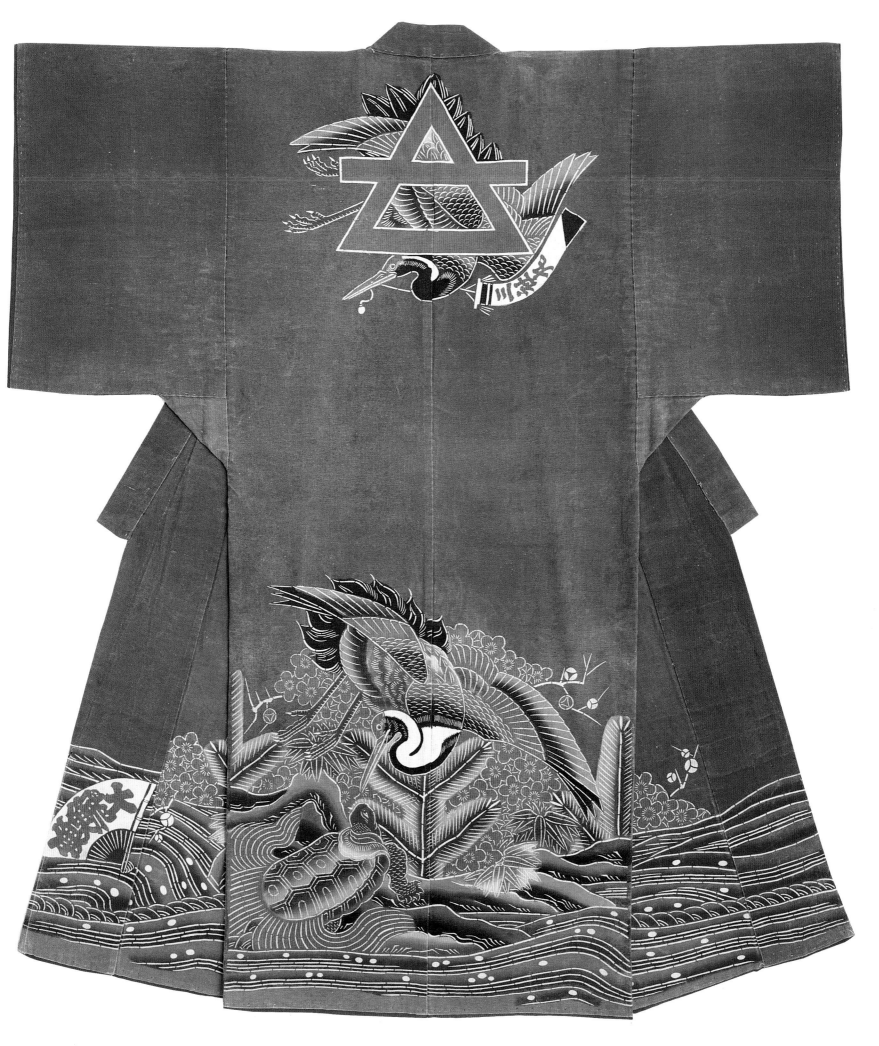

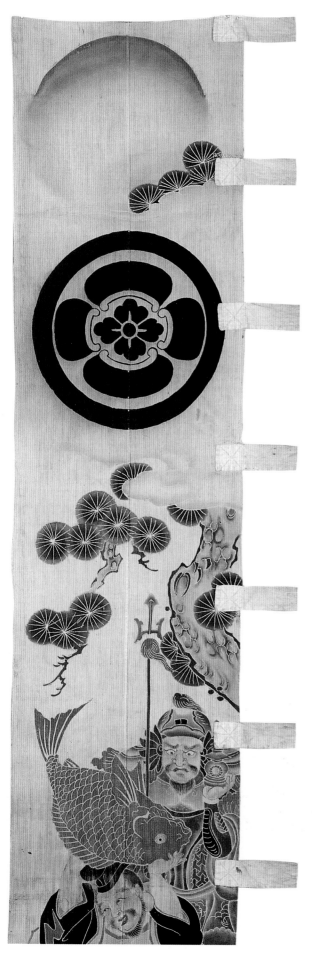
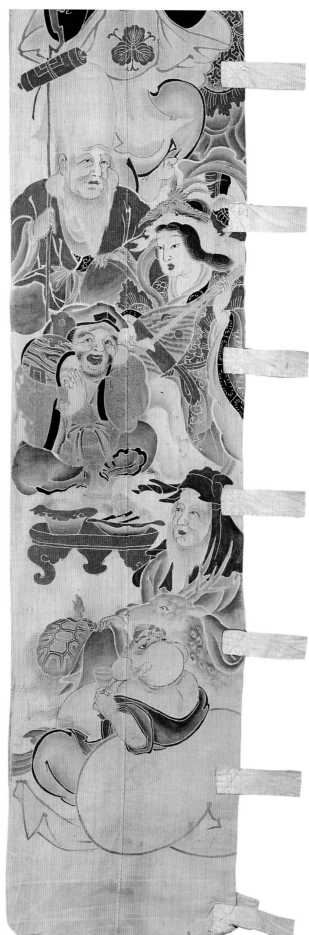

309 a-c. *Banner* (nobori)
Cotton with a free-hand paste-resist
(*tsutsugaki*) design of the Seven Gods
of Good Fortune
Approximately 620 × 51 cm
Late Edo period - early Meiji period,
19th century

310. *Festival under*-kimono (nagajuban)
Cotton with a free-hand paste-resist
(*tsutsugaki*) design of a dragon and
phoenix 'Yasuda Someshi' (Yasuda,
master dyer), in red pigment on lower
front right
128 × 138 cm
Late Meiji period - early Shōwa period,
1st half 20th century

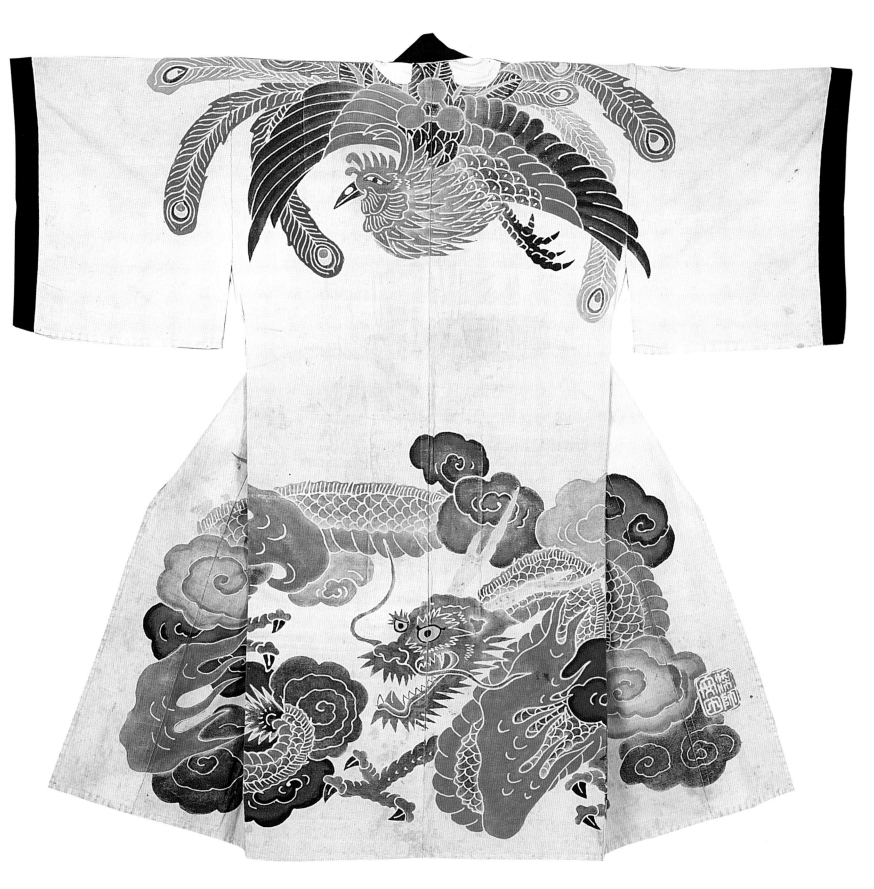

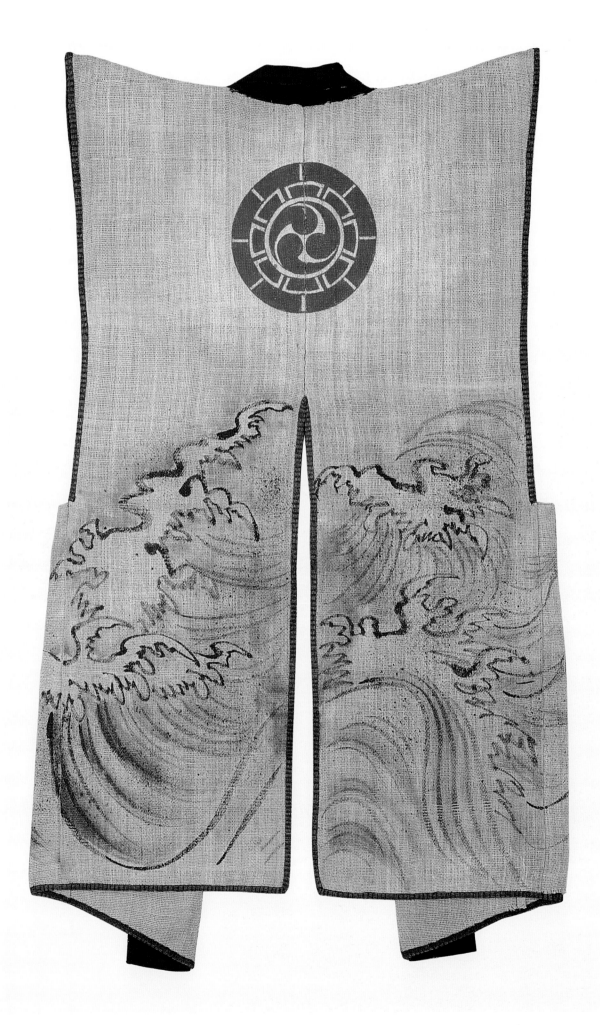

311. Samurai *surcoat (*jimbaori*)*
Bast fibre (*asa*), probably hemp, with
a hand painted design of waves
and a stencil dyed crest
77 × 48 cm
Edo period, 18th century

312a. *Fireman's jacket (*hikeshi banten*)*
Cotton with a free-hand paste-resist
(*tsutsugaki*) design of a Chinese lion,
peonies, rocks and waves quilted
in cotton thread (*sashiko*)
101 × 118 cm
Meiji period, late 19th-early 20th century

312b. *Fireman's hood (*zukin*)*
(Dragon)
Cotton with a free-hand paste-resist
(*tsutsugaki*) design of a dragon quilted
in cotton thread (*sashiko*)
58.5 × 77 cm
Meiji period, late 19th-early 20th century

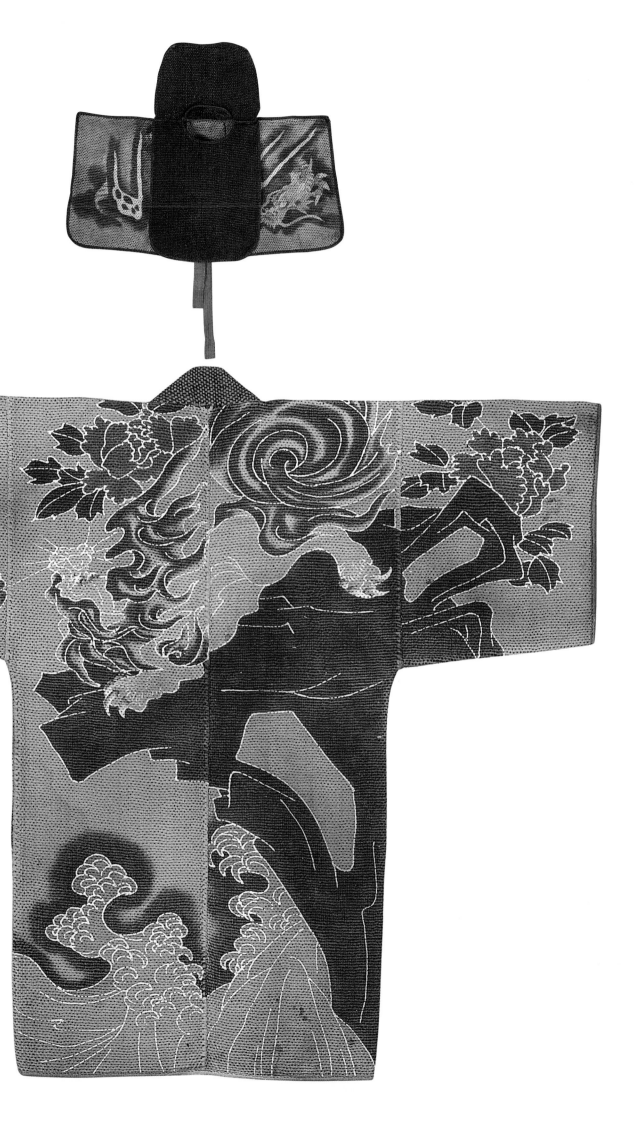

313. *Fireman's hood* (kawazukin)
Deerskin with paste-resist stencil
and smoked pattern (*inden*)
68 × 54 cm
Late Edo period - early Meiji period,
19ᵗʰ century

314 a-b. *Fireman's jacket* (kawabaori)
Deerskin with paste-resist stencil
and smoked pattern (*inden*)
102 × 136.5 cm
Late Edo period - early Meiji period,
19ᵗʰ century

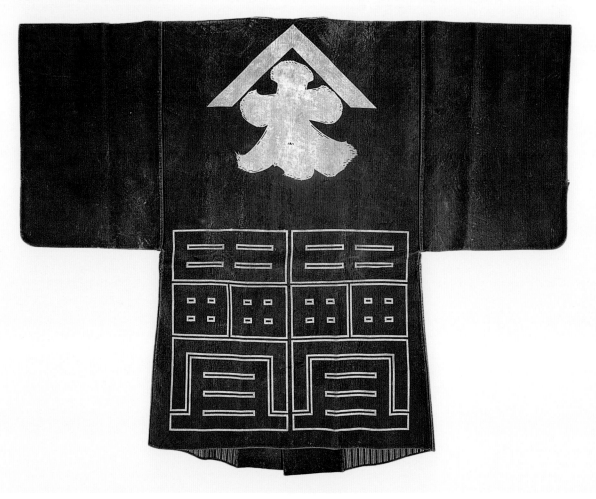

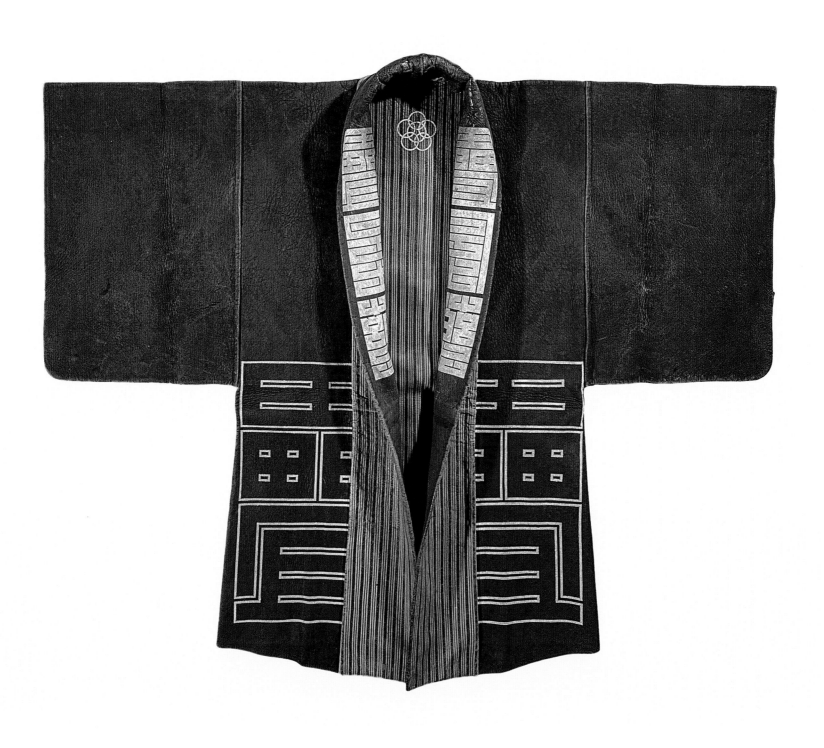

315. *Robe*
Hokkaidō
Striped cotton with cotton cloth appliqué
and cotton thread embroidery
122 × 125 cm
Late Edo period - Meiji period,
19th-early 20th century

316. *Robe*
Hokkaidō
Cotton with cotton thread embroidery
121 × 123 cm
Late Edo period - Meiji period,
19th-early 20th century

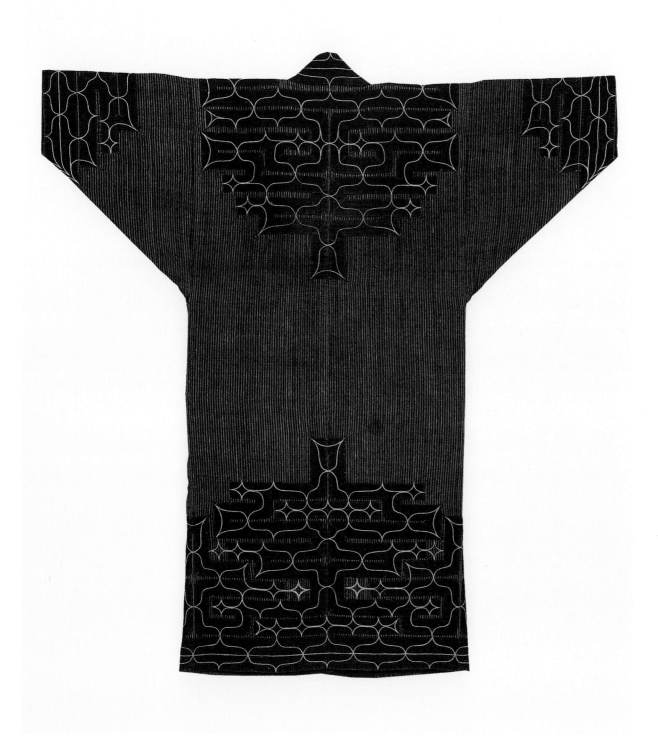

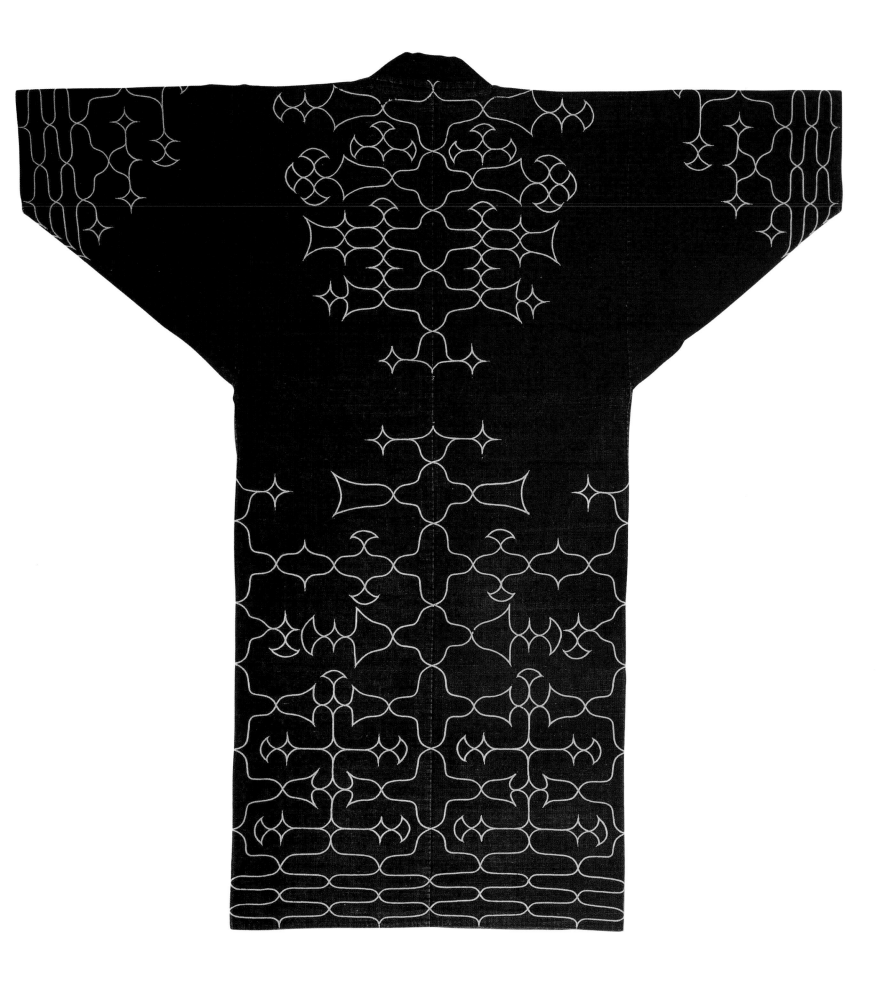

317. *Ceremonial robe (*attush*)*
Hokkaidō
Elm-bark fibre (*ohyō*) striped with cotton
with cotton cloth appliqué and cotton
thread embroidery, collar of cotton
quilted with cotton thread (*sashiko*)
126 × 166.5 cm
Late Edo period - Meiji period,
19th-early 20th century

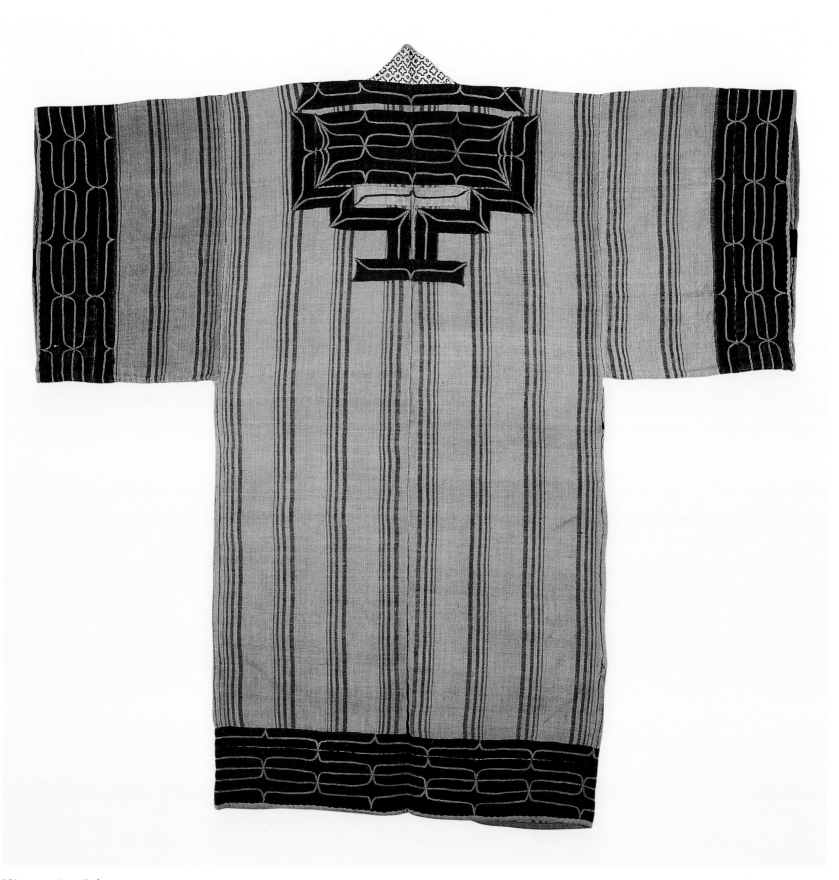

318. *Ceremonial robe (*attush*)*
Hokkaidō
Elm-bark fibre (*ohyō*) with cotton cloth
appliqué and cotton thread embroidery
117 × 130.5 cm
Late Edo period - Meiji period,
19ᵗʰ-early 20ᵗʰ century

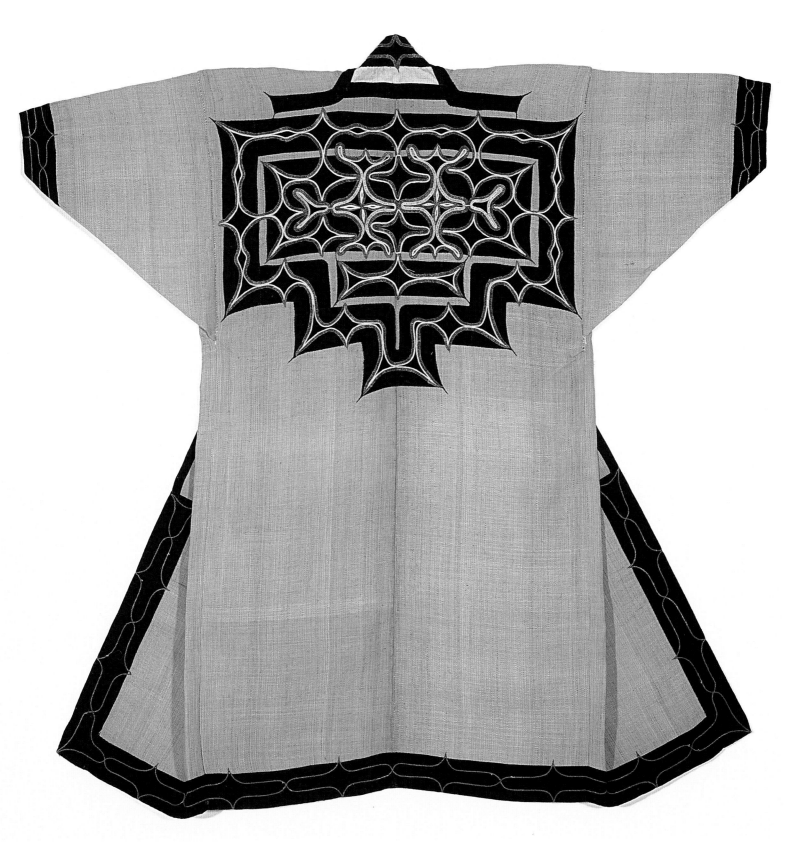

319. *Cape (*bōzukappa*)*
Cotton woven with selectively resist-dyed
yarns (*kasuri*) with paper interlining
100 × 243 cm
Late Edo period - early Meiji period,
19th century

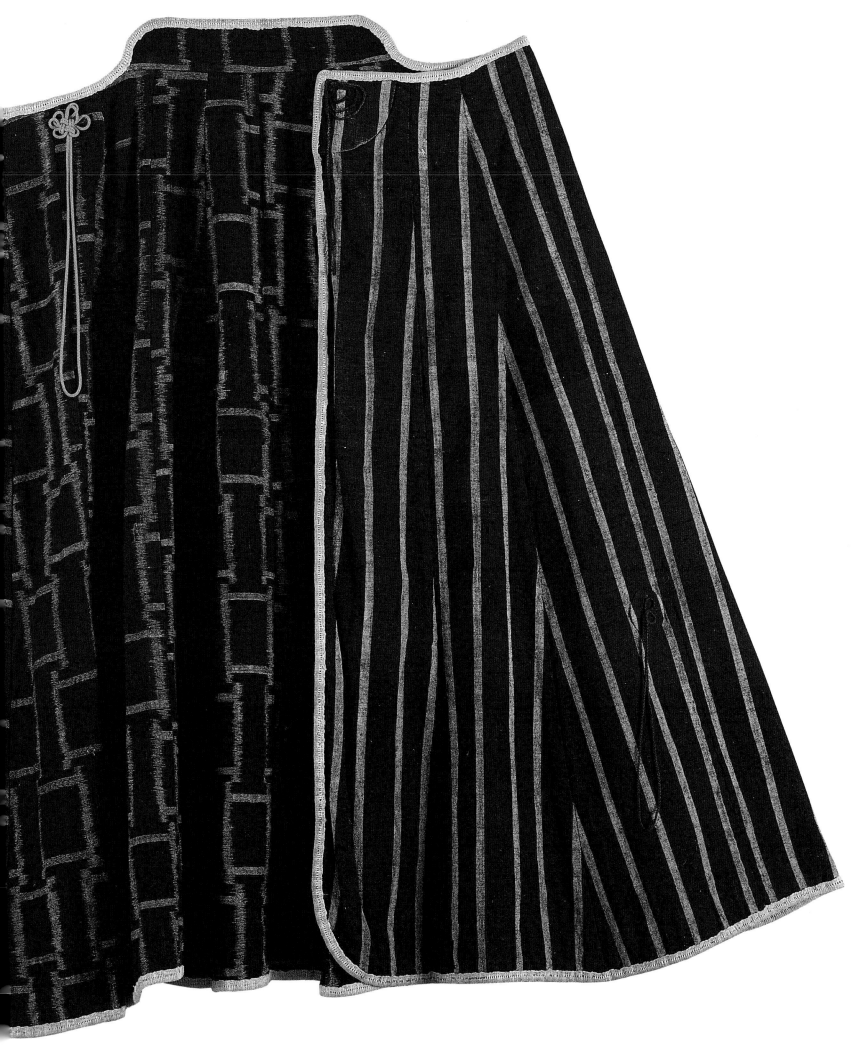

Annexes

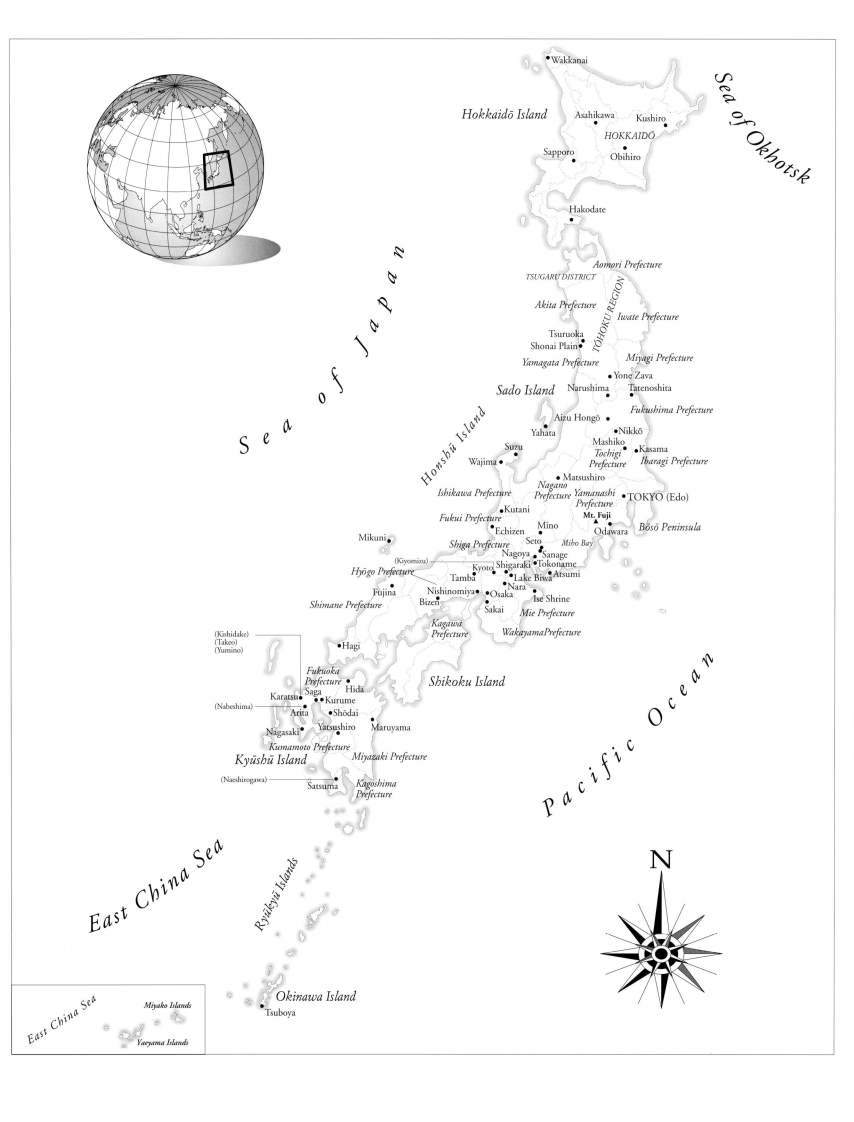

Wakkanai

Hokkaidō Island

Asahikawa Kushiro

HOKKAIDŌ

Sapporo Obihiro

Hakodate

Sea of Okhotsk

Aomori Prefecture

TSUGARU DISTRICT

Akita Prefecture

Iwate Prefecture

TŌHOKU REGION

Tsuruoka
Shonai Plain

Miyagi Prefecture

Yamagata Prefecture

Sado Island Narushima

Yone Zava
Tatenoshita

Fukushima Prefecture

Aizu Hongō

Yahata Nikkō

Mashiko
Tochigi
Prefecture Kasama

Suzu Ibaragi Prefecture

Honshū Island Wajima

Matsushiro
Nagano
Prefecture Yamanashi
Prefecture TOKYO (Edo)

Ishikawa Prefecture

Kutani
Fukui Prefecture Mino Mt. Fuji

Echizen Odawara Bōsō Peninsula

Seto
Mikuni Shiga Prefecture Sanage Miho Bay

Nagoya
(Kiyomizu) Shigaraki Tokoname
Hyōgo Prefecture Kyoto Atsumi

Tamba Lake Biwa

Nara
Fujina Nishinomiya Osaka Ise Shrine

Bizen Sakai Mie Prefecture

Shimane Prefecture

Kagawa
Prefecture Wakayama Prefecture

(Kishidake)
(Takeo) Hagi
(Yumino)

Shikoku Island

Fukuoka
Prefecture Hidā

Karatsu Saga
(Nabeshima) Kurume
Arita Shōdai

Nagasaki Yatsushiro Maruyama

Kumamoto Prefecture

Kyūshū Island Miyazaki Prefecture

(Naeshirogawa) Satsuma Kagoshima
Prefecture

Sea of Japan

East China Sea

Ryūkyū Islands

Pacific Ocean

N

East China Sea Miyako Islands

Yaeyama Islands

Okinawa Island

Tsuboya

Chronology

Jōmon Period	10,500-300 BC
Yayoi Period	300 BC-300 AD
Kofun Period	300-593
Asuka Period	593-710
Nara Period	710-794
Heian Period	794-1185
Kamakura Period	1185-1333
Nanbokuchō Period	1333-1392
Muromachi Period	1392-1568
Azuchi Momoyama	1568-1600
Edo Period	1600-1868
Meiji Period	1868-1912
Taishō Period	1912-1926
Shōwa Period	1926-1989
Heisei Period	1989-

Bibliography

Objects, Sculptures, Lacquerwares, Paintings, and Furniture

Arakawa, Hirokazu and Tokugawa Yoshinobu, *Ryūkyūs Shikkōgei* (Lacquerwares of the Ryūkyūs). Tokyo; Nihon Keizai Shimbunsha, 1977.

Art Gallery of Greater Victoria (ed.), 'Mingei, Folk Crafts of Japan', in *Collections of the Art Gallery of Greater Victoria*, no. 14. Victoria, B.C., Canada; Art Gallery of Greater Victoria, 1979.

Bauer, Helen and Sherwin Carlquist, *Japanese Festivals*. Tokyo; Charles E. Tuttle, 1965.

Brandon, Reiko and Barbara B. Stephan, *Spirit and Symbol, The Japanese New Year* (exhibition catalogue). Honolulu; Honolulu Academy of Arts, 1994.

Daitō, Shuppansha (ed.), *Japanese-English Buddhist Dictionary*. Tokyo; Daitō Shuppansha, 1991.

Dorson, Richard M., *Folk Legends of Japan*. Rutland, Vermont and Tokyo; Charles E. Tuttle, 1984.

Dowling, Judith, *Favorite Sons, Folk Images of Daikoku and Ebisu from the Jeffrey Montgomery Collection* (exhibition catalogue). Delray Beach, Fl.; The Morikami Museum and Japanese Gardens, 1998.

Earle, Joe (ed.), *Japanese Art and Design*. London; Victoria and Albert Museum, 1986.

Foissy-Aufrère, Marie-Pierre, *Mingei: Beauté Du Quotidien au Japon* (exhibition catalogue). Nice, France; Musée des Arts Asiatiques, 2000.

Furuto Kazuie, *et al.* (eds.), *The Shogun Age Exhibition from the Tokugawa Art Museum* (exhibition catalogue). Tokyo and Nagoya; The Shogun Age Exhi-

bition Executive Committee, 1983.

Gibney, Frank; Sneider, Lea and Levy, Dana, *Kanban: Shop Signs of Japan* (exhibition catalogue). New York; Japan Society and Weatherhill, 1983.

Guth, Christine, *Art of Edo Japan, The Artist and the City 1615-1868*. New York; Harry N. Abrams, 1996.

Hauge, Victor and Hauge, Takkoa, *Folk Traditions in Japanese Art* (exhibition catalogue). New York and Tokyo; Weatherhill, 1978.

Heineken, Ty and Heineken, Kiyoko, *Tansu: Traditional Japanese Cabinetry*. New York and Tokyo; Weatherhill, 1981.

Inagaki, Hisao, *A Glossary of Zen Terms*. Kyoto; Nagata Bunshodo and Ryūkoku University, 1991.

Iwao, Seiichi, *Biographical Dictionary of Japanese History*. Tokyo; Kodansha and International Society for Educational Information, 1978.

Japan Craft Forum (eds.), *Japan Crafts Sourcebook*. Tokyo, New York, London; Kōdansha International, 1996.

Japan Folk Crafts Museum (ed.), *Mingei, Masterpieces of Japanese Folkcraft*. Tokyo, New York, London; Kōdansha International, 1991.

Kakudo, Yoshiko, *The Art of Japan*. San Francisco; Chronicle Books and the Asian Art Museum, 1991.

Kindai Nihon Bijutsu Jiten (Dictionary of Modern Japanese Art). Tokyo; Kōdansha, 1981.

Kodansha. *Japan, An Illustrated Encyclopedia*. 2 vols. Tokyo and New York; Kōdansha International, 1993.

The Kojiki: Records of Ancient Matters. Translated by Basil Hall Chamberlain. Rutland, Vermont and Tokyo; Charles E. Tuttle, 1981.

Little, Stephen, *Visions of the Dharma, Japanese Buddhist Paintings and Prints in the Honolulu Academy of Arts*. Honolulu; The Honolulu Academy of Arts, 1991.

Moes, Robert and Gunhild; von Erdberg Avitable and Eleanor, *Japanese Folk Art: A Triumph of Simplicity* (exhibition catalogue). New York; Japan Society, 1992.

Moes, Robert and Stinchecum Amanda, *Mingei: Japanese Folk Art from the Montgomery collection* (exhibition catalogue). Alexandria, VA; Art Services International, 1995.

Moss, Robert. *Mingei, Japanese Folk Art from the Brooklyn Museum Collection*. New York; Universe Books, 1985.

Munsterberg, Hugo, *The Folk Arts of Japan*. Rutland, Vermont and Tokyo; Charles E. Tuttle, 1962.

Muraoka, Kageo and Okamura, Kichiemon, *Folk Arts and Crafts of Japan*. New York and Tokyo; Weatherhill and Heibonsha, 1981.

Murase, Miyeko, *Japanese Art: Selections from the Mary and Jackson Burke Collection*. New York; The Metropolitan Museum of Art, 1975.

Newland, Joseph N. (ed.), *Japanese Bamboo Baskets: Masterworks of Form and Texture from The Collection of Lloyd Cotsen*. Los Angeles; Cotsen Occasional Press, 1999.

Okada, Barbara Teri, *Symbol and Substance in Japanese Lacquer: Lacquer Boxes from the Collection of Elaine Ehrenkranz* (exhibition catalogue). New York and Tokyo; Weatherhill, 1995.

Rathbun, William Jay, *Yō no Bi: The Beauty of Japanese Folk Art* (exhibition catalogue). Seattle; Seattle Art

Museum and University of Washington Press, 1983.

Roberts, Laurance P., *A Dictionary of Japanese Artists*. New York and Tokyo; Weatherhill, 1990.

Saint-Gilles, Amaury, *Mingei, Japan's Enduring Folk Arts*. Rutland, Vermont and Tokyo; Charles E. Tuttle, 1989.

Sanders, E. Dale, *Mudra: A Study of Symbolic Gestures in Japanese Buddhist Sculpture*. Princeton, NJ; Princeton University Press, 1985.

Seckel, Dietrich, *The Art of Buddhism*. London; Methuen, 1964.

Shimizu, Yoshiaki (ed.) *Japan: The Shaping of Daimyō Culture 1185-1868* (exhibition catalogue). Washington, D.C.; National Gallery of Art, 1988.

Society of Friends of Eastern Art (ed.), *Index of Japanese Painters*. Rutland, Vermont and Tokyo; Charles E. Tuttle, 1973

Suntory Museum of Art, *The Collection of the Suntory Museum of Art, Life and Beauty/Form and Design for Feast* [sic] (exhibition catalogue). Tokyo; Suntory Museum of Art, 1999.

South Bank Centre London and The Japan Folk Crafts Museum, *The Woodblock and the Artist, The Life and Work of Shikō Munakata* (exhibition catalogue). Tokyo, New York, London; Kōdansha International, 1991.

Takeba, Toshio, *Ri Haku Shōden*. (Small biography of Li Po). Tokyo; Shinshōsha, 1995.

Tanaka, Yoshiyasu and Hoshiyama Shinya, *Me de Miru Butsuzō* (Looking at Buddhist sculptures) Serizu 5. Tokyo; Tokyo Bigaku (Tokyo Art University), 1987, pp. 115-119.

Tazawa, Yutaka, *Biographical Dictionary of Japanese Art*. Tokyo; Kōdansha and International Society for Educational Information, 1981.

Tokyo Bijutsu Company (eds.), *A Dictionary of Japanese Art Terms*. Tokyo; Tokyo Bijutsu Company, 1991.

Tokyo National Museum, *Tokubetsuten: Tōyō no shikkōgei* (special exhibition: lacquer arts of East Asia). Tokyo; Tokyo National Museum of Art, 1978.

Watt, James C.Y. and Barbara Brennan Ford, *East Asian Lacquer: The Florence and Herbert Irving Collection* (exhibition catalogue). New York; The Metropolitan Museum of Art, 1991.

Welch, Matthew, 'Ōtsu-e: Japanese Folk Paintings from the Harriet and Edson Spencer Collection', in *Orientations*, vol. 25, no. 10. Hong Kong; Orientations Magazine, 1994.

Yanagi Sōetsu, *The Unknown Craftsman: A Japanese Insight into Beauty*. Palo Alto, CA and Tokyo; Kōdansha International, 1972.

Yanagi Sōetsu (ed.), *A Thousand Cranes, Treasures of Japanese Art*. San Francisco; Chronicle Books, 1987.

Ceramics

Ayers, John, *et al.*, *Porcelain for Palaces: The Fashion for Japan in Europe, 1650-1750* (exhibition catalogue). London; Oriental Ceramic Society, 1990.

Baekeland, Frederick, *et al.*, *Modern Japanese Ceramics in American Collections* (exhibition catalogue). New York; Japan Society, 1993.

Barnes, Gina, *et al.*, *The Rise of a Great Tradition: Japanese Archaeological Ceramics from the Jōmon through Heian Periods (10,500 BC-AD 1185)* (exhibition catalogue). New York; Japan Society in association with the Agency for Cultural Affairs, Government of Japan, 1990.

Becker, Johanna, O.S.B., *Karatsu Ware: A Tradition of Diversity*. Tokyo, New York and San Francisco; Kōdansha International, 1986.

Cort, Louise, *Shigaraki, Potters' Valley*. Tokyo, New York and San Francisco; Kōdansha International, 1989.

Cort, Louise, *Japanese Collections in the Freer Gallery of Art: Seto and Mino Ceramics*. Washington, D.C.; Smithsonian Institution, 1992.

Faulkner, Rupert, *Japanese Studio Crafts: Tradition and the Avant-Garde*. London; Laurence King Publishing, 1995.

Impey, Oliver, *The Early Porcelain Kilns of Japan: Arita in the First Half of the Seventeenth Century*. Oxford; Clarendon Press, 1996.

Jenyns, Soame, *Japanese Porcelain*. London; Faber & Faber, 1965.

Jenyns, Soame, *Japanese Pottery*. London; Faber & Faber, 1971.

Leach, Bernard, *Hamada: Potter*. Tokyo, New York and San Francisco; Kōdansha International, 1975.

Mikami Tsugio, *The Art of Japanese Ceramics* (*Heibonsha Series of Japanese Art, vol. 29*). New York and Tokyo; Weatherhill/Heibonsha, 1972.

Mizuo Hiroshi, *Folk Kilns I* (*Famous Ceramics of Japan, vol. 3*). Tokyo, New York and San Francisco; Kōdansha International, 1981.

Moeran, Brian, *Lost Innocence: Folk Craft Potters of Onta, Japan*. Berkeley, Los Angeles and London; University of California Press, 1984.

Okamura Kichiemon, *Folk Kilns II* (*Famous Ceramics of Japan, vol. 4*). Tokyo, New York and San Francisco; Kōdansha International, 1981.

Rhodes, Daniel, *Tamba Pottery: The Timeless Art of a Japanese Village*. Tokyo, New York and San Francisco; Kōdansha International, 1970.

Sanders, Herbert, *The World of Japanese Ceramics*. Tokyo, New York and San Francisco; Kōdansha International, 1967.

Simpson, Penny, *et al.*, *The Japanese Pottery Handbook*. Tokyo, New York and London; Kōdansha International, 1979.

Wilson, Richard, *The Art of Ogata Kenzan: Persona and Production in Japanese Ceramics*. New York and Tokyo; Weatherhill, 1991.

Wilson, Richard, *Inside Japanese Ceramics: A Primer of Materials, Techniques, and Traditions*. New York and Tokyo; Weatherhill, 1995.

Masks

Addiss, Stephen (ed.), *Japanese ghost and demons: Art of the supernatural* (touring exhibition catalogue). New York; George Brazillier inc., in association with the Spencer Museum of Art, Kansas, 1985.

Averbuch, Irit, *The Gods come dancing: a study of the Japanese ritual dance of Yamabushi Kagura*. Cornell East Asia series, #79, 1995.

Baba, Akiko, *Oni no kenkyu (a study of the oni)*. Tokyo; San'ichi Shobo, 1971.

Blacker, Carmen, *The Catalpa Bow: A study in shamanistic practises in Japan*. George Allen & Unwin Ltd, 1975. (Reprinted by Curzon Press under the Japan Library imprint 1999).

'Bugaku Men', in *Nihon no Bijutsu*, # 62, 1972.

Dorson, Richard M., *Folk legends of Japan*. Charles E. Tuttle Co, 1962.

'Gigaku Men', in *Nihon no Bijutsu*, # 233, 1986.

'Gyōdō Men'. *Nihon no Bijutsu*, # 185, 1982, Hashimoto, Hiroyuki.

Hashimoto, Hiroyuki, 'Re-Creating and Re-Imagining Folk Performing Arts', in *Contemporary Japan Journal of Folklore Research*, 35(1), pp. 35-46, 1998.

Hoff, Frank, *Song, Dance, Storytelling – aspects of the performing arts in Japan*. Cornell University East Asia series, #15, 1978.

Honda, Yasuji and Tabaka, Yoshihiro, *Kagura Men (Kagura masks for Shintō shrine dances)*. Tankōsha, 1975.

Honda, Yasuji, *Zuroku Nihon no minzoku geinō (Illustrated account of Japanese folk arts and festivals)*. Asahi Shinbunsha, 1960.

Honda, Yasuji, *Nihon no matsuri to geinō*. Kinseisha, 1974.

Honda, Yasuji, 'Yamabushi Kagura and Bangaku: Performance in the Japanese Middle Ages and Contemporary Folk Performance', in *Educational Theatre Journal*, 26(2), pp. 192-208, 1974.

Honda, Yasuji, 'Yamabushi Kagura and Bangaku', in *Educational Theatre Journal*, 26(2), pp. 192-208.

Hori, Ichiro, *Mysterious Visitors from the Harvest to the New Year*, in Dorson, Richard (ed.), *Studies in Japanese Folklore*, pp. 76-103. New York; Arno Press, 1980.

Hori, Ichiro, *Folk Religion in Japan, Continuity and change*. Chicago; University of Chicago Press, 1968.

Hōryūji Treasures. Tokyo; Tokyo National Museum, 1990.

Inoura, Yoshinobu and Kawatake, Toshio, *The traditional theatre of Japan*. Weatherhill, 1981.

Irvine, Gregory, *Japanese masks: ritual and drama*, in Mack, John (ed.), *Masks: the art of expression*, pp. 129-149. London; British Museum Press, 1994.

Joly, Henri L., *Legend in Japanese Art*. Charles E. Tuttle Co., 1967 (first published Bodley Head, 1908).

Kobayashi, Kazushige, 'On the Meaning of Masked Dances in Kagura' in *Asian Folklore Studies*, 40(1), pp. 1-22.

Ko men no bi; shinkō to geinō (special exhibition: old masks, religion and performing arts). Kyoto; Kyoto National Museum, 1980.

Morse, Edward S., *Japanese homes and their surroundings*. London; Sampson Low, Marston, Searle and Rivington, 1886.

Nakamura, Yasuo, *Kamen*. Osaka, 1980.

Nishikawa, Kyōtaro (translated and adapted by Monica Beth), 'Bugaku masks', in *Japanese Arts Library*, no. 5. Kōdansha International, 1978.

'Nō/Kyōgen Men'. *Nihon no Bijutsu*, #108, 1976.

Noma, Seiroku, *Masks, Arts and Crafts of Japan #1*. Tokyo; Charles E. Tuttle, Vermont & Tokyo with Kōdansha, 1957.

Perzynski, Friedrich, *Japanische Masken*. Berlin; Walter de Gruyter, 1925.

Piggott, Juliet, *Japanese mythology*. Hamlyn Publishing Group, 1969.

A Reappraisal of Folk Performing Arts: From Ritual to Entertainment, from Entertainment to Ritual, in *Papers from the International Symposium on East Asian Folklore and Performing Arts*. Tokyo; Waseda University, pp. 249-257, 1995.

Sakurai, Haruo, 'The Symbolism of the Shishi Performance as a Community Ritual: The Okashira Shinji in Ise', in *Japanese Journal of Religious Studies*, 15(2-3), 1988, pp. 137-153.

Shishi Gashira. Edited and published by the Shishikaikan, Hida Takayama, 1995.

Smith, R.G., *Ancient Tales and Folklore of Japan*, A & C Black, 1908.

Thornbury, Barbara E., *The folk performing arts: traditional culture in contemporary Japan*. Albany; State University of New York Press, 1997.

de Visser, M.W., *The fox and badger in Japanese superstition*. Transactions of the Asiatic Society of Japan, vol. 36, 1908-1909.

de Visser, M.W., *The Tengu*. Transactions of the Asiatic Society of Japan, vol. 36, 1908-1909.

Metalwork

Arts, PLW, *Tetsubin: a Japanese water-kettle*. Groningen; Geldermalsen Publications, 1988.

Bird, Isabella L., *Unbeaten tracks in Japan: An Account of Travels in the Interior, including Visits to the Aborigines of Yezo and the Shrines of Nikko and Ise*. London; J. Murray, 1885 edition.

Fujioka, Ryōichi, 'Tea Ceremony Utensils', in *Arts of Japan*, no. 3, Weatherhill, 1973.

Hayashi Kakichi, Nishitsunoi Masahiro, *Nihon no minzoku geinō*. Ie no Hikari Kyokai, 1979.

Mingei: two centuries of Japanese folk craft (catalogue for a touring exhibition of the USA). Edited, produced and published by the International Programmes Department, The Japan Folk Crafts Museum, 1995.

Muraoka, Kageo and Kichiemon Okamura, 'Folk Arts and Crafts of Japan', in *Heibonsha Survey of Japanese Art*, no. 26. Weatherhill, 1973.

Nihon no Kinkō. Catalogue of the Tokyo National Museum, 1983.

Suzuki, Mitsuru, *Minka*, in *Kodansha Encyclopaedia of Japan*, pp. 192-194, 1983.

Textiles

Gensho, Sasakura, *Tsutsugaki Textile of Japan: Traditional Freehand Paste Resist Indigo Deyeing Technique of Auspicious Motifs*. Kyoto; Shikōsha, 1987.

Hauge Victor and Takako, *Folk Tradition in Japanese Art*. Tokyo; Kōdansha International, 1978.

Jackson, Anna, *Japanese Country Textiles*. London-New York; V&A and Weatherhill, 1997.

Jackson, Anna, *Japanese Textiles in the Victoria and Albert Museum*. London; V&A, 2001.

Jun, Tomita and Noriki, Tomita, *Japanese Ikat Weaving*. London; Rutledge & Kegan Paul, 1982.

Kenji, Kaneko, *Katazome and Chūgata*. Kyoto; Kyoto Shoin, 1994.

Kichiemon, Okamura, *Japanese Ikat*. Kyoto; Kyoto Shoin, 1993.

Kichiemon, Okamura, *The Clothes of the Ainu People*. Kyoto; Kyoto Shoin, 1993.

Kiyoko, Ogikubo, *Kogin and Sashiko Stitch*. Kyoto; Kyoto Shoin, 1993.

Milgram, Lynne, *Narratives in Cloth: Embroidered Textiles from Aomori, Japan*. Toronto; The Museum of Textiles, 1993.

Mingeikan, Nihon, *Mingei: Masterpieces of Japanese Folkcraft*. Tokyo-New York; Kōdansha International, 1991.

Mochinaga Brandon, Reiko, *Country Textiles of Japan: The Art of Tsutsugaki*. New York; Weatherhill, 1973.

Mochinaga Brandon, Reiko and Stephan, Barbara B., *Textile Arto of Okinawa*. Honolulu; Honolulu Academy of Arts, 1990.

Moes, Robert; Avitabile, Gunhild; von Erdberg, Eleanor, *Japanese Folk Art: A Triumph of Simplicity*. New York; Japan Society, 1993.

Moes, Robert and Mayer Stichecum, Amanda, *Mingei: Japanese GFolk Art from the Montgomery Collection*. Alexandria, VA; Art Services International, 1995.

Mustenberg, Hugo, *Mi,gei: Folks Art of Old Japan*. New York; Asia House Gallery, 1965.

Ōshiro, Sosei and Ashime, Kanemasa, *Okinawa Bijustu Zenshū (The Art of Okinawa)*, vol. 3, *Senshoku (Textiles)*. Okinawa; Okinawa Times, 1989.

Rathbun, William Jay, *Beyond the Tanabata Bridge: Traditional Japanese Textiles*. New York; Thames & Hudson in association with the Seattle Art Museum, 1993.

Sachio, Yoshioka, *Sarasa, printed and painted textiles*. Kyoto; Kyoto Shoin, 1993.

Sachio, Yoshioka, *Tsutsugaki Textiles*. Kyoto; Kyoto Shoin, 1994.

Shaver, Cynthia; Miyamoto, Noriko and Yoshioka, Sachio, *Hanten and Happi - Traditional Japanese Work Coast: Bold Designs and Colourful Images (The Sumi Collection)*. Kyoto; Shikōsha, 1998.

Yoshida, Shin-Ichiro and Williams, Dai, *Riches From Rags: Saki-Ori and other Recycling Traditions in Japanese Rural Clothing*. San Francisco; San Francisco Craft and Folk Art Museum, 1994.

Glossary

Ariake andon
Literally, 'dawn light.' Wooden oil lamp with removable paper shade. Often kept lit throughout the night.

Ashitsuki tarai
Footed wash basin.

Atazome
Textiles produced by the dyeing of pre-woven fabric (compared with *sakizome*).

Bashō
Banana fibre. Used to weave cloth in the Ryūkyūan Islands.

Bast fibre (*asa*)
Fibres extracted from the phloem, the tissue that conducts the sap, located in the inner bark of the stems of dicotyledonous plants. These include hemp, ramie, elm-bark fibre and banana fibre, although the latter is actually a leaf fibre rather than a stem fibre.

Bengara
Iron oxide, a red-brown pigment.

Benigara
Lacquering technique in which lacquer is applied to red hot iron. In the cooling process, the lacquer fuses with the iron, creating a durable black protective surface. Technique created by furniture craftsmen of Tsuruoka (Yamagata Prefecture) and used on cabinet hardware.

Beshimi
'*Compressed lips*' form of demon mask.

Bingata
Colourful resist-dyed fabric produced in Okinawa.

Bishamonten (God of War)
A Japanese deity of good fortune.

One of the Seven Lucky Gods (*shichifukujin*).

Bosatsu (Bodhisattva)
Compassionate divine being who has postponed his or her own enlightenment in order to save mankind.

Bugaku
Form of dance accompanied by music which is traditionally performed at court and at shrines and temples.

Bunko
Stationary box.

Bunraku
Japanese style of puppet theatre that originated 500 years ago on Awaji Island (as *ningyō joruri*).

Busshi
Professional Buddhist sculptor.

Butsudan
Literally, 'Buddha's (or Buddhist) shelf.' Family altar used in the home. Usually holds a statue of a Buddhist deity, (or deities) and photos of deceased members of the family. Daily offerings of food and incense are made to the deity.

Casting
Creation of an object by shaping it in a mould; in the case of ironwork a wax mould is usually created which is then heated to lose the wax (lost-wax technique) and molten iron then poured into the void left by the wax.

Chō-bako
Portable chest used by merchants at sea to store ledger books.

Chō-dansu
Small cabinet used by merchants to store ledger books, paper, writing implements, and money.

Chōshi
Saké ewer made of metal, ceramic, or wood. Used for ceremonial occasions.

Coil-building
Forming process in which coils of clay are placed on top of each other and pinched together, usually followed by beating with a paddle and/or scraping and smoothing.

Daikoku (Daikoku-ten; God of Wealth)
Deity of good fortune. One of the Seven Lucky Gods (*shichifukujin*). Also associated with the Shintō deity, Ōkuninushi no Mikoto. Originated as the Indian Tantric (Buddhist) deity, Mahakala. Worshipped in some parts of Japan as Ta no Kami (god of the rice field). Popularly worshipped as a 'kitchen deity' (*kamado kami*) with Ebisu (see *kamidana*).

Daruma (Bodhaidaruma)
Patriarch of Zen Buddhism.

Datsueba
One of the Ten Kings of the World of the Dead (*ju-ō*). Assistant to Emma-ō, supreme arbiter of The World of the Dead.

Dengaku
A type of religious performance derived from rice planting and harvesting rituals.

Doro-e
Literally, 'mud picture.' Genre of painting that first emerged in the eighteenth century. Executed with a think opaque medium made with pigments and ground shell. There are two distinct styles:

Kamigata style (Kansai area), and Nagasaki style (Kyūshū).

Dyes & pigments
Used to colour cloth. Dyes are soluble in water and penetrate the fibres of the fabric, while pigments are insoluble and adhere to the surface. The dyes used in traditional Japanese textiles are generally extracted from vegetable sources and the pigments derive from minerals.

Earthenware
Ceramic with unvitrified and water-permeable body made from clay fired to between 800 and 1100 degrees Celsius.

Ebisu (God of Merchants)
Indigenous Japanese deity of good fortune and patron saint of merchants, fishermen, and farmers. One of the Seven Lucky Gods (*shichifukujin*). Son of two Shintō deities, Izanagi no Mikoto and Izanami no Mikoto. Believed to be a 'drifted deity' (*hyōchakujin*) because he was found (as an infant) drifting in the sea. Received his name from the man who found him, Ebisu Saburō. Worshipped in some parts of Japan as Ta no Kami (god of the rice field). Popularly worshipped as a 'kitchen deity' (*kamado kami*) with Daikoku (see *kamidana*).

Edo-e
Literally, 'pictures of Edo.' Edo period genre of popular, inexpensive paintings and prints that depict scenes in and around the city of Edo (present-day: Tokyo).

Ema
Literally, 'horse pictures.' Small votive plaques. The first *ema* plaques (eleventh century) had images of horses, considered an auspicious animal in the Shintō religion, painted on them. Eventually, various subjects were included on *ema* plaques, including historical heroes and the auspicious animal of the new year (see *jūnishi*).

Embossing
A design raised above the surface of an object.

Engi mono
Literally, 'auspicious object.'

Engraving
Design drawn into the surface of an object with a sharp tool.

Forging
Fashioning an object into shape by heating and hammering.

Fukurokuju (God of Longevity)
Also called Jurōjin. Japanese deity of good fortune. One of the Seven Lucky Gods (*shichifukujin*).

Fukusuke
Popular, auspicious, big-headed, dwarf-like shop talisman.

Funa-dansu
Literally, 'ship chest.' Portable chest used by merchants and crew members while travelling by ship. *Funa-dansu* chests included money safes and ledger boxes (see *chō-bako*).

Gashira
Literally the 'head'; used with the honorific prefix Ō in reference to specific types of *shishi* masks.

Gesso
(See *Gofun*).

Gigaku
Ancient form of masked drama imported into Japan from mainland Asia around the sixth century AD.

Gilding
The application of a thin, bright metallic surface material to an object generally by means of a chemical process.

Glaze
Ceramic material prepared as a liquid suspension and applied to the surface of a pot; melts to form a glassy covering when fired; colour dependent on the presence of metal oxides.

Gofun
A type of chalk (or plaster of Paris) 'wash' used as an undercoat in the final decoration of a mask.

Gorintō (*gorin sotoba*)
A five-tiered, geometric, stone sculpture used as a funerary monument in Japan. An aniconic symbol of the Buddha.

Gosho ningyō
Literally, 'palace doll.'

Gyōdō
Temple procession which employs large masks to represent various Buddhist deities.

Haru Koma festival
A New year festival involving a type of hobby-horse and a man wearing a *Hyottoko*-style mask.

Hina ningyō
Dolls displayed on Girls Day (*hina matsuri*), celebrated each year on the 3rd of March.

Hinoki
Cypress wood.

Hiuchi-bako
Tinder box with striker used to start a fire.

Hotei (God of Happiness)
Deity of good fortune. One of the Seven Lucky Gods (*shichifukujin*). Believed to be the sixth-century itinerant Chinese monk, Pu Tai Ho Shang.

Hyakufuku-kai
Literally, 'meeting of one hundred fortunes.' Genre of painting that features Okame, the Goddess of Mirth, as Otafuku (see *Okame*).

Hyōtan
Large hour glass-shaped calabash gourd used as a saké container.

Inden
Smoking process used to pattern leather.

Indigo
Blue dye derived from plants containing indican (*ai*) a water soluble colourless substance that turns blue when exposed to oxygen.

Inlay
Metal inserted into cuts or grooves in the surface of another metal object.

Inome
'Boar's eye': so named because of its apparent similarity to the creature's eye.

Irori
Large, pit-like hearth located in the interior room of traditional Japanese home.

Ishime
A type of metal finish usually done with special chisels to produce an effect like that of rough stone.

Ishō kasane-dansu
Literally 'stacked garment chest.' Made in pairs and stacked one on top of the other. Made to order by the parent's of a betrothed daughter.

Itajime
Kasuri technique that involves the clamping of yarn between two boards carved with the desired image.

Ittō bori
Literally, 'single-chisel carving.' Technique of carving popularly used for folk toys.

Jizai kagi
Apparatus used to hang pots over *irori* hearth.

Jizai-gake
Large wooden hanger for *jizai kagi*. There are two distinct styles:

Daikoku type and Ebisu type, thus named after these deities' hat styles.

Jizō Bosatsu
Buddhist deity of infinite compassion and mercy (see *Bosatsu*).

Jōfu
Literally 'high quality cloth', the term is used to describe bast fibre, often ramie, that is suitable for summer wear.

Jū-bako
Stacked lunch box.

Jūnishi
Twelve animals of the ancient Chinese zodiac: rat, oxen, tiger, hare, dragon, snake, horse, sheep, monkey, rooster, dog and boar.

Kagawa shikki
Lacquering technique that originated in the early nineteenth century in the town of Takamatsu (Kagawa Prefecture, Shikoku Island). Distinguished by its use of polychrome lacquer designs arranged in concentric circles on round trays, bowls, tea caddies, etc. Also called '*sanuki nuri*' after the former name of the province.

Kagura
Literally 'music of the Gods'; a type of performance or ritual of Shintō origin. There are basically two types: *Mikagura* (performed at court) and *Sato-kagura* (performed away from court and in which there other sub-divisions).

Kaidan-dansu
Literally, 'step chest.' Set of stairs made with drawers.

Kakazome
Stencil paste-resist. A technique by which rice paste is applied to fabric through stencils. The dyes do not penetrate the pasted areas.

Kama
Large cauldron made of iron or brass, usually with flanged bottom, made for Japanese kitchen stove.

Kami
Shintō deities that encompass animate and inanimate elements, and ancestral and deified spirits of the deceased.

Kamidana
Literally, 'shelf for gods.' Shelf (often in the kitchen) that holds images of auspicious folk characters, such as Daikoku and Ebisu.

Kanban
Shop sign.

Kasuri
A technique that involves the binding of various sections of the yarn before it is dyed. The colours does not penetrate the protected areas creating a yarn that is partly coloured a partly white. The yarn is then used as the warp and/or weft and pattern emerges as the cloth is woven.

Katakuchi
Literally, 'mouth-shaped.' Large, footed, red-lacquered bowl used as a saké ewer for ceremonial occassions.

Keyaki
Zelkova wood.

Khaki
Persimmon wood.

Kichijōten (Goddess of Happiness)
Deity of good fortune. One of the Seven Lucky Gods (*shichifukujin*).

Kijiro
Lacquering technique used on furniture, creating a reddish honey-coloured surface. Concentrated form of lacquer used.

Kinuta
Fulling block and mallet used to soften Japanese linen (*asa*).

Kiō (sekiō)
Arsenic trisulphide, a bright yellow pigment.

Kiri
Paulownia wood.

Kirifuse
Meaning to 'cut and lay down', an appliqué method used in Ainu textiles.

Kishin
Demonic deity.

Kishingyo-ten
Buddhist guardian deity of the World of the Dead.

Kogin
Counted stitch embroidery, a technique used in the Tsugura district of Aomori, the northern-most part of Honshū.

Koma inu
Literally, 'Korean dog.' Guardian lion-dogs often seen at the entrance to Shintō shrine grounds. Sometimes called '*kara shishi*' (Chinese Tang lion).

Kone-bachi
Kneading basin used to prepare wheat and rice dough for noodles.

Kuruma-dansu
Literally, 'wheeled chest.'

Kyōgen
A type of light-hearted performance (not always masked) with similar roots to the Nō theatre.

Lug
A protruding handle or loop.

Magarikane
The curved side-pieces either side of the hilt of special types of swords dedicated to Amaterasu Omikami since the Nara period.

Machi eshi
Literally, 'town artist.' Self-taught artists who created inexpensive paintings and prints for the popular market in the Edo period.

Mame-doshi
Woven bamboo sieve used to clean beans.

Maneki-neko
Literally, 'beckoning cat.' Auspicious figurine of cat used by shopkeepers as a talisman. One paw raised in beckoning gesture.

Men
'Face' or 'mask'.

Mikage ishi
Granite stone used for Buddhist sculptures.

Minka
Japanese thatched roof farmhouse.

Mitate-e
Literally, 'parody picture.'

Mitsuda-e
Genre of painting done with a lead oxide-based oil paint (*mitsudasō*) made with mineral pigments and perilla oil.

Mizuya
Large cabinet used to store dishes and other food-related utensils. Made in two parts and stacked one on top of the other.

Mokugyo
Large wooden drum used during Buddhist meditation sessions.

Mushiro
A simple straw mat.

Nagamochi kuruma-dansu
Large storage trunk on wheels.

Nara
Oak wood.

Negoro-nuri
Lacquering technique that originated in the thirteenth century at the Negoro Temple (Wakayama Prefecture). Distinguished by a layer of red lacquer over black lacquer. In time, the red wears away, revealing the black layer of lacquer underneath.

Ningyō
Doll (literally: human figure).

Nō
Ritualised form of drama (usually masked) which derives from earlier *Dengaku* and *Sarugaku* performances.

Nunome zōgan
A from of inlay where the surface is cut and metal is pressed in to form a textile-like pattern.

Nyoi
Buddhist symbol of a wish-granting jewel. Sometimes called 'flaming jewel.'

Nyoirin Kannon Bosatsu
Buddhist deity of compassion, often shown with six arms. Received its name from two attributes: 'flaming jewel' (*nyoi*) and Buddhist 'Wheel of Law' (*rin*).

Ōda
Iron hydroxide, a dull yellow pigment.

Ohariya
Needle shops established in Japanese villages, and open only in the winter months, to teach sewing and other practical skills to young women.

Ohyō
Elm-bark fibre used by Ainu in the making of robes.

Okame (Goddess of Mirth)
Japanese folk character depicted as a jolly, plump, middle-aged rural woman. Capable of assuming various identities, including Ofuku, Otafuku and Ota Gozen. Associated with the Shintō deity, Ama no Uzume no Mikoto.

Oki-niku
Meaning 'placing and sewing', an embroidery technique used in Ainu textiles.

Omocha
Toy. Many *omocha* are considered auspicious (see *engi-mono*).

Oni
Demon, or devil. Popular Japanese monster-like creature who often appears in folktales, legends and proverbs.

Oni no nembutsu
Literally, 'the devil's invocation.' Favorite painting subject among Ōtsu-e artists (see *Ōtsu-e*).

Otafuku
Name given to a type of round *chagama* which has been likened to Otafuku (Okame) the plump village beauty (see *Okame*).

Ōtsu-e (Oiwake-e)
Literally, 'pictures of Ōtsu.' Genre of painting (and prints) created by self-taught artists living in the town of Ōtsu. Inexpensive paintings and prints sold to travellers and religious pilgrims travelling along the Tokaidō highway in the Edo period.

Overglaze
Ceramic decoration, usually painted and often involving the use of enamels, applied over the glaze after the high temperature firing; fused on by means of one or more lower temperature firing(s).

Oxidation
Firing technique in which sufficient air is allowed into the kiln for complete combustion of the fuel; the chemically reactive parts of the ceramic material emerge from the firing in an oxidized state.

Oxide
A compound of oxygen with another element.

Patination
A technique to induce a change in the surface of an object often to give the appearance of age and use.

Paulownia
Paulownia tomentosa; deciduous tree of the family *Scrophulariaceae* widely planted in various parts of Japan; *kiri* in Japanese.

Porcelain
Ceramic with translucent, white, vitrified and water-impermeable body whose main ingredients are kaolin and feldspar fired to between 1250 and 1350 degrees Celsius.

Raden
Mother-of-pearl inlay.

Ramma
Transom.

Reduction
Firing technique in which the flow of air into the kiln is restricted; the burning fuel draws chemically bonded oxygen from the chemically reactive parts of the ceramic material, leaving them in a reduced state.

Resist
Decorative technique in which an organic material that burns off during firing is used to protect areas of a pot from subsequent applications of ceramic material.

Resist-dyeing
General term used to describe a technique whereby parts of the yarn or cloth is protected to prevent the penetration of colour during dyeing. *Kasuri, katazome, tsutsugaki* and *rōketsu-zome* are all examples of resist-dyeing.

Rōketsu-zome
Resist-dyeing method that employs wax (rather than rice paste).

Rosoku tate
Candlestick.

Ryūkyū
Independent kingdom founded in 1429 that ruled over 55 islands stretching from the tip of Japan's Kyūshū island to Taiwan. Annexed by Japan in 1872. Name changed to Okinawa in 1879.

Sahari
An alloy of tin, lead and copper.

Sakizome
Textiles produced by the weaving of pre-dyed yarns (compared with *atazome*).

Samurai
'One who serves': the military class which evolved from Heian period imperial guards into a unique military aristocracy.

Sand casting
A method of casting in which a mould is made by packing layers of very fine damp sand around an original pattern.

Sanmen Daikoku
Literally, 'three-faced' Daikoku. Manifestation of Daikoku that incorporates Benzaiten and Bishamon. Associated with the Tendai Buddhist sect (see *Daikoku*).

Sarasa
Japanese term for the wax-resist or block printed textiles of South-East Asia. Also used to describe Japanese textiles inspired by these examples.

Sarugaku
A lively art form brought over from China (which included juggling and acrobatics in its repertoire) which combined with Dengaku to create the Nō theatre.

Sashiko
Stitching technique whereby layers of cloth are quilted together with running stitch.

Sato Kagura
(See *Kagura*).

Shin chagama
The orthodox or 'true' form of *chagama* since the Kamakura period.

Shinchū
A form of brass, an alloy of copper.

Shintō
Indigenous Japanese religion based on ancient, animistic beliefs.

Shōchikubai
Literally, 'pine, plum, bamboo.' Auspicious symbol of felicity, longevity, and good luck. Called 'three friends of winter.' Often appear together as a decorative motif on Japanese lacquerware, textiles, etc.

Shoi kago
Pannier used for small loads. Made of woven strips of bamboo, birch or cherry bark.

Shu
Mercuric sulphide, a bright red pigment.

Shuchū
Saké ewer used for celebratory events.

Shunkei nuri
Clear lacquer used for final finishing coat on furniture.

Slab-building
Forming process involving the joining together of sheets of clay of even thickness.

Slip
Liquid clay, usually of a different colour to the body of the pot to which it is applied.

Sode-daru (sashi-daru)
Literally, 'sleeve flask.' Saké flask thus named because its shape resembles a kimono sleeve. Specially made in pairs for weddings.

Stoneware
Ceramic with vitrified and water-impermeable body made from clay fired to between 1200 and 1300 degrees Celsius.

Sugi
Cryptomeria wood.

Sumi
Black calligraphy ink derived from pine soot.

Sumitori
Bamboo basket used in Japanese tea ceremony to hold chunks of charcoal.

Suzuri-bako
Box used to hold ink stone, water dropper, and dried cake of *sumi* ink.

Tabby
Simplest weave structure in which the weft (horizontal thread) passes over and under each successive warp (vertical) thread, each row reversing the order of the one before. Also called plainweave.

Take
Bamboo.

Takenouchi no Sukune
Famous fourth-century general known for his excellent skills in battle and unwavering loyalty.

Tame-nuri
General term for opaque lacquering technique used on furniture. Pigments added to the lacquer mixture to create red, brown, and black tints. Usually finished with a clear coat of lacquer.

Tango no sekku
Boy's Day celebrated on the 5th of May each year.

Tatami
A form of matting with a thick straw base covered with a soft surface of woven rush (*igusa*).

Te-aburi
Small, portable, handwarmer.

Tenjin
Posthumous name for Sugawara Michizane (845-903), Japanese statesman and scholar. Deified as the Shintō God of Literature.

Trailing
Decorative technique involving the trailing on of slip or glaze with a ladle or spouted applicator.

Tsuno-daru
Literally, 'horned flask.' Style of saké flask that takes its name from shape of water bucket designed with two, lateral slats of wood.

Tsutsugaki
A technique in which a design is drawn on fabric with rice-paste extruded from a tube. The dyes do not penetrate the pasted areas.

Uchida no kozuchi
Gold coin-producing mallet. One of Daikoku's attributes (see *Daikoku*).

Underglaze
Ceramic decoration, usually painted, applied to the body of a pot prior to glazing and high temperature firing.

Urushi
Lacquer derived from the lacquer tree, *Rhus verniciflua* (commonly called '*urushi no ki*,' 'lacquer tree,' in Japan).

Wajima nuri
Lacquering technique that originated in the fourteenth century in Wajima (Ishikawa Prefecture). Unique mixture of burnt earth and lacquer used to create a durable, thick, opaque surface.

Wheel-throwing
Forming process in which shapes are created through the action of the hands on clay rotating at speed on a potter's wheel.

Wrought iron
A contentious term, but one which is similar to forged iron but which increases the carbon content of the iron during the heating and hammering process.

Yagen
Medicine grinder.

Yokogi
Cross-piece used on *jizai kagi*. Functions as an adjuster to lower or raise pots hanging over *irori* hearth (see *jizai kagi* and *irori*).

Yoshino nuri
Unique lacquering technique that originated in Yoshino (near Kyoto). Distinguished by motifs rendered in red lacquer, painted over a black lacquer ground.

Yuto
Hot water ewer served with noodle dishes.

Zōgan
Inlay, or inlaid work.

Zudai gosho ningyō
Big-headed palace doll (see *gosho ningyō*).

Zushi-gama
Funerary urn made of stone. Often takes the shape of a miniature Shintō shrine.

Index